SCOTTISH PAINTING

— 1837 TO THE PRESENT —

SCOTTISH PAINTING

— 1837 TO THE PRESENT —

William Hardie

STUDIO
VISTA

To the memory of my father
A. W. Hardie CBE (1912–1980)
and to Gillie

The publishers gratefully acknowledge the help of
Murray Johnstone Limited, whose generous financial
support has made possible the publication of this book.

Studio Vista
an imprint of
Cassell
Villiers House
41-47 Strand
London WC2N 5JE

First published 1990

Parts of the text first appeared in the author's *Scottish Painting
1837-1939*, published by Studio Vista 1976 and reprinted with
corrections 1980

British Library Cataloguing in Publication Data

Hardie, William
 Scottish painting, 1837 to the present. – Rev. and enl. ed.
 1. Scottish paintings, history
 I. Title
 759.2911

ISBN 0-289-80022-6

Typeset by Litho Link Ltd.
Printed and bound in Spain by Graficas Reunidas

CONTENTS

LIST OF PLATES

PREFACE TO THE FIRST EDITION

During the hundred years from the beginning of the Victorian era in 1837 to the outbreak of the Second World War in 1939 – the period discussed in this short survey – Scottish artists made a lively and varied contribution to British painting. Particularly from about 1860 to 1914, painting in Scotland developed an individual character which is especially marked in the work of three successive generations of painters represented by William McTaggart and his friends trained in Edinburgh in the 1850s, the Glasgow School painters, who emerged in the early 1880s, and the small but influential group of J.D. Fergusson and the Scottish Colourists, who reached maturity in the early part of the twentieth century. I have therefore given proportionately greater attention in the following chapters to the period of little more than fifty years from the middle of Victoria's reign until 1914, during which the individual flavour of Scottish painting was at its most pronounced. When the Glasgow School painters made their London début alongside some of their older compatriots such as Orchardson and Pettie at the Grosvenor Gallery exhibition of 1890, the *Times* reviewer of the exhibition was able to discern in the work of these Scots 'a kind of family likeness' which seemed to him to indicate 'that existence of common tradition and common methods which constitutes a school of painting'. In attempting to evoke that likeness, I have tried to strike a balance between what is typical and what is not, and between what is familiar and of acknowledged importance and what is less well known but often of equal interest. My hope has been to provide a résumé of the best Scottish painters of the period, but it should be added that I have tended to prefer work by a painter or a group who began excitingly but fell away later to work which is competent but dull.

Sir John Rothenstein has recently commented in his *Modern English Painters* on the dearth of writing about English art of the later nineteenth and earlier twentieth centuries. Alas, this applies with even greater truth to Scottish painting of the same period. Although the tide of appreciation may be about to turn, at present none of the few books dealing with aspects of the subject published since Sir J.L. Caw's still indispensable and recently reprinted *Scottish Painting Past and Present* (1908) remains available, with the welcome exception of Margaret Morris's *The Art of J.D. Fergusson* (1974). Such a situation provides a *raison d'être* for the present volume, which describes the development of certain fairly well-defined movements in Scottish painting without attempting the detailed account of the careers of numerous artists, or of artists of other periods, which may be expected from the *Dictionary* by Dr McEwan, or Dr Irwin's *Scottish Painters at Home and Abroad* (1975), the former in preparation, the latter newly out at the time of writing.

ACKNOWLEDGEMENTS

The present book has had a lengthy gestation. When it first began to take shape in my mind in 1966-7, the late Professor Andrew McLaren Young and the late Dr T.J. Honeyman gave me early encouragement, which I recall with gratitude. My original intention – to outline the response of Scottish artists (hitherto perhaps undervalued because not appraised as a separate entity) to problems of style in the period 1860-1914 – was clear enough. But any historian of that period of Scottish art soon finds himself hampered by a dearth of such primary material as dealers' records or artists' letters, and by the paucity, already referred to, of recent research. As a result, it is at present difficult to reach conclusions on a number of interesting questions, such as the role of the dealers, the nature of patronage, or the theories and beliefs of some of the main artists. To the following I am therefore particularly grateful for allowing me access to manuscript material in their custody or possession, and in certain cases for permission to quote: the late Mrs M.G. Brown, formerly County Librarian, Castle Douglas, Kirkcudbrightshire, and the Trustees of Hornel House, Kirkcudbright; Mr and Mrs John Cadell; the late Dr Stanley Cursiter; Mr Ian Mackenzie Smith, Director of Aberdeen Art Gallery; Mrs Margaret Morris Fergusson; Mr Neil Foggie; Miss S. Fox-Pitt of the Tate Gallery Archive; Dr C.M. Grieve; Mrs M. Harrison; Dr Margaret McCance; Mr R.O. Mackenna, Librarian of Glasgow University; Mrs N. Mills and Mrs Helen Sandercock (granddaughters of Sir W.Q. Orchardson); Mr Denis Peploe; Miss Marjory Robertson of the MSS Department of Edinburgh University Library; Mr S. Simpson of the National Library of Scotland; Miss J. Macaulay Stevenson; Dr Ruth Waddell; the late Professor Emeritus John Walton; and Mrs J.I.C. Wilson and her father, the late Dr T.J. Honeyman.

The chief documents remain the paintings them-

selves. Here also, however, there are obstacles to a full study. The present whereabouts of too many once-exhibited pictures remains a mystery, and even those in public collections are often not catalogued or documented or easily seen. To the many individuals who in a public or private capacity have shown me paintings I therefore owe a very real debt, for without their cooperation and hospitality this book could not have been written. To those collectors and institutions, acknowledged individually elsewhere, who have allowed their pictures to be reproduced here I am especially grateful.

For over a decade a few special exhibitions arranged in public galleries, by the Scottish Arts Council, and by the Fine Art Society have provided the best available opportunity of seeing Scottish painting and have been almost the sole evidence of interest in the subject. With the encouragement of Mr J.D. Boyd, my Director at Dundee City Art Galleries and Museum, I have been fortunate enough to be involved in some of these exercises in revaluation, and I am indebted to Mr W. Buchanan, Art Director of the Scottish Arts Council, and Mr Andrew McIntosh Patrick of the Fine Art Society, and also to Mrs H. Maclean, editor of the *Scottish Art Review*, for permission to use material they have published in the past over my name. Much of the research embodied in this book was carried out initially for exhibitions.

The Scottish Arts Council and the Carnegie Trust for Universities in Scotland have contributed substantial grants towards the publication costs of this book, and I duly tender thanks to the Art and Literature Committees of the Council and to Professor Anthony Ritchie, Director of the Trust, and his Trustees for their generous support. My studies have been aided by research grants from the Paul Mellon Centre for Studies in British Art (London). A travel grant from the same source, added to funds made available by the English-Speaking Union of the Commonwealth and by the Corporation of Dundee, enabled me to undertake a study tour of galleries in the United States and Canada in 1973. To Professor Ellis K. Waterhouse, then Director of the Mellon Centre, Mr Ian Gilmore, Director of the English-Speaking Union

of Edinburgh, and their Trustees, and to the Museums and Art Galleries Committee of Dundee I acknowledge my appreciation. It should also be recorded that Mrs Ailsa Tanner conducted extensive bibliographical research for this book at my request, and that Mr David Walker, Mrs J.I.C. Wilson, and Mr N.S. Macfarlane have shown extraordinary tolerance of my tendency to borrow for indefensibly protracted periods from their bookshelves. For a variety of kindnesses I should also like to thank Mr Stephen Adamson of Studio Vista; Mr L.A. Arkus, Director of the Carnegie Institute of Pittsburgh, Pa; Miss Elizabeth Aslin; Mr Donald Bain; Mr Roger Billcliffe of Glasgow University Art Collections; Miss Vera Black; Dr David Brown of the Tate Gallery; the Dowager Countess and the late Earl of Crawford and Balcarres; Mr and Mrs Stanley Baxter; Miss Elizabeth Cumming, Keeper of Art, Edinburgh City District Council; Mr George Buchanan, Deputy Director, and Miss Anne Donald, Assistant Keeper, at Glasgow Art Gallery and Museums; Mr J. Davidson, formerly Curator of Perth Art Gallery and Museum; Miss Dilys Davies, Curator of Kirkcaldy Art Gallery; Mr Andrew Dempsey; Mr Brinsley Ford; Frances Hamilton; Mrs M. Harrison; Mr David Herbert of the Graham Gallery, New York; Mr Alex Hidalgo of Aberdeen Art Gallery and Museum; Professor Thomas Howarth of Toronto University; Mrs Margaret Macdonald of Glasgow University Library; Professor Alex Macfie; Mr Joseph McIntyre, Curator of the Orchar Art Gallery, Broughty Ferry; Mr Ian McNicol; Mrs Hazel Nichols; Mr Richard Ormond of the National Portrait Gallery; Miss Sybil Pantazzi of the National Gallery of Ontario, Toronto; Mr George Parks, formerly of Dundee Central Reference Library; Mr Andrew McIntosh Patrick of the Fine Art Society; and also Mr Peyton Skipworth, Mr Simon Edsor, and Mrs Una Rota of the Fine Art Society; Mrs Emily Pulitzer of the St. Louis Art Museum; Mr J. Roussakov of the Leningrad Library; Miss Magda Salvesen; Mrs Morag Sharp; Mr Robin Spencer of St. Andrews University Fine Art Dept.; Vice Admiral Sir James and Lady Troup; Susan Waterston; and especially my wife, Gillian.

William R. Hardie
Broughty Ferry, April 1976

PREFACE TO THE SECOND EDITION

When *Scottish Painting 1837-1939* was reprinted in 1980 a few errors were corrected but the text was not otherwise altered. The publication of this new edition of the book has provided a welcome opportunity for a necessary enlargement of the existing text together with the addition of three new chapters to bring the tale up to the present day. As a result, the present volume is more than twice the length of the original. Some may say that it is too long, others, including the author of course, that it is still too short. The book was never intended to be an encyclopaedia, and although that might have been one way of solving problems of balance and content, it would have meant sacrificing the narrative thread. My method has been to try to trace the elements which have gone into the formation of an artist's style. I believe that the processes by which an artist first arrives at maturity and individuality often – though not always – provide the key to later productions as well. Hence a tendency throughout the book to concentrate on earlier work.

I have tried to rectify some omissions which seemed to me important and also to expand or clarify where necessary. The chapters on The Glasgow School, the Fin de Siècle, and Between the Wars have been substantially rewritten and three final chapters are added to bring the story to a more resounding conclusion than was permitted by the earlier, decidedly downbeat, terminus of 1939. It is a satisfaction to have been able to publish several interesting documents which shed new light on important areas, notably Macaulay Stevenson's *Notes towards a History of the Glasgow School*, Anne Mackie's *Diary*, which includes an account of a visit paid to Gauguin, and some letters written by Stanley Cursiter about his Futurist paintings of 1913.

In my Preface of 1976 I lamented the paucity of the literature on Scottish painting. How different is the situation today, when interest in the subject by scholars, collectors, galleries and auctioneers has never been greater. Subsequent years have seen the publication of the short illustrated monographs on Modern Scottish Painters published by The Edinburgh University Press and Edward Gage's survey of contemporary Scottish painting which he titled *The Eye in the Wind*; Billcliffe's invaluable studies on C.R. Mackintosh and the same author's contributions to the literature of the Glasgow Boys and the Colourists; monographs by other authors on Dyce, Crawhall, Cadell, Redpath, Eardley, Walton, Russell

Flint and Blackadder; and autobiographies by William Johnstone and Benno Schotz, together with an extensive list of exhibitions with useful catalogues. Among the most important of these have been *Tribute to Wilkie*, *Master Class*, and *William McTaggart* at the National Gallery of Scotland, and *Scottish Art since 1900*, which is being shown in London as I write. I have aimed to reflect as much as possible of all this in the revisions to the Bibliography. The absence of footnotes was decided on for the first edition, and those interested in the primary sources used should consult the Bibliography, where I have tried to list them all.

ACKNOWLEDGEMENTS

Raymond Johnstone, Chairman of Murray Johnstone Ltd., heads the list of those to whom my gratitude is due. His interest in the new edition of *Scottish Painting* led to his distinguished company's association with the publishers in the production of this book. That he should have found time to become involved while steering Murray Johnstone Ltd. to their present eminence as one of Scotland's most successful financial enterprises, with the chairmanship of Scottish Opera and, more recently, of the Forestry Commission and Scottish Financial Enterprise making additional demands, is to me a matter of wonder. I here record my heartfelt thanks to him. His fellow board members at the head office of Murray Johnstone Ltd. in Glasgow have also been immensely supportive and helpful at various stages: Nick McAndrew, Ross Peters, and Fred Dalgarno. At Cassell, Barry Holmes as Senior Editor has been enthusiastic, practical and professional – everything an editor should be and more – from the start of our lengthy project. Lai-Ngau Pauson has compiled the Index and Ailsa Tanner has assisted with the Bibliography. I would also thank my readers, who, in exhausting two impressions of the first edition, have provided the conditions for a second one, which permits me to amplify and modernize the text. I renew my thanks to those acknowledged in 1976, and I would like to add the names of the following for their kind assistance in various ways: the owners of pictures reproduced; the many private collectors who have so generously shared with me their delight in their treasures; Louise Annand; Eunice Bain; Richard Calvocoressi at the Scottish National Gallery of Modern Art; Dr J. Lorne Campbell; Dr James

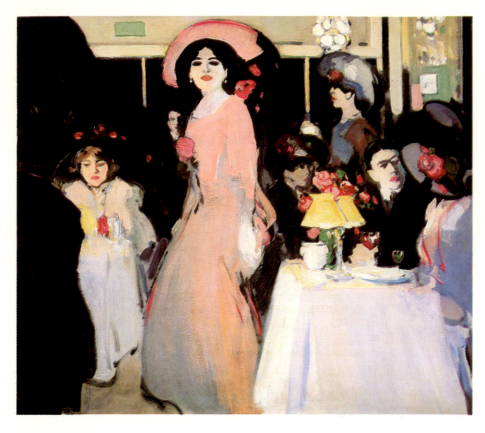

1 John Duncan Fergusson
La Terrasse, le Café d'Harcourt
c.1908–9 Oil 108.6 × 122 cm
Private collection
(Photograph: Scottish National
Gallery of Modern Art)
Painted at the Café d'Harcourt in
Paris, a favourite haunt of the
French artistic community, and
never short of attractive ladies
happy to model for the resident
artists. See Chapter 8, p. 127.

Coxson; Andrew Crawford, formerly of Christie's; Richard Demarco; Mr and Mrs M.C. Everist; the late Sir Hugh Fraser Bt.; Anne-Marie Fitzpatrick at Turnkey Computers; the Governors of Glasgow School of Art for permission to quote in full Charles Rennie Mackintosh's description of his *Cabbages in an Orchard*; Principal and Mrs M. Hamlin of the University of Dundee; Susan Hardie; Colin Harper; Professor J. Ross Harper; Iain Harrison; Ronald Harrison; Professor Thomas Howarth; Joan Hughson; James Hume; Margaret Cursiter Hunter; James Hunter Blair; William Jackson of the Scottish Gallery; the late William Johnstone; Jack Knox; the Librarians of Gray's School of Art, Aberdeen, and the Edinburgh College of Art; Ian McCulloch; John Milne; the Earl and Countess of Moray; James Morrison; the Trustees of the National Library of Scotland for permission to quote from Anne Mackie's Diary; Sir Robin Philipson; Fiona Robertson, who has so capably held the fort back at the William Hardie Gallery in Glasgow; Bill Smith at Robert Fleming Holdings Ltd.; George Smith; William Turnbull; the University of Glasgow (Mackintosh Collection) for permission to quote from Charles Rennie Mackintosh's 'Seemliness'; and Clara Young at Dundee Art Gallery.

William Hardie
The Steele, Roxburghshire,
and
New Lanark, Strathclyde,
April 1990

INTRODUCTION TO THE FIRST EDITION

It might be expected that a small nation lying on the Atlantic fringes of Europe, remote from the continental sources of style but inextricably if not always amicably linked to its southern neighbour, would develop qualities both independent and derivative, with the latter perhaps predominating. Scotland's contribution to the arts, reflecting her long but often turbulent past in which for centuries stability and prosperity could hardly ever be taken for granted, bears this out. Beginning about the year 397, when St. Ninian founded a monastery at Whithorn in Galloway, and especially after the arrival of St. Columba and his missionaries on the Hebridean island of Iona in the year 563, Scotland echoed the Celtic, Norman, and Gothic phases of Christian art, usually belatedly. Her sculptured stones and illuminations and her abbeys and cathedrals show successive Irish, Anglo-Norman, or Anglo-French influence, often interpreted with power and conviction, but containing little enough that is *sui generis*. The great *Book of Kells*, probably executed on Iona, shows a dominant Irish influence, and only the still-unelucidated symbol stones and sculptured cross slabs of the Picts represent a high level of indigenous art, but one which had no sequel beyond the Dark Ages. It is to the much later vernacular architecture of Scotland, from the medieval castles and keeps of the feudal aristocracy to the stone houses built for gentry and burgher in the sixteenth and seventeenth centuries, that one must look to find the beginnings of a tradition as native as the early works in dialect to which can be traced the origins of Scottish literature.

The Reformation in Scotland deprived painting of the patronage which at its most enlightened had brought to Edinburgh the *Trinity Altarpiece* by Hugo van der Goes at the end of the fifteenth century. However, by the time of the Union of the Crowns of England and Scotland in 1603 under James I and VI, son of Mary, Queen of Scots, the taste of the Stuarts and a few aristocratic houses for the secular graces of life had begun to bear fruit, as the palace of Linlithgow (completed in James V's reign) and the walled garden pleasance at Edzell Castle (completed in 1602) testify. But seventeenth-century England, rather than Scotland, was to be the scene of the great period of Stuart patronage. A remodelling of the Edinburgh palace of Holyroodhouse was the largest royal commission received by the distinguished Scottish contemporary of Wren, Sir William Bruce (1630-1710). The removal of the Scottish court to London in 1603 meant a considerable loss of artistic patronage in Scotland, and partly explains the attractive unpretentiousness of the best local work of the period, particularly in architecture, as well as the feeble condition of painting at the same time.

In Scotland as in England, easel painting in the seventeenth century was chiefly the preserve of Flemish-influenced portraitists, the earliest of whom was the Aberdeen-born George Jamesone (1587?-1644). Jamesone had an extensive but not very lucrative practice in Aberdeen and later in Edinburgh, and his apparent prosperity at his death may have been due to being involved in picture-dealing — a possibility suggested by his *Self-Portrait* (collection Earl of Seafield) posed against a background of pictures. In the century and a half from Jamesone's time until Raeburn's return to Scotland from Italy in 1787, during which Italian taste eclipsed Flemish, the best Scottish painters almost invariably left Scotland for long periods to work as expatriates, like Gavin Hamilton (1723-98) and Jacob More (1740-93) in Rome, or Allan Ramsay (1713-84) in London. The most famous of the architects who undertook the Italian journey and then practised in London was Robert Adam (1782-92), who in a letter of 1755 gave succinct reasons for not staying at home: 'Scotland is but a narrow place. [I need] a greater a more extensive and more honourable scene, I mean an English Life.' A training abroad followed by residence in London was still the normal pattern for Scottish artists who wished to be successful.

Although it produced a further concentration of patronage in London, the Act of Union of 1707, which united the Parliaments of England and Scotland, left virtually untouched such important attributes of national identity as the Scottish judicature and the body of Scots Law, the ancient universities of St. Andrews, Aberdeen, Glasgow and Edinburgh, the Kirk, the parish schools, and the Scottish army regiments. Its great benefit to Scotland was that for the first time for centuries a basis now existed for the development of a stable and prosperous community. Above all, freedom of trade, encouraged by the Act and given an internationalist direction by Adam Smith's *The Wealth of Nations* (1776), had a gradually invigorating effect on the Scottish economy. Government-sponsored instruction in design-related subjects was instituted in Edinburgh with the foundation of the Board of Manufactures in 1727, although painting was not taught at the Trustees'

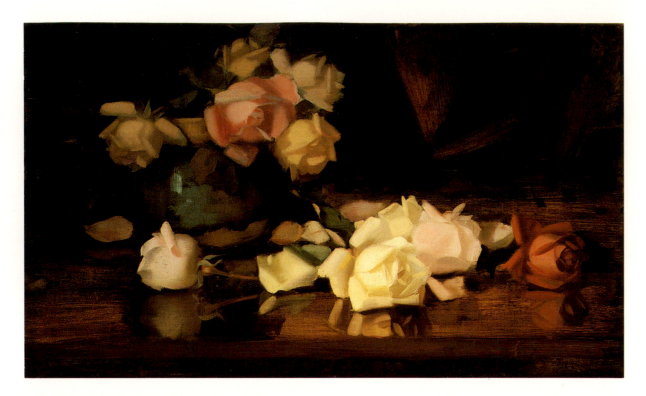

2 James Stuart Park
Yellow, Pink and Red Roses
c.1888 Oil 46.5 × 76.5 cm
Private collection
One of the small group of flower
paintings of 1888–89 that form
Park's contribution to the
decorative style of the Glasgow
School.

Academy until the end of the eighteenth century and the exodus of Scottish artists from Scotland continued. However, the last quarter of the century witnessed a remarkable upsurge in the cultural life of the country – Robert Burns and Sir Walter Scott in poetry and the novel, David Hume in philosophy, and Raeburn in painting – which was owed to the new prosperity, or rather to the more evolved and sophisticated society which it helped create. By the beginning of the nineteenth century, especially in Edinburgh, where the Adam contributions to the New Town had been built by 1800, most of the necessary preconditions for the foundation of a national school of painting were at last present.

Only one factor was missing: the existence of a sustaining native tradition. This could not be supplied overnight. Scottish painting of the first half of the nineteenth century still tended to look to London or Rome or even Madrid for inspiration, even if Velazquez reminded David Wilkie (1785-1841) of Raeburn, or if Wilkie himself seemed to many of his fellow Scots the chief ornament of contemporary English painting. The nineteenth-century Scottish school owed much to Raeburn and Wilkie, but in a limited sense only. Their individual importance as the most eminent and successful Scottish artists of their respective eras brought them numerous imitators, but their influence on their more progressive successors (as distinct from followers) was slight or transitory. Raeburn's technique was much admired but its relevance was chiefly to portraiture and his followers (with the exception of the young Wilkie) were on the whole craftsmen who lacked his artistry. Wilkie's, on the other hand, produced a type of rustic or historical genre which was easily trivialized and it

had an unhappy influence on a good deal of subsequent Victorian painting, English and Scottish (as did his unsound later use of asphaltum).

In fact, the most interesting of the Scottish painters who came to prominence in the years between Queen Victoria's accession in 1837 and the rise of the Scott Lauder group in Edinburgh about 1860 – the post-Wilkie generation – are those whose mature styles show little or no Scottish influence as such: David Scott, William Dyce, Noel Paton, Scott Lauder, and the later John Phillip. These artists spent important formative years outside Scotland – in Rome or in London – and the professional careers of Dyce, Lauder, and Phillip belong largely to the history of painting south of the Border. Later, when Pettie and Orchardson and others in the 1860s went to live in London, they were already equipped with a Scottish training which had a fundamental and lasting influence on their work. Prior to about 1860, then, there had indeed been Scottish painters, but not a readily identifiable Scottish style, whereas after that date a few of the more forward-looking artists in Scotland adopted methods significantly different from those current elsewhere in Britain. In addition, a measure of stylistic cross-fertilization and self-propagation was reached and sustained which allows Scottish painting of the period 1860-1914 to be seen as a distinct species, its blooms often short-lived and tending to reticence, and occasionally showing some want of cultivation, but nevertheless possessing an identity and character of their own.

Within that period, the Scottish school is a school of little masters in which the whole is greater than the sum of its parts. Some of them, indeed, are essentially *homines unius imaginis*, men of one picture. Stuart

Park, for example, would seem relatively insignificant were it not for his *Yellow Roses* now in Glasgow Art Gallery, painted in 1889 when the artist was twenty-seven. Equally, it is somehow characteristic of the cultural climate in Scotland in the nineteenth century that the creative years of several of her best painters were relatively brief, and usually occurred in the earlier part of an artist's career. David Scott (1806-49), Thomas Duncan (1807-45), George Paul Chalmers (1833-78), Arthur Melville (1858-1904), and George Dutch Davidson (1879-1901) all seem to have died too young, while the Glasgow School painters' best work was done in little more than a mere decade between 1885 and 1895 whereupon bathos rapidly supervened. Anything approaching an *avant-garde* in Scotland never quite found the strength or the encouragement it needed to take firm root, and much of the best painting was the product of a youthful originality which was all too soon nipped in the bud. Often, it is not hard to imagine how this happened. Reading the lengthy correspondence (preserved in the National Library of Scotland) between George Paul Chalmers and the patient and discerning Dundee collector G.B. Simpson in 1864-5, which refers to the painter's difficulties in composing

The Legend (never quite finished and now in the NGS), one becomes aware of the penalty paid by a talented artist for his isolation from enlightened, as opposed to well-meaning, patronage and the contact of intelligent colleagues in an artistic backwater. Had Edinburgh only been Paris! Perhaps Chalmers might have discarded his tonal palette and experimented with an optical mixture of colours on the canvas; perhaps we should have had McTaggart paint the steam locomotives in Waverley Station and life in Edinburgh as well as the Scottish coast and countryside; perhaps Orchardson would then have painted the contemporary London theatre of which he was so fond, instead of wasting his talents on factitious *Directoire* costume pieces.

Yet unexpected parallels with contemporary developments in Europe do sometimes arise in the work of the more adventurous younger Scottish artists in the latter half of the nineteenth century. Those youthful phases did not, of course, consciously aspire to the condition of advanced painting in Paris (or later, in Munich or Vienna), but rather offered independent and less complete solutions to somewhat similar problems. McTaggart's canvases bring us as close to the spirit of Impressionist landscape as

3 George Paul Chalmers
The Legend
Begun 1864 Oil 102.9 ×
154.3 cm
National Galleries of Scotland

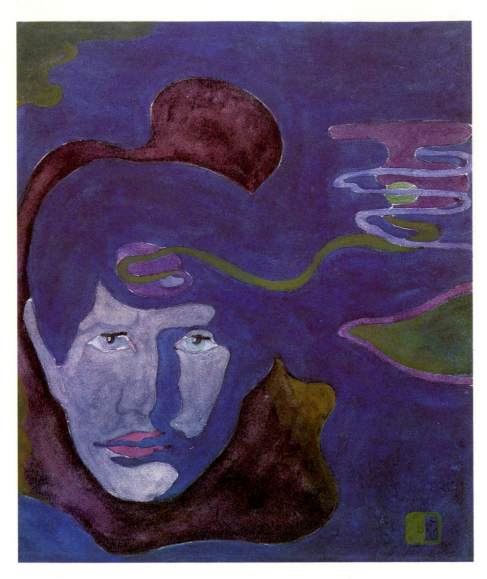

4 George Dutch Davidson
Self-Portrait
1898 Watercolour 30.5 ×
25.4 cm
Dundee Art Gallery
This psychoanalytical portrait
seems to situate the eighteen-
year-old artist in an aerial plan of
the Tay Estuary, where he lived.

remained remote from the European *avant-garde*. Much more representative of the everyday tenor of Scottish painting was and is the Royal Scottish Academy (founded in Edinburgh in 1826 and granted the royal charter in 1838), whose period of greatest authority lasted until the 1860s. Modelled on the Royal Academy, the Royal Scottish Academy's chief *raison d'être* was its annual exhibition; until 1858 (when a Treasury minute made it responsible for a Life Class) it appears not to have seriously rivalled the government-sponsored Trustees' Academy as a teaching institution. This was founded in 1760 in Edinburgh, but from the headmastership of William Allan in 1826 its posts were held by Academicians. The RSA thus filled a crucial rôle from its inception as the main channel of patronage and, less directly, as an influence on style and taste. Its spirited early struggle for existence, its popularity as 'the most fashionable lounge in Edinburgh', the fact that its early membership constituted a roll of the best painters in Scotland, and its usefulness to struggling young artists, made it widely respected by artists and laymen alike. It was to set the tone of Scottish painting until the middle of Victoria's reign, when its tenets began to be questioned.

The architect C.R. Cockerell, writing to his friend William Dyce in 1838 to console him on the failure of his candidature for Associateship of the Royal Academy, refers to 'an old superstition that "when we shall have five Scotchmen in the RA of London, it will be a Scotch Academy"'. Partly perhaps from necessity, the early Victorian painters in Scotland were convinced supporters of the academic system; and they show what that system, in a state of innocence, was capable of producing. The provincial situation of Edinburgh seemed for a while to foster talent rather than to inhibit it; local artists – those who did not go to London – were concerned and often content with local reputations; and from the 1830s onwards the RSA exhibitions contained pictures which ranged from David Scott's ambitious and imaginative essays in the grand manner to the native genre of George Harvey (1806-76) and the Scottish landscapes of Horatio McCulloch (1805-67). It is typical of the devotion of the RSA in its first decades to serious and sensitive craftsmanship even in a novel medium that the Secretary of the Academy from 1830 to 1869 was the pioneer photographer D.O. Hill. Were the pictures of the era immediately after Wilkie in Scotland more easily seen – and many of them have disappeared – it is quite likely that they would prove more interesting than we generally allow today. Their influence on the next generation of artists was limited to the more incidental aspects of national style, such as themes taken from Scottish history or literature. But the RSA itself broke valuable ground in gaining a wider audience for painting in Scotland, and in emphasizing the virtues of sound craftsmanship. The sheer professionalism of

the work of any other British painter, although his son-in-law tells us that he did not see a work by Monet until 1902. Certain pictures by the Glasgow School and their contemporaries contain elements of Symbolism or Expressionism, others are reminiscent of the Nabis, and contacts (albeit rather tenuous ones) can be shown to have existed between the Scots and Gauguin, Van Gogh and Sérusier. John Duncan's *Evergreen* illustration *Surface Water* (1896) and Georges de Feure's lithograph *La Source du mal* (1897); George Davidson's *Self-Portrait* (1898) and Edvard Munch's lithograph *Im Menschenkopf* (1897); J.W. Herald's crinoline ladies of the nineties and Kandinsky's *Lady with Fan* (Roethel 2; 1903) are only three instances of a sometimes striking parallelism. J.D. Fergusson both looks and was a member of the post-Cubist school of Paris, and represents the conscious francophilism of a later generation of painters. In a few of the works of artists such as these, Scotland contributes a marginal gloss to the European canon.

Comparisons of this kind are, however, only rarely appropriate, because on the whole Scottish artists

much nineteenth-century painting in Scotland is largely due to the stimulus provided by the early exertions of the Academy. 'The never-failing dexterity of the Scotch' (in Ruskin's words) became something of a commonplace of later Victorian art criticism as a result.

In the 1860s, however, attitudes to the Academy and to what it represented changed subtly. When William McTaggart became an Associate of the RSA in 1859 his father had advised against acceptance with the words 'you are better to be free'. According to his biographer McTaggart later regretted having accepted. In the previous year control of the Trustees' Academy passed into the distant hands of the Department of Science and Education at South Kensington; Scott Lauder was the last Master under the old regulations, and the change seems to have been to the detriment of the academic instruction available to artists in Edinburgh, or at the very least to have offered nothing to challenge the rising attractions of study elsewhere, especially in France. With the foundation of the Glasgow Institute of the Fine Arts in 1861 the RSA's virtual monopoly of large annual exhibitions was at an end. To make matters worse, the Academy began to adopt a position which made it difficult for Glasgow artists to become members, culminating in open hostility between it and the young men of the early Glasgow School in the 1880s.

The Glasgow School's most vital period coincides with the time of its strongest antipathy towards the RSA, and it is worth remarking that this anti-academic feeling resulted not only in new exhibiting habits, but also in a novel approach to the training of the artist. The life classes held in Glasgow in W.Y. Macgregor's studio seem to have resembled the more informal kind of Paris atelier, and were an important factor in cementing a group style among the young artists who attended them. But it is equally noteworthy that many of these artists later became Academicians, a reminder that in the context of Scottish painting the word 'independent', meaning anti-academic, must be used with caution. Yet it can begin to be applied to the early eighties in Glasgow, well before the nugatory 'London Salon of the Independants' (*sic*, the French spelling unnecessarily emphasizing its origin) which J.D. Fergusson and others (including Alexander Jamieson and Charles Rennie Mackintosh) attempted to re-start at the end of the First World War. The gradual rise of this independent strain gives to Scottish painting of that time its own leaven of individuality. At its most general, this can be equated with an increasingly complete departure from academic technical procedures involving high finish and imitative drawing. Gradually too, conventionally sentimental subject-matter of the sort associated with the Academy was abandoned.

'Painterliness' – a consistent reliance on the expressive possibilities of the brushstroke and on the beauties of the medium of oil paint itself – is a notable characteristic of the work of many of the Scottish artists discussed in this book. It is precisely this quality which enables Orchardson and Pettie in their best pictures to walk the difficult tightrope of genre, as Wilkie had done before them, with an indefinable balance of delicacy and strength usually lost in reproduction and forgotten in the rush to label these painters 'literary'. Although in other technical respects they and their contemporaries differ from the artists of the Glasgow School as much as the Glasgow School differs from the Colourists, it is possible to distinguish a continued predominance of the painterly mode in each of these phases of Scottish art. The national taste seems to have been for the well-made article, in terms of oil pigment which declares its own natural properties and is rarely illusionistically disguised or, at the other extreme, used as a mere vehicle of anecdote or theory.

It is tempting to wonder whether the conspicuous materiality of Scottish painting may be linked in some way with the Scots' apparent feeling for the sister discipline of architecture (and indeed for naval architecture and engineering) in the same period. But before invoking a hypothetical Scottish collective unconscious which would prefer concreteness to abstraction and the working definition to the general theory, it is as well to bear in mind that 'inhabitable sculpture', as architecture has been called, has precisely the economic and social advantage over sculpture that it is inhabitable. Sculpture has long made rather a poor showing in Scotland, except as commemorative portraiture or architectural ornament. On the other hand, a significant contribution was made by Scottish architects and designers to the succession of styles in Britain from Gothic Revival (J. Bruce Talbert, 1838-81) and Victorian neo-Greek (Alexander 'Greek' Thomson, 1817-75), *via* Aestheticism (R. Norman Shaw, 1831-1912) and the Art Nouveau (George Walton, 1867-1933) to the Modern Movement (Charles Rennie Mackintosh, 1868-1928). Indeed, the most considerable figure of the whole period now appears to us to have been not a painter, but an architect, Charles Rennie Mackintosh, whose work combines independence of thought and respect for traditional materials in a way that is wholly although not exclusively Scottish.

Nineteenth-century Scottish architecture indicates by its rich variety the vigour of a society based on flourishing commerce and ever-accelerating industrial growth. Throughout the Victorian and Edwardian eras Scots played a full part in the development of Britain as the industrial centre of the Empire, and in the development of the Empire itself. Queen Victoria's attachment to Scotland was in the main fervently reciprocated, as well it might be, since the Scottish cities, particularly Glasgow, had never seen such prosperity as resulted from the Union under her reign. Yet although nineteenth-century Britain was pre-eminently an industrialized community one

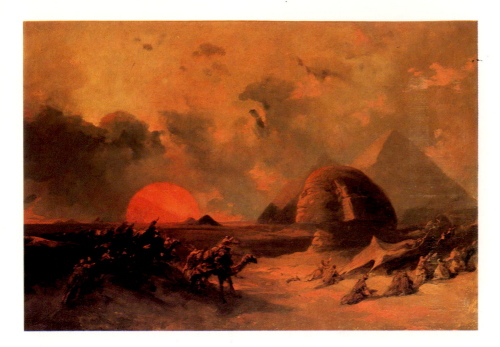

5 David Roberts
A Recollection of the Desert on the Approach of the Simoon
1850 Oil on panel 33.6 × 50.1 cm
Private collection
(Photograph by courtesy of the Fine Art Society)
The artist inscribed the back of the painting: 'Presented to Charles Dickens Esqre as a mark of respect and admiration for his talent and work by his very sincere friend and admirer David Roberts Jan 1850'. The composition was first published in Robert's *Egypt, Syria and the Holy Land*, 1846–50.

tion of the properties of the isotope in 1913; the Clyde-built liners *Queen Mary* (1934) and *Queen Elizabeth* (1938); James Logie Baird's work on television in the 1920s and Watson Watt's development of radar during the Second World War. In all theses examples, chosen at random, there is a notable absence of metaphysical speculation; intellectual inquiry is directed to physical problems and inventive energy to practical results. But if Scottish culture during the period discussed was quintessentially materialistic, it evidently was not devoid of vitality and originality nor was it without influence on the shaping of the modern world.

With the sole exception of William Dyce, Scottish artists had little or no direct contact with scientific advance, or apparent interest in it. Significantly, it was left to a French artist, Camille Pissarro, to refer in a famous letter of 1886 to Durand-Ruel to the relevance to contemporary painting of the colour experiments of Dyce's relative Clark Maxwell and others.

On the other hand, had Scottish patrons shown more willingness to regard painting as being susceptible to the tests of intelligence as well as to those of sensibility or sentiment, there might have been greater evidence in the work of the painters of real involvement with the main currents of thought of their own time. But science and art were out of touch with each other and their very polarity partly accounts for the presence of a mood of escapism or fantasy in Scottish art of the period.

The widespread belief that 'beauty', which was often mentioned but never conclusively defined, was the artist's chief goal was pernicious to much Victorian art because it led to a confusion of aims. The achievements of Victorian engineering might have suggested that engineers, and perhaps painters too, are more likely to create at a high aesthetic level when they submit to the physical disciplines imposed by their materials rather than when they endeavour self-consciously to realize a concept of beauty. The best of Victorian and Edwardian Scottish painting has a certain plastic emphasis which parallels the approach of those engaged on the other side of the cultural divide.

would hardly guess so from Scottish painting or literature of the period. In England the contemporary school of painting was accompanied by remarkable achievements in literature, particularly in the novel, and some painters such as the St. John's Wood Clique and writers like Dickens did indeed deal with the new realities of modern life. This was not paralleled in Scotland, where an Arcadian rusticity was the staple commodity of many genre painters and of the 'kailyard' schools of novelists and poets. If one can judge by the importance of the results, the Scottish intellect seemed to find its most characteristic expression in the area of technology and the physical sciences. Here it can be noted that some of these achievements include the civil engineering projects of Thomas Telford (1757-1834), one of which Sir Walter Scott regarded as the greatest work of art, and the Forth Rail Bridge (1890); Henry Bell's *Comet* (1812) and the *Cutty Sark* (1869); the work of James Clark Maxwell (1831-79) in telegraphy, optics, and X-rays and Lord Kelvin's restatement in 1851 of the Second Law of Thermo-dynamics. From the twentieth century one can cite Frederick Soddy's descrip-

INTRODUCTION TO THE SECOND EDITION

The Modern Movement in painting, as in architecture, has led away from representational values (historicism in architecture is only representation in another guise). Dadaism and Surrealism in Europe (with their frequent use of collage or readymades which allowed real objects to be incorporated into paintings and even sculpture, suggesting the artificiality of the division between art and reality), fundamentally changed the techniques and procedures of art, sometimes blurring the old distinctions between the different disciplines of painting, sculpture, printmaking and photography. Cubism and its offshoots connect ultimately with Realism in the classic succession of Courbet–Cézanne–Picasso; Surrealism adds dreams to the artist's subject-matter; but abstract painting in Europe and America introduces radically new thematic material as well as new techniques. The post-war dominance of abstract and conceptual art led to a situation where the linguistics of art were becoming more important than what it had to say. Such extensions of the parameters of art possess their own logic, but they have seemed to some to offer only a *reductio ad absurdum*, at best a diversion from traditional methods and concerns. Hydra-headed Modernism (abstraction, Pop, colour field, Op, Tachisme, minimal, conceptual art) in the belief of some artists of the eighties, had had its day. The best one could make of it was to teach it at an art college; the public collections were full of it and did not want any more, and the art galleries could not sell it even to them. The fact that the galleries which presented modernist work in Scotland were with the honourable exception of the Scottish Gallery almost to a man non-profit-distributing companies limited by guarantee – in other words, in enjoyment of charitable status – spoke for itself. Pluralism had arrived. In another form, it provided patronage through the exhibitions and purchases of the public galleries on an unprecedented scale. The new bureaucracy provided welcome support for uncommercial work, but it sometimes failed to discern that not all 'difficult' art is good art.

Writers on art are often justly accused, by artists as much as anyone else, of employing terms which cast an air of spurious intellectualism, pretentiousness or preciousness – and sometimes all three – over the subject. Problems arise when attempts are made to reflect the social, political, psychological, and historical aspects of art in a vocabulary which loads words with an unbearable weight of would-be significance.

We are too often confronted with a word which, like a cuckoo in the nest, is more imposing than helpful. 'Eidetic imagery' only means image-imagery; 'pluralism' can mean anything from public-with-private to abstract-with-concrete; 'post-painterly-abstract' and 'post-modernist' are manifestly absurd; 'post-modernist consensus' or the lack of it (a fashionable obsession today) is a chimaera, a will-o'-the-wisp, which has something to do with whether or not the ivory tower is believed by its occupants to be haunted. 'Trans-avant-garde' is not a place imagined by Bram Stoker, although it is true that Van Helsing, the mild-mannered doctor who disposes of Dracula, has appeared in paintings by one of the Scottish trans-avant-garde, Steven Campbell. 'Trans-avant-garde', incidentally, means roughly the same thing as 'post-formalist'.

Yet these and similar neologisms, frequently used in discussions of Scottish painting of today, reflect the search for new modes of expression which inevitably take account of the developments of the past, especially the recent past, and therefore are equally inevitably post-something or other: post-structuralist, post-conceptual, even post-painting. New Image painting in Glasgow today is indeed eidetic in the sense of dealing in strong, memorable images, which reassert the importance of the human figure and human action. This return to centre stage of the theme of humanity after decades of formal experimentation is sometimes called post-formalist. On the other hand, non-figurative painting, as we have seen, historically divides into two modes, the geometrical and the painterly; and in recent Scottish painting certain young artists (that is, artists who are ten years or more younger than the author), many of them connected with the 369 Gallery in Edinburgh, have continued within the traditions of painterly abstraction – although their work frequently has a figurative basis.

Although the recognizable Scottish hallmarks of strong colour and vigorous brush work are continued in the work of the 369 artists in Edinburgh, it is the Glasgow artists who mirror the social and psychological realities of modern Scotland.

New Image Glasgow was the apt title of an exhibition at the Third Eye Centre in Glasgow in 1985. The city was undergoing a period of far-reaching change as it attempted to slough off the accumulation of decades of industrial stagnation and the sooty patina which was its visible symbol. The

erection in the early eighties of exciting new buildings to house the Hunterian Art Gallery at the University and the Burrell Collection in Pollok Park was a sign, literally as well as metaphorically, of a better atmosphere. Sir William Burrell's stipulation of a site outside the city had been able to be waived by his Trustees as an anachronism, since the estate gifted by the Stirling Maxwell family was centrally located in a city whose air was now clean enough to pose no threat to Sir William's great collection of tapestries. In terms of cultural provision the city had never been livelier. Music, the theatre, the ballet and the opera were in a thriving condition. Mixed-economy funding, a determination at City Chambers to get things done in co-operation with business or central government despite political differences, and an evident public desire for a city of which its inhabitants could again be proud: all these factors determined the course which led to Glasgow's accolade as European Capital of Culture in 1990.

The demise of the old skilled labour-intensive industries had left swathes of unemployment in some of the largest housing estates in Europe whose bleak architecture, reminiscent of East Berlin, could no longer be indulgently viewed as the aberration of post-war utopianism. The glamorous restoration of Glasgow's architectural splendours co-existed with inner-city deprivation. Those who experienced the latter found themselves as much stranded by economics as those who lived in the estates were physically separated from the good things that were happening in town. A local government responsible for institutions of national importance cannot be blamed if its first thoughts are for the neediest of its own constituents. The concern continues and so must the transformation which had already achieved so much. In this contemporary dilemma Glasgow may be seen as a microcosm of Scotland – and of conurbations anywhere in the world where man aspires to live by more than bread alone.

1 PORTRAITURE AND LANDSCAPE IN EDINBURGH

When Queen Victoria came to the throne in 1837, certain artistic bodies were beginning to place in Edinburgh's possession facilities for the nurture of the fine arts which were markedly superior to anything that had previously existed north of the Border, and which for several decades represented the best available outside London. The recent past had produced Sir Henry Raeburn, Alexander Nasmyth, and Sir David Wilkie, the last two still living, from whom Scottish Victorian portraiture, landscape and genre received their first impetus. Fortunately, the rising generation of painters at this period included a wider cross-section of talented artists than any earlier group in Scotland, although this talent was perhaps more remarkable for variety than depth and no artist of the stature of Raeburn or Wilkie emerged. Of the painters born in the first decade of the century, only David Scott and William Dyce come within measurable distance, but their contemporaries included several notable artists, among them the portraitists Sir Francis Grant and Sir Daniel Macnee, the landscapists Horatio McCulloch and James Giles, and the figure painters Sir George Harvey, Robert Scott Lauder, and Thomas Duncan, all of whom were by 1837 regular exhibitors at the Scottish Academy.

Scottish artists of the earlier Victorian period are clearly divided into two groups by their training. The majority were trained at home and painted for the provincial taste of Edinburgh, of which the upper-middle-class membership of the Royal Association for the Promotion of the Fine Arts in Scotland, founded soon after the beginning of the new reign, was most evidently if not most actually representative. The many volumes of engravings after paintings by local artists published by the Association throughout the century give a good indication of staple Edinburgh fare in pictures: landscape with a strong topographical bent and figure painting which leant heavily towards illustration, preferably of Scottish history, or of the works of Burns or Scott. A few painters, on the other hand, including Dyce, David Scott, and Robert Scott Lauder, were powerfully influenced by visits they had made to Rome and as a result of their broader training were more sympathetic to the standards and ideals of what was called High Art – a peculiarly Victorian concept which contains a number of meanings. These painters are set apart from the less ambitious concerns of their contemporaries in two important respects: their subject-matter tends to be of a morally elevated character, and their experience of Italian art is reflected in a more adventurous use of colour.

Regarding colour, the stay-at-homes were almost all influenced by the tenebrous later manner of Wilkie, and tacitly shared his opinion that 'depth, and not brightness, is what is required in our *materia medica*; and as richness is the object to be aimed at in all systems of colouring, a dark brown may be a useful colour'. Sir William Allan, Harvey, early Scott Lauder, and in the next generation the young John Phillip followed Wilkie in their fondness for a brown tonality, and for a time Harvey and Lauder emulated him in the treacherous use of asphaltum black which, hallowed by Wilkie's example, caused the speedy cracking of many an early Victorian painting including Lauder's *The Trial of Effie Deans* (1842: Hospitalfield House) and several of Harvey's early convenanting scenes. Yet despite its provincial character, perhaps because of it, there is much in the work of the early Edinburgh Victorian portraitists, landscapists, and genre painters that merits more than its present neglect. First, however, it is necessary to outline some of the main developments which formed a background to it.

The Scottish Academy was founded in Edinburgh in 1826 and held its first exhibition in the following year. At the outset its prospects of continued survival were delicately balanced, but it tenaciously resisted and eventually defeated the attempts of a rival body, the Institution for the Encouragement of the Fine Arts in Scotland, to outdo it in attracting the best local artists and the public of Edinburgh to its exhibitions. The Institution (not to be confused with the Royal Association for the Promotion of the Fine Arts in Scotland already referred to) had been founded in 1819 on the initiative of one of the greatest collectors of the age, Lord Elgin, and other nobles and gentlemen, with the object of improving the standards of taste among artists and public alike by arranging loan exhibitions of old masters. Latterly contemporary artists, including Wilkie in London, had also been invited to exhibit. But they were denied any effective part in the affairs of the Institution, and the terms of the Royal Charter of Incorporation granted in 1827 to the Institution and denied until

1838 to the Academy, omitted all reference to the artist associates of the Institution, exacerbating their discontent. In 1829 they petitioned the Academy for admission, and were admitted as soon as the necessary constitutional amendments had been made. The membership of the Academy was broadly representative of painting in Scotland from that date until the eighties.

By 1835, the main agencies in Scotland for collecting important pictures, for exhibiting and selling modern art, and for teaching young artists had been physically brought together in a prestigious new building in the heart of Scotland's capital, although they remained under separate administrations. This building, called the Royal Institution (it is now the Royal Scottish Academy), was completed to William Playfair's design in 1826 and extended to its present plan in 1835 with funds controlled by the oddly titled Board of Trustees for Improving Fisheries and Manufactures in Scotland. From 1835 to 1855 the Academy held its exhibitions in the building, moving next door to the National Gallery of Scotland in 1855 until 1911, when it returned to its earlier home which it has occupied ever since. The Trustees of the Board of Manufactures, as their main function, administered an art school, the Trustees' Academy, which was founded in 1760 and was also housed in the Royal Institution building from 1826. The Scottish Academy likewise offered instruction to young artists, which it was able to reinforce by purchasing what were considered exemplary works of modern art, notably the five large history paintings by William Etty acquired between 1827 and 1831 now in the NGS. Following the secession of its artist members in 1829, the Royal Institution devoted its energies to the purchase of old masters and prints. By the time of its virtual demise in 1859, it had made some notable purchases for the Scottish national collection, owing much to the connoisseurship of Andrew Wilson, and had seen them housed in Playfair's National Gallery. The foundation stone for this was laid on 30 August 1850 by the Prince Consort on a splendid site made available by the City of Edinburgh immediately to the south of the existing Royal Institution by the same architect, the newer building providing a graceful Ionic foil to its earlier neighbour's Doric.

The portraitist Sir Henry Raeburn, for so long the cynosure of the community of artists in Edinburgh, had died in 1823. His knighthood, conferred in the previous year, was the first since the Union of Parliaments granted to a painter resident outside London. A contemporary of Sir Thomas Lawrence, Raeburn possessed a style which in its way was a complete as that of the virtuoso President of the Royal Academy. While it lacked nothing in subtlety, it was more powerfully masculine in its candid presentation of character and in its direct handling of the pigment. He had no rival in Scotland in his own lifetime as the painter of the men and women who were prominent personalities in the vigorous Scottish society of his day, but inevitably he had many imitators. Colvin Smith (1795-1875) was perhaps the most faithful and certainly one of the most pedestrian of them, but no established Scottish portraitist of the post-Raeburn generation was untouched by the master's influence which is felt even in the splendid early *Self-Portrait* (NGS) by Wilkie. John Graham-Gilbert (1794-1866) practised in Glasgow, where he was a leading light in local art affairs, being the first and last president of the short-lived West of Scotland Academy from 1841 to 1853, and his collection of pictures, including Rembrandt's *Man in Armour*, was bequeathed to Glasgow Art Gallery by his widow in 1877. He and his Edinburgh rival Sir John Watson Gordon (1788-1864) tended to be at their highly competent but not particularly inspired best in single male figures. Wilkie's friend, Andrew Geddes (1738-1844), a more distinguished artist, whose career after a late start was spent in London, showed a vivid natural talent of which *Summer* (exhibited 1828: NGS), probably representing Charlotte Nasmyth and based on the *Chapeau de Paille* by Rubens, is a good example. Tentative in conception (he was a frequent *pasticheur* of Old Masters) Geddes's work at its best is confident and attractive in execution. That of the *petit-maître* William Yellowlees (1796-1856) – 'Raeburn in little' as he was known to his contemporaries – combines a delicate painterliness with a sympathetic intimacy of characterization which is more appropriate to the invariably small scale of his portraits. The dainty art of the miniature itself was practised most notably in this period by the Aberdeen-born pupil of Nasmyth, Andrew Robertson (1777-1845), whose *Letters and Papers* published by his daughter offer fascinating insights into the life of a portrait artist in London and Scotland in his day; and his pupil Sir William Charles Ross (1794-1860), whose brilliantly baroque style led to commissions from the Queen and the royal family and a successful career in the English capital.

William Dyce, too, was capable of a more intimate style of portraiture, of which the best-known example is the sensitive child portrait of *Harriet Maconochie* (exhibited 1832: private collection). However, his portraiture mostly belongs to his early Edinburgh period, during which he was forced to paint over a hundred portraits for a livelihood despite his many other interests. As a result many of them are potboilers totally lacking the extraordinary technical qualities for which he was later admired by Ruskin. Dyce was among the new wave of figure painters who were still young at the start of the reign. The portraiture of his contemporaries Thomas Duncan, Scott Lauder and David Scott was of an occasional nature and forms a better-integrated part of their work, which is discussed in the next chapters. Sir Francis Grant (1803-78) and Sir Daniel Macnee (1806-82) were the most important Scottish portraitists among Dyce's contemporaries. Their contributions

to the Paris International Exhibition of 1855 earned them praise as the best portraitists of the British school in a review written by Théophile Gautier, and Macnee's *Lady in Grey*, painted four years later, which is probably his masterpiece, shows precisely the enamelled surface which one might expect the author of *Emaux et camées* to have appreciated. In reality it is painted directly in a manner which still shows Raeburnesque influence, although the camera-like variations of focus bespeak a later age, and above all, its high key and harmony of cool colours seem closer to *Le Déjeuner sur l'herbe* than to the romantic world of Raeburn's outdoor portraits. Macnee studied under John Knox in Glasgow with Horatio McCulloch and William Leighton Leitch, gradually increasing his share in what had been Graham-Gilbert's monopoly of Glasgow patronage, until he moved to Edinburgh in 1876 on his election to the presidency of the Royal Scottish Academy.

Macnee's humble beginnings contrast markedly with those of Grant, the spendthrift fourth son of a Renfrewshire laird, who saw portrait painting as a lucrative profession which would enable him to recoup the large inheritance which had rapidly run through his fingers on the hunting field. Grant had a natural facility and an elegant manner which quickly ensured his success, especially after his transfer to London in 1834, the year his famous picture *The Melton Hunt Breakfast* (Earl of Cromer) was exhibited. His work really falls into two categories, one being portraiture proper, the other sporting pictures in which the animals and the landscape are as much the object of attention as the riders or sportsmen. A picture like *Master James Keith Fraser on his Pony* (exhibited 1845: Mr and Mrs Paul Mellon) comes somewhere between these categories and reveals his essential qualities, which have often been belittled. It is a genuinely swagger equestrian portrait which suggests the gentle breeding of the young rider and his mount through their composed bearing and curiously self-regarding expressions. The eye is the window on the character of each subject; their demeanour indicates an aristocratic self-containment in contrast with the baroque animation of the composition as a whole. A similar expression of aristocratic refinement captured in the languorous gazes of a pair of society beauties, *The Countess of Chesterfield and the Hon. Mrs Anson* (private collection), results in fashionable portraiture of a sheer stylishness which can have left little to be desired by its feminine subjects, and is exceptional in Scottish painting. In *Golf at North Berwick* (private collection) and *A Hill Run with the Duke of Buccleuch's Hounds* (Bowhill), the actions of the participants and the terrain itself are conveyed with the excited accuracy of the *aficionado*. Grant's work may have been mannered, but it was also well mannered, and its popular success in its own day is easy to understand. In 1866 he became President of the Royal Academy, and is the only Scot to have held the office.

Although David Octavius Hill (1802-70) was familiar to the RSA exhibitions as a prolific but rather uninspired landscapist, his real achievement lay in photography, especially in the large series of calotypes, many of them portraits, made in collaboration with Robert Adamson (1821-48). But his *magnum opus*, began in 1843 and finished in 1866, was the large painting of *The First General Assembly of the Free Church of Scotland* (General Trustees of the Free Church of Scotland), which records the central event of the Disruption of 1843, the signing of the Deed of Demission by which the Free Church came into being. This is commemorative group portraiture at once on the largest and most minute scale; there are above four hundred and fifty portraits, many of which were painted from calotype studies. It would be hard to imagine a more detailed piece of reportage, but the herculean labour of its execution robs the painting of any element of life or drama. Hill's industry was extraordinary even for Victorian times. He worked tirelessly as secretary of the RSA from 1830 to 1869 and is credited with having suggested the idea upon which the Royal Association for the Promotion of the Fine Arts in Scotland was based.

Such faith in institutions is characteristic of the age. A high proportion of the best Scottish painters born in the 1800s did service in various official or academic capacities: Sir Daniel Macnee and Sir George Harvey as President of the RSA, Sir Francis Grant as President of the Royal Academy; Thomas Duncan and Robert Scott Lauder became Masters of the Trustees' Academy, where David Scott was a Visitor; and William Dyce, the most obvious example, devoted years to the reform of the national system of art education as Secretary of the new School at Somerset House, having briefly been master of the Trustees' Academy. As these names and their concomitant titles indicate, portraiture and figure painting were regarded by many Victorians as more serious pursuits than landscape painting. However, in 1837 the *eminence grise* among painters in Scotland was a landscapist, Alexander Nasmyth (1758-1840). Although he was two years Raeburn's junior, Nasmyth belonged to a more old-fashioned classical tradition. His portraits show little of the training he had received in Allan Ramsay's studio in London. They range from stiff Zoffany-like conversation pieces such as *The Erskine Family* (Christie's 1974) of 1780 to the famous but unremarkable portrait of *Robert Burns* (SNPG). His landscapes, after a sojourn (1783-85) in Italy, adhere to a Claudian ideal transposed to a Scottish setting. But although Nasmyth's style was quickly superseded, he has a strong claim to have been the originator of the nineteenth-century vogue for Scottish landscape views. Writing from Seville in 1828, Wilkie addresses Nasmyth as 'you whose taste has drawn so much from Italy and whose genius has made Scotland so

much the theme and the school of the landscape painting of our day'. John Ruskin, whose father received lessons from Nasmyth, himself owned to Nasmyth's influence on him in his young years. Nasmyth's theatre sets excited at least as much contemporary admiration as his easel painting but they can unfortunately no longer be judged, except in drawings. His younger contemporaries David Roberts (1796-1864) and William Leighton Leitch (1804-83) were rapturous in their praise of them. Roberts wrote of them as 'beautfiul works of art' and remarked, 'These productions I studied incessantly, and on them my style, if I have any, was originally formed.' A drop-scene by Nasmyth for the Theatre Royal in Glasgow, then one of the best theatres in Britain, was described by Leitch as 'a magnificent work of art and justly renowned as a masterpiece'. However, the work of these admirers of Nasmyth, and that of his son Patrick Nasmyth, 'the English Hobbema' as has been confusingly and confusedly called, had little effect on Scottish painting, as their careers were passed chiefly in London. Roberts

achieved great success as an architectural painter there, specializing in Mediterranean and Middle-Eastern subjects, and Leitch, who as a watercolourist was influenced by Samuel Prout, became Queen Victoria's drawing-master.

Although he moved to London in 1822, Roberts retained close links with Scotland, exhibiting from time to time at the RSA and visiting his friends on an annual basis until 1863, the penultimate year of his life. In 1858 he received the Freedom of the City of Edinburgh – the first artist to receive this honour. Starting as a scene-painter at the Theatre Royal, Glasgow, and (with Clarkson Stanfield) at the Pantheon Theatre, Edinburgh, which was managed by William Henry Murray, brother of Harriet Siddons, Roberts first went to London in 1822 at the suggestion of Murray, where his talents as a designer and painter of theatrical flats quickly found employment, notably in the first English production of Mozart's *Il Seraglio* at Covent Garden in 1826, for which Roberts produced sets for all seventeen scenes. By 1830 Roberts, having sold all the pictures he had sent to

6 Alexander Nasmyth
Distant View of Stirling
Oil 83.9 × 116.9 cm
National Galleries of Scotland
Exhibited at the Royal Institution, Edinburgh, in 1827.

7 William Clark of Greenock
*The Queen's Visit to the Clyde,
17th August 1847*
1848 Oil 77 × 112 cm
McLean Art Gallery, Greenock
The Queen, on her third visit to
Scotland, and accompanied by
Prince Albert and the royal
children, is seen here transferring
from the RY *Victoria and Albert* to
the tender *Fairy*.

the Royal Academy – including the huge, imaginative and positively de Mille-like *Departure of the Israelites* (1829: private collection), sold to his early supporter Lord Northcliffe – was confident enough to give up his theatre work and devote himself entirely to his chosen branch of art. Like his friend J.F. Lewis and his compatriot Wilkie, Roberts made extensive journeys, which are well documented in his letters and diaries, through Spain and the Holy Land, as well as (unlike them) to Egypt, Syria, and North Africa in search of fresh material, in his case scenes of architectural and archaeological interest. The resulting images of Spain (visited in 1832) and more especially of Egypt and the Holy Land (1838-39) – the latter published as a collection of lithographs in six volumes – were extremely popular and established Roberts as one of the most celebrated British artists of the day. It is not hard to understand their success, for Roberts, having with considerable foresight chosen subject-matter which itself made an exotic and even romantic appeal, was able to match the grandeur and novelty of his subjects with a consummate ability to suggest their power without omiting relevant archaeological detail or an architect's sense of the structure underlying form. His architectural studies combine admirable scholarship and grasp both of scale and detail with a compositional sweep which transforms them into works of art. Indeed, a relatively rare flight of fancy such as *A Recollection of the Desert on the Approach of the Simoon* (1850: private collection), based of course on

actual experience but revealing a strain of romantic poetry worthy of Delacroix, indicates that Roberts possessed an imagination which was the equal of his remarkable powers of description. This painting was presented by the artist to his friend the novelist Charles Dickens.

The most outstanding of Nasmyth's many pupils, the Reverend John Thomson (1778-1840), a gifted amateur landscapist and friend of Sir Walter Scott, effected the transition in Scotland to a romantic landscape type, with solitary castles, often ruined, sometimes perched on cliffs whose perspective is exaggeratedly steep, dimly seen through a misty atmosphere. If one compares master and pupil in two pictures now in the National Gallery of Scotland, Nasmyth's *Distant View of Stirling* (exhibited in 1827) and Thomson's *Fast Castle from Below* (circa 1824), the dainty and almost brittle formality of Nasmyth presents a marked contrast with the more subjective painterliness of Thomson. The latter's typical golden-brown tone, however, is reminiscent of the current admiration for Claude indicated for example in the *Noctes Ambrosianae*, published in *Blackwood's Magazine* between 1825 and 1835, and probably represents an attempt to reproduce what was then misguidedly thought to be a Claudian effect. Thomson's freer style and, for a time, his mannered use of almost monochromatic colour influenced later landscapists such as Horatio McCulloch. On the other hand, the Nasmyth tradition of panoramic views of Scotland ended with the career of

his pupil John Knox (1778-1845), whose views of *Old Glasgow Bridge* and *The Clyde at Glasgow Green* (GAG), peopled with many small figures, make him seem a kind of Glasgow Carlevaris. Knox was at his most naively personal in his street scenes; despite its up-to-date-sounding title, *The First Steam Boat on the Clyde* is still heavily dependent on the classical convention. Equally faithful to a different seventeenth-century convention, that of the minor Dutch marine painters, were the contemporaries of Thomson and Knox, John Wilson (1774-1855) and J.W. Ewbank (1799-1847) – the latter another Nasmyth pupil – who were frequent exhibitors at the Academy in Edinburgh. At the same time there exists a veritable school of artists, mostly unsung, who painted local views for a local clientele. Two may here stand for the many: George MacGillivray of Dundee and William Clark of Greenock (1803–83). Dundee Art Gallery possesses all that is known of the former's work, which includes the naive but attractive and historically interesting *The Opening of the Dundee-Arbroath Railway* (1838), and the more accomplished view of *The Union Hall, Dundee* (1847). Clark of Greenock's masterpiece is assuredly the large *The Queen's Visit to the Clyde, 17th August 1847*. Clark was a marine specialist for whom anatomical accuracy in the delineation of sailing ship subjects was a matter of course, but he was much more than a quayside painter of ship-portraits; his regatta and racing scenes possess a vivid sense of colour, of weather, of movement, and in this case even of pageant.

Among the early Victorians, some of the most distinguished work in landscape was done by painters not normally thought of as landscapists, especially David Scott and William Dyce, who are considered in the next chapter. The mountain views and ruined castles of the most interesting of the landscape specialists of their generation, Horatio McCulloch (1805-67), have a homespun look when compared with the exuberant colour and romantic imagination of Scott's *Puck Fleeing before the Dawn* (1837: NGS) or the Pre-Raphaelite botanical precision of Dyce's *Titian's First Essay in Colour* (1857: AAG). McCulloch trained in Glasgow under John Knox and belongs, like most of his contemporaries in this category, to the tradition of the landscape-topographer. On one occasion he was called upon to advise on the landscaping of the new railway line passing through the estate of Castle Semple, just as Alexander Nasmyth before him gave advice on projects like the laying out of the gardens at Culzean, and of the siting and design of St. Bernard's Well in Edinburgh. But McCulloch's large paintings have a compositional sweep and a nostalgic quality which are authentically romantic and place him on a higher level than his more humdrum contemporaries and fellow-academicians, William Simpson (1800-41) and Edmund Thornton Crawford (1806-85). His *Inverlochy Castle* (1857: NGS)

and *A Border Keep* (n.d.: DAG) successfully evoke the wildness of an untamed landscape in which once-mighty fortresses stand as ruins. Much of his work, however, suggests a rather mundane sensibility: *Glencoe* (1861: GAG) has little to add to what had been said for once and for all ten years earlier in Landseer's *Monarch of the Glen*. This is a fault which is most serious in his use of colour, which tended to a monochromatic brown or green. His pictures are really decorative pieces, although his brushwork is vigorous and represents a development of the painterliness of John Thomson, and he is as capable of painting with sensitivity on an impressively large canvas – *Loch Awe with a View of Kilchurn Castle* (Western Club, Glasgow), is a splendid example, as is his *River Clyde from Dalnoltar Hill* (circa 1859: Clydesdale Bank) – as equally on work of sketch dimensions.

Less subjective than McCulloch, the Aberdeen painter James Giles (1801-70), who advised many of the Aberdeenshire gentry on the planning of their gardens, was influenced as a topographer by his Italian journey (1824-26). The eerie romanticism of *The Weird Wife* (1832) is a rare excursion from the placid norm of his usual style, although the inclusion of Pictish standing stones of a type found in North-East Scotland echoes the interest in Scotland's ancient ruins which had been reawakened by Scott's novels.

The next wave of landscapists, who were in their thirties by mid-century, marks a transition to a more naturalistic, less interpretative mode from the subjective romanticism of McCulloch, who worshipped Wordsworth as 'Claude and Turner and Stanfield and Linnell all in one' according to his *Art Journal* obituarist. Landscape subjects came to be chosen less for their romantic or historical associations than for a tamer type of picturesqueness. The difference in treatment is even more pronounced, reaching a logical conclusion in the descriptive precision of Noel Paton and William Dyce, and resulting among landscape specialists like Arthur Perigal (1816-84), James Cassie (1819-79), and J. Miln Donald (1819-66) in a more factual approach, which in their hands veers dangerously close to the pedestrian. Their slightly younger contemporaries are more interesting: Sam Bough (1822-78), J.C. Wintour (1825-82), and James Docharty (1829-78) in particular managed to infuse an element of poetic drama into their own distinct styles. The enormously prolific Bough was clearly considerably under the influence of early Turner, but more detailed and circumstantial than that master, the busy facility of his drawing not always disguising a certain poverty of content and an apparent indifference to colour. Too often his would-be animation lapses into mere restlessness and a relentless cataloguing of incident weakens the unity of his compositions, but at its best his work possesses undeniable verve. But are we today in possession of the evidence necessary to a balanced evaluation of

OPPOSITE
8 William Dyce
Titian Preparing to Make His First Essay in Colouring
1856–57 Oil 91 × 71 cm
Aberdeen Art Gallery

Bough, whose centenary has passed without notice, who emerges so engagingly from the pages of the Gilpin biography (published posthumously as late as 1905) and who clearly was regarded by his all contemporaries as the giant of Scottish landscape painting of the mid-nineteenth century? Few indeed of the 224 works exhibited by him at the Royal Scottish Academy in the years 1844-78 are known today. One such is *Newhaven Harbour during the Herring Fishing,* offered in 1856 for £30, a large-scale composition full of detailed observation and an almost Boudin-like lightness of palette. Another picture shown in the previous year, and now lost, of the Iron Shipyard at Dumbarton, was priced at £100; as it cannot have been three-and-a-third times bigger, was it three-and-a-third times better? A second example of Bough's power in large-scale composition to appear recently in the Scottish art market has been the great *Peel Harbour in a Storm,* exhibited at the RSA in 1875 with a price of £472 10s. This beautifully suggested, elemental work seems to justify the artist's estimation of it as the highest-priced picture he ever showed in Scotland, and its undeniable authority suggests that a re-examination of this neglected artist is overdue, preferably in the form of a large-scale exhibition which would bring his mostly hidden work back into public view.

Totally different in mood, Wintour's earlier work, influenced by Constable, reveals a richer and more simplified sense of colour and composition, as in *A Woodland Well* (1857: Orchar Collection, DAG). A lingering sense of romantic nostalgia is especially apparent in the landscapes of the last twelve years of Wintour's life after he had freed himself from Constable's influence around 1870. *A Border Castle* (1872: NGS), painted for a patron who refused it on the grounds of the liberties taken with the topo-graphy, is a hauntingly evocative work which shows something of that Corot-like serenity and painterly brushwork which commended Wintour to the land-scapists of the later Glasgow School. James Docharty was a more severe artist; his descriptive *Loch Achray* (1866: AAG) and *Morning – Mist Clearing off the Hills* (1876: ibid.) suggest Courbet rather than Corot, but his seeming preference for the gloomier moods of landscape makes him difficult to enjoy, despite a photo-impressionistic concern with effects of atmosphere and light.

Landscape painting had in fact reached a low ebb with the generation of painters who separate the romanticism of Horatio McCulloch from the impressionism of William McTaggart. The slightly younger Alexander Fraser (1827-79), who worked in the open air in Cadzow Forest with Sam Bough and William Fettes Douglas, and had by his early twenties arrived at the style which he was to employ for the rest of his career, summed the matter up with the remarkable candour: 'I have followed certain rules and modes of procedure, chosen certain views and used certain colours. Success would lead to repetition, failure to trying another process, but the quantity of mere repetition is not to be denied. What then? Is not all life a repetition?' Fraser was predictably successful, repetitious, and prolific, but a certain responsiveness to the *genius loci* and to nature in her calmest moods gives life to the otherwise mechanical perfection of his style. His timid use of colour was also elucidated by himself in the *Notes* partly published by Pinnington: 'Working with one tint only should not be allowed to fall entirely into disuse. Like a solo on the drums, it may be made a very effective performance.' An infinitely richer orchestration of landscape was to be demonstrated by William McTaggart from the mid-1860s.

2 HIGH ART

The first fifteen years of Victoria's reign – which embrace Sir William Allan's election as President of the Scottish Academy in 1837 and the appointment of Robert Scott Lauder as Headmaster of the Trustees' Academy in 1852 – were particularly eventful ones for figure painting in Scotland. The new wave of young Scottish figure painters who came into prominence in the 1830s, born mostly in the first decade of the century, divided into two distinct groups, one concentrating on religious, allegorical, or mythological subjects, the other on genre scenes or episodes from Scottish history or romance. The second group absorbed a Scottish vernacular style mediated by Sir William Allan (1782-1850), under whom they studied at the Trustees' Academy. However, the slightly older members of that generation, including William Dyce, David Scott and Robert Scott Lauder, were among the last students taught at the Trustees' Academy by the outgoing Master, the landscapist and connoisseur Andrew Wilson (1780-1848). Wilson was an Italianist (once a pupil of the Italianate Alexander Nasmyth) who was Master at the Trustees' Academy from 1818 until 1826, when he was succeeded by Sir William Allan. Wilson's pupils Dyce, Scott and Scott Lauder (and to a lesser extent the precocious later figure of Sir Joseph Noel Paton) are effectively separated from their Scottish contemporaries by their Italianizing tendencies and their elevated conception of subject-matter. However, in the cases of Scott and Paton this did not preclude successful excursions into the field of fairy painting or imaginative fantasy, with themes from *Paradise Lost, A Midsummer Night's Dream,* or *The Tempest.*

Their extended Italian visits, which profoundly affected the work of Dyce, Scott and Lauder, increased the stylistic distance between them and their Scottish colleagues. Dyce had especially wide sympathies, and his friendship with the German Nazarenes in Rome enabled him to anticipate aspects of Pre-Raphaelitism and to play an important role in the triumph of the German style favoured by Prince Albert for the scheme to decorate the new Parliament buildings. He seems less a Scottish than a London figure – an impression heightened by his participation in the ecclesiological controversies of the age, by his preoccupation with matters of High Church liturgy and music, and by a close involvement with

art education after his appointment in 1838 as Superintendent of the Schools of Design at Somerset House. Despite the prodigal dispersion of his talents and time, he painted several of the most interesting pictures of the Victorian era, and his work, like that of his fellow expatriate Scott Lauder, continued to be occasionally seen at the annual exhibitions of the RSA.

Born in 1806 in Aberdeen, William Dyce gave early proof of intellectual versatility. In 1829 he published a prize-winning essay on *The Relations between Electricity and Magnetism* and in 1833 a paper on *The Jesuits* which resulted in correspondence with the future Cardinal Wiseman. At the same time he furthered his development as an artist with visits to Italy in 1825, 1827 and 1833 which brought him into contact with the Nazarenes. His introductory remarks to the treatise on electromagnetism give clear notice not only of the future polymath, but of the future eclectic as well:

> The boundaries of separate branches in philosophy . . . have become so undefined that we, loaded with the accumulated weight of experience, must acknowledge that our thorough understanding of even a single natural phenomenon has thus been made to depend upon our ability, with one comprehensive grasp, to apprehend the contexture of the whole system.

This suggests that his many-sidedness in fact resulted from deep conviction rather than, as has often been said, from the lack of it. Unfortunately it led him to enter into certain commitments, such as the directorship of the Schools of Design, which turned out to be enormously time-consuming, consequently restricting his output as a painter.

The brothers Redgrave saw Dyce's work as 'learned more than original', yet he was perhaps the first artist in Britain to appreciate early Italian art and to apply its lessons to his own style. In this respect he appears as a forerunner of the Pre-Raphaelites, whose early work he was one of the first to understand. Ruskin, quoted by Ernest Chesneau in 1882, recalled that his introduction to the Pre-Raphaelite School was by Dyce, 'who dragged me, literally, up to the Millais picture of "The Carpenter's Shop", which I had passed disdainfully, and forced me to look for its merits'. Dyce's own best

work has about it a certain Pre-Raphaelite intensity of mood as well as of observation, to a degree which seemed uncomfortable even in 1881 to the RSA Council, owners of Dyce's most important picture in his early Scottish period, *Francesca da Rimini*. The Council ordered that the 'objectionable' left-hand side of the picture should be cut, removing the figure of Francesca's deformed husband Gianciotto, who was shown advancing with murderous intent upon the unsuspecting lovers, dagger in hand. This and other subjects from Dante were to be treated many times by Rossetti, just as the Arthurian theme suggested by Dyce to the Prince Consort as a suitably patriotic alternative to the *Nibelungenlied* for the frescoes in the Queen's Robing Room at Westminster Palace, commissioned in 1847, again anticipated a fashion.

After his appointment to Somerset House in 1838, art education was only one of the onerous official concerns which Dyce added to his studies of church architecture, music and liturgy, and of the technique of fresco painting, in which he became the foremost expert in Britain. It is then perhaps not surprising that certain of his pictures, like the *Christabel* (1855: GAG) described by Ruskin as an example of 'one of the false branches of Pre-Raphaelitism consisting in an imitation of the old-religious masters', appear to have little more to recommend them than a certain agreeable sweetness which borders on vapidity. Other examples in this Peruginesque style are the *Madonna and Child* of 1845 bought by Prince Albert

for the royal residence at Osborne, where Dyce painted a fresco, *Neptune Resigning his Empire to Britannia*, and the *Omnia Vanitas*, presented to the RSA Diploma Collection in 1848. What is more remarkable in these circumstances is the taut control of a figure painting such as *Jacob and Rachel* (1853: Kunsthalle, Hamburg; version at Leicester Art Gallery), a very Nazarene work based on a composition of Führich, or the boldly simplified *Joash Shooting the Arrow of Deliverance* of 1844. This is an astringent design of real tonic vitality, described by the artist as symbolizing 'the arm of secular power directed by the Church', but which may well have had a private meaning for him as an allegory of self-liberation. The later landscapes possess an even more impressive meditative concentration. The anguished agitation of the figure of Christ in *Gethsemane* contrasts powerfully with the repose of the carefully observed Scottish Highland setting. Painted in 1850, this is the first of a small group of meticulously descriptive landscapes containing diminutive figures and preoccupied with the rendering of light and atmosphere in a final logical extension of the artist's love for the Umbrian painters of the *quattrocento*.

Ruskin wrote to Dyce in 1857 'to congratulate you on your wonderful picture' – *Titian's First Essay in Colour* – adding, 'you have beat everybody this time in thoroughness', but the picture, painted in 1859 and shown at the RA in 1860, is an even more extraordinary *tour de force*. This is the haunting *Pegwell Bay – A Recollection of October 5th, 1858*. Here, in

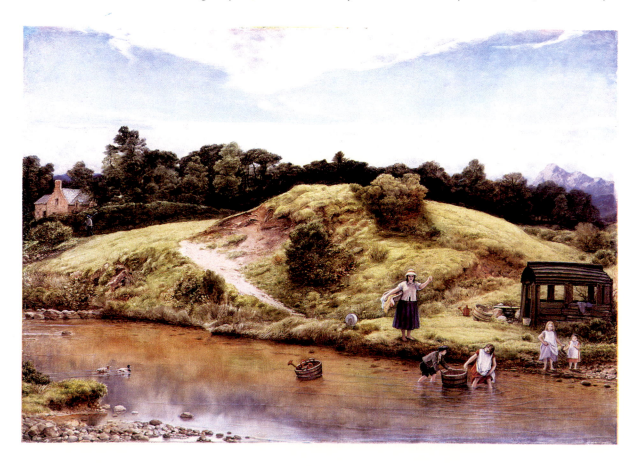

9 William Dyce
A Scene in Arran
1859 Oil on panel 35 × 51 cm
Aberdeen Art Gallery
A rare excursion into narrative painting, dating from a family holiday.

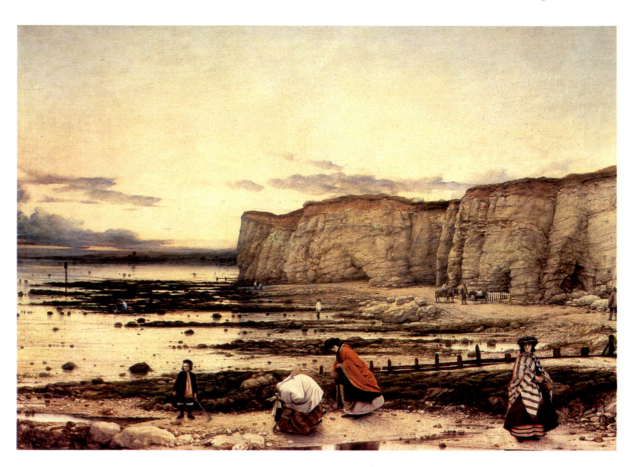

10 William Dyce
*Pegwell Bay: A Recollection of
October 5th, 1858*
1860 Oil 73.7 × 88.9 cm
Tate Gallery
The figures represented are the
painter's wife and her sisters,
Grace and Isabella Brand, with the
artist and one of his sons.

a landscape littered with rocks, elegantly costumed figures (members of the artist's family) ignore the presence in the sky of another, more spectacular piece of geological debris – Donati's Comet of 1858 – and instead stand irresolutely like exotic birds of passage in an unfamiliar and inhospitable terrain. The picture lacks the incident of Frith's *Ramsgate Sands* (1854) and the social message of Brett's famous *Stonebreaker* (1858), but an impression of mysterious significance is created by the almost surreal intensity of the obsessively rendered detail and the infinitely subtle modulations of a cool harmony of colours. *Pegwell Bay* remained until 1894 in the collection of the artist's father-in-law, James Brand, who also owned *Titian's First Essay in Colour*. *A Scene in Arran*, showing a more informal Dyce family outing in 1859, the year of *Pegwell Bay,* was painted for Mr Brand and not apparently intended for exhibition. It possesses a charmingly intimate quality in addition to its remarkable truth to natural phenomena. A similarly lyrical view of verdant nature is revealed in Dyce's last important work, *George Herbert at Bemerton* (1861: Guildhall Art Gallery), a subject taken from Walton's *The Compleat Angler* where Piscator quotes to Venator the following lines of Herbert:

> Sweet day, so calm, so cool, so bright,
> The Bridal of the earth and sky,
> The dew shall weep thy fall tonight
> For thou must die.

Dyce was fifty-seven when he died three years later in 1864. His career was acknowledged to have been a brilliant one, but somehow incomplete despite, perhaps because of, the variety of his achievements, of which his contribution to Victorian painting was by no means the least significant.

Like William Dyce, but with different results, the brothers Robert and James Lauder (born in 1803 and 1811 respectively) spent years in Rome studying Italian painting, but both brothers also showed a keen interest in the new genre style for which the novels of Sir Walter Scott had done so much to create a demand in Scotland. Prior to his departure to the Continent in 1833, Robert Scott Lauder's work was chiefly in portraiture, of which the *Henry Lauder* (NGS) and *Mrs Duncan* (DAG) are good painterly examples, with an isolated excursion into Scott in the style of Sir William Allan, the now bitumenized *Bride of Lammermoor* (DAG). The five-year tour which took Lauder to Rome, Florence, Bologna, and Venice did not quench his enthusiasm for Scott, and his then greatly celebrated *The Trial of Effie Deans* (now at Hospitalfield House but ruined by the effects of bitumen) was begun in Scotland, taken to the Continent, and completed in London, where the artist took up residence on his return in 1838. This is an ambitiously conceived work in which an animated crowd of large-scale figures is skilfully handled, while in terms of colour and the rendering of light the picture represents a great advance on *The Bride of Lammermoor*. Other less ambitious illustrations to

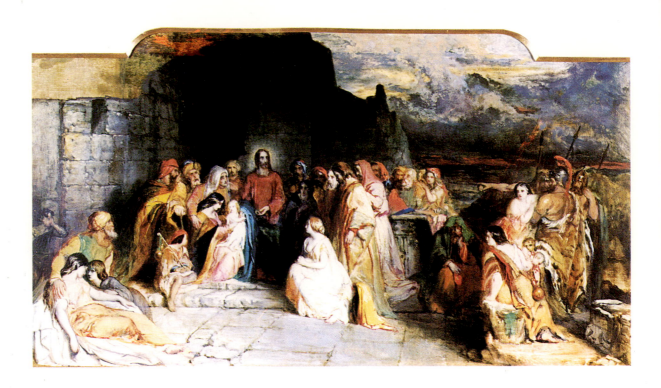

11 Robert Scott Lauder
Christ Teacheth Humility
1848 Oil 234 × 328 cm
National Galleries of Scotland

Scott followed, showing a preoccupation with a certain type of female beauty of which two graceful examples were predictably engraved for the Association for the Promotion of the Fine Arts in Scotland: *The Gleemaiden* (private collection) and *The Fair Maid and Louise Listening at the Dungeon Wall* (untraced), both from *The Fair Maid of Perth*, exhibited at the RSA in 1842 and 1848 respectively.

Scott Lauder's more obviously Italian-influenced religious works began with *Ruth* (untraced) of 1843. Unfortunately, pieces like *Christ on the Way to Emmaus* (DAG) and *Christ Walking on the Sea* (FAS), both exhibited in 1850, have a static and somewhat anodyne quality which contrasts unfavourably with the urgency of Dyce's *Gethsemane* of the same year. The use of deep Venetian reds and blues is confident enough, although rather low-keyed. *Christ Teacheth Humility*, measuring 234cm × 328cm in the largest version, which was purchased by the Association, is the most impressive of these later essays and reveals an undeniable unity of light and grouping, while the architectural and landscape background is painted with notable breadth and transparency. The landscape passage in this picture drew from Caw a comparison with Delacroix which might more justly have been applied to the small oil sketch for it (NGS), in which the lights are largely painted in primary colours. But the main importance of Robert Scott Lauder to Scottish painting derives not from his own work, but from that of the pupils whom he influenced after his appointment as Master of the Trustees' Academy in 1852.

James Eckford Lauder (1811-69), who returned to Edinburgh while his brother stayed in London after their Continental tour, is known today only as the painter of *Bailie McWheeble at Breakfast* (1854: NGS) from a passage in *Waverley*, but was a prolific exhibitor at the RSA and the *McWheeble,* a cabinet piece with much emphasis on still life, demonstrates more than average competence. Yet the artist's obituarist in the *Art Journal* of 1869 remarks sadly that 'neglect . . . it is scarcely too much to say . . . hastened his end'. In 1847 he had succeeded in winning a 200 guinea premium for his entry to the Westminster Hall competition, *The Parable of Forgiveness* (WAG), a well-organized, somewhat Poussinesque work of requisitely large size (198cm × 313cm). Separated by only seven years, these two paintings seem poles apart and illustrate the dichotomy that existed in the minds of many people in the late 1840s and 1850s and even later between the styles that were deemed appropriate for various levels of subject, with religious themes tending to appear as inflated academic compositions, humble domestic subjects receiving much more realistically descriptive treatment, and literary or historical painting occupying the middle ground. The dilemma produced by the conflicting demands of modern realism and the formal expressiveness of the Italian tradition was convincingly resolved in England by the Pre-Raphaelites, but their Scottish contemporaries were less systematic.

Sir Joseph Noel Paton (1821-1901), a Dunfermline-born painter, was an early and close friend of Millais in London and might have become a member of the Pre-Raphaelite Brotherhood had he not elected to return to Scotland in 1844. He was widely regarded in his own day (though not by Ruskin) as the

foremost religious painter in the land, together with Holman Hunt. Today this aspect of his work finds no favour, and with its overscaled, bland designs and undernourished pigment is hardly likely to do so again. But it was not until about 1870 that Noel Paton became almost exclusively a religious painter; in his early days he attempted a remarkable variety of themes ranging from fairy pictures and subjects from Dante, Malory, Keats and Coleridge, to modern subjects such as the Indian Mutiny and the Crimean War. Like Eckford Lauder, Paton was a prizewinner in the Westminster Hall competitions (in 1845 and 1847), but he enjoyed much greater success than Lauder. He numbered among his admirers Queen Victoria, who commissioned a replica of *Home from the Crimea* in 1856 and in 1864 the memorial picture *Queen Victoria in the Death Chamber of the Prince Consort*.

Home from the Crimea, exhibited in 1856, described by Ruskin as 'a most pathetic and precious picture', depicted the return to the bosom of his family of a soldier who sits wearily at last by his own fireside, embraced by his wife and mother, who abandon themselves to their painfully mixed emotions, for he has been severely wounded. Even in reproduction the image is arresting and conveys feelings which we know to have been genuine: Paton in the previous year had produced a drawing titled *Commander-in-Chief of the Crimea*, showing a skeleton holding a baton marked 'routine' riding a skeletal charger over the bodies of men and horses. *In Memoriam*, shown in 1858 at the Royal Academy to a public still stunned by the massacre at Cawnpore,

touched an exposed nerve and had to be changed from its first design, which showed sepoys advancing on a huddled group of English women and children, to the more comforting later version which substituted rescuing Highlanders for the sepoys and was called *The Rescue* (untraced), representing the relief of Lucknow. (Queen Victoria expressed her approval of the change.) *Dawn: Luther at Erfurt* (1861: NGS), unlike the two modern subjects just discussed, is not sustained by any topicality of content; it is inwardly rather than outwardly dramatic and thus a more strictly Pre-Raphaelite work, showing some influence of Holman Hunt in particular, but of the Brethren in general, in its meticulous drawing and strong colour. The picture combines historical verisimilitude with circumstantial realism; there is much antiquarian detail and the head of Luther was studied from a contemporary portrait, although the eyes were those of the artist's wife, 'the look of strain in them induced by a judicious application of onions'.

Noel Paton is best remembered today, however, as the painter of the fairy pictures of *The Quarrel of Oberon and Titania* and *The Reconciliation of Oberon and Titania* and *The Fairy Raid*, not surprisingly, as they show him at his best in terms of technique and invention. Painted while he was still in his twenties, the two *Oberon and Titiania* pictures (NGS) possess a degree of elaboration remarkable even by Victorian standards and not again attempted by the artist. Lewis Carroll saw *The Quarrel of Oberon and Titania* in the Scottish National Gallery in 1857 and wrote delightedly in his dairy: 'We counted 165 fairies!' Noel Paton's talent for minute

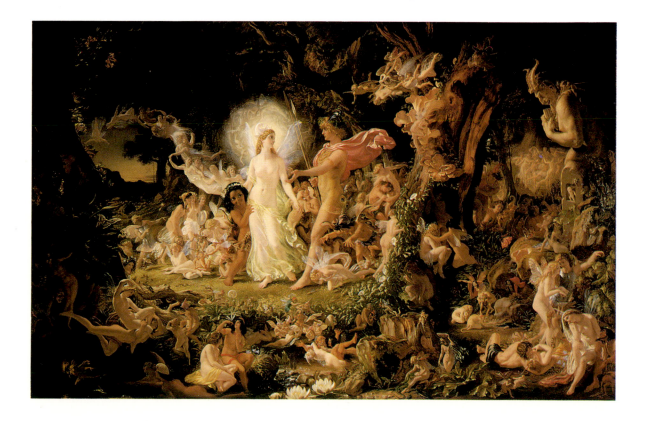

12 Sir Joseph Noel Paton
The Quarrel of Oberon and Titania
1847 Oil 99.1 × 152.4 cm
National Galleries of Scotland
A Midsummer Night's Dream II, ii.

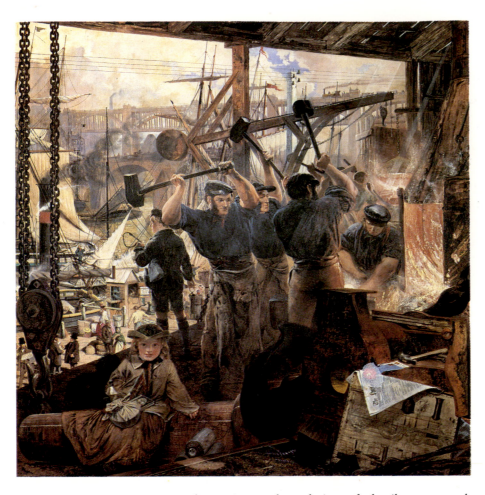

13 William Bell Scott
*Iron and Coal on Tyneside in the
Nineteenth Century*
1856–61 Oil 185.4 × 185.4 cm
Wallington Hall, a property of The
National Trust.

observation and rendering of detail was exactly suited to such a subject, which was dear, no doubt, to his highly developed sense of the supernatural; very young visitors to Ardmay, the Noel Patons' holiday house on Loch Long, would be taken on expeditions to look for fairies which, as his granddaughter tells us, had been one of the pastimes of the painter's own childhood at Dunfermline. The early fairy pictures were painted long before his marriage in 1858; later, as the father of eleven children, he showed himself intensely sympathetic to the imaginative fantasies of childhood. Lewis Carroll asked him to illustrate his *Through the Looking-Glass,* but the invitation was declined by Noel Paton, who said that Tenniel 'was still the man'. Dated studies in the RSA Diploma Collection and at Glasgow Art Gallery show that both the *Oberon and Titania* pictures were conceived at the significantly early date of 1846. *The Reconciliation of Oberon and Titania* was painted first and exhibited at the RSA in 1847, winning a government prize at the Westminster Hall competition in the same year, and bought by the RSA in 1848 – a remarkable honour for its twenty-seven-year-old author. *The Quarrel of Oberon and Titania,* shown at the RSA in 1850, was bought by the Royal Association for the Promotion of the Fine Arts for the NGS in the same year for £700, by far their most expensive purchase. This was recognition indeed, and it is not hard to explain. The painting has a high

finish, bright colours, and microscopic detail, together with a teeming cornucopia of chastely erotic life studies. Its myriad figures engaged in a multitude of actions quite incidental to the main drama are conceived with great vitality and much play on scale, and placed in a woodland glade rendered with the minute, loving precision of the botanical draughtsman. All these characteristics make the pictures widely and instantly accessible, and they are evident masterpieces in the fairy genre.

The *horror vacui* of the *Oberon and Titania* pictures, and their great variety of facial expressions, may have influenced Richard Dadd (1817-77), whose celebrated *The Fairy-Feller's Master Stroke* (1855-64) contains in the central figure of the anguished old man what appears to be a type taken from *The Quarrel of Oberon and Titania.* Dadd earlier was almost certainly an influence on Noel Paton: his *Come unto these Yellow Sands* (an illustration to *The Tempest*) was shown at the RA in 1842, when the twenty-one-year-old Noel Paton was attending classes there, and its numerous nude and semi-nude figures and lightness of design must have made an impression on the younger painter. *The Fairy Raid* of 1867, in contrast with the hard outlines visible in earlier pictures, displays a much greater concern with the evocation of an atmosphere of mystery, and its haunting rendering of a moonlit midsummer eve is full of poetry. To this later type also belongs *Fact and Fancy* (1863: private collection), a charming fantasy showing the artist's three-year-old son in conversation with fairies he has encountered at the bottom of the garden. *I Wonder Who Lived In There* (1865: private collection) shows the same child gazing into the opened vizor of a helmet drawn from Noel Paton's famous collection of armour.

Noel Paton the popular moralist is already apparent in the early *The Pursuit of Pleasure* (1855: engraved). The allegory shows a butterfly-winged girl flying away from a motley throng of pursuers, whom she contrives to entice despite her inane smirk. They are evidently having difficulty in staying the pace, and the winged Nemesis looming over them unnoticed, sword in hand, about to punish them for the pleasure they want to enjoy but can't, is a similar conception to the *Spirit of the Cape,* Adamastor, in David's Scott's *The Discoverer of the Passage to India Passing the Cape of Good Hope* (1841: Trinity House, Leith) and to the figure of Kühleborn in Maclise's *Undine* (1843: H.M. The Queen) which are clearly related and may have a common German origin. The earlier Scott version is the one more likely to have been known to Noel Paton. Already, we are far from the playfully amoral fairy pictures of the late forties and Noel Paton's claim to our attention as a painter – but not his hold on the Victorian public – declined with his growing adoption of didactic themes. In later life, when he had become in Ruskin's words 'the Genius of Edinburgh, more of a thinking

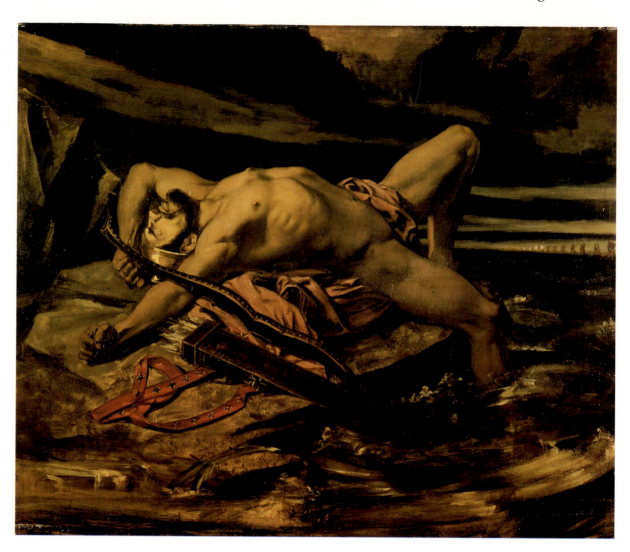

14 David Scott
*Philoctetes left in the Isle of
Lemnos by the Greeks in their
Passage towards Troy*
Oil 101 × 119.4 cm
National Galleries of Scotland
Exhibited at the Royal Scottish
Academy in 1840.

and feeling man than a painter', his alertness to new ideas deserted him, and later work like the *Beati Mundo Corde (How an Angel Rowed Sir Galahad over Dern Mere)* (1890: DAG) combined heavy literary bias with an almost total disregard of plastic qualities. In 1892 *Ezekiel in the Valley of Dry Bones: de Profundis* (1891: private collection) was seen by 30,000 people when put on view in Edinburgh, although the artist had feared that he 'could not afford to paint it – it would not sell'. Part of the preparation for this work, and for others of an historical or Biblical type, was in the reading of relevant literature; in this case, Layard's *Nineveh*.

William Bell Scott (1811-90), like Noel Paton, was a poet-painter. Today he is more often invoked, probably, as a poet or as the author of *Autobiographical Notes* (1842) and of the *Memoir* (1850) of his elder brother, David Scott, than as the painter of the mural cycles at Wallington Hall (1857-58) for Sir Walter Trevelyan and at Penkill Castle (1865-68) for Alice Boyd. He was in fact a minor member of the Pre-Raphaelite movement, contributing to *The Germ* in 1850, advising the Newcastle business man James Leathart on his collection of Pre-Raphaelite paintings after his appointment as Master of the School of

Design at Newcastle-upon-Tyne in 1843, and a neighbour of his friend Rossetti in Chelsea after his return to London in 1864. His painting *Albrecht Dürer of Nürnberg* (1854: NGS), which was actually painted from the balcony of Dürer's house, shows Pre-Raphaelite detail combined with the trivial circumstantiality of genre, and derives from Bell Scott's pioneering advocacy of early German art. The picture also indicates that archaeologizing tendency which found its ideal outlet at Wallington Hall, where he painted eight scenes from Northumbrian history on canvas. These were designed to fit blind arcades of an Italian courtyard with a glass roof which had been built at Ruskin's suggestion in the centre of the house. Painted in a light key which suits the well-lit interior, the Wallington Hall series, still in fresh condition, is a remarkably successful solution to a difficult brief, perhaps the best being those which include luminous passages of landscape, *The Building of the Roman Wall, St. Cuthbert, The Descent of the Danes, Grace Darling* and *The Nineteenth Century: Iron and Coal*, the last of the series. As a piece of industrial realism the last-named is only paralleled by Ford Madox Brown's celebrated *Work* (1852-65: MAG) in England. No other Scottish

painter had attempted a subject like this paean to commercial, industrial, and scientific progress. It shows the heir to Wallington as one of the three brawny 'strikers' hammering the red-hot iron beside a huge chain pulley, a marine air pump, an Armstrong shell and great gun, and a large anchor, with fisher-folk, a milk girl, a pit boy, and a photographer among the recognizable figures in the background.

David Scott (1806-49), while much less versatile than his brother and the unfortunate inheritor of the perhaps psychotic melancholy which pervaded the family home in Edinburgh, was the more considerable artist of the two. Rossetti regarded him as 'the painter most nearly fulfilling the highest requirements for historic art . . . who has appeared among us from Hogarth's time to his own'. After returning to Edinburgh in 1834 from an eighteen-month stay in Rome, Scott spent the remaining fifteen years of his life in the Scottish capital. Despite discouragement and neglect, his output was large and dominates by sheer force of individuality the first twelve years of Victorian painting in Scotland until his death. A dignified but embittered figure, he was the solitary protagonist in Edinburgh of the difficult ideals of the Grand Manner. 'He never looked on Art but as another Literature – able to address the age through history, poetry and morals', wrote W. Bell Scott in his *Memoir of David Scott* of 1850. But the themes which Scott chose were often stern and unfamiliar, even deliberately obscure: *Philoctetes Left* in *the Isle of Lemnos, Paracelsus, Vasco de Gama Encountering the Spirit of the Cape, The Russians Burying Their Dead*. Although he craved the acclaim which was always denied him (except by his artist colleagues, who admitted him to membership of the Scottish Academy in 1829 at the age of twenty-three), Scott refused to ingratiate himself with the buying public. He clung steadfastly to his view that

the art of painting . . . strives to create a world recognizable by the sense of sight, which will present things, or more properly, mental impressions, divested of those circumstances, which link with purposes aside from their more important or ultimate end – resting upon that alone which is most valuable in relation to mind.

Such an ideal was unlikely to be popular; even today the neglect of Scott continues and many of his pictures are lost. Yet his style is often far from austere and shows great dramatic invention and a powerfully pictorial sense of composition and colour.

In Italy in 1833-34, at the same time as William Dyce and Scott Lauder, David Scott's preferences among the works of the old masters seem a little old-fashioned in relation to contemporary taste. His chief admiration was reserved for the masters of the Roman *cinquecento* and *seicento* – Michelangelo, Caravaggio, Reni – although Caravaggio he grouped with Rembrandt and the author of the hellenistic *Laocoon*, that paradigm of Neo-classical perfection, as 'three of the most forcible minds that have been exerted in art'. This contrasts markedly with Dyce's *quattrocentist* and Lauder's Venetian tastes. Scott was evidently seeking models for a monumental style, although the mention of Rembrandt shows that painterly qualities also weighed with him.

Although Scott's style varies from picture to picture there is little development as such, and it comes as something of a shock to realize that the Daumier-like expressiveness of *Russians Burying Their Dead* of 1832 precedes the *Sappho and Anacreon* painted in Italy in 1833 and partially influenced by Guido Reni. The serene *Vintager*, also of 1833, shows how much a colourist Scott could be; but such moments of lyrical repose are rare in his work. As soon as he had seen Caravaggio's *Entomb-*

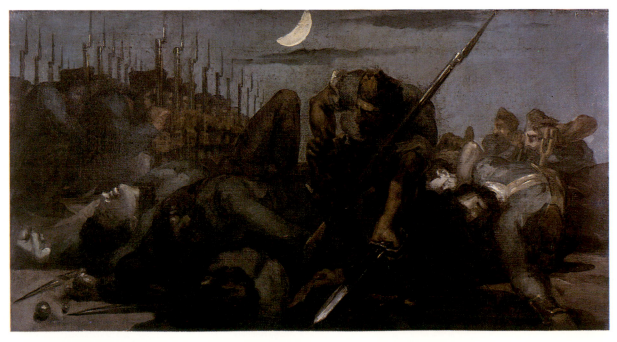

15 David Scott
The Russians Burying their Dead
1832 Oil 49 × 91 cm
Hunterian Art Gallery, University of Glasgow

ment in Rome, he declared himself 'ashamed of my own prettiness in *Sappho*' – on which he was then engaged – and the philosopher-painter quickly re-emerged in his next Roman work, *The Agony of Discord, or The Household Gods Destroyed* (engraved, but present whereabouts unknown). This contrived composition, in which the artist's admiration for the *Laocoon* and also for Etty's *The Combat* (by then in Edinburgh) is plainly visible, is a moral allegory on the passions which destroy family unity and by extension society itself. The protagonists' expressions of hatred, despair, and shame – as instantly legible as masks in a treatise on physiognomy – imply their opposites, the love, hope, and happiness whose destruction has turned harmony to discord. Scott wrote gloomily of this work in his journal for 10 October 1833, his twenty-seventh birthday: 'It will be my final effort for notice . . . I know what its fate will be; my acquaintances will be timid; a few foreigners may come to see it; it will be rolled up and follow me to Scotland.' In fact, the picture remained unsold at the time of his death.

Undeterred by his failure to win a following in Edinburgh, Scott continued to produce his large compositions on a wide variety of themes. The best of them are those which make their effect through striking simplifications of form – such as the rhythmical repetition of the distantly receding ships (*Philoctetes*, 1840), the teeth of the portcullis (*The Traitor's Gate*, 1842), or the moonlit bayonets (*Russians Burying Their Dead*, 1832) – allied to a dramatic use of light; in other words relying more on pictorial form than on narrative content. These powerful designs have the additional merit of being couched in a painterly language of bold brushwork and imaginatively used colour. Scott was a pioneer in a number of ways. His fairy paintings, *Puck Fleeing the Dawn, Ariel and Caliban* (both 1837: NGS), and *The Belated Peasant* (1843: NGS), anticipate a Victorian fashion; the *Paracelsus* (1838: NGS) sets a precedent for Sir William Fettes Douglas's *The Spell* of 1880 (NGS) and *The Dead Sarpedon* (1831: NGS) for the Edinburgh Symbolists of the 1890s and for Henry Lintott's *Avatar* (RSA Diploma Collection). Scott's painterliness, too, set an important example in an age of high finish and 'correct' drawing.

In his *Memoir of David Scott*, W.B. Scott alludes to

the truth – that in the present age and in this country, especially in the limited sphere of Edinburgh, high art of an original kind, and on an adequate scale, is not required by any desire in the public mind – that pictures take their value nearly

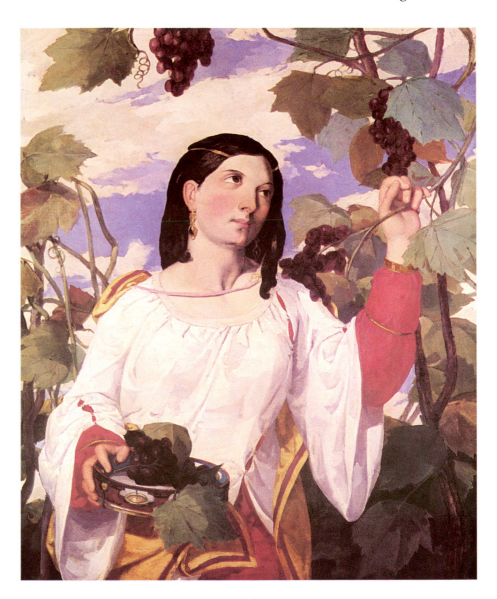

in proportion to their workmanship and scarcely ever by their intellectual expression.

It is certainly true that while David Scott found little support for his lonely endeavours in Edinburgh, the genre painters (one of whom, Thomas Duncan, was given the Chair of the Antique at the Trustees' Academy in preference to Scott in 1844) tended to be popular and successful. The appeal of genre lay not only in its familiar, accessible subject-matter but also in its adaptability to a wide range of moods and themes. It had special relevance to the new humanism of the nineteenth century. Here, the versatile David Wilkie had given the lead. This development is considered in the next chapter.

16 David Scott
Vintager
Oil 116.9 × 97.2 cm
National Galleries of Scotland
Exhibited at the Royal Scottish Academy in 1835, the first sketch was made in Rome from the model, La Fornarina, in April 1833.

3 DOMESTIC AND HISTORICAL GENRE

'The taste for art in our isle is of a domestic rather than a historical character', wrote Sir David Wilkie (1785-1841). No one, perhaps had done more than Wilkie himself to bring this about. When he died in 1841 his work enjoyed, in the words of his fellow Royal Academicians' letter of condolence to his relatives, 'a celebrity unsurpassed in modern times'. A still more splendid tribute came from J.M.W. Turner, whose *Peace: Burial at Sea* was painted to commemorate Wilkie's death, which occurred on board ship during his return voyage from the Holy Land. From his début at the Royal Academy in 1806 until the change of style which followed from his travels in Italy, Saxony, Bavaria, and Spain in 1825-28, Wilkie's art was universal in its appeal, and was

admired alike by his royal patrons, by the ordinary people who thronged his exhibited paintings or bought the immensely popular steel engravings made after them, and by his fellow artists, including Delacroix and Géricault, who saw his work during visits to England. In his earlier manner, Wilkie was really the perfecter rather than the inventor of a genre type which was partly of Scottish origin and later developed strong Scottish associations through his own and his followers' work. This tendency, curiously enough, became endemic to London with the migration to the capital of Wilkie himself and of such later Scottish artists as John Phillip, Erskine Nicol, the brothers Thomas and John Faed, and John and Alexander Burr. Even Landseer's brilliant gifts

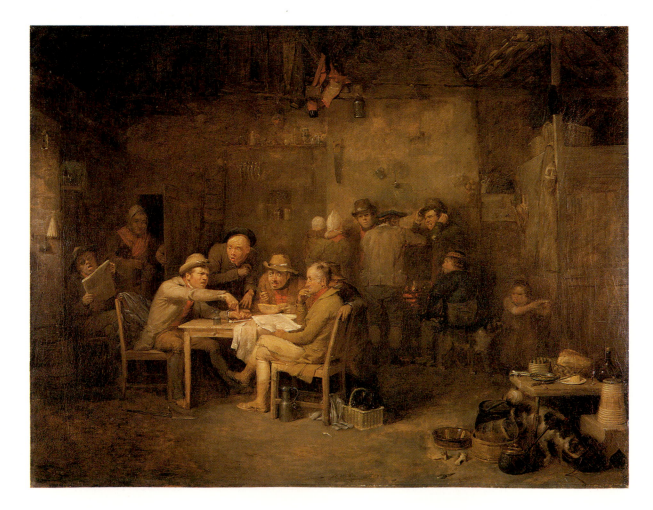

17 Sir David Wilkie
The Village Politicians: vide
Scotland's Skaith
1806 57.2 × 75 cm
The Earl of Mansfield
Painted in London for Lord
Mansfield, and based on an earlier
version done in Scotland.
Scotland's Skaith is a poem by
Hector MacNeill, illustrating the
dangers of addiction to political
discussion and whisky.

were more than once deployed on Wilkiesque themes such as *The Highland Shepherd's Home*, exhibited in 1842 at the Royal Academy.

The story of Wilkie's rise to fame as a painter of genre is well known. In 1806 at the age of twenty he exhibited at the Royal Academy the small painting *The Village Politicians* (Earl of Mansfield) which instantly made his reputation. Its success was due to a delicacy of touch, simple and well-observed subject-matter, and its humour. Cunningham relates that on seeing this picture Sir George Beaumont, who was to become Wilkie's lifelong friend and influential ally, presented the young artist with the mahlstick which had once belonged to Hogarth, which Beaumont had kept until he should find a painter worthy of possessing it. A series of similar subjects followed, sometimes drawn from the life of the Scottish peasantry Wilkie had known as a son of the manse in Fife.

A limited precedent had been created for this type of subject in Scotland by David Allan (1744-96), whose pioneering genre scenes and street cries were influenced by the *bamboccisti* whose work he had encountered in Rome. The poet Burns wrote of himself and Allan as 'the only genuine and real painters of Scottish costume in the world', and Wilkie's *The Penny Wedding* of 1819 painted for the Prince Regent contains a reminiscence – but nothing more – of Allan's *Penny Wedding* (NGS), which had been engraved in 1803. David Allan's genre work was mostly in watercolour. That of his pupil Alexander Carse, who died in 1843 (the date recently established in Lindsay Errington's valuable study), was in oils and had perhaps some early influence on Wilkie, whom he followed to London in 1812, the year of Carse's masterpiece, *The Visit of the Country Relations* (Bowhill), whose brittle delicacy of theme and treatment shows real independence. Wilkie's *Pitlessie Fair* (begun 1804: NGS) is perhaps the clearest example of the younger artist's debt to Carse – specifically, to the composition *Oldhamstocks Fair* (1896: NGS and GAG) – but beside the Wilkie version Carse's own later *Mauchline Holy Fair* (1816: private collection) appears wooden. Carse's wittily titled *The New Web* (NGS), which was exhibited in Edinburgh in 1813, showing a tailor's apprentice kissing a servant-girl behind her master's back, although adding nothing to the Wilkie canon, does reveal an admiration for Netherlandish painters of domestic genre like Ostade and Teniers which was certainly shared by Wilkie, whose *Letter of Introduction* (1813: NGS) is based on a composition of Ter Borch. Again, however, the qualities exemplified in this latter, partly autobiographical work inspired by a visit made by the aspiring young artist to the influential London connoisseur Caleb Whitefoord – the subtle and sympathetic characterization which at once individualizes and links the three participants, man, youth, and dog; the beautiful drawing, delicate finish, and gently understated humour – remained

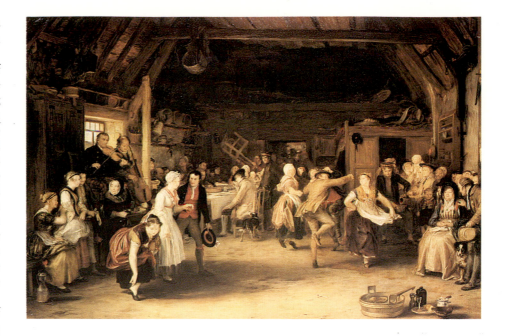

always beyond the reach of Wilkie's rivals and followers. The parallelism in subject-matter between the two artists interweaves closely in Carse's London years (until circa 1821) with subjects such as *The Pedlar* (Yale Center for British Art) or scenes from Burn's *Duncan Gray*, culminating in *The Penny Wedding* by both artists in 1819. But whereas the Wilkie wedding picture (H.M. The Queen) is nostalgically set in the costume of an earlier age, the Carse version (private collection) robustly portrays a contemporary scene in all its vigorous immediacy. It is no small tribute to Carse that he is able to emerge with credit from the comparison.

In Scotland the painters most immediately influenced by Wilkie were four of his former classmates at the Trustees' Academy in Edinburgh, William Home Lizars (1788-1859), Alexander Fraser (1786-1865), John Burnet (1784-1868), and Sir William Allan (1782-1850). These artists had studied at the Trustees' Academy under its sixth Master, the history painter John Graham (1754 or 1755-1817), one of whose sponsors to the post was the same Caleb Whitefoord immortalized by Wilkie. Graham, rescued from oblivion by Hamish Miles's recent study, was only a mediocre painter who nevertheless, as Miles points out, can be credited with the blossoming of the Trustees' Academy as a painting school in Edinburgh during the rise of the crucial generation of painters which included Walter Geikie and Sir John Watson Gordon, as well as the names mentioned above. Of these, Burnet is now chiefly remembered as Wilkie's engraver. *A Scotch Wedding* and *Reading the Will* (both 1811: NGS), the two best-known works of Lizars, who in 1812 virtually gave up painting while still in his mid-twenties to devote his energies to the family engraving business, foreshadow Wilkie in their subjects but show his

influence in treatment. Fraser's *The St. Andrews Fair* (1834: DAG) on the other hand clearly follows in the master's footsteps in subject as well, but here, as with Sir William Allan's *The Shepherd's Grace* (1835: RA Diploma Collection), any comparison with Wilkie is inevitably unflattering to his imitators. Of these, only two further names require mention here: William Bonnar (1800-1853) and Alexander Johnston (1815-91). Johnston studied initially at the Trustees' Academy in Edinburgh before moving to London and enrolling at the Royal Academy schools. His work is now rarely seen but suggests an artist deeply influenced by Wilkie in subject-matter, colouring, and treatment, who nevertheless was a draughtsman of real individuality. Bonnar (whose short career was spent in Scotland and whose pictures are equally rare) was perhaps a more subtle and more painterly artist. The quiet arcadian poetry of *Roger, Jenny and Peggy – a Scene from 'The Gentle Shepherd'* (1829: private collection) exemplifies the very real charm of what Sickert was pleased to call 'the old Scotch school', those 'descendants of Rubens, through Wilkie' whom

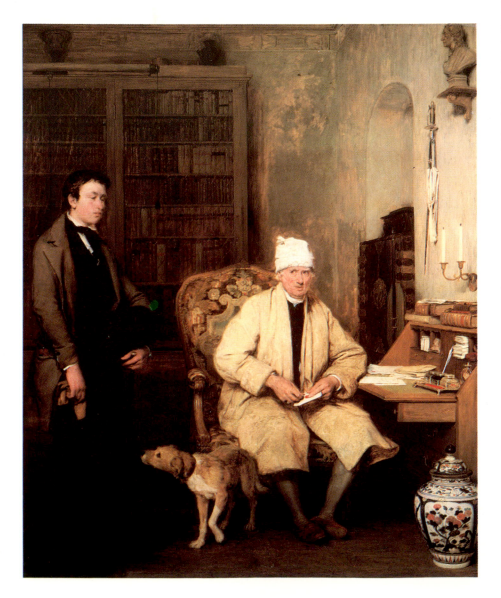

19 Sir David Wilkie
The Letter of Introduction
1813 Oil on panel 61 × 50.2 cm
National Galleries of Scotland

Sickert had 'always loved and admired', whose vernacular style at once created and satisfied a demand for fine painting among the connoisseurs and collectors of early nineteenth-century Scotland.

Wilkie gradually became dissatisfied with the limitations of domestic genre and evolved his own distinctive version of historical genre, frequently turning to contemporary events for his themes. Later in life he also changed certain technical aspects of his style, above all painting with a much greater breadth which was virtually imposed by the greatly increased scale of his compositions. As early as 1814, after seeing the Rubens *Medici* cycle in the Luxembourg Palace for the first time, he reported in his journal, 'They grew upon me amazingly, and before I left the room, I could not help being convinced that, with all his faults, Rubens is one of the greatest painters that ever existed'. Wilkie was then still painting in his meticulously finished earlier style and was not technically prepared to absorb the lessons of Rubens immediately, but it was perhaps inevitable in his search for a more monumental, broader style that Wilkie should turn to Rubens, just as his desire for greater depth and sonority of colour eventually led him to the two earlier Spanish masters who were also painters of the life of their own day, Velazquez and Murillo. *Chelsea Pensioners Reading the Gazette of the Battle of Waterloo* (1822: Apsley House), *The Entry of George IV into Holyrood House*, and the vast Rembrandtesque *General Sir David Baird Discovering the Body of Sultan Tippoo Sahib* (1838: Edinburgh Castle) show three clear stages in Wilkie's gradual progress towards a grander manner and subjects of greater or more overt historical moment. Past history also began to receive his attention at the end of his career. He painted two Napoleonic subjects, *Napoleon and Pope Pius IV at Fontainebleau* (1836) and *The Empress Josephine and the Fortune-Teller* (1838: NGS), which retained a measure of topicality, and two pictures of the reformer John Knox which, painted in the years immediately following Catholic Emancipation and preceding the Disruption, may have been of more urgent significance to their own day than we at first suppose. In the year of the Act of Emancipation, 1829, Wilkie exhibited *Cardinals, Priests and Roman Citizens Washing the Pilgrims' Feet* and *Baptism in the Church of Scotland*, which ought to have been satisfactory to both sides. The earlier composition, *The Preaching of Knox Before the Lords of the Congregation* (1832: TG, versions at Petworth House and NGS) was commissioned by the Earl of Liverpool, but eventually bought by Sir Robert Peel. Wilkie spared no pains to achieve historical accuracy in this painting, and it is worth recalling that it was to Robert Peel that Wilkie wrote before he died stressing the importance of travel in the Near East to the authentic rendering of religious subjects. The second Knox picture, which was never finished, was *John Knox Administering the Sacrament* (begun 1839),

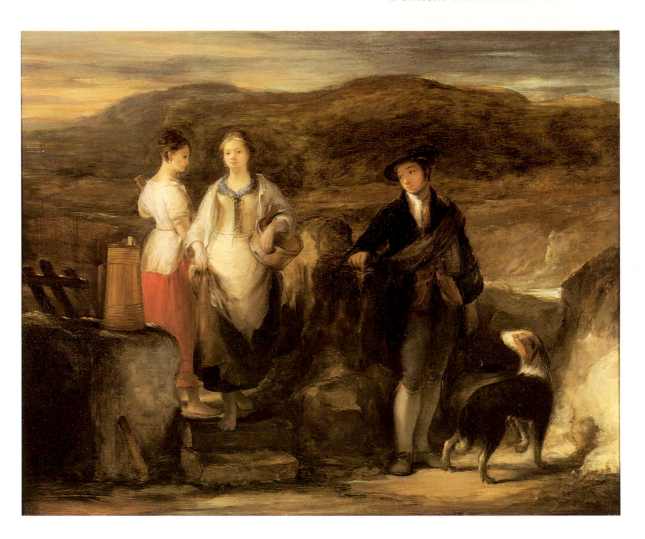

20 William Bonnar
Roger, Jenny and Peggy
1829 Oil on panel 41.9 × 52 cm
Private collection
A scene from Allan Ramsay's *The
Gentle Shepherd*.

the large version of which was bought by the RSA at the Wilkie Sale in 1842. This latter picture became well known to the younger Edinburgh painters, and William Dyce, Thomas Duncan, James Drummond, and W.Q. Orchardson produced works based on it.

Wilkie's contemporary and erstwhile fellow-student at the Trustees' Academy, Sir William Allan, was by the beginning of Victoria's reign established in Edinburgh in the highly influential positions of Master of the Trustees' Academy (from 1826) and President of the Royal Scottish Academy (from 1837). Like Wilkie, Allan had studied under John Graham in Edinburgh. Although Wilkie tended to discount what he had learned in Scotland and called William Allan 'Allan the First' in disparagement of David Allan, the admittedly scanty available evidence suggests that John Graham was a not unworthy master of the two Scots, who were in 1837 still among the most prominent figure painters in London and Edinburgh. Graham's *Othello and Desdemona* (lost; engraved), painted for the Boydell Shakespeare Gallery, is a confidently dramatic costume piece, but it looks forward more obviously to the interest of Sir William Allan and his Edinburgh pupils in illustration and costume genre than to the naturalism of Wilkie.

Allan spent the years 1805-14 in Russia painting romantic studies of Tartars and Circassian brigands. 'Do not forget to embellish your landscape with fine figures. You know that nature is like a desert to me if it doesn't contain brave men and fair women', wrote a St. Petersburg patron to Allan in 1808 (the original letter, in the NLS, is in French). This advice appears to have been taken to heart and Sir William Allan's Russian pictures contain their full complement of the brave and the fair, or at least of the picturesque. But Allan found on returning to Edinburgh in 1814 that Russian subjects did not have a ready market, and on the advice of his friend Sir Walter Scott he turned to historical romance, with subjects taken from Scottish history and literature, and especially from Scott's own works. In this field he became a specialist, the Scottish brave and fair replacing the Russian, and his example was largely responsible for the predominance of specifically Scottish themes in the work of the rising generation of painters in early Victorian Edinburgh. But the nationalism of a large painting of 1840, *Heroism and Humanity* (GAG), representing an incident in the life of Robert the Bruce, appears rather rhetorical when compared with Wilkie's festive *Entry of King George IV into Holyrood House*, a much subtler expression of patriotism, which reticently

introduces the newly rediscovered Honours of Scotland, the Scottish royal palace itself, and, in the large version in the Royal Collection, the figure of Sir Walter Scott as subordinate elements in what is essentially a state portrait. Allan, although generally independent and even original in his choice of subjects, was influenced by the later manner of Wilkie and transmitted to his pupils not only the broader execution which was one of its chief features but also, less happily, a prevalent use of brown which could only have meaning in the hands of an artist possessing Wilkie's mastery of tone. The ruinous effects of the use of asphaltum *à la* Wilkie can also be seen in several of the earlier works of Sir George Harvey, Robert Scott Lauder, and Thomas Duncan.

Sir William Allan's pupils, like their master, have fallen into an oblivion which seems unmerited, and since only a small proportion of their exhibited output can now be traced it is difficult to arrive at a satisfactory judgement of their achievements. Sir George Harvey, Thomas Duncan, and James Drummond were successful and popular artists during their own lifetimes, particularly Harvey, who became President of the RSA in 1864 and was knighted three years later. As the excellent reproductions in the revealingly titled volume *Harvey's Celebrated Paintings* of 1870 show, Harvey was an engaging and versatile artist. Unlike his contemporary David Scott, he never ventured beyond the limitations of his own technique, but displayed considerable inventiveness on a less grandiose plane. His first success came in 1830, with *The Covenanter's Preaching*, the first of several treatments of this aspect of Scottish history from which popular engravings were made. The awkward groupings and articulations in these compositions lend them an almost primitive air, yet this is curiously apt where the subject is, as here, austere and even stern, and they have a refreshing vitality. This latter quality appears to great advantage in *The Curlers* (1835), which also shows increased confidence in the handling of space and is part sporting picture and part landscape. Its sequel was *The Bowlers* (NGS), which was shown at the RA in 1850. *Drumclog* (1836: GAG) continued the series of Covenanting scenes, perhaps influenced by the battle scenes of Jacopo Cortese.

The series was interrupted by several not altogether successful 'histories': *Shakespeare before Sir Thomas Lucy* (1837: RSA), *John Bunyan in Bedford Gaol* (1838), *Argyle an Hour before his Execution* (1842), *An Incident in the Life of Napoleon* (1845), and in the same year *Mungo Park and the Little Flower* and *Dawn Revealing the New World to Columbus* (1855: all untraced). Perhaps the most important of these history paintings was *The First Reading of the Bible in the Crypt of St. Paul's*, painted in 1839-42. This picture was bought by the Liverpool collector John Clow and may have had some influence on the Liverpool artist W.L. Windus before he fell under the spell of the Pre-Raphaelites.

In 1859 the Association published Robert Burns's *Auld Lang Syne* with illustrations by Harvey, and in the following year four paintings each illustrating a line from the poem were sent by Harvey to the RSA. Two of them are particularly memorable images: 'But Seas between Us Braid Ha'e Roared', which shows a sailor perched high aloft among the rigging of a sailing ship and is seen from his viewpoint, and 'We Twa Ha'e Paidl't in the Burn', which shows two young boys playing on a grassy hill, a simple and nostalgic treatment of the outdoor pleasures of childhood.

On occasion Harvey showed himself to be an excellent and sympathetic recorder of contemporary life. *A Schule Skailin'* (1846: NGS) – translated as *School Dismissing* when lent to the RA in 1871 – and *Quitting the Manse* (1848: NGS), which deals with the situation of many parish ministers who resigned their charges at the Disruption and consequently found themselves and their families homeless, were both in their own day extremely well-known examples of this side of his work. Wilkie's influence is evident in these relatively early works by Harvey, but in *Sheep Shearing* (1859: SAG) it is no longer so. Caw wrote of this painting that it possessed a 'truth and subtlety of aerial effect new in Scottish Art', and of Harvey's landscape work in general that 'he realised the pensive charm and pastoral melancholy of the Highland straths and the Lowland hills with an insight and sympathy which make recollection of his landscape a precious possession'. Approximately thirty landscapes appear to have been exhibited at the RSA by Harvey between 1859 and his death in 1876, but most of these pictures, constituting the major part of the artist's later work, are now lost. One of the few traceable examples, *Holy Isle, Arran* (1873: DAG), is painted with a freedom and tonal control which would not have looked out of place on the other side of the Channel, although its colour scheme is still based on a harmony of browns. It is in its way an impressive and beautiful work, and supports Caw's suggestion that Harvey is to be seen at his best in the late landscapes.

Thomas Duncan (1807-45) was a year younger than Harvey but died more than thirty years before him. In the seventeen years from 1828 when he first exhibited at the Scottish Academy until his death, he was represented at the RSA by nearly 100 canvases, of which approximately two-thirds were portraits. Yet despite the success in that field suggested by the rank of his sitters it was as a genre painter with an evident predilection for subjects inspired by Sir Walter Scott and Shakespeare that he achieved his considerable reputation among his contemporaries. He was an Associate of the early Scottish Academy by the age of twenty-two and fourteen years later, in 1843, of the Royal Academy. In 1844 he succeeded his own teacher, Sir William Allan, as Headmaster of the Trustees' Academy, but was dead the following year. Today he is virtually forgotten and most of his

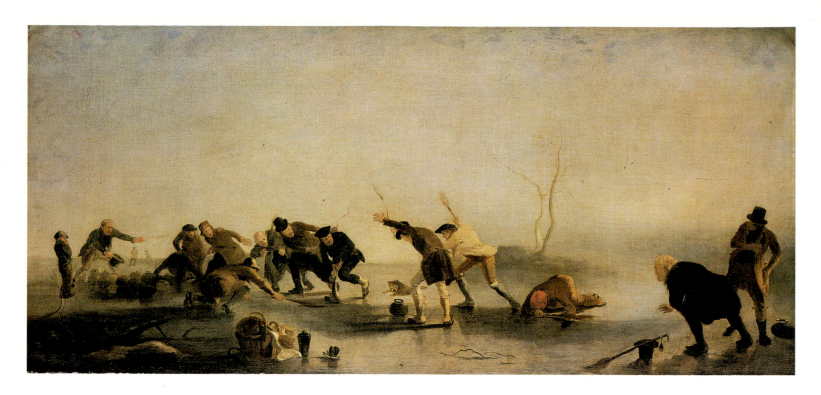

21 Sir George Harvey
The Curlers
c.1834 Oil 35.9 × 79.4 cm
National Galleries of Scotland
A study for the larger version
exhibited at the Royal Scottish
Academy in 1835.

recorded work has vanished. The recently redisplayed *Anne Page and Slender* (1836: NGS), regarded by Caw and earlier writers as his most characteristic work, is a piece of Shakespearian whimsy with an emphasis on period costume and theatrical gesture which looks forward to Fettes Douglas, Orchardson, and Pettie. Its use of richer colour than was usual in Scottish painting of this date indicates the considerable Venetian influence which Duncan's early copies (now in the NGS) from Titian and Veronese might lead us to expect. Somewhat more surprisingly and a little incongruously, there is a Dutch motif recalling Brouwer or Ostade in the faces of Falstaff and an elderly companion framed in a window casement as the unseen witnesses of the comic encounter of the principal figures. These secondary personages are painted in glazed browns in contrast to the impasted lights of the main figures. Transitional and inconsistent though this work appears in its use of colour when compared with the confident colourism of Robert Scott Lauder's sketch for *Christ Teacheth Humility* of twelve years later, it nevertheless looks forward more clearly than any of Lauder's work to the more robust use of colour and well-nourished pigment which became a hallmark of later Scottish painting.

The effect's of Duncan's training under Sir William Allan are evident in the bitumenized *Catherine Glover and Father Clement* (PAG), which is brownish and insubstantial. His later, more painterly approach may well have been learned from the Raeburnesque portraitists, and perhaps especially from John Graham-Gilbert, whose *Love Letters* of 1829 mixes genre with portraiture and shows the solid paint surface and glowing internal lighting which appear in the later Duncan, most notably and completely in the large *Prince Charles Edward Asleep in a Cave* of 1843 (Castlemilk). It is also likely that the example of Etty's smooth modelling of the figure has some bearing here. However, a further reminder of the Raeburn portrait tradition occurs in Duncan's portrait (n.d. illustrated RSA 1926) of his friend Professor John Wilson (the pseudonymous 'Christopher North' of the *Noctes Ambrosianae*), whose composition is indebted to Raeburn's grandly romantic *Colonel Alastair McDonnell of Glengarry*.

James Drummond (1816-77) gave an antiquarian turn to the interest in historical genre with a national emphasis which is characteristic of Allan's pupils. He was born in John Knox's House in Edinburgh's Royal Mile and his father, himself an historian of Old Edinburgh, inculcated in the son a love of the study of Scottish antiquity. This was to bear fruit in a book on the Celtic sculptured stones of the West Highlands and a series of drawings of Edinburgh streets executed between 1848 and 1867 with the object of recording the vanishing face of the ancient capital. Drummond's *George Wishart on His Way to Execution Administering the Sacrament for the First Time in the Protestant Form* (1845: DAG) is an early attempt at that species of archaeological reconstruction whose prototype was Wilkie's unfinished *John Knox Dispensing the Sacrament at Calder House* (begun 1840: NGS). It was followed by a series of paintings which either evoked the Scottish past and its notables, as in *Blind Harry the Minstrel Reciting the Adventures of Sir William Wallace* (1846), *James I of Scotland Sees His Future Queen* (1852), and *Ben Jonson's Visit to Hawthornden 1618* (1867: all untraced), or depicted the old architecture and

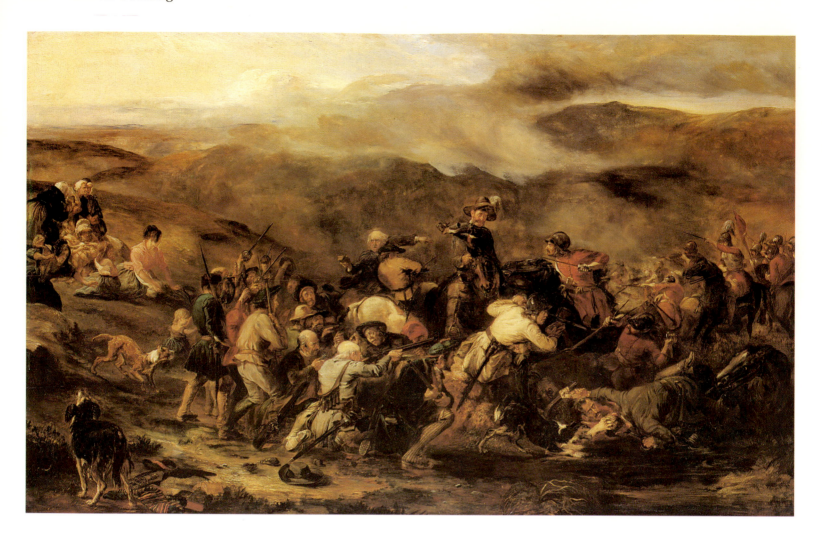

22 Sir George Harvey
Drumclog
1836 Oil on panel 100.9 ×
159.2 cm
Glasgow Art Gallery

historic streets of the Scottish burghs, particularly of Edinburgh. A picture purchased for the national collection by the Royal Association for the Promotion of the Fine Arts in Scotland, *The Porteous Mob* (1855: NGS), combines these two elements in a satisfactory way. It portrays a dramatic night scene described in *The Heart of Midlothian*, and shows as a backdrop for this a reconstructed Candlemakers Row and Grassmarket, depicted with a wealth of incident and historical detail made palatable by subordination to an architectural framework which contributes to the impression of authenticity. Drummond's treatment in this as in the *George Wishart* picture is redeemed from the meretriciousness to which this type of genre was all too prone by a certain scholarly integrity which triumphs over his graceless drawing and almost total eschewal of colour.

By mid-century the never very clearly defined boundary between High Art – historical and religious painting and the illustration of the heavier classics of literature – and genre was blurred still further. Sir George Harvey and Thomas Duncan had narrowed the idea of history painting down to the painting of historical narrative; Drummond merely continued this tendency towards the particular and the real as opposed to the universal and the ideal, and towards a

would-be factual rather than an imaginative reconstruction of events of the past. We have already seen how the realism of James Eckford Lauder's *Bailie McWheeble at Breakfast* and Noel Paton's *Dawn: Luther at Erfurt* represents a departure from the art of ideas to which David Scott alone in Scotland remained faithful. Yet even Scott in his *Paracelsus Lecturing on the Elixir Vitae* (1838: NGS) displayed an interest in the past for the sake of its curious lore, presenting in that work a disturbing gallery of bizarre characters in quaint dress: whispering conspirators, indolent courtiers, sullen priests, and venal ladies portrayed for their individual idiosyncrasy as much as for conformity to type. Throughout the 1850s, works by Millais and Holman Hunt were lent to the annual exhibitions of the RSA, providing an inescapable challenge to artists in Edinburgh, and above all accelerating the progress of realism. *Bailie McWheeble* and *Dawn: Luther at Erfurt* reflect this influence. William Fettes Douglas's portrait of a celebrated Edinburgh bibliophile and antiquarian, *David Laing and His Household Gods* (1862: NGS), notwithstanding a difference of subject-matter more in degree than in kind, shares with these two earlier pictures a common preoccupation with antiquarian staffage and with individual character. It is perhaps

the most satisfying work of the three because rather than strain after literary interpretation or religious expression, the artist has here found a subject in which the man and the milieu are one, and has deployed his remarkable skill on rendering with exquisite minuteness (hardly paralleled in any Scottish painting since Wilkie's *The Letter of Introduction* of 1813) the sitter's 'household gods', which are an extension of his own personality.

Sir William Fettes Douglas (1822-91) was a self-taught painter of exceptional gifts who became President of the RSA in 1882. The letters he wrote to David Laing from Italy in 1865 reveal him as a collector and learned antiquary, but are full of a feeling of *déjà vu* indicative of a fastidious temperament at once easily sated and wary of novelty. He writes: 'nature retains its beauty but the works of man seem poorer and falser the more they are studied. St. Peter's seems to me now neither so fair nor even so large as it did eight years ago, and not one picture, not one work of art of any kind repeats or revives the pleasure it afforded in former days', and elsewhere, 'I am so utterly sick of this idle wandering life that there is little likelihood of my going to Greece.' Perhaps the art galleries of Holland and Belgium which Fettes Douglas visited in 1878 gave him more pleasure. As an artist his affinities were above all with the Dutch and Flemish still life painters, and his paintings of astrologers, alchemists, and philosophers are in reality cabinet pieces, conceived on a larger scale, but akin in spirit to those of David Teniers, redolent of the arcane atmosphere of the study or laboratory and containing marvellously painted passages of still life. Several works painted in the 1860s demonstrate a delicate, rather dry virtuosity – *The Moneylender* (1861), *David Laing* (1862), and *The Spell* (1864: NGS). Their subtlety of colour and certainty of touch achieve a kind of minor perfection, more proper to the applied arts than to painting, satisfying the eye but leaving the mind and emotions untouched, and seeming to aspire to the material preciousness of the *objets d'art* shown in many of the paintings lovingly painted by an evident connoisseur. His disregard of the dictates of fashion is suggested by his later reversion to a Wilkie-like brown colour scheme from the conspicuously high key of *The Spell* to *The Antiquary* of 1875 (DAG). In the same year he began to turn his attention to landscape, which increasingly preoccupied him until his death. *Stonehaven Harbour* (1876: NGS) is the best-known example. It exploits the steep perspective provided by a viewpoint high on the hill behind the harbour, so that the surface of the water beyond, on which are dotted sailing boats returning in the early morning light after a night's fishing, rises in a flat vertical composition reminiscent of oriental art.

Among the more important Scottish genre painters born in the 1820s, Fettes Douglas was virtually the only one who did not spend his career in London, although his principal pictures were frequently sent first to the Royal Academy, and then to the RSA. This isolation created a refreshing independence, but at the same time his conservative temperament prevented him from contributing to new developments in the subject picture of the High Victorian period. As a result his own work has a slightly archaic air.

Fettes Douglas was a member of an Edinburgh sketching club called The Smashers, founded in 1848 and consisting originally of Douglas himself, John Ballantyne (1815-97), William Crawford (1811-69), the brothers John (1820-1902) and Thomas Faed, (1826-1900) and James Archer (1823-1904). While not exactly redolent of the revolutionary iconoclasm suggested by the club's title, these names severally indicate the transition that was taking place in the concept of genre from the earlier sometimes stern 'histories' of Sir William Allan, Sir George Harvey, and James Drummond (with their themes of murder, battle, and martyrdom, and events on a high level of historical significance), to the more human, more subjectively emotional, and later frankly sentimental, approach introduced especially by Tom Faed on a simple realistic plane in the early 1850s. In particular Faed depicted the agrarian population accepting its humble, sometimes deprived lot with resignation. Successful London Scots have never been prone to rock the boat and there is no hint of social criticism in Faed's work. By mid-century, in Scotland as in England, genre painting had become a medium of mass entertainment akin to the popular novel and its aspirations to profundity were generally no greater. In Fettes Douglas's *The Recusant's Concealment Discovered* (1859: GAG) a Pre-Raphaelite theme of religious persecution is reduced to a game of hide-and-seek, prettily coloured. In contrast Noel Paton, in a somewhat similar work, *The Bluidie Tryste* (1855: GAG), shows again that he understood the aims of the Pre-Raphaelites more clearly than any of his Scottish contemporaries, capturing and vulgarizing in a few paintings such as this something of the movement's intensity, in addition to the meticulous drawing and use of strong colour which were all that Fettes Douglas had absorbed. It is fair to add that Millais's *The Proscribed Royalist* of 1853 already shows a slackening of the Brotherhood's own early impetus.

James Archer, another member of The Smashers, was a portraitist in pastels who became a minor late follower of the Pre-Raphaelites, notably in a rather insipid Arthurian series painted in the 1860s, of which *The Death of Arthur* (1861: MAG), with its Tennysonian vein of sweet melancholy, is one of the better examples. Soon after his transfer to London in 1862 we find Archer a member of a London sketching club called the Auld Lang Syne, which was founded in 1863 and was in fact The Smashers reconstituted now that Archer and the Faed brothers were resident in London, where Tom Faed had in fact lived since 1852. Erskine Nicol (1825-1904), another

London Scot, was a member of the Auld Lang Syne, and three younger Edinburgh-trained painters who were soon to make their mark in the capital were frequently welcomed as guests: Pettie, Orchardson, and Peter Graham. Somewhat later, these younger artists formed a club of their own in London, known simply as The Sketching Club, which included virtually all the Edinburgh-trained artists of Pettie's generation resident in London.

These sketching clubs, with their lively and informal atmosphere, their competitions on suggested themes, and their cultivation of narrative inventiveness and rapidity of execution, were a common factor in the development of these Scottish artists in London. At the same time they were fertile forcing-houses of ideas for pictures planned on a very different basis from the high seriousness of a David Scott or the sensitive observation and careful calculation of a Wilkie. Martin Hardie, in the Pettie book, tells us that the subject for one evening's meeting was 'destruction', which was illustrated by C.E. Johnson by a shipwreck, while MacWhirter depicted a burning castle – 'the dark mass of ruins and some withered trees against the lurid glare of the sky, making a fine piece of composition and colour', while 'in Pettie's case the subject inspired a powerful drawing of Palissy seated despondently before his furnace door with his pottery lying in shattered fragments on the ground'. Several paintings shown at

the Royal Academy by members of the Club originated from rapid sketches made at one or other such meeting, including the famous *Funeral of the First-Born* (1876: DAG) by Frank Holl, one of the few English members of The Sketching Club. Martin Hardie tells a story which amusingly reveals the fertile and melodramatic habits of imagination formed by this type of approach: as a schoolboy he was to make a drawing of a pistol for a school prize and told Pettie (who was his uncle), who instantly suggested that the picture's title should be *The Suicide's Weapon* and that a smoking weapon should be shown beside a prostrate body. In a sense, this kind of slightly dubious ingenuity had its origin in Wilkie's much pilloried apophthegm that 'to know the taste of the public is to the artist the most valuable of all knowledge' (although Wilkie's early popularity has been achieved almost by accident and he actually defied popular opinion with his later change of style and subject), a remark which was only too prophetic, had he but realized it, of the desperate efforts of his own followers to palliate that taste. About 1868 one of the most successful and most talented of these followers, Tom Faed, most of whose career was spent in London, described himself in a letter to W. Hepworth Dixon as a 'slave to the Academy'.

The kind of over-production, in terms of number and scale, enjoined on successful artists by the Royal

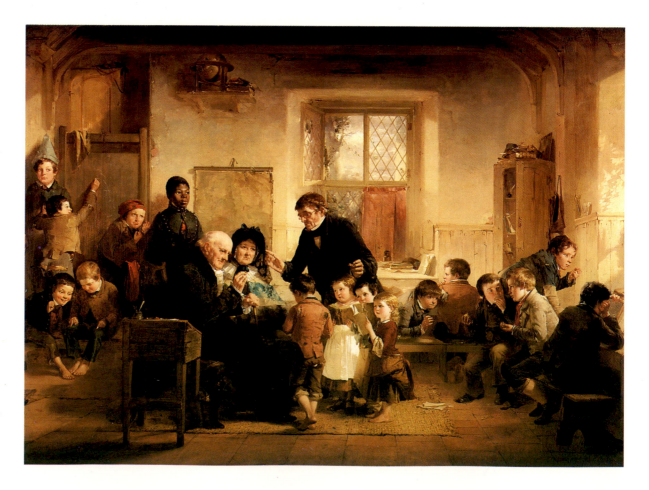

23 Thomas Faed
Visit of the Patron and Patroness to the Village School
1851 Oil on panel 96.5 × 132.1 cm
Dundee Art Gallery

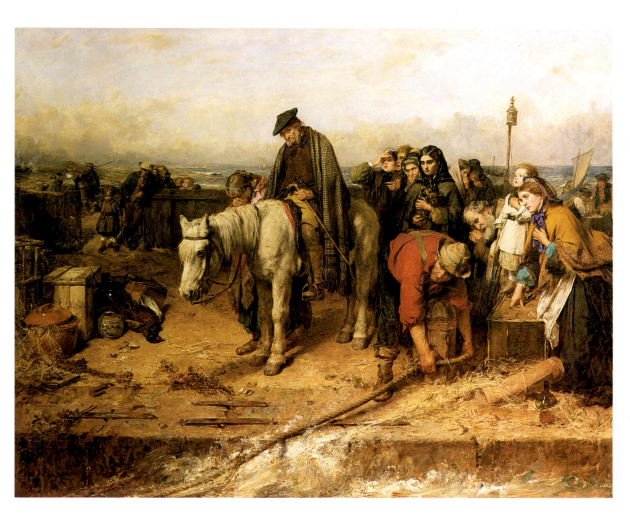

24 Thomas Faed
The Last of the Clan
1865 Oil 144.8 × 182.9 cm
Glasgow Art Gallery

Academy system, must have been a chronic problem for a painter of Faed's painstaking methods and laborious execution. The large and elaborately finished *Visit of the Patron and Patroness to the Village School* (1851: DAG), actually exhibited at the RA during the first year of Faed's residence in London, 1852, shows his remarkable manipulative skill (the enamel-like surface of the paint is still in beautiful condition), and a sensitive treatment of light which imparts a fine luminosity to the muted harmony of ochres and greys. In its subject of the pastimes and pains of young life the picture owes an obvious debt to Scottish predecessors like *The Village School* or *The Cut Finger* by Wilkie or Harvey's recent *A Schule Skailin'*, and it shares something of their robust humour. Several of the small figures are charmingly sympathetic studies, but by no means all: on the right the face of the boy about to steal the apples wears an ugly expression of stupidity and greed; and by the boy adopting a pugilistic stance behind the back of the negro boy servant (whose features are elsewhere being caricatured by another miscreant) will seem more alarming than amusing to those for whom the child is father to the man. This astringent element, inherited from early Wilkie, but added to an ingredient of social comment which reminds us of Faed's link with the circle of the

philanthropist Angela Burdett-Coutts in Highgate, is seen to best advantage in *The Mitherless Bairn* (1855: National Gallery of Victoria, Melbourne), upon which Faed's reputation in London as a painter of Scottish genre was founded. Here, the artist contrasts an unfortunate orphan with a horrible little bully in a way which is far removed from sentimentality. Faed according to McKerrow attributed the inspiration of the painting to a poem of the same name by William Thom, and the same writer tells us that Angela Burdett-Coutts liked the picture so much that she asked Thomas to paint a similar one for her (the less successful *Home and the Homeless*: 1856). An element of realism is also apparent in *The Last of the Clan* (1865: GAG), showing those left behind, perhaps on some Hebridean island, after the departure of emigrants from the community. But although Faed's later pictures retain the careful rendering of still life and costume in humble surroundings which makes them fascinating as social history, they are filleted performances in which the human content lacks any urgency, lacks indeed any real point. The large, beautifully painted *Where's My Good Little Girl?* (1822: GAG) is indeterminate in subject – a child is apparently being consoled with the gift of an apple, perhaps for a broken doll which lies on the floor, by her mother and older sister – but the focus

of the picture is the child's expression, which registers a hard-won victory over tears. To enjoy this painting and others like it, it is not absolutely necessary to like children, but it does help.

A parallel development in Tom Faed's career, aside from the elaborately executed subject pictures just discussed, is a small series showing the single figure of an attractive young woman in a landscape setting, with a title sometimes giving a literary reference as in *Evangeline* (n.d.: MAG), *Highland Mary* (1857: AAG), and *The Reaper* (1863: ibid.), with their respective overtones of Longfellow, Burns and Wordsworth. A sickle in the latter picture, and the titles of the others, are indispensable pointers to their literary origin, which would not otherwise be apparent. They are essentially fully clothed pin-ups as devoid of intrinsic meaning as another of the series, *A Seaside Toilet* (1862: AAG), which depicts a comely wench fastening or unfastening her bodice by the seashore, but which like the others is innocent (or nearly innocent) of erotic implications. In fairness to all concerned it should be mentioned that Longfellow himself wrote to Tom Faed in terms which appear to go far beyond mere politeness in thanking the artist for a sympathetic visual interpretation of the poem: 'The landscape, the melancholy seashore, the face and attitude of Evangeline, so full of sorrow and patience, tell the whole story with great power and truth. It is very beautiful and very pathetic.' In each of these pictures the landscape backgrounds are handled with greater breadth and spontaneity than is usual in Faed's work. In the case of *Highland Mary* there appears to be a debt, extending even to the facial type, to Millais's celebrated *The Blind Girl*. An associative title, in such pictures, is clearly an important part of the Faed armoury.

We have seen Tom Faed treat aspects of contemporary reality – the plight of the orphan and of the Highland emigrant, the provision of education in poor or country communities – and *From Hand to Mouth – He was one of the Few that would not beg* of 1879 (Wadsworth Athenaeum) reverts to the theme of destitution amid plenty, here the poverty and scarcity of employment which oblige a poor but honest old soldier to take his weary children with him as he plays for pennies in the street, while the pretty lady in her elaborate dress attended by her black boy servant, possessive terrier and sheltered child arrives after a day of idleness to the cetainty of a respectful reception from the hardheaded shopowner, who is clearly not about to extend credit to his poorer customer – or is he? Sentimental the treatment may seem to us to be, but this large picture is oddly compelling (it measures 148 cm × 207 cm and is wonderfully painted), and enshrines the Victorian artist's optimism regarding the future of a society which believed itself to be perfectible. Here everyone (including the concerned artist and the sympathetic viewer) is seen in an excellent light – the lady alone may be open to criticism, but perhaps she will

intercede for the war veteran, and she *is* very pretty – and perhaps we should acknowledge that in a less cynical age sentiment could not only soften hearts, but also bring about a climate of concerned philanthropy. The picture's purchaser from the RA was in fact a Member of Parliament, Angus later Lord Holden. That the social problem of mendicancy among old soldiers was a topical one has recently been demonstrated by Hichberger.

John Faed (1819-1902), less well-known in his own day and in ours than his younger brother Tom, was also an artist of great technical ability and was more versatile, but less popular in his choice of subject-matter. His early extensive practice as a basically self-taught but very accomplished miniaturist in Edinburgh may be represented by *The Evening Hour* (watercolour on ivory, 1847: NGS), which shows the children of Dr Archibald Bennie as musicians portrayed with an almost startling perfection of finish and a photographic precision which recall Ingres on the one hand, and on the other the contemporary calotypes of Hill and Adamson. In 1853 John Faed was commissioned to provide a series of illustrations to Burns's *The Cottar's Saturday Night* by the Royal Association for the Promotion of the Fine Arts in Scotland. The resulting engravings, published in the Association's edition of the poem, employ an appropriate Wilkiesque idiom as convincingly as Tom Faed's work of this date, suggesting that perhaps the most significant difference between the brothers lay in Tom's more inventive approach to subject-matter. This appears to be confirmed when we find as late as 1871 John Faed's *The Statute Fair* (Wolverhampton Art Gallery) – a subject associated with the earlier painters Sir David Allan, Wilkie, Carse and Walter Geikie – was exhibited at Brooks's Scotch Gallery in Pall Mall, and some of John's excursions into literary genre, like *The Death of Burd Ellen* (n.d., probably 1860s: Kelvingrove) and *Catherine Seyton and Roland Graeme* (1863: Wolverhampton Art Gallery) from Scott's *The Abbot* exploit a by now somewhat depleted seam, although full of passages of fine painting. Yet it fell to John Faed to paint what is certainly one of the great documentary paintings of the nineteenth century, *A Wappenschaw* (1861: The National Trust for Scotland), a canvas measuring 148 cm × 246 cm and containing over forty individual portraits as satisfyingly united compositionally as they were, no doubt, in real life – for here we have the tenantry of a country laird gathered for the traditional shooting competition, a ruined fifteenth-century keep in the background serving as a reminder of the historical origin of the event in the decree of James I obliging the crown vassals – the lairds – to muster with their men and their weapons four times a year in satisfaction of their fief.

Of the other genre painters born in the 1820s, only three are of note: Erskine Nicol (1825-1904), Robert Herdman (1829-88), and Robert Gavin (1827-83),

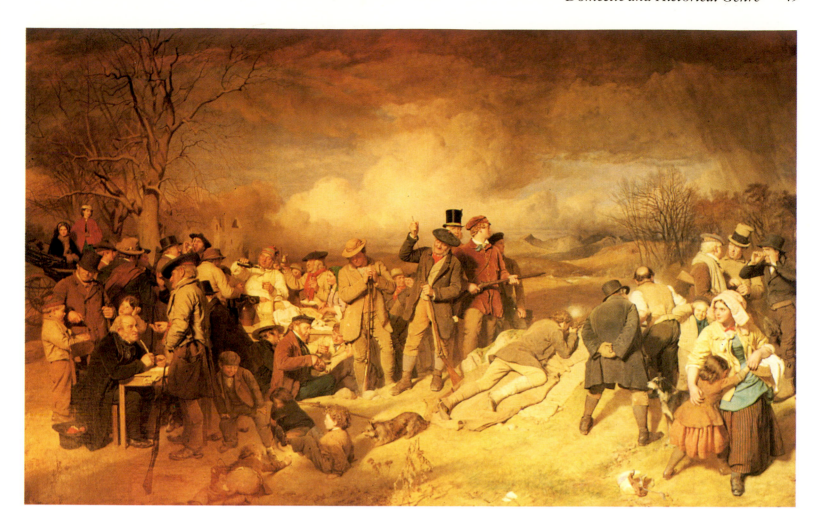

25 John Faed
A Wappenschaw
1861 Oil 149 × 236 cm
The National Trust for Scotland

each an accomplished but not very brilliant personality. Nicol was part of the wave of Scottish artists who descended on London in the early 1860s, and after 1863 his entire career was spent in the south. He specialized in Irish subjects which he is said to have derived from a four-year stay in Dublin begun in 1846 and which exhibit a relentless coarse humour which perhaps no longer amuses quite as it once did. These paintings bear titles like *They Talk a Power of Our Drinking but Never Think of Our Drought* (RSA 1862: sketch in DAG), *Toothache!* (1862: lost), *A Doubtfu' Saxpence* (1874: private collection), and *Steady, Johnnie, Steady!* (1870: DAG) in which a young angler is intently playing a trout under the eye of an experienced old ghillie. Nevertheless, the latter work indicates an ample measure of the ability to draw expressions which is essential to this type of painting, and the landscape background is handled with a breadth and a sensitivity which almost redeem the picture as a whole.

Robert Herdman spent his entire career in Edinburgh, apart from a visit as a student to Italy in 1855, where he divided his time between portraiture and genre, showing a particular bent for scenes from Scottish history. He is another example of a painter of sound and agreeable technical quality whose

notion of subject-matter finds little sympathy today. He learnedly reconstructed historical scenes like *The Execution of Mary, Queen of Scots* (1867: GAG), *After the Battle* (1871: NGS) which was engraved by Frank Holl for the Royal Association in Scotland, and seems to owe something to Henry Wallis's *The Death of Chatterton* (1856: TG), *The First Conference between Mary Stuart and John Knox: Holyrood 1561* (1876: PAG) and *St. Columba Rescuing a Captive* (1833: PAG). These now look academic and unconvincing, as if the characters were playing charades. His group portrait of the children of Patrick Fraser (1866: lost but photographed) *Dressing for the Charade* exploits an evident knowledge of period costume less pretentiously, and a little picture *Wae's Me* (1879: DAG) refers in a manner akin to the single female studies of Tom Faed to a literary source, in this case Lady Anne Barnard's well-known 'Auld Robin Gray'. This poem, which is about a girl who believes her sweetheart to have perished at sea and marries her elderly suitor only to find that her Jamie is alive after all, provides a subject potentially full of an almost Rossettian kind of anguish which in the hands of a better painter would have been made more explicit. A slightly earlier picture also using a literary prop is *The Quadroon*

Girl (1872: DAG) by Robert Gavin, which shows a semi-nude quadroon girl standing in the gaze of two seated men, and illustrates Longfellow's poem of the same name at the passage where her master is deciding whether to sell her to a slave-trader. Caw states that during Gavin's visit to the United States about 1860, 'he was struck by the pictorial possibilities of plantation life, and for a number of years painted the negro at work and play, principally the latter'. In 1874 his address in the RSA catalogue is Tangiers, and subsequently a number of North African subjects appear under his name. As none of these works can now be traced, their value as records of foreign places and people must remain an open question. A portrait of two unknown local sitters, both girls in their teens (n.d.: recently Maas Gallery), a direct luminous work, was fresh and attractive enough to make one regret the nearly complete disappearance of his work.

The last artist to be considered in this section, John Phillip (1817-67), was the most forward-looking of the Scottish genre painters of the post-Wilkie generation, although he was slightly older than those just discussed. In a few pictures produced in the 1860s, at the end of his career, he perceptibly enlarged the boundaries of the High Victorian subject picture in his painterly use of colour and in his ability to convey a wide gamut of human emotion. In both respects he looks forward to the work of those pupils of Scott Lauder who, like himself, passed the major part of their careers in London, particularly Orchardson and Pettie.

Although he was born in Aberdeen, Phillip's early training was in London, where he had become a pupil of T.M. Joy by 1836, and in 1837 was admitted to the schools of the Royal Academy, along with Richard Dadd and W.P. Frith, who became his friends. With these artists he became a founder-member of a sketching club called The Clique which contained, in addition to the three already mentioned, Henry Nelson O'Neil, Augustus Leopold Egg, Edward Matthew Ward and Alfred Elmore. Phillip returned to Aberdeen by the time The Clique ceased to meet, in 1841, where he was engaged on painting portraits and figure subjects. Writing in the *Art Journal* in 1898, John Imray recalled that the young Phillip was ambitious to paint incidents in the lives of famous persons. A large group portrait, commissioned by Queen Victoria in 1858, of *The Marriage of the Princess to Prince Frederick William of Prussia* (1860: H.M. The Queen) might well come into that category, but it is unlikely to have been the kind of thing the young Phillip originally had in mind during the period of The Clique. In more general terms, however, the stimulus provided by that talented company fostered an individuality which gradually emerged in his work, and which was eventually to make him one of the most successful of all Victorian artists. When he died in 1867, the value of his portrait commissions left uncompleted stood at

twenty thousand pounds. It is for his subject pictures that he is remembered now, not for his portraits, but the royal portrait mentioned here, exhibited at the RA in 1860, is a masterly performance containing over forty heads, grouped with no sense of strain in a lucid composition on a large scale (the picture is 102cm × 183cm), with an admirable execution reminiscent of the cameo-like smooth modelling of flesh and precise draughtsmanship of Daniel Maclise. Several single-figure studies, too, show great sensitivity in the perception of character and, latterly, an almost *alla prima* 'attack' in their painterly brushwork. Of the former, *The Spinning Wheel* (1859: GAG), strictly speaking a genre subject, is a very beautiful example which does full justice to a particularly lovely model; and the unfinished *Woman with Guitar* (undated late work: Nottingham Art Gallery) demonstrates that Phillip's discovery of Velazquez in the later part of his career was a revelation fully absorbed by the Scottish artist in its implications for late nineteenth-century painting, with its twin evils of starved surfaces and excessive anecdotal bias. Runs of paint rapidly and confidently applied in this study remind us that 'Spanish' Phillip's debt was as much to Spanish painting as to Spanish local colour, and it has a modern appearance akin to Manet's Spanish subjects or Whistler's treatment of the single figure in the *Sarasate* portrait.

Unlike the painters already discussed who were influenced by Wilkie, Phillip did not spend his entire career under the shadow of the earlier master and his is a comparatively rare case in the mid-nineteenth century of late development. However, it should be added that in his travels to Spain (initially in 1851 under doctor's orders, and again in 1856-57 and 1860-61) which were of such importance to the revitalization of his style, he was only following in Wilkie's footsteps. The early pictures reveal the all-persuasive influence of Wilkie in theme, treatment and handling. *A Presbyterian Catechising* (1847: NGS), relating to an old custom in the Church of Scotland, shows a good-humoured but attentive gathering of village folk grouped round the seated minister and the standing girl who is being asked questions about her religious faith. The picture is brownish in colour but without the transparency that Wilkie could achieve. *A Scotch Fair* (1848: AAG) and the full-scale drawing for it (DAG) are humdrum in execution and in the interpretation of a theme which Wilkie had made so much his own; they give little enough indication that their creator possessed other than ordinary talent. *Drawing for the Militia* (1849: Bury Art Gallery) is a more humorous subject, showing a rather stout recruit being measured for his uniform; both this picture and the sketch (WAG) show how heavily dependent Phillip was on Wilkie at this stage in his career, even when he attempted subjects that had not been touched by the master. The sketch (1850: Orchar Collection, DAG) for *Baptism in Scotland*, however, though in other

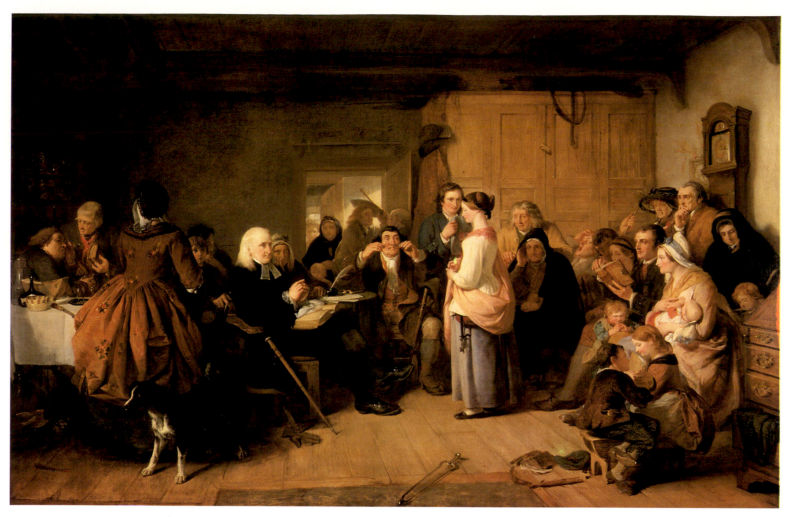

26 John Phillip
A Presbyterian Catechising
1847 Oil 101 × 154 cm
National Galleries of Scotland
A country minister tests his
charges' knowledge of the
Scriptures.

respects it could be taken at first glance for a work by Wilkie, is preoccupied with an almost Rembrandt chiaroscuro effect.

It is in the pictures painted on his visits to Spain that Phillip emerges, with gradually increasing power, as an original artist. The works of the first two visits were those which appealed especially to Prince Albert and to Queen Victoria, whose attention had been drawn to Phillip by Landseer and who is said to have given Phillip his brevet 'of Spain'. They still show the influence of Wilkie in their subject-matter, as in *The Letter-Writer of Seville* (1853: H.M. The Queen), given to Queen Victoria by Prince Albert at Christmas 1852, which derives from *The Letter-Writer, Constantinople*, and in *The Dying Contrabandista* (1858: H.M. The Queen), which is related to *Peep O'Day Boy's Cabin*, and was given to the Prince Consort by Queen Victoria at Christmas 1858. However, both paintings employ a light tonality which is quite unlike Wilkie. A perceptible difference in emotional atmosphere too, begins to differentiate the generally euphoric Spanish subjects from his other, less flamboyant works. In the *Lady Playing the Mandolin* (1854: WAG), a languid Victorian beauty – Phillip had a better eye for models than many of his contemporaries – reclines in a deeply upholstered chair, stunningly gowned and

accessoried, the embroidery on her knees suggesting a convalescence that is being whiled away. In complete contrast, *Gipsy Musicians of Spain* (1855: AAG) shows two dark-eyed, assertively smiling girls under a trellis of vine, making music with guitar and tambourine as loud, no doubt, as the colours of their clothes. One obvious contrast such as this should not be forced into a general rule, since there are serious and even melancholy subjects like *Spanish Peasants or The Wayside in Andalusia* (the animals and landscape painted by Richard Ansdell, Phillip's travelling companion in 1856, completed 1863: AAG), in which a girl on the donkey plays her guitar with the wistful concentration of Wilkie's *Pifferari*, while *Collecting the Offerings in a Scottish Kirk* (York Art Gallery; exhibited at the RA in 1855 with the subtitle 'Give and ye shall receive') has a vein of quiet humour. Nevertheless, it is broadly true that Phillip found in Spanish life the vivid contrasts which enabled him to deliver his anecdotes with greater pointedness than before. This applies particularly to the paintings that date from the last Spanish visit (1860-61) and after, notably *La Bomba* (1863: AAG), *La Gloria – A Spanish Wake* (1864: NGS), and *A Chat round the Brasero* (1866: Guildhall Art Gallery). These and other works of this last period are astonishingly bold in their use of powerful colour

and handling. They reveal that Phillip was studying Velazquez with particular attention at this point (his splendid copy of *Las Lanzas* is in the RSA collection). The subject, too, of his masterpiece *La Gloria*, unites in one composition the opposite extremes of a gamut of emotion, paralleled by the picture's abrupt division into two halves, light and dark. Here, the inconsolable mother of the dead child seen in the dark extreme left of the painting is being persuaded in vain by her husband and a friend to join the dancers at the wake, who uninhibitedly and even flirtatiously desport themselves in the bright sunshine beyond to the accompaniment of guitars and castanets. The picture was exhibited at the RA with the note that 'In Spain, when a child dies, it is firmly believed that it is spared the pains of purgatory and goes direct to heaven. The neighbours consequently assemble at the house of death, and celebrate the event by dancing and feasting'. As a symbol of this (less obtrusive in the picture than it sounds to describe) the child's pet bird, freed from its cage, is seen flying off against a blue sky.

27 John Phillip
Gypsy Musicians of Spain
1855 Oil 65 × 54.5 cm
Aberdeen Art Gallery
A memory of the artist's seven-month stay in Seville in 1851.

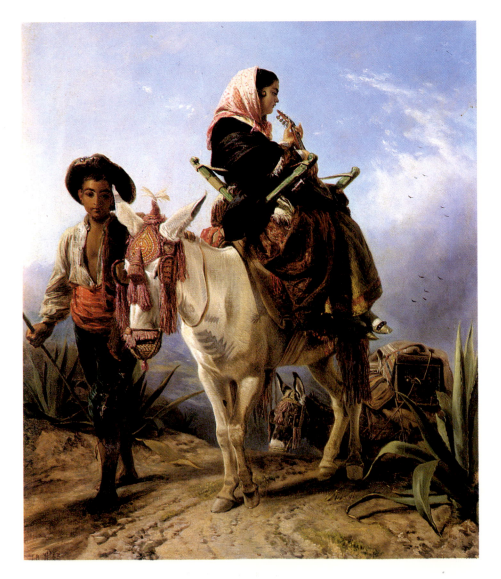

Several of the other late works show similar, if less extreme contrasts in emotion. In the large *La Loteria Nacional – Reading the Numbers* (n.d: AAG) the influence of Wilkie's *Chelsea Pensioners Reading the Gazette of the Battle of Waterloo* is still relevant. It appears again, somewhat more subtly, in *The Early Career of Murillo, 1634* (1865: Forbes Magazine Collection, U.S.A.), exhibited with a lengthy quotation from Stirling-Maxwell's *Annals of the Artists of Spain*, and showing 'the unknown youth' standing 'among the gipsies, muleteers and mendicant friars, selling for a few *reals* those productions of his early pencil for which royal collectors are now ready to contend'. Here, the contrast in types and expressions is explicit. In *La Bomba*, which is one of Phillip's most monumentally simple compositions, there is an implicit contrast between the gaiety of the toreador and the girl who fills his glass, and the dangers of his vocation.

Phillip seems never to have been robust and died at the age of fifty-nine in 1867. Despite the attention that has been paid to his work, he himself remains a surprisingly little-known figure. His first visit to Spain was made under doctor's orders, for an unspecified, perhaps nervous illness. It may be guessed that the colour, music, and continuous fiesta which are almost exclusively what he shows us of Spanish life had a particular attraction for an invalid. Graham Reynolds has plausibly suggested that 'the degree of his conversion to the choice of Spanish themes is one more example of the complete way in which the warm South can take hold of the scions of the North', and one certainly feels that this was what Phillip wanted us to believe. *The Evil Eye* (1858: Hospitalfield House; versions at Kelvingrove and Smith Institute, Stirling) contains a self-portrait of the artist as a general tourist sketching with avuncular amusement the shrinking figure of the Spanish peasant woman who superstitiously turns away from her portrayer but cannot resist fearfully looking back over her shoulder at him. Neither the patronizing air of the painter, nor the woman's discomfiture, are in any way played down, and the heartless humour which results has a painful quality. Has the artist revealed a disturbing truth deliberately or unconsciously? Either way, the picture presents the artist as a crass intruder upon a life in which he has no part. Recent research has shown that the benign artistic *persona* which Phillip also projected as a man – 'delightful, warm-hearted, generous to a fault, single and simple-minded . . . he had a large share of that quiet humour which his countrymen seldom lack', as Walter Armstrong wrote – can have owed little to his personal circumstances. Although less closely involved in the events surrounding Dadd's murder of his own father in 1843 than David Roberts (to whom Stephen Dadd immediately wrote a distraught account of the calamity), Phillip had been close to Dadd and must have been deeply affected. Shortly after his return to London from

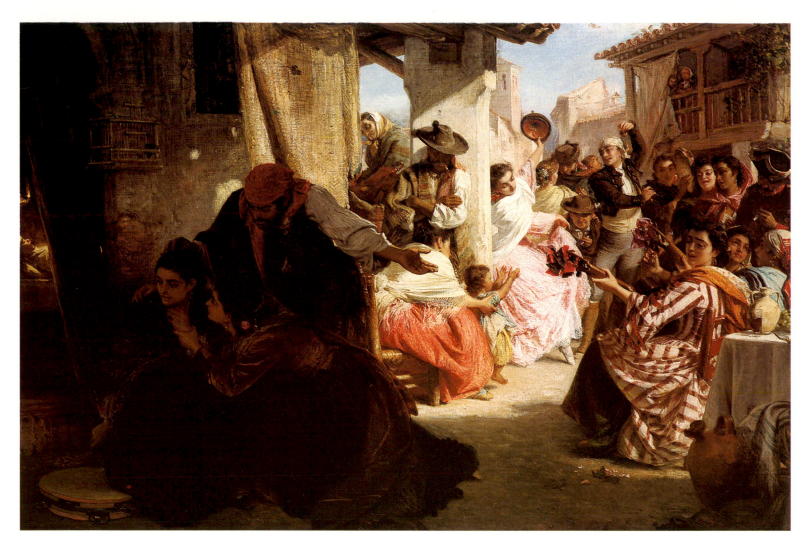

28 John Phillip
La Gloria – A Spanish Wake
1864 Oil 143.5 × 108.5 cm
National Galleries of Scotland
The principal of some twenty
pictures painted or begun during
last visit to Spain, 1860–61.

Aberdeen in 1846, he married Dadd's youngest sister Maria, but within ten years she too had become insane, and there is a contemporary account of her marriage with Phillip which related that at an unknown date she attempted to strangle one of their children before being committed to an asylum in Aberdeen in 1863, where she died thirty years later, twenty-six years after Phillip himself. From this unhappy tale, which has never been taken account of in any discussion of Phillip's mature works, we may at least suspect that the apparent hedonism of the Spanish pictures may conceal an almost desperate element of escapism, and that a full interpretation of the artist's masterpiece, *La Gloria*, for example, may

not be possible until we know more exactly how it related to the circumstances of the painter's life.

What is certain is that *La Gloria* introduces a frisson which we recognize now as belonging peculiarly to the High Victorian subject picture, in which emotionalism is allowed free play and the artist conveys subjective feelings which are not related to a moral or a literary theme. Phillip's painterly use of strong colour and generous brushwork are the other aspects of his late work which contribute something new to British painting in the 1860s. Regularly seen at the RSA Exhibitions, Phillip's work was widely admired in his native Scotland by artists and collectors.

4 PUPILS OF ROBERT SCOTT LAUDER IN LONDON

Robert Scott Lauder was appointed Headmaster and Director of the Antique, Life, and Colour classes at the Trustees' Academy in 1852, and his influence acted as a catalyst on the group of young painters who were his pupils in Edinburgh until his enforced retirement through paralysis in 1861. It was as a teacher and personality rather than as an artist that he most affected them. The rising generation of students included William McTaggart (1835-1910), Hugh Cameron (1835-1918) and George Paul Chalmers (1835-78), whose careers were spent almost entirely in Scotland. National fame was denied to them, but McTaggart's influence on subsequent painting north of the Border was to be greater than that of his fellows in London. Sir William Orchardson (1832-1910), John Pettie (1839-93), Tom Graham (1840-1906), John MacWhirter (1839-1911), John Burr (1831-93) and his brother Alexander Hohenlohe Burr (1835-99), and Peter Graham (1836-1921) were among the students of Lauder who as expatriates and close friends in London from the early 1860s made a considerable impact on the artistic life of the metropolis. With the exception of the Burrs and Tom Graham all these artists became full members of the Royal Academy. Peter Graham (a great favourite of Queen Victoria) and John Mac-Whirter (who was appreciated by Ruskin, if not as a landscapist, at least as a sketcher from nature) specialized in the popular commodity of wild, usually Highland mountain landscapes. Graham's titles such as *Caledonia Stern and Wild* and MacWhirter's such as *The Sleep that is among the Lonely Hills* indicate rather conventional sensibilities. The Burrs purveyed native genre with a Faed-like emphasis on child subjects; Tom Graham, a more reticent artist who sometimes touches a note of quiet poetry, was mainly a genre painter; and Orchardson and Pettie, whose work was most frequently linked and even mistaken for one another's by contemporary commentators in London, began their careers as painters mainly of historical genre.

Despite their evident involvement with subject, all these painters have, at their best, one saving grace in common. If their imagery lacks the peculiar intensity of the best work of the Pre-Raphaelites, some compensation is provided by their painterly qualities. These Scottish painters share a technical approach which goes far beyond the careful addition of colour to drawing. In general, their brushwork has an attractive freedom which stands in considerable contrast to the niggling finish of much contemporary work, and this broader approach to colour no longer applied in flat fields (a feature even of the method of John Phillip) can be attributed to the influence of Scott Lauder's teaching.

No full account of the methods or the content of Lauder's teaching exists, but some of his ideas can be inferred from the work produced by students at the Trustees' Academy soon after his arrival. Orchardson's student years bridge the years immediately prior to, and following on, Lauder's appointment in 1852. Such was the prestige of Lauder's name in Edinburgh that Orchardson had returned to the classes of the Academy in order to benefit from his teaching. Two pictures shortly thereafter show a considerable change from the almost monochromatic grey or brown of Orchardson's very earliest work, which is succeeded by a chromatically richer Venetian style very much in line with Lauder's known and practised Venetian enthusiasms. They are the very striking, already rather manneredly posed little *Self-Portrait* (probably 1853: Orchar Collection, DAG), and *Wishart's Last Exhortation in the Castle of St. Andrews* (1853: University of St. Andrews). The latter picture, painted when Orchardson had studied under Lauder for about six months, is compositionally much in advance of all his earlier work: the figures are grouped expressively, and painted in a higher key, and with more control of tone, than its predecessors. This picture bears out the account of Lauder's teaching method given by Martin Hardie, whose uncle John Pettie had been one of Lauder's pupils:

> Lauder set himself to teach his pupils how to see. In the Antique Class, for instance, he did not place a single figure, but a whole group of casts before him. He insisted on a grasp of the model as a whole . . . Thus he taught his pupils that power of grouping, of seeing things broadly . . . which is one common characteristic of their work. But he appears to have followed no cut-and-dried system, and to have made no attempt to mould his students into any uniformity.

A letter of 1858 from Pettie to McTaggart shows clearly that Lauder was the odd man out at the

29 Tom Graham
Alone in London
n.d. Oil 54.6 × 88.9 cm
Perth Art Gallery
Probably painted shortly after the
artist's move to London in 1863.

Academy in attaching as much importance to colour as to drawing in the curriculum: 'Lauder is wild at the new system which they [James Drummond, Noel Paton, and James Archer] are going to begin in the Life Class ... He feels that their rigorous drawing and inattention, in the meantime, to colour, imply that his system had been all wrong'.

Lauder's nine years in charge of the Trustees' Academy clearly mark a watershed in Scottish painting, and his influence may be measured by comparing the work of his students with the immediately preceding generation of Edinburgh-trained artists, such as the Faeds, Erskine Nicol, James Archer and Alexander Fraser, all of whom employed a technique in which colour was subservient to drawing. A comparison of Orchardson's *Wishart* picture of 1853 with the same subject (1845: DAG) by James Drummond, one of the three drawing-masters with whom Lauder disagreed, illustrates the beginning of the effort by the next generation to supersede the drier style of their predecessors. Yet it would be wrong to pretend that emancipation was swift and total, especially in the case of the later genre painters like Orchardson and Pettie who were as preoccupied with subject-matter as Wilkie and Sir William Allan before them had been. The main purpose of the sketching clubs was, as we have seen,

to foster this side of an artist's talent. The fact of the matter was that in the High Victorian period any figure painter remaining inside the academic establishment, as all the pupils of Lauder did, almost inevitably cast himself in the role of public entertainer; the public, in this case, who attended the annual exhibitions of the RA or the RSA. Only landscape painters were not expected to amuse, elevate, instruct or titillate, and this was to give William McTaggart a considerable advantage over his colleagues in his exploration of the possibilities of a painterly evocation of the visible world.

The brothers John and Alexander Hohenlohe Burr were the first of the artists of the Scott Lauder group to go to London, in 1861. Although plainly minor figures, they perhaps do not wholly deserve their present neglect, since each was aware of his own limitations and stayed within them. They painted small-scale canvases on childhood themes which remain within the territory conquered by Tom Faed, although the Burrs seem not to have had Faed's proneness to sentimentality. Thanks to their contact with the Lauder circle, they were able to add an element of colour which provides an apt setting for their cheerful art, although it is neither refined nor rich. The little *Grandfather's Return* (n.d., perhaps an early work: NGS) by John Burr is charming,

straightforward, and provincial in the best meaning of the word, and another version of a similar theme, *The New Toy* (n.d.: DAG) is equally, and as unostentatiously, full of life, amusingly capturing grandfatherly as well as infant glee. *The Careless Nurse* (1877: DAG) casts a level and wry glance at the domestic chaos resulting from the short absence of a mother whom we are relieved to see returning to wake up her young daughter who has fallen asleep despite the squalls of the baby in its cot. A.H. Burr is even less familiar a figure, but *Wild Flowers* (n.d.: DAG) has a title which perhaps conveys the artist's empathy with the children who are the subject of the picture, out picking flowers in a pleasantly painted landscape.

Orchardson and Pettie followed the Burrs in moving to London and, in 1863, when they had been there a year, they were joined by Tom Graham. Graham resembles the Burrs in his unassuming attitude to subject, and in the fact that he was evidently more at ease on a smaller scale. He was, however, a more original artist, and while the routine works from his hand are quite dull enough to make his comparative lack of success readily understandable, a small number show a real talent which never seems to have developed consistently. *A Young Bohemian* (1864: NGS), once owned by Sargent, suggests the influence of John Phillip in its subject of a young girl musician in a deliciously painted folk

costume with roses round the skirt, but its colour is cool and refined, and the figure suggests shyness and reserve. A presumably later work, *Alone in London* (PAG), is a remarkably freely painted view of the Thames at the Victoria Embankment in early morning haze, the pavement deserted except for the solitary figure of a young woman wrapped in a Scots plaid who looks out over the balustrade. The picture is not a tract in the style of Egg's *Past and Present, No. 3*, where an unfaithful wife and her child are seen alone under a bridge near the Strand as a consequence of her infidelity, and in fact we are not told what she is doing there, but the still cityscape is pervaded with a sense of homesickness sensitively captured. Like Robert Gavin (perhaps with him) he went to Tangier; a small painting of an Algerian woman sitting on a prayer rug (n.d.: Orchar Collection, DAG) delicately renders the luminous atmosphere of North Africa. Graham's best-known work, however, is the convincingly impressionistic *The Landing Stage* (n.d.: V&A), admirable alike in composition, observation and handling, and probably showing the Clyde at Craigendorran, looking towards Greenock. This is *au revoir* (rather than the often-painted *adieux* of conscription or emigration), a tender but informal farewell before the anticipated pleasure of a windy crossing on the river.

A large factor in John Pettie's decision to move to London in 1862, a few months after Orchardson,

30 James Archer
Summertime, Gloucestershire
1860 Oil 76.4 × 106 cm
National Galleries of Scotland
After 1862 Archer's career was spent in London. This luminous landscape shows the influence of Millais, which is also visible in early McTaggart (cf. *Spring*, 1864, Plate 36)

was the removal by the periodical *Good Words* from its headquarters in Edinburgh to London in the same year. Apart from Pettie himself, contributors of illustrations to *Good Words* included Millais, Holman Hunt, Whistler, Arthur Boyd Houghton and Fred Walker, as well as a Scots contingent of Orchardson, McTaggart, Tom Graham and MacWhirter. But Pettie did not have to rely for long on black and white illustration for income; in just four years he had become an Associate of the Royal Academy, and his biographer tells us that he had been earning over a thousand pounds per annum from his pictures for some years before he was thirty. Pettie's success then, and any claim he has now to our attention, rest on the vigorous work done when he was still in his twenties and early thirties. Unlike Orchardson, who was later to score an even greater popular success, Pettie's work shows little or no development in subject or technique from quite an early stage; and in his later years portraiture was to occupy an increasing proportion of his time.

An interesting glimpse into the characters and, to some extent, the *credo* of Pettie, Orchardson, and Tom Graham around 1863 is provided by Clarence Dobell, the brother-in-law of Briton Riviere. Dobell was invited to dinner by James Archer and his wife to meet the three Scottish painters, and later remembered:

> . . . the brilliant conversation of Orchardson, the strong sense of Pettie, and the calm confidence of Tom Graham delighted and astonished me
>
> They spoke in the coolest manner of the weakness of the Art leaders of London and were clearly well satisfied that their own school of art was certain to be welcomed by the picture-dealers and the public.
>
> The young English painters of that day were so anxious to crowd all that they could into a little space in order to have a better chance of being hung on the line, that they deemed it a sign of exceptional skill to arrange a group so that the heads nearly touched the top of the picture and the feet stood on the lower edge of the frame, while the background was crowded into the intermediate spaces. The Scotchmen laughed at these artifices and liked to surround their figures with illimitable spaces and boldly declared that the RAs dared not reject them; and to our amazement they were right. The pictures were hung, and not only hung but sold, and the dealers clamoured for more. In a single season Orchardson and Pettie were marked men and made men.

Fittingly, Pettie's decision to become a painter had received early support from James Drummond, who stood sponsor to the young artist's entry to the Trustees' Academy at the age of seventeen. Although in some ways a painter's painter, Pettie at the same time had Drummond's leanings towards historical subjects and had antiquarian interests, particularly (like Noel Paton) in armour. The kernel of his work lies almost exclusively in the subject, which is usually set in the past of history or romantic literature. We know that Pettie considered modern male attire drab and disliked painting it, so much so that his portrait of the novelist William Black (to take only one instance) was posed in Venetian costume. The prime function of Pettie's rapid brushwork, warm colour and sprightly drawing is to enhance the vividness of the tale. 'Significant form' would have meant little to him; and it is not altogether surprising that he considered Rembrandt's skill, which he admired, 'wasted' on his 'beef-steaks'.

For all his painterliness, drama for Pettie was inherent in the subject and not in the treatment, and no Rembrandtesque suggestion of mortal clay apprehended through the earth colours of the palette ever appears in his work. This division between subject and treatment often emphasizes the faults of each, exposing a *belle facture* applied as automatically as a sauce concocted by a chef, but not in itself able to compensate for an inadequate dish. The Edwardian view of Pettie's style expressed by Martin Hardie, however, was probably shared by the vast majority of visitors to the Royal Academy in Pettie's own day, and is understandable in the context of the Academy's continuing function as a provider of mass entertainment. Discussing *Treason* (1867: Mappin Art Gallery, Sheffield) and *The Sally* (1870: ibid.), he writes that 'they are both great pictures – great in the purely pictorial elements of line, form, colour and illumination. That they thrill, not only as a piece of painting, but for the story they tell, makes them greater pictures still'. In reality, Pettie's best pictures are those in which form and content, vehicle and tenor, are intrinsically related; in the two examples quoted, the vitality of the treatment – vivid colour, nervous drawing, and dramatic composition – contributes everything to the final atmosphere of dangerous suspense.

It is, however, extremely unlikely that such historical reconstructions will ever again seem as thrilling as they evidently did to the Victorians who bought them. Hollywood has added motion and a cast of thousands, on which there is no going back; but Pettie would surely have had a good eye for cinematic essentials; for cutting (the elimination of inessentials), camera angle, lighting, make-up and wardrobe.

Pettie's contribution to the developing use of colour among the pupils of Scott Lauder becomes clear when one compares him with his slightly older Scottish contemporaries: Drummond, Archer, the later Noel Paton, the Faeds, and Erskine Nicol. An Edinburgh pamphleteer of 1860 was still able to write of Pettie and of Lauder's other pupils: 'Their pictures want finish and they are objectionable in colour. The love of grey and grey-green exhibited by the school is ridiculous. It is their regulation colour. Their harmony of harmonies is grey agreeing with itself'. Orchardson, Hugh Cameron and George Paul

Chalmers retained a muted approach to colour throughout their careers with an emphasis on half-tones; McTaggart and Pettie on the other hand experimented more boldly and became more powerful colourists. Pettie himself said of his earliest period: 'I felt about colour then, like a boy looking at all the bright bottles in a sweetie-shop window, that it was something to be bought when I had saved up a pennyworth of drawing'. An early work such as *Alice in Wonderland* (Orchar Collection, DAG) – *Alice* was first published in 1865 – shows the quiet tonal style criticized by the writer just quoted, as well as the illustrative bias which informs Pettie's *oeuvre* from the beginning, with its preponderance of scenes from Scott, Sheridan, Shakespeare (especially from the history plays), and occasionally from historians like Macaulay and Lawrie. *The Drumhead Court Martial* (1865: MAG) was Pettie's first major success at the Royal Academy, paving the way for a whole series of similarly military scenes, very often set in the seventeenth century. The treatment of colour here, with its bold, high-keyed contrast of scarlets and off-white, marks an obvious advance on the other work, and Pettie always retained a preference for colours at the warm end of the spectrum, with notes of white or blue added for contrast. It cannot be said that he was a subtle colourist, but it was in itself a noteworthy achievement in his day to use such full-blooded colour orchestration as he did, with a sense of dynamics usually remaining within the range of *forte* to *fortissimo*.

Aside from the 'blood and thunder' scenes from the Civil War, the War of the Roses, and from the Jacobite rebellions with which his name is most often associated – *A Drumhead Court Martial, Treason, The Flag of Truce, Disbanded, A State Secret, Sword-and-Dagger Fight* and *A Highland Outpost* make a typical but far from exhaustive list – Pettie also painted a few pieces of humorous genre. In some cases these drew on Sheridan or Shakespeare, and in others on his own invention, like *Pax Vobiscum* which shows a friar blessing a mouse. *The Doctor's Visit* is one such humorous painting; it is a Burr-like subject although the humour is rather contrived, with a droll old doctor offering a shy little girl an apple to the amusement of her grandmother. As a raconteur of historical scenes, Pettie is as racy as any schoolboy could wish; as a humorist he tends to laugh so much at his own jokes that he forgets the punch line.

Sir William Quiller Orchardson, on the other hand, was truly versatile in his subject-matter, while at the same time the individuality of his technique was recognized, deprecatingly at first, from an early stage in his career. Discussing Orchardson's contributions to the Royal Academy exhibition in 1879 *Art Journal* commented: 'The theme is by no means original, but its manner of treatment is so; and that is the only kind of originality which can now be claimed for the works even of the mightiest of men.' Anecdotal ingenuity was the rage at the Academy, and *recherché* subject-matter the norm; and Orchardson, although quite without cynicism, undoubtedly had a happy knack of choosing tales which pleased his audience. For this, posterity has not forgiven him, and he has been remembered only as a painter of genre or (perhaps worse) of *chic*. In fact his subject-matter, despite its obvious diversity of period and theme, has a certain underlying unity which comes from the artist's preoccupation with moments of psychological drama (quite different from the external drama of Pettie), often set in luxurious surroundings which imprison the *dramatis personae* and whose calm atmosphere is momentarily troubled by their mental agitation. The paintings show a steady increase in the subtlety of Orchardson's approach to such subjects: *The Last Dance* (1905: private collection) has a poignancy not to be found in the Shakespearian pictures of the sixties and early seventies.

In his own lifetime, Orchardson achieved great popularity in both Britain and France, and his career is a paradigm of Victorian artistic success, rising in steady progress from provincial obscurity to Academic recognition, public honours, and a commission to paint the Queen's portrait. The real fascination of this career, however, lies in the fact that like another characteristic figure of the period, the architect R. Norman Shaw, who was a year older than Orchardson, and like him was born in Edinburgh, Orchardson contrived to work in a manner which satisfied his own standards of excellence while at the same time making a strong appeal to contemporary taste. Both men were unable to break the conventions of their period, but the new life they gave to stylistic modes derived from the past suggested possibilities later to be realized by younger practitioners. Orchardson

31 Sir William Quiller Orchardson
The Last Dance
Begun 1905, unfinished Oil 96.5 × 142.5 cm
The Hon. Alan Clark, MP
The dramatis personae include Orchardson's daughter, Hilda, who regarded the picture as the artist's farewell on the eve of her permanent departure for South Africa. It also offers enigmatic comment on Edwardian sexual mores.

was, we know, admired not only by his own contemporaries during his student years in Edinburgh but also by the young Glasgow painters of the next generation, including Sir D.Y. Cameron; *mutatis mutandis*, Norman Shaw stands in a similar relationship to Charles Rennie Mackintosh.

Although not prolific by Victorian standards Orchardson was able for the last thirty years of his life to maintain a good address in London and a house in the country out of income from pictures and reproduction rights. When the Tate Gallery acquired *On Board H.M.S. Bellerophon* in 1880, the price paid out of the Chantrey Bequest was £2000: twice the figure paid for Poynter's *A Visit to Aesculapius* in the same year. Although it came late and as something of an anti-climax in 1907, his knighthood was in the expected order of things, and, although the presidency of the Royal Academy was not to be his, he was a candidate in the elections of 1896, when Poynter succeeded Millais to what du Maurier called the 'Lord Mayorship of all the Plastic Arts'. Orchardson was also made a chevalier of the Légion d'Honneur in 1895, when the French ambassador's diplomacy carried him so far as to describe Orchardson as 'the greatest artist in England'. The key to this success story was the anecdotal element in Orchardson's work, which he himself took very seriously. Even at the end of his career we know that among the projected works which were never begun were pictures with titles such as *By Order of the Executors*, *The Burning of the Sarah Sands*, *Beethoven*, and *Nelson*. Orchardson insisted on choosing his own subjects, and appears to have sold his pictures to a mainly middle-class clientèle of industrialists and professional men. Many of his patrons were Scots, including John Aird and George McCulloch in London, whose collections, published in the *Art Journal* in 1891 and 1909 respectively, reveal an orthodox taste for anecdotal painting. Aberdeen collectors such as James Ogston, Alexander Macdonald, and Sir James Murray bought important paintings from Orchardson, while Dundee (especially the fashionable neighbouring burgh of Broughty Ferry), which has been such a fruitful source of revenue for the artist nicknamed 'the Laird' in *Trilby*, lived up to this fictional reputation for munificence. James Orchar, John M. Keiller, and G.B. Simpson in particular, bought several important paintings, including in Keiller's case two key works, *St. Helena 1816: Napoleon Dictating his Memoirs* (1892: The Lady Lever Art Gallery, Port Sunlight) and *Mariage de Convenance – After!* (1886: AAG). In Glasgow, James Donald and Sir Thomas Glen Coats, and in London Sir Henry Tate and his adviser Humphrey Roberts, Sir Walter Gilbey, and Lord Blyth were among Orchardson's most faithful patrons. Orchardson's pictures were thus collected in the main by wealthy men of rather conventional taste, but two exceptions to that general rule stand out. J.G. Orchar's purchases were almost exclusively from the Scott Lauder group, with the significant qualification that he owned not only an impressive collection of Whistler's etchings, many of them in states not recorded by Kennedy, but also an oil by Whistler, *Nocturne in Grey and Silver: Chelsea Embankment*. Another adventurous collector who bought from Orchardson was the Aberdonian James Forbes White, who was one of the first British owners of a work by Corot (the *Souvenir d'Italie*, bought in 1873, now at Kelvingrove).

Orchardson's patrons were clearly engrossed by the anecdotal element in his work. But a significant minority among his contemporaries admired him chiefly for his powers as an executant. He was one of the exceedingly few British artists of the day whom Whistler found himself able to admire. The Pennell biography quotes Harper Pennington, who had gone with Whistler to the Royal Academy exhibition of 1887, recording Whistler as standing before one of Orchardson's modern interiors 'for which he had expressed the most sincere admiration' and finally pointing to a particular passage with the words, '"It would have been nice to have painted that," almost as if he had thought aloud'. In the 1860s, when Whistler was still sending to the Royal Academy, the *Art Journal* critic on several occasions bracketed the two artists together. From Sickert we learn that Edgar Degas also appreciated Orchardson, as Sickert himself did. Sickert regarded Orchardson and Pettie as 'descendants of Rubens, through Wilkie', adding 'I have always loved and appreciated them'; a tribute which demonstrates that to a painter of the generation that came to prominence in the early 1880s, to which the Glasgow School also belonged, there was no contradiction in liking Orchardson's and Pettie's work while at the same time being alive to more contemporary developments.

Orchardson reciprocated Whistler's admiration and felt that recognition of his work in England had been unduly delayed, writing in 1889 (in accepting an invitation to speak at the dinner given in Whistler's honour at the Criterion), 'I am in entire sympathy with any proposal that will do honour to J. McNeill Whistler. The occasion . . . is I agree a good one, though perhaps late in the day – but it is never too late to mend and when we have a great painter to recognise we must do it while we can'. In the late 1890s Orchardson wrote his daughter that he knew Whistler's paintings 'by heart'. Temperamentally the two artists were not dissimilar, both possessing a fastidiousness which was both a strength and a weakness. The close-knit and introverted family circle which provided Orchardson with the right surroundings for his work was a kind of Mayfair equivalent to the no less rarefied but more unconventional atmosphere of the Whistler establishments in Chelsea. Orchardson is reported as a witty talker and his keen interest in military matters parallels Whistler's infatuation with West Point: but they supported opposite sides during the Boer War,

Whistler ardently taking the part of the Boers, while Orchardson grew exasperated with the incompetence of the British handling of the campaign. Orchardson's preferred old masters were Titian and Rembrandt, and his warmest admiration seems to have been reserved for Gainsborough. Among his contemporaries he appears to have been indifferent to French painting, with the possible exception of Fantin-Latour, and of the Pre-Raphaelites he predictably felt that they were 'too minute', adding the now rather surprising rider 'but it was a good training, and see what it led to in Millais'. Sargent he judged to be 'magnificently effective in the distance – but not finished'.

Orchardson left the Trustees' Academy in 1855 but continued to live in Edinburgh until his departure for London early in 1862. During these years he began to adopt literary as opposed to historical themes, using Scott, Dickens and Harriet Beecher Stowe as his originals. In 1856 he exhibited as the RSA a picture called *Claudio and Isabella* (now lost), three years after Holman Hunt's picture of the same name was seen at the Royal Academy. It is about this time that the influence of Pre-Raphaelitism becomes

evident in Orchardson's work, though in a diluted form. Between 1852 and 1860 eleven pictures by Millais were exhibited as the RSA including *Ophelia* (in 1853), *The Return of the Dove to the Ark* (in 1854), *The Blind Girl* and *Autumn Leaves* (in 1858), and *The Rescue* (in 1859, when Millais was living at Bower's Well in Perthshire). In 1860 Orchardson made an excursion into the field of illustration proper with the publications of six of his drawings in *Good Words*, to which Millais and Holman Hunt later also contributed.

Orchardson's work in London from 1862 until 1870, in common with English painters like Calderon and Yeames in the same period, shows a continuing influence of Pre-Raphaelitism both in subject and, to a lesser extent, in treatment. A series of pictures on Shakespearian themes painted at this time are an obvious case in point. In *Hamlet and Ophelia* (1865: private collection) the theme of cruelly disappointed love and the detailed treatment of the costumes are Pre-Raphaelite in derivation, as is the realism which allows Hamlet to appear with cross-garters undone, and shows him so much an anti-hero that, as a critic wrote in 1870, 'Hamlet

does not come up to our ideal of the Hamlet of Shakespeare in his self-assumed mental distraction'. At the same time, the stage-like setting, and the large flat areas of very broadly handled tertiary colour are entirely personal to Orchardson, whose colour-schemes at this period were likened by the French critic Ernest Chesneau to 'the back of an old tapestry'.

Similar evidence of Orchardson's early independence is provided by other pictures of this period which owe an apparent debt to Pre-Raphaelitism. The very title of *The Broken Tryst* (1868: AAG) suggests a Pre-Raphaelite subject, but its thin, transparent brushwork and subdued colouring are at a far remove from the enamelled surfaces and bright colours of the Brotherhood, whose work Ruskin described as 'like so much stained glass'. On the other hand, when one compares *The Flowers of the Forest* (1864: Southampton Art Gallery) with an example of the early work of another of Scott Lauder's pupils, profound similarities emerge. *Spring* (1864: NGS) by William McTaggart is particularly close to this work in subject, treatment, and mood. In the same way, comparing Orchardson's *Casus Belli* (1872: GAG) with any of Pettie's pictures on a similar theme at this period – such as *A Sword-and-Dagger Fight* (1877: Mappin Art Gallery, Sheffield) – the resemblances are so striking as to suggest that the continued association of these painters during the earlier part of their careers had at least as much influence on the formation of their respective styles as any outside influence. There are numerous examples of nearly identical themes, for example, Pettie's *The Gambler's Victim* (1868: FAS) and Orchardson's *Hard Hit* (1879: private collection, U.S.A.), Orchardson's *The Story of a Life* (1866: private collection) and Pettie's *Sanctuary* (1872: sketch in AAG), Orchardson's *Toilers of the Sea* (1870: AAG), and McTaggart's *Through Wind and Rain* (1874: Orchar Collection, DAG). Moreover, both Pettie and Orchardson moved from the Jacobean subjects of the 1860s to the Regency or Empire set-pieces of the 1870s and 1880s. But whereas Pettie always retained his illustrator's instinct for a good story clearly told, Orchardson's work was often found baffling because of its enigmatic content and he had to wait until 1868 – four years later than Pettie – before being elected to an associateship of the Royal Academy. Full academic honours came in 1877. Orchardson's main picture for that year was *The Queen of the Swords* (1877: NGS), which was the last of the series of literary subjects based on Walter Scott and Shakespeare. In that respect, it sums up the earlier part of Orchardson's career, but it also looks forward to the later scenes of domestic and social life in which Orchardson appears as the successor of Tissot.

The remaining thirty and more years of Orchardson's life were the years of such characteristically High Victorian pictures, famous in their own day, as *On Board H.M.S. Bellerophon* (1880: National Maritime Museum), *Voltaire* (1883; NGS), *Mariage de Convenance* (1883: GAG) and its two sequels, and *The Borgia* (1902: AAG). In these later works, Orchardson's craft reaches its zenith, and his very last pictures show undiminished mastery. During this period his circle of friends widened to include many eminent figures of the day, including W.S. Gilbert, Sir J.M. Barrie, and the scientist James Dewar, who received a knighthood with Orchardson in 1907, and whose *Portrait* by Orchardson (1894) is in Peterhouse, Cambridge. A certain cult of dilettantism characterized these friendships: 'shop' seems to have been taboo, and when Dewar wrote to Orchardson to tell him of his latest scientific discovery, his intention was obviously to amuse rather than to edify. Like other Academicians of his day, Orchardson was a frequent attender at dinners and a theatregoer, but his family and home were the real centre of his life. His daughter Hilda regarded the pictures which show domestic strife – the two *Mariage de Convenance* pictures and *The First Cloud* for example – as attempts by Orchardson to imagine the converse of his own happily married life. Orchardson greatly valued the calm refinement of his domestic surroundings and it is easily supposed that any disruption of it would appear to him as a form of nightmare. His fears were perhaps those of a common Victorian species of which he was an example: the self-made man. We know that he had a medically unjustified dread of weakening sight because 'then we shall all starve'. His close attachment to his daughter Hilda, born in 1875, may well have provided the emotional *raison d'être* for later pictures such as *Her First Dance* (1884: TG) and *The Last Dance*. Hilda herself seems to have regarded the latter picture, which shows her leaving the room with her fiancé, as the artist's farewell to her on her departure in 1905 for South Africa, from which she never returned. Be that as it may, two developments are conspicuous in Orchardson's later subjects: a growing preoccupation with a late-Victorian and Edwardian dream of material elegance, on the one hand; and, on the other, an increased empathy with the inhabitants of the gilded cage.

The later portraits – which Sickert especially admired – benefit strikingly from this increased psychological penetration. In his earlier years Orchardson placed portraiture and subject-painting in two very separate compartments, employing a near-caricatural rendering of 'character' in the early costume pictures while at the same time producing such soberly observed speaking likenesses as *John Hutchinson* (circa 1854: RSA) and *Mrs John Pettie* (1865: MAG). Later, when he began to deal with modern themes, the divergence in treatment becomes less marked. Orchardson's subdued palette suited male Victorian attire better than Pettie's, and the transparency of his thinly applied pigment imparted a luminous quality to the predominant browns and blacks. His portraits of his wife in a black dress with

their baby son Gordon, *Master Baby* (1886: NGS), of the architect *Alfred Waterhouse* (1892: RIBA), the Dundee manufacturer *Henry Balfour Fergusson* (1896: DAG), and the physicist *Lord Kelvin* (1899: SNPG) are, for all their reticence, masterpieces of late Victorian portraiture.

Portraiture aside, the development in Orchardson's subject-matter in his later years is matched by an increased technical subtlety. In a sense, the lighter touch of his later manner provides an apt vehicle for his more rarefied subject-matter, the tremulous poise of his brushwork and composition well suited to expressing the delicate anguish of *The Morning Call* (1883: private collection), *The Feather Boa* (1896 or 1897: Orchar Collection, DAG), *The Lyric* (1904: ibid.), and *Solitude*. The individuality of his style had always attracted as much attention as his subjects. Orchardson invariably used the traditional earth

33 Sir William Quiller Orchardson
The Morning Call
1883 Oil 81.5 × 62 cm
Private collection

colours, never experimenting with the more brilliant but unstable new aniline colours. Nor did he ever paint on to a wet white ground; his method of achieving luminosity was to apply oil colour direct on a dry white ground. In the earlier pictures he began his work on the canvas with a pencil drawing, which closely followed a fully elaborated working drawing. This done, he would begin to paint. His earlier pictures often betray their linear origins in the outlining surrounding the figures. Later, however, he was able to dispense with the aid of the pencil underdrawing, and painted directly on to the ground. Thus his later pictures tend to have a more painterly quality, and his preparatory studies too become more painterly as Orchardson's technique matures. The drawing for *Mariage de Convenance* is a striking example of this, and the directional brushwork noticeable in the background of the picture follows the soft diagonal hatchings visible in the drawing: a point of style which one also finds in Pettie and, less expectedly, in William McTaggart. This charcoal drawing, which does not even include a figure of the wife, who is so essential to the tale, suggests that Orchardson was concerned to capture a certain effect of light. An equally pictorial sense of placing is also evident in his work: a small drawing for *Her First Dance* (RA) indicates in a flurry of barely decipherable lines the dispositions of the main groups in the picture. In an era of crowded compositions, his use of empty spaces is refreshing.

A rapid glance at the names of the more prominent subject-painters who had studied under Lauder and stayed at home in Scotland suffices to indicate that London had the best of the bargain. Unimaginative competence reigns supreme in the *longueurs* of J.B. Macdonald (1829-1901) – notwithstanding the continuing popularity of his *Lochaber No More* (1863: DAG) – and his pupil W.E. Lockhart (1846-1932). Equally literary in approach was George Hay (1831-1912), who dressed the comic situations so beloved of the age in eighteenth-century costume, as in *An Alarm* (1890: Orchar Collection, DAG), which shows an overheard conspiracy. Although belonging to a later generation, George Ogilvie Reid (1851-1928) unabashedly continued the tradition of costume genre into the twentieth century, without any hint of the perception of mood and character or the painterly qualities found in the best of Orchardson's work.

As we have seen, Orchardson and Tom Graham occasionally painted landscape, and with enough success to make one regret that they did not do so more often; but only modified enthusiasm can be felt for the leading landscape specialists among this generation of expatriate Scots: Peter Graham (1836-1921, in London from 1866) and John MacWhirter (1839-1911, in London from 1869), who both attained full membership of the Royal Academy. Although they had been pupils of Lauder, his influence upon their work is hard to distinguish.

34 John MacWhirter
Night, Most Glorious Night, Thou Wert Not Made for Slumber
1874 Oil 99 × 165 cm
The Royal Holloway College,
University of London
(Photograph: Bridgeman Art Library)

There is every indication that Lauder himself viewed landscape as justifying a freer approach than figure painting, as the landscapes in his own figure paintings tend to be treated with the breadth which seems to extend to his approach to landscape proper, if *The Cobbler, Loch Long* (n.d.: FAS) is anything to go by. This work is much more freely and transparently handled than anything by Graham, whose style too often comes close to a meretricious virtuosity, and can be opaque and glib like imitation Ruisdael. *The Spate* (1866: untraced) was his first picture to appear at the Royal Academy, and its success brought the accolade of a commission from the Queen, for *Bowman's Pass: Balmoral Forest* (1868: HM The Queen). This painting included Highland cattle in a wild landscape and suggests the romantic influence of Horatio McCulloch, and of Landseer and his successor as Animal Painter to Her Majesty for Scotland, Gourlay Steell (1819-94). *Wandering Shadows* (1878: formerly Chrystal collection), a large work measuring 129cm × 180cm, is typical of Graham's later style, showing dappled sunlight on bracken-clad hills which are partly hidden by wisps of cloud. *Moorland and Mist* (1893: DAG) equally large, exploits the same effect, although the Highland cattle (doubtless painted from the live specimens which Graham kept at his Buckinghamshire studio) loom larger in the whole composition, their shaggy coats have a soft, fluffy

appearance as if recently shampooed. *Sea-Girt Cliffs* (untraced), presumably belongs to the group painted from studies made on the island of Handa, off the Sutherland coast.

Graham taught Joseph Farquharson (1846-1935), who painted almost nothing but snow scenes in the Highlands, often with effects of cloud or mist. That this rather bleak view of the Highlands of Scotland was for some reason a widely desired commodity in the south is suggested by the fact that Farquharson too became a member of the Royal Academy. MacWhirter was no less a purveyor of 'local colour': his pictures at the Royal Academy in 1875 included two with the titles *Land of the Mountain and the Flood* and *Nemo me impune lacessit*, the latter prominently featuring a group of thistles, the Scottish emblem. MacWhirter was a more adventurous colourist than either Graham or Farquharson, although sometimes in striving for a Turneresque intensity he would lapse into rather lurid purples and reds. His widow tells us that 'he gradually developed a habit of making a rapid sketch of anything that interested him while travelling by steamer or rail, and colouring it later from memory'. His devotion to and study of nature is not open to question, and Herkomer's portrait of him shows a keen gaze and sensitive face, but the task that he and other late romantics like Peter Graham set themselves, which was to capture and suggest the ineffable grandeur of

the world, was one suited to rarer and more heroic temperaments. Skye, the Alps, Norway (where he painted watercolour flower studies which were bought by Ruskin for his School of Art at Oxford), the Austrian Tyrol, and Sicily were all included in his travels for subjects, although he always spent autumn in Scotland, on the island of Arran, or in the Trossachs, at Aviemore in the Cairngorms, or near Glen Affric. All these places are spectacularly picturesque, and it is only rarely that MacWhirter includes human figures in his work as he does in *Night – Most Glorious Night, Thou Wert Not Made for Slumber* (1874: Royal Holloway College). Usually the landscape is allowed to speak for itself, or it dwarfs humanity, as in the Tate Gallery's *June in the Tyrol* (1892), or in *A Sermon by the Sea* (Orchar Collection, DAG). Otherwise it includes animal figures which only emphasize the vastness or the solitude of nature, as in *The Falls of Tummel* (1870s: DAG) or *A Donkey in Snow* (n.d.: ibid.).

David Farquharson (1839-1907) had a career spent mostly south of the Border and painted landscape in the Home Counties and Holland as well as in Scotland. Caw is rather dismissive of his work, but remarks that he 'brought a more instinctive feeling for tone ... and much greater facility of handling to bear upon the imitative faculty which he shared to some extent with his more widely-known namesake', adding that 'as facility of execution in itself holds no very lasting satisfaction, and David Farquharson's sense of the life and beauty of landscape was rather superficial and his design was wanting in true significance, his art is of less significance than appears on first acquaintance.' Had one been able to point to other examples to match the fine, sweeping *The Herring Fleet leaving the Dee* (1888: AAG) which shows much more than technical fluency and whose high viewpoint and unusual, silvery tonality seem very modern, Caw's strictures, written the year after Farquharson's death, could have been dismissed out of hand.

W.M. Gilbert's monograph of 1899 on Peter Graham quotes two letters which Graham wrote in 1870 to P.G. Hamerton, who later became a prolific writer on contemporary art, but was then struggling to become a landscape painter. Hamerton had asked for Graham's advice, and the latter's painstaking replies give a useful insight into his own methods. Graham begins encouragingly by listing the 'high

qualifications' for landscape painting which Hamerton 'obviously has': 'a sensitively impressionable nature, a strong loving admiration for whatever in heaven or earth is beautiful or grand in form, colour or effect', and finally 'the faculty of observation'. He then expatiates on his own practice. 'My method of getting memoranda ... is to study as closely as I can; to watch and observe, and make notes and drawings, also studies in colour,' and he adds, 'I believe I am much indebted to my long education as a figure painter for any little ability I may have in rendering the material of nature ... Continued study from the nude in a life class gives, or ought to give, an acquaintance with light and shadow which to a landscape painter is invaluable – nature affects our feelings so much in landscape by light and shadow'. Here Graham is, of course, referring to Lauder's teaching but in a context which might well have surprised Lauder. Graham remarks of the Antique Class at the Trustees' Academy:

I shall never forget the exquisite beauty of the middle tint or overshadowing which the statues had which were placed between the windows; those which were immediately underneath them were of course in a blaze of light, and we had all gradations of light, middle tint, and shadow. When I came to study clouds, and skies, I recognised the enchantment of effect to be caused by the same old laws of light I had tried to get acquainted with at the Academy.

The emphasis on the beautiful and the grand in nature, the method of working in the studio from annotated drawings, and the chiaroscuro treatment of light, inevitably deprive the work of Graham and his numerous kind of immediacy and directness. However, Graham enjoyed immense success, which demonstrates how well the resulting *grandes machines*, in Gilbert's words, 'impressively brought home to prince and peasant, and to the merchant overburdened with the bustle of city life' the romantic commonplaces of landscape. But the most fruitful developments in Scottish landscape painting of the period were the result of the very different approach and methods north of the Border by William McTaggart, George Paul Chalmers and Hugh Cameron, who had all been pupils of Scott Lauder, and by George Reid, who had studied in Edinburgh, Utrecht, and Paris.

5 WILLIAM McTAGGART AND HIS CONTEMPORARIES IN SCOTLAND

William McTaggart (1835-1910) was the most gifted, the most prolific, and the most single-minded of the landscapists who remained in Scotland and who first made their mark in the 1860s. Two other pupils of Scott Lauder who distinguished themselves as landscapists, or more properly as painters of rustic or pastoral genre, were George Paul Chalmers (1833-78) and Hugh Cameron (1835-1918). Chalmers's early death and perfectionist approach prevented him from developing his powers to their fullest extent; Cameron made a speciality of the childhood subjects which are ubiquitous but less emphasized in the work of his two colleagues. As with Orchardson and Pettie, it can happen that the work of each of these painters closely resembles that of the others, although McTaggart was the dominant personality. Cameron's seashore pictures with children playing at the water's edge or *The Italian Image Seller* (1862) – a subject treated by several of the Lauder pupils no doubt as a reminiscence of the 'whole group of casts' which would confront the student in Lauder's Antique Class – or (a rarer example) Chalmers's *Girl in a Boat* (begun 1867: Orchar Collection, DAG) looks much like works by McTaggart. But basically the three

35 Hugh Cameron
The Italian Image Seller
1862 Oil 82.5 × 111 cm
The Fine Art Society

36 William McTaggart
Spring
1864 Oil 45 × 60 cm
National Galleries of Scotland
See page 69

artists were individuals and their work can be taken as representative of the three main channels along which landscape painting developed in Scotland from about 1865 until 1885 and later.

McTaggart represents the 'purest' landscape type of the three; although only a few of his pictures are devoid of figures – *The Wave* (1880: KAG) is an early example – the landscape or seascape is always the main motive. In his definitive biography of the artist, Caw tells us that 'from the very beginning McTaggart had painted much out-of-doors, but prior to 1883 the larger pictures were frequently begun in the studio from sketches, and when considerably advanced were taken to the country to be worked on there'; and after 1883 even the largest pictures (unless dependent on earlier works) were painted in the open air. This differs radically from what we have seen of the method of Peter Graham and John MacWhirter, who were studio-bound landscapists who only sketched from nature. Another major difference between the two groups lies in the fact that human presence and human scale are much more to the fore in the work of the Scottish-based land-scapists of this generation, McTaggart included, than in that of the London Scots, Graham and Mac-Whirter. But although figures, usually children, are almost always present in his work and frequently occupy the foreground, from a quite early point in his career McTaggart removes emphasis from them. As a result, in the pictures dating from after 1880 one sometimes has to look hard to find them or to distinguish their actions, so completely are they integrated into the overall scheme. To most people today McTaggart gives pleasure in direct propor-tion to his success in integrating figures and land-scape; when he fails to do this, his work comes uncomfortably close to sentimental genre. In his best work, the figures provide human content rather than subject-matter as such.

Chalmers and Cameron usually give the figure much greater prominence. Chalmers, like the Aber-donian landscapist George Reid, was a close friend of one of the most enlightened amateurs and collectors in Scotland, the Aberdeen mill-owner J. Forbes White (1831-1904), whose circle of acquaintances included several of the Hague School painters and also Daniel Cottier, one of the most enterprising of all British art dealers. Forbes White collected the modern painters who were being handled by Cottier – mainly the Dutch Impressionists and the Barbizon School – and both Chalmers and George Reid reflect a similiar taste in their own work, from which a consciousness of Dutch Impressionism in particular is never far distant. Both Reid and Chalmers are extremely limited as colourists, being much more concerned with tonal values and chiaroscuro. Cameron, on the other hand, shares something of McTaggart's interest in colour in a light key, but his principal motive is an idyllist's view of the innocent joys of childhood – a subject equally dear to several of his near-contemporaries in Scotland, like George Manson and Robert McGregor.

Writing in 1937, Sir James Caw, McTaggart's son-in-law and biographer and Director of the National Galleries of Scotland, expressed a view of McTaggart's work which contains a grain of truth although it now seems hyperbolical: 'In the gradual yet impassioned growth of McTaggart's art the whole evolution of modern painting from Pre-Raphaelitism to Impressionism, and even farther, is epitomised'. The remark suggests a limited appreciation of both movements, as well as ignorance of Post-Impressionism. On the other hand, it is undeniable that, of all the Scottish Victorians, McTaggart today looks the most modern, and his best work shows a freshness of vision, an exuberance of handling, and a timelessness very different from the modishness of Orchardson, the sentimentality of Tom Faed, or the melodrama of Peter Graham and John MacWhirter. The outwardly uneventful life which McTaggart led facilitated the steady development of his style, which quite quickly found a sufficient public to free the artist from the necessity of illustration or portraiture, upon which he at first relied for income.

His slow but consistent development embraces an early Pre-Raphaelite phase showing some influence of the minutely observed landscape of Holman Hunt and Millais, a middle 'Impressionist' phase (datable roughly to the 1870s and 1880s) which shows an increasing preoccupation with the effect of light on the appearance of objects in the open air and with the surrounding envelope of atmosphere which modifies colour and form, and finally a late phase which may be called expressionist, in which the artist's view of nature takes on a rapturous subjectivity expressed in the title of a work of 1902, *All the Choral Waters Sang* (Orchar Collection, DAG) and in an *alla prima* freedom of handling. The young McTaggart was influenced, then, by Pre-Raphaelite landscape painting and went on to create an impressionism of his own, by all accounts unaware of French Impressionism. Perhaps the most striking aspect of his career is the calm independence with which he made a virtue of his provincial isolation. He painted the fields at Broomieknowe, the Atlantic and Kilbrannan Sound shores of his native Mull of Kintyre, and the North Sea at Carnoustie as concentratedly as Monet at Argenteuil or Etretat, but never ventured into the urban scene as Monet did. His humility before what he called 'the miracle of everyday life' was an emotional rather than a rigorously visual, rational or intellectual response. Yet his painterly instincts led him to develop an instrument capable of recording the most delicate perceptions with no corresponding sacrifice of power. The subjective nature of his aesthetic made it inevitable that his later style should derive from his own *facture* rather than from a considered redeployment of the elements of colour and form, since his increasingly rapid execution was peculiarly suited to rendering the flux and change of nature which became a central concern in his work.

Having been urged by Daniel Macnee, the foremost painter in Glasgow, to study in Edinburgh rather then Glasgow, the young McTaggart was enrolled as a student at the Trustees' Academy in 1852, joining Orchardson, Hugh Cameron, Peter Graham and John MacWhirter who were already students there under Scott Lauder. Chalmers, Tom Graham and John Pettie were to join the Trustees' Academy as students within the next three years, and McTaggart became their close friend. In 1857 he accompanied Chalmers to Manchester to see the great Art Treasures exhibition, where it can be imagined that two of the early triumphs of Pre-Raphaelite landscape painting, *Valentine Rescuing Sylvia from Proteus* (1851: BAG) and, also by Holman Hunt, *The Hireling Shepherd* (1851: MAG), must have particularly impressed McTaggart by their faithful transcription of detail illuminated by bright daylight. By Hunt's own later account his 'first subject' had been to paint 'not Dresden china *bergers,* but a real shepherd, and a real shepherdess, and a landscape in full sunlight, without the faintest fear of the precedents of any landscape painters who had rendered Nature before'. This realism was to some extent at odds with the teaching of Scott Lauder, whose 'reiterated injunction to look for the greys in colour' (the words are those of McTaggart's biographer and seem likely to have been suggested by McTaggart's own account of Lauder's instruction) at first encouraged his students to adopt a rather low-key approach to colour, with an emphasis on tonal unity considerably different from the bolder chromaticism of the Pre-Raphaelites. Hunt's precise draughtsmanship, too, is at variance with the more painterly approach of all the Lauder pupils, but his realistic treatment of subject-matter may well have been noted with approval by McTaggart. In the following year, 1858, a further group of Pre-Raphaelite masterpieces made their appearance at the Spring Exhibition of the RSA which can only have made a strong impression on the young Scottish landscapist. These included Millais' *Autumn Leaves* (1856: MAG) and *The Blind Girl* (1856: BAG), and Dyce's *Titian's First Essay in Colour* (1856-57: AAG). At least one local landscapist, Waller Hugh Paton (1828-95), brother of Noel, was clearly influenced by the Pre-Raphaelite works seen in Edinburgh in the 1850s, as his *Highland Cottages, Arran* (1856: recently Sotheby's) shows.

The tension implicit in the divergent influences on McTaggart in his early years was not fully resolved until his *Spring* of 1864. In the interim, McTaggart had been elected to an Associateship of the RSA in 1859 at the early age of twenty-four, and in company with Pettie and Tom Graham he went to Paris in 1860, with the unrealized aim of seeing the Salon, which he caught up with on his next visit in 1876 on the way to the Riviera, and saw again on his last journey abroad in 1882. Caw's biography records that McTaggart did not see a Monet until 1902 when

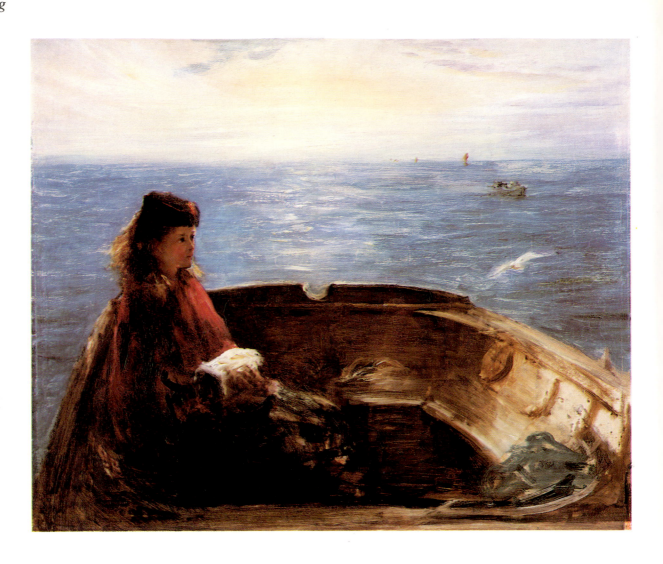

37 George Paul Chalmers
Girl in a Boat
Begun 1867 Oil 55 × 65 cm
Dundee Art Gallery (Orchar
Collection)

two canvases by Monet were included in the exhibition of the Society of Scottish Artists in Edinburgh. This implies that he did not go to the Monet exhibition of 1889 at Goupil's, or the London exhibitions of Impressionist pictures held at Durand-Ruel's in the 1870s and 1880s, or for that matter at Reid's in Glasgow during the last decade of the century. If one is to speak, as some have done, of McTaggart's work as 'Scottish Impressionism', the term is justified at least in the national sense that outside influences which might have operated on McTaggart seem in fact to have had very little bearing on his work; he demonstrated an almost complete indifference to contemporary developments abroad. McTaggart's pictures in the 1860s frequently show an illustrative bias: *The Wreck of the Hesperus* (1861: private collection) is from Longfellow. *Willie Baird* (untraced) commissioned in 1865 by the Dundee collector J.C. Bell, was based on the sentimental *A Winter Idyll* by the 'kailyard' poet Robert Buchanan and particularly on the lines:

Then with a look that made your eyes grow dim,
Clasping his wee white hands round Donald's neck,
'Do doggies gang to heaven?' he would ask.

Enoch Arden (1867): and *Dora* (1868: RSA Diploma Collection) are both Tennysonian subjects. McTaggart was active as an illustrator (contributing, as we have seen, to *Good Words*). Like his friends at the Trustees' Academy he was a member of a sketching club called The Consolidated in Edinburgh during the earliest part of his career, and the literary and anecdotal bias of his early work is shared by his contempories. A very early work, *The Past and the Present* (1860: private collection) which shows five young children playing on the grass in an old graveyard overlooking Kilbrannan Sound, invites comparison with a Pre-Raphaelite masterpiece on a related theme, Arthur Hughes's *Home from Sea* (first exhibited 1857 as *A Mother's Grave*, altered 1863: Ashmolean Museum). In the latter picture, the effect depends on details like the young boy's sailor costume which explains an absence long enough to have allowed the grass to grow over the grave, and on the beautifully drawn faces, with the eloquently restrained expressions. McTaggart aims at a much more indeterminate pathos. Similarily, in *The Old Pathway* (1861: Orchar Collection, DAG) the familiar sentimental theme of the soldier's return to his home and family, who are still unaware of his

uniformed figure arriving at the gate, is treated by McTaggart with considerable understatement, the landscape, illuminated by dappled sunlight, appearing as the chief motive for the picture. *Spring* (1864: NGS) is without a subject as such; two little girls, symbols of spring, muse on a grassy hillside where sheep graze with their lambs. The elder girl completes a daisy chain. Beyond that there is no incident, no story to distract from the main point of the picture, which is a startlingly faithful rendering of a fresh spring day. The lighting in this picture is brighter and more uniform than in any of its predecessors. The few shadows are luminous and painted with evident observation; the landscape, which as a whole is apparently full of detail and highly finished, is in reality transparently and openly handled. In adopting the precise vision of the Pre-Raphaelite landscapists, McTaggart has avoided the concomitant dangers of over-labouring. He was never again to produce a work in this style, despite the fact that even his most devoted patrons at this period (J.C. Bell, G.B. Simpson, W. Ritchie) were wont to comment on what seemed to them the unfinished state of his completed works. As early as *Dora,* the broad impasto and light palette characteristic of his mature style are apparent in the field of yellow barley which forms the background to the principal figure group. This picture was originally given evening lighting, but was changed by McTaggart in 1869 to the effect of broad daylight it now has.

Dora was McTaggart's last work conceived as illustration, apart from a small group painted in 1896-98 to illustrate an unpublished volume of stories by J.G. Orchar. Henceforward he treated the figure in landscape with an increasing concern for its unity with the landscape's own harmonies of colour and form, and beyond that, with the picture surface itself as a pattern of brushstrokes of a deliberately chosen weight, scale and rhythm. The artist's progress in this direction was gradual but decisive and can be seen clearly in the key works of the seventies and early eighties. *On the White Sands* (1870: Orchar Collection, DAG) with its unusually sharp contrast of bright sunshine and shadow, shows a boy and a girl prominently placed in the foreground, so that it is their actions which register first on the spectator as in a genre painting, but the figures are as broadly brushed as the landscape. An element of genre persists in *Something out of the Sea* (1873: ibid) – also the subject, more than coincidentally, of a lost painting exhibited by Orchardson at the RA in 1876, *Flotsam and Jetsam,* for which a drawing survives (NGS). Here three children, excited by the crash of the breakers, run towards us (one of them having fallen on the sand) pulling on a rope which leads into the water. They are seen from a high viewpoint which allows the foreground surf and the distant horizon to appear to rise above them in such a way that the sea occupies the main part of the composition and dwarfs the figures. *Something out*

of the Sea is a particularly beautiful example of McTaggart's subtlety as a colourist: characteristically, the light is not the strongest sunlight, but a diffused brightness which is represented in modulated dove-greys, blues, and pale lilacs. But perhaps, the masterpiece of the seventies, painted in 1874, the *annus mirabilis* of the first Impressionist exhibition in Paris, is *Through Wind and Rain* (Orchar Collection, DAG). It shows very different weather conditions from *Something out of the Sea*: a mist of rain and a full force six driving the green sea through which a small boat charges, heavily reefed. This work suggests the action of the vessel in the water, the scudding sails in the background, and the dynamic effect of wind on water as realistically as the excitement of the young crew and the concentration of the older helmsman. However, an imaginative elimination of inessentials reduces the figures to little more than ciphers while the straining sails make a dramatic *leitmotiv* fully developed only later in the century by a very different artist, the American visionary Pinkham Ryder, who visited Scotland in 1882. McTaggart, however, unlike Pinkham Ryder, painted no nocturnal seascapes, and never fully exploited the formal possibilities of the dramatic silhouette suggested in *Through Wind and Rain.* McTaggart's was an opposite type of art, rooted in realism and devoted to an ideal of truth to appearances, that is, the appearances revealed by light – to McTaggart 'the most beautiful thing in the world'. 'No amount of finish would ever make a lie a truth', he is recorded as saying no one occasion, and on another:

> To draw a few boats carefully is to get some knowledge of their build and form; but it does not enable one to give an impression of their actual sailing, and of the play of light on them, which sometimes gives them an appearance quite different from what close examination would reveal. You must trust to your observation and give a frank rendering of what you see. Sometimes a glint of sunshine will so modify the appearance of a boat or a group of distant sails that it becomes difficult to say what the actual form is, but one accepts that in nature for what it suggests, and in rendering it in a picture one should do the same.

These statements have more than a little in common with Impressionist theory, as far as they go, but it is noticeable that McTaggart seems to attach importance to the idea of movement, to the 'actual sailing' of the boats rather than to the frozen instant of time of Impressionism. In contrast with his French contemporaries, McTaggart frequently delight in turbulent weather conditions which set the northern land- or seascape in motion. With its long rhythmical brushstrokes, his technique was evolved to suggest the continuity of this motion as well as the instantaneity of a single impression. Therefore, whereas the later Monet painted static subjects in the series of

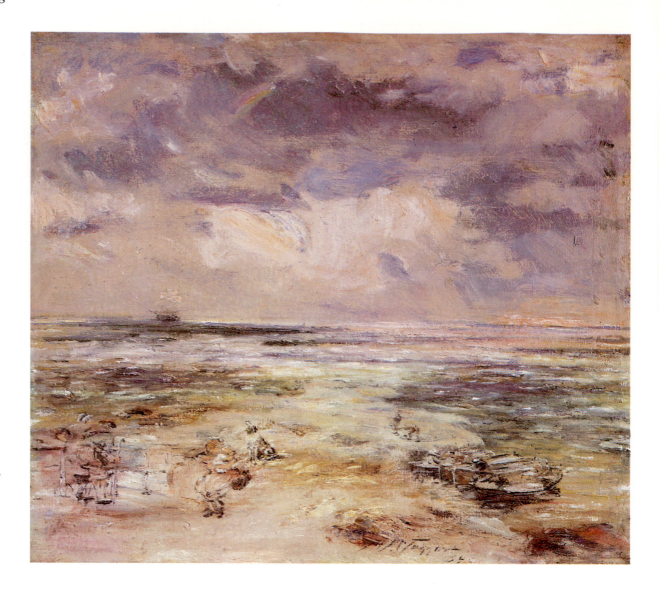

38 William McTaggart
The Sailing of the Emigrant Ship
1895 Oil 75.6 × 86.4 cm
National Galleries of Scotland
Given to the National Galleries of
Scotland in 1931 by the artist's
biographer and son-in-law, Sir
James Caw. Noel Paton's diary for
11 August 1882 records the
singing of 'Auld Lang Syne' to the
800 passengers on an emigrant
ship in Lamlash Bay before she
headed south past the Mull of
Kintyre – like this ship, bound for
America.

pictures of haystacks, of Rouen cathedral, and of waterlilies at Giverny, later McTaggart is concerned with moving things, clouds, waves, sailing boats, human figures. The dissolution of form which characterizes both artists' development is in fact the result of very different aims.

We have the evidence of McTaggart's biographer than he was a painstaking 'lifelong student' of nature. A deliberate cultivation of his own perceptions underlies the delicate nuances of colour of his carefully restrained early manner and the exuberant abandon of the late works. Gradually the human figure appears less *découpé* and is subordinated to the atmospheric and tonal unity of the whole even when shown full length. In a number of later canvases of which *The Wave* (1881: KAG) is the forerunner, the sea is painted – under what influence, of Whistler, whom McTaggart admired, or of Courbet, it is not known – without the addition of figures, as a living entity absorbing or reflecting the light of the sky, an apparently plane surface constantly changing its shape, or becoming formless as it turns to surf crashing on the shore, and whose

colours too, change through the constant agency of light sparkling on its surface or illuminating its depths. *The Paps of Jura* (1902: GAG) and *All the Choral Waters Sang* (1902: Orchar Collection, DAG) – the title is from Swinburne – are among the largest and most successful of this type. The former work was perhaps painted first; it derives from *The Sound of Jura* (1895: untraced) and was painted, leaving out the figures, in the studio, perhaps in order that the experiment would benefit from controlled conditions. *Choral Waters* however was painted in the open at Machrihanish where the Atlantic rollers encounter the first land for nearly three thousand miles and the surf is nearly always present. The rapidity of McTaggart's later technique – a painting would often take only a day to finish – here produces an almost gestural shorthand, the flickering notations of colour registering the artist's physical, kinetic, muscular response to the moving image before him, providing a visible record of the movements of his hand across the surface of the picture. There is a photograph of McTaggart painting at Machrihanish in 1898 a large canvas on an easel –

perhaps the seven-foot *Machrihanish Bay* – supported by guy ropes attached to boulders, which shows the sixty-three-year-old artist standing at the canvas which is at right angles to the shore line, his body taut as he looks intently at the sea before adding the brushstrokes which his outstretched arm is poised to make. Such close and immediate contact amounting almost to identification with the motif gives McTaggart's work its chief strength and freshness. These late pictures are among the artist's largest. 'Arguing that the impression of grandeur and vastness, which Machrihanish produces on the mind, was in no small degree due to its airy spaciousness, McTaggart believed that to suggest these qualities pictorially, size was . . . highly desirable,' Caw explains.

Of course, McTaggart, who visited the Vaughan collection of Turner watercolours annually in January when they went on display in the National Gallery of Scotland, was as aware as anyone of the fact that a sense of space in painting is not dependent on size. This is amply demonstrated by a small Turneresque watercolour of his (1889: recently FAS), showing a *Sunset* over water, with a large flight of gulls so distant as to appear as mere specks, but clearly only occupying the nearer part of the middle ground. His large late pictures seem to have an

incipient mural intention or function, but without the muralist's sense of the flat wall plane. Illusionism demands the retention of the compositionally uninteresting parallel bands of sea and sky, separated by the line of the horizon. Colour, too, is used not decoratively but descriptively, with unmodulated pure white frequently occurring – an obvious sacrifice of the more nuanced earlier approach, which for these reasons may be preferred. But the work which relates McTaggart distantly but recognizably to a line of thought which passes through Giverny (where Monet painted the first of the *Nymphéas* series in 1899) and culminates in the action painting of Jackson Pollock, exhibits a confidence in powerfully handled oil paint as a vehicle of expression which can make all McTaggart's British contemporaries seem timid or tame.

It is arguable that the germ of all later McTaggart, and the essence of his work is to be found in a few paintings of the early 1880s, beginning with *The Wave* of 1881, the forerunner of the group of late seascapes. *Away to the West as the Sun went down* (1881: untraced) requires only that the foreground should be reduced in importance and that the small sloops in the distance should be replaced by a dramatically lit large square-rigged ship to acquire a Claude-like suggestion of the magical potential of a

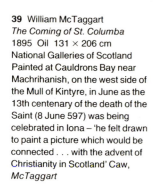

39 William McTaggart
The Coming of St. Columba
1895 Oil 131 × 206 cm
National Galleries of Scotland
Painted at Cauldrons Bay near
Machrihanish, on the west side of
the Mull of Kintyre, in June as the
13th centenary of the death of the
Saint (8 June 597) was being
celebrated in Iona – 'he felt drawn
to paint a picture which would be
connected . . . with the advent of
Christianity in Scotland' Caw,
McTaggart

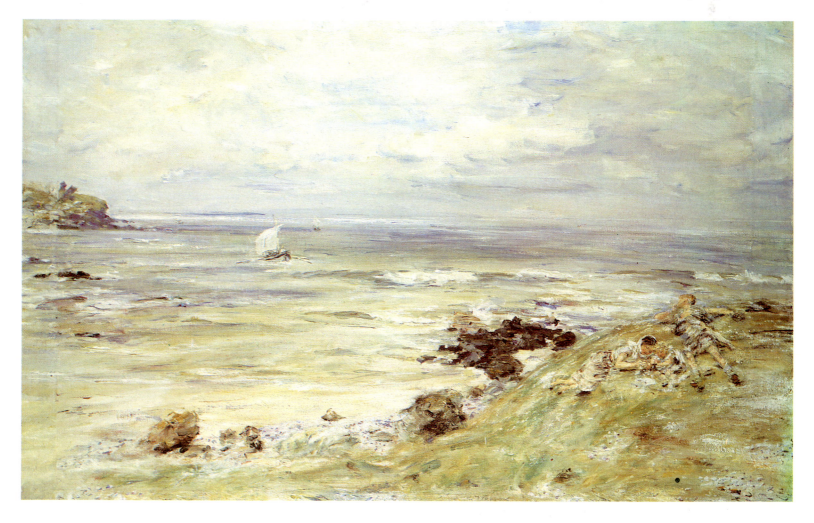

40 William McTaggart
The Storm
1890 Oil 120 × 182 cm
National Galleries of Scotland

voyage just begun, as in *The Sailing of the Emigrant Ship* (1895: NGS), a subject which McTaggart also painted in 1891 and 1893. Similarly, a change of emphasis and title leads from *Daybreak, Kilbrannan Sound* (1893: untraced), which shows a small boat with young children and their father returning from a night's herring fishing to a very different marine arrival in *The Coming of St. Columba* (1895: NGS). This was painted in Kintyre in the year when the thirteenth centenary of the death of St. Columba was being celebrated on the near-by island of Iona, where the saint had landed in 597 on his mission to convert Britain to Christianity. That McTaggart was affected by the idea of suggesting a landing of special significance and that this could be achieved through the medium of the seascape itself, is indicated by Caw's reminiscence that when McTaggart looked at the picture with anyone, he would murmur softly 'What a day for such a mission'. Two paintings of 1883 may finally be mentioned, both of which were the basis of later versions. Dundee's *Wind and Rain, Carradale* perfectly blends the figures into the landscape, although allowing them their substantiality. A storm is brewing, and boats are seen running for the shelter of the anchorage, where other small craft are

safely at their moorings. This is an example of the sparing use of human incident which characterizes McTaggart at his best, and it is at the same time unusually considered as a composition, while its restrained harmony of lavender, slate, and lilac shows the greatest refinement. *The Storm* (KAG; later versions NGS and Orchar Collection, DAG, both 1890), fully matched to its elemental theme, has a northern, expressionistic air which clearly looks forward to the late period, but still contains those delicate and transient effects 'not too tightly grasped' as McTaggart himself said, which reveal a highly developed art of suggestion. The small oil in the Orchar Collection is exquisite in its pearly colour and rich, enamelled surface (it is painted on wood) and in the extraordinary vitality of its brushwork. The largest version of the three, which used to be owned by Andrew Carnegie, was developed in the studio from the 1883 picture, which was painted in the open air at Carradale. The Edinburgh picture makes a powerful impression and vindicates McTaggart's belief in the advantages of greater scale to his later style.

It is as a painter of the sea and shore that McTaggart excels, perhaps, above all, and works in

this vein predominate numerically in his *oeuvre,* as well as in public collections. Generally speaking the figure subject appears more dominant in landscape proper, as already discussed in two works of the 1860s, *Spring* and *Dora,* and the actions of the figures of more central importance to the theme, as many titles indicate: *Half Way Home* (1869), *Village Connoisseurs* (1870), *The Dominie's Favourite* (1873), *At the Fair* (1874), *Fern Gatherers* (1875), *The Blackbird's Nest* (1887), *Caller Oo!* (1894). Even a late work such as *The Soldier's Return* (1898: PAG), as ambitiously large (134cm × 206cm) as the big seascapes of the same period and equally concerned with a suggestion of movement, is slightly marred by an insistent element of genre. The main pivot of the composition is an awkwardly drawn figure of a running soldier. Somewhat more successful is another large work of the same year *The Lilies,* (KAG), which shows two groups of children dancing in a ring in the artist's garden at Broomieknowe round a bed of tall lilies in bloom. Here the figure drawing is less eccentric and the lyrical impulse which suggested the picture's full title *The Lilies — Consider the Lilies* is carried through convincingly.

Two Scottish painters who became well known in London as painters of the west coast of Scotland, Colin Hunter (1841-1904) and Hamilton Macallum (1841-96), frequently painted in company with McTaggart at Tarbert during the summer, and their work show his influence. Both, however, have faults which may be taken to stem at least in part from the need to specialize in a certain recognizable landscape type which was more necessary to survival in the larger exhibition of the south. Colin Hunter, who became an Associate of the Royal Academy, was the more painterly artist, and an early work, *On the West Coast of Scotland* (1879: Orchar Collection, DAG) need only to be compared with Harvey's work of this time to show the younger generation's much freer confidence as colourists. Yet his technique often degenerated into slickness. Even his sketches, painted with considerable freedom and breadth, too often have a meretricious look, using unmixed ultramarine or cobalt to gain an immediate effect. Although less gifted technically, Macallum was perhaps a more genuine artist. In his hands the genre element, which in the minds of the public at large was one of the attractions of landscape, is soberly and objectively treated. *Haymaking in the Highlands* (1878: GAG) shows the new hay being loaded onto a boat on one of the Hebridean islands. This type of documentary transcript of life in the remoter parts of Scotland was appreciated more as social history than as art. J. Dafforne learnedly advised the readers of the *Art Journal* when describing *Shearing Wraick in the Sound of Harris* (untraced) of the value of this industry to the Highlands (£200,000) and on the soda, potash, iodine and bromine and other 'substances used largely in manufacture' which could be extracted from seaweed. Macallum settled in London

in 1865, and used broad Scots in his titles like *A Wee before the Sun Ga'ed doon,* less as a means of communication than as an advertisement of national subject-matter.

McTaggart had numerous followers in Scotland. Joseph Henderson (1832-1908), an almost exact contemporary of McTaggart who become his father-in-law when his daughter became the latter's second wife, was the most prominent artist in Glasgow of his generation. He exhibits similar interests to Macallum in *Kelp Burning* (Orchar Collection, DAG), and comes very close to McTaggart in *The Flowing Tide* (1897: GAG), yet his approach is workmanlike and rather pedestrian. He never became a member of the RSA, indicating the difficulty Glasgow painters had in the later decades of the century in having their claims to academic recognition heard. Sir James Lawton Wingate (1846-1923) was born in Glasgow but trained in Edinburgh, where he lived after 1871, ultimately becoming President of the RSA. His work, too, records without comment life on the land at its most placid. His figures are generally engaged in the unchanging work of the country, pausing only, one presumes, to discuss the weather, as in Dundee's *Watering Horses* (1885), exhibited at the RSA in 1887. Although an agreeable work, it cannot compare with the educated vision and subtly modulated colour of McTaggart's work of similar date. Like others, Wingate was more timid than McTaggart in his handling of paint. At his best he possesses an individual delicacy of brush-work and colour, but McTaggart's weakness in composition (which sometimes had to be made good by augmenting an already painted canvas with additions which were stitched on) is sometimes exaggerated to the point of formlessness in Lawton Wingate's later seascapes.

Even more dependent on McTaggart, to the extent of working at his favourite locations at Carnoustie and Machrihanish, Robert Gemmell Hutchison (1855-1936) concentrated almost exclusively, in the later part of his career, on one area of McTaggart's subject-matter — small children playing at the seashore — but was influenced in his treatment of the figures by the nineteenth-century Hague School. For all his considerable popularity and a long and productive career, Gemmell Hutchison has remained a surprisingly little-studied artist and a chronology of his work is difficult to establish precisely as few of his pictures are dated. However, a tentative dating to the 1880s and 1890s seems appropriate for a series of little works often measuring a mere six by eight inches more often than not showing children either alone or in groups, or perhaps a baby with its older sister by whom it is being spoonfed or told a story in the humble familiarity of a cottage interior. These modest compositions frequently demonstrate the most delicious painterly quality on a small scale, together with a genuinely sympathetic treatment of the lives of the very young; they have always been more prized by collectors than appreciated by art

historians. Tom McEwan in Glasgow frequented similar territory; his domestic interiors are stiffer and less natural, but also more detailed in terms of dress and furniture. Gemmell Hutchison's later and probably better-known seashore paintings retain a charming freshness and spontaneity and are often handled with impressive freedom. *Shifting Shadows* (exhibited 1913: RSA Diploma Collection), which is very large and shows a buxom young wife hanging out the washing on a windy day, is untypical in size and subject and suggests that in his usual smaller pieces he was deliberately reining-in an exuberant talent.

Two later artists whose work bears a family resemblance to that of Gemmell Hutchison are Jessie McGeehan who concentrated on Dutch children playing at the water's edge or in small boats; and John McGhie (1867–1952), who seems to have drawn all his subjects from the ancient Fife fishing village of Pittenweem where he lived when he was not working in his Charing Cross studio in Glasgow. A typical subject will show a handsome young woman mending nets, gathering shellfish, or simply waiting for the arrival of the fishing boats, against the ever-present background of a North Sea as blue as her eyes.

A major influence on artists from the north-east in the last quarter of the nineteenth century was the Aberdeen collector John Forbes White. He was a polymath of advanced tastes, with particular enthusiasm for the Dutch Impressionists and the Barbizon School and a classicist who would typically delight in recounting how on a journey by coach from Stettin to Danzig he talked Latin for hours with a Polish professor of mathematics. He founded the Homeric Club of Dundee, and in 1889 gave a lecture there on the newly discovered Tanagra figurines. He was in addition a pioneer photographer, and knowledgeable enough about Rembrandt and Velazquez to write *Encyclopaedia Britannica* articles on them. A wide circle of artists visited his house as their friend and patron, including the Scots Arthur Melville, Hugh Cameron, Orchardson and Daniel Cottier (whose firm in 1863 installed nineteen stained-glass windows of Cottier's design in Seaton Cottage, White's retreat on the Don), as well as George Paul Chalmers and Sir George Reid. The English painters William Stott of Oldham and Paul Falconer Poole were also occasional guests, as was Josef Israels, who contributed to the joint portrait of himself now in Aberdeen Art Gallery and inscribed '*à notre ami White*'. White bought Mollinger's *Drenthe* from the International Exhibition in London in 1862, and secured an introduction to the young Utrecht artist, with whom he developed a friendship. When Mollinger died, White took responsibility for disposing of the contents of his studio on behalf of the family. Through Cottier and Mollinger, White met Arzt, Maris, and Bosboom and bought their pictures. He bought the Corot *Souvenir d'Italie* (GAG) in 1873 for £600

('Maister White, are ye mad?' said his father's old head clerk), selling it again in 1892 for £4000.

Their contact with White was a decisive factor in the development of the painters George Reid, who was also an Aberdonian, and George Paul Chalmers, who came from nearby Montrose, and led them in a more conspicuously European direction than McTaggart. McTaggart's three-week tour of European galleries in 1882, made in company with J.G. Orchar, included a visit to Israels at The Hague, but although McTaggart admired the Dutch painter, there is no sign that he was influenced by him. The opposite is true of Chalmers, who first met Israels at White's Seaton Cottage, and then renewed his acquaintance when he visited Paris and the Low Countries in 1874. And when George Reid went to Holland in 1866 it was to study under Mollinger, apparently with financial support from White. Mollinger's *Drenthe* is a clear influence on Reid's *Montrose* (1889: AAG), just as White's large Corot inspired Chalmer's *Autumn Morning* (late work: untraced).

Reid and Chalmers were only occasional landscapists. Chalmers also painted genre, and both were exceptionally accomplished portraitists. Yet it is their landscape work, and in Chalmers's case, a handful of the genre pictures, which are of chief interest today. They show a consciousness of atmosphere as a diaphanous element interposed between the seer and the seen, altering the appearance of things far more subtly than the dense mists and 'effects' of artists like Joseph Farquharson. Chalmers studied under Lauder at the Trustees' Academy for only two and a half years, and it is possible that this short training, which contrasts markedly with McTaggart's seven-year apprenticeship, was a considerable factor in Chalmers's extremely hesitant production, forcing an undue reliance on his undoubted natural gifts in the absence of a clearly identified aesthetic. There was a good deal of head-shaking at Chalmer's want of determination and habit of rising late, but he clearly enjoyed a good reputation among his contemporaries. However, it rested upon an extraordinarily small output, much of which has now vanished, although just enough remains to demonstrate his quality. There are the portraits proper, of which perhaps the most important are *John Charles Bell* (1875: DAG) and the unidentified *Portrait* (n.d. MacDougall Art Gallery, Christchurch, N.Z.) which show a Rembrandtesque sense of contrast, although in colour they are closer to Velazquez's use of black and white. In both works the chiaroscuro effect is handled with extreme delicacy, and there is real sympathy with the serenity of old age. The Drumlanrig *Old Woman Reading* by Rembrandt was an obvious influence on a little portrait of a sitter of similar age in the Orchar Collection. That Chalmers could also paint a sympathetic study of a very young sitter is demonstrated by his portrait of Forbes White's daughter *Aitchie* (exhibited 1874: AAG).

41 Robert Gemmell Hutchison
Shifting Shadows
c.1912 Oil 116.8 × 149.9 cm
Royal Scottish Academy (Diploma
Collection)

Chalmers comes closest to his admired Dutch contemporaries in a few paintings which show a domestic interior with figures, usually including children. *Prayer* (1870: untraced but reproduced in Caw) shows a young girl kneeling beside an old woman who holds a Bible on her lap and the relationship between the two figures is tenderly conveyed. *The Lesson* (n.d.: Orchar Collection, DAG) shows a similar contrast of youth and age. His most ambitious work of this kind was *The Legend* (circa 1864-67: NGS) which shows a group of children gathered round an old lady who is telling them a story. The room is filled with a grey-blue light which is rendered with the greatest delicacy and was the main cause of the trouble which this composition caused the artist. Alexander Gibson tells us that 'Chalmers rarely kept to the original conception of his picture, but was continually being led astray by new ideas or by passages of colour, which were beautiful in them-

selves, but which involved a rearrangement of the whole picture; and then, when the process went on for a while, he lost the fresh feeling with which he began the work, grew sick of it and finished it as a piece of disagreeable taskwork'. In 1865 the unfortunate artist wrote to G.B. Simpson, who had commissioned the picture, 'I have wrought harder this year than ever I did and have completed nothing', and in a subsequent letter tells his correspondent with understandable wryness of a painting by Orchardson (whose London career was just beginning) that had been sold to a dealer for £400, and resold 'immediately for twice that figure; painted in five weeks!' Generally, Lauder's other pupils developed an ability to exploit not only the freshness but also the rapidity of the sketch aesthetic. Chalmer's adherence to Old Master models made this an impossibility for him, despite that fact that 'his sketches, if he intended them to be merely

sketches, were done with extreme facility and pleasure'. It is perhaps for this reason that his very rare landscapes are perhaps the most satisfying of all his works.

At the End of the Day (private collection) is set in the flat countryside of the artist's native Montrose, and shows a luminous evening sky reflected on a wet road. Its technique completely eschews the expressive brushwork typical of Lauder's pupils, but instead provides infinitely subtle gradations of tone, with no trace of the movement of the brush over the surface of the picture. This work probably dates from the period 1872-75, when he spent some months in summer and autumn at the village of Edzell painting from nature. Chalmers appears to have approached the problems of painting in the open with the excessive conscientiousness which he brought to portraiture (on one occasion a portrait required ninety sittings), but the large *Running Water* (untraced) was finished, together with numerous sketches. The pains which Chalmers took to achieve the maximum truth to appearances – 'the detail always emerging into prominence and having to be beaten back into mystery' – indicate a predominantly realistic concern which could only be reconciled with Chalmers's technique with the greatest difficulty. For the main aim of that technique was to suggest the most ethereal and evanescent effects, paradoxically, through a high finish which would have the immediacy of an apparent sketch, but not its material flimsiness. When Chalmers succeeded in achieving this as he did in *The Head of Loch Lomond* (Orchar

Collection, DAG) and *The Ferry* (ibid), he appears as one of the most poetic and delicate of landscapists, especially in his use of a range of colour which is much wider than is seen in his studio paintings.

In 1876 Chalmers went to Skye. *Rain in Sligachan* (untraced) has the same atmospheric transparency and depth as the two pictures in the Orchar Collection, suggesting that the enthusiasm for Corot that Chalmers was heard to express on the night before his mysterious death was to some extent that of a disciple of the French painter.

The very extensive correspondence of Sir George Reid (as he became) and James Forbes White contains a number of clues concerning the painter's views on landscape painting and certain of its practitioners which are more of interest for the light they shed on his early views than instructive regarding his own work. From Paris, where he studied under Yvon, he writes, 'I cannot but feel sorry that Gérôme's star is so much in the ascendant here – he is exercising a strong and very hurtful influence upon many of the young fellows, both in regard to choice of subject and manner of painting . . . Jules Breton and Daubigny have their worshippers too – but their numbers are few.' In the same letter Reid describes his impression of Veronese's use of light in *The Marriage at Cana* (Louvre): one group of columns in the picture has, he observes, 'only the borrowed light from the blue sky above. You can feel the blue of the sky repeated over their surface like a kind of glossy skin'. The same letter states that Reid's friend the Dutch artist Artz is to arrange for Reid to

42 George Paul Chalmers
The Head of Loch Lomond
n.d. Oil 28.6 × 43.8 cm
Dundee Art Gallery (Orchar
Collection)

43 Sir George Reid
Evening
1873 Oil 42.5 × 69 cm
Dundee Art Gallery (Orchar Collection)

meet Daubigny through a mutual friend. Although it is not known whether this meeting did in fact take place, the correspondence reveals that Daubigny was, with Jules Breton, the artist whom Reid most admired in Paris in 1869.

It is probably unfortunate that Reid did not remain a landscapist and that his considerable technical skill was of a kind which could be and very quickly was pressed into what the later Victorians sometimes called the 'sin of commission', portraiture. Reid had the same view of the respective merits of portraiture and landscape painting as Gainsborough, but despite this and the very real gift, nourished by the perceptive intelligence which shows itself in the young artist's reactions to current painting in Paris, and demonstrated in the Orchar Collection's *Evening* (1873), he painted very few landscapes and concentrated from an early point on portraiture. His neat draughtsmanship also led to many commissions as an illustrator. The Reid-White letters reveal a rather dry temperament – 'fou' o' seriousness', as he says himself – which borders on aridity. At the end of his career, as President of the RSA (1891-1902) he came to represent to the younger generation of painters of the Glasgow School all that was reactionary in the academic system that then prevailed in Edinburgh, and his tenure of the presidency was an uneasy one.

In 1893 Reid attacked *ex cathedra* the young painters of the Glasgow School in an article in the *Westminster Gazette*. The wheel had turned full circle for the young Scot in Paris who criticized the *pompier* influence of Gérôme and briefly indicated his own awareness of new developments as the painter of *Evening*.

George Smith (1870-1934) was another artist from the north-east who went abroad to train, in his case with Verlat in Antwerp, who had been the teacher of Hornel and his friends of the Kirkcudbright School, Mouncey and MacGeorge. Like these landscapists, Smith demonstrates the influence of the watered-down impressionism which was becoming endemic in some of the Continental schools in the 1890s, together with the rudely vigorous handling of paint which Verlat seems to have inculcated and which is appropriate to the bucolic scenes of farm and field favoured by Smith.

Hugh Cameron (1835-1918) has been mentioned as representing a third strand of development in the landscape painting of the later Victorian period, namely the taste, almost amounting to obsession, for paintings of children. To some extent this identification is artificial since all the pupils of Scott Lauder treated this theme. Our more cynical age regards the subject as sentimental and escapist, but for the

Victorians, with their positivistic belief in the perfectibility of man and society, it to some extent represented the more pleasant of the two possible reactions to the inescapable inference that if man and society are perfectible in the future, they must be at present be imperfect. One of the reactions is to criticize society and the vices of man, either by ridicule and caricature or by objective description of what is wrong. *Punch* (which had no specifically Scottish equivalent) exercised this function, as did the graphic work of the Scottish artist William 'Crimean' Simpson (1823-99). The other possibility is to emphasize what is good in existing society, as William Bell Scott believed he was doing in *Iron and Coal*. The Victorians saw childhood as a time of innocence. This appears clearly in Cameron's work and in that of a slightly later group of artists in Scotland whose work began to appear in the 1870s. It presents a Scottish parallel to the shortlived contemporary English development which was led by George Mason, Fred Walker, G.J. Pinwell and Arthur Boyd Houghton.

The Edinburgh-trained R.W. Macbeth (1848-1910), the son of the genre painter Norman Macbeth, became an illustrator for *The Graphic* and moved to London in 1870, becoming an Associate of the Royal Academy in 1883. His work as a painter was thereafter little seen in Scotland, but as the engraver of Walker's *Bathers* and *The Plough,* of Pinwell's *Elixir of Love* and of Mason's *Pastoral Symphony* Macbeth played a crucial role in the taste of the day for idyllic pastoral subjects. As an engraver he was outstanding; his large plate of Titian's *Bacchus and Ariadne* is a *tour-de-force*.

Hugh Cameron, George Manson and Robert McGregor were the most interesting of the Scottish-based adherents of the new movement, which influenced such artists as the short-lived P.W. Nicholson, John Reid, J.C. Noble and A.M. Macdonald. Cameron's work, especially when it is on a small scale, has a tender lyrical quality seen at its best in a small oil *The Swing* (Macfarlane Collection), rather than in a large exhibition piece such as *The Funeral of a Little Girl on the Riviera* (1881: DAG). Both pictures convey a convincing sense of the open air, as we might expect from an artist who was a contemporary and friend of McTaggart, but Cameron's elongated and wistful figures, which can be charming on a small scale, seem mannered or simply inept when enlarged. Or is it possible that the emotionalism implicit in the heart-rendering subject of infant mortality requires the powerful colour and forceful composition which Phillip had employed in *La Gloria* Cameron's use of colour is restricted to pale harmonies of blue and green appropriate to his gentle style. What is known of George Manson (1850-76) comes from the well-produced illustrated memorial volume of 1879. His early death prevented

44 Charles Martin Hardie
An Unrecorded Coronation
1888 Oil 106 × 155 cm
Private collection
The Royal Scottish Academy
catalogue of 1889 adds ' "The Isle
of Rest", A.D.1548' to the title.

45 Robert Macgregor
The Knife Grinder
1878 Oil 76.2 × 137.8 cm
Dundee Art Gallery

the development of a sensitive artist whose precocious talent as a watercolourist can be seen in the early two examples of his work in a public collection, *The Cottage Door* (1871-73: Orchar Collection, DAG) and *What is It?* (1873: ibid).

John Henry Lorimer (1856-1936), brother of the architect Sir Robert Lorimer, trained in the RSA schools under McTaggart and Chalmers prior to a period in the atelier of Carolus-Duran in Paris. His work as a flower painter can seem wonderfully showy and exotic. As a subject-painter, Caw writes of him: 'None except Sir W.Q. Orchardson . . . had painted the more refined and cultured side of modern society, until Lorimer took up figure subjects and gave delightful glimpses of life as it passes in many a Scottish home.' Many of these include the children of the household as the main protagonists, with titles such as 'Sweet Roses,' 'Winding Wool', 'Lullaby', and 'Grandmother's Birthday – saying Grace', all from the 1890s; perhaps the best known of all is the late work, 'The Flight of the Swallow', purchased by the Scottish Modern Arts Association in 1908, a charming Edwardian group with a mother and three pretty daughters (one of them in tears) watching the departure of a flight of swallows at the end of summer. Charles Martin Hardie (1858-1916), similarly, studied at the RSA schools and absorbed (as far as can be judged from the little that has appeared

of his work in recent years) a fresh and pleasing technique seen to considerable advantage in one of his best-known works, *An Unrecorded Coronation* (1888 – how academic such a work appears in comparison with the Glasgow School at the same date!), where, watched by a patient old nun, the four young Marys who were the companions of Mary, Queen of Scots during her sequestration on Inchmaholm Priory in 1508 surround her on the summer sward and one of them 'crowns' her with a daisy chain. Equally wedded to childhood subjects, but of considerably greater talent and originality, Robert Macgregor (1847-1922) was born in Yorkshire and worked with his father as a designer of damasks at Dunfermline before joining the Life Class of the RSA. He seems at some unknown date to have worked in Brittany, but of his life and training surprisingly little is known. In any event, his style seems more French than Scottish; more than any artist before Guthrie or the Newlyn School he appears either to have absorbed the lessons of Bastien-Lepage, or to have arrived independently at a similar *plein-airisme*. Two large early works at Dundee Art Gallery, *The Knife Grinder* (1878) and *Great Expectations* (1880) show that in his vigorous handling of paint and concern with rich, low-keyed colour, he prefigures the early work of the Glasgow School painters James Guthrie and E.A. Walton.

6 THE GLASGOW SCHOOL AND SOME CONTEMPORARIES

A remarkable burst of creative vitality in the visual arts took place in Glasgow in the last two decades of the nineteenth century. The Second City of the Empire (by 1890 just ahead of Melbourne in terms of rateable value) had owed its recent rapid growth to shipbuilding, the locomotive and heavy machinery industries, and (assisted by vast local reserves of coal) the production of iron, reaching at one stage a third of Great Britain's output. When steel took the place of iron, Glasgow's steel production was increased nearly twenty-five fold in twenty years, to reach a million tons by 1900. Despite the bank failure of 1878 – which immediately gave a splendid excuse to provide employment by the expediently labour-intensive erection of a palatial City Chambers – at the end of the century the city rode on the crest of a wave of confidence and prosperity which was reflected in more widespread and gradually more discerning patronage. The 'beautiful little city' admired by Daniel Defoe on his visit in 1715 with its venerable Cathedral and ancient University, its merchant city thriving on the American tobacco and cotton trades, prettily situated on the banks on the Clyde, had by the end of the nineteenth century become an international manufacturing and trading giant successfully selling its goods to the world.

In the *Notes* written in 1891 Macaulay Stevenson, pointing out that the Glasgow School artists 'did not seek the name and were but a dozen or so in all' (a total he later increased to twenty-three in a letter to T.J. Honeyman in 1941), estimated that there were about one hundred and fifty professional artists working in the city. But painting did not exist in a vacuum and the burgeoning of the visual arts in Glasgow at the end of the century has three main aspects: architecture, design and painting. First, in addition to its strong local architectural tradition, which bore the very personal impress of Alexander 'Greek' Thomson (1817-75) and of Charles Wilson (1810-63) and others, late-Victorian Glasgow boasted a number of accomplished and original architects. The most eminent of these was Sir J.J. Burnet (1857-1938) whose Glasgow work dates from his return in 1878 from a period of training at the Ecole des Beaux-Arts in Paris. In a long series of buildings he developed an approach to architectural design which showed historicism applied with unpedantic inventiveness to contemporary urban

requirements, from the skilful, witty addition to the Glasgow Stock Exchange (1849) in Venetian Gothic to the Sullivanesque McGeoch's warehouse (1905). Burnet's Glasgow contemporaries included William Leiper (1839-1916), designer of a delicious Venetian Gothic extravaganza in polychrome brick and tile known as Templeton's Carpet Factory (1889), James Salmon II (1874-1924), and J. Gaff Gillespie (d. 1926) whose paths away from historicism led them to an Art Nouveau architecture. Outside the old city, with its handsome new banks, insurance offices, churches and terraces, new communities sprang up in the pleasant green acres of Cathcart, Bridgeton and Pollokshields, along Great Western Road and out to the Clyde resorts like Helensburgh, where the newly-rich merchant class built themselves imposing stone mansions which provide a domestic counterpart to the public architecture of the Victorian city. Bare walls in many a grand drawing-room simply cried out for pictures.

Art Nouveau in Glasgow in the 1890s is the second important aspect of late nineteenth-century style in the city. With it came a revival in the decorative arts of furniture, metalwork, and stained glass which gives Glasgow its own equivalent of the Arts and Crafts Movement, although the English movement regarded its Scottish counterpart with active distaste. Although it owes something to the purifying influences of Christopher Dresser, E.W. Godwin, Thomas Jekyll and Whistler, this Glasgow movement was above all impelled by the protean originality of Charles Rennie Mackintosh (1868-1928), a designer of genius whose earlier work, culminating in the first part of the Glasgow School of Art (built 1897-99) and containing many Art Nouveau elements, further added to the international standing so recently and so surprisingly achieved by its school of painters. These young Turks of Scottish painting form the third section of our triptych. Collectively known as 'The Glasgow School' – unconnected with the Glasgow School of Art – they provide a slightly earlier background to the esoteric *fin de siècle* movement of Mackintosh and his friends. The first mature works by these young artists – the 'Glasgow Boys' – appeared in the middle 1880s, but their creative impulse slackened after 1896. This third aspect of the flourishing visual arts in Glasgow sprang from a happy combination of favourable economic con-

ditions and a new consciousness on the part of the Glasgow public of the art of painting. The evolution of that taste requires a brief description here.

Through the decades preceding 1880 Glasgow had developed a fine tradition in the appreciation of good pictures. The city's artistic independence may be said to date from the foundation in 1753 of the Foulis Academy within the University for the training of painters, sculptors, and engravers. This brave new enterprise was the brainchild of the brothers Robert and Andrew Foulis, printers to the University, and Robert, in McLaren Young's words 'an ardent if somewhat gullible collector', accumulated a collection of 450 mostly spurious 'Old Masters' for teaching purposes. The Academy produced the medallionist James Tassie (1735-99) and the genre painter David Allan, one of several students who visited the Glasgow alumnus Gavin Hamilton on the obligatory visit to Rome. It closed when Andrew Foulis died in 1775. After over thirty years, in 1808, the Hunterian Museum at the University was opened – the second public museum in Britain after the Ashmolean – with its excellent examples of Rembrandt, Koninck, Chardin, Stubbs and Ramsay, and much else besides, left to the University by a collector of a very different stamp, the pioneer obstetrician, friend of Reynolds and connoisseur William Hunter. A variety of Glasgow exhibition societies had existed from the earlier nineteenth century, notably the Dilettante Society (begun in 1825) and the West of Scotland Academy, which lasted from 1841-53. By the middle of the nineteenth century the taste of two widely travelled Glaswegians, the art dealer William Buchanan – a student at the University during the Foulis years – and the master coachbuilder and collector Archibald McLellan, had made a considerable impact on public collections in both Glasgow and London. Buchanan was responsible for bringing many important Old Master paintings to Britain, including Titian's *Bacchus and Ariadne* and *The Toilet of Venus* by Velazquez, both now in the National Gallery. He may have acted as adviser to Archibald McLellan, who in 1853 left to the City of Glasgow an Art Gallery and a large collection of paintings including Giorgione's *The Adultress Brought before Christ* (GAG). The landscape background of this famous picture seems to have influenced the early Glasgow School painters.

In the 1860s two institutions were founded which were to have an immediate bearing on the development of the Glasgow School of painters – the Fine Art Institute (later the Royal Glasgow Institute of the Fine Arts) in 1861, and the Glasgow Art Club in 1867. The early exhibitions of the Fine Art Institute were held in the McLellan Galleries at 254-290 Sauchiehall Street, and there is no clearer indication of the Glasgow's public's interest in art at the time than the Institute's decision in 1879 to provide itself with sumptuous new premises at 171 Sauchiehall Street, merely a year after the crash of the City of Glasgow Bank had brought financial ruin to many of its shareholders and had caused a short-term cash crisis in the city. The new Fine Art Institute, designed by Sir J.J. Burnet, had an elaborate sculptured frieze by John Mossman (1817-90), who was the teacher of Pittendrigh Macgillivray (1856-1938), the only sculptor to be associated with the Glasgow group. The importance of the annual exhibitions held at the Glasgow Institute in the 1870s and 1880s was twofold. First, an outlet was provided for the products of artists living in Glasgow and the west of Scotland who found themselves tacitly debarred from membership of the RSA in Edinburgh; in the second place, the Loan Sections of these exhibitions began to reflect the taste of the more advanced collectors in Scotland for the works of the Barbizon School, Bastien-Lepage, and the Hague School. In the middle eighties, works by Monticelli, Whistler, Rossetti, Burne-Jones and William Stott of Oldham began to appear. The Glasgow Art Club's exhibitions were less ambitious, having more the role of a market for the work of members of the Club. This was a necessary economic function, but it may be supposed that much of whatever lustre the Club possessed must have departed when two of its most distinguished members, Daniel Macnee and the landscapist David Murray (both later knighted), moved to Edinburgh and London in 1876 and 1883 respectively. In the early eighties, therefore, the situation in Glasgow was such as to provoke in any young artist of talent and originality a sense of frustration at the prospect of long years of exclusion from the RSA establishment in Edinburgh, and an awareness of the superiority of the works of the foreign schools which were represented in the annual exhibitions of the Glasgow Institute. Added to that was a feeling of disgust at the frank commercialism and sub-Wilkie sentimental and ancedotal approach of the so-called 'Gluepots', who formed the majority of the membership of the Glasgow Art Club and whose use of heavy brown megilp varnish earned them that unflattering but apt sobriquet.

The MS *Notes* on the history of the Glasgow School written by Macaulay Stevenson in 1891-92 and apparently revised by his wife in 1895 (until recently in the possession of the artist's daughter) trenchantly underscore the views of the younger generation of Glasgow painters who were still struggling to make their way against public apathy or official benightedness. Stevenson castigates the preference of the selection committee of the RSA for anecdotal painting, commenting 'Alas poor Edinburgh! It was left to live on traditions. The life of the community is fettered by the effete conventions of a faded gentility and eaten into by the dry rot of an exclusive and self-sufficing "culture"'. Praising the great display of modern French and Dutch masterpieces assembled by T. Hamilton Bruce for the Loan Section of the Edinburgh International Exhibition of 1886, Stevenson describes the Barbizon School as

46 Sir James Guthrie
A Hind's Daughter
1883 Oil 106.7 × 76.2 cm
National Galleries of Scotland

'the greatest event that had occurred in art since Rembrandt'. He then emphasizes the important role of the Glasgow Institute in bringing in annually to Scotland excellent examples of the work of the Barbizon and the Hague School artists and of Bastien-Lepage, praises the fact that these borrowed works were often instructively hung in juxtaposition with works by local young artists, and emphasizes that the Institute was 'the real school – not Paris.' Stevenson, ever the controversialist, actually goes out of his way to dismiss suggestions of French influence: 'Even in W.E. Henley's brilliant paper *The National Observer* in which appear the most capable art critiques in the country the whole group are to this day blunderingly described as the Scoto-French school – much to the amusement of the men themselves'.

The enlightened activity of a small number of collectors and dealers in Scotland, especially in Glasgow, provided a further stimulus for the revolt of the young painters who were to form themselves into the Glasgow School. The culmination of this activity was, of course, reached in the last years of the nineteenth century and the first decades of the twentieth with the dealing of Alexander Reid (1854-1928) and with the formation of Sir William Burrell's vast collections. Reid's Glasgow firm La Société des Beaux-Arts was started in 1889. He supported the young Glasgow painters from the early eighties, and until 1892, when Reid held his first exhibition to include French Impressionist paintings in Glasgow, he seems to have concentrated on the Barbizon painters and the Hague School. He was on friendly terms with Fantin-Latour and showed him in Glasgow first in 1897. Reid knew Van Gogh with whom he shared lodgings in 1886 in Paris and who painted his portrait (GAG). A note by Mrs S.J. Peploe (Peploe MSS.) mentions that Reid also knew Gauguin, but Reid did not buy examples of his work until well after about 1900.

As early as 1874, the Glasgow dealer Craibe Angus (1830-99) had opened a gallery in Glasgow, and he seems to have introduced paintings by Corot, Diaz, Rousseau, Bosboom, the brothers Maris, Israels and Anton Mauve to Glasgow, although unfortunately he was unsuccessful in selling the great J.F. Millet *The Sower* to a Glasgow client, bringing it briefly to the city at an unknown date. One of his principal Glasgow customers was the collector James Donald. Angus's son-in-law, the Dutch dealer Van Wisselingh, handled Courbet, and the family connection is a likely factor in the early arrival of paintings by the French Realist in Glasgow. Angus, furthermore, acted as the Glasgow agent of the Aberdeen-born dealer Daniel Cottier (1839-91) who had galleries in London and New York and was the first to introduce paintings by Monticelli into Scotland. The Cottier Sale in Paris included no fewer than twenty-five paintings by Monticelli – a total approached by the sixteen in W.A. Coats's collection (which also contained thirteen by Corot). John Reid of Glasgow had seven Corots and eleven pictures by Josef Israels. Among other important collectors at this period were T. Hamilton Bruce in Edinburgh (noted above in connection with the French and Dutch Loan Section of the Edinburgh International Exhibition of 1886) and A.J. Kirkpatrick of Glasgow, whose collection included works by the Hague and Barbizon painters, and Courbet. As we have seen, the Aberdeen collector J. Forbes White had been to Paris in 1873 and had bought the large Corot *Souvenir d'Italie* (GAG) in the same year. His collection also included a Courbet and works by the Dutch Impressionists, some of whom he knew personally.

The most vital period of the Glasgow School lasted from approximately 1885 until 1896. This period encompasses early groupings based on close friendships and artistic congeniality which formed, initially as separate entities, around Sir James Guthrie (who was mainly self-taught), W.Y. Macgregor (Slade-trained), and Sir John Lavery (who studied at Julian's in Paris). It includes the eighteen monthly issues of the *Scottish Art Review* (1888-89), the organ of the

47 Joseph Crawhall
A Lincolnshire Pasture
c.1882 Oil 91.4 × 127 cm
Dundee Art Gallery

School, and ends shortly after the return of E.A. Hornel (who had trained in Antwerp) and the Glasgow-trained George Henry from their visit to Japan in 1893-4. Initially, the work produced during this period stemmed from a rejection of the academic finish and sentimental narrative style, which were the stock-in-trade of the majority of contemporary painters, together with a wholehearted adoption of realism in subject and style. The main sources of this early realism were Bastien-Lepage, the Hague School, Courbet, and the Barbizon painters. In the later 1880s, a decorative tendency began to appear in the work of the School. This later development promised well, and a number of works of real originality were produced, notably by Arthur Melville, George Henry, E.A. Hornel, Stuart Park, Joseph Crawhall, Alexander Roche and W.Y. Macgregor. A highly successful exhibition at the Grosvenor Gallery introduced this Scottish phenomenon to a London audience and led to exposure at the Munich Secession and large sales throughout Europe, North America and elsewhere. However, the vitality of this later impulse seems to have evaporated shortly after 1895, when commercial and other considerations began to tame the vigour of most of these artists. The Glasgow School is thus almost exactly contemporary with the New English Art Club, which several of the Glasgow painters joined at its foundation in 1886, and acted as a rallying point for young artists in rebellion against academic standards and anecdotal painting.

The Glasgow School's origins may be traced to 1878 and two friendships. In that year W.Y. Macgregor (1885-1923) – 'the father of the Glasgow School' – and James Paterson (1854-1932) were painting together at St. Andrews. Also in 1878 Sir James Guthrie (1859-1930) and E.A. Walton (1860-1922) met and became friends. By then Walton's brother Richard had married one of the sisters of Joseph Crawhall (1861-1913) and this relationship resulted in Crawhall's first visit to Scotland in the summer of 1879, when he is found painting with Guthrie and Walton at Rosneath in Garelochside, some twenty miles from Glasgow. Very few paintings from before 1880 by these five artists can now be traced, but Caw's opinion, based on acquaintance with many of the Glasgow painters, that Macgregor and Paterson were the first exponents of the early realism of the School, must carry some weight. In the autumn of 1879, Guthrie and his mother were living in London, where Crawhall stayed with them. At this time Guthrie was receiving advice and encouragement from Orchardson and Pettie and at the latter's suggestion stayed in Britain instead of going to France to train as he had originally intended. Caw tells us that Guthrie 'always spoke with respect of Pettie and Orchardson'. In 1880 Guthrie and Crawhall exhibited a joint work, *Bolted*, in an exhibition in Newcastle, and in the summer of that year, were painting with E.A. Walton in the open air at Brig O'Turk in Perthshire, where in the following year

48 Sir James Guthrie
Causerie
1892 Pastel 50.5 × 57 cm
Hunterian Art Gallery, University of
Glasgow

they were joined by George Henry (1858-1943) and others. The slightly older Edinburgh artist Robert McGregor was then also painting in the village.

The winter life classes in W.Y. Macgregor's Glasgow studio seem to have been started in 1881. By all accounts these were of great importance in the development of the Glasgow style in encouraging artists to reject anecdotal subjects and to use a freer technique and bolder colour. By 1885 these winter classes were attended by James Paterson, T. Corsan Morton, Alexander Roche, John Lavery, E.A. Hornel and Thomas Millie Dow. They were also attended by Henry, Walton, and Crawhall, who during these years painted in the summer with Guthrie (who never attended the classes in Macgregor's studio) at the newly discovered Cockburnspath in Berwickshire, where Arthur Melville (1855-1904) was also working in 1883-84. A rare photograph (Walton family collection) from this period shows Walton and his brother, the designer George Walton, with Guthrie, Crawhall and Whitelaw Hamilton at Cockburnspath and conveys the *joie-de-vivre* of the young artists; another slightly later photograph from

the same collection records the little bohemia of Walton's studio at Cambuskenneth near Stirling in 1888, the mantel decorated with four Japanese colour prints and with what appears to be a palm fan or perhaps an easel decorated in Whistler fashion with a Japanese motif. The sense of a youth movement, strong in these rare records, is further conveyed in Macaulay Stevenson's *Notes*, in a passage written circa 1892: '. . . so great were the difficulties of some in getting the bare means of subsistence and of carrying on their work that one or two of the largest earners among them seriously proposed having a common purse, as the only means of meeting the case . . . the common purse has practically existed during all these years and exists still'.

These groupings of artists still in their early twenties had a stimulating effect on their development, and several works dating from this first phase of the Glasgow School until about 1885 show real accomplishment and originality. Visiting Guthrie at Cockburnspath in 1884, Caw formed the impression that at that stage Guthrie was the mainstay of the group – an impression confirmed by the rapid

progress of his style in the space of a few short years, and independently corroborated by the fact that two works by Guthrie acted as the magnet which drew the charismatic figure of Arthur Melville to the Glasgow group and persuaded the brilliant John Lavery to return to Glasgow instead of to London at the end of his period of study in Paris. In 1882, at the age of twenty-three, Guthrie painted *A Funeral Service in the Highlands* (GAG) inspired by a funeral he had witnessed at Brig O'Turk. This ambitious work, measuring 129cm × 193 cm, is a vigorous if somewhat clumsy piece of realism which probably owes both its bold handling and its subject to Courbet, and it marks a complete break from the influence Pettie had on Guthrie's early work. On seeing this painting exhibited at the Glasgow Institute Arthur Melville, himself at that date working along similar realist lines, asked for an introduction to the artist. Guthrie seems (according to the Stevenson *Notes*) to have visited Paris for a few days in 1880, and to have made another short visit in 1882. It is therefore entirely possible (*pace* Billcliffe) that he would have been aware of the *Burial at Ornans* (finally accepted by the Louvre in March of 1883 and immediately the object of renewed controversy) and perhaps also further works by Jules Bastien-Lepage, who is usually mentioned in connection with Guthrie's next ambitious work, *To Pastures New* (1883: AAG). This large picture represents a considerable advance and shows great assurance in handling and colour, although it should be added that *The Highland Funeral* had originally been painted in a higher key and had only been darkened at Walton's suggestion. *To Pastures New* still appears notably light in key, and a certain element of the 'Kodak' realism of Bastien-Lepage is tempered by the chromatic delicacy of the work, which is tenderly coloured in harmonies of white quite unlike the predominant browns and greys of the French painter, and at the same time has a considerable richness of surface. This was the work which persuaded Lavery to return to Glasgow. It more than holds its own with another important Glasgow School painting of the same date also produced in all probability at Crowland: *A Lincolnshire Pasture* (1882-83: DAG) by Joseph Crawhall. This was possibly painted in Guthrie's company, and is dependent to some extent on Jacob Maris but already reveals the peculiarly vivid draughtsmanship which makes Crawhall unique among animal-painters of any period. Two other notable pictures by Guthrie in 1883 indicate an effervescent talent. *Hard at It* (GAG), painted in the same harmony of pale blue and white as *To Pastures New,* shows a fluidity of handling worthy of early Peploe. *A Hind's Daughter* (1883: NGS) adds a powerful but controlled impasto (laid on with the palette knife) to a sympathetically rendered theme of country-style young girlhood, akin in feeling to the work of Robert McGregor, but more general and less anecdotal. In its powerful handling, rich tonality

and sense of childhood at one with nature, this work anticipated an important aspect of the early Glasgow School (particularly what might be described as its Kirkcudbright offshoot, the work of Henry and Hornel and to some extent Bessie MacNicol). *Schoolmates* (1884: Museum of Fine Arts, Ghent) shows Guthrie in what may seem to be a Bastien-Lepage vein, but actually it again bears more resemblance to such earlier works of Robert McGregor as *The Knife Grinder* and *Great Expectations* (both DAG). With the heads much more minutely modelled than any other area of the composition, the finish of *Schoolmates* is treated discrepantly, as is another childhood subject *In the Orchard* of 1885 (private collection) although here the trees, foliage, and grass are painted with a breadth of expression which produces a generalized and decorative effect. A similar tendency appears in E.A. Walton's rare early figure subjects. The impasted colour of Walton's portrait of *Joseph Crawhall* (1884: SNPG) which, were the picture not

49 Sir James Guthrie
Schoolmates
1884 Oil 137 × 101.5 cm
The Museum of Fine Arts, Ghent

dated, would cause one to place it ten years later, is succeeded in Walton's most important work in the following year, the wistful *The Daydream* (Andrew McIntosh Patrick), by a subdued tonality and inconsistencies of handling as between the flesh tones and the draperies and landscape. It is as if Guthrie and Walton had taken to heart Ruskin's stricture on John Phillip's treatment of detail: 'It is indeed quite right to elaborate detail but not the ignoblest details first'. Realism posed a problem for these painters in their treatment of the human figure in landscape, and their eventual specializations in portraiture and landscape evaded the problem by dealing with its parts. However, Guthrie, made a successful attempt to solve it in the years 1888-92 with two series of pastels of domestic subjects, of which *Causerie* (1892: HAG) is a fine example. Indeed, Guthrie's pastels with their subtle, intimist approach and delicate evocations of light – qualities which he seems only on one occasion to have attempted to translate into oils in his Diploma work at the RSA, the impressionistic *Midsummer* (1892) – crown and effectively terminate an impressive decade of artistic progress. Guthrie had received a gold medal at the Munich Exhibition of 1890, not, as his friends had hoped, for *In the Orchard,* but for a portrait of the

Reverend Andrew Gardiner. It seems likely that this was the beginning of his successful career as a portraitist of many of the notables of the day, culminating in the herculean *The Statesmen of the Great War* (1930: NPG). A clear debt to Whistler's *Miss Cicely Alexander* appears in Guthrie's *Miss Jeanie Martin* (1896), but for the most part his later work – much interrupted by his long tenure of the presidency of the RSA – deals with male sitters.

Guthrie's great friends and brother artists Edward Arthur Walton and Joseph Crawhall each made profound – and profoundly different – contributions to the School in its early realist phase. The portrait of *Joseph Crawhall* by Walton was originally inscribed 'Joe Crawhall, The Impressionist, by E.A. Walton, The Realist', an affectionate joke between two young artists which contains more than a grain of truth. Although both practised in oils, Crawhall is usually thought of as a master of drawing and watercolour, and some of Walton's most significant works from his early maturity are in small-format watercolour. Walton's *In Grandfather's Garden* (1884), *En Plein Air* (1885), *the Herd Boy* (1886) and *The Gamekeeper's Daughter* (1886: GAG), particularly the two latter, are sensitive and contemplative works which achieve poetic stature. Walton exhibited a few other

50 Sir James Guthrie
Midsummer
1892 Oil 99 × 124.5 cm
Royal Scottish Academy (Diploma Collection)

51 Edward Arthur Walton
Bluette
Oil 75 × 78 cm
National Galleries of Scotland

watercolours of this type of subject, but these examples of his talent in the lighter medium are rare, although he was throughout his life a frequent and distinguished landscapist in watercolour. Rather later than these, probably, is his undated oil *Bluette* (circa 1889-90: NGS), which shows a young girl as pretty as her name holding blue flowers, against a freely painted landscape background. This charming picture is an early example of Walton's skill as a portraitist, a field in which he was increasingly engaged after his removal to London in 1894 where Whistler, a friend since the successful 1891 campaign orchestrated by Walton to have the *Carlyle* portrait purchased by Glasgow Art Gallery, became a neighbour in Cheyne Walk. In 1899, Walton was one of four artists – the others were Lavery, Henry and Roche – involved in a major project to provide mural decorations for the Banqueting Hall in Glasgow City Chambers, where the results can still be seen in the extremely imposing room reached by two sumptuous flights of marble staircase. Walton's contribution rises to the challenge of the very large scale with a depiction of a medieval fair on Glasgow Green;

Roche and Henry are somewhat less successful, and Lavery departs altogether from the medievalizing brief in a rare essay in modern industrial realism, *Shipbuilding on the Clyde,* which is not unreminiscent of William Bell Scott's work at Wallington Hall. In 1903 Walton was persuaded by his friend Guthrie (who had been elected President of the Royal Scottish Academy in the previous year) to return to Edinburgh. Here he specialized in portraiture, numbering *Andrew Carnegie* (1911: University of St. Andrews) among his sitters.

Walton referred to his friend Crawhall as 'the Impressionist'. An enigmatic and taciturn man whose circumstances allowed him to paint purely for his own amusement, Crawhall was also called 'the Great Silence' by his friend and fellow member of the Tangier Hunt, R.B. Cunninghame-Graham, with whom Crawhall shared a passion for horses. A brilliant horseman whose favourite pastime was riding to hounds, Crawhall might have stepped from the pages of *Memoirs of a Fox-Hunting Man.* His two short months of training in Paris under Aimé Morot in 1882 were clearly of much less importance

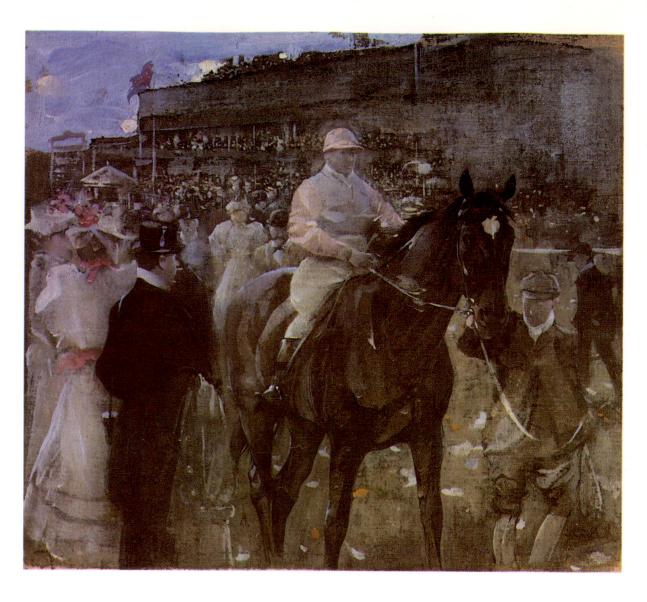

52 Joseph Crawhall
The Racecourse
c.1894–1900 Gouache on
Holland 29.3 × 32 cm
Glasgow Art Gallery

to his development as an artist than the sympathetic encouragement and sound practical advice of his father, an inventive gentleman-artist who taught his son to draw from memory. Crawhall heeded the advice and cultivated a phenomenal visual memory which enabled him to reduce to a rapid shorthand an exquisite, vibrant technique as a draughtsman and to capture the most fleeting appearance, above all of animals and birds in motion. His production was small; most of it was collected immediately by two main supporters, William Burrell and T.H. Coats, and a few other connoisseurs. With Crawhall, technique was always subordinate to observation and design; the resulting portrayals of horses or birds combine the spontaneity of an instant's impression with the truth to type of *animalier* or sporting art. This is done with a consummate economy of means in such celebrated masterpieces as *The White Drake* (circa 1890, painted in gouache on brown holland), *The Pigeon* (Burrell Collection) or *The Jackdaw* (circa 1900: National Gallery of Victoria, Melbourne). As single studies of birds these examples

represent a pinnacle of perfection even by Crawhall's ruthlessly self-critical standards and show a developing sophistication in the elimination of all inessential detail and indeed of all hesitancy in line or weight of brushstroke which would retard the effortless fluency and immediacy of the final effect. In an earlier *tour de force, The Aviary* (1888: Burrell Collection), which showed the fashionably dressed sisters of Crawhall and Guthrie dwarfed perspectively by the other gaudily feathered occupants of the parrot-house, Crawhall stretches the conventional medium of watercolour (mixed apparently with a little Chinese white) to the limits of its capacity. The result is brilliant indeed, but the discrepancies of handling or surface which have been noted with regard to the 'Kodak' realism of Guthrie and Walton are also evident here, in the sense that the tiny human figures which are 'in focus' are treated with more 'finish' than their surroundings. Crawhall himself, according to Bury, was dissatisfied with this work and had to be restrained from consigning it to the usual fate of anything which did not meet his exacting standards,

summary destruction. It seems to have been approximately at this period that Crawhall began the fruitful experimentation with a fine-woven textile support – brown holland – which became the preferred ground for the decoratively simplified works of his maturity.

Crawhall's precise chronology has never been satisfactorily established, but three very beautiful equestrian subjects, all in the Burrell Collection, suggest a clear line of development. Each is painted in gouache on holland. *The Racecourse* is an immensely complex composition – the wonderful racehorse, jockey up, led by the stable lad and watched by the owner and his fashionable lady all in the foreground and, in the background, the stand full of hundreds of spectators painted in Melvillesque shorthand – which has slightly experimental awkwardness, just as the technical difficulties of applying gouache to textile result in a somewhat uneven handling of the pigment. *The Flower Shop,* partly through the selection of a simpler subject, achieves a more satisfactory unity of style – the dark form of the horse silhouetted against the bright flowers in the shop window – while the perhaps slightly later *The Farmer's Boy,* articulated by a series of gently curving lines which proclaim the 1890s, finally resolves surface and design in effortless unity. The absorbency of the textile support requires a more loaded brush and the greater weight of pigment in turn confers a more solid and less flickering and variegated effect, while the brown colour of the holland contributes to the tonal unity of

the picture, just as its fine weave helps unify its surface. The way was now clear for the consciously decorative single studies of birds mentioned above, which miraculously blend spontaneity of application and instantaneity of vision with the most exquisitely balanced effects of bold colour and *mise-en-page.*

The pictorial evidence in support of William York Macgregor and James Paterson as the originators of the early realism of the Glasgow School makes up in quality what it lacks in quantity. Painting did not come easily to Macgregor, as we learn in Paterson's *Memoir,* and ill-health and the necessity of foreign travel further combined to reduce his output. *Crail* (1883: Smith Art Gallery & Museum, Stirling) and *A Cottage Garden, Crail* (1833: private collection) are unadorned, masculine works of obvious integrity but hardly prepare us for the artist's masterpiece of the following year. In 1884 Macgregor, who had trained under Legros at the Slade, painted several big canvases of vegetables, of which only one, *The Vegetable Stall* (1884: NGS) can now be traced. This picture marks the climax of the first phase of the Glasgow School's development. Whereas the early work of Guthrie, Crawhall and Walton indicates mastery of an existing idiom, *The Vegetable Stall* is a picture which it is impossible to ascribe to any outside influence, and its bold realism and confident handling are equally astonishing. Cursiter describes how Oskar Kokoschka, seeing this picture in the National Galleries of Scotland for the first time,

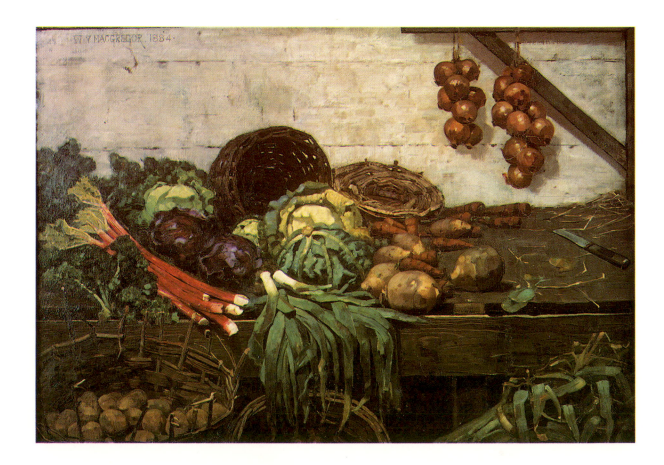

53 William York Macgregor
The Vegetable Stall
1884 Oil 75 × 78 cm
National Galleries of Scotland

exclaimed, 'To think that the picture was painted before I was born – and I never knew!' The work demonstrated in convincing fashion that the imitative truth or realism of *plein-air* painting might be of secondary value to the truth of reality reconstructed in terms of artist's vocabulary of form and colour, with the brushstroke as the smallest unit of the composition. In other words, reality is rendered in a painterly style which does not at the same time lose its own integrity.

The Vegetable Stall was to be Macgregor's masterpiece; ill-health forced him to leave Glasgow in 1886 for the cleaner air of Bridge of Allan, and then for South Africa in 1888-90, and when he returned the more progressive 'Boys' had overtaken him. However, a later work like *A Rocky Solitude* (exhibited 1896: NGS) shows that Macgregor retained something of the virile, austere quality of his earlier period later in life, when we find him exhibiting in Edinburgh with the much younger artists of the Society of Eight and expressing admiration for the paintings by Gauguin shown at the SSA Exhibition of 1913 (Paterson MS).

James Paterson (1854-1932), who had known Macgregor since school days and remained a close associate, and whose correspondence with Macgregor is our main source of information concerning him, had studied in Paris during the years 1874-76 and 1879-83 and in an account of those years in the fifth number of the *Scottish Art Review* recalled the emphasis his French masters had placed on tonal values in painting. Paterson's *Moniaive* (1885: private collection) is a thoughtful and competent application of the system of tonal unification Paterson had learned in France; it has a smoother and more assured, less experimental appearance than the other Glasgow School landscapes by Crawhall, Guthrie, and Walton which have just been mentioned. Paterson was never one of the front runners in the rapidly changing succession of leaders of the Glasgow School.

In the early 1880s the Glasgow School was slowly coalescing in Scotland through the gradual amalgamation of the two groups of painters who surrounded Guthrie in summer and Macgregor in

54 James Paterson
Moniaive
1885 Oil 107.3 × 152.4 cm
Private collection (Photograph: Hunterian Art Gallery)

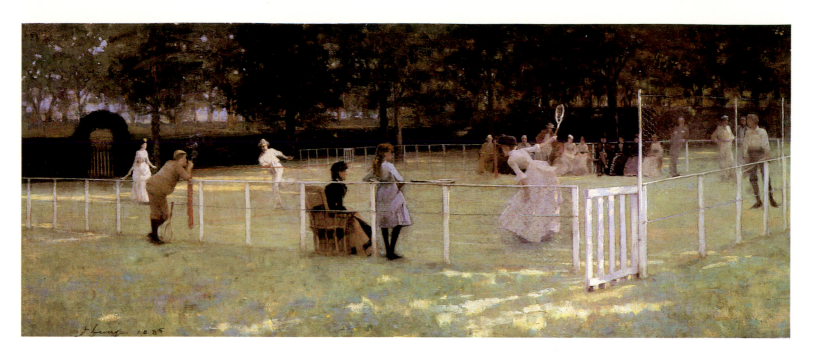

55 Sir John Lavery
The Tennis Party
1885 Oil 71.1 × 182.2 cm
Aberdeen Art Gallery

winter. At this time a third group was studying and painting in France. Sir John Lavery (1856-1941), Alexander Roche (1861-1921), William Kennedy (1859-1918), and Thomas Millie Dow (1848-1919) painted outdoors at Grez-sur-Loing, where they were joined by William Stott of Oldham, and the critic R.A.M. Stevenson, adding to the small colony of British artists and writers who had recently included Stevenson's cousin Robert Louis Stevenson. The composer Frederick Delius was also resident at Grez at the same time as the Glasgow painters, but Lavery's autobiography gives no indication that there was any real contact between them. Lavery's work at Grez is exemplified by *The Cherry Tree* (1884: Ulster Museum), which bears a considerable general resemblance in its unified tonality to Paterson's *Moniaive* picture, with the significant difference that Lavery shows great confidence in introducing human figures on a quite large scale into his tonal scheme, without any discrepancies of handling. The chief influence on Lavery during his French stay, however, was not his older contemporaries, the Impressionists, but their chief 'vulgarizer' (as Lucien Pissarro called him), Jules Bastien-Lepage. Lavery had known Marie Bashkirtseff, Bastien-Lepage's disciple, and had encountered and received advice from Bastien-Lepage himself in Paris. Lavery followed Lepage briefly as a practitioner of his 'gray impressionism', but the influence of the later Manet rapidly began to assert itself in Lavery's work, paradoxically after he had returned to Britain in 1884. The Manet memorial exhibition was held in Paris in January 1884, and it is at least probable that Lavery visited it.

Lavery tells us that his decision to settle in Glasgow rather than London was made in 1883 when he saw Guthrie's *To Pastures New* at the Glasgow Institute. In 1885 he painted and exhibited at the Institute a canvas which sums up most completely his early, French-derived realism, *The Tennis Party* (AAG). In it he seems to put into practice Bastien-Lepage's advice on capturing the human figure in action. Lavery remembered this as: 'Always carry a sketch-book. Select a person — watch him — then put down as much as you remember. Never look twice.' Lavery's comment was that from that day on he became 'obsessed by figures in movement, which resulted in *The Tennis Party*'. This picture immediately stamps Lavery as possessing greater natural dexterity than any of the other Glasgow painters, and it is not spoiled by the over-facile virtuosity which creeps into his later work. Fittingly, it was awarded a Gold Medal at the Paris Salon of 1888. It is arguable that Lavery was at his best in the 1880s. A series of fifty small canvases depicting the events of the Glasgow International Exhibition of 1888 are as impressionist in the French sense of the word as perhaps any work by a British painter at this date. A *plein-air* example like *The Musical Ride of the 15th Hussars during the Military Tournament at the Glasgow International Exhibition* (DAG) or an interior such as *The Dutch Coffee House* (NGS) show a complete assimilation of the French style, although the nocturnal scenes, painted with equal brilliance, seem indebted to Whistler, whose *Sarasate* portrait provided clear inspiration for Lavery's portrait of *R.B. Cunninghame Graham* (1893: GAG). The same International Exhibition gave Lavery his first important portrait commission — to paint the *State Visit of Queen Victoria to the City of Glasgow, 1888* (1890: GAG). As a direct result of its success much of Lavery's later work belongs to one of the less interesting manifestations of painting in his own period — fashionable portraiture — a field in which he was surpassed probably only by Sargent and Orpen, and in which he achieved success on a transatlantic scale. He was to number Shirley

56 William Kennedy
The Deserter
1888 Oil 88.9 × 152.4 cm
Glasgow Art Gallery

Temple, Pavlova, Lady Diana Duff Cooper, Lloyd George and his friend and pupil Winston Churchill among his sitters.

Lavery moved to London in 1896 and in 1898 became Vice-President of the International Society of Painters, Sculptors and Gravers, of which Whistler was president. When Whistler died in 1903, Macaulay Stevenson wrote Lavery a letter (Tate Gallery Archive) which typically combines the zealotry of Stevenson as the prophet of the gospel of modern art with his usual impish irreverence and is worth quoting *in extenso*.

> To you it will be a more personal loss than to some of us who are nevertheless all at one in appreciation of his transcendent genius and admiration for his inimitable personality. He held the torch for Europe and indeed the world when even Japan was infected with the evils of the accursed Protestant movement – every man doing what was right in his own eyes – which was usually very far wrong – no authority no noble tradition – the R.A. and the Salon all in their anecdotage . . . I was immensely tickled at that International meeting to see you in the chair. You did it so delightfully badly. Worse even that Henry . . . that's why you're the right man for the job. [Stevenson concludes ringingly:] Landscape art will yet write the Bible of His Revelation for the Common people.

Stevenson studied at the Beaux-Arts in Paris, and although his nocturnal landscapes show the inevitable influence of Whistler, his chief inspiration seems to have been Corot. On their return from Paris, Lavery's friends William Kennedy, Alexander Roche, and Thomas Millie Dow painted several pictures which show French inspiration. These artists, like many of the Glasgow School painters, are minor figures who briefly demonstrate the catalytic effect which the movement had on its members. Kennedy (regarded by Macaulay Stevenson as one of the more important members of the early group) began robustly as a powerful and accomplished realist, attested by the interesting group of his early watercolours, mostly of military subjects now in Stirling Castle Museum. *The Deserter* (1888: GAG), a subject which might have appealed to Daumier, is not only convincing in its monumental treatment of the working-class central figure, but shows mastery of tonal unity and draughtsmanship of a high order. Similarily, *The Harvesters* (Paisley Art Gallery) and the masterly pastel study for it reveal Kennedy's technical sophistication in an unorthodox composition which looks very French. Kennedy painted *Stirling Station* (circa 1888: private collection) in an evening light which shows less of the influence of Monet than might have been expected from the subject, and more than a little of Whistler's.

The glowing lights and the cloud of steam produce a decorative as well as realistic effect. In fact the

picture belongs to a Glasgow School group of nocturnal subject-paintings which begin to appear at about this point in the group's developments, in the hands particularly of Roche, Guthrie, Henry and Hornel. At least one of the series Lavery painted during the Glasgow International Exhibition shows a night scene lit by bright lanterns (1888: private collection). Kennedy, however, did not move forward from the territory he had convincingly conquered in *Stirling Station* and *The Fur Boa* (circa 1892: GAG), though a vivacious portrait, harks back to the realism of Bastien-Lepage, just as *Homewards* (circa 1892: GAG) relates (as Elizabeth Bird has recently shown) to a picture by Anton Mauve then in the collection of T. Hamilton Bruce in Edinburgh, and which appeared in the International Exhibtion of 1886. Nevertheless, the latter work with its impasted colour and lyrical celebration of an orchard in blossom, indicates a genuine response to the beauty of a bright spring day, as *The Harvest Moon* (circa 1890: untraced), illustrated in Martin's book of 1897, is suggestive of the mystery of a moonlit autumn dusk. But Kennedy's later military and North African subjects (he went to live in Tangiers in his later years) show diminished originality, and are almost uniformly a bore.

Thomas Millie Dow began to exhibit regularly at the Glasgow Institute in 1880, and lived in the city from 1887 to 1895 before moving to St. Ives. He was a close friend of William Stott of Oldham and shared with Stott a concern for tonal values and a silken finish which is at odds with the general tendancy of the Glasgow School artists towards vigorous handling. His early flower pieces seem all to have disappeared, surprisingly, as his gifts were those of a decorator and the flower subjects look well in the period journals. On the other hand, his rather static or stiff figure drawing made him less well suited to the kind of allegorical figure painting represented by two large works in the Dundee Gallery, *The Herald of Winter* (1894), which represented Dow in Martin's book, and *Sirens of the North* (1895). *The Herald of Winter* shows a winged figure in a white robe standing on the crest of a hill sounding a horn, while migrating geese fly past. The picture owes something to the mural style of Puvis de Chavannes and is not far in concept from John Duncan's slightly later work in a similar vein. *Sirens of the North*, too, is a faintly comical treatment of the theme of the *femme fatale* dear to the Symbolists of the 1890s, where woman often appears as sphinx, harpy, or here, as mermaid, representing a threat to men as the hesitant oarsman, who approaches in his eminently sinkable skiff, appears to be fully aware. *The Hudson River* (1885: GAG) is a much more prepossessing work; partly because it is less pretentious but not less ambitious, and adopts the same tonal approach as Paterson's *Moniaive* already discussed, but using a lighter palette.

Few works of the 1880s, however, are more quintessentially of the Glasgow School style than Alexander Roche's *Good King Wenceslas* (1887:

57 Thomas Millie Dow
Sirens of the North
1895 Oil 107.9 × 152.4 cm
Dundee Art Gallery

private collection), which shows the page following the king through snow and uses gold leaf to indicate Wenceslas's sainthood. The subject is one that might have appealed to the democratic humanitarianism of Whitman or Thoreau whom the 'Boys' admired, but it is treated without bombast, and the page is the main figure in the composition. The decorative gold nimbus in the background adds an element of mystery and spiritual significance to the winter landscape, and is in a sense repeated in the incised Japanese seals with which the frame is decorated, making a contrast with the very boldly painted snow-scape. Roche's later career was devoted almost exclusively to portraiture. *Miss Loo* (1889: private collection) is an unusually well-composed example, but it does not possess the originality of *Good King Wenceslas*, which appears to be unique in Roche's *oeuvre*.

Arthur Melville (1855-1904), who asked for an introduction to Guthrie when the latter's *A High-land Funeral* was first exhibited at the Glasgow Institute in 1883, was like W.Y. Macgregor sufficiently senior in age and experience to the 'Boys' to be something of an elder brother to them. By the time of his first visits to Cockburnspath with Guthrie, Walton and Crawhall, Melville had received training first in Edinburgh and then at Julian's in Paris and had completed a two-year painting tour from

Karachi to Baghdad, crossing Asia Minor on horse-back (one wonders whether Crawhall and Melville ever found time to discuss anything as mundane as watercolour painting) with a series of adventures and narrow escapes which rival David Roberts's and make him seem, with his 'big, handsome, courageous cavalryman presence' like a character from the romances of Robert Louis Stevenson, whom he met at Grez in 1878. Melville in fact, came not from the west of Scotland, but from Angus in the north-east of the country. He was the first of the group to be elected an Associate of the RSA in 1886.

Melville therefore had a considerable body of work to his credit by the time of his first encounter with Guthrie and the others. *The Cabbage Garden* (1877: Andrew McIntosh Patrick), a small work, emerges from the rurual realism practised by W.D. McKay (1844-1924) and associated with the Lothians. It prefigures much work typical of the Glasgow School in a similiar vein – for example Walton's *A Berwickshire Fieldworker* (1844: TG) or Henry's *A Cottar's Garden* (watercolour, 1855: Hornel Trust) – in its painterly vigour. *Paysanne à Grez,* dated 1880 (private collection), like the earlier work, unsentimentally gives equal importance to both the landscape and the figure subject, and marks a further advance in decorative terms, with its strong colour and painterly surface. Painting of this stength

58 Alexander Roche
Good King Wenceslas
1887 Oil 50.8 × 76.2 cm
Private collection

cannot have failed to capture the imagination of the Cockburnspath group. *Audrey and her Goats* (begun 1882: TG), a Shakespearian subject which Macaulay Stevenson tell us 'cost the artist an infinity of time and trouble' over several years, has an inchoate quality which is surprising in an artist of Melville's very real virtuosity as a watercolourist. It is clear that for Melville as for Guthrie, at this stage a struggle was taking place, the very birth-pangs of a new style. In the same year that Guthrie triumphantly brought *In the Orchard* to a successful conclusion, 1885, Melville also produced one of the most original works by any member of the Glasgow School up to this point, the brilliant and bold *Red Poppies* (Mr and Mrs Tim Rice). Although the *Portrait of Mrs Sanderson* exhibited at the New Gallery in London in 1889 – and pronounced by Whistler the best portrait shown in London that year – in Macaulay Stevenson's words was 'attempted on no less than three separate canvases and carried each a long way towards completion ere he reached the fine expressive result which the finished picture shews', no such hesitancy troubled the artist at least in two major landscapes with figures dating from his trip to Spain with Frank Brangwyn in 1892.

A Spanish Sunday: Going to the Bullfight (Dundee University) and *The Contrabandista* (private collection) infuse into the more intractable oil medium the vitality and spontaneity of Melville's highly individual watercolour style, although his oil technique is quite different. *A Spanish Sunday* shows Melville using long sweeping brushstrokes which impart movement to the whole work, in such a way that the brushstroke is simultaneously descriptive and frankly decorative. The artist's harmonic knowledge is evident in the single bold accents of colour placed at telling intervals in the design, in unexpected touches of lemon yellow or bright red, while over the whole composition there hangs a realistic suggestion of the faint haze of a very hot day in a terrain where the dusty earth reflects back the sun's glare. *The Contrabandista* is an equally original work. Here, shadows cast on a hill by poplars which are not shown but understood to be behind the spectator, are bluer than the sky itself, and the white cloud in the sky is as solid as the hill down which a mule train descends in a cloud of fine dust. The composition is of a consciously decorative flatness and the shapes and colours schematic in a way that recalls Monet's series of poplars on the Epte of similar date. From the same period also come a small group of landscape panels which show even greater confidence in the abstract possibilities of form and colour, fully realized finally on a large scale in *The Chalk Cutting* (private collection) dated by Mackay to 1898. The richly decorative, large-scale portrait of 1897, *The White Piano* (Harris Museum, Preston), resolves the conflict between realism and decoration as successfully as any Glasgow School portrait.

Melville, however, is best known as a watercolourist,

and with a good reason, for this was his preferred medium in which he developed a highly individual virtuosity. *The Turkish Bath* (Paris, 1891: recently Keith Collection) may remind one of Gérôme in its exoticism and use of an elaborately architectural interior as the *Arab Interior* (NGS: oils, also 1891) is reminiscent of J.F. Lewis, an obvious model for such a subject; but the two works are fascinating as demonstrating the ease with which Melville adopted and as quickly abandoned two contrasting styles – *beaux-arts* and English romanticism – at this early stage. *The Call to Prayer; Midan Mosque, Baghdad* (1882: private collection) exemplifies one of the two main types among the watercolours which originate from Melville's two-year painting tour of North Africa and the Middle East. It has an architectural background and an amazingly numerous group of figures wearing the colourful jellabah. While the architectural subject, the sky and foreground are painted with flat washes, the crowd is suggested in passages of heavily worked pigment which has been wiped, sponged, run and dripped on to the page. The busy crowd scene thus provides an exciting staccato counterpoint to the legato of the rest. In terms of colour Melville can seem surprisingly subdued in these earlier works, which retain a tonal reticence much in contrast with his later style. The second of the two types of watercolour mentioned comprises the interior scenes which tend to be broader in treatment: *A Cairo Bazaar* (1883: GAG) is an example. Here, the figures are much larger in the overall composition, the colour is warmer and the brushwork more conventional.

59 Arthur Melville
A Spanish Sunday: Going to the Bullfight
1892 Oil 81.3 × 99.1 cm
University of Dundee

60 George Henry
A Galloway Landscape
1889 Oil 122 × 152 cm
Glasgow Art Gallery

Melville's full *tessitura* – to continue the musical analogy – is revealed in the mid-eighties, and announced by the astonishing *Awaiting an Audience with the Pasha* (1887: Mr and Mrs Tim Rice). This large watercolour allies the formal counterpoint analysed above, to a daring chromaticism of hot colours and technically (in terms of beautiful draughtsmanship and unbelievably intricate brush-work) probably surpasses anything ever done by Melville. It prepares the way for such remarkable examples of decorative pyrotechnics, full of realistic suggestion, as *Bravo Toro!* (exhibited 1899: V & A) and *Banderilleros à Pied* (1890: AAG). He was resident in London after 1889, but died prematurely in 1904 from typhoid contracted on a visit to Spain. Writing in 1891, Macaulay Stevenson commented justly that 'the value of such a personality to the young Scottish School has been incalculable'.

Melville was evidently an influence on the style of the more mysterious J.W. Herald (1859-1914), who also studied at Herkomer's school at Bushey and lived in Croydon until 1899 when he returned to live in his native Angus. Erratic, a recluse who disposed carelessly of his best completed work, Herald possesses a haunting style very different from the vigorous Melville, although technically there are considerable affinities between the two. *The Portico* (circa 1898: Mr and Mrs Stanley Baxter), however, suggests the influence of Conder rather than Melville in its delicate use of colour.

A new phase in the development of the School began in 1885 with the return of Edward Atkinson Hornel (1864-1933) from his studies in Antwerp and the beginning of his friendship with George Henry, whom he met in Kirkcudbright in the same year. George Henry had been with Walton and Guthrie at

Brig O'Turk in 1881 and exhibited two small pictures painted there at the Glasgow Institute in the following year. He was in Eyemouth in 1883, near Cockburnspath, where Guthrie and Walton were to be found, and in the winter of that year worked in W.Y. Macgregor's Glasgow studio, accompanying Macgregor on a painting trip to Dunbar in the following spring. Billcliffe convincingly traces the influence of Guthrie on Henry's early work. A comparison of Henry's *Noon* (1885: private collection) with Guthrie's *In the Orchard* of 1885-86 reveals similarities in subject, colouring and technique, with the Henry picture if anything slightly ahead in its progress from Realism towards Symbolism: in *Noon* the girl in her peasant's apron stands in flattened profile in the shade of an equally flattened tree trunk, while the shaded ground and the sunlit field beyond halve the composition into two horizontal bands of colour. Henry's grasp of style seems the firmer. Hornel's teacher Verlat taught his pupils to handle paint vigorously 'so that one was painting and drawing at the same time', as Hornel later said. This Belgian influence is visible in an impressive, if conventional, early work called *The Bellringer* (1886: private collection), which shows Kirkcudbright's 'town crier', Winefield Nellens, in a composition and pose strongly dependent in two very similar paintings of elderly men in uniform with Hornel painted in Antwerp (both 1885: Nottingham Art Gallery and Hornel Trust [gift of Mrs L. Walmsley]). Hornel's *Resting* (1885: private collection), exhibited at the Glasgow Institute in the same year, so resembles the Henry *Noon* that an indebtedness of the former to the latter seems clear, as the Hornel picture is comparatively tentative in handling. Again, measuring the progress of the two friends by comparing two works of 1887, Hornel's *In Mine Own Back Garden* (HAG) and Henry's *Sundown* (ibid), the conscious decorativeness of the Henry picture stands in marked contrast with the early realism of the Hornel. Another Henry work of 1887, *Gathering Mushrooms* (private collection) – which Henry thought enough of to send to the Munich exhibition of 1890 – is a daringly Symbolist concept both in its schematic design and in its rather fey subject (to Victorian eyes) of a girl gathering mushrooms by the light of the full moon, although its handling is almost crude. Henry's *Autumn* (1888: GAG) is a woodland scene in which the figure of a girl can be inferred, her face only being clearly discernible, among a pattern of leaves and slender tree trunks, painted with masterly variations of

61 Edward Atkinson Hornel
The Brook
1891 Oil 40.6 × 51 cm
Hunterian Art Gallery (MacFie Collection)

handling from palette knife to delicate brushwork. Not by coincidence, Hornel's most ambitious work of 1888 has the same title of *Autumn* (private collection); this is a ravishingly painted small picture in which the boldness of the application with the palette knife is matched by the poetic subject which suggests a mystical connection between the girl and the tree with its apples. The progress of the two artists to this point tends to support the contemporary view of Macaulay Stevenson that Henry, on meeting Hornel in Kirkcudbright, offered friendly practical criticism of the younger artist's work by showing him his own, and that Henry's at that early

stage was 'the original mind', although he qualifies this by adding that Hornel's 'is no secondary mind'. The *Notes* of 1891 add of Henry that 'In any walk of life he would be a remarkable man . . . Not a little of what is best in the work of some of (the others' work) is at least partly due to Henry's generous help – both the help of actually working on some of the pictures and the more intangible yet nonetheless real influence of his stimulating personality.'

It remains a matter of conjecture whether Hornel met James Ensor during his stay in Belgium but certainly in 1893 Hornel sent to the final exhibition of the Groupe des XX – of which Ensor was a founder – and at least one work of Hornel resembles that of the Belgian master in its macabre subject-matter: *The Brownie of Blednoch* (1889: GAG), an apparition which in turn prefigures the 'spooks' which came to haunt some artists of the 1890s. Also in 1889 Hornel painted a beautiful little picture titled *The Goatherd* (private collection) which takes one stage further the tendency to represent landscape as a decoratively flat pattern united by strong colour and a richly nourished and increasingly fragmented surface. Hornel and George Henry shared a studio in Glasgow, painted in the country around Kirkcudbright where Hornel had been brought up and where he had ancient family roots; and, as Stevenson asserts, even painted on each other's pictures. Two large pictures, *The Druids; Bringing in the Mistletoe* (1890) and its companion *The Star in the East* (1890: both GAG) are the best-known examples of their collaboration. Hornel brought his considerable antiquarian knowledge to bear on *The Druids* which is full of Pictish symbolism and interestingly anticipates something of the Celticism of the later nineties. The decorative approach to painting evolved by Hornel and Henry in the late eighties had its most remarkable result however in Henry's *Galloway Landscape* (1889: GAG). In his book *A Painter's Pilgrimage* A.S. Hartrick, who had known Gauguin at Pont-Aven and even painted a picture of Gauguin's house there (1886: private collection), wrote of Henry's picture: 'I have seen the spot where it was painted, a very ordinary field with a hill in it; but Henry introduced a blue burn, painted with a palette knife, around it; then put a stain over all, and it become an object of derision for the man in the street as well as for the Glue Pot School, but an ineffaceable memory for any artist who has ever seen it'. (The Stevenson *Notes* agree that 'It is almost a literal transcript of a particular scene.') The emphasis on arabesque and flat colour pattern in this painting represents a complete departure from the realistic descriptiveness of earlier Glasgow School landscapes. In the wider context of British painting, the *Galloway Landscape* is an extraordinarily advanced work for 1889, and in the light of Mrs S.J. Peploe's assertion that the Glasgow dealer Alexander Reid (who was Henry's dealer) had known Gauguin in Paris – no doubt during his spell with Boussod and Valadon (formerly

62 Edward Atkinson Hornel
The Dance of Spring
c.1891 Oil 142.6 × 95.3 cm
Glasgow Art Gallery

63 George Henry
Blowing Dandelions
1891 Oil 49.5 × 59.7 cm
Yale Center for British Art (Paul
Mellon Fund)
(Photograph: William Hardie
Gallery)

Goupil) in Paris in 1887 – it seems at least to be a reasonable hypothesis to link its novelty directly to Gauguin.

Both artists now embarked on a period of consolidation in a series of paintings which represent a high point in the achievement of the Glasgow School. Hornel's *The Brook* (1891: MacFie Collection, HAG) resembles the *Galloway Landscape* but unlike it contains human figures unorthodoxly posed against the landscape, or rather within it, so that they form with the landscape a pattern of rich colour in which the individual elements are difficult to distinguish from each other. The relevance of Monticelli to this kind of painting is clear. Equally decorative is *A Galloway Idyll* (1890: private collection). These are small pictures. Hornel's confidence in his new manner is demonstrated in two large paintings in the following year: *The Dance of Spring* (1891: GAG), which resembles Ensor in its exuberant impasto and truculent vitality; and the powerfully painted *Summer* (Walker Art Gallery, Liverpool) which was the first picture by any of the young Glasgow artists to be acquired by a public museum. The latter work is tightly composed in a swirling circle of movement. Henry's work in the same period lacks the raw

vitality of Hornel's but is increasingly concerned with static decoration as in *Blowing Dandelions* (1891: YCBA) and *Through the Woods* (1891: FAS). *Poppies* (1891: ECAC) unusually shows only the heads of four pretty girls among the flowers; this is a Symbolist treatment of the subject which distinctly anticipates the Art Nouveau. A little landscape, *Barr, Ayrshire* (1891: NGS) is as fresh and modern looking as a Peploe, while *The Fruiterer* (1894: private collection), painted in a light key, is as sophisticated with its off-centre design as the other is artless.

When he went to Japan with Hornel in 1893 Henry produced much less than Hornel during their eighteen-month stay, and many of his Japanese pictures are in media other than oil. They consist in the main of delicate drawings and sensitive pastels which hark back to Sir James Guthrie's pastels of 1888 and 1890, and of watercolours which seem indebted to the watercolours produced by Sir Alfred East in Japan and seen in the Glasgow International Exhibition of 1888, as well as in the pages of the *Scottish Art Review* in the same year. The rather rare examples of Henry's work in oils from the Japanese visit are of fine quality and the ruin of a quantity of them on the return journey from Japan is a matter of

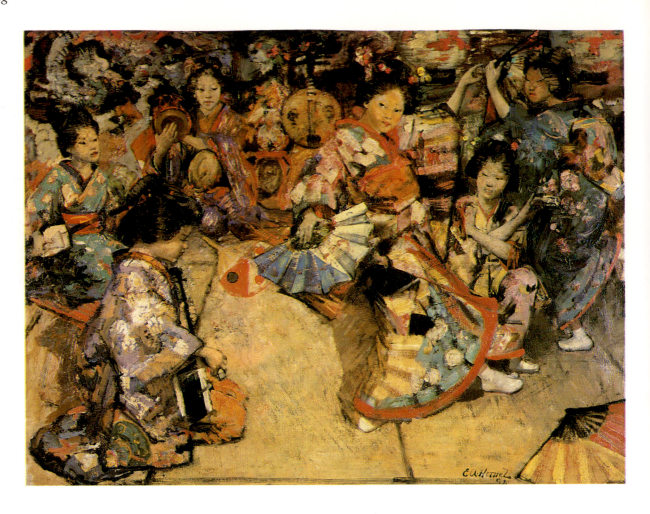

64 Edward Atkinson Hornel
Japanese Dancing Girls
1894 Oil 71.1 × 91.4 cm
Private collection

real regret; but they seem to add little in stylistic terms to what Henry had already achieved. It was left to Hornel to add an impetus of his own to the momentum of the decorative style which these two artists had initiated. Hornel's Japanese paintings are among the most exciting of all the pictures produced by the Glasgow School. It does not detract from their originality to say that Monticelli's formal diffuseness and rich colour (which Hornel must have noted in the great International Exhibitions of 1886 and 1888 in Edinburgh and Glasgow, which included several Monticellis) are important elements in Hornel's style of the middle nineties. Such a work as *The Japanese Garden* (1894: private collection) is very nearly *sui generis,* and the repetition over the whole surface of the canvas of the formal *leitmotiv* of the flashing smile that is the focal point of the design is a sophisticated device. About forty paintings from his Japanese tour were assembled by Hornel for an exhibition in the Glasgow gallery of Alexander Reid, who had been the main sponsor of the expedition. The exhibition received enthusiastic reviews and nearly every picture was sold.

Alexander Reid's exhibition of Hornel's 'Japanese' paintings in the galleries of the Société des Beaux-Arts marks the climax of Hornel's association with Glasgow and the Glasgow School. The assurance and originality of these paintings must have appeared to

many to mark the rise of a new leader of the 'School'. However, by 1895 Hornel had become permanently resident in Kirkcudbright, and had began to do all his painting in the studio in the High Street there, and although there was no abrupt cessation of good relations between Hornel and the other members of the School (Hornel continued to exhibit at the Glasgow Institute every year), there seems to have been a gradual weakening of ties. Hornel refused an associateship of the Royal Scottish Academy in 1901, to the annoyance of friends who had supported his nomination. In a letter to his friend the publisher Thomas Fraser (Hornel Trust) he wrote:

> Many thanks for your letter of congratulation. It will not surprise you to learn that I have declined the honour of Associateship. I am very happy as plain Hornel and I mean to remain such, as far as these trumpery affairs are concerned. I am not built right someway for wearing purple and fine linen. This decision will no doubt surprise some, gratify others, and disappoint few. I am quite indifferent . . .

(George Henry was made a full member of the RSA in the following year.)

As early as 1892, as a brief correspondence between Macaulay Stevenson and James Paterson shows (Stevenson MS), an amusing altercation had

taken place involving two factions which, independently of each other, had attempted to set themselves up as the 'official' Glasgow School of painters. This piece of 'Glasgow school-boyishness', as Stevenson called it, symptomizes a malaise within the movement, and it comes as no surprise to find Hornel, in a letter to Stevenson of 13 August 1905 (ibid) referring to the 'brotherhood' as something of the past. But the parting of the ways was certainly very much of Hornel's choosing. In 1901 he removed from his studio to Broughton House, also in the High Street in Kirkcudbright and to this day open to the public under the auspices of the Hornel Trust, and thereafter his time appears to have been equally divided between painting, and other occupations connected with the fine seventeenth-century mansion that was his new home. A considerable proportion of the correspondence with Thomas Fraser, which spans twenty-three years, is devoted to talk of gardening and the purchase of books for the library in Broughton House. It is obvious that Hornel gave a great deal of thought to the planning of this remarkable Japanese garden, and with Fraser's help he built up an excellent library which contains a unique collection of Burns editions, a manuscript collection, which includes items by Bishop Percy, Scott and Carlyle, and a comprehensive Galloway collection including works on local Dark Age archaeology. Hornel added a studio to Broughton House, and a gallery whose furnishings (including a huge Renaissance mantelpiece by his friend John Keppie of Honeyman, Keppie and Mackintosh, and a plaster cast by John Henning of the Parthenon frieze) are in markedly Victorian taste. In a word, then, Hornel's isolation from Glasgow and its 'School' was partly due to that movement's increasing debility, and partly to the fact that Hornel had formed other interests which tied him to Kirkcudbright.

The paintings produced by Hornel between 1895 and 1907 reflect changes just described in his personal circumstances and in his relationship to the Glasgow group. These were the crucial years which saw the power and audacity of the thirty-year-old's style give way to the prolix and mannered charm of the middle-aged elderly Hornel. They were also the years in which Hornel became the leader of a small group of Kirkcudbright painters, among them Bessie MacNicol (1869–1904), who painted a powerful portrait of Hornel shortly after his return from Japan (Hornel Trust), W.S. MacGeorge (who had studied with Hornel in Antwerp), and William Mouncey, Hornel's brother-in-law. Thomas Bromley Blacklock (1863-1903) trained in Edinburgh, but the influences on his work were his fellow Kirkcudbright artists E.A. Hornel and Jessie M. King, whose very different styles are reconciled in Blacklock's attractive painterliness, which resembles Hornel's, while his subject matter resembles Jessie M. King's: Caw lists *Red Riding Hood, Bo-Peep* and *Snowdrop*, as well as several other titles in which 'children and fairies and the creatures of the wilds and the sea-shore live on terms of intimate companionship in an enchanted land.'

After 1895, Hornel's Monticelli-based handling and lighter palette (which never returned to the earlier rather sombre 'Glasgow School' richness) were a major influence on these artists. After Hornel's return from Japan, says Sir James Caw, 'for some years he seemed to be in cul-de-sac and made little or no progress. The large painting *The See-Saw* (1896) shown at the Glasgow Institute in 1897, although it has all the old exuberance – a quality that was soon to disappear from Hornel's work – is (as far as one can judge from a photograph) badly drawn and badly composed. After the successes of the Japanese period, such uncertainty comes as an anti-climax, and Hornel seems to have been content until about the turn of the century to produce atmospheric colour schemes whose rich impasto and formal diffuseness recall Monticelli. The Kelvingrove *Fair Maids of February* (1899) is an exception however. As a contemporary writer noted it had 'much more precision than is usually observed by the painter' and with its fine quality of paint and conventional drawing this work seems to foreshadow the insistence on *belle matière* which became so characteristic an aspect of Hornel's later style. The little girls who populate Hornel's pictures after 1900 are increasingly well-behaved and do the things that little girls were supposed to do: catch butterflies, pick flowers, and play ring-o'-roses, unlike their tomboy sisters in the earlier pictures. It is hard to agree with a *Studio* critic of 1907 according to whom Hornel 'paints the gamins of Kirkcudbright as Murillo painted those of Seville, with the uncompromising fidelity not of the satirist but of the true nature-lover, for whom the unkempt, ragged urchin engaged in the manufacture of mud pies is lovelier than the daintiest suburban miss in pink muslin . . .' Mud pies and unkempt ragged urchins are conspicuously absent from Hornel's work after 1900. The fact that shortly after 1900 Hornel used photography for his figures provides proof, if any were needed, of his predominantly decorative intention; he was not remotely interested in psychological portraiture. According to the late Mrs E. Johnstone, who 'sat' for Hornel as a little girl and whom I interviewed in 1967, the models were grouped and posed by Hornel, photographed by a professional photographer, and then added as figures to a backcloth of flowers which Hornel painted *sur le motif*. Some of the Japanese photographs in Broughton House are beautiful in their own right.

Photography led Hornel to the practice of painting several versions of the same pose or grouping which were differentiated only by size or colour. But the later treatment of flowers is often magnificently rich and lyrical, and shows an interest in pattern making (with the petals of the flower species in question providing a kind of modulus for the whole surface of

the painting) which may owe something to Hornel's admiration for the Pre-Raphaelites. He was recorded in 1905 as saying that Madox Brown was 'the greatest modern British colourist' and he especially admired Madox Brown's Manchester Town Hall frescoes (1879-93), but the last word may be left with an old friend of Hornel's, the late Owen Bowen, who wrote to me in 1967 that Hornel 'treasured an old Paisley shawl, this he took with him when painting in the open, as an inspiration for a colour scheme'.

In connection with the later decorative phase of the School, another name must be singled out – Stuart Park (1862-1933). Park's whole claim to attention as one of the important members of the School rests on a small number of paintings of flowers produced in 1888-89. These paintings reveal a highly original use of simplified planes to denote surface and volume and their colour is most subtle, although the later examples have the cardboard appearance of an exhausted formula, for all their ingenuity. As a

65 James Stuart Park
Girl with Poppies
c.1892 Oil 51.1 × 41 cm
Dundee Art Gallery

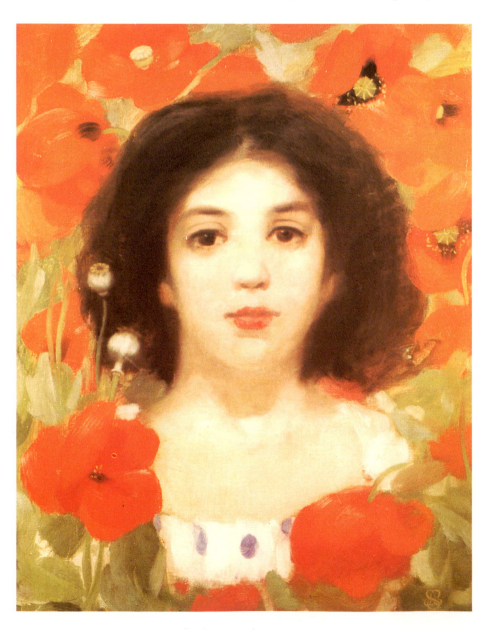

slightly later development on the theme of the flowers, Park painted several single head-and-shoulder studies of pretty girls surrounded by flowers. Only one is known – the *Girl with Poppies* (DAG) – probably because these confections must have been highly saleable in their day and are presumably still in private collections. These must be dated slightly later than the series just referred to, as they lack the rigorous draughtsmanship of the 1888-90 pictures, but they are lusciously painted and amusingly comment on sensual temptation: one wonders if the Dundee girl has been eating the poppies. Park was a genuinely individual colourist and developed a swift and sure painterly dexterity which can pall; but his flower paintings, which were sold in a popular one-man exhibition held every February in the McLellan Galleries and also abroad, preferably in their opulent Italian carved giltwood or feigned-oval ebonized frames, can be wonderfully decorative. Each flower petal is formed by a single stroke, often with striking contrasts of dark flowers against a light background or *vice versa*.

As Art Nouveau is essentially a linear rather than a painterly style, and broad handling of paint is strongly characteristic of all Glasgow School painting, there is little of the Art Nouveau style *per se* even in the later paintings of the Glasgow group who were its immediate forerunners. An exception however is provided by the early work of David Gauld (1865-1936), who was one of the younger members of the group. Gauld was a friend of Mackintosh (who in 1893 gave Gauld a set of bedroom furniture as a wedding present), and Gauld's *St. Agnes* of 1889, perhaps inspired by Keats's poem or the Christmas carol 'Good King Wenceslas' which had in 1887 provided Roche with the theme for his most successful picture, and depicting the village of Cambuskenneth on the Forth in the background, is pervaded with *fin de siècle* feeling – more than ten years before the end of the century. The Stevenson *Notes* describe Gauld in glowing terms: 'The youngest of them all . . . his work simply burns with spiritual power.' A smaller work, *Music* (1889: private collection) is very similar in style and contains the same ingredients as the *St. Agnes* picture: a form of Cloisonnism which makes both pictures look as if they had been conceived as stained glass; a division of the landscape background into parallel bands of colour; and the foreground figures ('dressed in the aesthetic garb of the nineties with a hint of Japanese influence') symbolizing the presence of saints and angels on the earth with which they blend so harmoniously. The static decorative style of Burne-Jones is a distant influence on *St. Agnes,* and this is also evident in the stained-glass designs which Gauld produced for Guthrie and Wells from about 1891, which include a lyrical three-window triptych installed at Montgomerie Quadrant, based on *Music*. Perhaps *St. Agnes* was similarly realized in stained glass. In one of the most curious of these designs – Gauld's

stained-glass windows for the proto-Art Nouveau house Rosehaugh (circa 1893) on the Black Isle – a free adaption was made of the composition of *The Druids* by Henry and Hornel. Gauld's largest commission as a designer of stained glass was for a series of windows for the Scottish Church of St. Andrew in Buenos Aires, made and assembled by Guthrie and Wells over most of the decade before 1910. This work seems to have preoccupied Gauld virtually to the exclusion of all else during that time. Partly as a result, Gauld's work as an innovative painter ceased, and he became well known and widely collected in Scotland as a painter of calves in landscape. Two little early landscapes at Sorn, and *Homeward* (circa 1891: private collection), which Elizabeth Bird has shown to derive from Matthew Maris, indicate Gauld's return to a more conventional style; one ought to add that repetitious though this became, Gauld's painterly touch never seems to have deserted him. He did paint a delightful *Head of a Girl* (circa 1893: Andrew McIntosh Patrick), with the head showing the influence of Bastien-Lepage surrounded by boldly painted foliage, which one may guess to have been his own epithalamium, and a few watercolours in a similar style have appeared in the salerooms. Few artists base a secure place in the history of the Glasgow School on such a tiny handful of pictures.

Sir D.Y. Cameron (1865-1945), who remained on the periphery of the Glasgow School, with his sister Kate Cameron (1874-1965) contributed to the *Yellow Book* (making a rare link with London aestheticism, but looking a little out of their depth). D.Y. Cameron's *The White Butterfly* (circa 1892: FAS) influenced by Matthew Maris, has a decorative emphasis rare in his work, which tends to severity, a quality shared with the more dramatic James Pryde, with whom Cameron had trained at the Trustees' Academy in Edinburgh. Pryde, as one half of the Beggarstaff Brothers, made an important contribution to illustration and poster design in the nineties, but his career was entirely spent in London.

The Beggarstaff Brothers' collaboration lasted from 1894 to 1896 and although the easily printed, flattened outline style of their lithographs became fashionable and produced some of the most characteristic images of London in the 1890s, it did not earn much for the two young artists, Pryde and Nicholson. James Pryde (1866-1941), after study at the Trustees' Academy, moved permanently to London in 1890, following his sister Mabel who, at the age of seventeen, had run off to study painting in the metropolis, where she was to meet and marry the painter William Nicholson. Pryde's memories of Edinburgh, which he called 'the most romantic city in the world', were to inform his painting: the formal grandeur of the New Town; the monumental architecture of the Old Town; the romance of Holyroodhouse with its great bed of Mary, Queen of Scots, which inspired a series of twelve paintings. As he said, 'A bed is an

66 David Gauld
St. Agnes
1889 Oil 61 × 35.6 cm
A.McIntosh Patrick

important idea. Look what happens on it and how much time we spend on it.' The similarities between the early work of Pryde and D.Y. Cameron are obvious, and must stem from their common training. Both display an interest in rather austere architectural subject matter which is in each case matched by a restrained use of colour – sepia, ochre, burnt sienna. But an influence other than Edinburgh's imposing buildings operated from the beginning on Pryde. His parents were great lovers of the theatre and included Henry Irving and Ellen Terry among their friends. Ellen Terry's son Edward Gordon Craig became a close friend of Pryde in London and even put several small touring parts his way when income from painting was insufficient for basic requirements. There is a good deal of common ground between Craig's dramatic designs for theatre sets, with their sense of scale and chiaroscuro, and Pryde's style as a painter. *The Unknown Corner* (1912) is reminiscent of Edinburgh's Cowgate with its huge subterranean arches, while the little figures dwarfed by the great wall behind them are simultaneously a memory of the strolling players and human flotsam of Edinburgh's Old Town, and of the seventeenth century mannerist figures which inhabit the etchings of Bellange and Callot. In this typical work there is indeed a strong sense of the theatre, of the way in which the players are dwarfed by the vast height of the backdrop, and also of the intensely dramatic, artificial quality of stage lighting.

Perhaps no twentieth century artist before Utrillo could invest a blank wall with as much significance as Pryde. *The House* (1914) presents a single architectural elevation without depth, exactly like a stage flat; but the windows which penetrate this surface hint at a mysterious interior with glimpses of figures and drapes. The surface of the wall is weathered; the building possesses a mysterious life and is somehow animated, just as the sky beyond is also dramatically alive, each rendered by a painterly, scumbled technique. The artist's horror at the destruction of war is conveyed most powerfully in *The Monument* (1916-17). Before a desolate landscape under a lowering sky, a huge statue in a shattered architectural niche appears to bleed. Pryde's dramatic qualities as an artist attracted the patronage of Lady Cowdray, who commissioned twelve large works for the Library at Dunecht; other commissions followed, including several for portraits – his sitters included Lady Ottoline Morrell and his parents' friends Ellen Terry and Henry Irving – and a period of success and acclaim from about 1905 until 1925 preceded a sad final period of decline and neglect. A recent exhibition at the Redfern Gallery in 1988 has done much to recall this important artist to our attention.

Like James Pryde, James Watterston Herald (1859-1914) studied at Herkomer's school at Bushey (he enrolled in 1891) where Pryde's work impressed him and is perhaps behind the sophisticated *mise-en-page* which characterizes Herald as a composer: a tiny watercolour, *Femme assise au Café* (FAS) could indeed have come straight from the pages of *La Revue blanche,* although no connection can be demonstrated between Herald and Paris beyond his admiration for the Beggarstaff Brothers' French-inspired work. As already noted, the no less modernistic style of Arthur Melville, who like Herald was native to Angus in the east of Scotland, and of whose work he would have been well aware if only from the Glasgow International Exhibition which Herald visited in 1888, was equally a determining influence in his style as a watercolourist. For Herald was a true artist, brilliantly gifted as draughtsman and the most poetic watercolourist of his day, who was keenly interested in the new style of the nineties despite his voluntary rustication after 1901 in the old and historic burgh of Forfar where his roots were, where he felt comfortable with his drinking cronies or among his musical friends for whom he played the violin and who bought his watercolours, and where a drawing was acceptable tender for many a bill.

Although David Gauld, George Henry and E.A. Hornel's work of the nineties betrays many of the characteristics of the new style, they are part of the history of the Glasgow School, while in the same city J.Q. Pringle, quintessentally a painter of the nineties, is no less part of Glasgow's *fin de siècle* efflorescence. It may smack of truism to say that Bessie MacNicol, like Pringle, was not one of the Glasgow Boys; but as the most accomplished of a remarkable group of women artists who in those separatist days exhibited under the auspices of the Glasgow Lady Artists' Club at their elegant premises in Blythswood Square, where her contemporaries included the painters Stansmore Deans, Robertson, and the illustrators Olive Carlton Smythe, De Courcy Lethwaite Dewar, Annie French and Jessie King, Bessie MacNicol seems to belong with a small and select group of Scottish artists whose intimist, tender and reflective styles as easel painters working in oils stamps them as children of the nineties. Other names that immediately occur in this context are W.J. Yule (1869-1900), who was a contemporary of George Dutch Davidson and John Duncan in the Dundee Graphic Arts Association, and studied under Professor Fred Brown at the Westminster School before being taught by J.-P. Laurens in Paris; Robert Brough (1872-1905) who came from Aberdeen and studied under Laurens and Constant in Paris; and Beatrice How (1867-1932), who seems to have attended the Herkomer School at Bushey at the same time as Herald and the Beggarstaffs, and was then trained at the Académie Delecluse in Paris, where she lived in the same street as J.D. Fergusson, rue Notre-Dame-des-Champs.

Bessie MacNicol's work is rather rare and infrequently dated. There seem to have been three main phases in her style: a tonal manner using a dark palette deployed in vivacious portrait studies (e.g. *A*

French Girl) often in semi-profile or *profil perdu*; a more open manner employing a lighter palette in *maternités* of great intimacy and delicacy which inevitably recall Berthe Morisot or Mary Cassatt, of whose work she was surely aware; and what one might term a Kirkcudbright style exemplified in her painterly portrait of Hornel. The work of Beatrice How (d. 1932), exemplarily revived by The Fine Art Society in 1979, is more delicate still. The absence of dates makes a chronology difficult, but again we are in the presence of an artist of impressively consistent quality whose subtle intimacy in studies of mothers and babies and in portraiture makes her a worthy contemporary of the Nabis and above all of her friend Albert Besnard.

Robert Brough and William Yule share an east coast background and a Paris training – and the special qualities of delicacy, intimacy and tenderness which mark them out as paragons of the nineties. The present state of knowledge of both artists is again scanty. Yule is best documented in Messrs Geering and Colyer's sale catalogue of 22 September 1982, where his brilliancy with the pencil in a style very close to that of Herald, and his incisiveness as a portraitist are much in evidence. Brough we know to have specialized in portraiture after his return from Paris in 1897, when he spent three years in Aberdeen before removing to London where he become Sargent's neighbour and friend and enjoyed tremendous success, Caw tell us, until his premature death – the norm for this little constellation of artists – in a train crash in 1905.

Some of the key Glasgow School painters became members of the New English Art Club on or shortly after its foundation in 1886. Lavery and Alexander Mann were founder members and J.E. Christie (a Paisley artist who moved to London in 1885), Guthrie, Henry, W.Y. Macgregor, Paterson, Roche, Crawhall and Walton together with two other Scottish artists, J. Cadenhead and Maurice Greiffenhagen, became members or sent pictures in the years immediately following. By then the Scottish contingent were fully-fledged exponents of the new Realism and would have little to learn from their English contemporaries, but recognition in the metropolis was, as ever, important, and Henry, Lavery and Walton were soon to pursue their careers in London.

The Glasgow School's representation was at its most numerous in 1890, but they resigned almost as a body in 1892 due to what they saw as a political rejection of a Scottish picture by the London Impressionist group who were attempting to dominate the Club. The Scots must have felt encouraged by the reception accorded to their exhibition at the Grosvenor Gallery in the summer of 1890, to which the most important of these artists, with the addition of Thomas Millie Dow, William Kennedy, Thomas Corsan Morton, and George Pirie, sent some of their strongest works. This exposure in London and the

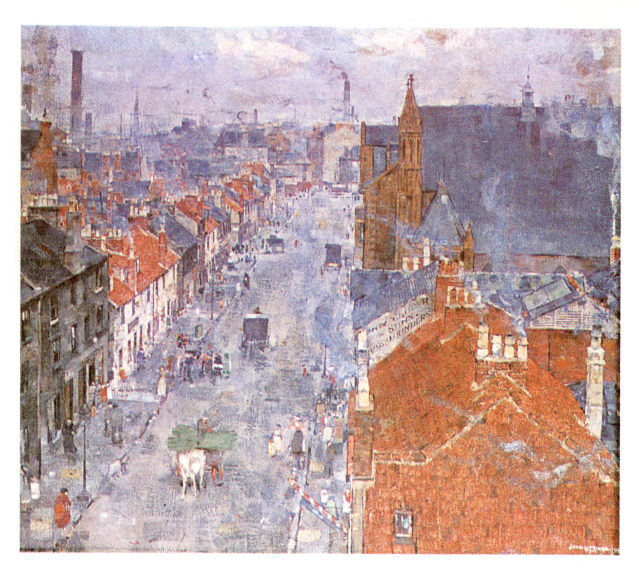

68 John Quinton Pringle
Muslin Street, Bridgeton
1895–96 Oil 35.9 × 41.2 cm
Edinburgh City Art Centre

resulting *succès d'estime et de scandale* led directly to the invitation from Herren Firle and Paulus to exhibit with the Munich Secession at the Glaspalast later that same year, which was the beginning of international recognition and the first of many exhibitions and sales abroad, both in Europe and in North America. The critic of the *Muenchener neueste Nachrichten,* Fritz von Ostini, wrote in unequivocal terms of admiration:

> . . . a Glasgow School really does exist! It is not merely that a score or so of painters have established their studios in Glasgow and now happen all to paint good pictures. They form an organic whole, heterogeneous as they may be; they are united by one aim, one spirit, one power, they all spring from the same soil. This spontaneous growth of a school of painters of such importance is perhaps without parallel in the history of art . . .

Although not one of the Glasgow Boys – he never took part in their exhibitions and was only an artist in the time he could spare from his practice as a optician – John Quinton Pringle (1864-1925) was in some ways the most gifted of all his contemporaries in Scotland. His associations are entirely with Glasgow, where he was born. He studied at the Glasgow School of Art's evening and early-morning classes from 1885-95 and in 1899-1900, all the while uninterruptedly pursuing his daytime profession of practising optician at his shop in the Saltmarket near Glasgow Cross (where the television pioneer James Logie Baird and the playwright James Bridie were among his clients). He was thus a most thoroughly trained artist but never a professional in the financial sense and to this independence and the consequent lack of temptation to over-produce can be attributed the smallness of his output, his extreme consistency of quality and his individuality of style. Technically his work possesses a degree of refinement unique in the Scottish and indeed in the British context of the day. It is an astonishing fact that he seems to have had very little contact with the Glasgow School artists who were constantly in the local news; his artistic mentor and encourager was Fra Newbery, the far-sighted head of the Art School, and there exists a fascinating photograph which shows him in the company of his contemporary at Glasgow School of Art, Charles Rennie Mackintosh, at Gladsmuir,

William Davidson's house at Kilmacolm. He created works of consistent quality that can be both dreamily poetic and painstakingly observant. In his choice of subject-matter, however, he departs little from his precursors of the Glasgow School.

Pringle's earlier pictures exhibit the most fastidious and detailed realism allied to the most minute execution and it is not surprising that he later painted a number of portrait miniatures on ivory (of which Sir James Guthrie possessed two examples). Two early portraits in oils, of himself and his brother Christopher Pringle, *Artist with Palette* (circa 1886: GAG) and *Portrait of the Artist's Elder Brother* (circa 1890: TG), are painted with relative freedom and are sensitive studies of their subjects reminiscent of E.A. Walton's early watercolours. From the same period date several delicate and subtle views of Glasgow back-court scenes – *Old Houses, Bridgeton* (1890: formerly Davidson Collection), *Back Court with Figures* (1890: private collection), *Old Houses, Parkhead, Glasgow* (1893: private collection) – the last-named having a special meaning for the artist as his mother was born in one of the houses, and died in it in the year the picture was painted. The culmination of this group is the remarkable *Muslin Street, Bridgeton* (1895-96: ECAC), the artist's own

favourite of which he commented, 'There will never be another *Muslin Street* – quite apart from the skill no-one could afford to spend the time on it.' Yet despite its minuteness of execution, the painting has a fresh immediacy and a sense of scale which belie its small size. Here too, Glasgow School precedents exist in the Glasgow Street scenes painted a little earlier by James Nairn – *West Regent Street* (1884: untraced) and Thomas Corsan Morton – *St. Vincent Street* (1887: collection: Revd. and Mrs J.P. Wilson), which both adopt the high viewpoint also employed by Pringle. Pringle here uses a noticeably tonal palette with infinite variations on a narrow range of blue-grey enlivened only by the inclusion of passages of rust-red. A similarly restricted palette is visible in another realist *tour de force*, *The Loom* (1891: ECAC), a composition of immense spatial complexity with every detail sharply articulated yet retaining a sense of air and atmosphere, each surface painted with infinite variations of brushstroke in such a way that it is simultaneously described and illuminated by the light in the room. Meldrum records that this canvas, measuring nine by eleven inches, took three summer months to complete, during which Pringle devoted two hours to it every morning before setting out for the shop. In a slightly later group of pictures

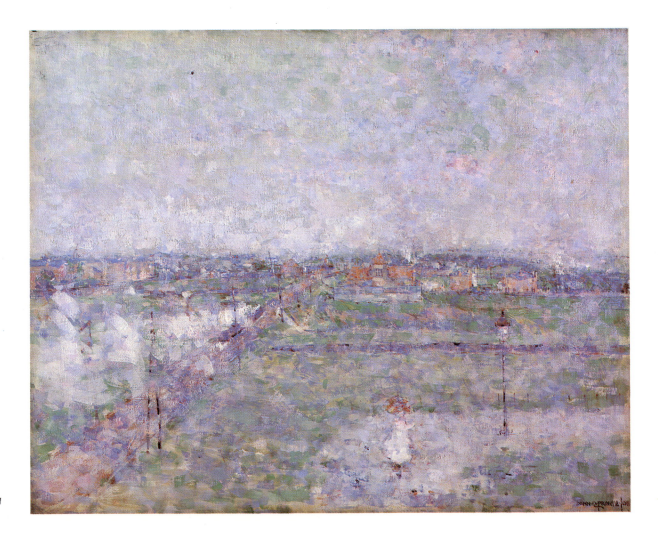

69 John Quinton Pringle
Tollcross, Glasgow
1908 Oil 42.5 × 52 cm
Hunterian Art Gallery, University of Glasgow

painted between 1903 and 1908, a more poetic conception of subject-matter is evident – *Girls at Play* (1905: HAG) – and a more open, transparent execution which is intriguingly close to the pointillism of the Neo-Impressionists whose work Pringle is most unlikely to have known at this stage in his career, as Meldrum has emphasized, *pace* Buchanan who claims to see the influence of Le Sidaner. These works are in fact astonishingly original in technique, the subject emerging through a mesh of tiny brush strokes of colour which form the bejewelled surface of the painting and at the same time suggest the surrounding atmosphere which diffracts the colours perceived within the three dimensions of the picture space. The most consistently divisionist work in his *oeuvre*, probably, is *Tollcross, Glasgow* (1908: HAG), which on examination turns out not to be a pointillist work at all – the paint is applied transparently with a square brush in overlapping layers of pure colour or, to be exact four colours: a dominant primary, blue, with its complementary, orange; and the remaining secondary colours green and lilac, with white. This phase Pringle referred to as his 'very extreme' style in a letter (Meldrum Trustees). Tantalizingly of this very rare artist, it is known that a Continental dealer bought several canvases from him at around this time, although it was not Pringle's normal practice to dispose of his pictures outside the small circle of his family and friends. Two other important works date from this middle period: *Two Figures and a Fence* (1904: GAG) may be unmatched in Pringle's work for its sheer exquisiteness of technique, although it has an indeterminate, dreamlike quality also visible in Pringle's largest canvas, *Poultry Yard, Gartcosh* (1906: SNGMA), which so poetically transforms a prosaic theme. A visit to Caudebec in Normandy in 1910 (his only excursion abroad; he never realized his ambition to take his paintbrushes to Japan) resulted in four oils which were to be the last in that medium for over a decade. It seems likely that the increasingly onerous demands of the shop on his time, and the discouraging climate of the war years, rendered the relative speed of watercolour attractive to the artist. The most important of these is the delicate landscape *On the River Sainte-Gertrude, Caudebec*, which interestingly once belonged to an early collector of C.R. Mackintosh, David Turnbull, who was a partner in Templeton's carpet factory.

The Curing Station at Whalsay (1921: AAG) dates from Pringle's last period and marks a return to oil, after a decade of painting only in watercolour. The legacy of painting in the more fluid medium is visible in the increased transparency and fluidity of *The Curing Station*. The return to oil painting caused Pringle no difficulty and he wrote happily in a letter of this time from Whalsay, where he was staying with his friend Dr. Wilson '. . . my hand is as light as a feather, no difficulty in what I want . . .', adding that his new Orkney pictures were *not* of the 'extreme school' – a view with which we would now concur. The pictures painted in Orkney only a year or so before the onset of the artist's final illness, show that Pringle's limpid style had lost nothing with the passing of a decade.

At the same time as international acclaim was being granted the School began to disintegrate. In a postscript dated 1895 to the MS *Notes* written in 1891-92, Macaulay Stevenson describes how they gradually separated, owing to marriage, honours and success, which prejudiced the School's spiritual force, so that 'a sort of apostolate . . . now got broken up into a number of individuals with at most a grouping into twos and twos, with perhaps a third in occasional sympathy'. Stevenson concludes, 'This fair bud of promise put out by Nature came too early in the still tarrying springtime of human progress and the frosts of the winter from which our civilisation has not yet emerged have nipped it'. Between 1887 and 1892 there appear to have been various attempts to formalize the *de facto* existence of the Glasgow School but rather than unifying the group these appear only to have succeeded in ruffling the feelings of various individuals, and the Glasgow School was a spent force by the later 1890s, although its work continued to be seen in special exhibitions all over Europe and America. On two occasions Diaghilev borrowed Glasgow School pictures for exhibitions in St. Petersburg in the late 1890s.

The significance of the School for subsequent Scottish painting lies in its rejection of academic values and its return to the expressive qualities of colour and the vigorous handling of paint. Its impact on contemporary English painting, except in the single case of Frank Brangwyn, was negligible, but in Scotland it had considerable influence on the next generation of painters.

7 FIN DE SIÈCLE: A NEW ART

Scotland made a distinctive contribution to the international Art Nouveau in the last years of the nineteenth century. In the Scottish context, the exquisiteness, not to say preciousness, of Art Nouveau and its linear nature are at variance with the painterly characteristics we have seen grow up in Scottish easel painting in the latter half of the nineteenth century. The essence of Art Nouveau is its intense inwardness, its emphasis on mental intuition rather than sense-perception. Paintings by the younger members of the Glasgow School around 1890, such as Hornel's *Young Girl* (1888: private collection), Henry's *Sundown* (1887: HAG), *Girl Gathering Mushrooms* (1888: private collection) and *Galloway Landscape* (1889: GAG), and above all the *St. Agnes* by C.R. Mackintosh's friend David Gauld, one of the earliest of all Art Nouveau images, prepared the way in Scotland for a style which would concentrate on spiritual essences rather than on visual impressions of the material world. This contrasted with the evolving interpretation of realism which had provided the stylistic connections throughout the nineteenth century. The prophetic *St. Agnes* (1889: exhibited in Munich, 1890), painted in a *cloisonniste* style related to Gauld's very similar stained-glass designs for the Glasgow firm of Guthrie and Wells demonstrates the elongations, the formalization, the pensive wistfulness, and even the interest in vernacular architecture (in this case, that of Cambuskenneth, one of the Glasgow Boys' favourite painting locations) so characteristic of the new movement in Scotland.

In Glasgow alone, however, more exotic contemporary influences were at work and Jessie Newbery, writing in 1933, recollected the importance to Charles Rennie Mackintosh and his friends of 'contact, through the medium of *The Studio*, with the work of the following artists: Aubrey Beardsley (his illustration to the play *Salome* by Oscar Wilde); illustrations to Zola's *Le Rêve* by Carlos Schwabe; reproductions of some pictures of Toorop – a Dutch artist; the work, architectural and decorative, of C.F.A. Voysey. These artists gave an impetus and a direction to the work of 'The Four'.'

Glasgow, Edinburgh and Dundee were each in turn the centre of creative activities which are surprisingly little related. Gauld's *St. Agnes*, as already noted, is dated 1889. In 1891 the French-trained Edinburgh artist Robert Burns (1869-1941) produced the perhaps de Feure-inspired drawing *Natura Naturans* (dated 1891 but only published as a wood-block engraving in *The Evergreen* in 1895), which at this early date confidently exploits the whiplash curve which became the movement's hallmark. French inspiration and an illustrative bias inform the graphic work of the main contributors – Burns himself, Charles Mackie and John Duncan – to *The Evergreen*, whose four numbers appeared in Edinburgh in the years 1895-97. Duncan was the foremost of the Celtic revivalists, with the designer-ceramicist Phoebe Traquair in Edinburgh, which also boasted two interesting disciples of Morris among its architects, Sir James Gowans and F.T. Pilkington, whose Bruntisfield Church is the epitome of picturesque illustration in architecture.

But the main direction of the style in Scotland in the early nineties is determined by Mackintosh and

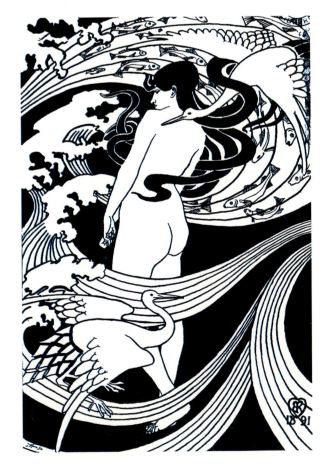

70 Robert Burns
Natura Naturans
1891 Printed in the spring number
of *The Evergreen*, 1895
Wood engraving by Augustus Hare

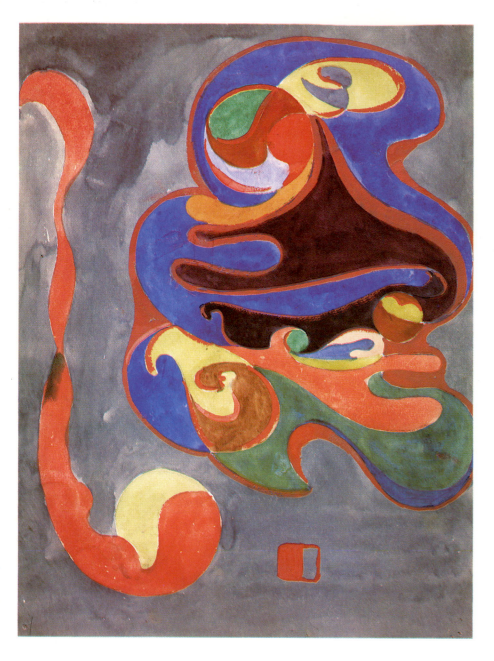

71 George Dutch Davidson
Abstract
1898 Watercolour 35.6 ×
25.4 cm
Dundee Art Gallery

In the realm of the applied arts Glasgow witnessed an immensely rich flowering of talent, partly inspired by the ever-encouraging presence at the Glasgow School of Art of Fra Newbery as Director. Apart from the 'The Four' there are the major furniture designers George Walton, Jane Fonie, E.A. Taylor, and George Logan, the two last named producing many designs for the Glasgow firm of Wylie & Lochhead; in metalwork Peter Wylie Davidson and many others; in stained glass, Oscar Paterson and Alf Webster; in embroidery and dress design, Jessie Newbery née Rowat, Ann Macbeth and a host of feminine talent; in glasswork, the Clutha glassworks; in pottery, the Allander kilns. And finally, third in chronological order after Glasgow and Edinburgh, Dundee requires mention in any survey of Art Nouveau in Scotland because of the brief incandescence of George Dutch Davidson's career in the north-eastern city.

In terms of painting Art Nouveau was an interlude which passed without sequel, vanishing as suddenly as it had appeared, leaving behind a handful of enigmatic watercolours by 'The Four' and by G.D. Davidson which hint at the world of Munch, Klee and Kandinsky, together with a much larger body of decorative work whose period charm has experienced a nostalgic contemporary revival. Its more lasting influence was in architecture, the applied arts and graphic design; and the dominant figure in each field was Charles Rennie Mackintosh (1868-1928). The international significance of his architecture and design, particularly to the Vienna School, but also in Germany and Holland and from thence to the Bauhaus is well documented. In Mackintosh's hands the new style evolved as an instrument of purification capable of great expressive power and never threatened merely to replace the old historicism with a new mannerism.

Yet pioneer as he was, Mackintosh was not alone. In the 1893 lecture on 'Architecture' he names to his Glasgow audience several precursors in England who 'are freeing themselves from correct antiquarian detail and who go straight to nature' – Norman Shaw, John Bentley, John Belcher, G.F. Bodley, Leonard Stokes and J.D. Sedding – while in Scotland through the nineties and immediately after the turn of the century the work of J.M. Maclaren, J.A. Campbell, John Ednie, A.N. Paterson, Salmon and Gillespie, W.J. Anderson and W. Gibb Morton – were some of them in his audience? – provides a background in harmony with Mackintosh's revolutionary achievement. Of these Scottish names, only W.G. Morton was active as an occasional designer of furniture, notably for 'Lintknowe' at Darvel, and he seems also to have been a competent watercolourist, demonstrating a level of versatility not surprising in an architect whose family's business of Alexander Morton & Co. of Darvel commissioned fabric designs from Voysey. What sets Mackintosh apart from all his contemporaries, however, is his ability to

his small circle in Glasgow. A fully-fledged Art Nouveau of astonishing assurance and originality emerged in the work of Mackintosh, the sisters Margaret and Frances Macdonald and Herbert MacNair – 'The Four' as they were known from 1894 – at an early point in their respective careers. In the realm of the graphic arts, this flowering is nowhere seen to better advantage than in the four surviving scrapbooks, preserved by Agnes Raeburn and now appropriately in the possession of the Library of Glasgow School of Art, collected for circulation among the contributors and their fellow students at the School in the years 1893-96, and known as *The Magazine*. This compilation of autograph work must rank as one of the most extraordinary ever produced by students at any art college, and it underscores Glasgow's pre-eminence in the development of the new style.

view all the branches of the visual arts in a kind of synaesthesia which allowed his search for new forms in one branch constantly to be enriched by explorations in another. The experimental and 'Symbolist' watercolour paintings of the 1890s were one of the most rewarding avenues of exploration in terms of form and colour. The idea of form as symbol pervades Mackintosh's view of architecture and design. In the work of what other designer might we encounter a chair with a shaped backrail which frames the sitter's head like a halo, another with the hieratic solemnity of the throne of Minos; a games table formed (although gambling would certainly have been forbidden at Miss Cranston's) as a lucky four-leafed clover; or a revolving bookcase of tree-derived form; a library (at Hill House) whose panelling resembles angel's wings; an organ case (Craigie Hall) decorated with carved songbirds; another (Queen's Cross Church) with minims on a kind of vertical staff; a school (Scotland Street) with a miniature entrance for its infants; a School of Art (with its east elevation's reference to Maybole Castle) whose 'fortifications' include railings shaped as crossbows with quivers full of – tulips? In these and in countless similar but more abstract examples, Mackintosh takes the idea of fitness or 'seemliness' (a favourite term) to a level of aesthetic expression undreamt of in the philosophies of his contemporaries. Mackintosh possessed a technical mastery which was the servant of a powerfully creative mind; he had a Mozart-like ability to endow decoration with significance. For him, form was like a veil shaped by and part-disclosing meaning while itself always remaining separate and visible, as the wall-veil (one of the few Ruskinian terms of which he approved) at once disguises and expresses the function of a building. Unlike the Macdonald sisters and MacNair, he always thought of himself as an architect first and foremost; his own writings indicate succinctly that the applied arts and painting were in his opinion subordinate to architecture.

His joblist for Honeyman and Keppie in the years prior to the commission in 1896 for the Glasgow School of Art was very considerable, and if one were to characterize his chief works of this phase – *inter alia* the Glasgow Herald building (1893) with its extraordinary, romantic tower and early Art Nouveau carved embellishments; Queen Margaret's Medical College (1894-95) visualized in the beautiful perspective drawing as a medieval nunnery surrounded by its own glebe; the medievalizing Queen's Cross Church (designed 1896) – one would qualify them as subjective, emotional rather than rational, and even romantic. As Billcliffe has pointed out, these are characteristics shared with his graphic work in the same period. After 1896 until the start in 1907 of the second stage of the School, which was to become his built masterpiece – others did not proceed beyond the drawing board, although the Art Lover's House unpremiated in 1902 is being built in Glasgow to

open in 1990 – his architectural output is truly phenomenal, but even so the list of projects alone gives only a partial indication of the scale of his creativity; in David Walker's words, 'One room would cost him more real effort than half a dozen buildings would another man'. The ten-year period from 1897-1907 coinciding with the gestation of the School of Art encompasses an early phase in which decoration is chiefly supplied by structural features or the simple provision of a stencilled mural, as at the Buchanan Street tearoom (1897); the middle phase adding ever more complex enrichments in furniture, glass, enamels, and metal works – compare the relative austerity of Windyhill (1900) with the complex bedroom and drawing-room schemes for Hill House (1902), and the transitional vernacular elevation treatment of both with the timeless modernity of the Haus eines Kuntsfreundes (1902); and a third, architectonic manner typified in the Willow tearoom of 1904, with its endless spatial interplay and elaborate plaster frieze abstractly symbolizing the willow theme. This third phase culminates of course in the 'overwhelmingly full polyphony of abstract form' (Pevsner) of the Art School Library interior, with its 'thrilling' (Howarth) exterior elevations, begun in 1907 and completed in 1909. Essentially, Mackintosh's main periods of activity as a painter occur before and after this decade of intensive architectural invention. In the difficult and frustrating years after the School of Art, when his architectural practice dwindled precisely when the completion of masterpieces of the stature of the Cranston tearooms, Hill House, Scotland Street School, and the School of Art itself (to say nothing of the brilliant unrealized designs for a Concert Hall, for Liverpool Cathedral, and for the Haus eines Kunstfreundes) had given proof to the world of his outstanding talents as a designer of limitless versatility, Mackintosh turned increasingly again to painting. Apart from Miss Kate Cranston, the one serious patron to employ Mackintosh after 1909 was W.J. Bassett-Lowke, for whom Derngate was built in Northampton in 1916 with interiors by Mackintosh. Here Mackintosh employed a newly-minted language of geometrical decoration and a range of strong colours with which he had already begun to experiment as a painter.

Charles Rennie Mackintosh was apprenticed to the Glasgow architect John Hutchinson in 1884, and in 1889 entered the firm of Honeyman and Keppie as a qualified draughtsman. In 1891 he made a visit to Italy as the winner of the Alexander Thomson travelling scholarship, making architectural sketches of exceptional intelligence and accomplishment and recording his impressions in a diary later developed into a lecture given to the Glasgow Architectural Association at some time in late 1891 or early 1892. Mackintosh seems to have been in considerable demand as a speaker, understandably, as despite some indebtedness to W.R. Lethaby and the occasional

phrase borrowed from Sedding, his written ideas are penetrating, and expressed with clarity and an engaging mixture of passion and humour. Several further papers read to the same Association follow in swift succession: *Scotch Baronial Architecture* (1891), *Elizabethan Architecture* (1892) and *Architecture* (delivered to the Glasgow Institute of Architects in 1893); and finally after a gap of nine years the revealing *Seemliness* (1902) (all MSS. University of Glasgow, Mackintosh Collections). In the first-mentioned of these hobbyhorses, Scottish baronial architecture, 'a subject dear to my heart' which he considers to have the same claim on his love and loyalty as his own ancestors, he expatiates on its honesty of form and its fit use of materials. The paper on Elizabethan architecture, like its predecessor,

72 Charles Rennie Mackintosh
The Descent of Night
1893–4 Watercolour 24 x 17 cm
Glasgow School of Art
From *The Magazine*, April 1894.

describes the forms of the style through perceptive analysis of a few examples, but prophetically (in view of Mackintosh's own future achievement) quotes Fergusson on the interior decoration of the Elizabethans, to the effect that theirs was a style formed by artisans and not by artists, 'not of the true artistic character which calls for the cooperation of the sister arts of painting and sculpture'. In the *Architecture* paper of 1893 he goes still further: 'you ask what is the connection between architecture and painting. Everything . . . what is art but the fixing into substance the "invisible".' Addressing himself to the painters in his audience, Mackintosh writes of '. . . form, colour, proportions, all visible qualities – and the one great invisible quality in all art, soul. These are the essential qualities of all true architecture, and of the various subordinate arts – in the days when there was true art – for its further enrichment as a work of art . . .'

His colleagues at Honeyman and Keppie included Herbert MacNair (1868-1955) and the two became close friends. Mackintosh and MacNair attended the evening classes for architects which Fra Newbery had instituted at the Glasgow School of Art. Francis Newbery (1853-1946) had trained as an artist at South Kensington, where he taught before his appointment as Head Master of Glasgow School of Art in 1885. His enthusiasm for a form of art education which placed as much emphasis on the applied arts and crafts as on the traditional classes in his own discipline of painting was responsible for the considerable increase in new subjects offered – among them metalwork, enamels, embroidery and dressmaking – and would have attracted 'The Four' to the School. In 1893 – also the year of the first highly influential numbers of *The Studio* – Newbery organized a series of lectures on the crafts, the speakers including the great founding father of the English Arts and Crafts Movement, William Morris (1834–96), and probably Newbery himself. In the lecture on 'Seemliness' of 1902, Mackintosh conveys something of the flavour of just such an evening at the School: '. . . as I heard Mr Newbery say the other evening the education of all artists must be conducted on one grand principle – all must be educated alike – with one common aim'. Here they met their future wives, Margaret (1865-1933) and Frances (1874-1921) Macdonald, to whom they were introduced by Newbery, sensing the affinities between them, some time before November 1894 when they exhibited together at the Glasgow School of Art Club exhibition in the Institute Galleries. Fra Newbery's judgement was borne out by their formation into an artistic grouping, known as 'The Four', which lasted until the MacNairs' departure for Liverpool in 1899, the year of their marriage; Charles Rennie Mackintosh married Margaret Macdonald in the following year.

'The Four', with Newbery's encouragement, developed great versatility in the design of metal-

work, enamels, book illustration, furniture and posters, and their work was exhibited, with that of several other Glasgow designers, at the London Arts and Crafts Society exhibition in 1896 in London, where it was received with vociferous hostility. Only Gleeson White, the editor of *The Studio*, admired the work of 'The Four', and he wrote an important series of articles on them, which received more attention abroad than at home.

> The appearance of this article led to an invitation to Charles Mackintosh and Margaret Macdonald . . . to hold a show in Vienna. The consequent exhibition there not only established his place as one of the first modern architects and decorators of the day, but gave new life to a group of brilliant young architects, decorators, sculptors and metal workers, who at once acknowledged him as their leader. The rooms in the Turin International Exhibition of 1902 . . . were very rich in the work of 'The Four' (Jessie Newbery, ibid.).

Margaret's collaboration with Mackintosh took the form chiefly of decorative panels for individual pieces of furniture or for specified interiors, where they were of central importance to the whole scheme, in terms both of colour and content. Writing to Hermann Muthesius in 1900, Mackintosh says, '. . . just now we are working at two large panels for the frieze [*The May Queen* and *The Wassail* for the Ingram Street Tearoom] . . . Miss Margaret Macdonald is doing one and I am doing the other. We are working them together and that makes the work very pleasant. We have set ourselves a very large task as we are slightly modelling and then colouring and setting the jewels of different colours'. Here Mackintosh is describing the extraordinary technique visible also in the most celebrated of these panels, that designed by Margaret for the 'Room de luxe' with its silver-painted furniture and 'inexplicable splendour' of enamelled and mirrored glass, on the first floor of the Willow Tearoom, based imaginatively on Rossetti's sonnet, 'O ye, all ye that walk in Willowwood', where string and coloured beads are worked into the modelled and painted gesso. Pamela Robertson informs us that Margaret provided five panels for furniture designed by her husband, and that her work was included in eleven of his projects. We know from the evidence of his letters how much he appreciated her and respected her work. Professionally as well, it was clearly a marriage made in Heaven. Although Mackintosh's espousal of the ethereal, Maeterlinckian, fairytale subject matter which we rightly associate with Margaret, and to a lesser extent Frances Macdonald, was of short duration and only a handful of his graphic works can be ascribed to it – *Part Seen, Imagined Part* (1896: GAG) and *In Fairyland* (1897: private collection) are examples – one wonders whether a masterpiece such as the astonishing bas-relief plaster frieze for the Willow Tearoom (1904) would have been within his grasp

73 Charles Rennie Mackintosh
The Shadow
1895–96 Watercolour 30 × 18 cm
Glasgow School of Art
From *The Magazine*, Spring 1896.

74 Charles Rennie Mackintosh
Cabbages in an Orchard
1894 Watercolour 8.6 × 26 cm
Glasgow School of Art
From *The Magazine*, April 1894.

had it not been for the encouragement of Margaret's interest in modelled gesso reliefs.

Much ink has flowed on the difficult question of who among 'The Four' was the first to arrive at the new style. The available evidence may be inconclusive on this point, but it is extremely impressive as regards the originality of 'The Four' themselves. Well might the Macdonald sisters have teased the earnest Gleeson White who was questioning them on the sources of their style with the answer 'We have no basis'. Very early drawings such as Mackintosh's design for the Diploma of the Glasgow School of Art Club (1893: Howarth collection) – perhaps Mackintosh's immediate response to Jan Toorop's *The Three Brides* – or his *Conversazione* programme for the Glasgow Architectural Association (1894: ibid.), or Margaret's invitation card for a Glasgow School of Art Club 'At Home' (probably 1893: HAG), or the sisters' work for an illuminated manuscript within beaten metal covers, *The Christmas Story*, which includes very early work by Margaret and Frances (1895-96: ibid.), reveal such confident individuality that the truth is probably that these artists arrived independently at similar conclusions at the same time. Interestingly, the two invitation cards by Mackintosh and Margaret share an important and unusual compositional device, which seems to be based on a section cut through an apple or a pomegranate, formed in Mackintosh's case by a flight of birds, in Margaret's by the wings of an angel. This is an early hint of much that is to come in Mackintosh's vocabulary of ornament, just as his Diploma design is a distant forerunner of the Willow plaster frieze of circa 1904. However, David Walker has reminded us that in the interior of the Hall of Glasgow Art Club (and, he might have added, in the carved decorations to Craigie Hall in the same year) the details 'whose strange attenuated figures and elongated S-stems with balloon flowers and friezes of sinister whorls of thistles anticipate any mature work

of this type by the Macdonalds so far discovered'.

From the beginning Mackintosh's work as a watercolourist and draughtsman appears calmer, and less eccentric or eerie than that of his three colleagues. His wonderfully assured, poetic watercolour of 1892 *The Harvest Moon* (GSA) is a transitional work. It is his earliest masterpiece in this medium, which was favoured by 'The Four' and their contemporaries to the virtual exclusion of the more material, denser oil medium. Here, the subject itself is reminiscent of the crepuscular mysticism of the Kirkcudbright artists of the later Glasgow School, particularly Hornel and Henry, while the classically-draped recumbent female figure personifying a cloud distantly echoes the Aesthetic Movement. But the angel whose wings ring the moon, with her elongated limbs, tiny extremities and S-curve drapes clearly anticipates the new style, while the beautifully articulated thorn branches in the foreground, so strangely and vividly alive with their autumn berries and quinces, seem as vitally engaged in the mysterious drama of dusk as the personified moon and cloud. *The Harvest Moon*, related in its atmosphere of mystery to some of the work of the Glasgow School painters, like *The Descent of Night* (*The Magazine*, April 1894: ibid.), using the female figure as symbol, fascinates the viewer, irrespective of the subject, by the brilliant solution of the technical problem of a stencil-like separation of areas of paint from each other. This technique was also adopted in the extraordinary *The Shadow* (1895-96: *The Magazine*, Spring 1896: ibid.), an exquisite wash drawing in three colours of a plant form like a thistle but equally resembling one of his own wrought-metal finials, with its shadow drawn isometrically. On the other hand, Mackintosh was occasionally as ready as his three colleagues to be deliberately obscure, although with amusing disingenuousness he rebuts this charge in the justly celebrated text which accompanies his watercolour *Cabbages in an*

Orchard which appears in *The Magazine* of April 1894. The watercolour anticipates Klee; the text is equally original and since it offers a rare view of Mackintosh's imaginative processes at work is reproduced here in full:

Cabbages in an Orchard

The above title explains the picture on the opposite page, but to satisfy the ordinary ignorant reader I am forced to give the following explanation – The before mentioned kind of reader may imagine that the cabbages here shewn are the usual kind of every-day cabbage, or as some people call it 'Common or garden cabbage', but that is just because they never see cabbages unless when they are not growing. The cabbages in this orchard are different – they have stood through a severe winter of snow and hail and frost, and thunder: they have stood through a spring lasting three months, and raining all the time, and before they had time to dry in an ordinary way the sun came out with frizzling ferocity – yet still they stand. A glance at the sketch will convince anyone – (although it conveys but a poor idea of the rich variety of colour, the beautiful subtlety of proportion and infinity of exquisite form) – that the cabbages shown here are a particularly hardy and long-suffering kind. Neither is the orchard a common kind of orchard. I explain this because some people may not distinguish between cabbage and orchard, and will grumble accordingly. They might be right, the trees are old trees, very old trees, they are far away from any other trees, and I think they have forgotten what trees should be like. You see they have lived alone a long time with nothing to look at but cabbages and bricks, and I think they are trying to become like these things. That at least is what their present appearance would suggest (and the sketch suggests the same thing in a less perfect way). I know this much, I have watched them every day this winter and I have never once seen an apple, or an orange, or a pear on one of them, and I have seen clothes – and what is more I have seen mud – and a brickmaker once told me that bricks were made of mud. The mud I saw must have been the beginning of bricks. I would explain before concluding, that anything in the sketch you cannot call a tree or a cabbage – call a gooseberry bush. And also that this confusing and indefinite state of affairs is caused by the artist – (who is no common landscape painter, but is one who paints so much above the comprehension of the ordinary ignorant public, that his pictures need an accompanying descriptive explanation such as the above).

C.R. Mackintosh.

Mackintosh seems only once to have reverted to this mode of watercolour painting in the marvellous, mysterious later *At the Edge of the Wood* (circa

75 Charles Rennie Mackintosh
At the Edge of the Wood
n.d. Watercolour 50 × 37 cm
Private collection
Although dated to c.1905–6 by Roger Billcliffe, it appears on stylistic grounds to relate to earlier work.

1905-06: private collection). The large watercolours, *The Tree of Influence, The Tree of Importance, The Sun of Cowardice* (1895: GSA) and *The Tree of Personal Effort, The Sun of Indifference* (1895: ibid.) resemble the 'thinking machines' or mandalas which Patrick Geddes favoured to present the mechanics of thought as graphic symbols at about this time. The long titles with which they are inscribed *recto* by the artist are indispensable pointers to their meaning, the alleged impenetrability of which is in danger of becoming a hallowed tradition among Mackintosh commentators. In fact, their meaning is clearly revealed by a close study of what they actually represent and would immediately have been recognized by the close circle of students among whom *The Magazine* was circulated. *The Tree of Personal Effort*, whose healthy roots are visible, thrives in the

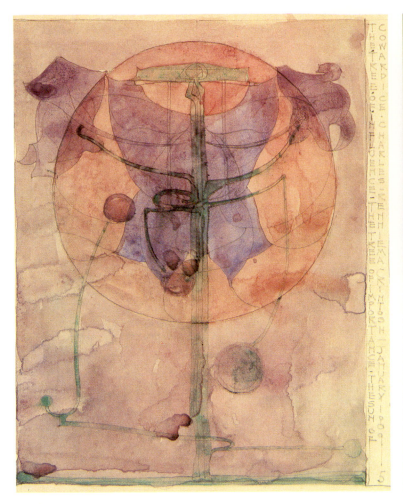

76 Charles Rennie Mackintosh
*The Tree of Influence, The Tree of
Importance, The Sun of
Cowardice*
1895 Watercolour 21.4 ×
17.2 cm
Glasgow School of Art
From *The Magazine*, Spring 1896.

77 Charles Rennie Mackintosh
*The Tree of Personal Effort, The
Sun of Indifference*
1895 Watercolour 21.1 ×
17.4 cm
Glasgow School of Art
From *The Magazine*, Spring 1896.

hostile climate of a freezing sky and arctic sun – the
Sun of Indifference – wonderfully suggested by subtle
washes of slate and emerald. Its leaves and blooms,
though little, are healthy, well ordered and beautiful
in colour. (In the famous lecture on 'Seemliness' in
1902 Mackintosh will write, 'Art is the flower – Life
is the green leaf'.) But the 'personal effort' and
'indifference' of the title are anthropomorphic and
can only refer to the artist and his public. The
symbolism is clear: the artist will create and thrive,
through his own efforts, in a climate of indifference.
Whereas, in the companion watercolour, the baneful
glare of the *Sun of Cowardice* produces in the *Tree of
Influence, the Tree of Importance*, which is rootless,
a crop of imposingly large fruit which however tend
to break their own branches, together with sinister
flowers as large as flags joined to a strange vegetable
form shaped like a *cuirasse esthetique*, or classical
breastplate, a familiar prop of the antique class of
contemporary art education, and the 'influence'
referred to in the title. Here we have a portrait of the
very soul of the artist in travail, personified by the
tiny, skrinking female figure of the tree itself, whose
artistic growth is stunted by a 'cowardly' dependence
on past influences and material reward.

The thought expressed by these two works is
repeated in the paper on 'Seemliness' of 1902:

. . . you must be independent, independent, inde-
pendent . . . Shake off all the props – the props
tradition and authority offer you – and go alone –
crawl – stumble – stagger – but go alone . . . The
props of art are on the one hand – the slavish
imitation of old work – no matter what date and
from what country – and on the other hand the
absurd and false idea – that there can be any living
emotion expressed in work scientifically pro-
portioned according to ancient principals (*sic*) –
but clothed in the thin fantasy of the author's own
fancy. The artist's motto should be, "I care not the
least for theories for this or that dogma so far as
the practice of art is concerned – but take my stand
on what I myself consider my personal ideal".

If Mackintosh's work is the least florid and the
least convoluted of all that was produced by the main
exponents of Art Nouveau, that of the other three
members of 'The Four' seems to deserve better the
sobriquet of 'spook school' which came to be applied
to their work in Glasgow. Frances Macdonald's *A
Pond* (1894: GSA), included in *The Magazine* for
November 1894, shows two emaciated and pallid
figures beneath the waters of a pond gently lapped by
weed-like growths with heads like tadpoles. Her *Ill
Omen* (1893: HAG), also called *Girl in the East Wind*,

shows a girl standing with hair streaming in the wind with a flight of ravens – an ill omen – passing the moon behind her; a disturbing, forceful and haunting image of raw originality which must have been very striking in *The Yellow Book*, where it was published in 1896. (In the same July number, another work by Frances and two each by Herbert MacNair and by Margaret Macdonald were also published.) Margaret Macdonald's *Summer* (circa 1894: HAG), which appears to have been a design for stained glass, shows a man of ancient Egyptian appearance indentified with the sun kissing an immensely elongated, pale girl who perhaps symbolizes the organic life of the earth. The pair are nude; three years later, in the watercolour *Summer* (GAG), also by Margaret, we find a virtual replica of the earlier composition, but greatly prettified – and it *is* a very pretty work – by the replacement of the grotesque man by a group of cherubs who symbolize the fertility of the warm season, and above all by the fact that the Junoesque figure of summer herself, now no longer etiolated and sun- or sex-starved, is clothed in a floral gown. The contrast between the two versions illustrates clearly the sisters' tendency at this point to move towards subject matter of ever more feminine whimsicality. This is noticeable in the companion watercolours *Spring* (1897) and *Autumn* (1898) by Frances and *Winter* (1898: all GAG) by Margaret. In each case also the extreme attenuations of drawing have virtually disappeared; Frances's treatment of the female nude is frankly and surprisingly sensual. Her large delicate watercolour *Ophelia* in following year (private collection), with its ubiquitous butterflies, harebells and flowing draperies, resembles the work of Katherine Cameron (who contributed an amusing article on butterfly collecting to *The Magazine*) and Jessie M. King.

From 1896 the Macdonald sisters occupied a studio at 128 Hope Street, Glasgow, where painting was only a small part of their remarkable output in various applied media; in 1899 Frances married Herbert MacNair and left Glasgow for Liverpool, where he had been appointed instructor in design; and by 1899 Margaret had begun her long and immensely important collaboration with Mackintosh, whom she married in 1900, as contributor to several of his decorative schemes. After 1900 her work retains the perfumed melancholy of the nineties to a greater extent than that of Frances, although both sisters in different ways remain equally wedded to the formal vocabulary of that era. Margaret's *The Mysterious Garden* (1911: private collection), for which Billcliffe convincingly suggests a source in Maeterlinck's *The Seven Princesses*, relates to the Mackintoshes' scheme for the Waerndoerfer Music Salon in Vienna and employs a suitably Klimt-like decorative frieze of masks; while the almost monochromatic *The Pool of Silence* (1913: private collection) transforms the Ophelia-like subject in a near-abstract treatment which also has a sculptural

quality like one of her own gesso reliefs. It is a strange fact that after Frances's return to Glasgow with her husband in 1908 after nearly a decade of disappointed ambitions and dashed hopes, Frances and Margaret never resumed their former collaboration. After her return, Frances produced two moving watercolours which technically may suggest an unpractised hand but demonstrate that the Art Nouveau style of 'The Four' was still capable of poignant, painful expressiveness. The eternal triangle is the theme of *The Choice* and *'Tis a long Path which wanders to Desire* (both circa 1909-15: HAG); gone indeed, in the cold light of the new century, are the carefree fancies of the artist's young womanhood. The sequel is sadder still. Frances died in 1921; her husband lost all interest in art and destroyed the bulk of her work. As a response, surely, to the death of her sister, Margaret painted the beautiful *La Mort parfumée* (1921: private collection), where five mourning figures (possibly a single figure viewed episodically in a stooping forward movement) place roses on a bier, above which the soul of the departed rises serenely.

78 Frances Macdonald
'Tis a long Path which wanders to Desire
c.1909–15 Watercolour 35.2 × 30.1 cm
Hunterian Art Gallery, University of Glasgow (Mackintosh Collection)

In contrast with the sometimes outlandish conceits of the other members of 'The Four' in their youth, Mackintosh's graphic style seems almost classically serene. Throughout his life he made architectural notes and jottings, many of them beautiful in their own right, but strictly outside the scope of the present book. He also habitually drew flowers and plants, with such precision that several were used for teaching purposes in the Botany Department of the University of Glasgow by Professor John Walton (E.A. Walton's son), as he himself told me in 1968. It would not be too much to say of the botanical drawings that they provided Mackintosh with source material for the new vocabulary of form he was creating as architect and designer. Patently, they belong to a venerable tradition of botanical art which runs from Leonardo and Dürer to the Dutch flower painters of the seventeenth century and the later botanical illustrators like Redouté, for whom accurate description of the species in bud, flower, leaf and bulb or root is as important as a suggestion of its beauty. Mackintosh's father, Howarth records, was passionately interested in his garden; his family was surrounded by flowers from their earliest years.

Young Charles inherited his father's enthusiasm and habitually made studies from nature. The close examination of natural forms seems to have refreshed him; he loved flowers and found them inspiring, their natural structures helping to endow his own inventions with the energy and logic of their own organic life. There are on the one hand the botanical drawings, usually marked with the name of the species, and signed and inscribed not only with the date and place but also with the initials of those who were present on the day, rather like a scientific writing-up of a day in the field. These are essentially line drawings of the utmost lucidity, often with different 'elevations' superimposed on each other (Billcliffe makes a justifiable comparison between these and analytical Cubism), and with delicate wash indications of colour. We know from Desmond Chapman-Huston that it had been Mackintosh's intention to publish a collection of these in Germany, but the advent of war prevented it, and after the war the idea was considered but rejected as too expensive by John Lane at The Bodley Head. After 1914 he also painted flowers arranged in vases and here the technique was infinitely more elaborate, Mackintosh

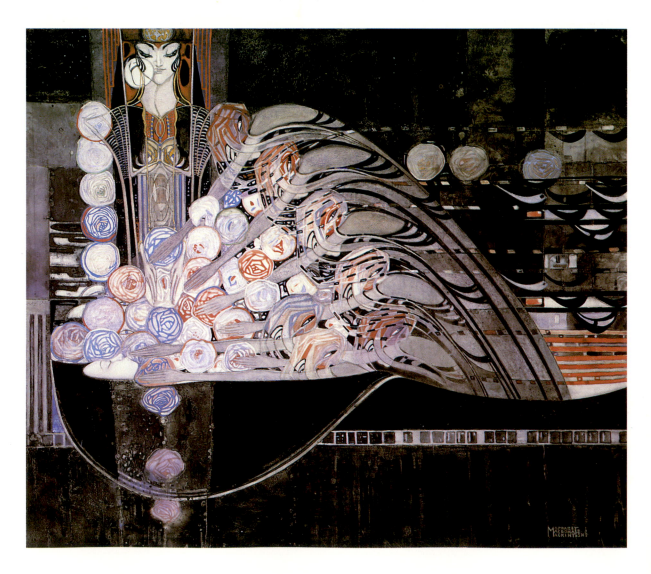

79 Margaret Macdonald
La Mort parfumée
1921 Watercolour 63 × 71.2 cm
Private collection

frequently delighting (as we have seen him do in earlier years) in solving fiendishly difficult self-imposed problems of technique in a successful effort to convey the beauty of the sumptuous blooms through an intoxicating display of virtuosity. This virtuosity is of no mean order. *Faded Roses* (1905: GAG) renders the very flesh quality of the drooping flower heads, their leaves on the turn, with a consummate sense of design and colour which gives tangible poignancy to the subject. *Anemones* (circa 1916: private collection) contrives to articulate two dozen examples of the species of all sizes and in whites, reds and blues of all shades with minimal drawing, the effect being achieved through brush-work of a delicacy and subtlety with which Arthur Melville himself would have struggled – and none of Mackintosh's contemporaries could have hoped – to compete, such is its combination of exciting immediacy with impressionistically descriptive accuracy. In the background, for we are now in a recognizable interior, an extraordinary abstract design (perhaps for a textile) based on a repeating sweetpea motif, hangs on the wall in a frame which is counter-balanced by the vertical blue stripes of the flower vase in the foreground. Abstract wave patterns of wallpaper add excitement to *White Roses* (1920: GSA) and *Peonies* (circa 1919-20: private collection) while in *The Grey Iris* (1900: GAG) all the colour comes from the wonderfully rendered still life – a Derby 'Imari' jug and a *famille rose* tea bowl. In *Pinks* (1922: GAG) Mackintosh paints nigh on fifty flower heads with the most attractive kind of virtuosity; the kind, namely, which communicates and proceeds from deep knowledge that is not merely technical. Their colour and form are brilliantly described, but their peculiar quality, character and beauty are also rendered with an amplitude which only just fails to convey their very perfume.

Discouraged by his failure to attract any commission commensurate with his architectural abilities – after the School of Art he was given no major architectural opportunity – Mackintosh resigned his partnership in Honeyman and Keppie in 1913, and in the following year he and Margaret left Glasgow for Walberswick in Suffolk. Here Mackintosh concentrated on painting flowers with the intention, mentioned above, of having them published by John Lane. The area was then and still is rich in certain varieties of wild flower, *Fritillaria* (1915: HAG) being a famous example in which nature appears to imitate geometry. The rather bizarre *The Little Hills* (HAG), painted in oils on two panels by Margaret but possibly designed by Charles, produced during the Walberswick period, revives the well-used 'Glasgow style' motif of subterranean figures – the cherubs who personify the 'little hills' – but its precise symmetry and mechanical design give it a Viennese look. A number of pensive landscape watercolours also date from this time of retreat. The end of the idyll, with Mackintosh's Glasgow accent,

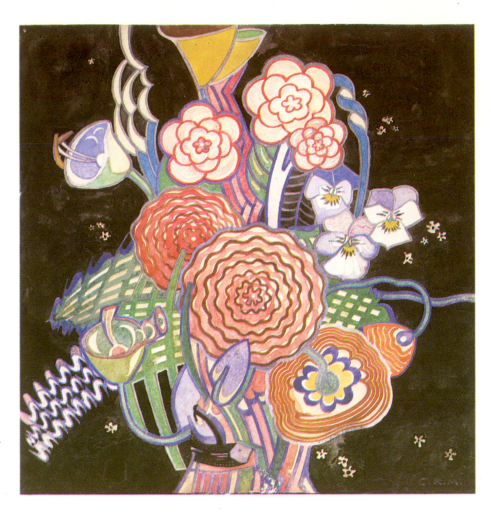

ever-present sketchpad, and correspondence with German and Austrian colleagues leading to his being suspected of spying, could have come straight from the pages of 'Mozart on the Journey to Prague' when the composer's manuscripts aroused similar suspicions. The story of this and of his ultimately unsuccessful attempt, after moving to Chelsea in 1915, to set up an architectural practice in London in the difficult years during and immediately after the war, has been well told by others. Suffice to say that from this point until his death, and especially after his decision in 1923 to give up architecture, Mackintosh devoted himself increasingly again to painting.

A Basket of Flowers (circa 1916) is a characteristic *jeu d'esprit* in the Jazz Age idiom, but it is also something more than that. In this, one of a small group of geometricized studies of flowers painted against a black background of which seven examples are known, Mackintosh actually appears to anticipate one of the themes of Op Art, namely the eye-deceiving properties of a moiré design which can appear to move or to change pattern. Each species of flower – there are harebells, gypsophilia, pansies, pinks, peonies and chrysanthemums – is drawn in ground plan. The chrysanthemums alone, however, are presented *on the page* as lobed, concentric circles of alternating red and blue. But *to the eye*, these read as intersecting arcs, and not as the lobed circles they

80 Charles Rennie Mackintosh
A Basket of Flowers
c.1916 Watercolour 31.7 ×
30 cm
Hunterian Art Gallery (Mackintosh Collection)

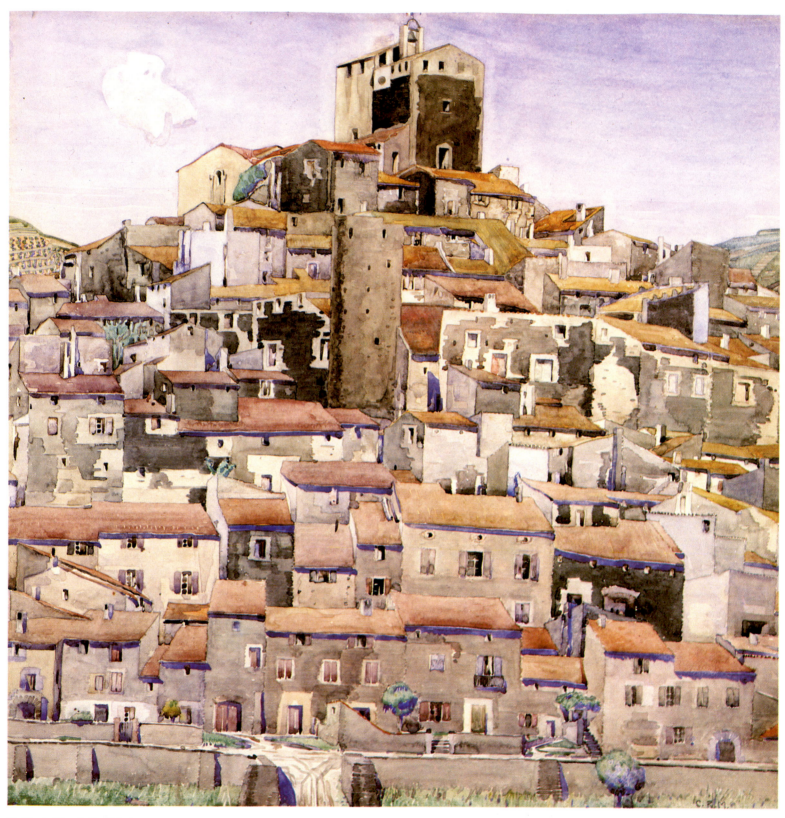

81 Charles Rennie Mackintosh
Boultenère
c.1924 Watercolour 44.7 ×
44.7 cm
Private collection

actually are – and in this respect describe the species admirably. These 'geometrical' flower paintings produced near the beginning of the Mackintoshes' London sojourn when they hoped to earn a living as textile designers, are related to textile designs of 1916. Lifted the merest jot from their modest origins as applied art, Mackintosh's astonishing textile designs, scaled up and presented as paintings like the framed sweetpea design seen in the background of *Anemones* would justly be regarded as precursors of Art Deco, of geometrical abstraction, of Op Art, Pop (in the American sense), as well as paralleling contemporary movements such as the *Section d'or*, or for that matter the colourism of Scottish painting; but they were never seen or exhibited, and remain objects of wonder without progeny or posterity.

The late landscape watercolours painted at Collioure and Port-Vendres, where the Mackintoshes settled on the advice of Margaret Morris and J.D. Fergusson in 1923, employ a chaste style of draughtsmanship and continue to the end to reveal the perfection of Mackintosh's technical gift in a series which allows no play of his remarkable imaginative powers. Their originality derives from the structural analysis of the motif and its translation into an extraordinarily pure combination of colour and line. We sense from these late works and also from his extensive correspondence of this period with Margaret, the artist's delight at his new-found freedom to experiment, without the worries of architecture or business, in a medium which tested to the limit his skill as painter and draughtsman. *Boultenère* (1924: private collection) typifies the architectural purity of his late landscape watercolours.

Among the associates of Mackintosh in Glasgow was George Walton (1867-1933), the younger brother of Glasgow School painter, E.A. Walton. George worked chiefly as an interior designer, in which capacity he became well-known for his designs for Kodak shops throughout Britain and the Continent. He shared with Mackintosh the responsibility for two of the brilliant schemes for Miss Kate Cranston's tearooms in Glasgow, at Buchanan Street and Ingram Street. His style is less radical than Mackintosh's and relates to Aestheticism; this is especially noticeable in his treatment of the figure and in his more crowded type of composition.

Outside Mackintosh's immediate circle in Glasgow, but owing much to it, and especially to the fairyland period of Margaret and Frances Macdonald, were the illustrators Jessie M. King (Mrs E.A. Taylor, 1875-1949) and Annie French (1873-1965), and the designers E.A. Taylor (d. 1952) and Talwin Morris (1865-1911). In the charming and accomplished decorative work of Jessie King and Annie French, the ethereal and other-worldly elements of Art Nouveau are sweetly intensified to a point where the world is reduced to a puff of thistledown, a web of gossamer, a diadem of forget-me-nots or a charm of finches, in which love-in-a-mist is personified as a pair of lovers, or where mermaids teach their babies to swim. These pretty conceits, delicate as butterflies' wings, will justly never lack admirers.

The hitherto unpublished *Journal* of Charles Mackie's wife Anne Mackie (MSS. Collections, NLS), recently sold by her nephew, provides fascinating insights into the connections of this Edinburgh artist with leading French painters of the day. These turn out to be much closer than previously realized, and the diary is worth quoting *in extenso*. The first person is used throughout and refers to the writer Anne, and her husband the painter Charles Mackie. The young couple had been married in 1891. The undated diary begins:

> In high spirits we set off for France in the spring in 1892, spending a few days in London to see the National Gallery, then on to Cherbourg to make a pilgrimage to Millet's birthplace at Gréville [in fact, Millet was born at Gruchy. After spending a fortnight at Vauville nearby, the couple travelled on through Normandy and Brittany] always searching for a little town of the beauty of which we had read a description in a magazine but had forgotten the name. This turns out to be Huelgoat – a quiet little village in the heart of Normandy [it is actually in Brittany] and then only to be reached by a very long drive from Morlaix in a ramshackle *diligence* with two horses [where they found accommodation in a fine old hotel]. And here we made our first acquaintance with the most advanced French art and artists, calling themselves 'les Symbolistes' – Paul Sérusier and Clément, a Dane. Although to us their work seemed queer, yet it had a curious fascination in spite of misshapen peasants and pink ploughed fields. We were all very happy but our happiness had an abrupt and tragic end' [when young Mme Sérusier suddenly died, probably of cholera] ... There was a midnight service in the chapel where her coffin lay until it was taken to Paris. Never shall I forget the solemnity of that service – the bowed heads of the mourners, the dimly lit chapel, the chanting and the incense.

Accompanied by Clément whom they introduce to the works of Turner, they return to London where they stayed for a month studying the treasures of the National Gallery and of the British Museum.

> We returned to Paris the following May to be most hospitably received by M. Sérusier who introduced us to his friends at a delightful luncheon party in his beautiful apartment – 10 Place de la Madeleine, where he lived with his father and brother. He himself was on the point of leaving for Brittany but his friends welcomed us with open arms – Ranson, Vuillard, Redon and others whom I forget. [Sérusier recommends the great Manet exhibition which is about to close at

Durand-Ruel's] a great opportunity and lasting pleasure for still after many years his beautiful work remains in my memory. [Unfortunately the authoress does not say after how many years.] There we met Guthrie and Lavery. Lavery was a charming person to meet – Guthrie more self-conscious and aloof. [The diarist goes on to describe the Mackies' visit to Paul Gauguin in his Paris studio.] M. Ser[usier] had told us of another exhibition which was about to close – Renoir's, and also took us to a house which Renoir had just decorated . . . and last but not least gave us an introduction to Paul Gauguin who had just returned to Paris after his first visit to Tahiti. Mons. Gauguin asked us to visit him at his studio and there we spent one of the most interesting afternoons of our lives. The door was flung open by a tall young man with thick lips and very curly coal-black hair . . . who ushered us in to a beautiful studio where we were most courteously received by an enormously fat man, clad in a thin white silk undervest and a pair of trousers, for all the world like a great Chinese god with the same urbane, dignified smile. He was charming to us taking me under his wing, while the tall young man, who turned out to be a well known poet of the name (I think) of Leclerc, acted as guide to C.H.M. [Charles Mackie]. Strange, weird things we saw – wonderful pottery and wood carvings, paintings extraordinary to eyes which had been revelling in the beauties of the National Gallery and the Louvre but of beautiful colour and intensely interesting and sincere. The strong personality and charm of manner of our host, the amazing and varied collection of work, unlike anything we had ever seen and far removed from the affectations of his followers made a deep and lasting impression. [As one can readily imagine. Anne Mackie continues, with a now educated eye,] M. Serusier's work disappointed me . . . I could not help feeling that his work although quite sincere, had little originality and seemed to have merit from his having associated with very clever people.

The diary continues with an intriguing account of the Mackies' obviously close acquaintance with the painter Paul Ranson and his wife, and ends with a visit to Vuillard's studio, where the leading Nabis makes the Mackies a present of one of his own paintings – the little *Deux ouvrières dans l'atelier de couture* which remained until he died in Charles Mackie's collection in Edinburgh, where it must have acted like the famous 'talisman' which Sérusier had brought back from Gauguin at Pont-Aven in 1888. The diary describes with such artlessness connections which are of great significance that no apology is needed for a final extensive quotation from it:

Our little studio in the rue Bara was open to our kind and hospitable friends . . . they loved my tea parties . . . tea and thin bread and butter and thin Paris cakes . . . Then on Saturday afternoons at M. Ranson's great, beautiful studio . . . an assemblage of friends presided over by his warm-hearted impulsive wife from the South of France with her black hair and large dark eyes and ample proportions and her beautiful sister, tall and slim of a dusky fairness with great violet eyes & golden hair curling all over her head in enchanting ringlets. It was delightful to see Mme. Ranson's pride in her beauty . . . The other studios we visited were more workaday and poverty stricken. I remember Mons. Vuillard's little garret stacked with pictures as if buyers came but rarely and his kind command to take the picture we liked best. And we were so afraid of being greedy that we took the smallest we could find but that picture is still a joy. And what quiet happy hours we spent looking over Japanese prints . . . the trusting shopkeepers letting us have great bundles home with us to choose what we wanted. We wanted all but although they were so cheap we never had money to spare . . .

In Edinburgh, *The Evergreen: a Northern Seasonal* published in four numbers by Geddes and Colleagues in Edinburgh in 1895-97, briefly had, through the French connections of its contributors Robert Burns and Charles Mackie, contacts as international as their Glasgow colleagues. Like 'The Four', Burns contributed to *Ver Sacrum*, and his own later work – e.g. the collection of Klimt-inspired illustrative drawings at the Hunterian Art Gallery – suggests that Burns was more influenced by the Vienna Secession artists than any of the other Scottish artists: unlike 'The Four', it could be said that the Edinburgh artists were more influenced than influential. However, this Vienna Secession journal seems to have borrowed at least one of the ideas of *The Evergreen*, the almanacs which preface some issues, although the idea may derive ultimately from the seasonal content and plan of *The Magazine* to which Mackintosh and his circle at Glasgow School of Art were contributing from 1894, and which it is entirely possible may have been seen by Geddes through his friendship with Newbery, rather than with the Mackintoshes whom he came to know later.

The Evergreen was a brave but short-lived venture producing results of mixed quality as far as the visual arts were concerned; its literary content is dominated by the 'Celtic twilight' sensibility of William Sharp, pseudonymously 'Fiona Macleod'. Perhaps the best things are the covers in embossed leather designed by Charles Mackie, and his charming, very Nabis black and white illustrations on such themes as 'Hide and Seek', 'When the Girls Come Out to Play' and 'Chucks'. Patrick Geddes, the publisher of the four seasonal numbers of *The Evergreen*, wrote to him to announce his delight that Mackie should have chosen for one cover the plant *aloe plicatilis* which d'Arcy Thomson and he were 'prepared to prove was the

original *arbor vitae* itself'. He adds, 'I take it as an omen that Science and Art are to be better friends than ever'. A note in the National Library of Scotland shows, too, that *The Evergreen* had at least two subscribers at Pont-Aven in 1895, one of them a Madame A. Henry at the Hôtel Gloanec. Charles Mackie, whose acquaintance with Gauguin and his circle brought him into closer contact than his Glasgow colleagues with the fountainhead of Symbolism, looks like a French Symbolist in the small study for *The Bonnie Banks O'Fordie* (1894: private collection). The convincing Nabis quality of this work was visible also in the wood engraving printed in *The Evergreen* but was lost in the scaled-up version exhibited at the RSA in 1897 as *There were Three Maidens Pu'd a Flower*. One wonders whether any others among Mackie's excellent compositions for *The Evergreen* were also painted in oils.

Robert Burns's *Natura Naturans* apparently produced during his stay in Paris in 1891, is the most original of all the illustrations; the contribution by Paul Sérusier – *Pastorale Bretonne*, in the Spring 1895 number – is disappointing, having perhaps suffered from bad block-making. The Celtic revivalism and biological mysticism which dominate the articles make heavy reading today, yet these are elements firmly interwoven also in John Duncan's work and which he passed on to his protégé, George Dutch Davidson, after the demise of *The Evergreen* in 1897. Duncan, Burns, Robert Brough and Mackie produced the most interesting work for the four issues, but this was their best period. Mackie's little sketch *By the Bonnie Banks O'Fordie* has an authentically Nabis appearance, but his work, and that of the others, later becomes humdrum, unless one has a special taste for the elaborate *kitsch* of Duncan's *Riders of the Sidhe* (DAG) and the many works of similarly Celtic inspiration which Duncan produced well into the late part of his career. Phoebe Traquair (1852–1936), the ceramicist who was Edinburgh's outstanding applied artist of the period, was inspired by similarly Celtic subject-matter. Mackie's Venetian studies painted in the early years of the century are beautiful but hardly break new ground.

In 1902, to commemorate their recently deceased colleague, members of the Dundee Graphic Arts Association published by subscription a memorial volume edited by John Duncan illustrating many of George Dutch Davidson's works in collotype and publishing his letters from Italy. The poet W.B. Yeats, returning a copy of this beautiful book which had been lent him by one of the members of the Association, wrote an accompanying letter full of a sense of *lacrimae rerum* appropriate not only to the death of a young artist, but perhaps also to the passing of a decade in which youthful originality had promised, and achieved, so much. Yeats writes:

... the book is beautiful with a kind of ritual beauty – as of things that have by very energy of feeling passed out of life, as though precious stones were made by the desire of flowers for a too great perfection – all such art delights one as if it were part of a religious service speaking to the whole soul, the passions not less than the moral nature uniting it to an unchanging order. Of course one can see influences, but that is an original nature using all, a nature more delicate and sensitive but less cold and logical than Beardsley's – whom I knew. How strange that these lyrical and decorative natures should so often be short-lived – Beardsley, Shelley and lesser men whom one has known, though the world has not.

George Dutch Davidson (1879-1901), the most talented of the east coast contemporaries of Mackintosh, achieved enough in a short life of twenty-one years – several haunting and startlingly prophetic watercolours and a group of supremely fine pen drawings – to make one wonder where his precocious visual intelligence might have led him granted only a few years more. He left school in 1895, intending to become an engineer. But in the spring of 1896 when he was sixteen, he fell victim to a severe attack of influenza, which left him with a serious heart condition that drastically shortened his life and left him a semi-invalid until his death at the age of twenty-one. A long convalescence was spent at Baldragon, near Dundee. He recovered slowly, and in the autumn of 1897, despite contrary advice from his physician and although he had shown no previous interest in drawing, he enrolled in the art classes of Dundee High School.

The return to Dundee enabled Davidson to extend his circle of companions to include a number of local artists, among them David Foggie (1878-1948), Frank Laing (1852-1907), John Duncan (1866-1945), Alec Grieve (1864-1933), and Stewart Carmichael (1867-1950). The young artist's style would probably not have developed as rapidly as it did without the benefit of his friendship with these talented and (in John Duncan's case), erudite artists. David Foggie, whom he met at this period, records:

Together we studied energetically after the antique and after the life when we could persuade our friends to pose for us. We also worked much at applied ornament. The immediate outcome of this zeal, for him, was a phase during which he made some half dozen drawings in watercolour, applied in flat wash and with great strength, the form being curved lines merely ... in them was first shown his unique decorative powers.

This very early period of experimentation bore fruit in the spring of 1898 with the *Abstract* of which only two versions have survived, one with a theosophical or cosmic setting of stars which the other lacks; and the powerfully symbolist *Envy* (all DAG). Davidson had probably met John Duncan by the time he painted this singular work, which shares certain

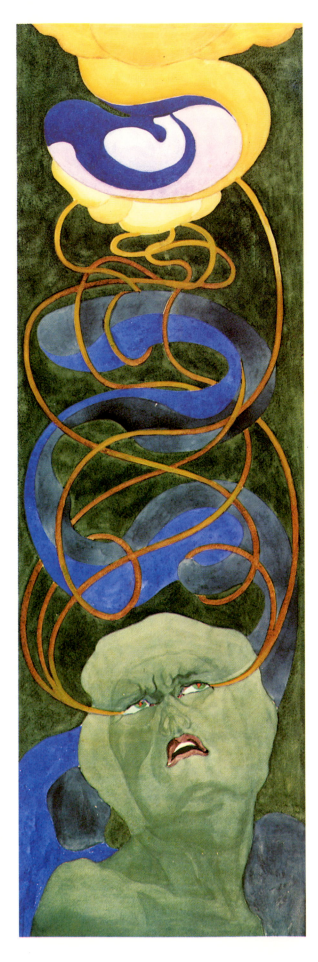

features with Duncan's line illustration *Anima Celtica* which had appeared in the Spring number of *The Evergreen* in 1895. In both designs, the head of the dreamer is shown in the lower half of the picture, but whereas Duncan's version of the reverie takes a concrete and illustrative form, Davidson's much more concentrated use of the decorative motif (a form of loose Celtic knot-work) is logically and dramatically superior. His colour is equally original. This extraordinary green-skinned creature, whose green eyes have bright red pupils, may be a distant cousin of the spooks engendered earlier in the decade by the Macdonald sisters in Glasgow, but even they, puzzling though their actions sometimes were, were never recorded with bad dreams sprouting from their eyes in the form of Art Nouveau tendrils exploding into gadroon-shaped blossoms of orange, lilac, and blue. Already in his first completed works Davidson had shown the personal quality of his imagination and subtle colour. The remarkable *Self-Portrait* belongs also to this period. Its fortuitous resemblance to a composition of Edvard Munch – *Im Menschenkopf*, 1897 – is all the more noteworthy when one realizes that of the two images it is the Davidson which is the more susceptible of Freudian interpretation. Rarely can there have been a more graphic illustration of the Freudian principle of id, ego and superego than here. Similarly, the abstract works seem extraordinarily prophetic and one can only speculate on how, and how far, their eighteen-year-old author would have developed this line of thought had he lived.

The symbolic style of *Envy* was discarded almost immediately, but the Celtic strain appeared again more conspicuously in a *Celtic Illumination* painted on vellum in 1899, in all probability under the influence of John Duncan, whose studio in Dundee at 31 Albert Square Davidson shared from the summer of 1898 until the autumn of 1899. The most purely decorative of George Davidson's works date from this period of his closest association with John Duncan. George produced several embroidery designs of great originality, some of them woven by Nellie Baxter who had (with Annie Mackie and Helen Hay) contributed interesting Celtic *culs de lampe* to *The Evergreen*, the artist's ultimate intention being to develop an embroidery school in collaboration with his cousin Elizabeth Burt. Of this period John Duncan wrote:

He was the most ardent student, assimilated everything that came his way, Celtic ornament, Persian ornament, Gothic architecture, early Renaissance art, seventeenth century tapestries, and wove every new influence into the tissue of his style. For he already had a style, mere youth as he was . . . His ornament was made up of Celtic and Persian elements, sometimes one and sometimes the other prevailing, and at other times drawn direct from nature. He made a number of very beautiful drawings of flowers and of foliage,

82 George Dutch Davidson
Envy
1898 Watercolour 76.2 × 24.1 cm
Dundee Art Gallery

seeking the rhythmic laws of their being. His colour always tended to be sad, though he was ill satisfied that it should be so . . . But he strove forward into the light, and achieved a pensive sweetness of faded pinks, and gold, and misty blues, and clouded violets.

In September 1899 George and his mother left Tayport, where they were now living, for the ten-month period of residence in London, Antwerp, and Florence which was to be the great experience of George's life. Three weeks were spent in London, where he assiduously visited the National Gallery, the South Kensington Museum, and the British Museum, his highest enthusiasm being reserved for the early Italian painters, especially Fra Angelico, and for the Greek vases and Oriental textiles in the collections of the great museums.

Antwerp was reached at the beginning of October. Four productive months were spent there. The little *Flemish Landscape* which records an impression of the country seen while sailing up the Scheldt, shows the muted use of colour which henceforth character-ized his work in this medium. It also shows how the artist saw nature in pattern – although by his own account the pattern in this case was pre-existing:

> We were sailing up the Scheldt. The country looks distinctly foreign and I found it very interesting no doubt because it is extremely decorative. There are no woods – the trees are placed in long straight lines at regular distances apart, and the foliage assumes some very nice forms . . . I could never have conceived houses so like toy ones – no! not even in a sampler design.

The pen drawing of a shrine opposite his window in the rue des Beggards, *A Street Corner in Antwerp* (1899: DAG), is an equally remarkable example of his faculty for seizing the decorative essentials of a subject. A sensitive pencil portrait of his mother drawn in November 1899 completed this trio of works of a semi-objective nature.

The next group of Davidson's works – four in number, all executed in Antwerp – belongs to the category of imaginative illustration. He now moved still further from what he regarded as 'the deep pit of Realism', a hazard he had been advised by John Duncan to avoid by staying away from the classes of the Antwerp Academy. *The Hills of Dream* (1899: DAG) illustrates a quatrain from a book of the same name by the pseudonymous Fiona McLeod, the chief poet of the Celtic Revival:

> And a strange Song have I heard
> By a shadowy Stream
> And the Singing of a snow-white Bird
> By the Hills of Dream.

But the apparent influences on this picture are early Italian and Persian rather than Celtic, although the passage upper left showing the girl transported episodically and literally on the wings of the song seems entirely original. Fiona McLeod's *On a Dark Wing* inspired another illustration, this time in watercolour grisaille, with the lettered text incorpor-ated in the design – an idea which was taken further in a later project drawing for an illumination of the poem *A Dream of a Blessed Spirit* by W.B. Yeats. The last two works done in Antwerp, both

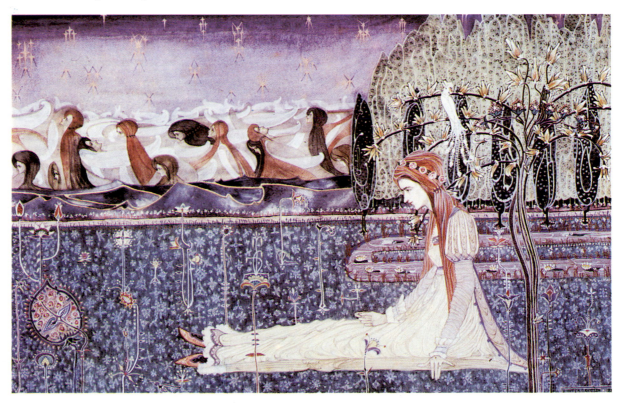

83 George Dutch Davidson
The Hills of Dream
1899 Watercolour 43.2 ×
68.6 cm
Dundee Art Gallery

84 George Dutch Davidson
The Tomb
1899 Pen and ink 24.1 × 29.8 cm
Dundee Art Gallery

illustrations to passages from *The Rubáiyát of Omar Khayyám*, are extremely intricate pen drawings entitled *The Tavern Door* and *The Tomb* (both DAG). Both drawings, especially the latter, mark a technical advance on the awkwardness of *The Hills of Dream*. Indeed, *The Tomb* is something of a *tour de force* in its complex refinement.

On 1 February 1900, Davidson and his mother left Belgium for Italy. He left Florence at the end of June and arrived in Scotland in August, having spent the intervening time chiefly in Ravenna and Venice. The works produced after his return, in the last five months of his life, are still of a complexly decorative character; but the influence of *quattrocento* painting, and of the Tuscan landscape, is visible in *Ullalume* (1900: DAG) – an illustration to a poem of Edgar Allen Poe – and in *Apotheosis of the Child* (DAG), his unfinished last work. Both designs are more expressively poignant than any of their predecessors, in a more purely Italianate way. They also show an even greater degree of technical refinement. Of the other works from this final period, *The Silent Pool* (private collection), for which a drawing had been done in Antwerp, is the most ornamentally decorative of all his watercolours; an embroidery design (DAG) which Davidson regarded as his best was executed posthumously; and three small pencil drawings exist (DAG) for projects which were never completed.

George Davidson had no artistic progeny. The little group of which he was briefly the centre in Dundee had already lost John Duncan to Chicago in 1901. Art Nouveau in Edwardian Dundee was restricted to architecture, notably the six schools designed for the Dundee School Board, and the fascinating Church of St. Mary's Forebank with its pagoda twin spires, by the Dundee firm of J.H. Langlands between 1905 and 1913. But in Davidson's work Dundee may be said to have made an original contribution to the iconology of that exotic movement. With its combination of intensity and refinement and its syncretic use of several decorative influences, it is one of the rarest blooms in the hothouse.

8 THE COLOURISTS

One possible view of the four painters who have been called the Scottish Colourists – S.J. Peploe (1871-1935), J.D. Fergusson (1874-1961), Leslie Hunter (1877-1931), and F.C.B. Cadell (1833-1937) – is that they continue a specifically Scottish tradition first established by William McTaggart and his younger contemporaries in Glasgow who formed the Glasgow School. McTaggart from before the 1870s and the Glasgow painters from the 1880s introduced vigorous handling and bold colour to Scottish painting at a period when accepted academic practice still rested on the twin pillars of high finish and imitative drawing. McTaggart's seashore pictures, and such a work as W.Y. Macgregor's *The Vegetable Stall* (1884), had restored to landscape and still life a certain monumentality and expressive breadth which resulted from powerful brushwork and the use of a lighter palette than was then common. That Fergusson and his friends were influenced by the example of these earlier painters is evident from some of their early paintings. Other evidence points to the same conclusion. A notebook of Leslie Hunter's, written about 1914, records the colours used on the palettes of Van Gogh, Gauguin, Cézanne, Whistler – and William McTaggart; and Cursiter states, 'Peploe had a high regard for McTaggart – one of his greatest regrets was that he never met this fine Scottish artist'. Peploe knew and admired W.Y. Macgregor, the 'father of the Glasgow School', one of whose paintings was the only work by another artist which Peploe hung in his own studio. F.C.B. Cadell also had a Glasgow School connection in the friendship of his parents with Arthur Melville, who was godfather to his young brother and persuaded his parents to send the young Cadell to study at Julian's in Paris. An early *Flower Piece* (1907: private collection, Rhu) by Cadell is decidedly Melvillesque, and Cadell's *Jack and Tommy* drawings (1916: private collection, Helensburgh) provide the clearest case of a Glasgow School influence; their humour is of the London Sketch Club variety, but their extreme economy of line emulates Joseph Crawhall. J.D. Fergusson claimed that Arthur Melville was the 'first influence' on his own painting, and that 'Although I never met him or saw him, his painting gave me my first start; his work opened up to me the road to freedom not merely in the use of paint, but freedom of outlook'.

Fergusson's remark serves to summarize the relation of the Colourists of his own generation to the Glasgow School as a body. There is little trace of Melville's highly individual style in Fergusson's own manner, with the notable exception of *On the Beach, Tangier* (1899: GAG), which is strongly reminiscent of Melville's *Mediterranean Port* (1892: GAG). The interest of Melville's style lay, more generally, in his painterly execution and exuberant use of colour; and it was under Melville's influence that Fergusson first went abroad to paint, visiting Paris in 1896 and North Africa in 1897. Foreign travel and the contact it provided with advanced painting on the Continent were of the greatest importance to each of the Colourists in their formative years. Fergusson's attitude in this respect is symptomatic. In his idiosyncratic and infuriating book *Modern Scottish Painting* (1943) he justifies his decision to exile himself from Scotland in terms which excoriate the philistine environment – equated variously within Victorianism, Calvinism, and academic art – which smothered the early vitality of the Glasgow School. We learn from Honeyman's account of Leslie Hunter that Hunter too was critical of the absence of colour in Scottish life, and in the Peploe correspondence we find the remark 'it is terrible to be an artist and live in Edinburgh' (1908), and in 1912, written from Edinburgh to his wife in Paris, 'I couldn't go back to this house and this life – it all seems so cramped and dull'. Whether or not one accepts these points of view, it is evident from them that in the eyes of Hunter, Fergusson, and Peploe, at least, colour had an important role to play in the salvation of a Scottish painter. Here is one explanation of the pilgrimages made by the Colourists to France: to the Paris galleries where they could see the works of the Post-Impressionists, and to the dazzling light of the Côte d'Azur.

The Glasgow School was at the zenith of its influence on Scottish art affairs in the Edwardian period when these artists were still at an early stage in their careers. Many of its members had by this time been made members of the RSA, and although most of the Glasgow painters had become formula-bound, at least three of them began in the earlier part of this century to use colour in a high-keyed manner which represented a genuine development from their earlier styles. These artists were E.A. Hornel, Stuart Park and W.Y. Macgregor. The two versions of *Oban Bay*

(neither dated: GAG) by Macgregor present a remarkable and by no means disappointing contrast with his earlier style: they indicate a convincing grasp of a new colour idiom. Hornel's paintings from 1900 until his second visit to the Far East in 1907, include some of his best work, not yet entirely spoiled by sentimentality or crude handling, and also in a higher key than previously. Stuart Park, too, had arrived by this time at a second, admittedly more superficial, phase in his work, but his use of strongly accented colour contrasts at this period is as striking as his fluid technique with a full brush. Certain parallels may be drawn between this artist's flower paintings and Peploe's 'white period' pictures painted between 1905 and 1910. But the comparison should not be pressed too far. It suffices to say that, while Peploe, Fergusson, Hunter, and Cadell were forming their characteristic styles, a few other Scottish painters were groping towards the consistent use of colour in a high key. With the exception of Robert Bevan, the Camden Town painters were less thorough-going than their Scottish contemporaries in this respect.

However, it would clearly be absurd to suggest that the sources of the Colourists were exclusively Scottish. In fact, the early lives of these artists were unusually cosmopolitan. This is especially true of Leslie Hunter, who left Scotland for the Mediterranean climate of California at the age of thirteen,

worked as an illustrator in San Francisco, and returned to Glasgow in 1906, after the earthquake of that year had destroyed all his pictures in his first one-man show on the eve of its opening. He had managed to visit Paris in 1904 and continued to do so at intervals during his career as an illustrator in Glasgow, which seems to have lasted until 1914. A compulsive draughtsman, Hunter was largely self-taught, like Fergusson, whose only formal instruction in painting seems to have been received at the Académie Colorossi briefly about 1898. Fergusson himself lived in France until the outbreak of war in 1914; after 1918 he made frequent return visits and was again permanently resident there from 1929 until 1939, when he returned to Glasgow. Peploe received a formal training in Edinburgh and Paris. However, he appears to have despised it and described Bouguereau, his teacher at Julian's, as a 'damned old fool' in a scribbled catalogue note to his exhibition at the Kraushaar Gallery in 1928. Before 1910 he had visited Paris on several occasions, and Amsterdam once. A mischievous early drawing, dated 1898 (J. Cadell) by F.C.B. Cadell, indicates an equal disrespect for the local establishment; it shows C.W. Hodder, head art master at the Edinburgh Academy, as a decrepit valetudinarian surrounded by plaster Venuses. Cadell studied in Paris from 1899-1903, and seems to have spent most of the decade from

85 John Duncan Fergusson
Afternoon Coffee
c.1904 Oil on panel 28 × 35.5 cm
Private collection

1899 to 1909 on the Continent.

As their different ages and backgrounds would lead one to expect, the early achievement of these painters indicates unequal levels of maturity. As the oldest of the four, S.J. Peploe developed earlier than Hunter and Cadell, and two distinct phases are evident in his work before 1910, both showing his decided francophilism. J.D. Fergusson wrote: 'Before we met, Peploe and I had both been to Paris – he with Robert Brough and I alone. We were both very much impressed with the Impressionists whose work we saw in the Salle Caillebotte and in Durand-Ruel's gallery. Manet and Monet were the painters who fixed our direction, in Peploe's case Manet especially. He had read George Moore's *Modern Painting* and Zola's *L'Oeuvre*'. Peploe's Comrie landscapes of 1902 are indeed Impressionistic, while his early portraiture indicates an admiration for the *peinture claire* of Manet, although the influence of Frans Hals can be discerned in his *alla prima* method and the informal poses chosen for his sitters. The large portrait of *Old Tom Morris* (n.d.: FAS), clay pipe in hand and whisky glass upraised like a Hals toper, is a typically fluent example; the work of Peploe's close friend of this period, the Aberdeen artist Robert Brough (1872-1905), whom we have already encountered as a contributor to *The Evergreen*, reveals a similar fluidity of handling. With his move in 1905 to the studio which had once belonged to Raeburn at 32 York Place in Edinburgh, and which Peploe decorated 'in a pale grey with a hint of pink', the Manet strain became dominant in his work. Between 1905 and 1910 the mastery of Peploe's handling of his creamy, lustrous medium, and the boldness of his brushstroke are considerably more personal than anything achieved by Hunter or Cadell in the same period.

In 1906 Fergusson and Peploe spent the summer painting together at Paris-Plage, and in the following year Fergusson decided to settle in France and exhibited at the Salon D'Automne (of which he became a *Sociétaire* in 1909). In the first decade of the century Fergusson developed with great assurance and rapidity towards a fully Fauve style, which does not always seem entirely French. *The Pink Parasol* (1908: GAG) shows a remarkably early grasp of Fauvist colour practice, but sometimes his style has a bejewelled, ornamental quality (cf. *The Blue Hat*, 1909: ECAC) and at others an Expressionistic forthrightness (*Torse de Femme*; circa 1911: GAG) more reminiscent of Jawlensky or Erbslöh, but quite sufficiently individual to stamp Fergusson as one of the most powerful personalities among the contingent of foreign painters in Paris. Fergusson began as an admirer of the Glasgow School, particularly of Arthur Melville, and of Whistler. *Dieppe, 14th July 1905: Night* (David Long Co., New York) is joyfully indebted to Whistler's *Cremorne Gardens* fireworks pictures. There is something also of James Pryde's *John Jorrocks* in Fergusson's *Le Cocher:*

86 John Duncan Fergusson
The Blue Hat, Closerie des Lilas
1909 Oil 76.2 × 76.2 cm
Edinburgh City Art Centre
The sitter was Yvonne Davidson, wife of the American sculptor, Jo Davidson.

Crépuscule (1907: J.R. Ross). By 1910 Fergusson had already demonstrated his command of a wider range of themes than his Scottish colleagues possessed, and in the remarkable groups of works produced in the years 1910-18, the female nude was added as a further major theme, and was followed, but not replaced, by the exceptionally original war paintings of naval dockyards.

Leslie Hunter at this time was still producing illustrations which show an admiration for Forain and Steinlen. About this period he became acquainted with the paintings by Kalf at Kelvingrove Art Gallery in Glasgow and with the three paintings by Chardin in the Hunterian Museum, which were influences on his early realism, of which *Kitchen Utensils* (circa 1914: TG) is an example. Hunter was the least intellectual of artists and never showed the formal sophistication of the other Colourists, preferring to develop gradually his use of high-key colour in a craftsmanlike way. Similarly, Cadell's work before 1910 does little more than hold some promise of future originality. The facility of his draughtsmanship and gift of colour are evident in the early *Flower Study* (1907) already referred to.

It was in the years 1910-14 that Peploe and Cadell began to paint in the distinctive way which J.D. Fergusson had to some extent pioneered for them, which was to be followed later by Hunter, and which

87 Samuel John Peploe
Boats at Royan
1910 Oil 26.7 × 34.3 cm
Private collection

earned for these artists the title of 'Colourists' (which incidentally does not seem to have been used until 1948, when only Fergusson was still alive). Peploe, Hunter and Cadell had first exhibited together in 1923 at the Leicester Galleries, but they were joined by Fergusson as *Les Peintres de l'Ecosse Moderne* at the Galerie Barbazanges in 1924, and brought to a total of six by the addition of Telfer Bear (b.1874) and R.O. Dunlop (b. 1894) as *Les Peintres Ecossais* at the Galeries Georges Petit in 1931. In 1910 Cadell visited Venice, sponsored by his friend Sir Patrick Ford, and also in 1910 Peploe moved with his family to France, where he painted at first in Paris and Normandy and then on the Côte d'Azur with Fergusson and Anne Estelle Rice. For both men their experiences provided the release which drew from them a number of novel works. Rapidly painted on panel, Cadell's little *St. Mark's Venice* (1910: J. Cadell) and Peploe's *Boats at Royan* (1910: private collection) boldly employ bright colour which achieves a striking lyrical intensity and simple immediacy.

Fergusson's *Royan Harbour* (1910: HAG) presents an obvious and close parallel to the Peploe, but already heavy outlines which expressionistically reinforce the composition are evident in Fergusson's work. These appear with greater aptness in the figure subjects of this period. In *Blue Beads* (1910: Fergusson

Foundation), the simplifications of plane recall Matisse's portrait of Marguerite Matisse (*Girl with a Black Cat*) of the same date; *La Force* (1910: ibid.), fully justifying its title, calls to mind Fergusson's own later words in his chapter on *Art and Engineering*: 'We admire the woman that looks as if she was capable of procreation, in other words healthy and capable of functioning'. The sensuously hedonistic *Torse de Femme* at Kelvingrove is another example in which powerful handling is matched by a robust voluptuousness in the model. Thus, by 1910, the year of Roger Fry's celebrated exhibition of paintings by Manet and the Post-Impressionists in the Grafton Gallery, Fergusson, Peploe and Cadell were producing work which in terms of colour was as closely in sympathy with advanced French painting as anything in British painting. For his 1910 exhibition Fry had considered applying the title 'Expressionist' to the chromatic daring of Van Gogh and Gauguin, but in his Second Post-Impressionist Exhibition of 1912 he removed the emphasis which his earlier exhibition had laid on colour, and placed it instead on formal and constructional values in painting. The development of the Scottish Colourists at almost exactly the same period presents something of a parallel to the development of Roger Fry's views. Between 1912 and 1914 Peploe and Fergusson worked together and began to draw and paint in a more formalized

manner which reveals a knowledge of Cézanne and his Cubist followers. Furthermore, as described by E.A. Taylor in Paris in 1914, Leslie Hunter was 'Full of Cézanne – he had been to where Cézanne worked etc. and he . . . showed me a number of chalk drawings he had done, quite a departure from the things he had originally shown me'.

In December 1913 the Society of Scottish Artists, not to be outdone by London, included in its Annual exhibition a number of invited works by Cézanne, Gauguin, Herbin, Matisse, Russolo, Sérusier, Severini, Van Gogh and Vlaminck as well as works by Fergusson and Duncan Grant. In twelve letters written to me in 1973-74 (NLS) Stanley Cursiter (1887-1976) wrote that a chance introduction to Roger Fry and Clive Bell at the Grafton Gallery

exhibition of 1912-13 set in motion the loan of these European works to the SSA exhibition. Cursiter writes: 'I was actually responsible for the [SSA] Exhibition of Post-Impressionists in 1913 . . . Circumstances made it possible for me to borrow a group of pictures from the exhibition held in London in the Grafton Galleries . . . The Exhibition in Edinburgh nearly wrecked the Society!' Cursiter further explains that the SSA of which he was then a Council member 'had a very definite aim to secure on loan for each Exhibition, important works from France, etc.' Since Futurist artists were not in fact included in either of Fry's exhibitions, it is probably safe to assume that at the distance of some sixty years the artist had forgotten the Futurist exhibition of 1912 (Sackville Gallery) and the Severini exhibition

88 Stanley Cursiter
The Sensation of Crossing the Street, West End, Edinburgh
1913 Oil 50 × 60 cm
Private collection (Photograph: William Hardie Gallery)
Four streetcars, a hackney carriage, twenty-three figures and a white dog at the corner of Princes Street and Lothian Road.

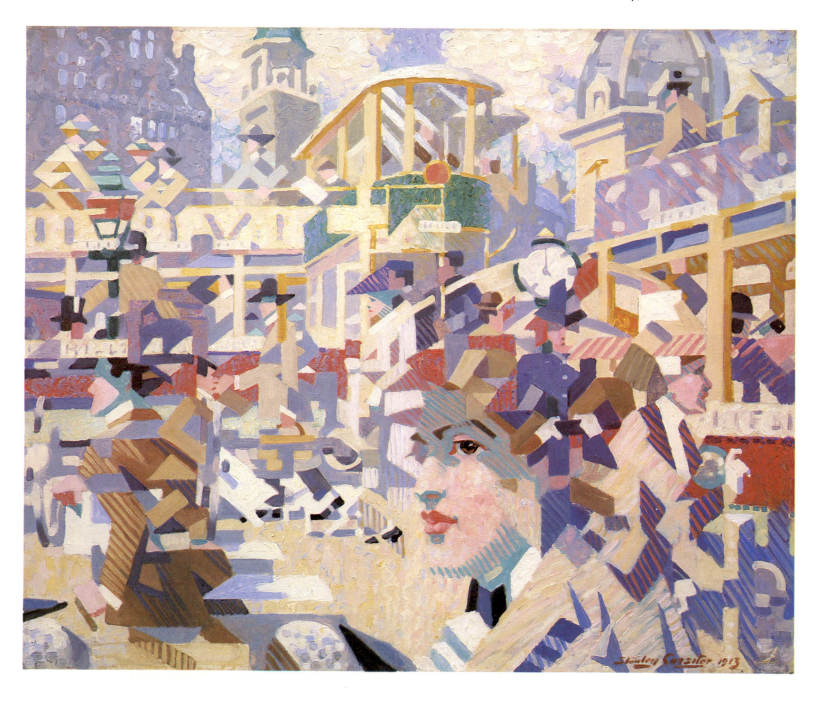

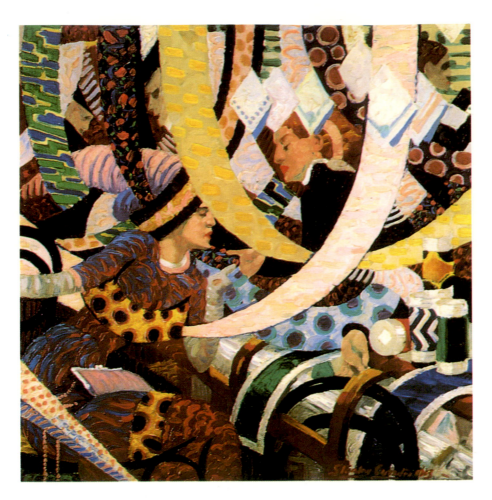

89 Stanley Cursiter
The Ribbon Counter
1913 Oil 48 × 48 cm
Private collection
(Photograph: William Hardie
Gallery)
Fashionable customer and
deferential assistant amid the
colours and patterns of Jenner's
haberdashery on Princes Street.

of 1913 (Marlborough Gallery) which he could well have seen in London. The pictures by Severini and Russolo were among several which were also shown at the Glasgow Institute a month before their appearance in Edinburgh at the SSA in December 1913. Stanley Cursiter's *The Sensation of Crossing the Street – the West End, Edinburgh* (1913: private collection) was the artist's sole exhibited response in the SSA show of 1913, to his recent experience of Italian Futurism, and particularly the work of Severini, with whose *Le Boulevard* in the same exhibition it would immediately have invited comparison. This spectacular painting and J.Q. Pringle's *View of Bridgeton* interestingly, were shown at the Whitechapel Art Gallery's *Twentieth Century Art: A Review of Modern Movements* in the following year. In fact the painting was one of an astonishing series of seven Futurist compositions painted by Cursiter in 1913 and depicting that modern life – if not quite the machine age – so beloved of the *Futuristi* using the multi-faceted simultaneity of Severini and then the elastic rhythms of Boccioni. These paintings reveal such intensity of invention, such excitement at the discovery of a new formal vocabulary, and such painterly quality of colour and brushwork, that they merit listing individually in a chronological order suggested by stylistic progression and also by information provided by the artist himself in the 1974 correspondence already quoted.

Tea Room and *Synthesis of the Supper Room at an Arts Club Reception* (ECAC), are small, deliciously painted, and tentative in the use of the Futurist style. *The Ribbon Counter* (private collection) is much more confidently composed and brilliant in colour and is based on a Severini composition, as is *The Sensation of Crossing the Street – the West End, Edinburgh*. The most complexly geometrical of the series, the latter is a *tour de force* containing a crowd of figures, a hackney carriage, cable cars, a dog and a self-portrait of the artist against a detailed architectural portrait of Edinburgh's West End (including Binn's clock showing four in the afternoon). The viewpoint is from the south side of Princes Street and the whole busy, modern scene provides a 'sensation' pleasing to the pretty girl in the foreground. In the related, unfinished *Princes Street on Saturday Morning* (private collection), the artist is beginning to introduce a Futurist, Sant' Elia-like treatment of the architecture, this time looking towards the east. *Rain on Princes Street* (DAG), painted with a nearly monochromatic palette, contains a striking passage which shows the lamp standards outside the New Club modelled in the manner of sculpture by Umberto Boccioni. Almost certainly last in the series is the unfinished, Fergusson-like *The Regatta* (SNGMA). From the Commodore's yacht, flying the white ensign of the Royal Yacht Squadron at Cowes, an elegant party of spectators watch an afternoon's racing on one of those carefree summer days which the war was to bring to an end.

Cursiter, like so many artists, enlisted at the outbreak of the war and was sent to the trenches of the Somme, but not before completing several figure paintings of compelling quality, of which the most important is undoubtedly the beautiful *The Evening Hour* (1914: NGS), a conversation piece including portraits of the artist's sister, her husband and friends in the artist's studio in Queen Street, Edinburgh, and a passage of still life painting worthy of early Peploe and Fergusson. Incredibly a third style was added by Cursiter to the two we have already examined from this pre-war period, in a group of Maja-like reclining studies of an extremely pretty brunette model, at least one of them nude (except for a head band and a wrist watch). Brief mention only can be made of his vastly accomplished earlier work as an illustrator working for the Edinburgh firm of McLagan & Cumming (1904-1908); the early lithographs, often illustrating Northern legends, provide ample evidence of his versatility and technical prowess. Cursiter made a significant contribution to the development of aerial cartography during the war. His great talents were exercised in other fields after the war – in his own words he 'became a portrait painter more or less by accident', and also, he might have added, a distinguished painter of the landscape of his native Orkney. From 1930 to 1948 he was an innovative Director of the National Galleries of Scotland, laying plans for a Gallery of Modern Art and writing a

useful study of Scottish painting and the standard biography of Peploe.

Press reaction to what must have been an unusually exciting SSA exhibition in 1913 was surprisingly open-minded. *The Scotsman* commented: 'Mr Stanley Cursiter, one of the younger Scottish artists, may be complimented on the step forward he has taken in his art. He has never before been so strikingly represented in an art exhibition as he is here. His "Studio Corner", in which a girl figures, is vigorous and realistic, but he will surprise his friends more by his life-size study of the nude, with a mirror reflection, in which the figure is satisfactorily drawn, and the colour has power and vitality. Mr Cursiter has also tried his hand at a cubist composition of the maze at the West end of Princes Street . . . It is a pretty bit of patchwork, but was there ever such colour seen on the humble double-deckers and open roofed cars . . .? The pretty face in the foreground is quite like Edinburgh.' The *Glasgow Herald* on the same day (13 December 1913) was equally receptive: 'One of the members of the Society, Mr Stanley Cursiter, has apparently come under the spell of the new movement. In cubist style he has painted the scene of a 'West End Crossing', . . . coloured cubes representing humanity and cable cars . . . Mr Cursiter's adventure is not to be lightly dismissed; it seems to suggest that Cubism may really have a future.'

The Studio commented on the SSA Exhibition of 1913 as follows: 'That some of the younger men are not unaffected by these modern developments was seen in Mr Peploe's fruit and flower studies, which are a limited and tentative essay in Cubist practice', and the same writer singled out a painting by Cadell, *Fancy Dress*, as a 'bold impressionist picture distinguished by the dexterity and surety of its colour design'. The comments quoted above indicate something of the respective responses of Peploe and Cadell to their experience of recent French painting. We would not now apply the term 'impressionist' to Cadell's work. Nevertheless, such a brilliant example of his early maturity as *The White Room* (1915: private collection) and the *Still Life* (1914: DAG) put colour and fluent handling above volumetric considerations, whereas the paintings produced by the other Colourists at the same time show more evidence of the lessons of Cézanne. Writing to T.J. Honeyman in 1939, E.A. Taylor throws an unexpected sidelight on the development of Hunter

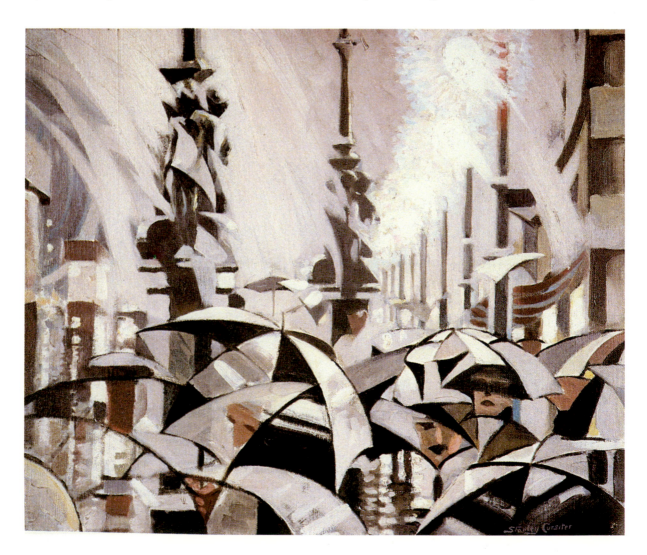

90 Stanley Cursiter
Rain on Princes Street
1913 Oil 50 × 60 cm
Dundee Art Gallery

and Peploe before their return from France at the beginning of the First World War: 'while in Paris Peploe was tremendously taken up with an artist's work, an artist named Chaubad (sic), *very strong stuff, thick thick lines* and flat colours, and Hunter was very much taken up in a way with it too'. Auguste Chabaud (1882-1955), a follower of the Fauves, had his first one-man show at Bernheim-Jeune's in 1912, and, like Peploe and Fergusson, exhibited at the Salon d'Automne as well as contributing to the English journal *Rhythm*, of which Fergusson was art editor, in 1911. Taylor's report is of particular interest, because it suggests that in the midst of the brilliant extremes of pre-war artistic life in Paris, Hunter and Peploe (and presumably Fergusson too) were still attracted by a painter of relatively conservative disposition. Chabaud's connection with Provence and with the aged poet Mistral invited analogy with the decision of Cadell, Peploe, and Hunter to base themselves in Scotland at a time when authors such as Pittendrigh Macgillivray were conducting a minor revival in Scots dialect poetry. Yet the illustrators whom Fergusson was able to persuade to contribute to *Rhythm* in 1911 constitute a veritable Who's Who of the contemporary Parisian *avant-garde*: Derain, Friesz, Gaudier-Brzeska, Gontcharova, Larionov, Marquet, Picasso, and Segonzac, as well as Peploe, Anne Estelle Rice and Fergusson himself.

91 John Duncan Fergusson
Damaged Destroyer
1918 Oil 73.6 × 76.2 cm
Glasgow Art Gallery

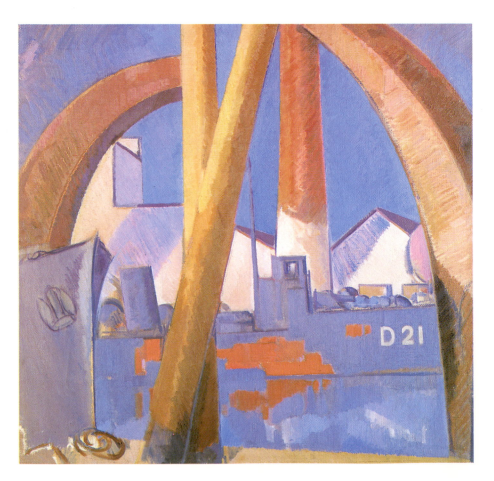

The contemporary use of the word 'Cubist' in connection with Peploe's work in 1913 is somewhat startling, but there is no doubt that, broadly speaking, he and Fergusson were more immediately affected by Cubism than Cadell or Hunter. Between 1911 and 1913, when J.D. Fergusson was art editor of *Rhythm*, both he and Peploe contributed drawings to that journal which have a schematic, geometrical quality absent from the work of the other Colourists. Fergusson went further in this direction than Peploe, however, and his style subsequent to this period shows an interest in the abstract qualities of linear rhythm which aligns him with the post-Cubist School of Paris. This and the long periods during which he was domiciled in France effectively separate him from his three Scottish colleagues, whose later development in Scotland follows tamer paths. In fact the Colourists pursued independent careers except on the infrequent occasion of a group exhibition, although Cadell and Peploe did go painting together in the Hebrides in the 1920s. In 1936 Cadell, writing to Ion Harrison, remarks that he had not seen Fergusson since 1909. Malcolm Easton has convincingly suggested that the origin of the visual style of *Rhythm* lay in the first performances of the Russian Ballet. In his *Memories of Peploe* Fergusson himself wrote of the evenings they spent together at the *Ballets Russes*: 'No wonder S.J. [Peploe] said these were some of the greatest nights of his life. They were the greatest nights in anyone's life – *Sheherazade, Petrouchka, Sacre de Printemps*, Nijinsky, Karsavina, Foukine'. Larionov and Gontcharova both contributed to *Rhythm*. Fergusson's most ambitious work of the *Rhythm* period, the monumental *Les Eus* (1910-11), a neologistic title meaning 'the possessed', or, as Margaret Morris suggests, 'the healthy ones', with its frieze of athletic men and maenads, carries at least an echo of the ballet. More than Derain's *La Danse* (circa 1906: Josefowitz collection, Geneva), *Les Eus* is full of a powerful tonic vitality which derives principally from the rhythmical repetition of arcs which give the dancing figures the outline of a bow drawn taut. A remarkable drawing for the flying female figure on the extreme right shows real mastery of the nude in movement (private collection).

Together with certain other works of the same period such as *At My Studio Window* (1910: Fergusson Foundation) and *Rhythm* (1911: University of Stirling) *Les Eus* announces a recurrent preoccupation in Fergusson's later work, that of the female nude treated monumentally, with conical breasts and cylindrical limbs. An example of this is the punningly titled *Megalithic* (1931: private collection), a portrait of the artist's wife, the dancer and painter Margaret Morris. Two of Fergusson's regrettably rare excursions into figure sculpture, the *Dryad* (1924: HAG) and the brass *Eastra, Hymn to the Sun* (1924: SNGMA) – representing 'the triumph of the sun after the gloom of winter' – are likewise dithyrambs to youthful female vigour expressed in

92 Samuel John Peploe
Spring, Comrie
1902 Oil 40.5 × 51 cm
Kirkcaldy Art Gallery

generalized, almost totemic forms. The painting *Eastra with Fruit* (1929: Fergusson Foundation) incorporates the *Eastra* piece with the pile of ripe fruit which often accompanies these subjects. The inanimate remoteness so conveyed is not far different from the effect gained with a living model, as in the later *Full of the Warm South* (1953: DAG). The title of this latter work is taken from Keats's *Ode to a Nightingale*, a poem presumably particularly sympathetic to Fergusson's meridional taste. The very late *Wisteria, Villa Florentine, Golfe-Juan* (1957: Fergusson Foundation) is quite as hedonistic as the other painting despite the absence of the model. It is a lyrical work showing a table set *al fresco* with a *compotier* and overlooking the blue sea on which appears the white triangle of a sail. It incidentally shows that Fergusson's artistic output remained undiminished in quality, although it lost some of its original edge, until the end of his long life.

During the years of the First World War, which Fergusson spent in London and Edinburgh, his work continued to develop. The first pictures of this period suggest an attempt to consolidate and to codify the discoveries of the *Rhythm* years of 1911-13. The portraits *Complexity: Mrs Julian Lousada* (1915: Fergusson Foundation), *Simplicity: Kathleen Dillon* (1916: Angus Morrison), and *Rose Rhythm: Kathleen Dillon* (1916: Kathleen Dillon) are conspicuous

for a formal organization which is still very dependent on line but already less two-dimensional and more planar than the *Rhythm* work. Fergusson's own comments on *Rose Rhythm* illuminate the remarkable unity of portraiture and fashionable *chic* in the painting. It arose from his initial observation of the sitter's hat which she had just made: it 'was just like a rose, going from the centre convolution and continuing the *Rhythm* idea developed in Paris and still with me. Looking at K. I soon saw that the hat was not merely a hat but a continuation of the girl's character . . . I painted *Rose Rhythm* – going from the very centre convolutions to her nostril, lips, eyebrows, brooch, buttons, background cushions, right through. At last, this was my statement of a thing thoroughly Celtic'.

Landscape, which was to be important to Fergusson in the post-war years, was also fruitfully developed by him during the war, with a new delight in the Scottish scene. *A Lowland Church* (1916: DAG) shows a convincingly Cézannesque simplification of volumes into geometrical colour areas, and looks forward to the later Scottish landscapes painted as a result of Fergusson's tour of the Highlands with the Glasgow writer John Ressich in 1922, of which *A Puff of Smoke near Milngavie* (1922: Macfarlane Collection) is an outstanding example. In 1918 Fergusson produced a small group of pictures which

93 Samuel John Peploe
Roses in a Blue Vase, Black Background
c.1904–5 Oil 40.6 × 45.7 cm
Private collection

are among the most freshly original of all his works. The Léger-like dynamism of *Damaged Destroyer* (1918: GAG) produces a remarkable sense of space and volume, and of the scale and strength of the dockyard installations.

Peploe took the two numbers of *Blast* published by Wyndham Lewis in 1914 and 1915, and it is reasonable to assume that Fergusson would also be aware of the work of the Vorticists, although both artists remained entirely outside Wyndham Lewis's circle and show very little of its influence. We know from a letter of 1916 that Peploe met McKnight Kauffer in Edinburgh and thought his work 'interesting', but he does not appear to have had more than an academic interest in Cubism and its offshoots in Britain. Peploe's experimental paintings produced from about 1913 until about 1918, with their rhythmical abstract backgrounds, make only a cursory bow towards Cubism – but a bow nevertheless. A painting such as the *Still Life* (circa 1916: SNGMA) is plainly influenced by Cubism, and makes a serious attempt to digest the new style. Yet its seriousness does not entirely redeem the

awkwardness of the relation of the abstract linear pattern of the background to the figuratively drawn objects in the foreground. Like Fergusson, Peploe possessed painterly instincts and a concern for colour which forbade experimentation with analytical Cubism. Writing on Peploe in 1923, Sickert noticed two areas in which he had matured:

> He has transferred his unit of attention from attenuated and exquisite gradations of tone to no less skillfully related colour. And by relating all his lines with frankness to the 180 degrees of two right angles he is able to capture and digest a wider field of vision than before . . . His *volte-face* has been an intellectual progress. And it is probably for this reason that, obviously beautiful as was Mr Peploe's earlier quality, his present one will establish itself as the more beautiful of the two.

Sickert has here put his finger on Peploe's two most admirable qualities: the intellectual probity of his line, and the subtle power of his colour. These were the qualities which, untrammelled by a too-conscious imposition of another style, re-asserted themselves

quickly in Peploe's work. In about 1920 he began to paint on an absorbent ground and eschewed the heavy black outlines characteristic of his earlier paintings, and the use of varnish. The effect is an increased emphasis on the two-dimensional aspect of his design. Each colour-area now explodes laterally into the neighbouring patch of colour, and colour is given a dynamic rather than a monumental function. *Roses and Fruit* (circa 1923: private collection) is an example of this. These paintings on gesso are perhaps the most exciting of all Peploe's pictures. Throughout the rest of his career he continued to paint variations on the themes of landscape, still life, and flowers, with the exception of *Old Duff* (1921-22: GAG) which is a rare but entirely successful excursion into the field of portraiture.

Unlike Peploe and Fergusson, Hunter and Cadell were totally unaffected by the Cubist revolution. In Hunter's series of still life and flower paintings with dark backgrounds (generally assumed to be early: Hunter like Peploe and Cadell rarely dated pictures) the influences of Kalf and Chardin are still visible, and among modern masters one does not have to go beyond Monticelli (who, thanks to the advocacy of Daniel Cottier and then Alexander Reid, was extremely well known to Scottish collectors, and of whose work Hunter himself possessed several examples), for a precedent in the use of sombrely glowing colour. The early still life paintings show Hunter still concerned with a realistically suggestive treatment of surface and texture. In landscape, however, his style showed the influence of Cézanne from an early stage, and from about 1916-20 both landscape and still life are treated with ever-growing freedom in the use of colour and expressionistic impasto. The second *Loch Lomond* series, painted at the very end of Hunter's life, includes some of his finest paintings, one of which elicited from Peploe the compliment 'that is Hunter at his best and it is as fine as any Matisse'. *Reflections, Balloch* (1929-30: SNGMA) and *House-boat, Loch Lomond* (1929-30: private collection) are subtle enough to make such praise seem not too exaggerated. Hunter's control of colour in his best pictures shows the greatest sensitivity and his palette takes on a limpid quality which sometimes recalls the great Fauve master. It was Hunter who persuaded William McInnes to buy the Matisse still life *La Nappe Rose*, which is now in the Glasgow Art Gallery.

By contrast with Hunter, whose development was slow and steady, during the course of his career Cadell employed four quite distinct styles. The early interiors and still life pictures are painted with great verve and brilliant use of whites, with dashes of orange, mint green and lemon. The best-known example is *The White Room* (before 1915: private collection). Equally fine is the *Still Life* (1914: DAG). A similar range of colour appears in the earlier landscapes. The white sand and bright green stretches of water characteristic of the east shore of

94 George Leslie Hunter
Still Life – Lobster on a Blue and White Plate
1927 Oil 35.5 × 40.5 cm
Private collection

95 George Leslie Hunter
House Boats, Loch Lomond
c.1929–30 Oil 51 × 61 cm
Private collection

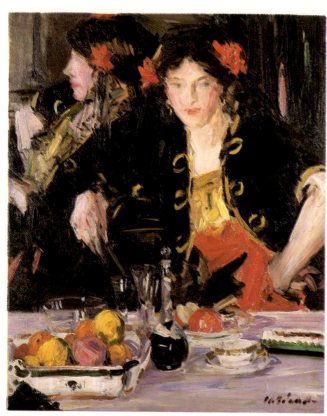

96 Francis Campbell Boileau
Cadell
Crème de Menthe
1915 Oil 107 × 84 cm
McLean Art Gallery, Greenock

97 Francis Campbell Boileau
Cadell
The White Room
1915 Oil 63.5 × 76 cm
Private collection

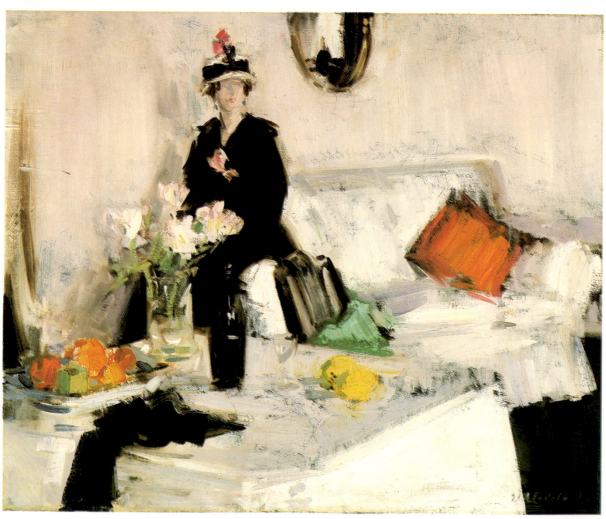

Iona in certain weather conditions provided a pretext for the bold colour schemes of the earlier Iona pictures, as the vermilions of Collioure had for Matisse. Cadell's later Iona pictures of the twenties, when he sometimes worked in company with Peploe, are more quietly coloured and more precisely drawn. A third style, in which elegant interiors are painted with a flat, unmodelled use of scarlets, oranges and bright greens, appears in the early twenties, and is strikingly evident in *The Opera Hat* (circa 1922: private collection) and in the audaciously coloured *Still Life with Lacquer Screen* (n.d.: recently Sotheby's), which implausibly but successfully juxtaposes black, pink, bright green and orange. A fourth mode is used to evoke the airy interiors of Croft House in the early thirties, in a series of pictures commissioned by Ion Harrison. It was to Harrison that Cadell wrote in a letter of thanks for a copy of *The Whistler Journal* in 1933 that Whistler was

> the most exquisite of the 'moderns' and he had what some great painters have, a certain 'amateurishness' which I rather like and feel always in Gainsborough. I can best describe what I mean in the words 'a gentleman painting for his amusement' . . . Raeburn, on the other hand, was a pro. if ever there was one.

There is something of the gentleman amateur in Cadell himself, who was related to the Dukes of Argyll, and had a considerable reputation in Edinburgh as a wit. This quality was apparent in his works, and it is none too common in Scottish painting. Cadell was also a founder-member of the Society of Eight, which started in Edinburgh in 1912 and included Lavery and, later, William Gillies (1898-1973). Two other Scottish painters of this generation, Telfer Bear and Joseph Simpson (1879-1939), were considerably influenced by Cadell's work.

In the two decades from about 1910 until 1931 the Colourists produced a number of minor masterpieces. Stanley Cursiter's espousal of Futurism in 1913 was brief but intense. The four Colourists, however, showed a much greater ability than the Glasgow School to stay the course, so that their later work generally stands up well to a comparison with their vigorous early productions, and does not leave behind the taste of disappointment and embarrassment characteristic of the later productions of the Glasgow School. If the Colourists derive more from Cézanne and Matisse than from the radical group of French painters associated with Picasso who were their closer contemporaries, this does not diminish the originality of Peploe, Fergusson, Hunter, and Cadell. Nor, paradoxically, does it diminish their Scottish character or compromise their natural evolution. An absence of theory need not imply an absence of logic. The best paintings by these four Scottish artists are eminently logical, but their logic is primarily determined by the material, the paint itself. This painterliness, this insistence on the quality of paint and the beauties proper to it, is their greatest strength. It is also the source of their considerable influence on subsequent Scottish painting.

9 BETWEEN THE WARS

The 1920s and 1930s were years of retrenchment for painting in Britain generally. The First World War had a less immediate effect on Scottish than on English painting because Scotland had at that point no radical equivalent of the Vorticist movement in England, which was first dispersed by conscription and then decimated through fatalities in action. Several Scottish painters became official war artists, and although J.D. Fergusson received a commission for only one picture for the Ministry of Information in 1918, he painted a series of naval dockyard subjects at Portsmouth including the powerful *Damaged Destroyer* (dated to 1918: GAG). But Scotland produced no artist of the calibre of Nash or Nevinson as chroniclers of war. Cursiter, Peploe, Fergusson and Mackintosh (the latter two remaining in London after the war before taking up prolonged residence in France), who in their various ways had kept abreast of *avant-garde* developments on the Continent and had mastered the language of Modernism in one form or another, found that no-one at home was interested in what they had to say. Mackintosh alone, despite all difficulties and discouragement, sustained the momentum of his earlier innovatory work in a new discipline, that of textile design. Stanley Cursiter pioneered advances in aerial cartography during the war, but, as with so many of his contemporaries including Peploe, his post-war career was emphatically a case of 'goodbye to all that' in terms of stylistic innovation. Two members of the former Glasgow School, Sir D.Y. Cameron and Sir John Lavery, and also Sir Muirhead Bone and James McBey, who with Cameron and the portraitist William Strang had a large share of responsibility for the revival of etching in Britain in the early twentieth century, also received commissions for work documenting aspects of the war. Lavery's *The First Wounded in London Hospital, August 1914* (DAG), Cameron's *Bailleul* (1919: DAG) and *The Battlefield of Ypres* (1919: Imperial War Museum), and McBey's portrait of *Lt-Col. T.E. Lawrence*, 'Lawrence of Arabia' (1918: Imperial War Museum), are all conspicuously successful documentary records. Cameron remarked that the Ypres picture was 'not a portrait of any one spot (photographers can do all that) but is founded on my notes on the road from Ypres to Menin', yet the utterly still desolation which he depicts appears closer to the bare facts than the

eye-witness accounts of Paul Nash in canvases like *We are making a New World* (1918: Imperial War Museum) – the very title full of a bitter irony. In this Nash conveys with great dramatic intensity the scene which he described as 'the most frightful nightmare of a country more conceived by Dante or Poe than by nature', with the intention that his work would 'bring back word from the men who are fighting to those who want the war to go on for ever'.

Retrenchment can lead to consolidation. Much of the best painting in Scotland in the two decades after the war was the work of already established artists. The four Colourists all produced work whose masterly colour and handling are worthy of their best earlier efforts – indeed Hunter only really comes into his own as a Colourist after circa 1922 – and Charles Rennie Mackintosh's French landscape watercolours of 1925-27 are an important aspect of his career as a painter. But of the younger artists who remained in Scotland, only very few showed any willingness to experiment with new forms of expression. In 1918, Peploe's brother William painted two little Vorticist-inspired near-abstract watercolours, one of them titled *Souvenir of the Red Triangle*, the other untitled, both now SNGMA. They mark a startling advance from his earlier Beardsleyesque drawings for a privately printed book *Memories and Illusions* (1906), but appear to have had no sequel in his work.

The only Scottish artists to come to prominence in the 1920s who showed a serious interest in a radically contemporary style were William McCance (1894-1970) and William Johnstone (1897-1981). McCance was influenced by Vorticism and Analytical Cubism (in that historically inverted order) and took part with his first wife Agnes Miller Parker in the revival of wood engraving in the 1930s. Johnstone developed a form of surrealistic abstraction and became an eminent and influential teacher and writer on art. Both McCance and Johnstone spent the main part of their creative lives in London and the south, finding Scotland still the 'narrow place' Robert Adam had deprecated.

Plainly, there was a lack of confidence in the 1920s which can be attributed to the aftermath of a war which had exhausted both sides (the victor having less motive, however, for the angry iconoclasm of Dada or Expressionism). In Scotland this was accompanied by worsening economic conditions, due

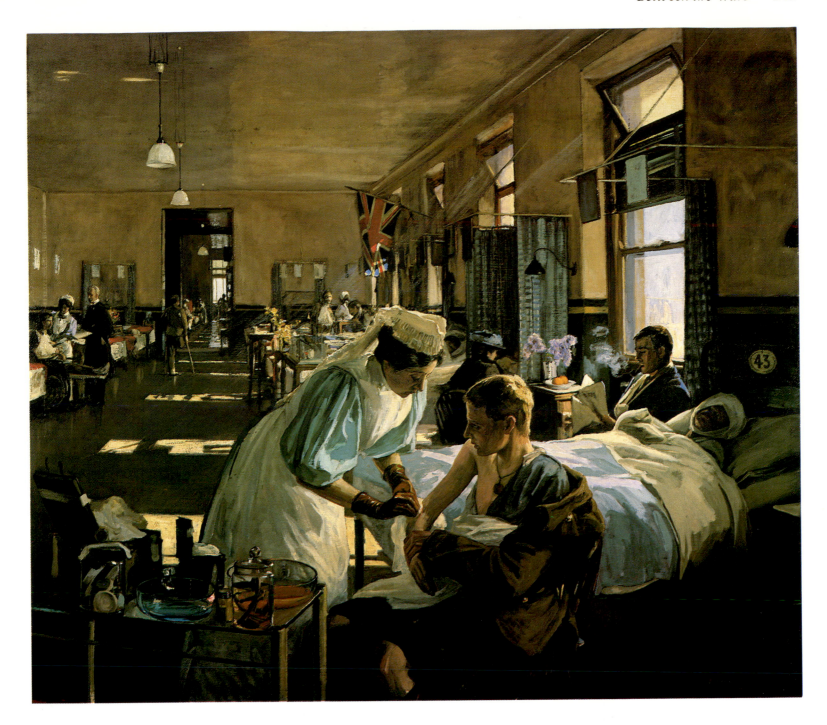

98 Sir John Lavery
*The First Wounded in London
Hospital, August 1914*
1915 Oil 175.6 × 200.7 cm
Dundee Art Gallery

to over-reliance on heavy industry, which made the Depression of the 1930s particularly severe in the industrial central belt of the country. In 1931 we find F.C.B. Cadell writing to his friend and faithful supporter, the shipowner Ion Harrison,

> Shipping certainly sounds depressing! But everything appears to be in a hopeless state and I have never known such depression in my trade as exists at present. I sell my things now at a quarter of what I got for them some years ago and I furthermore sell *very* much fewer.

Cadell, at least, was more fortunate than many painters in having a group of wealthy patrons who could be relied on to buy his work regularly.

In a climate generally so unfavourable to patronage, it is understandable that most artists should, first, turn to forms of expression which are accessible, exerting a frank appeal to the eye and untroubled by undue intellectualism. The great majority of the more interesting Scottish artists of this period appear as traditionalists who show a cultivated awareness of the more decorative styles of the recent European past. Second, in such a period the security of salaried employment was particularly valuable, and it is noticeable that almost all the more prominent figures taught at one of the four art colleges (Edinburgh, Glasgow, Dundee, and Aberdeen). S.J.

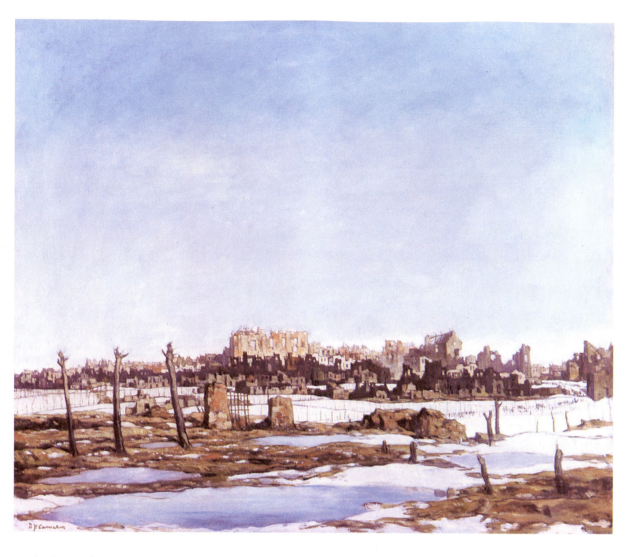

99 Sir David Young Cameron
Bailleul
c.1918–20 Oil 99.1 × 114.3 cm
Dundee Art Gallery

Peploe himself taught at the Edinburgh College at the end of his career, where David Foggie, D.M. Sutherland, William Gillies, Sir William MacTaggart, Henry Lintott, and John Maxwell – the founders, with Anne Redpath, of the Edinburgh School – were all at one time or another on the teaching staff. James Cowie (1886-1956) was a schoolmaster for twenty years until his appointment as Warden of Hospital-field House in 1935 enabled him to exert a wider influence on younger painters. Of the other outstanding figures who emerged in the 1930s, J. McIntosh Patrick, Edward Baird and Robert Sivell became teachers at the colleges of art in Dundee and Aberdeen. The period is *par excellence* that of the teacher-artist, not only in Scotland; local style is generated largely at the local art school.

A characteristic development in the earlier part of the twentieth century is the proliferation of small exhibition societies which sprang up in Glasgow and Edinburgh, following to some extent the lead given in 1891 when, through the efforts of Robert Noble and others, the Society of Scottish Artists was founded to provide an exhibiting body in Edinburgh which would be independent of the RSA. Many of the Glasgow School painters like Arthur Melville who

were already academicians had also joined the SSA as did the veteran William McTaggart, whose relations with the RSA by this time had apparently become somewhat strained. The SSA thus was never a secessionist body; many painters retained membership of both societies. In 1912 the Society of Eight was formed in Edinburgh, comprising a mixture of Glasgow School and slightly later names: P.W. Adam, David Alison, F.C.B. Cadell, James Caden-head, James Paterson, Harrington Mann, Sir John Lavery and A.G. Sinclair. Since, with the exception of Cadell, most if not all these artists were already well established, the Society of Eight was not in any sense the expression of a new wave of Scottish painting, but instead united artists who all tended to adopt a painterly approach and to use light-keyed colour. In the same year, 1912, however, a group of younger artists including Eric Robertson, W.O. Hutchinson, A.R. Sturrock and D.M. Sutherland exhibited as a group at Doig, Wilson and Wheatley's Gallery, and in the following year at the following year at the New Gallery in Shandwick Place in Edinburgh. This group became known as the Edinburgh Group when it was reconstituted in 1919 with Dorothy Johnstone, Mary Newbery, and Cecile Walton (E.A. Walton's daughter

and by now Eric Robertson's wife) joining it. Their 1920 exhibition was particularly successful and it was said by the critic of *The National Outlook* that 'people look to the Edinburgh group for something unique rather than universal; for something of pagan brazenness rather than parlour propriety'. *Dreamer* (1911: the artist's daughter) by Eric Robertson (1887-1941) exemplifies that variety of post-1900 Symbolism in which figures levitate ubiquitously through the firmament; forerunners perhaps of the 'floaters' of Henry Lintott, perhaps even distant ancestors of the fantasy figures of John Maxwell. It plainly demonstrates the connection between Robertson and John Duncan, which was to be terminated in 1915 by Duncan, who disapproved of what he considered to be the immorality of Robertson's art and private life. Robertson's *Dreamers* (1911: private collection) is a rather innocently sensual work obviously by a highly talented draughtsman, which nevertheless must have caused a few raised eyebrows when it was shown at the RSA in 1913. The same artist's *The Two Companions* (1913: the artist's daughter) derives from the *Rose + Croix* manner of Duncan and shows a young man (a self-portrait) accompanied by two familiars, a young man and a girl both nude, who seem to compete for his mental and physical allegiance. In *Love's Invading* (1919: ECAC) which resembles a Poussinesque bacchanale choreographed by Margaret Morris, Robertson essays a kind of Edinburgh version of Fergusson's *Les Eus* of circa 1911 – an unlikely-sounding combination which is strangely effective. Robertson's post-war works show the influence of Vorticism – *Cartwheels* (1921: the artist's daughter) is an obvious instance of this – although the use of something very like the 'rays' of the strip-cartoonist to indicate movement suggests a superficial assimilation of a style which the Edinburgh public clearly found as hard to take as they did Robertson's unorthodox behaviour. *Despair* (1921: GAG) shows a rather conventional nude despairer posed theatrically against a Nevinsonian background; but it does no doubt reflect the difficulties of Robertson's life at this time, which resulted in his departure from Edinburgh in 1923 to years of unrewarding exile in Liverpool. He was the most experimental of the 'Idylls' as this group of friends were wont to style themselves, but three of the women in the group had painting in their blood: Dorothy Johnstone, Mary Newbery and Cecile Walton being the daughters of three distinguished figures in Scottish painting, George Whitton Johnstone, Fra Newbery and E.A. Walton. Breeding tells: each artist – each daughter that is – demonstrates formidable professional skill, Mary Newbery concentrating on embroidery and flower painting, Dorothy Johnstone and Cecile Walton introducing refreshingly modern, intimate subject-matter into their portraits and interiors. Cecile Walton's *Romance* (1920: private collection) is a self-portrait semi-nude lying on a bed holding aloft her newly-born second son, whose older brother and a nurse are also present: a tender, and for those days, an unconventional theme. The characterful 1918 portrait of Cecile Walton by Dorothy Johnstone or the earlier *Marguerites* (1912: RSA), a portrait of the artist's young sister, exemplify her fine quality. Between 1914 and 1924 Dorothy Johnstone was a popular teacher in Edinburgh College of Art, a post she relinquished in 1933 when her husband, the landscape artist D.M. Sutherland, was appointed Head of Gray's School of Art in Aberdeen. At the same time, another of this talented circle, W.O. Hutchinson, became Head of Glasgow School of Art; and so the Edinburgh Group was finally dispersed.

In Glasgow James Kay (1858-1952), and in Dundee and latterly on the Isle of Arran, James Maclauchlan Milne (1885-1957), stand a little apart from their contemporaries. Essentially self-taught artists (Kay briefly attended evening classes at Glasgow School of Art, and Milne's father was the excellent Tayside painter Joseph Milne), these two independently pursued a precarious living as landscape artists, producing some of the most interesting work of the period. As the older man, Kay's style reflects the dominance of the Glasgow Boys and of The Hague School whom they admired, in the early part of his career, while Maclauchlan Milne's early work is rural, tonal and descriptive like his father's. Their characteristic later styles, which in different ways give a new impetus to the painterly Colourist tradition in Scottish painting, develop only slowly, but in each case it is a maturity worth waiting for. Kay's father had been a naval officer taking part in operations in the Black Sea in the Crimean War, and young James was brought up on Arran – a coincidental point of contact with Milne, whose last years were spent on the island – to a life of fascination with the sea and the river. The seagoing traffic of the great days of the Clyde became a favourite theme, but Kay rarely romanticizes, preferring the 'dirty British coaster with a salt-caked smoke stack', the bustling commercial traffic with cargo vessels and tugs by the wharves or the steam ferries at the Broomielaw in the centre of the Clyde. He did paint the *Lusitania* (1912: GAG), but at the moment of her launching, not during her brief reign afloat as queen of the liners. The earthy realism of the Glasgow Boys had prepared Kay's patrons for these views of their river, and their ready acceptance was no doubt due to recognition, pride, and pleasure in fine painting in which a vigorous technique and an individual, often austere palette were matched to workaday river subjects.

Kay's younger contemporary Maclauchlan Milne is another artist whose personal handwriting develops without the rigid training of the art school. Sinclair Gauldie remembers that 'he did indeed display in his own person much of the *bravura* which characterized his own painting'. Milne's attractive, ebullient and urbane temperament is described in affectionate

100 John Maclauchlan Milne
The Harbour, St. Tropez
c.1928 Oil 49.5 × 59.7 cm
Private collection

detail in the centenary catalogue (DAG), from which we also learn that his francophilism dated from the war years spent in France, during which he fought on the Western Front. From 1919 until 1932 he spent a substantial part of every year in France. Milne's first stay was in the rue des Quatre-Vents in Paris, but the habit of going to the Mediterranean coast was soon established and in 1924 the Milnes were in the company of Peploe, Cadell and Duncan Grant at Cassis (a favourite painting location for Cursiter and Fergusson also); later they spent much time at Saint-Tropez. Through the 1920s almost all his exhibits at the RSA were landscapes of the Midi. His obituarist at the RSA wrote of this period: 'Like Peploe, he saw Cézanne and was immediately conquered . . . Here in the Midi, Milne found himself and the impact of this new experience stamped all his subsequent work'. We may today feel the reference to Cézanne to be a little wide of the mark: Milne modelled form with colour, but without aiming for the monumentality of Cézanne. Rather, his modelling tends to a decorative flatness which emphasizes the picture plane and simplicity of outline and form; the results have a beguiling, lyrical innocence suggestive of the serenity of life in these quiet places. In the paintings dating

from 1940 onwards, when he had moved to High Corrie on Arran, his palette too is simplified to include a tinted white for the whitewashed cottages like his own which formed the tiny village. Sometimes he would paint the little jetty below the village, sometimes the interior of the island with the peak of Goat Fell, and he was always a notable painter of flowers. Many of Milne's supporters such as Matthew Justice and the collector of Impressionists William Boyd, lived in Dundee or in neighbouring Broughty Ferry, and it was to Angus that he returned in 1956, the year before his death, to become Warden of Hospitalfield House at Arbroath.

It is clear that for Milne, as for Rennie Mackintosh and so many other Scottish artists at this period, the attraction of France lay in the country itself and in the life one could live there (thanks to a favourable exchange rate) as an artist. To be domiciled in France was in itself a form of hedonism, celebrated in the paintings of its landscape, its flowers, its warmth and colour, by Milne and numerous Scottish artists of the same generation. These Scottish francophiles include the Aberdeen artist and potter Majel Davidson, who, with Edward Overton Jones, studied in Paris (and also painted with J.E.H. Macdonald and other

members of the Group of Seven in Ontario); the Edinburgh-based New Zealander Francis McCracken whose ECA travelling award took him to France to study under André Lhôte; the Selkirk artist John McNairn who like so many of his compatriots also gravitated to Lhôte in his scholarship year in Paris; and of course the colourists like William MacTaggart the younger who were connected with the Edinburgh College of Art. William Macdonald's annual painting tours of Spain, like those of John Lavery, James McBey and Alexander Graham Munro in Morocco were part of the same pattern, the attraction of the warm Mediterranean to northern eyes in a depressed period of European history. The artists mentioned share with the Colourists not only their avowed francophilism but also an interest in broad effects of colour which go beyond the merely descriptive, together with an emphasis on surface rather than perspectival pattern. These are characteristics of French landscape painting, especially of Derain, Marquet and Dufy and the influence of these artists, and of Marquet above all, is clear in Graham Munro's *The Admiral's House* (circa 1930: William Hardie Gallery), painted in Tangier, and John McNairn's *The Harbour Saint-Mâlo* (circa 1936: ibid.). McNairn's splendidly confident *Champagne and Oysters* of about the same date, very much in the austere, spare style of Derain whose work he

had admired in Paris, may be compared with McCracken's no less assured *Champagne Breakfast* (circa 1930-35: private collection), which shows a stronger influence of the Franco-Scottish *belle peinture* practised by Cadell and Peploe in Edinburgh. Francis McCracken, claimed like his compatriot Frances Hodgkins for the New Zealand School despite long exile from that country, came to Europe at the tender age of sixteen with the New Zealand Expeditionary Force in 1914, lost a leg in the fighting, and attended classes at the Edinburgh College of Art. His lifelong friendship with Graham and Ruth Munro in Edinburgh began at this point, and around 1924 we find him painting in Paris and Concarneau, probably in Graham Munro's company although we do not know whether he attended the life class, as several oil studies from this period prove Munro to have done. Of the two artists, McCracken alone went on to paint figure subjects of an earthy realism in the tiny studio in Forth Street to which his lameness increasingly confined him. He also went, as Munro did, to Tangier in the late 1920s, but probably because of his disability did not follow him to Rabat, Fez and Marrakesh and into the remoter foothills of the Atlas Mountains, where Munro in 1926-27 produced a remarkable series of pastels. These drawings by Munro, sent home as scholarship material from Morocco at regular intervals to

101 Alexander Graham Munro
The Admiral's House, Tangier
c.1930 Oil 92 × 122 cm
William Hardie Gallery

102 John McNairn
St. Malo Harbour
1936 Oil 75.5 × 99 cm
William Hardie Gallery

demonstrate his assiduity to the assessors, which he had kept for nearly sixty years in a drawer as never-used compositional notes until I persuaded him to ventilate them at the Edinburgh Festival in 1984, compare interestingly and by no means unfavourably with Mackintosh's watercolours of the same period. Munro in his early years was a beautiful draughtsman, in a style Mackintosh would have appreciated – crisp, elegant, spare, precise – and had a keen eye for the architectural or structural essentials of his subject. Pastel suited his style better than any other medium; Munro thought naturally in terms of its rich colours and pearly surface. The smooth gradations of plane in these drawings remind one of Georgia O'Keefe's early landscapes.

Of course, all these artists also painted the Scottish landscape. For other painters, however, the Scottish landscape, especially their own place in it, was subject enough for a lifetime's work. Sir D.Y. Cameron (1865-1945), George Houston and James McIntosh Patrick (born 1907), despite great differences of temperament and style, share a common preoccupation with Scotland's topography. Although Cameron was included in the studies of the Glasgow School by Martin (1897) and Baldwin Brown (1908), he was not associated with that group in its formative years and his most characteristic works were painted after the turn of the century. The main early influences on his style in the 1890s were Whistler, the Barbizon painters and Matthew Maris, but from an early date Cameron was laying the foundations of his reputation as one of the most outstanding of a brilliant generation of British landscape etchers. He was also a prolific watercolourist and many of his informal landscape sketches in this medium are especially fine. The main ingredients in his landscape style, which changed imperceptibly from Realism to Romanticism, are his dainty draughtsmanship and sense of form, together with a Glasgow School breadth of handling and use of a richly sombre palette which lightens over the years. The Trossachs and the countryside around Kippen, where he lived from 1908, were his favourite themes, with an occasional tour to Perthshire or the western Highlands. Cameron was a deeply religious man, it seems; the emphatic colour contrasts in the large landscapes of the twenties and thirties express a quasi-mystical view of the majesty of the natural scene, rather than a descriptive or decorative intention. The equally prolific George Houston interpreted the quieter and less dramatic landscape of Ayrshire and the intimate and magical landscape of the Mull of Kintyre by the shores of Loch Fyne or Loch Awe, using a painterly technique and tonal palette influenced by the Glasgow School.

The landscapist James McIntosh Patrick – whose

popularity as an artist and wide circle of congenial friends stem from an indefatigable and kindly intelligence which continues to illuminate his views of his native Angus, as it does his views on a host of other topics from modern painting to the walled garden at his home of which he is justly proud – returned to Dundee from his studies at Glasgow School of Art in 1928. In the same year his friend Edward Baird returned to Montrose. Obvious parallels exist between the work of these two remarkable draughtsmen, who between them carried off all the prizes worth having at the School, a fact which indicates, at the least, that their precise style of drawing was compatible with what was being taught there. Under the aegis of Maurice Greiffenhagen as Principal, printmaking was being taught by Josephine Haswell Miller, among whose other pupils was Ian Fleming (born 1906), another brilliant etcher, who became Head of Gray's School of Art in Aberdeen. Patrick's father was an architect and young James had begun to experiment with etching at the age of fourteen. In the summer months of 1926 he made a series of etchings in Provence, including the hill towns Les Baux and Carcassonne. These are *tours de force* of technique, influenced by the high horizon, architectural detail, and meticulous line of Meryon. A large painting of 1927, *The Egotist* (collection of the artist's family) is an architectural fantasy which shows a mountainous landscape based partly on that of Mantegna's *The Agony in the Garden*, littered with the Classical monuments of Provence – the Maison Carrée, the Pont du Gard, the amphitheatre at Nîmes, and the Arch at Saint Rémy – and populated with figures in modern dress who debate with the egotistical architect/builder the modern-looking building concealed under wraps in the foreground with which he hopes to rival the monuments of old. With the benefit of hindsight it is fascinating to see in this bravura performance all the skill which Patrick was to deploy in rearranging landscape and buildings to suit his compositional requirements in the paintings of his earlier period before 1940. After that date, his landscapes are all painted *en plein air* and with correspondingly greater immediacy.

Patrick was achieving a considerable reputation in his preferred discipline of etching, with the support of the etcher F.L. Griggs whose strong contrasts of light and dark and ability to create depth in landscape Patrick admired, but by 1930 it was becoming apparent that the demand for etchings was falling off. When he turned to painting, the lessons learnt as a printmaker stood him in good stead, and it is to that testing early discipline that the clarity and conciseness, the confident massing and tonality of the studio landscapes of the thirties is owed. *Winter in Angus* (1935: TG) shows the fortified manor house of Powrie Castle, which stands a little to the north of Dundee, against a background which the artist tells us was painted separately, but of course, *sur le motif*

– actually from a window at Glenalmond many miles away. Further, Patrick has turned the building round by one hundred and eighty degrees, as he shows us the south instead of the north elevation of the building facing uphill; for the excellent reason, no doubt, that the north elevation is blank, windowless and therefore less welcoming to the eye. The composition employs a serpentine series of curves to lead the eye in through the various stages of the composition to the background in the far distance. Patrick pursued Bruegel's theme of the seasons through *Midsummer in East Fife* (1936: AAG), *Autumn, Kinnordy* (1936: DAG), and *Springtime in Eskdale* (1938: WAG). In each one the high horizon and elevated viewpoint provide an immense vista, through which the eye meanders as the composition subtly directs. The immediate experience provided by these beautiful and pondered works and their fellows is one of close identification with the landscape; but as time increases the distance between the viewer and these scenes, their significance as fixed portrayals of the very character of the land, and through it the people who have shaped it, becomes clearer as the years pass.

Immediately after the First World War, a short-lived Glasgow Society of Painters and Sculptors was founded in 1919, including the three Glasgow-trained artists Robert Sivell, James Cowie and

103 James Cowie
Noon
1946 Oil 55 × 55 cm
Scottish Arts Council
Painted at Hospitalfield House, the residential art school where Cowie taught until 1948. The figure of the girl was composed in 1938. 'A picture . . . must be built of much that . . . it would never be possible to see and to copy'. James Cowie, 1935.

Archibald McGlashan. They are usually thought of together as figure specialists who employ a noticeable restraint in their use of colour, as drawing is the quintessence of their styles, partly as a result perhaps, of the presence at the Glasgow School of Art of Frederick Cayley Robinson from 1914 to 1924 as professor of Figure Composition and Decoration. The sculptor Benno Schotz was also an exhibitor with this Glasgow group, as were two younger artists, William McCance and his wife Agnes Miller Parker, who in 1920 moved to London.

The older painters of this group, Cowie, Sivell and McGlashan, were traditionalists who emphasized careful drawing. McGlashan (b. 1888) was more spontaneous and more painterly than the others, and his *Mother and Child* (before 1931: GAG) is as free from mannerism (in a period when draughtsmanship was frequently forced and affected) as Augustus John at his best. But James Cowie (1886-1956) was the most original artist of the three, and the most adventurous, making excursions into a personal kind of Surrealism which suggest a possible knowledge of

the metaphysical painting of de Chirico – whose work was included in an exhibition of Surrealism by the SSA in 1937, and then in a major one-man exhibition at Reid & Lefevre in London in 1938 – in drawings and paintings produced at Hospitalfield near Arbroath after he had moved in 1935 to become Warden of the residential art school founded there by Patrick Allan Fraser. His earlier works all date from his time as art master at Bellshill Academy in Glasgow, as his frequent choice of children in their school uniforms as subjects indicates. Its linear precision and conciseness gives Cowie's work a palpable, spartan air of integrity. His schoolgirl subjects attend to their lessons only slightly distracted by the *Falling Leaves* (1934: illustrated Memorial Catalogue 1957, untraced) passing the classroom window. In *Two Schoolgirls* (AAG) two of them sit as models with expressions of innocence and sagacity, in calm and dignified indifference to the plaster art class 'prop' of a nude *discobolus* placed behind them on a pedestal. *Noon* (1946: SAC), which shares something of the nostalgic view of early

104 William McCance
Boatyard
c.1922 Oil 63 × 67.5 cm
Private collection
(Photograph: William Hardie Gallery)
A Vorticist design, based on Nevinson, with figures loading a yacht from the quayside. There is an abstract painting on the reverse.

105 William McCance
Conflict
c.1922 Oil 76.2 × 63.5 cm
Glasgow Art Gallery
The most sculptural of this
sculptor-artist's works, its severity
modified by its unusually powerful
colour and painterly surface.

adolescence of Andrew Wyeth's *Christina's World* (1948: Museum of Modern Art, New York), combines Realism and Surrealism in a highly individual way; the plaster male figure is now life-size and is placed in the open air beside the sleeping girl, and it is reflected in a lozenge-shaped mirror which typically suggests the world outside the canvas rectangle as well as defining aerial space within it. Cowie's later drawings, which develop this type of complex reference with great ingenuity, are perhaps the most characteristic of all his works.

In an article 'Idea in Art' published in *The Modern Scot* in summer 1930, another Glasgow-trained artist, William McCance (1894-1970) wrote a brief critique of *fin de siècle* aesthetics and of the theories and practice of the Bloomsbury painters who were his own contemporaries. By implication his piece also attacks the drawing-room sophistication of the current Edinburgh School. He comments that the Aesthetic Movement (art for art's sake) was succeeded by an 'art-for-craft's sake' attitude which invited us not to talk about art but instead 'to admire

the magnificent brush-WORK . . . Then there arrived on the scene a new foreman called Roger Fry whose ancestors had been marking oblong pieces of chocolate into four oblong sections and he saw that art was not only brush work and vibration of colour, but also Design, while Mr Clive Bell evolved an idea that it was not the milk in the coconut that counted, but the 'Significant form'. When you painted a chair, according to Mr Bell you had to get 'the chairness of the chair'. Since the Great War Bloomsbury has been sitting on comfortable divans surrounded by cushions, trying to discover the 'chairness' of chairs'. McCance then differentiates between pattern which is two-dimensional and design which involes spatial relationships, and stresses the value of Cubism and of the

106 William McCance
Mediterranean Hill Town
1923 Oil 92.1 × 61 cm
Dundee Art Gallery

Expressionist reaction against 'the cold intellectualism of the Cubist'. McCance concluded that the future of painting could lie in a synthesis of the two, and that this might be done in Scotland, provided that the Scot could break through his 'narrow provincial barriers and gain a knowledge of what is actually taking place in the world around him'. When this was written, three expatriate Scottish painters, J.D. Fergusson, William Johnstone and McCance himself had achieved something like McCance's desiderated synthesis, although of the three painters only Johnstone continued to develop. McCance had been living in London for ten years, illustrating for *Lloyd's Magazine*, holding a variety of teaching appointments, and writing a column of art criticism for *The Spectator* from 1923-26. As an art critic he displays the incisiveness of his best work as an artist, which belongs approximately to the period from 1919 until 1930, when he became controller of the Gregynog Press at Newtown in Wales and began a distinguished separate career as a typographer and book designer.

McCance never seems to have supported himself by his painting. His works have a private, experimental quality, and he was the opposite of prolific. An early *Self-Portrait* (1916: Dr Margaret McCance) is a competent exercise done shortly after he had left Glasgow School of Art, where Fra Newbery was still Principal. It shows the influence of Pryde and Nicholson in its fluid handling and monochromatic tonality. It is a startling jump from this sober performance in an earlier style to *Conflict* (circa 1922: GAG), with its bold colour and even bolder, sculptural approach to form. There can be little doubt that *Conflict* is McCance's most important surviving work. It shows a well-assimilated Vorticist influence combined with an almost Surrealist content – a landscape contains a recognizable cat and human figure (both modelled on small clayslip figurines which McCance had made), as well as unidentifiable writhing vegetable forms and a tree whose branches turn into girder-like shapes. In it the inanimate hovers on the point of being animate and vice versa. The simplification of form and powerful use of colour produce a work of forceful individuality. There are only a few other works on a similar scale in this style dating from the early 1920s, including an untitled oil – which bears more than a passing resemblance to C.R.W. Nevinson's lithograph *Loading the Ship* of 1917 – showing figures working in a *Boatyard* (circa 1922: private collection) again schematized to a point approaching abstraction; and the powerful *Mediterranean Hill Town* (1923: DAG), a very striking example of his faculty of simplification through drawing of almost mechanical precision and a smooth, geometrical rendering of form. This latter work also possesses a certain surreal atmosphere contributed by the Corbusier-like architecture including a menacing villa which is almost anthropoid, like Epstein's *The Rock Drill*. This motif was

107 William McCance
Charleston
1925 Oil on card 35 × 26.4 cm
Private collection
(Photograph: William Hardie
Gallery)

108 William McCance
The Bedroom
1925 Oil on card 35 × 26.4 cm
Private collection
(Photograph: William Hardie
Gallery)

possibly taken from a sculpture by McCance which has not been preserved.

A few paintings from the middle 1920s give evidence of continuing development. *Charleston* (1925: private collection) and *The Bedroom* (ibid.) are evidently a pair, showing with abrasive humour a couple firstly dancing the Charleston and later nude in a room which contains only a bed. Although small, both pictures are painted with a powerfully Expressionistic use of colour which suggests that McCance had seen the works of the German Expressionists whom he mentioned later in the 1930 article already quoted. But some evidence of failing impetus is visible in the painting of the later twenties, and the best works from then are mostly small, beautifully executed prints and drawings in a Synthetic Cubist style, as *The Engineer, his Wife and Family* (1925), and *Moloch of the Machine* (1928, both linocut), *Early Telephone* (1927: Dr Margaret McCance), and *From a Window in Thrums* (1926: private collection), an anti-Romantic reading of J.M. Barrie's fey tale of life in Kirriemuir of which McCance also produced a scaled-up version in oils. One painting from this period, *The Fall* (1928: private collection) resembles the work of Picasso's Neo-Classical

period. It contains a typical joke in the Xs with which Adam and Eve have signed their marriage contract. Thereafter, McCance worked at the Gregynog Press where he was responsible for the beautiful editions of (among others) *The Fables of Aesop* (with wood engravings by Agnes Miller Parker and initial letters by McCance), *The Singing Caravan* by Sir Robert Vansittart and *The Relevation of St. John the Divine* (with wood engravings by Blair Hughes-Stanton). That and his subsequent job as a lecturer in typography at Reading University effectively brought McCance's development as a painter to an end, although he continued to paint occasional pieces with his usual intelligence, producing an acidly pacifist *Hiroshima* in 1947 (Dr Margaret McCance).

William Johnstone (1897-1981) is a very different figure. As consciously a Scot as McCance and their mutual friend the poet Hugh McDiarmid, and equally concerned that Scottish art should be aware of developments outside, he was consistently concerned with art as expression, and in his work we confront the man and never a mere material fact. His sometimes inchoate, formally dense work at times has a gestural element, as if in impatience or frustration at the puniness of man's efforts to suggest

or capture immensity. His art is technically sophisticated but naïve in effect – to the point almost, of suggesting the incapacity of paint to grasp the riddles of life and man's subconscious. His technique is always individual, from the sombre and subtle earth tones of the early palette to the 'bright' later use of black with colours in a high key applied with great variations of brushstoke, and a tendency to combine a background of saturated colour with a surface tracery of lines which indicate perspective in a manner reminiscent of Giacometti as a painter. As with naïve art, we discern in Johnstone's work less a perception of the thing itself, than an account of the artist's excited inner reaction to it.

Johnstone first received encouragement to paint from the Borders artist Tom Scott, whom he met in 1912, and several of whose grisaille wash drawings of landscape Johnstone acquired at an unknown date. He studied at Edinburgh College of Art from 1919 to 1923 and then in Paris in 1925 and 1926, in André Lhôte's studio. The Proto-Abstract painting in two gessoed panels of 1926 (William Hardie Gallery) began as a single composition which was divided and continued in separate halves. It has an elemental vigour and an interest in patternless forms suggestive of mass and density, with landscape references, to which one looks in vain for any influence of Lhôte.

Rather, the automatic drawing of André Masson seems more relevant – how one regrets the lost opportunity of asking the artist himself about Masson's work, and the amused, quizzical, and probably highly unexpected response which would follow – especially in the light of the psycho-sexual content of the painting indicated by the figurative overdrawing. The little *Composition* of 1926 in black watercolour (published in Douglas Hall's short monograph) is fully an automatic drawing in the surrealist sense of allowing the hand and eye to follow subconscious stimuli; it also anticipates action painting and much of Johnstone's own later output. In the following year Johnstone painted the large *Folies Bergères* (private collection) which codifies the academic synthetic cubism of Lhôte with something very close to brute strength in a composition of genuine power.

In a letter I received in 1972 Johnstone gave me a succinct account of his own early work. When he went to Paris in 1925, he says, Abstraction and Cubism were being criticized and the influence of the Symbolists – of the viewpoint that, as Gustave Moreau said, 'I believe only in what I do not see, and solely in what I feel' – led to the cult of the unconscious which is the essence of Surrealism. Johnstone writes:

109 William Johnstone
Abstract
1926 Oil on gessoed plyboard 61
× 76.5 cm
William Hardie Gallery
Painted in Paris.

110 William Johnstone
A Point in Time
1929–37 Oil 137 × 244 cm
Scottish National Gallery of
Modern Art
'Through painting I began to
understand a concept of eternity in
which always and forever there is
illimitable change, a continuous
metamorphosis and new
identification . . . These paintings
grew out of my horror of the
disease of war, of the anticipation
of future tragedy.' William
Johnstone *Points in Time–an
autobiography*.

All the influences of the school of Paris were most valuable but one thing had to be remembered and that was that the finding of oneself was the main purpose of the exercise. What did I have that was mine? . . . On my return to Scotland [in 1925] I was thrown back on my own resources. There was no immediate tradition in Scottish art worth talking about. So I turned to the Queen Street Museum [The National Museum of Antiquities] in Edinburgh to study the early Pictish carved and incised stones . . . The study of Celtic or Scandinavian primitive art made a powerful impression on me. This seemed to be an earlier form of symbolism or surrealism. I worked on several large paintings . . . These pictures began to be motivated from an inner being, the subconscious, and had no relation to the visible world as seen by the photographic eye. In these paintings too I was trying to bring back form into painting as I felt that form had disappeared from painting. These paintings, too represented a feeling of disillusion after the war.

The most important painting from this post-Paris phase is probably *Painting, Selkirk Summer 1927* (SNGMA) which is a reworked version of a virtually identical composition (published by Hall) which naïvely combined biomorphic, curvilinear abstractions with suggestions of a bird and a human eye. In the second version the artist seems to have realized that Nature – the presence of life in a landscape with

a human observer – could be more effectively evoked by substituting for these obtrusive symbols a ballet of abstract forms painted in earth colours of ochre, sienna and black, with a tracery of lines to suggest scale, perspective and contour. If disillusion is too strong a word – the 'paranoia' of the Surrealists certainly is – to describe the mood of this mysteriously compelling work, its feeling is close, rather, to that lack of illusion with which the farmer regards the landscape upon which man depends, as a great mechanism obeying its own slow rhythms heedless of those who would control it.

Johnstone was in America (where a large number of his pictures have been lost) in 1928-29, and after an unrewarding sojourn teaching in the Borders left Scotland for London in 1931. Here again he took a succession of teaching posts but found time to paint and exhibit (his first one-man show was at the Wertheim Gallery in 1935), met the circle associated with Alfred Orage's *New English Weekly* including Eliot, Pound, Dylan Thomas and Wyndham Lewis, and frequented E.L.T. Mesens's London Gallery which promoted the work of the Surrealists. The paintings dating from the years immediately after his return from the States suggest a knowledge of the American painters Georgia O'Keefe and Arthur Dove, as Hall has suggested; but the resemblances are restricted to a smoother and more coherently formal approach in Johnstone's work which at this stage has become virtually *sui generis*. Of *Ode to the North Wind* (1929: DAG), Hugh McDiarmid wrote

111 Edward Baird
The Birth of Venus
1934 Oil 51 × 68.6 cm
Dr J. McIntosh Patrick

in 1933 (in a series of poems based on Johnstone's paintings written in 1933 but only published in 1963):

> Our task is not to reproduce Nature
> But to create and enrich it
> By method like musical notes,
> mathematical tables, geometry.
> Of which Nature knows nothing.
> Artificially constructed by man
> For the manifestation of his knowledge
> And his creative will.

The last two lines summarize Johnstone's approach. The paintings produced in the late twenties and early thirties, of which *A Point in Time* is the most ambitious, are unique in the history of modern painting; they hint at the biomorphic world of Tanguy or the palaeological sources and planar ambivalence of Henry Moore, but with a technique that suggests Abstract Expressionism, while often exploiting the contrived situations dear to Surrealism. It may be questioned whether Johnstone was not too ambitious and whether his magniloquence found its proper vehicle, despite the manifest originality of his periods, which are now quicksilver, now lead, with the former predominant. His pedagogical work can still be gauged by his extensive and far-seeing writings, with their advocacy of child art and the art of primitive societies; by all accounts he was an

inspired teacher, as anyone who knew him in his old age can readily believe. In 1938 he became Principal of Camberwell School of Art and Crafts, a post he held throughout the war until his appointment in 1946 as Principal of the Central School of Arts and Crafts in London. His retirement from this position in 1960 to resume the life of a farmer in the Borders, his emergence ten years later from that seclusion to growing public awareness of him through an initiative at the Scottish National Gallery of Modern Art, and the immensely productive new career as a painter (and autobiographer) which unfolded in the last dozen years of his long life – all this is a story which belongs to a later chapter.

Surrealism took many forms, but perhaps none more fantastic than the whimsical art of Scottie Wilson (1889-1972), born in Glasgow but resident in Toronto when at some time in the late twenties or early thirties, in the back room of his second-hand junk shop, he picked up a pen and began to doodle. 'The pen', as George Melly has said in his biography of the artist, 'like the red shoes in Andersen's story, refused to stop' but Scottie's mode of automatic drawing appears precisely guided by a logic of the absurd. In silhouette (his drawings make a very sparing use of outline as such) the endlessly varied forms (one almost wrote, creatures) are crisply Rococo: s-scrolls, f-scrolls, c-scrolls, indeed virtually every scroll known to calligraphy. The fields bounded

by the silhouette are subdivided by gadroon-shaped areas of gently curvilinear hatching which gives the whole a soft, invertebrate appearance like a swarm of plankton magnified. The forms themselves include plants, birds, fishes, hippocamps and bulbous-nosed 'greedies' or 'evils', half-materialized incubi and succubi bodied forth from the artist's subconscious and expressing moods of serenity or, more often, feelings of persecution or unexplained dread. Scottie returned permanently to London in 1945 with his style essentially fully formed and was quickly claimed by the Surrealists.

His later work pays more regard to pictorial values and shows an expressive use of an individual range of colour – velvet blacks, midnight blues, burnt orange – and he was an obvious choice for commissions for tapestry at Aubusson and for porcelain decorations for the Royal Worcester Porcelain Company.

Three Glasgow-trained artists, Edward Baird (1904-49), William Baillie of Hamilton (b. 1904), and William Crosbie (b. 1915) showed a brief interest in different aspects of Surrealism in the 1930s. Baird, who came from Montrose and was a friend of the Dundee artist McIntosh Patrick, who had also come to Glasgow School of Art, won a travelling scholarship which enabled him to study in Italy. Here, like Patrick, he was especially impressed by the work of the early Renaissance masters, especially Mantegna. *The Birth of Venus* (1934: private collection) exemplifies Baird's tightly controlled draughtsmanship and high finish. It is contemporary with and resembles the work of Tristram Hillier in its minute rendering of the flotsam of the shore, but the lenses (of a collector or a film director,

112 William Baille of Hamilton
Painting
1939 Oil 61 × 77 cm
William Hardie Gallery

113 William Crosbie
Heart Knife
1934 Oil 60.3 × 43 cm
Scottish National Gallery of
Modern Art

William Baillie of Hamilton is a rare excursion into Surrealism with echoes of Paul Nash and Edward Burra. The artist has explained to me that the painting was born out of feelings of premonition prior to the outbreak of war. The dream-like atmosphere in which time is accelerated, bringing sudden death and somewhat ominous vegetable growth, is enhanced by a delicate effect which works like a gauze in the theatre to suggest interstellar dust in an impending cosmic drama. Alone of these three artists, William Crosbie was able to make a study of Surrealism at first hand in Paris where he studied under Léger and Maillol in 1935-36. One of the most brilliant students to have graduated from Glasgow School of Art, Crosbie has demonstrated enormous versatility in a career that has included mural commissions and decorative schemes for several of the Clyde-built liners as well as easel paintings, including decorative nudes and still lifes which show the influences of Maillol and Picasso. *Heart Knife* (1934: SNGMA), however, suggests Ozenfant and Jeanneret and Purism; although as it predates his Paris year it may reflect a knowledge of the work of the English Constructivists of Unit One and particularly Ben Nicholson, whose predilection for pure geometry and a distressed, painterly surface it shares. The painting is a brilliant construction of geometrical abstract forms inscribed with set square and dividers on the plane surface and yet occupying three-dimensional space, demonstrated by the presence of areas of light and shadow and by the spring-like line with a ball at its top which is in arrested motion. In *Design for Living* (1944: private collection), a self-portrait in Navy clothes, the artist literally toys with Abstraction: is this the way forward?

The designer and painter Alastair Morton (1910-63), was on terms of close friendship with Ben Nicholson and his first wife Winifred from the early thirties when the Nicholsons and Morton himself were living near Carlisle. Morton was a member of the Morton family of Darvel, already encountered in the architect W. Gibb Morton and in the link of Voysey with the firm of Morton Sundour of Carlisle, a successor of the Darvel, Ayrshire family lace-making and textile firm of Alexander Morton and Company. Through his directorship from 1932 of the Scottish firm Edinburgh Weavers, founded by his father in 1928 to develop textiles compatible with the most recent developments in architecture and design, Morton was able to support one of the most fruitful and original developments in twentieth-century design in Britain, and at the same time to pursue his own experiments as an abstract painter to a remarkable and successful conclusion. After only two years in Edinburgh, the slump of 1930 forced the firm to merge its Edinburgh workshops with the main factory in Carlisle, but Edinburgh Weavers continued in business from its new base, with showrooms in London in Hanover Square and, after 1935, in New Bond Street. It not only continued in business, but

who knows?) and the enigmatically smiling antique head suggest an ironical view of what, suitably for a picture given to the Patricks as a wedding present, was a Hollywood-glamorous subject. Baird's output was small but of consistently beautiful draughtsmanship. *Unidentified Aircraft* (1942: GAG) began as a view of the town of Montrose rendered with Mantegna-like precision to resemble a northern Italian town, its suspension bridge, no longer extant in 1942, included to impart a strangely medieval antiquity to the town, now threatened by the unseen enemy aircraft towards which the heads in the foreground look skywards, added later when the bombing raids had begun.

Painting 1939 (William Hardie Gallery) by

under Morton's increasingly well-informed and enthusiastic artistic directorship – he visited Hoffmann in Vienna in 1936, and would certainly have seen the exhibition of Constructivist art organized by Edinburgh University in May 1937, which included Piper, Moore, Hepworth and Nicholson – entered a highly creative phase in which superb modern designs, particularly by Hepworth and Nicholson, were sympathetically realized in textiles using mixtures of different yarns as well as prints. These designs were launched in 1937 as the 'Edinburgh Weavers Constructivist Fabrics'. In the previous year Morton had commissioned a house from Leslie Martin and Sadie Speight, and had added a canvas by Piet Mondrian – *Composition* (1932-36) – to the paintings and sculptures he had bought from his friends.

Morton began to paint abstract compositions in 1936. In a letter to Ashley Havinden of 12 May he writes, 'I have had great fun since I got back trying abstract painting. I have nearly finished my second and have a third in mind ... It takes much longer than I thought but it is exceedingly interesting work'. C.H. Waddington's account of Mondrian in *Behind Appearance* succinctly analyses the arcane differences between Mondrian and pesudo-Mondrian; this can be simply summed up in Ben Nicholson's words to Morton in a letter of 18 February 1940 regarding Morton's own work: 'I expect the new oil abstracts are very good. It is the *sustained* tension in these more serious works which is really satisfying'. Morton's paintings, often in gouache and on a small scale after 1940, possess the delicate poise of weight and counter-weight of Mondrian as well as Mondrian's impassive surface and an almost identical, sparing use of red and yellow, but he resembles Nicholson in his occasional introduction of circles, lines which suggest shadows and hence the presence of light, and straight lines which depart from the rectilinear grid of Mondrian. In at least two examples, as Calvocoressi has pointed out, a four- or six-frame quasi-animation of the component shapes of the composition results in a sense of movement, as if these forms were turning in space, like a Calder mobile. The plywood constructions and related paintings of the Edinburgh-trained artist Margaret Mellis (b. 1914) likewise show the humanizing influence of St. Ives, where Nicholson and Naum Gabo were neighbours after her move there in 1939 with her first husband Adrian Stokes.

The playfulness of the Jazz Age and the geometrical emphasis of Art Deco, brilliantly anticipated by Mackintosh in the work for his Northampton clients Mr and Mrs Basset-Lowke and in his textile designs, belong essentially to the big city, to Glasgow rather than Edinburgh. Weddell and Thomson's Beresford Hotel, the Cosmo Cinema, the great gates to the Shawfield dog stadium, and Thomas Tait's Art Deco tower at the Glasgow Exhibition of 1938 were among the more conspicuous monuments of the style in Glasgow. There were also the interiors designed by Charles Cameron Baillie for luxury liners and, famously, for Rogano's Restaurant in Royal Exchange Place. Charles Cameron Baillie was also an extremely incisive portraitist, often painting on small

114 Alastair Morton
Untitled
1940 Gouache, watercolour and pencil 35.6 × 51 cm
Scottish National Gallery of Modern Art

115 John Laurie
The Cocktail
1936 Oil 138 × 91 cm
William Hardie Gallery

glass panels; sadly, his work is very rare and he has remained an obscure figure about whom virtually nothing is known. But perhaps the Art Deco interlude is most convincingly represented in Scottish painting by a single large painting, *The Cocktail* (1936: William Hardie Gallery) by John Laurie (d. 1972), who taught drawing at Glasgow School of Art from 1946-1972, having himself been taught by James Cowie at Hospitalfield. One wonders what Cowie would have made of the suddenly emergent decorative panache of his pupil, which unfortunately did not resurface after the war when delicious decadence had given way to austerity and rationing.

The last aspect of the work of Scottish artists of the twenties and thirties briefly noticed here is perhaps also the best-known today. The 1922 Group, consisting of students who had qualified at the Edinburgh College of Art in that year, included W.G. Gillies (1878-1973) and William MacTaggart (1903-81), respectively a future Head of Edinburgh College of Art and future President of the Royal Scottish Academy, with whose names the twentieth-century Edinburgh School is practically synonymous. Francophile, colourful, serious and civilized, these prolific artists have stamped contemporary Scottish painting with an image which refuses to fade even today. In MacTaggart we find a powerful impasto and glowing colour reminiscent of Rouault, applied chiefly to landscape and still life. Gillies employed a decorative idiom resembling the later Braque – who was made an honorary member of the RSA in 1957 – to some extent a legacy of his Paris experience, in treating very similar subject matter. Equally painterly and partly inspired by their example, Anne Redpath (1895-1965) employed an increasingly rich palette when she returned to painting after living for many years in France, and her travels to France, Spain, Corsica, Britanny and the Canary Isles provided themes. A more wistful, haunted art which owed a good deal to Chagall and Redon was developed in Edinburgh by John Maxwell (1905-62). As these Edinburgh painters and their colleagues and successors at Edinburgh College of Art continued and renewed the Franco-Scottish painterly tradition of the Colourists well into the post-war period, their work will be described in the chapter which follows.

10 POST-WAR PAINTING IN EDINBURGH AND GLASGOW

The star of Edinburgh was again in the ascendant between the wars and after World War II. This was due firstly to a negative factor, the decline in influence of the Glasgow Boys, the dispersal of many of them to Edinburgh or London, and the lack of any convincing succession to them in the west. But there were real, underlying strengths to Edinburgh's position. Its Art College, founded in 1908, drew upon traditions established by the Trustees' Academy and the RSA Schools in earlier decades and thus enshrined the major part of the history of Scottish painting and especially the painterly Colourist tradition. Two of the Colourists, Cadell and Peploe, had studied there, and Peploe had recently been a member of the teaching staff. An enlightened regime prevailed in the College – Sir William MacTaggart singled out Adam Bruce Thomson, D.M. Sutherland and Henry Lintott as inspiring teachers – and the Andrew Grant Bequest, which from 1930 enabled nearly all the most gifted or promising students to spend a post-Diploma year abroad, was of crucial importance. In addition, the SSA in Edinburgh played a major role, which is only beginning to be recognized, in introducing the Scottish public to the work of unfamiliar masters such as the Post-Impressionists, the Futurists and Picasso in 1913, Paul Nash in 1919, Munch in 1931, Klee in 1934, Braque and Soutine in 1935, and Max Ernst and other Surrealists in 1937. As Council member and then President of the SSA (1933-36), of which he had been a member since 1922, MacTaggart played an important role in securing these shows, the first of which was in fact also shown in Glasgow before travelling to Edinburgh. None of this would have counted of course without the five singular artistic personalities who were the originators of the new Edinburgh style: Anne Redpath (1895-1965), William Gillies (1898-1973), William Crozier (1897-1930), William MacTaggart and John Maxwell (1905-62). Precisely at the time when the rising stars of painting in Glasgow – Patrick, Baird and Fleming and the older James Cowie – were concentrating on linear precision and the hard edge to the virtual exclusion of all else including colour, these Edinburgh artists, inspired by frequent visits to France,

opposed painterliness to line, richness to austerity, and decoration to descriptiveness whether of colour, modelling or perspective. Of the Glasgow names, only Fleming was a native of that city, and by 1948 he had moved to the north-east of Scotland on his appointment as Warden from 1948 to 1954 of Hospitalfield House. Cowie preceded him as Warden from 1937 to 1948 after serving two years as Head of Painting at Gray's School of Art in his native Aberdeen and as we have seen, Patrick and Baird returned to their native Dundee and Montrose immediately on completion of their training in 1938. Their dispersal prevented the Glasgow-trained artists ever being regarded as a group, despite the obvious homogeneity of their work; not so the Edinburgh artists who remained attached to the capital city.

The teaching of André Lhôte in Paris, under whom Crozier and Gillies studied, might have been expected to provide a resolution of the Edinburgh – Glasgow polarization of styles by introducing the Edinburgh artists to the formal approach of Synthetic Cubism. Instead, the unexpected happened, and Gillies and Crozier, in temporarily espousing the more structural method of Lhôte, also adopted his earthy palette: perhaps Derain's later style too was an influence in this respect. Gillies's *The White Lodge* exhibited in the 1926 exhibition of the 1922 Group and the *Two Pots, Saucer and Fruit* of 1933 both look decidedly French, but in terms of colour it is as if Fauvism had never existed, nor for that matter its Scottish aftermath in the Colourists. Crozier's palette is similarly subdued. Before his early death his French enthusiasms had influenced his friend William MacTaggart. The delicate health of both men disturbed, or perhaps stimulated, their early training; they made frequent winter visits to France and in Crozier's case to Italy, and attended classes at the ECA when they could. MacTaggart, who had intended to study under Lhôte with his two friends, but was prevented by ill health, later remembered in those days hearing a lot of Lhôte's philosophy from Crozier. The Old Town of Edinburgh as it rises towards the Castle was a frequent subject for Crozier, both in etching and in painting. Repeated study of the city enabled him to reconstruct it in

simplified planes and volumes illustrated typically by a soft sunlight, with pliant outlines blunted by a light haze to produce a soft edge, as in *Edinburgh (from Salisbury Crags)* (1927: SNGMA). If this is Cubism, it is soft Cubism, but the influence of Lhôte is clear.

In 1926, his training and a year's teaching in Inverness behind him, William Gillies returned to Edinburgh to take up a part-time appointment at the ECA and so began the association which was to last forty years. He became Head of the School of Painting in 1946, and Principal in 1960; he was knighted in 1970. In the same year his lifelong friendships with the painters D.M. Sutherland, Donald Moodie, and John Maxwell began. After Crozier's death in 1930, Gillies shared the studio at 45 Frederick Street with MacTaggart. These friends shared many painting holidays throughout the thirties and when Henderson Blyth joined the ECA staff in 1946 he too became involved in these trips, which were to prove a cementing influence on the style of this group of individualists. Throughout the thirties ·Gillies and John Maxwell went every Sunday evening to visit Dr Frederick Porter and his wife Margery (Peploe's sister), in Morningside Road, Edinburgh, where the issues of modern art would be eagerly discussed in a nursery of ideas to which Gillies later acknowledged his indebtedness. After the Gillies family's move to Temple in Midlothian in 1939, the village and its surroundings became the mainstay of his landscape work, and his still lifes were painted in the studio there.

Gillies is *par excellence* the kind of painter whose naturalness defies verbal explanation. There are no iconographical mysteries to unravel and little in his uneventful life which appears to be reflected in his work, and in the very large *oeuvre* in watercolour as well as oils produced over half a century there are few, very few, deviations from a steady and stately course. A work of his early years will not have so very different an appearance from a late one. There is a slow development towards a higher key and greater transparency, and an increasing tendency towards the disembodiment or dematerialization of the object and its detachment from its surroundings, in the process of which the ground plane will tend towards the vertical and function also as background. But this is itself only a late stage in a preoccupation which is constant in his work, and to which the experience of relevant masters such as Munch and Braque brings only a mild and temporary distraction. Gillies's gift is such that, painting every day – 'What else is there to do?' he would ask – he found in the daily exercise of the craft of painting all that he required to solve the problems of painting as an art. The preoccupation was, essentially, the composition currently before him on the easel and how to marshal its constituent elements so that the 'mood' (a favourite word) of landscape or the 'almost pure abstraction' of still life (by this he must have meant the purity of inanimate form) could be preserved in their conveyance from three dimensions on to two. The skill was in the touch which ensured that in the process none of these delicate things was bruised. Although equally at home in oils and watercolour, the transparency and fluidity of watercolour he clearly found particularly congenial.

Gillies himself mentioned Matisse, Pissarro, and Braque as the three artists whose work had meant most to him since his year in Paris but was dismissive about the importance of that year to his own development. Perhaps it was the serenity of mood of Pissarro and the flat, decorative style of Matisse that seemed in sympathy with his own practice, although Gillies's palette is a long way short of Matisse's chromaticism and employs secondary and tertiary colours in preference to anything more assertive. When he does use primary colours, he does so judiciously, aiming always at subtlety and understatement. In landscape, and also in still life, where the example of Braque is more relevant, Gillies remains wedded to the motif and to the sense of place, of man's domestic or landscape environment, with its associations preserved intact. His fluent, economical drawing is perhaps the key to his style. Where Braque will combine two or more elevations of an object simultaneously in a single fluid line, Gillies will select one viewpoint and draw it with sure elegance. Braque's objective imagery thus transcends the particular; Gillies, conversely, renders the particular transcendent. One is always conscious in his work of the individual landscape in just *that* set of weather conditions at just *that* time of the year, of those particular flowers or that still life as being a true record, as well as possessing great decorative beauty of colour and form in their new juxtapositions on the canvas. By all accounts his felicitous touch was the accurate reflection of the inner felicity of the man. His sane and positive influence on his contemporaries was immense as painter and teacher.

Gillies's lifelong friend William MacTaggart attended the ECA at the same time (when he was not painting in France) and with Gillies founded the 1922 Group of artists who had gained diplomas in that year. The 1922 Group held annual exhibitions for about ten years and as well as William Crozier included A.V. Couling, William Geissler, David Gunn, George Wright Hall, Alexander Graham Munro and George C. Watson in its membership. From a very early point in his career – he began attending classes at ECA at the age of fifteen – MacTaggart shows a greater feeling for the handling of paint than any of his contemporaries. MacTaggart's father was an inventor and marine engineer, co-founder of the firm of MacTaggart and Scott, and an amateur watercolourist who encouraged his son's desire to be an artist. As the son of the great Scottish landscapist William McTaggart, Hugh MacTaggart had none of the usual parental qualms about the artist's life for his own son. William MacTaggart the younger (as he habitually signed his paintings,

abbreviating the last word to 'ynr') possessed several major examples of his grandfather's work – more of his work than that of any other artist – including three large and very painterly landscapes from the elder McTaggart's impressionistic late phase. It is not known when these came into his possession, perhaps in 1930 on his father's death; but they were always there in the background, an ever-present reminder of the family tradition of artistic independence and the painterly treatment of landscape.

At the risk of oversimplification, it is possible to divide MacTaggart's career into four phases, which spring in turn from his encounters with four European Modernists. André Lhôte's formalist influence, mediated by Crozier, is visible in his work of the early twenties: but in the mid-1920s a gradual return to fidelity to the forms of nature rather than of geometry is accelerated by the example of Dunoyer de Segonzac – 'I remember being very, very thrilled by Segonzac' were his words to Douglas Hall. Segonzac, a friend and admirer of Fergusson in Paris (Fergusson had enlisted him as a contributor to *Rhythm*), was opposed to Cubism; his own paintings of landscape have a meandering, free-flowing line. This came to MacTaggart as a welcome release from the aridities of the earlier style. Like Gillies, he was a compulsive sketcher from nature, as his many note-books testify, preferring charcoal and its broader effects to the nervous pen and ink technique of Gillies. But MacTaggart's encounter with French painting seemed to mute his use of colour for a period – it affected Gillies and Crozier in the same way – and the powerful colourism with which his name is associated was hardly apparent until MacTaggart had seen the Munch exhibition in Edinburgh in 1931. (This exhibition, initially suggested to him and the SSA by the etcher Harold Morton, was arranged on the Norwegian side by MacTaggart's future wife Fanny Aavatsmark.) In the later works shown by the Norwegian master MacTaggart found a model for a style which expressed the moods of landscape with a strength of colour and handling which were congenial to his own temperament. After the war the MacTaggarts were able to resume their visits to France, and in 1952 MacTaggart saw the large Rouault exhibition at the Musée de l'Art Moderne in Paris. This exhibition changed the course of MacTaggart's work and prepared the way for the very rich final phase which only ended with his death in 1981. The glowing colours, sumptuous impasto, and emotional charge of MacTaggart's late work are frankly indebted to the French artist, with the significant difference that while for Rouault the human figure always remained the central concern, MacTaggart confines himself exclusively to landscape and still life which he infuses with human feeling. This humanism remains the chief point of contact between the art of MacTaggart the younger and that of his grandfather, but the revelation of Rouault was required to set it free.

116 Sir William MacTaggart
Poppies against the Night Sky
c.1962 Oil 76.2 × 63.5 cm
Scottish National Gallery of
Modern Art

The confident, fluid handling of the little painting of *The Croisette at Cannes* (1923: Arnold Clark), painted on the first of his winter visits to the south of France, suggests an influence of Fergusson's and Peploe's Royan period, and in the more formally composed slightly larger paintings of the twenties such as *Cassis* or *Bormes-les-Mimosas* (Studio nos. 238 and 270) awareness of Lhôte is evident. But it is also noticeable from the beginning that MacTaggart's style is his own, with a concern for *matière* and for beauties of surface which determines the way the paint is applied as much as any descriptive requirement. The artist remained true to this view of painting throughout his long career, and it is a noteworthy feature of his gradual development that form and content advance at the same pace. The formidable technique grows to accommodate the increasingly profound and dramatic subjects, the mysterious, brooding landscapes, and the view from his studio window over the garden in Drummond Place one day filled with a meek procession of nuns (Studio no. 100) painted with great simplicity, and

on another dominated by a magical night sky with stars and a red moon (*Starry Night, the New Town,* 1955) above a still life of fruit, painted with a palette of lapis, amethyst, sapphire and cornelian. The assumptions underlying a career devoted to painting landscape and still life must include a view of the value of such subject-matter itself. MacTaggart shares from the beginning the hedonism of the traveller-painters who take pleasure in nature, in unspoiled places, in the sun, and for whom landscape, like the flowers, the food and wine and the man-made things in still life, conduces to man's well-being and is indeed necessary to it. He begins by describing these things objectively but ends with a more subjective suggestion that their beauty and necessity depend on man and that these qualities have no independent existence outside man's perception of them. In the richly painted, visionary later work a tremulous sense of flux parallels the fragility of our grasp on them as well as their own transience. Their beauty is a function of our perception, but their being remains ultimately as mysterious as our own existence. The worked surface, the sulphurous yellows and reds, the petrol blues and greens of a palette in harmony with its own geological origins, present a paradigm of human creativity, man working with the materials of nature. In *Poppies against the Night Sky* (SNGMA), the flowers possess something of the poignancy with which Rouault invested the human figure, because MacTaggart's true subject, perhaps, is not the beauty of this world so much as man's struggle to hold it fast.

> We are the music makers,
> And we are the dreamers of dreams,
> Wandering by lone sea-breakers,
> And sitting by desolate streams; –
> World-losers and world-forsakers,
> On whom the pale moon gleams:
> We are the movers and shakers
> Of the old world for ever, it seems.
>
> Arthur William Edgar O'Shaughnessy, *Ode*

John Maxwell appears as a solitary phenomemon whose art of fantasy and dream is unparalleled in Scottish painting of the twentieth century, unless one harks back to Jessie Marion King and the other Art Nouveau illustrators who employ a very different vocabulary and technique. Yet we know Maxwell to have enjoyed the company of fellow artists like his close friend William Gillies and to have appreciated his student years at ECA as well as his years there as a teacher, where, as David McClure stresses in his excellent and sensitive monograph, he in turn was greatly valued by the students for his encouragement of individuality. His pupils at ECA included Alan Davie and William Gear. His own teachers were Henry Lintott, David Alison, D.M. Sutherland, Adam Bruce Thomson and Donald Moodie all of whom, with the exception of Lintott, were essentially realists and admirers of Impressionism. Lintott alone

followed a very different tradition, that of Symbolism informed by the painterliness of Impressionism. His 'floaters', as he liked to call his allegorical figures would be noted by Maxwell as presenting an alternative to the more literal style of his other teachers. Maxwell did not spring Minerva-like, fully-armed from the head of Chagall, but he did develop his unique style at an early point in his career and did not alter its essentials thereafter. He would of course have received encouragement from Chagall's work as that of a kindred spirit; but until we know more of the precise circumstances of his acquaintance with that artist's *oeuvre,* it is premature to talk of influence.

Regarding Maxwell's relationship to the other master of the French School whose work has the most obvious affinity with his, Odilon Redon, it will be remembered that Charles Mackie had actually met Redon in Paris in 1892-93. Although Mackie died in 1920, it is clear from his widow's diary, which records this meeting, that Redon was regarded at that early date (and at the later date of the diary) as a figure of considerable importance. Charles Mackie, as a prominent member of the Royal Scottish Academy living in Edinburgh, can be assumed to have regaled his brother artists there with the tale of his early encounters with Vuillard, Ranson, Gauguin, Sérusier and Redon, and would certainly through his extensive circle of friends have increased awareness in the artistic community in Edinburgh of these *avant-garde* names. It is probable that Maxwell would have been alerted in such a way to the work of Redon, and also to that of Gauguin, whose drawing of the figure Maxwell's resembles in the 'Floral Queen' and 'Trellis' series. But this is conjecture. What is important is that Maxwell's art amply demonstrates that inner necessity which is the basis of genuine style. It is mysteriously, magnetically self-sufficient. In 1927, after a brilliant final year at ECA Maxwell received a travelling scholarship which took him to Spain and Italy where, as Anne Redpath had done before him, he discovered the painters of the Sienese *trecento,* and finally to Paris, where he enrolled in the classes conducted by Ozenfant and Léger at the Académie Moderne. We may assume that it was at this point that he encountered the work of Chagall and Redon. In 1929 he was given an appointment at ECA from which he retired in 1943 on receiving a small legacy to concentrate in painting full-time. His friend Gillies persuaded him to return to teaching in 1955, however, and he held the post of Senior Lecturer in Composition at the college until his early death in 1962.

Maxwell, unlike his friends, did not work naturally from the motif; the figures, plants, animals and birds that populate his pictures are imagined, and even the landscapes or little street scenes are transformed by his imagination. The panel *View from a Tent* (1933: SNGMA) is revealingly different from

117 John Maxwell
Harvest Moon
1960 Oil 76.2 × 101.6 cm
Private collection

Gillies's open-air studies: Maxwell uses the open door of the tent like a theatre curtain to frame the enchanting scene of the little house and boats beside a jetty with the hills beyond so that these assume the expectant air of an empty stage, lit and ready for the play to begin. Immediately, we are in a very different world from the naturalism of Gillies. A similar atmosphere of *Marionettentheater* (but without marionettes) is visible in *Harbour with Three Ships* (SNGMA) painted in 1934, the year of the Klee exhibition at the SSA, a homage to the master which eschews Klee's diminutive scale and delicate handling. A watercolour of a similar subject, *Harbour with a Warning Light* (1937: AAG), achieves the authentic Maxwell resonance using his favourite method of painting on paper supported by a sheet of wet glass so that the pigment stains spread over the surface in a way which is partly random, adding to the effect of mystery. What danger threatens the Milk Wood-like village which seems to huddle in

concern? With the tender *Two Figures in a Landscape* (1934: private collection) we sense an unmistakable debt to early Picasso, just as *Flowers in a Square* (1938) or *Flowers on a Beach* (1937-39: private collection) dwarf village houses and churches in a manner strictly the property of Chagall. But the flower pictures are wonderfully, magically, rendered in colours which run the gamut from low to high register and justify his empirical view (quoted by McClure): 'if the colour's right, the tone will be right'. Maxwell (whose student life drawings in a conventional style are among the most beautiful ever done at ECA) arrives at a perfection of a new, simplified, hieratic style of figure drawing at about the same time as his power of colour comes to maturity, around 1938. The large *Three Figures in a Garden* (1938: private collection) has the archaic look of a Minoan fresco, partly through the use of deliberately primitive drawing and a palette of earth colours dominated by terracotta, and partly by the

device of placing the figures in an irregular panel like a wall-painting at Knossos. They are in a garden with flowers against a flat background which can be read as a wall or as a horizon and sky. The antique air of the painting lends timelessness to its theme of love and innocence which has special poignancy in the uncertain period before the cataclysm of war.

We forget too readily perhaps the degree to which the state of Europe immediately prior to 1939 contributes to the *Angst* discernible behind the apparent sybaritism of the art of the period. *The Falling Vase* (1941: private collection), painted in the year after Dunkirk, could almost illustrate a passage from *The Snow Goose* which was inspired by Dunkirk and published in the same year; it shares the same tragic view of the transience of the individual life which gives rise to the eternal ideals of love or of beauty. It also shares its unbearable poignancy, its ellipses, and its sense of the beauty of the 'Lost Princess', of the girl Fritha, and of the nobility of soul of the artist Rhayader:

> Wild spirit called to wild spirit, and she seemed to be flying with the great bird, soaring with it in the evening sky and hearkening to Rhayader's message. Sky and earth were trembling with it and filled her beyond the bearing of it. 'Frith, Fritha, Frith, my love. Goodbye my love.' The white pinions, black-tipped were beating it out upon her heart, and her heart was answering, 'Phillip, I love 'ee'.

Man with Flowers (1942; private collection) inhabits the same emotional atmosphere of passionate and unrequited longing. The ugly man offering flowers to the unseen object of his hopeless suit could almost be an imaginary portrait of Rhayader. The female figures of this period, known as the Floral Queens, have a very different demeanour; proudly bearing flowers like attributes of themselves, they are at once sensuous and impassive, distant yet vulnerable: *Floral Queen I* (1939-1940: private collection), *Woman with Flowers (Phyllida)* (1941: private collection). The hieratic mode is retained in the Trellis series which follows, in which Maxwell explicitly adopts a mural style with flat panels against which the figures stand with frozen gestures like players in a masque. In *The Trellis* (1951: private collection), measuring nearly four feet by five, fantasy reigns: a crown is placed by a bird on the head of the Queen of the four garlanded nude figures and a cat who dance to the beat of a drum and at the same time seem to be reserved in the biscuit of a painted antique terracotta bas-relief. Ambivalently, all these figures appear simultaneously to be absorbed by their own rites and to provide a decoration for ours, all, that is, except for the Queen, who looks out of the picture as if the spectator were also part of the dance.

Maxwell's paintings from the fifties until his death in 1962 demonstrate further decorative enrichment, with incrustations of colour and impasto in which meaning and allusion are enmeshed. The watercolour *Moon Changes* (1958: private collection) hauntingly evokes the mystery of the lunar phases with childlike images of a sickle moon, flowers and stars, and a pair of birds on the wing watched by a dark flower queen like a Tahitian girl painted by Gauguin. Unexpected juxtapositions of scale give a child's perspective and suggest the intimate relationship of animate and inanimate nature in a way at once credible and mysterious. A beautiful example of Maxwell's painting of these twin sides of nature is *Flowers and Frost Flowers* (1958: ECAC) where the frost flowers crystallized on a window pane (among which a characteristic hunting scene with an archer and a cockerel is visible) surpass in scale and rival in profusion of form the living flowers in the white jug beside them. In the same year, Maxwell produced the most complex design of his career for a commission from the Scottish Committee of the Arts Council for a tapestry woven by the Edinburgh Tapestry Company. This is *Phases of the Moon* (SAS) which is a large and very much more elaborate version of the *Moon Changes* composition. Maxwell went to considerable lengths to master the technical aspects of designing for the loom; the triumphant result has a Lurçat-like richness and sense of ornament, brilliantly combining the staccato of the central panel with a legato effect in the medievalizing border which is subdivided into twenty-two emblematic panels of birds, animals and insects. The endless creative profusion of natural history and the cosmic laws of natural philosophy are happily married in his work, which hints at the grandeur of Creation itself.

Textiles were in Anne Redpath's blood as the daughter of a Borders textile designer. 'I do with a spot of red or yellow in a harmony of grey, what my father did in his tweed', she once said. Born in Hawick in 1895, her productive life as an artist divides with unusual sharpness into four phases: her student years at ECA (1913-17) and a post-Diploma year spent in Brussels, Bruges, Paris, Florence and Sienna in 1919; her career as a wife and mother after her marriage in 1920 until the family's return from France in 1934, when she settled in Hawick while her husband, the architect James Michie, worked in London; then a period of gradually increasing activity as a painter culminating in her first solo exhibition at Gordon Small's gallery in Edinburgh in 1947. Finally, after her move to Edinburgh in 1948, and earlier visits to Skye and Paris, extensive travels to Spain (1951), Brittany (1953), Corsica (1954), the Canary Isles (1959), Portugal (1961), Holland (1962), and Venice (1963), which provided landscape or interior themes for her rapidly burgeoning career as a painter.

Redpath's work is seldom dated, and although one would like to understand better her transition to the vibrant colour and delicate sense of form of her maturity, it is clear that this coincides with, or

118 Anne Redpath
Still Life with a Jug of Flowers
c.1948 Oil on panel 61 × 50.8 cm
Private collection
(Photograph: William Hardie
Gallery)

precedes by a short period only, her return to Edinburgh in 1948. *The Indian Rug* (SNGMA) has been dated to 1942 on the strength of a catalogue entry for a picture with the same title exhibited in that year. On the reverse, rather puzzlingly, is a *Landscape near Hawick* which lacks the confidence and indeed the sophistication of the interior subject. If the two compositions really were painted at the same time, this is only possible if even at this early stage in her career the artist employed two modes for the two genres. Her compositional method, which involved balanced massing of shapes and the use of strong colour applied locally within the outlines of the drawing, seems to have predisposed her to greater experimentation in the more easily manipulated area of still life. For she was as wedded to the motif as Gillies, and, perhaps more than he, cherished surface pattern and texture. Certainly, *The Indian Rug* is a *tour de force* which displays to the full her natural feeling for paint and colour. The drawing is delicate and the decorative pattern and colours of the rug itself are closely followed – the rug departing from the horizontal considerably more than is demanded by perspective, in order to bring it closer to the

picture plane – while the modelling achieves great plasticity with the most sparing of means, producing a characteristically painterly surface. The whole composition is in fact calculated as a vehicle for a remarkable exhibition of colour at once strong and subtle, a bold combination of the pastel shades of the rug and the crimson slippers and scarlet chair.

A surface pattern of strong colour in clearly defined forms originating in still life sounds like a recipe from Matisse and, as her biographer has pointed out, Adam Bruce Thomson, who was one of Redpath's teachers at ECA, had returned from a scholarship year in Paris in 1910 with the news that the name of Matisse was on everyone's lips. But in fact there is no need to look further than local examples – Cadell's 'geometrical' still life style of the twenties, and Gillies's tip-up tabletop still lifes – for precedents with which Anne Redpath would be thoroughly familiar, and with which her work indeed has more affinity. Having mastered the principles of flat pattern defined in areas of self-colour with minimal modelling, solid and void being indicated through crisp outlines, it was natural that an artist with her feeling for paint should proceed to the freer,

less deliberate manner of her later work. This is the tendency which marks her later still life, landscape and interior pictures (the latter including a group of church altarpieces and icons or Madonnas painted in Mediterranean countries), which are painted with Expressionistic breadth of handling and wonderful vivacity of colour.

By temperament a great lover of life with a wide circle of devoted friends, Redpath was perfectly equipped to play a major role in the development of the Scottish Colourist tradition. One may speculate that had she come from a more intellectual school – with her exquisite sense of form, colour and surface, she would have made a brilliant addition to the Nicholson-Hepworth circle at St. Ives – the result would have been no less a thing to conjure with. But she was well aware of the alternatives and chose her own path as a painter more concerned with colour and form as the means of heightened visual enjoyment than as aesthetic ideals. She thought naturally in terms of colour, shape and texture. Her art is that of a traditionalist for whom the still life in a painting could never be dissociated from its role in the artist's life. The humblest teacup bespeaks a way of life as eloquently as a Baroque altarpiece suggests religious yearning. The landscapes reflect back personal meaning, like pages from a diary. An aesthete she unquestionably was, but always accessible.

Sir William Russell Flint (1880-1969) was perhaps the most popular in terms of public appeal and also probably the most commercially successful of the Edinburgh-trained artists of this generation. His success should not be grudged him. He was a genuine artist who possessed a wonderful feeling for *matière*, especially for watercolour of which he was one of the outstanding exponents in the modern era. In this medium he was a purist, allowing the white of the page to provide all the luminosity, transparency and depth of which watercolour is capable without ever resorting to the meretriciousness of Chinese white. No artist records as well as he the topaz, amethyst, and sapphire depths of the sea, the waterlogged fluidity of sand after the tide has run out, the flounces of a Spanish flamenco dancer as well as her fiery carriage, or the firm breasts of a beautiful young model. In an approximately ascending order of interest to collectors, such subject matter could hardly fail to please. His concentration, increasingly, on groupings of bare-bosomed girls in hot and sunny picturesque locations are escapist, but they undeniably convey and impart a hedonistic pleasure. Escapism, deny it as one might, is inescapably a natural human reaction; his paintings should not be reproached with any failure to record the grimmer aspects of a difficult period in history, not only because they make no attempt to do so, but also because they

119 Sir William Russell Flint
Disobedient Jane at Elie
c.1935 Watercolour 24.5 ×
33 cm
Private collection
Although he usually preferred more
exotic places, Russell Flint also
sketched in Scotland.

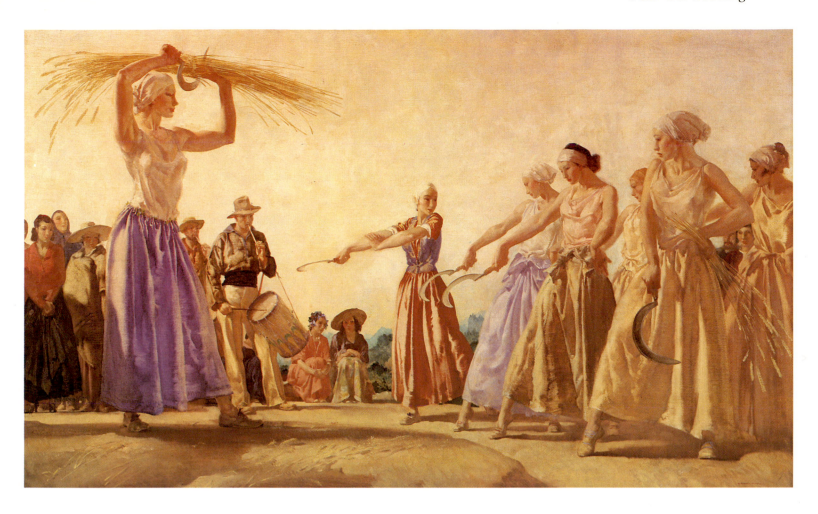

120 Sir William Russell Flint
Homage to Demeter, Provence
c.1932 Tempera 91.4 ×
152.4 cm
Private collection
(Photograph: William Hardie
Gallery)

embody the very real daydreams of a generation. It is not the least of their aesthetically satisfying characteristics that these daydreams are recorded in watercolours of such stuff as dreams are made on – transparent, exquisite, delicate and evanescent. Russell Flint's sanguine drawings and his easel paintings, often in tempera rather than in the less fluid oils, show equally great technical command and a never-failing sense of *chic*. *Homage to Demeter* is a large and classically choreographed composition which has something of the period elegance of Art Deco together with one of most commonly recurring themes of its iconography, the beautiful Amazon, in this case wielding little scythes which ought to make any mere male think twice before assuming that these pretty harvesters are intent on cutting off anything as mundane as sheaves of corn.

Wartime Glasgow witnessed a surprisingly vital and determinedly Modernist revival of creative activity in the theatre, letters and visual arts. There were productions of James Barke and other writers of the literary left at the Unity Theatre; modern dance by Margaret Morris's Celtic Ballet; and the Citizens' Theatre, founded in 1942 by James Bridie, T.J. Honeyman and others. A remarkably enterprising list of Scottish poets and writers was published by William MacLellan in finely produced *feuilletons* often illustrated or decorated by the members of the

'New Art Club', several of whom – notably Donald Bain, William Crosbie, and Tom Macdonald – were also active as designers for theatre productions in Glasgow. Although the riverside areas of the city like Clydebank suffered badly in the Blitz, the city centre was relatively lightly affected, and life went on as near normally as possible.

The return of J.D. Fergusson and his wife Margaret Morris from France to live in Glasgow shortly before the outbreak of war in 1939 was the single factor which, more than any other, galvanized the Glasgow scene. We have seen that a small but highly talented group of painter-draughtsmen (McIntosh Patrick, Edward Baird, Ian Fleming) had recently carried off all the prizes at Glasgow School of Art, where Hugh Adam Crawford, a greatly respected and influential teacher, had taught for ten years before becoming Head of the Painting and Drawing School in 1938. The great English artist Stanley Spencer was also in the city at this period, working in isolation at Port Glasgow. But the new movement owed allegiance to no institution and its mentors were its own senior members: the Polish *émigré* Josef Herman, who arrived in Glasgow at the end of 1940, Jankel Adler, who was demobilized from the Polish Army and came to Glasgow in 1941, where he shared a studio with Benno Schotz and then with William Crosbie and, of course, Fergusson himself.

121 Hugh Adam Crawford
Theatre
c.1935 Oil 66 × 66 cm
University of Dundee
(Photograph: William Hardie
Gallery)
Crawford (1898–1982), trained at
The Glasgow School of Art, is
remembered as a teacher who
inspired Eardley, Colquhoun and
MacBryde at The Glasgow School
of Art and as an influential Head of
the art colleges of Aberdeen and
Dundee. This work shows an early
receptiveness to Paul Klee.

There were two centres of activity. On the initiative of the Fergussons, informal discussions were held in November 1940 at Glasgow School of Art on the possibility of founding a New Art Club. The 'old' Art Club, its bastions stormed by the Glasgow Boys of fifty years earlier, was once again regarded as a citadel of the Establishment, with a subscription which seemed rather expensive to young and impecunious artists. The New Art Club duly came into being in December 1940, with a one-pound subscription 'which may be paid in quarterly instalments', and a no-jury system like that of the Salon des Indépendants of which Fergusson had been a *sociétaire*. In the following year, 1941, The Centre – Gallery, Bookshop, Coffee Room – was founded by the bibliophile David Archer who published Dylan Thomas, David Gascoyne, W.S. Graham and many

others for the first time at his Parton Press in Glasgow. The painter Benjamin Creme, a member of The Centre, became friendly with these and other writers from Archer's stable; they tended to stay in his flat when they came to Glasgow. Many members of the New Art Club also joined The Centre, which as Dennis Farr has written seems to have been an attempt at an Institute of Contemporary Arts. Four one-man exhibitions were held there and it is unfortunate that no catalogue seems to have survived, as the artists were of real stature: Adler, Herman, Crosbie and Taylor Elder. Farr (the writer's authority for most of the foregoing) tells us that Robert Frame and Benjamin Creme took over management of The Centre before it finally collapsed after some eighteen months of precarious existence. The closure of The Centre and the occupation of its former premises by

the Unity Theatre left a vacuum and led directly to the foundation of the New Scottish Group in November 1942 with Fergusson as its President.

The informal, at times anarchic nature of the NSG, and the greatly varying aspirations, styles and talents of its members, would not lead us to expect much stylistic common ground among them. Individualism was greatly prized and encouraged, particularly by Fergusson. But three main strands of influence, running from Fergusson, Herman and Adler are clearly visible. Fergusson's Cézannesque treatment of landscape has clearly inspired Margaret Morris's *Les Toits rouges, Dieppe* (1924: SNGMA), and Donald Bain's landscapes (e.g. *Environs de Saint-Paul-de-Provence* (1947: DAG); his Fauvism, Bain's early cityscapes such as *Place de la Concorde* (1946: author's collection). Josef Herman's admiration for the proletarian subject matter and painterly social realism of Permeke is relevant to Bain's early figure style, e.g. *The Blind Musician* (1943: HAG), and

122 Margaret Morris
Les Toits rouges, Dieppe
1924 Oil 35.5 × 27 cm
Scottish National Gallery of
Modern Art

also to the work of Millie Frood and Tom Macdonald who took over Adler's studio on the latter's departure for London in 1943. Adler's influence, in which the example of Picasso combines with that of Adler's friend Paul Klee, informs the work of Ben Creme, who moved to London in 1946, where he retained his close link with Adler. Adler from 1943 shared a studio in Bedford Gardens with John Minton, having left Glasgow in 1942, and here his work was to have a decisive bearing on two Glasgow-trained artists who were already installed in the same studio, Robert Colquhoun and Robert MacBryde.

The New Scottish Group produced a body of work which provides an alternative to the incipiently anodyne Edinburgh style. Fergusson's *Spring in Glasgow* (1941-42: HAG), where the model is posed against the view of the University and Kelvingrove seen from the window of Fergusson's studio apartment at No. 4 Clouston Street, must have seemed like a veritable breath of Paris spring air to his friends in Glasgow. The picture is typical of the generalized monumental style of this late period of his long career, when Fergusson also showed an increasing interest in his own Highland ancestry and in Celtic mythology (he had long been interested in Celtic art). Donald Bain added his own highly original contribution

to the Celtic movement in two extraordinary works which have Celtic subject-matter. These are the rebarbative, fiercely vehement *Ossian* (1944: Bain Sale 1981) and the placid *The Children of Lir* (1945: SNGMA). Despite titles which might suggest the recent Celtic Revivalism of John Duncan in Edinburgh, *Ossian* looks as much like a work by one of the COBRA painters (1948-51) in Paris as anything produced in Britain at this date, while the pantheistic *The Children of Lir* has affinities, albeit tenuous, with English Neo-Romanticism. Of *Ossian*, the artist wrote to me of a 'sudden realization that I was able to say something of my own in paint and I didn't care whether anyone liked it or not. But Fergusson realised what I was doing and didn't discourage me.'

Significantly, much of Bain's work is on a small scale. For one thing, his studio was the kitchen in a tiny flat in Springburn in north Glasgow where he and Eunice Bain raised three sons; for another, as his work stood small chance of selling, there was little point in saying at length what could be said equally well with brevity. Fortunately he was sustained by a courageous self-belief with which posterity is increasingly in agreement. Throughout the 1940s and 1950s – not always successfully – he essayed a wide range of subject-matter and styles, leaving his sources behind. The little watercolour *Jazz* (1943: SNGMA),

123 Donald Bain
Ossian
1944 Oil 86.36 × 61 cm
Private collection
The visionary Celtic bard of myth is Bain's subject in this work, which parallels contemporary COBRA painting or Ernst Wilhelm Nay. Bain frequently visited France in the later 1940s; these visits were to inspire a rejection of raw experimentation in favour of a return to the Franco-Scottish Colourist tradition.

124 Donald Bain
The Children of Lir
1945 Oil 107 × 91.5 cm
Scottish National Gallery of Modern Art

125 Donald Bain
Pleasure Craft
1968 Oil 49.5 × 61 cm
Museum of Modern Art, Calouste
Gulbenkian Foundation, Lisbon

for example, is much more abstract than anything ever attempted by Fergusson, and shows Bain's very individual sense of design. He spent several months in 1946-47 in Paris and the Midi and met Matisse at Vence and Picasso at the Colombe d'Or at Saint-Paul, where he drew the latter's portrait (private collection) and where he was welcomed as a compatriot of Leslie Hunter who was well remembered as an *habitué*. *Autumn* (1943: private collection) and *Fisherman* (1944: author's collection), with *Ossian* represent three aspects of his earliest, pantheistic style which already shows great originality. Several little abstract panels were painted with titles like 'Spring'; these seem to date from his time in Paris, but it is not known whether he was aware of the work of the COBRA artists and his compatriot William Gear in Paris at this time, which Bain's resembles. *Encroachment* (1948: Bain Sale 1981) was the most ambitious and largest of these; strictly, it is semi-abstract, with a recognizable animal's head surrounded by 'encroaching' urbanization. An abstractly structured *Calvary* (1958: Bain Sale 1981) further demonstrated his intelligent command of a fully contemporary idiom. Despite his isolation in Glasgow, Bain never stood still for long, consistently showing a painterly ability to adapt technique to

style. Never aiming at virtuosity, his technique involved a firm control of strong colour harmonies, and an awareness of the weight and scale of the brushstroke as unifying factors in the design. The turbulent brushwork and murky colour of *The Blind Musician* are essential to its powerful impact, while in the later work, such as the beautiful *Deux citrons* (1966: private collection) or *Pleasure Craft* (1968: Calouste Gulbenkian Foundation) the paint is applied very flat in broad areas of bright colour to give an effect of great simplicity and clarity.

Louise Annand, Marie de Banzie, Isabel Babianska, Anne Cornock-Taylor, William Crosbie, Andrew Taylor Elder, Robert Frame, Millie Frood, George Hannah and Tony St. Clair were among the other artists whose work benefited from the stimulus provided by the NSG. Their pictures from the war years show a varied and individual striving for modern forms of expression, from the biomorphic fantasies of St. Clair and Cornock-Taylor to the atmospheric Glasgow street scenes of Hannah. Louise Annand, in particular, painted one of the most striking images in her *New Art Club Meeting* (1944: William Hardie Gallery), which presents abstract symbols of the various factions in the New Art Club. She followed this successful and original parody with

126 Louise Annand
New Art Club Meeting
1944 Oil 51 × 61 cm
William Hardie Gallery
The artist uses abstract symbols to
personify individual members of
the New Art Club and their styles of
argument: nebulous or brilliant,
convoluted or political; the last
symbolized by a red star.

two brilliant Rayonnist paintings of crossed beams of colour – *Magic* (1944: lost), and *Heraldry* (1945: Murray Johnstone Ltd.) without, as she has informed me, ever having seen a work by Larionov or Gontcharova. The NSG included several particularly interesting sculptors, notably the wood carver T.S. Halliday, and George Innes, whose work looks so interesting in the literature but most of which seems to have vanished into private hands. The New Scottish Group seems to have held only four annual exhibitions with well-produced catalogues with essays by Naomi Mitchison, Professor Alan M. Boase (whose portrait was painted by Herman), Maurice Lindsay and William Montgomerie. The last was also the author of the only monograph published by MacLellan on any Group member, Donald Bain. The last such exhibition was held in 1946, although in 1947 several NSG artists sent works to an opening exhibition of Modern Scottish Painting organized for the first Edinburgh Festival by the Society of Independent Scottish Artists. To this exhibition the 'two Roberts', Colquhoun and MacBryde, were also invited to send. Sadly the NSG seems not to have survived as a group much after 1951, when a retrospective show was held. They, and especially Donald Bain, today seem to us to have been 'primitives of the new sensibility'; they appeared at a

difficult time, but perhaps it was something of a miracle that they appeared at all. Although no equivalent grouping rose to succeed them, they initiated in Glasgow a certain receptiveness to new ideas from outside Scotland and – equally importantly – the idea of that independent art which J.D. Fergusson wished to foster in Scotland in a period when Scottish art was either linked to the local art establishment or was losing its identity in a welter of efforts to catch up with earlier twentieth-century styles.

The most striking work produced by this conscious cosmopolitanism is that of Robert Colquhoun (1914-62) and Robert MacBryde (1913-66), who both trained under Hugh Adam Crawford and Ian Fleming at GSA and under James Cowie at Hospitalfield House in company with John Laurie (1916-72) and Henderson Blyth (1919-70). A fellow student at GSA, John Houston, recollects that Colquhoun's painting was markedly different from that of his contemporaries even in his student days, and suggests the influence of Picasso (particularly an unidentified drawing seen at the MacLellan Galleries in Glasgow in the mid-1930s), and also the impact of Herbert Read's *Art Now*, published in 1933. The two artists met in 1932, when they were both beginning their first year of study at GSA. For the rest of their lives

they were inseparable. Both showed remarkable talent as draughtsmen and were consequently well equipped to carry on the Glasgow linear tradition recently established at GSA. An early stylistic direction was given above all to Colquhoun by the work of Jankel Adler which they encountered, meeting the artist himself, during Adler's brief sojourn in Glasgow. Adler acted as a vivid channel of the Synthetic Cubism of Picasso, and his drawing of the figure is given a certain indefinably central-European *Weltschmerz* by emotive distortions which surface again in Colquhoun's work at its most stark. We should also remember that, as John Houston has convincingly reminded us, the desperate conditions of the hungry poor in the artist's native Kilmarnock and the atmosphere of the Hunger Marches of the thirties deeply affected Colquhoun's view of the human condition. After Colquhoun was invalided out of the army in 1941, Colquhoun and MacBryde moved to London to join John Minton in the studio at 77 Bedford Gardens, which became an important focal point for some of the most *avant-garde* names of literary and artistic London in the war years: the poets W.S. Graham, George Barker and Dylan Thomas were *habitués* as were the painters Michael Ayrton, John Craxton, Prunella Clough and Keith Vaughan, with less frequent visits by Francis Bacon, Lucian Freud and the young Hamilton Finlay. In these early years they must have made a striking pair, with mutual obsessiveness leading to fierce jealousy followed by reconciliation and the inevitably unequal interdependence of a latter-day Verlaine and Rimbaud, whom they admired, their artistic and social isolation a matter of pride, their noisy and often drink-inflamed Scottish nationalism expressed in strong Glasgow accents. Lefevre's keen-eyed Duncan Macdonald, the 'discoverer' of L.S. Lowry, gave the Roberts an exhibition in 1943; several more followed, but Macdonald, their most enthusiastic advocate, died in 1949 and Colquhoun's last show with Lefevre was in 1951.

Another success, minor but significant, came in 1945, when after an interview with Kenneth Clark, Colquhoun was commissioned to record *Women Weaving Army Cloth* (War Artists' Advisory Commission) in the Hebrides. Both artists also made prints in the late 1940s including monotypes and lithographs, the latter printed at the Miller's Press in Lewes run by the sisters Frances Byng Stamper and Caroline Lucas. Kenneth Clark was again supportive in 1948, suggesting the Roberts to Léonide Massine as designers for his projected Scottish ballet *Donald of the Burthens* which was performed in 1951 at Covent Garden with sets and costumes by MacBryde and Colquhoun and choreography by Massine. Colquhoun also designed décor and costumes for *King Lear* at Stratford in 1953. In 1951 both artists were invited to contribute to the Festival of Britain Exhibition *Sixty Paintings for '51,* and MacBryde received a commission for a mural for the Orient liner *SS Oronsay*. But by the time of the Colquhoun Retrospective exhibition organized by the Whitechapel Art Gallery in 1958, for which the artist painted eight new canvases, the reckless lifestyle and years of penury were beginning to take their toll of Colquhoun, who died in 1962, while working on a drawing of a man dying. MacBryde was inconsolable and died in obscurity, run over by a car in Dublin, four years after his friend in 1966.

The fact that their lives were lived and their careers as painters developed permanently in each other's company, added to their common training and background, inevitably meant that their work would be extremely closely related. But there are major differences between the two artists, and something of the difference appears in two interviews they gave to *Picture Post Magazine* in 1949, to which Malcolm Yorke has recently drawn attention. The essential difference is that Colquhoun's art is ordered by a subjective view of the world; MacBryde's is dispassionate and aims to reveal hidden relationships which underlie appearance. Colquhoun begins with a defence of Cubism in the guise of an explanation of his own method: 'Each painting is a kind of discovery, a discovery of new forms, colour relation, or balance in composition. With every painting completed, the artist may change his viewpoint to suit the discoveries made, making his vision many-sided.' Crucially he adds, 'The special forms, evolved from the relation of colour masses, line and composition to express the painter's reaction to objects, will be the reason for the painting's existence.' In stressing the reaction of the artist, Colquhoun admits the possibility of that emotional, humane response that characterizes his formal distortions as a figure painter. By contrast, MacBryde's formalism as a painter predominantly of still life is revealed in his own words as that of a classicist who seeks universal truth behind accidental appearance:

> I set out . . . to make clear the order which exists between objects which sometimes seem opposed. I do this because it is the painter's function, generally speaking, to explore and demonstrate in his work the interdependency of forms. This leads me beneath the surface appearance of things, so that I paint the permanent reality behind the passing incident.

When MacBryde paints the figure, as in *Two Women Sewing* (SNGMA), it is reduced to a mere cipher which contributes to the formal relationships of the composition, having no intrinsic significance greater than that of the sewing machine, the table, and the material, each one of them an object suggested in a brilliant shorthand which emphasizes formal essentials: the woodgrain of the table end, the planks of its surface, like the simplified masks of the two women, undergoing a kind of distillation by which each becomes an equal component in the unified composition of two-dimensional shapes. In

certain pictures, presumably the later ones (a chronology has never been established) MacBryde adds these distilled forms as a background which is more frankly abstract and often suggests alternating light and shadow; but even at his most abstract, that reference to the world of natural shapes so characteristic of Neo-Romanticism – and so unlike the machinelike forms of Vorticism, for example – is never far away. The sinewy uninhabited landscapes of Benjamin Creme, who had left Glasgow and the NSG for London in 1946, similarly add a certain Glasgow muscularity to English Neo-Romantic content.

Colquhoun's spare and economical approach to composition can ultimately be traced back to Cowie's training. An early Cowie-esque drawing such as the powerful *Allegorical Study* (Dick Institute, Kilmarnock), couches a very un-Cowie-like theme of religion and sexual repression (a caged man, nude, is ignored by a despairing plaster Madonna whose classical drapes also seem to form the steps of a church) in the pseudo-academic language of metaphysical painting. If anything, it was Colquhoun of the two Roberts who initially owed the greater debt to contemporary English painting. His *Portrait of David Haughton* (circa 1941: Mayor Gallery) is obviously derived from Wyndham Lewis (who, like the Roberts, was represented by the Lefevre Gallery) just as the early *Tomato Plants* (1942) and *The Barren Land* (1942: both ibid) have the look of Craxton or Minton. But after Adler's arrival at Bedford Gardens in 1943, and especially after the Picasso exhibition held at the Victoria and Albert Museum in 1945, Colquhoun forsakes local influences, and with the example of Adler and Picasso develops his own Expressionistic style. The *Woman Weeping* (circa 1945: Dick Institute,) shows itself less concerned than the well-known Picasso archetype with a Cubistic interplay of planes; the emphasis is on continuity rather than fragmentation, the continuous line of the drawing expresses on the one hand the artist's 'reaction' to the subject and at the same time functions as a means of articulating the flat surface of the picture plane. An increasingly heroic manner is evident in the paintings of the late forties, which invariably contain figures such as the *Woman with a Birdcage* (Bradford Art Gallery) or *The Fortune Teller* (TG) set against a wall in a shallow space as oppressive and constricting as their own destinies. At this period Colquhoun's palette is individual – acidulous, acrid, and as astringent as a *Weltanschauung* which views humanity and animals as equals in appetite and in suffering, although the vitality and independence of the cat in *The Whistle Seller* (1946: private collection) contrast with the hopelessness of the human figure. Mannerism ousts feeling generally, in Colquhoun's later work, except in the late prints, where unfamiliar techniques and a more private sense of scale draw forth the artist's tragic vision in a series of compelling images, again often on the theme of men and animals. Always more painterly than MacBryde, Colquhoun in the late monotypes achieves a richness of texture too often absent from the declamatory late oils. His powerful style of draughtsmanship never deserted him. The obscene grin of the huge pig in *Figures in a Farmyard* (1953: SNGMA) has an uncomfortable familarity and graphically suggests callous human greed, suggesting that the stoicism and resignation displayed by the human figures in the painting originate in bitter experience of this form of inhumanity. Alienation, futility, desolation, isolation were all states of mind expressed by Colquhoun's best paintings of the period; it need not be doubted that they were as familiar to many of his audience in the austere climate of the Cold War as they were to the artist in the difficulties of his own personal life.

Joan Eardley (1921-63) in her short life brings together several Glasgow traditions – an emphasis on the importance of line and drawing, a certain earthy realism and preference for realist subjects, and a belief that an artist's life must be one of independ-

127 Robert Colquhoun
Boy with a Basket
1949 Oil 61 × 51 cm
University of Dundee

ence and commitment. She was a remarkable draughtswoman, with a vital sense of line and *mise-en-page;* with brushes or palette knife she held in painterly balance the opposing demands of surface and depth, of objective 'decoration' and subjective 'theme'. She possessed not only humanity, but spirit; compassion and passion too. Thus in a fascinating correspondence with her mother and with Margot Sandeman, recently published by Cordelia Oliver in her excellent biography of Joan Eardley, we find the artist on a study-tour of Italy in 1948 lamenting her inability to talk to potential subjects in their native tongue:

> You can't converse and get to know the peasants who speak to you. There is always this stumbling block – to me a very great one. To become friends and, in this way, to partly understand these people, is the only way I feel I can paint them with truth . . . otherwise, as I am now, I only know what I see from outside. I suppose painting is only a visual reaction to things, in a way – but to me it must be more. The story part of it does matter.

At the same time, her painter's eye leads her to analyse the secret behind the beauty of Giotto's frescoes at Assisi:

> It's the thing that makes the beauty in everything outside, here – that is the way a dark figure – a peasant, say, dressed in a suit of dark colours, appears in the sun and the shade *all in one,* black. And a peasant dressed in clothes washed and bleached by the sun appears, against the white stone, *all in one,* almost as white as the stone. They are single unbroken shades of dark and shades of light, unbroken by shadows or chiaroscuro.

In each case, what mattered to her was the authenticity of her own experience whether of the heart or of the eye; this for her was a prerequisite to the act of recording it in paint.

Joan Eardley returned to Bearsden with her mother in 1939, and in January 1940 began her studies under an outstanding teacher, Hugh Adam Crawford, at Glasgow School of Art, obtaining her Diploma in 1943. Among her contemporaries was Margot Sandeman, who became a close friend and painting companion, especially at Corrie, where her family had a small house. At this early stage in her career there is an obvious dichotomy between her considerable facility as a draughtswoman and her awkward technique – or lack of it – as a painter. The hard-won achievement of a level of painterly skill commensurate with her fluency of line and her expressive vision is not the least engrossing aspect of her early development. Having seen the ladder to Heaven, like Jacob she wrestled with her angel. A Lowry-like, almost childlike painting, *The Rush Hour* is followed by the noticeably more confident, monumental but still inchoate *The Mixer Men* of 1944, which dates from the period when for the

remainder of the war she worked at the reserved occupation of joiner's labourer in a small boatyard where part of her time was spent painting camouflage on boat hulls, and it was occasionally possible to find time to paint. She painted *A Pot of Potatoes* in the same year. The subject matter of both these early efforts reminds us that the NSG were currently prominent in Glasgow: Herman, and Bain's oil *The Porridge Pot* (1944: lost) are at no distant remove from Eardley at this point. After a spell on her own in London after the war she successfully applied for a place as a student at Hospitalfield House in 1946. Here she began a lifelong mutually supportive friendship with the mentally unstable but gifted painter Angus Neil – and encountered for the first time the redoutable James Cowie. Oliver quotes a revealing letter written by Eardley from her first week at Hospitalfield: 'I think I will have to be very strong to stand against Mr Cowie, and I don't feel very strong just now – he asked me if I had changed my way of painting since I left the art school, and when I said, yes, that I was trying to tighten it up a bit, he said "I'm very glad to hear it – this self-expression business is no good at all." ' Strange comment, one might think, from a present master to a future mistress of line: but Cowie was certainly expressing criticism of her painterly approach, so different from his own, on canvas. In 1947-48 she spent a year of post-diploma study at GSA at the end of which she travelled to Italy and France, returning in April 1949. From this tour resulted several fine ink drawings of landscape and towns in the manner of Van Gogh's drawings at Saint-Rémy, and also a number of studies of individual peasant figures of great expressiveness, including an oil of *Beggars in Venice* (private collection) which is prophetic of her later work, although in the Glasgow or Port Glasgow street scenes which came later her subject was not abject poverty and destitution so much as stubborn human vitality in the midst of urban deprivation.

Her student years past, Eardley turned with impressive assurance to the aspect of the urban scene which was to remain a major preoccupation throughout her career, the depiction of the underprivileged and undernourished children who flourished, despite everything, in the decaying industrial slums of Glasgow and Port Glasgow. Before her departure for Italy she had secured tenancy of a studio at Cochrane Street in the then unreconstructed Merchant City area of Glasgow; and a new friendship with Dorothy Steel, begun as a result of her part-time lecturing commitment at GSA, brought her to Port Glasgow in 1949. Her first truly characteristic work dates from these encounters. Apart from the expected facility of her beautifully taut, nervous drawings of the seaward skyline of Port Glasgow filled with the shipbuilders' cranes, the waifs and urchins of the streets now appear, at first tentatively as in the Vuillard-like *Shipbuilders' Street* (dated by Oliver to circa 1952 but surely earlier), then with increasing

128 Joan Eardley
Little Girl with a Squint
c.1961 Oil 76 × 51 cm
Scottish Arts Council

The problems of integrating the figure aspect into the composition, and of reconciling linear expressiveness with painterly colour, were now close to resolution. Several oil studies of Angus Neil in his lodging at Montrose Street – *Angus Reading* (1953), *A Glasgow Lodging* (1953), *The Table* (1953-54) – achieve an aesthetic balance between expressive accuracy and pictorial self-sufficiency. The most striking of the series is *A Sleeping Nude* (1955: SNGMA), in which the gaunt recumbent figure is modelled in simplified planes against a similarly simplified background. The result is powerfully realistic and achieves grandeur alike of form and of feeling.

The scene was now set for the accumulation of riches which is Eardley's last phase and for the series of paintings of street children and of the Catterline sea and landscape by which she established her pre-eminence in post-war Scottish painting. Catterline was discovered in 1950; she acquired No. 1 Catterline in 1954 and it remained her studio until the end of her life, although she also acquired No. 18 in 1959 as it had greater living space. This ancient, tiny fishing village on the exposed north-east coast of Kincardineshire retains its unspoiled character even today, perhaps because there is so little to spoil, just two rows of little single-storey houses, perched on a rocky outcrop looking down to a wide expanse of sea and the little harbour, with their backs turned to the cornfields which still hide them from the visitor until the last moment. Here at last Joan had a home which she could call her own, which she loved and which rewarded her love by providing endless subjects for painting: the sea in all moods, and the cornfields and the village in all seasons, painted in the open air. But she always retained her Glasgow base, moving from Cochrane Street to St. James's Road in Townhead, which became her studio from 1951. In a letter to her mother in that year, before she had secured her new Townhead studio, she wrote:

> It is desperate to lose the [Cochrane Street] studio . . . because I have become attached to it and it has been so useful in my work in that it is so near the slum parts of the town that I draw. And so easy to get the slum children to come up. And I have become known in the district . . . I wouldn't like . . . anything that was not in town, because my work is among the towny things, particularly places like the tenements around my studio. I know that now, much as I love the country and country things, my work does lie in the slummy parts – unfortunately.

Eardley's mature Glasgow work fuses European Expressionism and intensely local subject-matter: her children belong to Glasgow as surely as the gauche gamines portrayed by Duncan MacRae or Stanley Baxter in Bridie's *The Tintock Cup* of 1949 and its fifties successors which are today still part of Glasgow pantomime tradition. It is interesting that

authority: *Street Kids* (circa 1949-51: SNGMA) shows three boys in typically nonchalant poses, one reading a comic, another eating an apple, all sitting on the pavement (what would their mothers say?) in a tightly-knit group but wearing highly individualized expressions. *The Kitchen Stove* (circa 1950: SNGMA), which contains no figure, is perhaps one of her most satisfying designs, since the distortions of drawing aid the composition and are not expression-linked as in her figure painting. Here the quality of paint and the powerful but subdued palette with the spare drawing, invest the humble stove with surprising monumentality.

three major shows of German Expressionism had been seen in Scotland in 1939, the year of her arrival in Glasgow, and in 1950 (SSA) and 1953 (ACGB), as her figure painting immediately brings German practitioners such as Nolde or Käthe Kollwitz to mind. In *Children, Port Glasgow* (1955) a group of five small boys pass two girls of the same age who are pushing a rickety baby chair, with a huge but not unfriendly tenement and a tracery of shipbuilders' cranes in the background. Joan Eardley did not, as a rule, paint adults, but she had no need to: male self-superiority versus female as the persecuted guardian of the race, the battle of the sexes is joined at an early age. These hard-bitten, street-wise kids have a universality in which we recognize something of ourselves, and their good humour stems from a sense of survival despite their unpromising surroundings. A favourite model from her favourite Townhead family the Samsons, *Andrew* (1955) stands temporarily still, hands in pockets, wearing his hand-me-down clothes with as much masterful nonchalance as the selfsame Lord Snooty whose adventures he is perhaps studying while eating a jeely piece (prepared by the artist

perhaps?) in *Andrew with Comic* (circa 1955). These paintings reveal a new technical assurance and the figure is painted with the same rapid shorthand as the still life. The comic in the latter picture is denoted with an inventive painterliness which also provides the main visual *raison d'être* for the poetic *The Music Stand* (1955), a private memento of her friendship with Audrey Walker and of their mutual love of music.

The work of Joan Eardley's last years both in Glasgow and at Catterline, because it employs increasingly powerful colour and handling, can be called decorative rather than realist, but that would be to describe its surface characteristics only. During her Italian tour, Joan had worried that the language barrier was preventing her from painting the people there 'with truth' and 'only from the outside'. Her ambition implicitly was to paint them from the inside, from personal knowledge and understanding, not (in her words) only as a 'visual reaction to things'. Increasingly we find her identifying with the motif, whether the Samson children and their friends who haunted her studio, or the sea and fields at

129 Joan Eardley
Catterline in Winter
1963 Oil on board 120.5 ×
77.5 cm
Scottish National Gallery of
Modern Art

Catterline, in the act of painting them in a manner which imitates their living energy. Perhaps the most obvious form of this new *mimesis* are the wall graffiti so prominent in *Three Children at a Tenement Window* (1956); the artist is literally recreating (with the aid of photography: it would be impossible to achieve this degree of authenticity without it) the original calligraphy, and thus reliving – and conveying to the viewer – the mysterious impulses which prompted these scrawlings. Purposeful though they are, they are obviously the work of young hands, and thus provide an inspired setting for the three little girls at the window, suggesting something of their interior life or that of their near contemporaries. Several beautiful variations on this theme were painted, with increasingly bold use of colour and schematic drawing, and with a further layer of meaning provided by the stencilled words 'metal', 'licenced broker', 'rags' from the adult milieu. In the unfinished masterpiece *Two Children,* her last work, Eardley achieves a kind of near-abstraction which is indeed decorative but which at the same time penetrated to the core of the life of her subjects.

At Catterline the artist's identification with her subject led her to paint out of doors, in all weathers. Having characteristically taken a good deal of time getting to know the village, its people and its history, she began by painting the fields to the landward side of the cottages, and the makin' green below it. *Cornfield at Nightfall* (1952) is a view over the red field with corn stooks towards her house, and a moon in the dusk sky above. The composition is of exquisite simplicity and the palette has an almost Nabis tonality. *Sheep and Neaps* views the same field from the house, but this time in winter. The original harmony of grey and red, suggested by the red earth of the place, is accompanied by painterly brushwork which, not without a touch of humour, explores the similarity of the round bodies of the sheep and of the turnips. For Eardley, landscape was far from the 'passive creature which lends itself to the author's mood' which T.S. Eliot saw in Thomas Hardy's literary use of landscape; on the contrary, for Eardley what mattered was not her own mood, but the landscape's; the role of the artist was to be alert to the nuances of mood of the living scene before her. If a frozen winter's day with the white rime still on the hard earth, then the paint would be applied with the palette knife or with restricted movements of the brush (*Catterline in Winter,* 1963: SNGMA) to accord with the motionless, frozen rigidity of the scene; in the warmth of *A Field by the Sea, Summer* (1962), freer brushstrokes suggest the movement of warm air and life through the landscape. Occasionally, as in *Seeded Grasses* (1960: SNGMA), actual flower heads, grasses and earth were incorporated in the composition and painted over, not with the emotive symbolism of Kiefer with whom this technique has become identified, but simply in order to add an element of the real to the *tessitura* of the

work, and by this means to aid the feeling of identification.

In comparison with the sea and sky, of course, landscape is static. The vast elemental forces which every day altered the panorama of the North Sea seen from her studio window offered a theme well suited to her independence and largeness of vision. Audrey Walker's famous photograph of the artist standing dressed in waterproofs as close to the waterline as possible, a four by six-foot plyboard on the easel, before a boiling sea covered with white foam (SNGMA Archive) reminds us of that other great photograph of the elder McTaggart painting the Atlantic combers at Machrihanish shore. There were obvious similarities of approach, but in a fascinating interview with Sydney Goodsir Smith, Eardley disclaimed McTaggart's influence on her method with the remark: 'As a matter of fact my greatest influence is just looking at Nature. I never look at other painting at all.' In the same interview, she revealed that while the art of Jackson Pollock, de Kooning and the Tachistes interested her, the emphasis in her own painting lay in the direction of concrete subject matter. Two large paintings on ply (supplied by a local joiner) illustrate the essence of her powerful late manner. *The Wave* (1961) is as painterly as the well-known Realist works on the same theme by Courbet, but Eardley's painterliness has a different object: her brushwork imitates the movement, not the appearance, of the wall of water. *Foam and Blue Sky* (1962) is less formal than *The Wave,* more 'abstract', but this is determined by the subject, no longer a wall of advancing water, but a confused mass of flying spray and foam which has the colour of the sand below. Through Joan's love of Catterline we have in her paintings an extraordinarily full representation of Nature in microcosm; of the sea which provided the little fishing village with its *raison d'être,* the cornfields and the wild flowers – *Flowers* (1963) is a too rare example of her work as a painter of flowers – which nourished the inhabitants of the cottages and the beehives too. Joan Eardley's vision of the vitality and beauty of the world was celebrated with rare lyricism in the work of her last short years.

In the exceptionally fine summer of 1957 four young Glasgow artists who were all in their final year at GSA, together with two older Glasgow painters, Tom Macdonald and Bet Low, hung an exhibition of their work on the railings of the Botanical Gardens at the corner of Queen Margaret Drive and Great Western Road. The artists were Douglas Abercrombie, Alan Fletcher (1930-58), Carole Gibbons (b. 1935), and Alasdair Gray. The four friends together formed a little bohemia of which Gibbons and Fletcher were the centre; they stood somewhat apart from the Young Glasgow Group founded at about this time by several of their contemporaries. Alasdair Gray was the literary member of the quartet, as well as being a talented line illustrator and muralist. Douglas Abercrombie at this point was painting in a semi-abstract

style, and Carole Gibbons was painting a series of cat-figures which retained a witty feline character, although painted in a style of simplified colour and volume which was part-abstract. Her drawing came a little later to resemble Hockney, with a metaphysical content in a strange personal poetry further developed in an increasingly painterly abstract style which, however, never quite loses its references to mythical landscape. In many ways her work prefigures the work of the woman artists associated with the 369 Gallery today.

Fletcher's premature death in an accident in Milan at the age of twenty-eight robbed Scottish painting of one of the most exciting young artists of his generation. He had decided to specialize in sculpture on enrolment at GSA in 1951, partly out of a desire to keep his painting free from influences. Twelve pieces were shown at his Memorial Exhibition in 1958, but most of them are now lost. His terracotta *Self-Portrait with Tuba* (HAG) and *Underwater Hunter* (William Hardie Gallery) show his confidence and originality as a modeller in a modern European tradition absorbed from his teacher at GSA, Benno Schotz. Fletcher's style of draughtsmanship, like that of his friend the cartoonist John McGlashan, was developed during his Glasgow student years through contributions to the student magazines *GUM* and *Ygorra*. He evolved a personal iconography of a man carrying a ladder, or perched precariously on a wheel, tense and full of fear. As Benno Schotz has written: 'Alan Fletcher had an inherent fear of accidents and he made no secret of it, as if he had a premonition that one day fate would play a trick on him'.

The de Staël exhibition organized by the SSA in 1956 was a revelation to Fletcher and immediately suggested possibilities of an existentialist treatment of still life which resulted in a remarkable series of about seventy paintings, many of them studies of single paraffin oil lamps, sometimes accompanied by other still life, e.g. *Lamp and Pears* (DAG). This has a soft-edge, friendly quality; in other examples a more linear, hard-edge treatment is suggestive of the Readian 'geometry of fear', and something of the same atmosphere is obvious in *Screaming Man*, *Shattered Clown*, and *Man on Wheel*. Fletcher uses unusual and sombre colours made from a recipe including printer's ink, and invariably restricts his palette to three, four or five colours which are never mixed or modulated. His treatment of the edge is one of the fascinations of his work, as he achieves a sense of spatial ambiguity by reserving foreground objects in the underpainting of the picture; objects closest to the viewer are often bordered by a 'background' which is applied last and overlies them as it defines

their outlines. This device lays bare the mechanics of spatial illusion, while the spare elegance of his draughtsmanship and very personal palette contribute to an *oeuvre* which is among the most haunting of its period. Alan Fletcher's fears for the future were only too justified in his own case, but he expressed them in a manner which sums up much of the mood of his time.

130 Alan Fletcher
Lamp and Pears
1957 Oil on board 83.8 ×
57.1 cm
Dundee Art Gallery
See page 179.

11 CONTEMPORARIES: ABSTRACTION AND NEW FIGURATION

Although several of the most interesting British abstract painters have been Scottish or are Scottish, like the expatriates Colin Cina (b. 1943), Alan Gouk (b. 1939) and John McLean (b. 1939) in the present day, it is noticeable that abstract art has never found a receptive climate in Scotland itself, as William Johnstone discovered in his one and only exhibition at Dott's in Edinburgh in 1935, when not one picture was sold. (In fairness, one should add that even Cadell had difficulty selling pictures in the depressed 1930s). Johnstone's first essays in abstraction date from the later 1920s. In previous chapters we have also noted the various early abstract conclusions reached in two little *jeux d'esprit* by W. Peploe in 1918, by Charles Rennie Mackintosh in London at about the same time, and over twenty years later by Alastair Morton who, by 1939, was working in the studio of his new house designed by Leslie Martin in Brampton, Cumbria. It is no accident that the abstract work of Mackintosh and Morton coincides with their activity in the applied art of textile design, although Morton's Mondrian-inspired abstracts were in fact conceived independently of his design work, and Mackintosh, as we have seen, thought at least one of his own highly schematic flower-based designs suitable to be hung as a picture in its own right (*Anemones*). There remain two extraordinary and prophetic mural decorations by Mackintosh, the coloured stencilled panels which seem based on a clock movement for the hall at Hill House in 1903, and the white plaster frieze panels for the Willow Tearoom circa 1904. Aspects of Mackintosh's work were well known in Munich and Moscow through articles in *Mir Iskusstva* and *Deutsche Kunst und Dekoration* from as early as 1903 as well as from exhibitions and we can assume that his work in general, if not these works in particular, formed part of the background against which the pioneers of abstraction – the Constructivists and Suprematists in Moscow and Kandinsky in Munich – were working before The First World War.

During the later 1940s and 1950s several Scottish artists demonstrated an intelligent interest in the European abstraction of Constructivism, then in Klee (but not in Kandinsky, whose work long remained unknown in Britain) and later still in the New York school. Margaret Mellis and Wilhelmina Barns-Graham in the 1940s and in the following decade Gear, Paolozzi, Davie and Pulsford – all of them trained at ECA – with William Turnbull, made significant contributions to the abstract canon. But like William Johnstone they had to leave Scotland for this to be possible. Margaret Mellis (b. 1912), who had been taught by S.J. Peploe at ECA, became an early adherent of the Constructivist tendency of which Alastair Morton was the chief apologist in the north, after her move to St. Ives in 1939 where she was influenced by Ben Nicholson and Naum Gabo. Here she began to create abstract wooden reliefs of pure geometrical forms which exploited effects of grain, figuring and colour in the woods used in a very English version of Constructivism. A little after Mellis, her ECA contemporary Wilhelmina Barns-Graham (b. 1912), on a suggestion of Hubert Wellington who was Principal at ECA, chose to work in St. Ives during her Andrew Grant scholarship year in 1940. Here she met Nicholson, Hepworth and Gabo. But it was not until a visit to Switzerland in 1948 that the glaciers suggested a subject which would offer the vehicle she had been seeking. The glacier theme was to haunt her for many years. *Glacier* (*Vortex*) (1950: private collection) shows the distressed or weathered textures, the vestiges of naturalistic colour, and the naturally occurring forms which are characteristic of the St. Ives school of Constructivism, particularly of Gabo whose transparent structures she admired. Her later work is often playfully decorative and uses bright colours and textured geometrical patterns. The only Scottish-based artist of that generation who had consistently remained faithful to the abstract ideal as expounded by R.H. Wilenski and as practised by Nicholson and the Unit One and Circle artists of the 1930s, is William Baillie of Hamilton (b. 1905). A similar use of pure geometrical shapes and of textures of limestone, alabaster or schist informs his work, except for a brief Surrealist interlude noted in the previous chapter. Baillie's pupil William Bunting (b. 1951)

131 William Bunting
Rondo
1987 Oil on paper 30.5 ×
43.2 cm
Private collection (Photograph:
William Hardie Gallery)

OVERLEAF
132 David Donaldson
Bright Morning
c.1975 Oil 121.9 × 96.5 cm
Private collection
(Photograph: St. James's Art
Group)

employs a closely related vocabulary with a personal accent of interlocking forms defined by taut lines and modelled by subtle gradations of light, rather than texture. Baillie has recently said, 'We find ourselves two painters who believe implicity in two aphorisms – that art begins where imitation representation ends, and that all art is abstract. We also believe with Schopenhauer that art should aspire to the condition of music.'

In Scottish painting of the 1950s the outstanding reputations were still those of the forward-looking traditionalists: Gillies, MacTaggart and Maxwell who, with the more recently established Anne Redpath, were exponents of the Colourist tradition of still life and landscape; Joan Eardley, an innovator in the Realist mainstream; and, working in London, Robert Colquhoun, whose paintings of the human figure fuse a personal vision with a manner ultimately derived from Picasso. Each of these artists can be seen to continue specifically local traditions absorbed during their student years, with colour and *belle peinture* a continuing preoccupation in Edinburgh, and GSA's concentration on line and tonal painting

equally determinant for Eardley and Colquhoun. These local traditions have shown surprising durability.

David Donaldson (b. 1916), Painter and Limner to Her Majesty The Queen in Scotland since 1977, who was until his retirement in 1981 the enormously influential Head of Painting and Drawing at GSA, where he had been a student from 1932-37, and where he began teaching in 1938, has a deserved reputation as a brilliantly incisive portraitist. But he has over the years also painted imaginative, mysterious and witty fantasies as much for his own pleasure as with any audience in mind. These may have their roots in an earthy realism which never disappears altogether from his work – *Susanna and the Elders* (1978-82: GAG), although ostensibly very different from *Annette and the Elders* (1980-81: private collection) in theme is actually very close to it in treatment. One is a well-worn vehicle for painting the life model via the Biblical story, the other frankly contemporary as its 'elders' are Donaldson's colleagues at GSA James Robertson, John Cunningham and a favourite model, Annette.

Another Biblical theme is represented by *The Marriage at Cana* (1972: private collection), but here the artist deals with a recurring concern, the transience of life, beauty and happiness. This modern bride seems weighed down by her finery and oppressed by the revellers around her, who include her starchy in-laws and a madly gay dancing couple. She clutches a pathetic nosegay as she contemplates a hand on which a pretty butterfly has alighted. The inventive and cerebral approach revealed by this side of his work – a cult of the unexpected – nourishes his portraiture, e.g. *The Skater* (circa 1975, a portrait of the artist's daughter on roller skates). Even in his still life a certain wittily acerbic detachment holds good: the delicious recent *Dessert* (private collection) departs from the usual tasteful arrangement with a newly opened tin can of juicy pears which have just been emptied into a vulgarly twee glass dish. Low marks to the cook for presentation, perhaps, but the still life is more visually appealing than any *nouvelle cuisine*. Similarly, in landscape Donaldson's sense of irony often adds point to his subject: *Rage* (1972-3) shows a naked man wrestling with an angry swan, the two of them seemingly bent on each other's destruction, oblivious to the fragile stem of lilies dominating the foreground; in pure landscape he seizes often on an unexpected visual impression rather than resting content with a mere record of the scene: *Olive Trees, Pierrelongue* (1975: Vallar Fine Art). Donaldson's formidable technique belongs recognizably to a Glasgow tradition with subtle drawing with-the-brush matched by a rather sombre palette which has only lightened in recent years. Another Glasgow virtuoso is Alexander Goudie (b. 1933) who has remained a devotee of the *peinture claire* of Manet in portraiture, landscape and especially in still life. But whereas a glint of irony or a *frisson* of psychological unease is never far from the surface in Donaldson, Goudie's work shares the untroubled hedonism of the later Edinburgh School: of David McClure (b. 1926), Elizabeth Blackadder (b. 1931), John Houston (b. 1930), David Michie (b. 1928), Denis Peploe (b. 1914) and Lord Haig (b. 1918).

These ECA-trained artists share a love of colour and painterly handling; they are at once conscious traditionalists and independent individualists. Elizabeth Blackadder's painting of still life and flowers is derived from Gillies and Redpath, but also possesses an almost oriental mood of quiet contemplation and a delicate, minimalist sense of composition which have recently translated easily into the medium of tapestry. She tends often to adopt a cool colour harmony which allows the individual colours of the flowers to sing like a solo voice before a chorus. Her husband John Houston is known chiefly as a landscapist whose work shares with that of Sir William MacTaggart an admiration for Munch and Nolde – for their effects of strong colour and an atmospheric treatment of landscape – although he briefly showed an interest in landscape-abstraction of

which *Village under the Cliffs* (1962: private collection) is an example, and has in recent years adopted a style in which landscape increasingly serves as a pretext for colouristic abstraction. David Michie retains only the colourist bias of his mother Anne Redpath's style. Principally a landscape painter, and very often of beach scenes with figures, he has invented a painterly shorthand which is akin to that of Craigie Aitchison (b. 1926), a Scottish artist long resident in London where he was trained at the Slade School. Denis Peploe, son of the great colourist and brother of Willy Peploe (q.v.), of all his contemporaries is the leading exponent of 'truth to materials': in his landscapes and still lifes each brushstoke is left visible as a carefully considered unit in a construction which never ceases to declare itself as paint on a plane surface. His palette is subdued and this, with his quietly craftsmanlike approach, reminds one of Bloomsbury and particularly of Vanessa Bell. David McClure interestingly combines the fantasy of Maxwell with the earthier, more empirical approach of Anne Redpath in a range of subject matter which parallels theirs: mysterious Redon-like flowers, still life seen against flat fields of colour with ornaments and toys invested with magical properties, Sicilian church interiors or studio interiors, often with a female nude, which reflect the Matisse of *Luxe, calme et volupté* or the *Red Studio*.

David McClure has lived in Dundee since his appointment in 1957 to the staff of Duncan of Jordanstone College of Art, where he succeeded Alberto Morrocco (b. 1917) as Head of the Painting School, and where his colleagues included Gordon Cameron, a subtle follower of Vuillard. The presence in Dundee of these three highly professional and accomplished artists instigated a conspicuous upturn in Dundee's position among the four Scottish art colleges, presided over by the genial and protean Alberto Morrocco. Picasso has been as much an influence on Morrocco as on Robert Colquhoun, not the Picasso of *Femme pleurante*, but rather of *Pêche de nuit, Antibes* or of *Jeune fille devant le miroir*. His first teachers at Aberdeen were James Cowie and Robert Sivell whose exacting instruction Morrocco enjoyed. As he has explained in a recent interview with Alice Bain, the well-ordered city of Aberdeen and its Neo-Classical art school, in which he and a few other students took instruction 'in the way a Renaissance apprentice might learn from a master', was not uncongenial to his Italian temperament (he is the son of Italian immigrants parents). Although his paintings are executed in his Dundee studio, they often begin life as sketches made during long periods spent in Italy or Tunisia. With rare exceptions his work is 'full of the warm south', although there have also been a few excursions in the romantic vein associated with Chagall. Morrocco's pictures convey the enjoyment of holiday or carnival; recently, unframed pictures-within-the-picture have made an appearance, but this evidence of a *working* holiday need not elicit sympathy; the pictures seem to be

133 David McClure
Children's Tale
c.1978 Oil 46 × 56 cm
Private collection
(Photograph: William Hardie
Gallery)

coming along well, and the artist clearly enjoys his work. Few paintings by a contemporary hand are as sheerly pleasurable as those by Morrocco. Their firm structure and sophisticated drawing underlie a surface rich in colour if not in material. A witty show of his Picasso-inspired sculpture of painted *objets trouvés* at Compass Gallery circa 1968 made one regret the rarity of his excursions into three dimensions.

Donaldson's and Morrocco's Edinburgh counterpart was Robin Philipson (b. 1916), who was Head of the School of Drawing and Painting from 1960 to 1982 at ECA (where he had been a student from 1936-40 and a member of staff since 1947), and was President of the RSA from 1973 to 1983, receiving a knighthood in 1976.

High office confers distinction on its recipients; Philipson is a case of the converse also being true. As teacher, as Head of Department, and as President, he has performed with an effective urbanity which has perhaps obscured his perpetual willingness as a painter to experiment. In a School where painterliness is second nature he has extended the painter's vocabulary in a constant effort to forge a language capable of clarity and eloquence side-by-side with a veritable fireworks display of form and colour. His recent Edinburgh Festival retrospective exhibition (ECA 1989) has reminded us that in range of subject-matter, painterly bravura, and in his largeness of

conception and of execution as well, he has been the outstanding subject-painter (in the Victorian sense) of his generation in Scotland. Like almost all his generation, Philipson saw service with the Army – as a Cumbria man, with the King's Own Scottish Borderers – during which he fortuitously discovered and devoured a book on Oskar Kokoschka, the sole example in Edinburgh of whose painting, *Summer*, (NGS) was to provide inspiration at a crucial and formative stage after the War. While on station in Burma he made several sketches of village life including studies of the cockfights that were to become a recurrent theme. Philipson has explained the link between the influence of Kokoschka on his work and the choice of the cockfight subjects in these terms:

I particularly recall my careful scanning of the National Gallery's painting *High Summer* . . . hoping that [Kokoschka's] creative strategy might be revealed to me . . . My satisfaction was in identifying the achievement of a rich plasticity of form within a limpid and impressionistic structure. I began to learn to construct through the grouping of small lightly placed brushstrokes of rapidly changing hue. With this method firmly established, I moved to the painting of the cockfights and I realised that I did indeed owe a great debt to Kokoschka. But it was not his style that I sought

after . . . It was his ability to create resonances of colour and animation of the surfaces of the picture plane. It was the dynamism that was created in the forms themselves that appealed to me.

Several cityscapes of Edinburgh, reminiscent of Kokoschka's wartime views of London, are as near the Austrian master's style as Philipson was ever to come. The cockfight theme, suggested to the artist by his colleague at ECA, Henderson Blyth, from a drawing of a cockfight in one of Philipson's Burmese sketchbooks, began to dominate Philipson's work in the 1950s. In his own words, 'With these pictures I moved away from Kokoschka's 'phrasing' completely with the impulse to make the fighting cocks into something other than just bird descriptions with strands of very thick paint and their strange unpredictable behaviour'. The Scottish Arts Council's *Fighting Cocks* of 1952, one of the earliest examples, remains close enough to its subject to be instantly identifiable; in later versions, e.g. *Fighting Cocks, grey* (1960: SNGMA) the paint itself, with its 'strange unpredictable behaviour', all but completely usurps the place of the motif, providing an analogue for the aggression, violence, movement and energy of a cockfight while retaining an often exotic richness of descriptive colour. It was a logical step to the near-abstraction of certain works by Philipson at this period – e.g. *Burning at the Sea's Edge* (1961: SNGMA) – which suggest a knowledge of COBRA practice and of the abandoned gesturalism of Willem de Kooning.

Philipson has never been the kind of artist to give himself over completely to abstraction, and his 'abstract phase' – which was never wholly abstract – was of short duration. His natural gifts include a remarkable graphic power of suggestion and description which seems often to have required the spur, the injection of adrenalin, of emotions aroused by the visual evidence of the stupid cruelties perpetrated by martial man or of the literally fatal feminity exerted indolently, innocently, and irresponsibly (witness a predella of a falling soldier beaneath a scantily-clad chorus of *demi-mondaines*) on the distaff side. Philipson's treatment of such themes suggests that the roles of man as aggressor and woman as victim are at the root of the war of the sexes and perhaps also at the root of war *tout court*. There is no doubt however on which side the glamour lies, and in case we miss the point, a large wardrobe of exotic lingerie provides a powerful *aide-mémoire*. Hand-in-hand with the introduction of a variety of technical and compositional innovations calculated to add richness and clarity to his style after he had established his basic technique by about 1950 – the use of a vinyl toluene medium and paper collage, and of colour ladders and a two- or three-panel presentation – Philipson added further themes: cathedral interiors with their jewel-like stained glass, the 1914-18 War, 'humankind', the French Revolution, 'women observed', and –

after an English-Speaking Union scholarship tour to South Africa and Kenya in 1976 – white boys and black girls with zebras doing nothing in particular, perhaps practising English? Latterly he has painted a spectacular group of paintings of poppies executed in very rich, resonant colour glazes or stains over a white ground. From 1960 he has occasionally presented a subject episodically in a triptych or with predella divisions, or with meaningful juxtapositions of unlike subjects, as in the large *Women Observed* of 1979, where the coquettish nude girls on a purple divan occupying the left panel are observed by a pack of eager dogs beside a dead bird painted in sepia monochrome on the right. When not over-emphatic or melodramatic, the expressive power of this procedure is considerable and is perhaps best exemplified by the large triptych *The Trap* (1984-87). But Philipson's preoccupation with the alchemy of *matière*, his sense of colour and his ability to create images simultaneously exotic and intensely real have also enabled him to work on a small, intimate scale with no loss of strength of colour or sense of sexual excitement or physical danger.

Emergent in the same decade of the 1950s were several young artists whose links with any Scottish tradition were much more tenuous, and who continued their training in Paris and their careers ultimately in London or elsewhere in England: William Gear (b. 1915), Alan Davie (b. 1920), Eduardo Paolozzi (b. 1924) and Charles Pulsford (b. 1912). These artists had all studied at ECA, Pulsford alone returning to teach there from 1947 to 1960. Together with William Turnbull (b. 1922) who studied at Dundee Art College and then at the Slade School, they introduce a profoundly new set of concerns and approaches to problems of style. Their attitudes were aggressively Modernist when Modernism was virtually synonymous with abstraction, whether geometrical or painterly. Turnbull and Paolozzi are sculptors who move easily between sculpture and painting (Turnbull) and sculpture and graphics (Paolozzi). Gear, who was actually an exhibiting member of the COBRA group in Paris, had the most international career of them all in the sense that he lived and worked abroad until returning to England in 1950; but all of them share a profoundly non-parochial, internationalist outlook. This takes various forms. One of them is Abstract Expressionism, to which Alan Davie was introduced during his ECA travelling scholarship tour to Venice in 1947 by Peggy Guggenheim, who as well as buying one of Davie's paintings showed him work by Jackson Pollock and Mark Rothko in her own collection. The same transatlantic painterly abstract style was also an influence on Charles Pulsford whose richly-textured web-structured surfaces have particular affinities with Pollock, and also with the flickering, flame-like colour field painting of Clyfford Stills. The minimalist painting of Turnbull, with its Zen overtones – a rare point in common between this master

of understatement and the dionysiac Alan Davie – is in striking contrast with the interest of Turnbull's friend Eduardo Paolozzi in Dada and Surrealism. The relevance of these European movements to Paolozzi's many-sided style is primarily semiotic; they offer the means by which the artist comments on today's hi-tech and pop culture and its relationship to the concept of Art. His discovery of an unexpected humanity in the animal, monster, robot – and human – characters of the pulp media, and of the pathetic mortality or laughable *hubris* of man-made machinery, provides a theme at once highly contemporary and yet universal: the soul of modern man reflected in his artefacts.

William Gear has recently been the subject of renewed interest as his contribution to European abstract painting becomes clearer. After ECA he spent a year in Europe including several months in Paris in 1937-38 studying at Léger's studio. During the second war he travelled widely with the Royal Signals Corps and then served from 1946-47 with the Monuments, Fine Art and Archives Section of the Central Commission. At this point he met the artist Karl-Otto Goetz, another future member of the COBRA group, who was later to devote an entire number of his review *Meta* to 'Young Painting in England' (March 1951), which concentrated on the abstract movement: Peter Lanyon, Charles Howard, Alan Davie, Stephen Gilbert and Gear himself. Davie never joined the COBRA group, as Gear did with his Scottish compatriot Stephen Gilbert in 1948 when he moved to Paris, where he remained until 1950. COBRA was an informal grouping round Alechinsky, Appel and Jorn of artists from the northern countries – the first letters of Copenhagen, Brussels, and Amsterdam giving the acronymic title – who adopted an expressionist or lyrical mode of abstraction. This was opposed to the Tachiste style of Atlan, Hartung, Poliakoff and Souglages (all of whom Gear knew well), then causing a considerable stir in Paris. Gear exhibited widely in Paris at the Salons and also with the COBRA group and until his return to England in 1950 was in every sense a member of the *Ecole de Paris* of this period.

It is perhaps still too early to give Gear a precise place in the ferment of influence and counter-influence in the heady early years of the new gospel of abstraction. There was clearly a considerable measure of cross-fertilization between COBRA and the Tachistes, and indeed between the COBRA painters themselves; realization was dawning too of the far-reaching innovations of Klee and Kandinsky, and of the potent work of Jackson Pollock and Arshile Gorky in New York. What is undeniable is that Gear's COBRAbstractions (as they have been called) of the years 1946-49 form an impressive body of work and certainly possess as much confidence and authority as anything emanating from Paris in the later forties. Figurative elements, as in the gouache *La Danse de l'or* (Galerie 1900-2000) of 1946, which is reminiscent of Matisse's *papiers collés*, are quickly discarded, although tree and leaf forms

134 William Gear
Intérieur
1947 Oil 46 × 65 cm
(Photograph: England & Co.,
London)

135 Alan Davie
Jingling Space
1950 Oil 122 × 152.5 cm
Scottish National Gallery of
Modern Art

and other vestiges of reality are retained in the landscape subjects for a short while. But by December 1947 these props too have all but vanished. The *Intérieur* (ibid.) of that year is resolutely non-figurative and sets a pattern of often sombrely coloured compositions articulated by means of a semi-geometrical armature of dark lines which suggest form and space. The *Paysage* (ibid.) which follows it in January 1948 is equally powerful, if less austere, and there follows a series of adventurous variations on the newly discovered theme, with occasional excursions into pure geometry. By 1950 these have led in turn to a new manner which incorporates light, with a slight suggestion of the Rayonnism of Larionov, the patches of colour now divided from each other, not by black outlines, but by intersecting straight lines which result from the edge-to-edge confrontation of colour with colour. This latter manner has provided Gear with his main theme until the present day. Klee's belief that art should penetrate the inner mysteries of the natural world and not confine itself to surface description certainly finds an echo in Gear's approach, although with very different results. Unlike Klee, Gear improvises on the canvas, allowing instinct to guide his hand. He has said 'My paintings are ways of relating to the visible world of nature. They are made with

both eyes on the canvas, but with a visual repertoire of things seen, selected and stored in my mind's eye. It is essentially a physiological process'.

Alan Davie met Gear in Paris in 1948 during his scholarship year. It seems most likely that Gear's view of painting as a physiological process involving hand, eye and intuition in a kind of *perpetuum mobile* – an instinctive gesture with the brush suggesting another to the eye which would evoke another instinctive response, and so on – would have struck an immediate chord with the younger artist. Or rather, that the paintings demonstrating Gear's approach would have done so more eloquently than any theory. Davie's subsequent encounter with the abstract works of Motherwell, Rothko and Jackson Pollock in Peggy Guggenheim's collection in Venice provided further evidence of the power in performance of the theory of intuitive abstraction. And as an accomplished jazz musician Davie had long been familiar with the practice of improvisation.

The very title of an early work, *Jingling Space* (1950: SNGMA), indicates the direction in which Davie was moving soon after absorbing his experiences of Paris and Venice. Whereas the landscape-abstractionists like Gear or the less abstract Joan Eardley provide a painterly analogue for aspects of the visual world, Davie appropriates the non-visual

world as a sphere of legitimate interest to the painter also. The musical, improvisational overtone of *Jingling Space* invites the viewer to 'listen' to the painting as he would a jazz solo; there is no specific 'meaning' beyond the creative will which produced the melodic line and tone-harmonies; but the flight of fancy can be spellbinding, liberating. If Alan Davie's paintings may be said to 'aspire to the condition of music', it is to the spontaneity of the solo break or the extempore cadenza rather than the preordained formality of written music. In this work and in much of Davie's output of the early fifties there is a conspicuous sense of germinal organic growth which seems to arrogate to itself the entire surface of the canvas: the painting seems to be creating its own form with minimal interference by the artist beyond the provision of a grid of vertical and horizontal divisions. Space, light and form are ambivalent, miasmic. By the middle and later 1950s there has been a significant change. Individual forms are now given greater prominence and scale, and they are set against a flat background of a single colour. The empty spaces isolate the forms which now begin to assume concrete and recognizable archetypal shapes: the wheel, the cross, the egg, the crescent, the triangle, the cube. Davie presumably realized that automatic drawing yielded its own repertory of strangely compelling forms, and beyond that, that some of them suggested a more or less legible symbolism as religious or sexual emblems: *Fetish with a Yellow Background* (1954), *Witches' Sabbath* (1955), *Martyrdom of St. Catherine* (1956). At about the same time Davie was also practising a quite different mode which develops the very dense early style but without the controlling grid or framework: *Sorcerer's Apprentice* (1957) and the triptych *Creation of Man or Marriage Feast* (1957) seem to echo the *automatiste* mode of the *Ecole de Paris*, and are somewhere between Masson and Dubuffet. It is fascinating to note that these works which are intensely dramatic in the true sense of creating, resolving, and releasing tensions *in the paint* can also serve to illuminate – one almost said, illustrate – the human dramas suggested by the titles obviously chosen *post facto*. There is somehow a sense of human panic before chaos in the *Sorcerer's Apprentice*, as there is something celebratory or momentous in the triptych.

Occasionally however Davie inserts a disconcerting element of realism. *The Blue Bubble* (1957) shows, against a background resembling corners of stretched canvases, a large bubble shape actually modelled with a highlight which seems to make fun of all the other, abstract, shapes in the 'scene'. (Fun and games of all kinds seem to happen in this nursery of shapes when their father's back is turned or when he is not feeling like being serious; which fortunately is quite often.) Realistic elements of the *Farmer's Wife No. 1 or Annunciation* (1957) are an interior with a window and a rather Gordon Russell chair

and lamp. But the two figure shapes are transparent and dematerialized to a greater extent than in Giacometti or Bacon; they become presences which have more in common with the non-material ether than do the material things which surround them; they belong more to the spiritual than the material world. These untypical works provide clues to the artist's interest in the spontaneous world of child art and in a religious and, despite the Christian alternative title of *Annunciation*, specifically Zen Buddhist view of life, with its emphasis on intuition as a way to enlightenment. As he has said, 'Sometimes I think I paint simply to find enlightenment and revelation. I do not practise painting as an Art; and the Zen Buddhist likewise does not practise archery as an exercise of skill but as a means to enlightenment'. *Portrait of a Buddhist* (1960) might suggest a figure bowed in prayer beneath the sun; its reduction to very simple, bold forms and strong colours looks forward to Davie's style of the sixties and beyond to the present day. *Magic Serpent No. 2* (1971: private collection) shows an interior with religious emblems and a sign of the trefoil on the walls; on the floor stands a little figure which resembles an East African idol, but which may also be Christian, while through the air the 'serpent' – a low form of life in the Buddhist hierarchy – coils itself into a figure-of-eight in an unmistakable writhing movement. This conjuring trick-without-a-conjuror brilliantly evokes an atmosphere of primitive magic with mysteriously religious overtones relating to Fate, Chance and Enlightenment. These works are decorative in their joyful celebration of myriad form and high-keyed colour and their idiom has translated with brilliant success into the medium of tapestry.

Mythic, totemic, Jungian, fetishistic, childlike: these and similar adjectives are frequently applied to describe Davie's form of abstraction, quite justly, for they are all applicable. In the lines written above we have seized gratefully on fragments of recognizable reality and on picture titles which seem to offer clues to the content of these works. Yet the titles are often highly ambiguous and are carefully chosen to discourage a too-restricting interpretation, while there is no discernible system to which the few visible symbols relate, so that they are not so much symbols as totems which possess their own life and significance. We may conclude that Davie goes to considerable lengths to dissociate form from specific content in the paintings because in a real sense their form is also their content. Their inherent drama (comedy rather than tragedy) or playfulness, solemnity or gaiety are analogous to the same manifestations of the human psyche.

Totemic imagery and a suggestion of primitive (specially, Cycladic) art are integral features of the earlier sculpture of William Turnbull which might suggest a kinship with the work of Davie. The common ground lies not in the forms these artist employ however (as a moment's comparison of their

work will confirm), but in the region of a shared Zen mysticism. Where Davie would stress the importance of instinct to action, however, Turnbull would emphasize the role of contemplation. Where Davie's work is spontaneous, rhythmical, riotous, Turnbull's is calculated, still, silent. Yet to the accustomed eye his art is no less rich than that of Davie: the concentrated intensity of his extreme reductions of form and colour simply provide a diametrically different experience.

Before leaving his native Dundee and Scotland for good in 1941 on enlisting with the RAF, William Turnbull had been working as an illustrator employed by D.C. Thomson's in Dundee while attending evening classes at Duncan of Jordanstone College of Art. To the aspiring young artist Dundee must then have seemed very remote from the centres of art. But as Britain's centre through the huge Thomson concern of the pulp magazine and comics industry, Dundee offered first-hand experience of the unselfconscious, vital graphic style of the commercial artists. Supplemented by American comics sent by relations, this diet of an eloquently contemporary style owing nothing to academe made art-school teaching at Dundee, and later in London, seem effete and nostalgic. Turnbull became a pilot in the Royal Air Force and flew on war service in Canada, India and Ceylon. In 1946 he enrolled as a student at the Slade School of Art which he found parochial and inward-looking; he stayed for only a few terms. Here, however, he met Nigel Henderson and Eduardo Paolozzi, who like Gear and Davie went to Paris in 1947. After an initial visit in 1947, Turnbull also went to live in Paris for two years from 1948 to 1950. Here he met Hélion, Léger, Giacometti, Tristan Tzara, Brancusi, and of course his compatriots Gear and Paolozzi. At this stage Paolozzi and Turnbull as sculptors show some influence of the table sculptures of Giacometti. Paolozzi's *Growth* of 1949 is a true table with four supports. Turnbull's *Aquarium* and *Game* are stylistically close to it, with stick-like figures and forms sprouting from flat bases. Throughout Turnbull's career sculpture and painting have evolved in parallel, and in 1949 he had produced at least two paintings on the Aquarium theme which have a Klee-like playfulness and sense of movement, the fish in one of them denoted as arrows, as they are in the sculpted version and also in a mobile made the same year.

On his return to London in 1950 he shared a studio for a while with Paolozzi, whom he had seen frequently in Paris. Until about 1957 the main motif of Turnbull in both painting and sculpture is the Head or Mask, which is also one of Paolozzi's preoccupations at this time. But the divergent treatment by the two artists of this theme is striking. Paolozzi's fascination with the discarded artefacts of the consumer society which is largely synonymous with modern culture led him to a collage method owing something to Picasso and Dubuffet, but

producing remarkably original results. Paolozzi's silkscreen *Engine-Head* (1954) has a head-shaped contour filled with drawings and diagrams of machinery; his bronze *Head* (1957), similarly, is a head-shaped accretion of real mechanical parts, toys, etc. collaged by the *cire-perdu* method. Paolozzi himself listed some of the things that went into his compositions at the time: 'Dismembered lock, toy frog, rubber dragon, toy camera, assorted wheels and electrical parts, clock parts, broken comb, bent fork, various unidentified found objects. Parts of a radio. Old RAF bomb sight. Gramophone parts. Model automobiles. Reject diecastings from factory tip sites.' The remarkable anthropoid bronze sculptures – icons of our age – *Krokodeel*, *St. Sebastian*, *AG5*, *His Majesty the Wheel*, and *9XSR* date from 1956 to 1959, and were assembled and patinated to suggest the ravages of time: they are like relics of a lost society. It was appropriate to their imagery that these works should be realized in the form of metal sculpture. They also conveyed something of the immediacy of Action Painting, but as Paolozzi himself pointed out, 'A sculptor's task is much more slow and laborious than that of a painter . . . The use of *objets trouvés* as the raw materials of sculpture makes it possible to suggest a kind of spontaneity that is of the same nature as that of modern painting, even if, as in my case, this spontaneity turns out to be . . . an illusion.'

How different are Turnbull's concerns. Gradually all accretions of association, movement, and gesture that distract from the quintessential experiences offered by each medium are discarded: in sculpture, form; in painting, colour on a rectangle of canvas; and in each case, their precise relationship to the artist and to the spectator. The 'Head' series represent a transitional, reductive stage in this process as the motif is used to suggest things that are non-head, or in the artist's words:

> how little will suggest a head
> how much load will the shape take and
> still read head
> head as a colony
> head as landscape
> head as ideogram
> head as mask, etc.

Mask (1955-56) might suggest several of these possibilities, but it is essentially a vehicle for pure colour used chromatically rather than tonally, most conspicuously blue and its complementary orange, but also red and yellow and their complementaries green and purple. Unencumbered from associations, it is a liberating work and surely one of the most beautiful paintings of our age. Morphet has observed that 'in these paintings Turnbull attempted to make marks having the general character of drawing, but entirely free from denotative significance. This was another means of focusing, for artist and spectator, the autonomous reality of the action and of the work produced.' The next stage in the development of

Turnbull's style was the eschewal of the painterliness which indicates the action of the painter's hand, and a movement towards one-colour painting. He had already produced several nearly monochromatic works before visiting New York for the first time in 1957. Here he saw at first hand the work of all the Abstract Expressionists (except Barnett Newman), being more drawn to the work of Rothko and Still than to gesturalists like de Kooning and Kline, although as Richard Morphet once again points out, 'aspects of the work of Rothko and Kline to which he did not respond were its evocation of the sublime, and its tendency to illusion'. The beautiful and still-experimental paintings of the late 1950s are increasingly thinly painted, emphasizing rather than dissolving the surface. Their soft-edge flashes are a little reminiscent of Rothko; since red gives more saturation and luminosity than the other colours, new ideas would be tried out in a red painting, e.g. *15.1959*; alternatively, other canvases such as

136 William Turnbull
Mask
c.1955–56 Oil 101.6 × 76.2 cm
Swindon Art Gallery

7-1959 are closer to the colour-field painting of Still. This was also a particularly productive phase in Turnbull's sculpture, in which he adopts a Brancusi-like, gnomic language of very simple, self-contained forms in various materials which together make up the often columnar, totemic structures: *Hero, Aphrodite, Magellan, Eve, Sungazer, Oedipus, Lotus* (all between 1958 and 1963).

From about 1958 the paintings are titled by number and year only, and the last vestiges of figuration and *matière* vanish one by one; at about the same time, from about 1963, Turnbull's sculpture follows suit and is based on pure geometry with the subtlest entases or surface embellishments such as burnish-marks or monochromy, and the titles are purely descriptive, not associative: *Duct, Steps, Transparent Tubes, Angle,* and so forth. In a sense the purity of Turnbull's style – not to be confused with rigidity or aridity – makes him an heir of the Constructivists of the 1930s. Like them he saw the artificiality of the traditional divisions of fine art. The large single-colour canvases of 1960 and later seem by their very size and stillness to aspire to the condition of the interior wall, but emphasizing the wall as *Gestalt* and not as the no-thing which it has become in modern architecture. This is implied in the following far-reaching statement of 1963:

> What is the nearest we have come to the equivalent of a temple or shrine in this century (and of this century)? The closest I have got to this experience has been the large exhibitions of Pollock or Rothko; the Monets in the Tuileries (the Nymphéas); and especially the late Matisses exhibited in the Museum of Modern Art, New York. These were for me an experience close to the exaltation of the sacred, a ritual of celebration which avoided the guilt of the Crucifixion or the blood of sacrifice which I often associate with such sensations. Is it a desire to create environmental experiences of this sort that makes some artists prefer personal exhibitions, and find group showing unsatisfactory? It is with some such idea in mind that I work.
>
> As confused ideas about purity were causing architects to banish sculpture and painting from their world, and when the apotheosis of the glass box had almost banished architecture also, sculpture and painting in an outburst of magnificent vitality have been creating heroic personal environments that lack only the necessary walls to be complete.

Turnbull is thus no iconoclast whose object is to make a *tabula rasa* of everything that had previously made a painting interesting (or deplorably bourgeois or dully materialist, depending on one's point of view): association or illusion, theme or subject-matter, shape, movement, seductive colour, or painterly gesture. These blandishments of the old art are indeed jettisoned one by one in his work, but with the

137 William Johnstone
*Celebration of Earth, Air, Fire and
Water*
1974 Oil 137.2 × 242 cm
Scottish National Gallery of
Modern Art

sole aim of enriching and strengthening the oneness of
the painting or sculpture, so that we apprehend it, its
colour and its form, the more vividly as the thing that
it is – a flat, rectangular woven canvas primed and
painted with an unmodulated single colour. On the
subject of colour Turnbull wrote in 1960: 'I'd like to
be able to make one saturated field of colour, so that
you wouldn't feel you were short of all the others.'
The aim is plenty, not dearth.

Throughout the exciting period of the 1950s when
these Scottish artists were prominent members of the
avant-garde, the abstract painter William Johnstone
was Principal from 1947 to 1960 of the Central
School of Arts and Crafts in London. Here his
imaginative appointments included Paolozzi (from
1949 to 1955) to teach textile design, Davie (from
1953) to the Jewellery Department and Turnbull
(from 1952 to 1961) to teach experimental design.
Johnstone's administrative and pedagogical activities
in London limited his own work as a painter, exactly
as those of William Dyce had done over a century
earlier. Nevertheless Johnstone continued to experi-
ment in London with an increasingly automatic,
tachiste form of abstraction which drew strength
(like so much English abstract painting of the same
period) from landscape references. *Earth Movement*
(1948-49) is built of solidly constructed dense forms
which are modelled by light, and whose colours
bespeak the green land and the black earth. *Land-*

scape (Fields) circa 1954-57 similarly offers a horizon
with a delicate line of dripped-on trees (as if in
comment on the gravity-defying nature of biological
growth) which seem infinitesimally small in the vast
scale of the landscape itself. After his retirement in
1960 from the Central School, Johnstone returned to
live close to his ancestral roots as a farmer in his
native Borders country. In this isolated situation he
adumbrated the painterly, gestural, tachiste, auto-
matiste style which characterizes his extraordinarily
prolific last phase. The *Northern Gothic* series whose
title was suggested by Picasso's dealer Daniel Kahn-
weiler, begun in 1959 and continued through the
middle sixties, are large works in oil which retain a
sense of landscape and aerial space, but now light
interpenetrates form rather than illuminates its surface.
The result is a complex metaphor for the visual world
which may suggest many things – the oxygenation
of the earth, meteorological forces at play on a vast
scale – but which also possesses its own decorative
power. These are painted in one colour (usually
black) on a white ground. A beautiful later example,
however, *Celebration of Earth, Air, Fire and
Water* (1974: SNGMA) employs explicit colour-
symbolism, with red (fire), blue (water), and green
(earth) painted transparently on the visible ground,
which is white (air) and is as necessary a component
of the colours as oxygen is of the elements of fire,
earth and water.

These works clearly anticipate the elliptical, calligraphic watercolours of the 1970s (usually grisaille, sometimes with tiny touches of colour) of which Johnstone latterly painted a large number and of which he would discard many. These seem, like a visual equivalent of five-finger exercises, to have satisfied a daily technical and emotional need to keep in practice. The watercolours show enormous variations of application, from tiny, delicate fossil-like striations, splashes and drips to broad washes which often suggest atmosphere and distance. They form a small-scale counterpart to the mural-sized abstract oils painted at the very end of his life, in which the artist demonstrates his continued willingness to take calculated risks, like a practised actor in performance. In 1973 Johnstone had been working with plaster as a means of mounting his collection of found objects and by accident realized the expressive potential that the unfamiliar material had for him. The result was a series of about twenty large white plaster reliefs which he called *Genesis* and of which he gave the following account: 'I knew that in myself I must produce a condition, relaxed and free from thought or deliberation; that which would be produced through my hands would then be from my inner self and completely unconscious. I throw the lump of crude, wet plaster on the smooth, polished surface; a gesture of creation, a brief experience of the variation of a simple earth movement, and the plaster sets.' Such a view of the artist as the dedicated but self-obliterating medium of his own subconscious was the lasting legacy of Surrealism to Johnstone's quixotically individual practice of abstraction as a painter.

In Johnstone's *Genesis* the exigencies of the search for new ways of expression cracked the old mould of easel painting as the main receptacle of the painter's ideas. Several of the most innovative Scottish artists in the present century habitually cross interdisciplinary boundaries, and traditional easel painting does not enjoy its former monopoly. This is related to the fact that never before has graphic design pervaded our culture to the extent true today, and as a corollary, never has technical drawing – in engineering, electronics and the media for example – reached such levels of discipline, inventiveness and skill as in our own day. For these usually anonymous draughtsmen drawing is a serious business and they are very, very good at it. Paolozzi has half-seriously said that he would have liked to be a commercial artist, but it is too difficult. But *hic labor, hoc opus est* – the graphic work involved in industrial or commercial design is only a stage in the long process leading from conception to realization in a vast variety of media, from semi-conductors to jet engines, from chemical compounds to – everything on the production line. It is not an end in itself, and its quality and inventiveness are directly related to that fact, and are not due to aesthetic criteria in the fine art sense. No artist has done more to draw this to our attention than

Eduardo Paolozzi. His brilliantly inventive sculptural collages from real objects derive their theory ultimately from the readymades of Marcel Duchamp and their interest in mechanical drawing from Duchamp's friend and fellow Dadaist Picabia. As we have seen, Paolozzi had actually met Tzara, one of the original Dada circle in Paris. But there is a most significant difference. Paolozzi 'interferes with' his pre-existing material, either by editing it as in the *Bunk!* collection which provided the material for his famous lecture to the Independent Group at the ICA in 1952, or by transmuting it through printmaking or casting processes. And Paolozzi's sources are very different from those of his French predecessors.

'Abstraction' in Paolozzi frequently derives from concrete sources: electronic games or circuit boards, wave patterns, mechanical diagrams or sections of components (cams, valves, the gear wheel). In their use of this polyglot vocabulary his remarkable screenprints show as clear an admiration for the industrial draughtsman as his later sculpture does for the processes and forms of mechanical engineering. As Paolozzi himself famously expressed the matter in a television interview with Jakob Bronowski,

a wheel, a jet engine, a bit of a machine is beautiful, if one chooses to see it that way. It's even more beautiful if you can prove it, by incorporating it in your iconography. For instance, something like the jet engine is an exciting image if you're a sculptor. I think it can quite fairly sit in the mind as much an art image as an Assyrian wine jar.

The *Bunk!* images with which Paolozzi had bombarded his audience in 1952 were culled from a vast collection of toys, robots, games, comics and pulp magazines and also car manufacturer's manuals including reports on terminal collision in automobiles and books on prosthetics and physiology such as *The human Machine and how it works* which were the source of Surrealist images in the matter-of-fact vein of Max Ernst's collages. Ernst's influence is perhaps strongest in the *As is when* screenprints (1965) inspired by Paolozzi's reading of the biography of Ludwig Wittgenstein, in which the artist exploits the experience he had acquired at the Central School of silkscreen printing, a technique then used mostly in the commerical art sphere (a recommendation as far as Paolozzi was concerned). Paolozzi's collection has provided him with a mine of images which are either presented straight or more often collaged, retouched and then photolithographed or photo-etched as in the set of twenty-four prints comprising *The conditional Probability Machine* (1970) and *Cloud atomic Laboratory* (eight tandem images; 1971). Paolozzi's large colour silkscreen prints which are of breathtaking technical quality, also use collage, but in an infinitely more complex way. *Standard Pacific Time* (1969) for example, includes a section of an internal

combustion engine, a telephone switchboard, a skeleton watch, photographs of model girls and children among its recognizable images, within a framework which apes Op Art – or perhaps the flashing lights of the pin table. The overall result is witty, richly suggestive – and very decorative. *Who's afraid of Sugar Pink and Lime Green?* (1971) is a brilliant example of which the reader may at least imagine the colour scheme. Such images, which date back to Paolozzi's ICA lecture of 1952 and before, are Paolozzi's main contribution to British Pop Art.

The imagery of the earlier collagist sculpture of Paolozzi has been briefly discussed on page 189. Here also, Paolozzi's role as collector of the industrial detritus and junk of the throwaway technological society fed the imagery of his art. But after a two-year tour as visiting professor at the Art School in Hamburg (1960-62), a more positive attitude appears to what the artist calls the machine aesthetic. An unmistakably original, transitional group of sculptures appeared, which combine the anthropoid element visible in the earlier works with an emphasis on a new machine-made look (many of their parts began life as real machine components), but which characteristically retain a sense of fun. They are at once totems of the age of hi-tech, and at the same time strangely friendly, like juke boxes or the machines in a penny arcade. *Konsul* (1962), *Wittgenstein at Casino* (1963), *City of the Circle and the Square* (1963) are three impressive examples. These worshipful entities, with their impressive elevations of straight lines and right angles, are quickly succeeded by an incorrigibly playful tribe of tubular, contorted specimens, much less prone to stand on their dignity or to take life too seriously. *Parrot* and *Crash* (both 1964) – their anatomies are as absurd as the latest scrape they have got themselves into – cast in aluminium and frozen in gesticulating animation, acquire heroic status through the ironic view of the artist. They are a form of homage to Mickey Mouse. A related drawing is titled 'variations on a theme of Micki'. Like so many strip cartoon characters Mickey Mouse is not only anthropomorphic; his experience of life as refreshingly inconsequential and fun, or irritatingly hectic and absurd is actually more lifelike than that of the humankind often portrayed in academic art. *Hamlet in a Japanese Manner* (1966), which like the others is a freestanding sculpture without a base but unlike them is gaily painted, in its complexity and animation, with anthropoid forms that are also part-machine, again suggests the ironic modern hero rather than the tragic or comic hero of the schools. These sculptures adopt a language very different from, but share a perspective on the human condition akin to, that of Marcel Duchamp in *The Bride stripped bare by her Bachelors, even* – human life as seen by a visitor from another planet who can't make head or tail of it all – reminding us again of Paolozzi's roots in Dadaism. It was a logical next step for Paolozzi now to exploit

138 John Byrne
Self Portrait: The Yellow Cigarette
1986–87 Oil 76.2 × 76.2 cm
Manchester Art Gallery
(Photograph: William Hardie Gallery)

the new repertory of forms provided by his machine aeshetic. This he does in increasingly abstract pieces, which may be chromium-plated to suggest the smooth perfection of mechanical engineering and also in the case of *Ettso* (1967) to provide a distorting mirror, like a fairground mirror, giving the earnest viewer a comical appearance like Paolozzi's cartoon heroes. In a further equally logical separation of iconography from form, his later ready-mades at once embody his admiration for them as given forms and underline his ironic view of the modern hero. As *Three American Heroes* (1971) Snow White, Batman, and Bugs Bunny appear in their own characters, moulded in rubber; *The Hulk* (1970) in moulded plastic-sprayed chrome; and the engaging *Florida Snail* in black wax.

The anti-modernism of Pop Art was in a sense short-lived because having begun with a wholesale plundering of images from the popular media, it itself soon became an esoteric form. But this did not happen in two cases where the artists concerned had a connection with the most truly popular art form of the sixties and seventies, pop music. Mark Boyle spent part of his early career devising light shows for Jimi Hendrix and The Soft Machine; and John Byrne, whose multifarious talents have enabled him to turn with equal success to writing for the stage and television, and to theatre design as well as painting

139 John Byrne
The Beatles
c.1969 Oil on board 91.4 ×
121.9 cm
Private collection
Signed 'Patrick' in Byrne's naive or
pop style, this was his contribution
to *The Illustrated Beatles Lyrics*.

and illustration in a bewildering variety of styles, has the distinction of having painted one of the most evocative as well as one of the most famous of all pop icons, his study of The Beatles for the *Illustrated Beatles Lyrics*. This work, with its obvious debt to the Douanier Rousseau, is signed 'Patrick', the signature Byrne used for the series of dreamlike, *faux-naif* works painted in the sixties and seventies which, despite his initial desire to conceal his authorship of them, have become alternative landmarks of the period. Perhaps no other Scottish painter of our day possesses Byrne's technical mastery; these works carry off the most difficult feats with consummate ease and inventiveness – the folding patterns of a silk scarf, the inner glow of negro skin or of a flower, the surface tension of a drop of water – in images which often include a kind of Simple Simon figure reminiscent of Paul Macartney's *Fool on the Hill* or *Country Boy*. Byrne is still regarded at GSA, where he gained his Diploma in 1950, as one of the most gifted students ever to have studied there. His 'Patrick' style, which was used in a portrait of his friend Billy Connolly (People's Palace, Glasgow) and for record sleeves for the group Stealer's Wheel and for Gerry Rafferty, was only one of several options employed by this chameleon-like artist. Another manner is a

kind of Chardin-like sobriety in still life, yet another a brilliant series of story-board illustrations to his own innovative television drama in six parts, *Tutti Frutti*. A recent self-portrait further demonstrates his quixotic brilliance.

A powerful and fascinating secondary current, of which Paolozzi is a precursor, has run counter to abtract painting and Modernism and offers an alternative to both. To this stream one might give the name of Concrete Art (by analogy with the concrete poetry of one of its main practitioners, Ian Hamilton Finlay) because it is the antithesis of abstraction. We are dealing here with a handful of original individualists whose work has nothing in common except a new objectivity in the literal sense of actually incorporating or reproducing real objects in a way which goes far beyond collage or *bricolage*. Some of the main names which come to mind in this context are Boyle Family, Hamilton Finlay, Bruce McLean, Rory McEwen, Will Maclean, Robert Callender and Glen Onwin. In their very diverse ways these artists refresh us with visual experiences which are communicated directly and not couched in the elaborate mandarin of one of the contemporary modernisms.

The brilliantly gifted Rory McEwen (1932-82) was the very paradigm of the contemporary artist

who was aware of the challenge of abstraction, and who after long preparation met this challenge in a series of glass sculptures, shown by Richard Demarco in 1969, which were built as box constructions and sometimes incorporated polarized light. The artist explained that his use of glass was dictated by its combination of density and transparency. These qualities allow the constructions to act as a medium for the play of light, so that they become sculptures with light and at the same time display the beauty of the material. Rory McEwen as a painter concentrated to the exclusion of virtually all else on botanical studies, and achieved an unassailable primacy in this field. His *Autobiographical Fragment* relates how Wilfrid Blunt at Eton, who was then working on *The Art of Botanical Illustration*, and Sacheverell Sitwell at Cambridge, were the chief influences that drew him to the study and painting of flowers. He adds:

> I came to modern art largely, it seems, through twentieth-century music; but that is not a matter of regret for me. Today Nature is everywhere abused and insulted, art is everywhere made to serve commerce; too many shallow half-truths pass muster for what they are not, too much of the past is forgotten or misunderstood . . . So I paint flowers as a way of getting as close as possible to what I perceive as the truth, my truth of the time in which I live.

McEwen's art is minimalist in that nothing is added for the sake of interpretation, effect, or expression. But his choice of subject-matter is subjective and is connected to one of the most ancient branches of the art of painting.

Boyle Family (Mark Boyle, b. 1934, his partner Joan Hills, b. 1936, and their children, Sebastian and Georgina Boyle) equally strive for absolute objectivity of treatment. But their objectivity extends also to the subject. In the *Journey to the Surface of the Earth* which has been a continuing project for twenty years, the *1000 World Sites* which they set themselves to record were chosen by a scientifically random method; between 1967 and 1969 darts were thrown by blindfolded friends and family at a map of the world. At each site a metal right-angle is thrown into the air to determine precisely which area of the earth's surface is to become the subject of the work. This area, often measuring six feet square, is then subjected to scrupulous documentation and translated with absolute fidelity from a plastic mould of the surface including all the loose material lying on it, into a fibreglass-based relief which replicates the patina of the original surface with quite startling verisimilitude. These works are indistinguishable to the eye from the real thing; they look like actual slices of road, or field, of whatever surface happens to have been studied. As Boyle Family have increasingly refined their technical means, less and less of the actual is retained, although as Lynne Green explains, 'In the latest pieces real elements – a pebble, a tile, a

fragment of carpet – set the standard to which the painted surface aspires.' For these are in a sense paintings: a resin-based paint is used to amplify the fidelity to concrete facts of these works which appear so heavy and are in fact only of about the same weight as a canvas of the same size: they are translucent when seen against the light. At the time of writing about sixty of the sites have been recorded.

Mark Boyle in 1966 succinctly put the case for an artistic credo which refused to alter, edit, or interfere with the objective facts of the concrete world:

> The most complete change an individual can effect in his environment, short of destroying it, is to change his attitude to it. This is my objective . . . From the beginning we are taught to choose, to select, to separate good from bad, best from better . . . I believe it is important to accept everything and beyond that to 'dig' everything with the same concentrated attention that we devote to what we consider to be a good painting or a good film . . . I am certain that, as a result, we will go about so alert that we will discover the excitement of . . . our environment as an object/experience/drama from which we can extract an aesthetic impulse so brilliant and strong that the environment itself is transformed.

Although Boyle Family's aim has been to produce as objective a work as possible, as Boyle has said, 'to cut out . . . any hint of originality, style, superimposed design, wit, elegance or significance' in their work, their underlying aesthetic is undeniably original, elegant and significant and the resulting work possesses an inescapable authority directly due to its lack of pretension.

Lack of pretension and a keen eye for pretension in others: are these perhaps traits of the Glasgow character? Like Mark Boyle, Bruce McLean (b. 1944) comes from Glasgow where he studied at GSA before accepting a place on the post-graduate sculpture course at St. Martin's School of Art in London where, like Boyle, he has been based ever since. McLean directs a parodist's caustic barbs at aspects of modern art and above all of modern sculpture, which must be among the most esoteric of contemporary pretensions. The installations and performances through which he pricks the pomposities of the *derniers cris* in the art world are correspondingly esoteric and often ribaldy funny. As a critique of the styles of Henry Moore, Anthony Caro (with whom McLean came into contact at St. Martin's), and of the land artists like Richard Long, McLean's *Pose Work for Plinths* (1971) and *People who make Art in Glass Houses, work* (1969) – photographed performances with himself as sole performer – and *Landscape Painting '68* – a photographed installation – are hilarious and devastating. In fact, McLean has made his own interesting contribution to land art, not by making his own marks on it like Long in England (or more recently Kate Whiteford

(b. 1952) who was trained in Glasgow), but by intervening in, or just simply recording, nature's processes, for example of evaporation (*Evaporated Puddle Work January '68*) or the freezing and melting of water and the action of the wind (*Scatterpiece Woodshavings on Ice '68*), and photographing the result. With their self-mocking titles and alert respect for nature these 'works' approach the ego-effacing attitude of Boyle Family.

Two slightly younger artists who were contemporaries at ECA, Eileen Lawrence (b. 1946) and Glen Onwin (b. 1947) continue a related vein. Lawrence has concentrated on painting an austerely limited repertoire of such natural forms as feathers, shells and twigs until quite recently in monochrome, and often on scrolls of handmade paper as if in allusion to a fetishistic primitive religion, in other words, suggesting that these simple natural forms possess a power or significance of importance to man, as well as depicting them in and for themselves. Onwin has been equally self-restricting in his interest in the role in nature of one of the simplest compounds, salt, beginning with a series of beautiful photographs of a salt marsh near Dunbar in 1974. The photographs were accompanied by a simple text:

Today I came across a spit of land, a joining of the river to the sea, brackish water, flooding salt resistant grassland, a near grid of circular pools not yet covered by the constant rise, regular with

undercut edges, some reflecting back the sky, solid underfoot, one easy leap from land to land, flooding, patterned oily water, mud, undrained, stagnant near the edge, alive, replenished twice daily, high pitched sounds, sea bird wader water, velvet blocks beneath the green of trees.

The fascination for the artist was in the constant change wrought on the appearance of the marsh by the tides, and in the ability of salt, now brine and now crystalline, to change its form in a manner at once inimical to and supportive of life. In a subsequent exhibition, *The Recovery of dissolved Substances*, the eternal metamorphoses of salt itself became the subject of his work in a mixture of media. Onwin's more recent interest in the ecology, in the perfection of the natural world and its vulnerability to the trivial self-absorption of mankind, has provided a logical continuation of his earlier concerns.

But mankind is not wholly unregenerate, or more correctly *was* not so, as we are reminded in the work of Will Maclean, who studied at Gray's School of Art in Aberdeen (1961-67). Here the Principal, Ian Fleming, was at this point painting local landscape and harbour subjects, as was also the exciting Glasgow-trained William Burns (1921-72), whose work combined an Eardley-like vigour and sense of the *genius loci* with a tendency towards abstraction. An ethnic sensibility was in the air. Maclean, a scion of a family of Inverness fishermen, was commissioned in 1973 to undertake a study of ring-net fishing (as opposed to modern trawling) in Scotland. Will Maclean had himself worked as a ring-net fisherman and his fascination with, and deep understanding of, this pre-industrial way of life led to a voluminous portfolio of drawings and diagrams documenting a vanishing aspect of Scottish society. The drawings of the fishing vessels in particular are executed with the precision and attention to technical detail of a marine architect's blueprint; nevertheless, they are redolent of a bygone age, of the shipwright's craft and of the fishermen's skill, and of a nostalgia for a life lived in harmony with nature, when the boats and the tackle had a simple functional beauty often summed up by the evocative names of the vessels themselves. Within the terms defined above, Maclean after this moved into a more concrete phase which began in 1974 and was certainly nourished by his 1973 researches. Using a mixture of found objects, flotsam and jetsam, and carved pieces, he created a series of box constructions, which like the mariner's ship in a bottle, seem to transmit the look, the feeling, the very sounds of a seafaring way of life which now belongs to the past. The sculptor Fred Stiven adopted similar imagery in his carved constructions at about the same time; another artist, Robert Callender (b. 1932), created in painted cardboard similar objects of uncanny realism, like so many specimens towards an archaeology of the pre-industrial world.

140 Boyle Family
Cliff Study
1980–84 Polyester resin 183 × 183 cm
Mr and Mrs Tom Conti.

Ian Hamilton Finlay's early collection of poetry, *Rapel* (1963), dwelt on the antithesis of the Fauves and the Suprematists: a script which might almost have been written to William Turnbull's swing from the pure colour of the *Head* series to the Minimalist purity of his work of the early 1960s. Like Paolozzi, Hamilton Finlay too is interested in the linguistics of style, and has appropriated the Classical mode in much the same way as Paolozzi adopted the language of Dada and Surrealism. But whereas Paolozzi employs Dadaist collage and Surrealist juxtapositions to comment powerfully on the machine age and man's place in it, Hamilton Finlay's approach is more strictly philological, that is, more concerned with specific individual words or images as concrete entities and with their relationship to actuality. Hamilton Finlay's art, which comes in unexpected and original forms, most frequently executed by other hands under his direction – carved stone tablets, postcards with printed line drawings, screen-prints whose imagery seems in its simplicity the opposite of *avant-garde*, all invariably accompanied by an inscription or title – attempts to bring us as close to absolute truth as language can, whether visual or verbal. Again like William Turnbull he operates reductively by dispensing with or eliminating everything extraneous to 'the thing itself' which he wishes to describe. Since unlike Turnbull, however, he is also dealing with words, he must take account of the objects embodied by nouns, or the action by verbs. Or, put the other way round, the object will suggest a word, a title, which will then be suddenly and clearly illuminated by juxtaposing it with another word or object. For example, in his garden 'Little Sparta' at Stonypath, planned, as he would say, not as a 'retreat' but as an 'attack' of Classicism against Modernism, a tree bears the simple label

A PINNATE EVERGREEN
sea

The presence of the single word 'sea' suddenly reveals sea and tree with brilliant clarity, thus. The botanical word pinnate describes how the branches of the tree grow laterally from the trunk and also the way the needles grow out from the branches; the word 'sea' reminds us that this is also how waves are constructed in appearance, with lines running up and down their slopes joined by their crests in a single long line. We now visualize 'sea' as ramified by as many 'pinnate' waves as there are branches in the tree, and we have a colour, 'evergreen' for each, which describes sea by tree and vice versa. The image is extraordinarily complete. It even operates out of context, on the page; in front of the actual tree it must seem richer still. It does not suffer from the pathetic fallacy and there is no overlay of emotion or sentiment, nothing in fact which distorts the expression of a pure and significant visual perception. Similarly

THE CLOUD'S ANCHOR
swallow

describes to our mind's eye the swallow, with its swept wings resembling the arms of an anchor, suspended on an invisible cable far below the cloud, but it also makes us visualize an (unmentioned) ship riding at anchor.

Perhaps these two small examples (they are in fact physically tiny: Hamilton Finlay characteristically works on a miniature scale) indicate something of his visual quality as a conceptual poet. In the screen-prints and carved tablets and inscriptions, words whether titles or inscriptions are an indispensable pointer to the meaning of the work. *The little Seamstress* (1970: screenprint with Richard Demarco) may on one level be the name of the little gaff-rigged yawl whose wake makes a line of ripples like little stitches on the surface of the calm water behind her, but the name also draws attention to the action of her hull going through water like a needle drawing the thread through the cloth in a line of little stitches. In *Homage to modern Art* (1976: screen-print with Jim Nicholson) an equally pretty gaff-rigged two-master with tan sails (perhaps a sturdy Thames barge; certainly a venerable design) sports a Robert Indiana-like two-colour triangle on its topsail. Modern art, it is suggested, has no momentum of its own and is merely carried along by the seaworthy barque of the classic art of the past; it is the gaudy and unnecessary gilding on the lily (to mix metaphors) whose sole purpose is self-advertisement.

Hamilton's Finlay's thematic material is restricted to a narrow compass – the sea and sailing boats, the reflection of natural cycles in his garden; as a minor diversion, the distorted Classicism of Nazism or the French Revolution; and, as a major distraction, his polemical warfare waged against a philistine Establishment: 'Whenever I heard the words Scottish Arts Council I reach for my water pistol.' He is fascinated by the forms and inscriptions of classical civilization and as an extension of this, by the more recent manifestations of 'classic' design in a single area, boat design. Thus we find *Mozart* personified as that ultimate in sailing ships, the four-masted ocean-going clipper under full sail; *Kandinsky*, as a modern destroyer, superstructure bristling with the bizarre shapes of its instruments of aggression. The inscriptions on stone set in his garden may consist of words only, as

ONE·ORANGE·ARM OF·THE·WORLD'S OLDEST·WINDMILL
autumn

which prompts the visitor to the garden to meditate on the cycle of the seasons. Or, as in *ET IN ARCADIA EGO after Nicolas Poussin* (1976), there may also be a carved image, in this case a tank which

replaces the monument in Poussin's two famous paintings on this theme; hence, 'I, death (and warfare), am also in Arcady.' The latter was actually executed by John Andrew in a style reminiscent of Eric Gill; Finlay always remains at one remove from the imagery he conceives, speaking through the personality of the executant as a further means to Classical detachment.

Ian Hamilton Finlay's styleless approach has run counter to the conscious modernism of many artists in the post-war years. The realization that Britain was not the supreme law-giver in the arts that the Victorians liked to believe her to be had led since the beginning of the century to a more sympathetic and admiring view by Scottish artists of what was happening abroad, especially in Paris. From being the preserve of a few individualists in the days of the Colourists it was logical that modernism – emulation of what was perceived to be best in world contemporary art – should become enshrined in the academies and colleges. Colin Thoms, who taught from 1951 to 1977 at Gray's School of Art in Aberdeen, had a Damascus road conversion to the work of Miro at the latter's Tate gallery exhibition in 1963: an experience which Thoms quite correctly has likened to Peploe's earlier discovery of the significance of Cézanne; he might equally have instanced MacTaggart's discovery of Munch, Philipson's of Kokoschka, Alan Fletcher's of de Staël, Paolozzi's of Giacometti and others too numerous to mention. Yet individualism has always remained strong in Scotland and such movements as Op or Pop Art, *art brut, arte povvera* and others have met a limited response. Instead there has been an admirable determination among certain artists to depart from the more stifling aspects of local tradition and to experiment with new modes of expression. Not surprisingly, this was most evident at the newest of the four Scottish art schools, Dundee. In Edinburgh, however, John Bellany and Alexander Moffat boldly set their faces against the *belle peinture* and landscape-and-still-life syndrome by concentrating on a new form of realist figure painting. Bellany's search for a fully contemporary mode of expression is as Anti-modernist as that of Ian Hamilton Finlay, but has led to very different conclusions.

Bellany and Moffat were already well on the way to the foundation of a new school of Scottish Realism in the late 1960s when an interesting group of painters emerged who had recently been appointed to the staff of Duncan of Jordanstone College of Art in Dundee. Introducing an exhibition of their work in 1970, I disclaimed any identifiable 'Dundee style' of painting and pointed out that the seven Dundee artists did not constitute a movement, nor did they seem to adhere to any of the currently fashionable international 'isms'. But certain important links did exist which to some extent set them apart from their contemporaries in Scotland and especially from the new realists in Edinburgh. The Dundee artists

appeared as individualists who all, however, tended at this point in their careers towards great restraint in the use of colour and a high degree of refinement of handling and finish. Such a development ran counter to the recent traditions of Scottish painting, and while there were other young painters in Scotland whose work showed similar tendencies, Dundee seemed to contain a cadre of exponents of this type of painting. Further there was a general unwillingness among the Dundee seven to abandon a figurative mode of expression: Jack Knox (b. 1936), Peter Collins (b. 1935) and Ian Fearn (b. 1934) had recently returned from abstraction to a semi-figurative style, and Neil Dallas Brown (b. 1938), James Howie (b. 1931), James Morrison (b. 1932) and Dennis Buchan (b. 1937) all retained figuration to a greater or lesser degree in their work, although Buchan's diffuse, atmospheric treatment of aerial space comes close to painterly abstraction. My conclusion was that 'what the French have called *la nouvelle figuration* provides the only term which describes the work of the Seven with any degree of general accuracy'.

A figurative element was always conspicuous in the work of Neil Dallas Brown, and he had always been an overtly naturalistic painter. But often the naturalism is more apparent than real. The intertwined limbs and torsos – analogous in form and texture to the pieces of bleached wood occasionally incorporated into his compositions around 1970 – are frequently seen on closer inspection to be imaginary anatomical assemblages which are nonetheless explicitly erotic. The almost monochromatic tonality of these paintings, the strong contrasts of lighting and the smooth modelling of surfaces, achieved by a refined use of thin glazes, produce a soft lyrical quality or alternatively a sombreness sometimes amplified by the presence of a sinister animal figure. Whether the subject be Vietnam, Belfast or a girl in a hayfield, Dallas Brown's paintings possess a dramatic ambivalence at once voluptuous and menacing.

If Dallas Brown is primarily a tonal painter, Ian Fearn is more of a colourist, although his colour tends to be in a low key and he often restricts himself to combinations of not more than two colours. Fearn often uses photography directly in his paintings, transferring a carefully composed image with an air gun through an organdie screen on to the canvas, making delicate alterations to the image in the process. Colour combinations are arrived at by long experimentation, and are sometimes calculated to produce an Op vibration where they meet. *Garden City* (1967: private collection) which is based on a photograph, much interfered-with, of a television valve, appears to represent a mantis-like figure seated at a piano under a crescent moon. There is a distinct feeling too of the strange city paintings of Tapies (an important influence on Fearn's early work and also greatly admired by Robert Cargill, a Dundee-trained

141 James Howie
Wait
1970 Oil 162.6 × 177.8 cm
Dundee Art Gallery
Minimalism by Howie, a landscape
specialist associated with the
Dundee Seven.

artist slightly younger than the Dundee Seven). Tapies was also an influence on James Howie, whose *City Painting* (1964: SNGMA) has a firm structure which evokes an imaginary urban landscape in the atmospheric style of the Spanish artist. But in later paintings by Howie structure became secondary to effects of light of increasing lyricism and classical serenity. *Wait* (1970: DAG) is an exquisite example with its minimalist composition, resembling a horizontal fluted column of palest blue suffused with light, suggested by waves at the shore at Broughty Ferry, where Howie was living at the time.

Like James Howie, James Morrison is essentially a landscapist, although he first made his mark with a series of paintings of Glasgow which capture the intimate grandeur of its Victorian terraces as they appeared in the late 1950s before restoration. These remarkable studies, painted in a virtually monochromatic style, are affectionate portraits of the artist's native city and demonstrate the expressive dexterity of his handling of paint.

Morrison began painting Glasgow terraces and

tenements in their sooty but very real grandeur in 1955. In his own words 'The paintings were done for a number of reasons. While I was a student I became friendly with Tom Gardner, an art teacher in the city, and his wife Audrey Gardner. Gardner, along with Bill McLucas and an older teacher George Mcgavin, saw painting in a socially relevant way. They produced works of considerable power and commitment, which in the light of the subsequent development of painting in Glasgow, were well ahead of their time. I learned of their ideas through Gardner particularly and he recommended two books to read – *Goya in the Democratic Tradition* by Klingender, and *The Social History of Art* by Hauser. The Glasgow painters and these two books made me think that simply by looking and recording I could make some valid comment on the city and its people.' Morrison adds: 'As a student rich colour and thick paint were beyond me. I never really responded to the Post-Impressionist paths travelled by many of my colleagues, and in any case could not work adequately in such a language. My hero was Daumier, a

purely tonal painter in whose works colour does not have a prominent role. In the city tenements I had a subject which matched both my social and aesthetic aims and fitted my limited technical ability.'

Morrison moved to Catterline in 1958 and the associations of the village with Joan Eardley encouraged for a time a landscape style less tonal and less descriptive, and painterly in the Eardley manner. Before leaving Catterline in 1965, Morrison had already began to paint landscape with the refined, calligraphic approach familiar today, with the vast horizon of the countryside around Montrose under immense banks of cloud and the details of the landscape indicated with economy and elegance. Peter Collins too had abandoned an earlier, more painterly manner, reminiscent of the work of John Maxwell with whose style he was familiar from his day as a student at ECA. In his case the transition was abrupt, the first example of a new interest in Magritte after a brief flirtation with geometrical abstraction being the *Winter Rose* exhibited at the RSA in 1969, which indicated a new commitment to very precise drawing and fastidious treatment of detail and finish allied to surreal content and atmosphere. Latterly his work has been more super-real than surreal, and his immense craftsmanship has been devoted to minutely detailed landscapes which call to mind the Scottish Pre-Raphaelite William Dyce (q.v.) who like Collins hailed from the far north of the country and with whom as an artist Collins has more than a little in common. In the past decade John Gardiner Crawford of nearby Arbroath has developed a similarly concentrated landscape style, although he has no link with the Dundee Seven.

Jack Knox's acrobatic stylistic leaps have included a development in the late 1960s in the direction of a tighter and more controlled style which is the antithesis of the immediacy and exuberance of his own earlier work – and of his later work as well. After study with André Lhôte in 1958, Knox visited Brussels the following year to see the great exhibition of Abstract Expressionism which made a lasting impression. Through the early sixties when he was living on the Isle of Bute, he painted a number of essays in various forms of abstraction including a few collages which incorporated objects found on the beach. A little later he developed a de Kooning-like, gestural near-abstraction (*Studio 11.1.64:* MAG) in parallel with a wholly non-figurative manner which made no reference to the rhythms or textures of landscape. The works of this period show something of the influence of Rauschenberg's or Kline's Abstract Expressionism; they are powerful rhythmical and have clue-titles like *Aftermath* (1961: SNGMA), which refers to atomic holocaust; or are riotously coloured and make play with perspective and colour planes in a modern version of Cubism, like *Pedestal for Georges* (1965: Cyril Gerber), which is a homage to Georges Braque. In the later 1960s in the *Studio* and *Battle of San Romano* series, formalism takes

over completely and we find this painterly artist producing extremely spare, austere compositions, hardly more than coloured drawings, which continue his spatial concerns with a strange repertoire of delicate forms executing a weird ballet in the picture space.

The obvious kinetic bent of his work at this stage – even at its most abstract his work had always suggested movement – was only on one occasion taken to the logical conclusion of a kinetic construction, a sparklingly witty piece which justified the flimsiness of these *jeux d'esprit* of which the artist had begin to tire by about 1972. A visit to the Stedlijk Museum in 1972 provided a clue to the way out of the impasse of minimalism. Negatively, a large exhibition of colour field painting at the Museum depressed him and confirmed his doubts about the path he was currently pursuing in his own painting. Positively, his admiration for the unpretentious directness of the little seventeenth-century Dutch masters of still life had an almost immediate impact on his subject-matter – cheeses, loaves, fishes, lobsters, and on a more modern note, cakes and ale, the beer glass replacing the *rohmer* of the old masters. The title of Knox's *Dutch Still Life: Pronkstilleven* (1977: SAC) pays tribute to the origin of what for him was a new-found freedom to paint with simplicity subjects which offered a welcome relief from the minimalism which he increasingly felt as a constraint. With only an occasional foray at this stage into a rather Hockney-like treatment of interiors, Knox has continued until the present to paint still life and, less frequently, landscape. Returning to his old school, GSA, as Head of Painting and Drawing in 1981, he has in recent years painted some of his most characteristically exuberant works – *Lamp and Oysters* (1980) and *Cafe* (1981) are among his most successful – which proclaim a revived kinship not only with the values of Braque, but also nearer home with earlier Glasgow contemporaries such as Alan Fletcher and Joan Eardley.

Abstraction, particularly Abstract Expressionism, presented an inescapable challenge to the forward-looking artists of Knox's generation. Two of his contempories at GSA, Ian McCulloch (Lecturer in the Architecture Department of Strathclyde University) and William Crozier (Head of Painting at Winchester College of Art), were among those to respond; and in Aberdeen Knox's friend Ian McKenzie Smith (Director of Aberdeen Art Gallery since 1968) and William Littlejohn (Head of the Painting School at Gray's School of Art since 1970) came close, approaching abstraction from different aspects of external reality. McKenzie Smith's painted low-relief construction *Yellow Celebrator* (1968), with its minimalist geometry and cheerful colour, was something of a landmark of modernism in Scotland; following his return to Aberdeen in 1968 he has concentrated exclusively on those minimal but delicately painterly atmospheric paintings described by

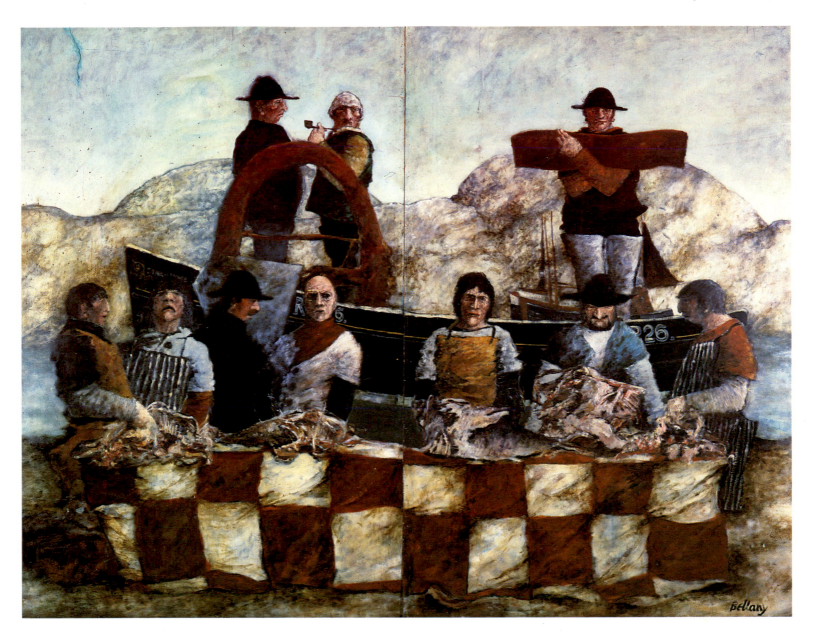

142 John Bellany
Kinlochbervie
1966 Oil on hardboard 243.5 ×
320 cm
Scottish National Gallery of
Modern Art

Edward Gage as 'a distillation of some quiet state of weather as it hangs perhaps softly poised over sea-towns, streets or breakwaters'. Phillip Reeves (b. 1931), long a lecturer at GSA, employs painted collage in subtle evocations of similar themes.

Less abstract, but abstractionist in tendency, are the landscapists Alexander Fraser in Aberdeen and James Robertson and Barbara Rae in Glasgow, each occupying teaching posts at the colleges of art in the respective centres. Robertson and Rae frequently use collage in their paintings, Robertson to increase the richness of the picture's surface and to give objectivity (he often places the composition within a painted rectangle which is anti-illusionist), Rae unusually employing collage to inject a momentary sense of illusion into her abstracted landscapes. Another Glasgow-trained artist, Duncan Shanks (b. 1937), brilliantly employs a painterly technique involving an almost de Kooning-like use of strong colour applied

gesturally with a loaded brush in large-scale land-scapes – a recent group entitled *Falling Water* concentrated in the theme of the Falls of Clyde near the artists's home – which are among the most exciting landscape paintings produced in Scotland in recent years. Archie Forrest is another painterly landscape specialist whose work, with its powerful and subdued colour harmonies, contains that earthy vibrancy which the Glasgow painters of the post-Donaldson era have made peculiarly their own.

To celebrate the twenty-fifth anniversary of the Edinburgh Festival, and as a counterblast to the Düsseldorf exhibition staged at the College of Art in the previous year by Richard Demarco, which had featured the work of Joseph Beuys, ECA in 1971 assembled an exhibition which surveyed twenty-five years of work by artists who had been students at the College. This show was inevitably somewhat hetero-geneous as it represented more than 140 artists,

nearly a dozen of them on the College staff. Nevertheless it was instructive to see on the one hand the ubiquitous evidence of the continuity of the Edinburgh manner – the first Edinburgh School were represented, then Robin Philipson, Penelope Beaton, Margaret Hislop, John Houston, Elizabeth Blackadder, David Michie, Denis Peploe, and William Baillie – and on the other, young Modernists such as Gordon Bryce, Derek Roberts, Kenneth Dingwall, James Cumming and others who appeared beside Alan Davie. In this company the work of John Bellany and his friend Alexander Moffat, who exhibited a portrait of the chief literary ally of the new Realism, the poet Alan Bold with his wife, stood out in stark contrast alike with the decorativeness of the Edinburgh School and with the internationalism of the Modernists.

The luxury of hindsight permits us to view John Bellany (b. 1942) as an eloquent link between earlier exponents of the human figure such as James Cowie, Joan Eardley, and Robin Philipson, and the current interest in figure painting of the younger painters who have emerged in the past few years. Not that his predecessors in Scotland influenced his development, except negatively. Bellany's humanism springs from a passionate belief that art should be about life and that it should communicate universally recognizable truths. His real mentors have been those northern European masters, past and modern, who have worked within the great humanist tradition. His theme is fallen, suffering humanity, racked by religious doubt, guilt of conscience, the seven deadly sins, mortal dread, weaknesses of the flesh and spirit; but also redeeemed by fortitude, integrity, love. Joan Eardley's figures show a resilient instinct for survival but lack a moral dimension. Bellany provides that extra dimension. He achieves this through an autobiographical perspective and the use of an arcane but legible system of symbols. Alexander Moffat has vividly recorded Bellany's and his own early development, their admiration of the exiled Alan Davie and his rebel status 'as one who had abandoned the Scottish art scene because it was out of touch with the modern movement'. Moffat describes the determination of the young friends to be artists of their own time, their questioning in late 1962 of the premise that modernity was synonymous with abstraction, and their search for a figurative mode capable of dealing with the realities of life in the twentieth century. Certain figurative masters suggested themselves as exemplars: initially Kokoschka, Picasso, Matisse and Léger and then 'Breughel, Bosch, Cranach, Gruenewald, Rembrandt. Munch and Beckmann came later. Oddly enough in this context Goya seemed more a "northern artist." In the following year, 1963, Moffat and Bellany were stunned by the power of the French Neo-Classical and Romantic masterpieces in the Louvre by David, Ingres, Géricault, Delacroix and by the master of Realism himself, Gustave Courbet. Courbet's exam-

ple, Moffat tells us, led directly to their exhibiting canvases in the open air during the Edinburgh Festival in the three years (1963-65), when Bellany was producing the powerful works of his earliest maturity. The work of these French masters also suggested the possibility of epic scale for modern figure painting, soon to be realized by Bellany in four important works.

Alexander Moffat has written that 'Without an understanding of this essential Scottishness, this absolute identity with the people, the landscape, the sea-coast between Musselburgh and Eyemouth, it is impossible to grasp the real meaning of John's activities as an artist.' (Bellany originates from fishing stock on this part of the Scottish coast.) The fishing community features in Bellany's extraordinary early masterpiece *Allegory* (1964: SNGMA). This is a triptych which shows three gutted fish hung out to dry on three crosses. The fish is the early Christian symbol for Christ and the scene is like a Calvary as each panel is dominated by the crucified fishes; the nineteen bystanders – fishermen, porters, gutters in their working clothes – form a frieze in arrested motion, facing the viewer like an early photograph of tradesmen at work which required the suspension of activity and movement. Like the shepherds in a Piero *Nativity*, they have a still, sober demeanour which suggests both fatigue and awareness, participation. The allegory is of the necessity to life of sacrificial death. The boldly original placing of the three fishes centre stage is as important as it is successful: the arresting image impresses the sacramental dimension of the scene on our minds like a solemn ritual.

In 1965 Bellany moved to London, where he has remained ever since, for three years of study at the Royal College but, as Alan Bold has told us, his house in Battersea and then in Clapham Common has remained an enclave of Scottishness where Bellany continues to paint scenes inspired by his memories of his background among the fishfolk of Port Seton. *Kinlochbervie* (1966) is a large-scale composition which shows figures gutting fish on a long table parallel with the picture plane, and behind them a fishing boat with additional figures one of whom is carrying a piece of tackle which looks like a cross. The allusion is to the Last Supper and, again, to the Crucifixion. *The Obsession (Whence do we come? What are we? Whither do we go?)* painted in 1968, further concentrates the expressive elements of *Kinlochbervie*: this is still a scene of fish guttting, but the facial expressions suggest suffering, even madness, while the figures are either armless like butchered trunks – as if they themselves had suffered the tender mercies of the flensing knife as well as the fish – or, in one case, crossed to form the cross of St. Andrew, or in another, with hands clasped in an attitude of prayer. Bellany's work passes through a dark phase at this period as a result of his visit to Buchenwald concentration camp in 1967, but

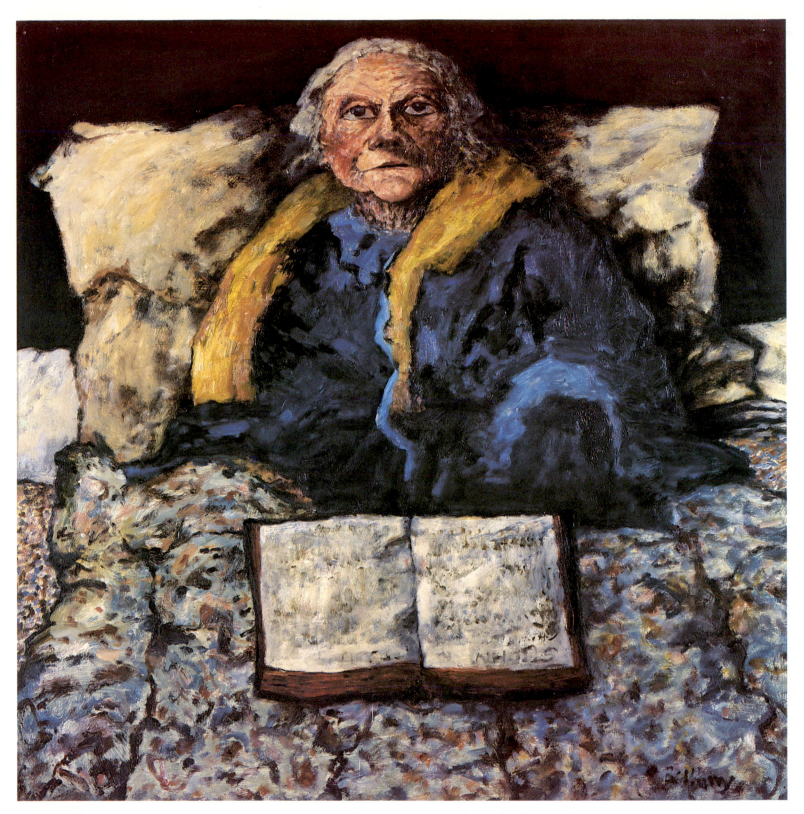

143 John Bellany
The Bereaved One
1968 Oil on hardboard 91.5 ×
91.4 cm
Scottish National Gallery of
Modern Art

astonishingly, man's inhumanity to man is hardly ever taken as a theme; what Bellany conveys is the humanity in suffering man, rather than the agencies through which man suffers. But *Homage to John Knox* may be regarded as an exception; here the strict Calvinist ethos with which the artist was familiar from his own experience of life in a small Scottish fishing village, is portrayed with all the appurtenances of a sinister cult: furtive, minatory priests, baleful religious symbols including a Goyaesque bat, a religion which, it is implied, actively adds to the dolours of matrimony, of work and of conscience. Whether self-imposed or not, humanity's miseries are real enough: the left panel of the triptych has a couple literally chained together in bed, he wearing a prisoner's striped pyjamas, she naked, her face a mask of terror, watched over by priests who clutch symbols of lust, procreation, and holy matrimony; the centre, two fishermen with raddled faces in anguished prayer, and a third holding up a skate so that its disturbingly human face *in extremis* replaces his; the right panel, a Day of Judgement, with a naked woman smiling dementedly like a *dulle Griet* from Bruegel, and a man who raises a broken bottle to his mouth in a gesture which also reminds us of the Last Trump. Several moving portraits were also painted at this point, most notably *The Bereaved One* (1968), a portrait of his grandmother reading the Bible in bed. The dignity of self-knowledge through suffering and recent bereavement is manifest in her gaze as she looks at us and beyond to her own mortality.

The Max Beckmann exhibition at the Tate Gallery in 1965 was perhaps the most crucial single influence on Bellany's work. Here was a modern master working in a figurative expressionist idiom whose concerns were with humanity, with human sympathy and understanding as well as man's inhumanity to man, and who had forged a contemporary vehicle of form and colour to match these humanistic themes. Although the triptych form of *Homage to John Knox,* and its use of the theme of a voyage in the central panel, are reminiscent of Beckmann's *Departure,* just as Bellany's very fine portrait of his sister *Margaret* (1968) gives her an expression very like that of Beckmann's wife in *Quappi with White Fur,* Bellany's full assimilation of Beckmann was not immediate. It is noticeable that he employed the darker palette and more detailed, old-masterish approach typical of his earlier style as appropriate to the portrait of his grandmother, while the portrait of the younger woman is aptly couched in the more modern idiom of Beckmann. Beckmann's monumentally simple treatment of the figure and his use of strong, expressionist colour increasingly inform Bellany's work throughout the 1970s.

So often regarded as a Realist, Bellany is an artist whose work is permeated by a spiritual dimension. The sign of this is, on the one hand, the invariably moral implications of Bellany's themes: and on the other, the language developed to serve those themes, the bestiary developed in the paintings of the early 1970s – dog/fidelity, monkey/lust, lobster and ram/male desire, fish/Christ, sheep/abnegation – which with the later, more familiar symbolic images of the Cross, the heart, the clock, and the puffin-or fish-mask disguises of the human protagonists (often the artist himself), form a coherent and personal symbolism. The function of these symbols, instantly recognizable though they are in themselves, is the opposite of realistic verisimilitude; they provided a literal glossary on the moral and spiritual themes developed in the paintings. In a later treatment of *My Grandmother* (1971), for example, the subject is now the grandmother as venerable ancestor seated on the bed which at once symbolizes her progenitive role and death, as the lobster she holds also signifies procreation and the means by which a fishing family have gained their livelihood; indeed, their life stems from its death. The theme may be a very Scottish one, but it is also universal.

The Calvinist ethos is never far from the surface. *Madonna* (1971) luridly represents the guilty ecstasy of forbidden female desire. *The Fishers* (1972) shows a further development of the central panel of the *John Knox* picture, but now one of the fishermen on the boat of life holds a skate, which seems to take the part of the man who holds it like a ventriloquist, while another fish provides solace to its capturer like a doll. Is the latter to be seen as taking comfort in religion, or sex? The defeated men seem as much victims of life as the abused fish creatures. A similarly cowed male (a self-portrait) appears in *Lap-Dog* (circa 1973) entering through a doorway with his familiar monkey (desire) a claustrophobic room where a naked woman sits on couch which is also a raw steak, the lap-dog of fidelity on her bare thigh, and the meekness of her sheep's mask belied by her predatory, carnivorous smile. A ladder symbolizes the gates of Heaven – an ambiguous concept given the presence not only of the object of desire but also of the Christian symbol of the sacrificial fish whose eye witnesses the scene. *Obsession* and *Celtic Feast II* (both 1973) further explore the tensions of holy matrimony, but with a gradual erosion of the distinction between protagonists and symbols; the human figures seem to metamorphose into fishes or animals and vice versa. The triptych *The Sea People* (1974: ACGB) represents a culmination of Bellany's exploration of the theme of the relationship of the sexes through the language of animal-symbolism. Much simplified in colour and form (Hartley has identified a parallel in Munch, whose exhibition the artist would have seen in London in the same year), and indeed, showing a masterly sense of decorative unity, the bridal couple – he wearing a top hat, she represented as a fish – are flanked and witnessed *sub specie aeternitatis* by two familiar, perhaps ancestral, spirits as they journey through their life together. In *Celtic Fish People* and *The Voyagers* (both 1977) the metamorphosis is complete; the figures no longer

carry masks but are literally half-fish, half-human, acquiring a new autonomous reality rather than the borrowed reality of masquerade.

Bellany's paintings of the early 1980s are at once more overtly autobiographical than before, and at the same time are couched increasingly in terms of gestural abstraction. These are revealing and moving documents in which the artist candidly shares with the viewer the vicissitudes of his inner life. *Mizpah* (1978) is an epithalamium which celebrates his marriage, as does *The Voyagers* painted in the same year. Their compositions are respectively dominated by the form of a cross (a sea-harvest suspended from a mast) and the form of a ring (a radar aerial on a fishing boat). But the fish and bird symbols representing the artist and his new wife Juliet are more deeply incorporated into the texture of the painting; the surface forming one painterly continuum in which recognizable forms appear and disappear. The premonitory *Self-Portrait with Juliet* (1980) and *Time and the Raven* (1982) chronicle her illness and the tensions and transience of a marriage which ended with her death in 1985; less overt, but equally passionate, are the more abstract paintings *Time will tell* and *Shipwreck* (both 1982) which come closer to de Kooning than any other works by Bellany. Hartley has pointed out that in these works, 'The ancestral voices prophesying doom, formerly restricted to side panels, have come centre stage', and has also drawn attention to their kinship with the new *wilde Malerei* in Germany, as well as to American Abstraction when Bellany was exhibiting for the first time in New York.

Recent years have seen further changes in Bellany's style which as usual have mirrored the circumstances of the artist's life. His odyssey has brought him through the perils of serious illness and has brought the hero back to his first wife Helen, their reunion inspiring the profoundly optimistic *Celtic Lovebirds* (1985). Nothing daunted by a major surgical operation in 1988, Bellany produced with the aid of a mirror a remarkable series of watercolour studies of himself starting almost from the moment of his emergence from the anaesthetic. This was entirely consistent with a lifelong practice of art in which the artist has always used his own emotions and experiences as the basis of an impressive commitment to their expression and communication in a style of powerful eloquence.

12 *CODA*

The *New Image Glasgow* exhibition at the Third Eye Centre in Glasgow in 1985 was the first to present a coherent view of the new figure painting emanating from Glasgow. Organized by Alexander Moffat, who had been an early associate of John Bellany in Edinburgh and had since 1979 been a Lecturer at GSA, it consisted of works by six young artists – Stephen Barclay, Steven Campbell, Ken Currie, Peter Howson, Mario Rossi and Adrian Wiszniewski – for whom the human figure was a central preoccupation, whether as a vehicle of communist propaganda (Ken Currie) or of conundrums in natural philosophy (Steven Campbell), or imaginative fantasy (Wiszniewski) or social realism (Peter Howson). Stephen Barclay and Mario Rossi stood somewhat apart from the others, since Barclay's interest lay in haunted landscapes or interiors where the human presence may only be suggested, while Rossi is a painter-sculptor concerned with a modern re-interpretation of the classical tradition. The *New Image* paintings demonstrated extraordinary self-certainty: often on a very large scale, they were painted with a raw vigour which did not exclude formidable technical qualities.

Even more importantly, their commitment to the difficult art of the human figure clearly derived from a refreshing desire to communicate rather than from the more usual desire simply to be different. But different they also were. These artists not only had something original to say, but had also found original ways of saying it. *Pace* the Edinburgh writer Alan Bold, the acknowledged influence of Beckmann and the artists of Weimar Germany has had the same importance to Currie and Howson as to John Bellany; like Géricault, Fernand Léger and the Mexican muralists Orozco, Siqueiros and Rivera, the German artists are part of the general education of any artist attempting figure painting on a large scale, but they add an element of contemporary *Weltschmerz* which had commended them to Howson, Currie, Hugh Byars and other young Glasgow painters like Scott Kilgour and Keith Ross who frequented Moffat's studio in the early 1980s. As Ken Currie has said 'At that time, in 1980-81, we were the only students in the art school producing new figurative painting.'

While these students of Alexander Moffat were working towards a figurative style with social relevance or containing social comment, Adrian Wisz-niewski and Steven Campbell were working under the guidance of Roger Hoare in the experimental Mixed Media course at GSA which included performances, some of them staged by the students. This was a radically different route to a new style in figure painting. A memory of Polish folk art, too, informs the work of Adrian Wiszniewski. Campbell adopts the intensely individualistic methods of *faux-naïveté* in pursuit of aims which are far from naïve. It is as possible to refer to Titian's interpretations of Ovid's *Metamorphoses* as to John Byrne's whimsical improbabilities in the 'Patrick' pictures as precedents for Campbell. Each would be equally wide of the mark – and equally true – but it is worth emphasizing that Byrne, in a lighthearted vein, had shown that an alternative treatment was possible for the figure. His Simple Simon figures appear as distant relations to the ingenuous young men who inhabit Campbell's paintings.

The *New Image* painters have a notably graphic emphasis in comparison with the painterly modern genre of Joan Eardley or the subject-pictures of Sir Robin Philipson. John Bellany's sparer technique and anti-modernist stance, which was also anti-bourgeois, provided an important Scottish precedent for Currie and Howson. Where Sir Robin Philipson's figures inhabit a certain social milieu (even his courtesans look expensive), and his unashamedly decorative colour is very much in the Edinburgh tradition, Bellany's are unequivocally working people and his use of colour is more dramatic than decorative. Bellany's neo-expressionism, like that of two Glasgow contemporaries Anda Paterson and Patricia Douthwaite, involves a return to the figure and human, indeed humanitarian, subjects. Perhaps Peter Howson comes nearest to Eardley's compassionate view of those who live at the margin of society in the inner city. But Howson's denizens of flea markets, the sleazy joints, the betting shops and drinking dens, his winos, prostitutes, thugs and derelicts are on the way down. The artist does not share their rare moments of optimism: *On a Wing and a Prayer* (1980: Summer Collection).

Howson uses the methods of realism based on his memories and observations of life in the Army (he was in the Infantry and boxed for his Division), and in the Gallowgate area of Glasgow near his studio. He infuses into that realism an imaginative vision at

once apocalyptic and monumental. *Regimental Bath* (1985) and *The Great Log Race* (1986: private collection) are large-scale compositions which are obviously based on Army experiences. The powerful concentration of Howson's sense of composition based on the human figure is immediately evident in these large confident works, where any indebtedness to Beckmann, Rivera, or Léger (who are frequently quoted as influences) is submerged in the momentum of the artist's verve as a draughtsman and his monumental treatment of form. Howson, like Bellany, has found inspiration in the work of Géricault, most obviously in the impressive large *The Final Parade* (1986: GAG) modelled on *The Raft of the Medusa*. This frightening vision shows a group of mindless thugs roaming the deserted, hostile city; like so many blind leading the blind, they are in peril of falling to disaster impelled by the one-track energy of the group spirit. Several of Howson's recent paintings have continued the theme of group mindlessness with bodies clambering on each other's shoulders or moving together closely in a kind of unrehearsed drill-parade where everyone's uncoordinated movements impede those of everyone else. On the lighter side of Howson's exclusively masculine world, the football crowd of *Just another bloody Saturday* (1987) comes into this category; on the darker side, *The Fools of God*, *The Psycho Squad* and *The Stool Pigeon*, and most apocalyptically of all, *Death of the Innocent* (all 1989).

The large pastel study for the complex and monumental composition of *The Last Parade* has a steely tension like a Vorticist drawing and reminds us that for Howson drawing is a nursery of ideas for the larger paintings, whereas Campbell and Wiszniewski develop their ideas in front of the canvas itself. Howson's use of pastel and his extremely impressive graphic works both in etching and woodcut confirm the expressiveness of his line. His powers of observation and ability to create striking compositions were well displayed in his three contributions to the sheaf of lithograph illustrations commissioned for George Mackay Brown's *A Scottish Bestiary* in 1986. *The Mouse* was inspired by the idea of Burns gazing at a 'red, red rose' while a 'wee, sleekit, cowerin', timorous beastie' is seen in the foreground helping itself to the poet's supper; *The Stag* is a stuffed deer's head on the wall of a drinking den with the taxidermist's stitching visible on its snout but with enough intelligence still in its glass eye to remind us that this was once a monarch of the glen, and a good deal more intelligent than its new human companions. *The Moth* brilliantly shows in two views of a single episode a death's-head moth striking the upstairs window of a house where a party is going on and startling the inhabitants. Howson's smaller scale works in the graphic media include a large number of studies of single figures, like *The Seer* (Howson is good at titles) which shows a half-demented blind man sitting on a pavement declaiming like a shaman;

Saint Jim and *Journey's End*, the former beatifically resisting the demonic blandishments of a half-suggested devil with horns at a window – is the devil a pawnbroker, barman, or bookie, or only a friend? – the latter down-and-out on the street by a fire hydrant on which the firemark glows red like a half-imagined scene from hell. This is one of the group of studies which includes *The Heroic Dosser*, one of Howson's most telling compositions in which the craggy figure of the down-and-out stands holding a rail exactly like a heroic oarsman in a storm.

Howson's range of expression is wide. At the darker end of the spectrum his scenes of violence and brutality suggest man's folly and stupidity rather than his capacity for evil. Or rather, that it is these

144 Peter Howson
The Stool Pigeon
1989 Oil 274.5 × 183 cm
Private collection
(Photograph: Angela Flowers Gallery)

qualities in man that create evil. The aggressors are as much victims as the victims themselves; there is little to choose between *The Psycho Squad* and *The Fools of God*. The victims – the dossers, inebriates, prostitutes and the victims of the mob or the gang – may be innocent, but they are also benighted, work-shy, shiftless. The giant man who is too blind to see that the *Sisters of Mercy* whom he has exploited are sending him over the cliff edge becomes a victim of the victims because he cannot see what is happening to him. There are no winners, there is only the struggle, with only temporary refuge provided by The Game, whether it be the oldest game or the masculine sports of boxing (*The Stare, Marvin*) or football, body-building or arm-wrestling.

Ken Currie has given us his own account of the steps which led to his figure style which is founded on a belief that art can change society. His study visits to Calderpark Zoo where he was fascinated by 'the idea of incarceration for public display and the related themes of brutality and persecution' took him through the blighted east end of the city. Currie remarks:

> I had never seen such scenes of dereliction . . . The mysterious buildings, machinery and railway sidings of the sprawling Ministry of Defence bomb-making plant at Bishopton fascinated me . . . I saw people moving amidst all this, going about their lives, surrounded by unremitting bleakness and began to identify completely with their plight . . . That whole revolutionary culture which flourished in Europe between the wars remains the richest and most inspiring reservoir of historical precedent and, naively, we thought it possible to reproduce that culture in Scotland in the nineteen eighties. In perceiving what we recognised as a period of reaction in Britain, with the ascendancy of the New Right, we saw parallels in Weimar Germany and realised that there could not be a better time in which to produce this new kind of painting.

In his final year at GSA in the Session 1981-82 Currie took many photographs of people and locations all over Glasgow:

> the monolithic Red Road flats, the shipyard gates all along South Street, the huge dusty Meadowside Granary and, across the Clyde, the stark outlines of Govan Shipbuilders; the deserted Queen's Dock with its mysterious rotundas and the powerful shape of the Finnieston Crane; Parkhead Forge, slowly fading away and that whole area around Barrowland, London Road, Celtic Park, Duke Street and the Gallowgate. These locations became vital resources for ideas and images.

Currie then became involved in two further projects which were to persuade him of the validity of the medium of painting as opposed to his early preference for film, and which at the same time clarified in his own mind what his subject matter was to be. As organizer of a large Third Eye Centre exhibition on unemployment in 1982, Currie again, in his own words,

> was confronted with the reality of people's lives in our city and was particularly moved by the spirit of resistance and construction which motivated people in seemingly hopeless situations. I became convinced that artists had to abandon purely aesthetic concerns and directly assist people in communicating that spirit.

The second project, *The Clyde Film*, of which Currie was director, came in 1985 (after Currie had made visits to Europe which brought disillusion at the spectacle of the drab and grim cities of the Eastern bloc, and had experienced the intensest contrasts of despair and optimism in visits to Dachau, and then to the Léger Museum at Biot). Currie tells us that it was during the editing 'surrounded by thousands of feet of film depicting images of Glasgow today and in the past that I decided to take on the theme of Scottish labour history'.

The large, mural-sized paintings and charcoal drawings on this theme have thus had a long gestation. Currie began by reverting to charcoal which he had favoured in his earlier work, and in which he soon showed remarkable mastery, in terms of both handling and composition. His line is incisive and a tendency to mannerism in the treatment of the profile is soon abandoned for a more genuinely observative realism, although he does tend to favour a very limited repertoire of facial types and self-portraiture is ubiquitous. Compositionally many of these large works containing many figures are *tours de force*, combining the utmost clarity with an enormous amount of politically significant detail (inscriptions abound, whether slogans or union banners or book titles, or negatively, the dread words 'bar', 'tattoos', 'amusements' in lurid neon) quite brilliantly fused into a rhythmical, lucid, at times almost decorative whole. Currie's studies of single figures – *Young Mother, Study for The Wandering Man, Shipyard Poet* (all pastel, 1987-8) are close to those of Peter Howson, although in Currie polemics are never far from the surface.

The *Glasgow Triptych* (1986: SNGMA) was the first large work completed by Currie since leaving GSA three years earlier, but its confident execution and inventiveness give no hint of his absence from his easel. Three panels, each measuring seven by nine feet, comprising *Template of the Future, The Apprentice*, and *Young Glasgow Communists* treat the single theme of a lesson in communist theory conducted round the workers' warming brazier, as the hope of revolution kindles their spirits, in the cold, hard environment where they sell their labour. This work led directly to a commission to paint a mural cycle for The People's Palace Museum in Glasgow to commemorate the bicentenary of the massacre of the Calton Weavers in 1787. Currie tells

us that 'in completing the People's Palace mural I realised that I no longer wanted to deal with history . . . I felt that my new commitments lay in the realities of today and my own urban experiences . . . I wanted to explore the tension, broadly speaking, between self-education and self-destruction in our communities'. This more recent phase, with its contemporary subject matter still set in the same milieu of industrial wasteland, is typified by *A Scottish Triptych* (1987-88: private collection) – *Night Shift*, *Departure*, and *Saturdays* – where single figures in settings of apocalyptic dereliction express the isolation of the part-time worker, the unemployed, and the young mother who reads a political work as she passes the packed, men-only Riveter's Arms pushing a boy in a pram whose toys, ominously, are a warplane and a war missile. Several of these recent works do include many figures, but these are now treated with less of the formalism of the mural style. They employ bold effects of light and receding space as well as a palette which is less tonal than in his earlier work. *On the Edge of the City*, *Boy's Night Out*, and *The Scottish Mercenaries* are among the most powerful images to emerge from the new painting in Glasgow, and they are adequate to the ambitious ideals of the artist who declares that his aim is 'to paint about the realities of the human condition as well as to depict the existing possibilities for world reconstruction'.

Performance Art – pioneered by the Futurists before the First World War and more recently developed by Joseph Beuys whose performances were seen at ECA in 1971 – has a notable Scottish exponent in Bruce McLean, whose work had a considerable bearing on the early productions of Steven Campbell and Adrian Wiszniewski, and has had the effect of helping to concentrate minds again on the human figure and on art as performance, as drama. Campbell and Wiszniewski work improvisationally as figure painters. To the degree that their paintings are composed in execution rather than to a pre-ordained plan, they are records of the artist's performance, as well as presenting a tableau performed by their dramatis personae. As Campbell has succinctly put it: 'The painting starts off as one thing and if that doesn't work I try something else until a memory of all these things is in it but none of them is particularly true except the one I've picked to title the work. The picture is a summing-up of all the mistakes; it's what's left.'

Painting is a static art which 'freezes' movement or represents it episodically, or as a kind of optical illusion, a blur, which can then be represented in stasis. Our perception of movement can be recorded cinematically, episodically (as in Futurism) or Impressionistically (as a blur). Steven Campbell presents us with a jigsaw of interlocking forms in arrested movement, described not merely for their own sake, but for their meaning. His *Footballing Scientist* (1984) is not only not on the ball; he is

145 Ken Currie
The Scottish Mercenaries
1987 Oil 274 × 213 cm
Private collection
(Photograph: Raab Gallery)

deluded, as there is in fact no ball visible; and inept, since he has fallen into the ridiculous pose of kicking at a ball and missing it. The outlines of each piece of the jigsaw, with the human figure the main element in its composition, is (unlike a jigsaw) no more arbitrarily determined than form and colour are arbitrary elements in composition. Campbell's chief *formal* principle is gesture, which is another way of saying significant movement: his main *thematic* principle is that of metamorphosis. His work is concerned with the constant changes in nature which confound man's desire to control or to keep pace with them. In *After the Hunt* (1983) the two sportsmen have become dimly aware of the bleakness of man's relentless war against Nature; in *English Landscape with a disruptive Gene* (1987) Nature seems in insurrection against the two heavily armed and by now seriously worried sportsmen who are surrounded by rebellious lobsters and a half-human ape. Metamorphosis in Campbell has a Kafka-like

work, often on a large scale, which demonstrates an intensity of creative imagination that places him on a lonely pinnacle among his contemporaries. The formal density of his work, with its closely-worked surfaces and impenetrable tangle of forms, challenges the visual faculty much as the meaning of his work resists the logical interpretation offered by the engaging titles. In a fascinating recent radio interview with Professor Martin Kemp, the artist described how the deliberate chaos of his studio provides a kind of mine of ideas which may be gleaned randomly from a book, an illustration, or some similar chance encounter which may provide the means to go forward in the composition on which he is currently engaged. He innocently declares that he never reads any book to its end, which (taken with a pinch of salt) ought to warn us against the temptation of seeing him as an expositor of his favourite authors. He is in fact a true artist who rarely loses sight of the purely visual imperatives of art, which in his case, as we have already noted, relate to a visual language of gesture – significant movement – applied to the metamorphoses of nature. The authors who have spurred his imagination have included Wodehouse (Campbell's heroes show a Wooster-like propensity for ingenious schemes which have a wildly improbable denouement, as well as sharing Bertie's fondness for 1920s tweeds and turn-ups), Michel Foucault, whose casebook man made of glass who finally becomes invisible provides a recurring theme, and Hume and Darwin, whose writings provide the inspiration for a painting of two of the former's disciples 'preaching causality' to an unheeding Nature, or the (Wellsian more than Darwinian) *English Landscape with a disruptive Gene* or the (very Darwinian) *Portrait of an Island Splitting*, referring specifically to the cataclysm which divided Bali and Lombok and caused their flora and fauna to evolve along different paths. Yet sight should not be lost of the poetic qualities of these works, which interpret the complexity and energy of Nature with a lyrical humanism reminiscent of the late landscapes of Titian or Poussin.

Four main phases are discernible in Campbell's development. In the primitive early works, such as *Man with Spiral Tree* and *To the North with Good Luck* (1983: William Hardie Gallery) the hero is a solitary protagonist against an antagonistic nature whose elemental presence is suggested by tempestuously painted skies. The man with the spiral tree seems a kind of rain god who is able to conjure the elements; the hiker who clutches like a drowning man the kiln unaccountably placed at the summit of a hill – the others who have been there before him were made of sterner stuff – needs luck to reach his goal, but the wishbone has fallen from his grip. In the following year, 1984, at the end of which Campbell held his first major exhibition in Britain which Stuart Morgan titled 'Between Oxford and Salisbury' Campbell begins to paint figures like walking table

146　Steven Campbell
To the North with Good Luck
1983　Oil on paper laid
down　182.9 × 121.9 cm
William Hardie Gallery

literalness – as in the opening sentences of *Die Verwandlung*, when the hero wakes to discover that he has turned into a giant beetle. There is a similarity between his literal description of events which defy logic and that of the New York writer Barry Yourgrau, whose 1984 collection of short stories *A Man Jumps out of an Airplane* appeared in a jacket designed by Campbell. Campbell however, unlike Yourgrau, does not suspend in dreamlike fashion the dramatic unities of time, place and action: Newtonian physics and Darwinian biology are still intact, but they operate in vast indifference to man whose pretensions, endeavours and ambitions are comically unsynchronized with the rest of Nature.

In the space of less than ten years since the Fulbright Award which took him to New York in 1982, Steven Campbell has produced a body of

sculptures by Giacometti, who are entrammelled by layers of impedimenta –*Through the Ceiling through the Floor*– or who, as lost hikers on an imaginary journey from Oxford to Salisbury, encounter an increasingly mystifying or downright hostile Nature – *Hiker's Ballet with yawning Child, Owl butting Hiker on the Knee, Fall of the House of Nook with Tree Blight* (all 1984) – or teeter on the brink of disaster like the architect hero who stands in hen-toed embarrassment high up on a gargoyle in *Building accusing the Architect of bad Design.*

The pictures assembled for Campbell's exhibition in London in 1987 were introduced by the artist in a 'Pre-Ramble' in the form of a narrative linking several paintings into a cycle:

A man moves to a small town which is traversed by a railway. The town has been designed so that it can grow in only one direction, east, so in consequence the centre of the town is in the west.

The railway is a later development and cuts the town directly in half. He decides after careful consideration to live near the railway, the location offering greater mobility and accessibility to other regions, particularly a small town which at a distance seems to be made from gorgonzola cheese. He is amused by this and remembers Wodehouse talking at length about cheese mites and their impish ways . . .

As time goes by the man becomes disenchanted with life by the tracks and begins to imagine what life is like in the direction west. After various encounters, he decides to head east, in other words home, but not before 28 other small adventures befell him.

The town at first appeared beautiful, until he saw it move. He ran to his home by the tracks, only to see the last chair leg being carried off. He reached to stop this theft but was too weak after his journey. Lying down tired, all his possessions gone, he saw

147 Steven Campbell
The Mousetrap: a Play based on the Inability of Animals to breed in Zoos
1986 Oil 218.5 × 246.5 cm
(Photograph: Marlborough Fine Art, London)
A 'gothick' scenario strewn, Agatha Christie-like, with clues to meaning.

the last piece of the town disappear, it was a sign which read, west bound to termite town.

The emphasis in these paintings moves from Nature to the natural sciences and there is a concentration too on questions of psychology or psychosis: *Portrait of Rorschach testing himself and finding himself guilty, Travelling Silhouette Collector* focusing on problems of identity, while the painting which concludes the cycle in narrative terms, although it was completed in 1986 before some of the others, *Down Near a Railway a Man's Possessions are carried away by Termites*, suggests that the unexplained cataclysm which annihilates the town may have been a man-made catastrophe. Perhaps the most successful of these is the gothic *The Mousetrap: a Play based on the Inability of Animals to breed in Zoos*. Here the ancestral hall, decorated with views of Etna erupting and with antler trophies, is the zoo whose inmates are the elder brother favoured by primogeniture and aloof but armless in his suit of armour: the disembodied arms catch the other by the

leg and by his progenitive equipment. Above them the woman whose head appears upside down has a plait of hair which reaches to the floor but is in the process of ossification to resemble the spinal vertebrae lying on the floor nearby. The men have enlarged snouts like overbred animals which have difficulty in breathing. Campbell's fourth and most recent phase, seen in his 1988 exhibition, has entailed a development of the play/parable form in paintings which deal with questions of aesthetics, such as the brilliant parody *Collagist in the Drama*, where Picasso's Harlequin lies dead on the ground against a Pointilliste landscape upon which an eighteenth century tapestry imposes an earlier sensibility. In *Down there between a Rock and a Hard Place* Campbell contrasts the megalomania of an architect with the venerable stones which he is intent on dismantling. One should add that Campbell does not invariably paint on a large scale, and that his small paintings equally reveal the vigour of his imagination and his feeling for paint: *Role Reversal* amusingly shows a man delivering a baby to a stork on its roof

148 Fionna Carlisle
Theresa's Place
1984 Acrylic on paper 182 ×
197 cm
Scottish National Gallery of
Modern Art

149 June Redfern
My Baby Moon
1983 Oil 190.5 × 214 cm
Scottish National Gallery of
Modern Art

top nest; *Whispering to a Wall* evokes all the secrecy of 'o wall, show me thy chink'; and a little painting of a *Man in a Fire* can be read as a study of panic – or of a man playing bongo drums.

Adrian Wiszniewski (b. 1958), who is of Polish extraction, attended the Mackintosh School of Architecture for four years before studying at GSA, where Steven Campbell was a contemporary, from 1979-83. He attracted a considerable amount of attention, with pictures being bought by the Museum of Modern Art in New York and by the Tate Gallery, in the few years between graduation and his move to Alnmouth in Northumberland in 1986 – 'They don't appreciate art in Scotland unless they're told it's good by someone outside', he commented to Alex Kidson in an interview conducted for his Walker Art Gallery residency exhibition in 1987. His early work was characteristically done in charcoal on paper, with a recurring theme of the dreams of adolescence. These drawings possess an interlacing, meandering, improvised line which at once provides decorative background and a lively, vitalized surface; their spontaneity allows happy *trouvailles* in the way of symbols,

juxtapositions and staffage of trees, flowers, birds and animals which are cognate with the artist's subconscious intention. Wiszniewski's line provides a kind of *perpetuum mobile* which unifies his compositions as well as defining their subject matter. The dense texture of his earlier work has recently given way to a more objective placing of the figure or figures – always the same facial type, an alter ego of the artist and a companion – 'the kind of troupe that tours about using the minimum of props, but always does a good job because the actors know each other so well', as Wiszniewski told Kidson – usually against a plain background of a single colour. *Toying with Religion* (1986-87) is a well known example of this style and typifies Wiszniewski's use of symbolism. Two young 'non-believers bored with being atheists' literally toy with religion, symbolized in a paraphrase of Marx as a giant opium plant one of them holds as they turn their backs on the distant church building, which stands for conventional or institutionalized religion. However, a literal knowledge of his sometimes arcane use of symbols is not essential to an apprehension of the overall mood – a

150 Caroline McNairn
In the Making
1987 Oil 182.9 × 182.9 cm
Edinburgh City Art Centre

mood of quiet elegy for the fleeting Arcadia of adolescence – which pervades Wiszniewski's richly decorative paintings and his brilliantly accomplished, complex etchings and woodcuts.

In earlier chapters we have identified something Scottish in an art which is more painterly than linear, more visual than intellectual, more concerned with colour for itself than in any descriptive role. Although these traditional qualities persisted in the work of the Edinburgh School, they were much less evident in the advanced painting of the fifties, sixties and seventies – or for that matter in the *New Image Glasgow* painting which has attracted international attention on a scale not enjoyed by Scottish art since the Glasgow Boys of last century. They reassert themselves in the other of the two main strands to have dominated new Scottish painting in the eighties: the lively 'wild painting' (*wilde Malerei*) emphasizing colour and painterliness and centred to some extent

on the 369 Gallery in Edinburgh. Fionna Carlisle, June Redfern, and in Glasgow Anne Elliot and Alison Harper – the predominance of female talent here is striking, and several other artists could be mentioned, like Sheila Mullen and Caroline McNairn. The latter is the sister of another talented artist, Julia McNairn. As befits the daughter of John McNairn (q.v.), Caroline McNairn's work is strongly francophile and demonstrates a sensitive grasp of a decorative language originating in Matisse's *papiers collés*.

The work of these artists provides a refreshing feminine contrast with the dinosaur masculinity of the communist realism or macho headbangers which the new Glasgow School holds up to our view. Redfern and Carlisle have tended to concentrate on the constructive solidarity of women in modern society or on the theme of woman caught in the web of time or in the turmoil of her own emotions.

Specifically feminist, however, are Gwen Hardie, who has undertaken under Georg Baselitz's direction in Berlin a campaign to turn the female body inside out in order to remind us that is possesses concavities as well as convexities – this must relate to Baselitz's fascinating discovery that a painting representing a human figure when turned upside down will still be a painting; and Sam Ainsley, whose 'warrior women' are paradoxically battling for 'such traditional female virtues as caring and gentleness'. The formal vocabulary employed – Hardie's knotwork of line and Ainsley's adaptations of traditional Japanese costume – in each case seems outweighed by the polemical task it is called on to perform.

Stephen Conroy's degree show at GSA in 1986 announced the arrival of a brilliant new star among the young figure painters of Glasgow. Conroy (b. 1964) immediately became the talk of Glasgow and in a short space of time (via a much publicized lawsuit with his first agent) followed Campbell to the Marlborough stable, Howson, Currie and Wiszniewski having also signed with London dealers. Conroy was the most outstanding of a 'second wave' of young painters which included a group of 'Glasgow girls' – Rosemary Beaton, Helen Flockhart, Mary McLean, Alison Harper, Margaret Hunter, Karen Strang, Kirsty McGhee and Annie Cattrell – as well as several Dundee-trained artists – Phil Braham (b. 1959), Ian Hughes (b. 1958), Keith McIntyre (b. 1959) and Joseph Urie (b. 1947) who exhibit an absorbing concern with the human figure which enabled the organizers of the SNGMA's compelling survey exhibition *The Vigorous Imagination* to show them with the *New Image Glasgow* people at the Edinburgh Festival in 1987.

Conroy is a phenomenally gifted painter who is still very young. Two things are always noticed about him; the eclecticism of frequent quotation from artists he admires – Degas, Spencer, Sickert, Titian, Rembrandt – and the old-masterish technique, based partly on his assiduous attendance at the Life Class and on an extraordinary natural flair for the craft of painting, with an emphasis on tone and chiaroscuro rather than chromatics, and an ability to employ half-forgotten recipes for coloured varnishes, for traditional scumbles and glazes, which make him seem a repository of the old lore of the artist's pharmacopoeia. (It was wholly appropriate that he was the winner in 1985 of the Harry McLean Bequest for picture restoration at GSA). The masculine self-sufficiency of the world he portrays, with its profoundly unattractive unsmiling gallery of strangely typecast characters – clubmen, actors or singers, boffins, or businessmen who shelter behind formal dress or impenetrable glasses or tinker with scientific apparatus which all emphasize the feeling of distance from normal life – seems hermetically sealed against the world outside. Or perhaps, rather, it is the artist who, still a very young man, feels excluded from this establishment network of experts,

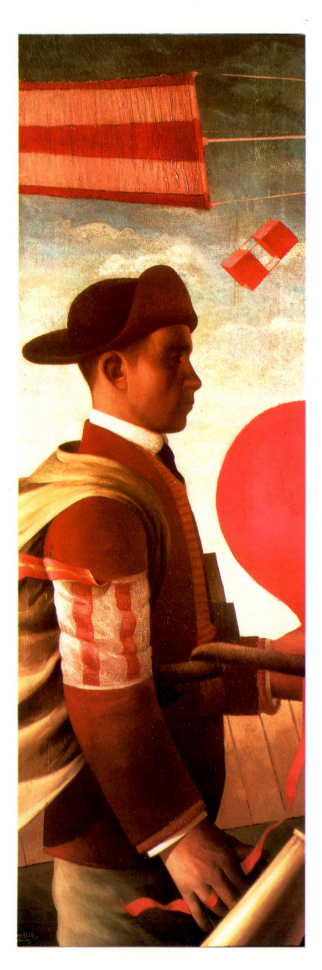

151 Stephen Conroy
Resolve: In a Sea of Trouble he Tries to Scale the Wind
1988 Oil 182.9 × 61 cm
(Photograph: Marlborough Fine Art, London)

dealers, and parasites. Conroy, whose work seems superficially so realistic and whose success with a wide audience has much to do with this illusion, is in fact a master of the artificial: his tableaux are essentially as puzzling as those of Steven Campbell, but where Campbell tantalizes us with the possibility of interpretation, Conroy's work seems essentially devoid of meaning. Devoid, that is, of referential meaning; as painting, as composition, as *matière*, they have immense presence. An example is *Resolve: in a Sea of Trouble he Tries to Scale the Wind* (1988). Here the single figure, like a *quattrocento* portrait seen in profile against a blue sky containing a meteorologist's box kite, is lashed (to a mast or wheel) and seems about to launch a red balloon with one hand while the other holds a loudhailer. He is clearly involved in some scientific field exercise, and the wind catches his cape and the brim of his trilby hat, and streams to the horizontal a coloured burgee immediately above his head. Yet the painting seems, despite all this information, to be completely static, nor is there any sense whatsoever of 'resolve' or 'trouble' or indeed any drama other than that of the interesting massing and contrasts of shapes and colours of the composition itself. Conroy's work often contains strong suggestions of mystery, but their drama is less in the human action depicted, however arcane that often is, than in the interaction of the artist's craft with the forms he invents.

In the work of artists as different as Eduardo Paolozzi, Will Maclean and Tom Macdonald, collage offered a direct evocation of the real world; the sculptor David Mach today uses real objects to create large structures – a Greek temple, a submarine, a tank, a tidal wave carrying a real piano – made of car tyres, books, newspapers, glass bottles. The photographers Calum Colvin and Ron O'Donnell (both graduates of Duncan of Jordanstone College of Art, Dundee) make permanent chromalin prints from tableaux containing real objects interfered-with and touched-up. Ian Hamilton Finlay habitually crosses dividing lines between concrete and discrete, between verbal and visual art, and between different media. Concrete art, land art, and performance art have all questioned the primacy of the discipline of easel painting in oils.

Despite all the extensions of the boundaries of technique, materials and subject-matter, the challenge of the plane surface will always be there as the ultimate test. Its challenge has been met by Scottish artists of the past with vigour, style, and imagination; the prospect that this independent tradition will continue looks brighter today than it has for many years.

SELECTED BIBLIOGRAPHY

GENERAL

Armstrong, Sir Walter, 'Scottish Painters' reprinted from *The Portfolio*, London, 1888

Brydall, Robert, *Art in Scotland; its Origin and Progress*, W. Blackwood, London, 1889

Cursiter, Stanley, *Scottish Art to the Close of the Nineteenth Century*, Harrap, London, 1949

Errington, Lindsay and Holloway, James, *The Discovery of Scotland*, National Galleries of Scotland Exhibition, Edinburgh, 1978

Firth, J., *Scottish Watercolour Painting*, Ramsay Head Press, Edinburgh, 1979

Gage, Edward, *The Eye in the Wind: Scottish Painting since 1945*, Collins, London, 1977

Gordon, Esmé, *The Royal Scottish Academy of Painting, Sculpture and Architecture 1826-1976*, Charles Skilton, Edinburgh, 1976

Halsby, Julian, *Scottish Watercolours 1740-1940*, Batsford, London, 1986

Hartley, Keith and others, *Scottish Art since 1900*, Scottish National Gallery of Modern Art Exhibition, Edinburgh, 1989

Irwin, David and Francina, *Scottish Painters at Home and Abroad*, Faber & Faber, London, 1975

McKay, W.D., *The Scottish School of Painting*, Duckworth, London, 1906

Macmillan, Duncan, *Painting in Scotland: The Golden Age*, Tate Gallery Exhibition, Phaidon, Oxford, 1986

Rinder, F. and McKay, W.D., *The Royal Scottish Academy 1826-1916*, Glasgow, 1917

Thomson, Duncan, *Painting in Scotland 1570-1650*, Scottish National Portrait Gallery Exhibition, Edinburgh, 1975

Tonge, J., *The Art of Scotland*, London, 1939

CHAPTER 1

Sam Bough RSA, Sidney Gilpin. London, 1905

'Alexander Fraser RSA', Edward Pinnington. *The Art Journal*, 1904, pp. 375-9

James Giles, Exhibition Catalogue by Fenton Wyness. Aberdeen Art Gallery, 1970

'Notes on Sir John Watson Gordon' by his grand-nephew, R.D. Watson. *The Art Journal*, 1903, pp. 301-4

'The Art of Sir Francis Grant PRA', Jack Gilbey. *Apollo*, 1951, pp. 154, 182

David Octavius Hill and Robert Adamson, Centenary Exhibition Catalogue by Katherine Michaelson. Scottish Arts Council, Edinburgh, 1970

John Knox, Landscape Painter, Exhibition Catalogue by Ian McClure. Glasgow Art Gallery, 1974

William Leighton Leitch: A Memoir, A. MacGeorge, Blackie, Glasgow, 1884

Horatio McCulloch 1805-1867, Catalogue by Sheenah Smith. Glasgow Art Gallery, 1988

Jacob More 1740-1793, James Holloway. Scottish Masters 4, National Galleries of Scotland, Edinburgh, 1987

Alexander Nasmyth 1758-1840, Janet Cooksey. Crawford Centre for the Arts, St Andrews, 1979

David Roberts RA, Helen Guterman. London, 1978

David Roberts 1796-1864, Artist and Adventurer, Scottish Arts Council Exhibition, Edinburgh, 1982

John Thomson of Duddingston: Pastor and Painter, William Baird. Andrew Eliot, Edinburgh, 1895

CHAPTER 2

William Dyce 1806-1864, A Critical Biography, Marcia Pointon. Oxford University Press, 1979

The Life, Correspondence and Times of William Dyce, RA, typescript by J.S. Dyce (the artist's son). In Aberdeen Art Gallery

Centenary Exhibition of the Work of William Dyce RA, Catalogue by Charles Carter. Aberdeen Art Gallery, 1964

Fact and Fancy, Exhibition Catalogue of Sir Joseph Noel Paton, by A.A. Auld. Scottish Arts Council, 1967

Tales of a Grand-Daughter, M.H. Noel Paton. Privately printed, Elgin, 1970

Memoir of David Scott RSA, William Bell Scott. Edinburgh, 1850

David Scott and his Works, J.M. Gray. Edinburgh, 1884

A studio sale catalogue of David Scott's works was printed by Neill & Co., Edinburgh, 1849

'Pre-Raphaelite Paintings at Wallington: a Note on William Bell Scott and Ruskin', Robin Ironside. *The Architectural Review*, 1942, pp. 147-9

'A Pre-Raphaelite Gazette: the Penkill Letters of Arthur Hughes to W.B. Scott and Alice Boyd 1886-97', William E. Fredeman. *Bulletin of the John Rylands Library*, 49, pp. 323-62 and 50, pp. 34-82

'William Bell Scott: Observer of the Industrial Revolution' by M.D.E. Clayton-Stamm. *Apollo*, 1969, pp. 386-90

CHAPTER 3

The Indefatigable Mr Allan, Exhibition Catalogue by Basil Skinner. Scottish Arts Council, 1973

Alexander Carse c.1770-1843, Lindsay Errington. Scottish Masters 2, National Galleries of Scotland, Edinburgh, 1987

'William Douglas', James Dafforne. *Art Journal*, 1869, pp. 137-9

The Faeds, Mary McKerrow. Edinburgh, 1982

For a discussion of Tom Faed's *From Hand to Mouth*, see Joany Hichberger, *The Mythology of the Patriotic Old-Soldier in Academic Art 1815-1880*, in *Patriotism*, ed. R. Samuel. London, 1989

Walter Geikie 1795-1837, Talbot Rice Art Centre Exhibition Catalogue by Duncan Macmillan. Edinburgh, 1984

'John Graham and the Trustees' Academy', Hamish Miles. *Scottish Art Review*, new series, XIV, 4 & XV, 1

Harvey's Celebrated Paintings, Rev. A.L. Simpson. Andrew Elliot, Edinburgh, 1870

'Erskine Nicol RSA ARA', James Dafforne. *Art Journal*, 1870, pp. 65-7

John Phillip, Centenary Exhibition Catalogue, by Charles Carter. Aberdeen Art Gallery, 1967.

Pictures by John Phillip RA, James Dafforne. Virtue, London, n.d.

For Phillip, see also *The Late Richard Dadd*, Exhibition Catalogue by Patricia Allderidge. Tate Gallery, 1974

David Roberts, Helen Guiterman and Briony Llewellyn. London, 1986

David Roberts: Artist and Adventurer 1796-1864, Patsy Campbell. Edinburgh, 1981

William Simson RSA, 1800-1847, Catalogue by Robin Nicholson. The Fine Art Society, Edinburgh and London, 1989

The Life of Sir David Wilkie, Allan Cunningham. 3 vols, London, 1843.

The Etchings of Sir David Wilkie & Andrew Geddes, Catalogue by Campbell Dodgson. The Print Collector's Club, London, 1936

Tribute to Wilkie. Contributions by Lindsay Errington and others. National Galleries of Scotland Exhibition, Edinburgh, 1985

Sir David Wilkie of Scotland, H.A.D. Miles and D.B. Brown. North Carolina Museum of Art, Raleigh, 1987

Correspondence between Wilkie and William Allan is preserved in the National Library of Scotland, Edinburgh.

CHAPTER 4

'Alexander Hohenlohe Burr', James Dafforne. *Art Journal*, 1870, pp. 309-11

'James Burr', James Dafforne. *Art Journal*, 1869

'The Life and Work of Peter Graham RA', W. Matthews Gilbert. *Art Journal*, 1899

Master Class. Robert Scott Lauder and his Pupils, Lindsay Errington. National Galleries of Scotland Catalogue, Edinburgh, 1983

The MacWhirter Sketchbook, Introduction by Edwin Bale. London, 1906

Sketches from Nature, John MacWhirter RA, Introduction by the artist's widow. London, 1913

The Life of Sir William Quiller Orchardson RA, Hilda Orchardson Gray. Hutchinson, London, n.d.

Sir William Quiller Orchardson RA, Exhibition Catalogue by W.R. Hardie. Scottish Arts Council, 1972

Sir William Quiller Orchardson 1832-1910, Exhibition Catalogue by Lindsay Errington, National Galleries of Scotland, Edinburgh, 1980

John Pettie RA, HRSA, Martin Hardie. A. & C. Black, London, 1908

CHAPTER 5

'Hugh Cameron RSA', Edward Pinnington. *Art Journal*, 1902, pp. 17-20 and 297-300

'A Few Recollections of Student Days', Hugh Cameron. *The Cairn*, 1911, pp. 6-10

George Paul Chalmers RSA, Alexander Gibson and John Forbes White. David Douglas, Edinburgh, 1879

George Paul Chalmers RSA and the Art of his Time, Edward Pinnington. Glasgow, 1896

'The Angus Rembrandt', Charles Carter (on George Paul Chalmers). *Scots Magazine*, 1963, pp. 345-9

The Art of Joseph Henderson, Introduction by Percy Bate. Glasgow, 1908

Robert Herdman (1829-1888), Lindsay Errington. Scottish Masters 5, National Galleries of Scotland, Edinburgh.

'Mr Colin Hunter ARA', n.d. *The Scots Pictorial*, 1898, pp. 295-6

'R. Gemmell Hutchison RSW, RBA,' Gabriel Setoun. *The Art Journal*, 1900, pp. 321-6

'The Works of Hamilton Macallum,' James Dafforne. *The Art Journal*, 1880, pp. 149-51

'R.W. Macbeth ARA', A.L. Baldry. *Art Journal*, 1900, pp. 289-92

'Robert McGregor RSA', by James Shaw Simpson. *Scottish Country Life*, 1919, pp. 338 ff.

William McTaggart: A Biography and an Appreciation, Sir James L. Caw. Glasgow, 1917

William McTaggart 1835-1910, Lindsay Errington. National Galleries of Scotland, Edinburgh, 1989

George Manson and his Works, J.M. Gray. Edinburgh, 1880

'Sir George Reid PRSA', G. Baldwin Brown. *Magazine of Art*, 1892, pp. 196-203

Sir George Reid's correspondence with J. Forbes White is preserved at Aberdeen Art Gallery

For J.F. White, see Ina May Harrower's biography, Edinburgh, 1918, and *John Forbes White* by Dorothea, Lady Fyfe, Edinburgh, 1970

Sir James Lawson Wingate PRSA, 1846-1924, Catalogue by Jack Dawson. Fine Art Society, Edinburgh and Glasgow 1990

Two Van Gogh Contacts: E.J. Van Wisselingh, Art Dealer; Daniel Cottier, Glass Painter and Decorator, Brian Gould. Bedford Park, 1969

CHAPTER 6

William Buchanan and the 19th Century Art Trade in London and Italy, London, 1982

D.Y. Cameron: an Illustrated Catalogue of his Etched Work, with Introductory Essay & Descriptive Notes, Frank Rinder. James Maclehose, Glasgow, 1900

Joesph Crawhall. The Man and the Artist, Adrian Bury. Charles Skilton, London, 1958

Sir James Guthrie, Sir James L. Caw. Macmillan, London, 1932

Guthrie and the Scottish Realists, Catalogue by Roger Billcliffe. Fine Art Society, Glasgow, 1981

James Watterson Herald, Catalogue by Roger Billcliffe. Fine Art Society, 1981

J. W. Herald 1859-1914, Kenneth Roberts. Forfar, 1988

'E.A. Hornel Reconsidered', W.R. Hardie. *Scottish Art Review*, new series, XI, 3 & 4, 1968

Edward Atkinson Hornel 1864-1932, Catalogue by Roger Billcliffe. Fine Art Society, Glasgow, 1982

Beatrice How 1867-1932 – a Scottish Painter in Paris, Foreword by Arnold Haskell. Fine Art Society, 1979

John Lavery, the Early Career 1880-1895, David Scruton. Crawford Centre for the Arts, St Andrews, 1983

Lavery, W. Shaw Sparrow. Kegan Paul, Trench and Trubner, London, 1911

Sir John Lavery RA, 1856-1941, Introduction by Kenneth McConkey. Ulster Museum & Fine Art Society, London 1984

The Life of a Painter, Sir John Lavery. Cassell, London 1940

Alexander Mann 1853-1908, Catalogue by Christopher Newall. Fine Art Society, London, 1983

Alexander Mann 1853-1908, Catalogue by Martin Hopkinson. Fine Art Society, London, 1985

Arthur Melville 1855-1904, Catalogue by Gerald Deslandes. Dundee Art Gallery, 1977

Arthur Melville, Agnes Mackay. Frank Lewis, London, 1951

'Francis Newbery and the Glasgow Style', Isobel Spencer. *Apollo*, XCVIII, 1973

The Paterson Family. One Hundred Years of Scottish Painting 1877-1977, Ann Paterson Wallace, Belgrave Gallery, London, 1977

James Paterson, Introduction by Ailsa Tanner. Lillie Art Gallery, Milngavie, 1983

John Quinton Pringle, Centenary Exhibition Catalogue by James Meldrum. Glasgow Art Gallery, 1984

John Quinton Pringle, Exhibition Catalogue by David Brown. Scottish Arts Council, Edinburgh, 1981

James Pryde, Derek Hudson. London, 1949

James Pryde 1866-1941, Foreword by John Synge to Exhibition Catalogue, Redfern Gallery, London, 1988

Edward Arthur Walton, Fiona McSporran. Privately printed, Glasgow, 1987

E.A. Walton, Exhibition Catalogue by Helen Weller. Bourne Fine Art, Edinburgh, 1981

The Glasgow School of Painting, David Martin. Blackie, Glasgow, 1897

The Glasgow School of Painters, G. Baldwin Brown. 1908

The Glasgow Boys, Exhibition Catalogue, ed. W. Buchanan. 2 vols., Scottish Arts Council, Edinburgh, 1968 and 1971

The Glasgow School of Painting, Exhibition Catalogue by William Hardie. Fine Art Society, London, 1970

The Glasgow Boys: the Glasgow School of Painting 1875-1895, Roger Billcliffe. John Murray, London, 1985

A Man of Influence: Alexander Reid, Exhibition Catalogue by Ronald Pickvance. Scottish Arts Council, Edinburgh, 1967

'International Glasgow', Elizabeth Bird. *The Connoisseur*, August, 1973

George Buchanan, 'Some Influences on McTaggart and Pringle', *Scottish Art Review*, new series, XV, 2 draws doubtful conclusions from the mass of valuable infomation on the collecting of French pictures in Britain to be found in Douglas Cooper, *The Courtauld Collection*, London University Press, London, 1953. James Paterson's *Memoir* of W.Y. Macgregor exists in typescript (private collection). Macaulay Stevenson's ms *Notes* and papers are in the William Hardie Collection, Mitchell Library, Glasgow.

CHAPTER 7

George Dutch Davidson (1879-1901). A Memorial Volume, Dundee Graphic Arts Association, Dundee, 1902

'George Dutch Davidson; The Hills of Dream Revisited',

William Hardie. *Scottish Art Review*, new series, XIII, 4, reprinted with checklist of Davidson's work, 1973

Jessie M. King, Exhibition Catalogue. Scottish Arts Council, Edinburgh, 1971

Charles Rennie Mackintosh and the Modern Movement, Thomas Howarth, second edition 1977. Routledge and Kegan Paul, London, 1977

'Charles Rennie Mackintosh: Great Glasgow Pioneer of Modern Architecture by David Walker', *Glasgow Herald*, 8 June, 1968

Charles Rennie Mackintosh: The Complete Furniture, Furniture Drawings and Interior Designs, Roger Billcliffe, third edition, John Murray, London 1986. This definitive and beautifully produced book supplements the comprehensive bibliography in Howarth with a list of recent publications on Mackintosh and the Glasgow Style, including Billcliffe's own writings on J.H. MacNair, and *Mackintosh's Architectural Sketches and Flower Drawings* (1977), *Watercolours* (1978), and *Textile Designs* (1982).

Charles Rennie Mackintosh. Margaret Macdonald Mackintosh. The 1933 Memorial Exhibition: a Reconstruction. This reprints Jessie R. Newbery's original Foreword. Fine Art Society, Glasgow 1983

Mackintosh Flower Drawings, Catalogue by Pamela Robertson. Hunterian Art Gallery, Glasgow, 1988

Remembering Charles Rennie Mackintosh. An Illustrated Biography, Alastair Moffat. Colin Baxter, Lanark, 1989

Mackintosh's Masterwork: The Glasgow School of Art, editor, William Buchanan. Glasgow School of Art, Glasgow, 1989

Charles Rennie Mackintosh. The Architectural Papers, ed. Pamela Robertson. White Cockade in association with Hunterian Art Gallery, Oxford, 1990

Newsletter of the Charles Rennie Mackintosh Society, Glasgow, 1973 et seq.

Margaret Macdonald Mackintosh 1864-1933, Catalogue by Pamela Robertson. Hunterian Art Gallery, Glasgow, 1984

Glasgow Society of Lady Artists, Centenary Exhibition catalogue by Ailsa Tanner. Collins Gallery, Glasgow, 1982

The Glasgow Style 1890-1920, Exhibition Catalogue, Glasgow Art Gallery, 1984

Charles Rennie Mackintosh, Architect and Artist, Robert Macleod. Collins, Glasgow, new edition 1983

Founder Members and Exhibitors 1882-c.1920 at The Society of Lady Artist's Club, Exhibition Catalogue. Scottish Arts Council, Glasgow, 1968

Glasgow School of Art Embroidery 1894-1920, Catalogue by Fiona C. Macfarlane and Elizabeth F. Arthur. Glasgow Art Gallery, 1980

'Ghouls and Gaspipes; Public Reaction to Early Work of "The Four" ', Elizabeth Bird. *Scottish Art Review*, new series, XIV, 4.

Arts and Crafts in Edinburgh 1880-1930, Catalogue by Elizabeth Cumming. Edinburgh, 1985

Sir Patrick Geddes's papers are held by the National Library of Scotland and by the University of Strathclyde

Anne Mackie's Diary describing visits to France in 1892 and 1893 is in the Manuscripts Division of the National Library of Scotland.

The Evergreen: A Northern Seasonal, editor, Patrick Geddes. 4 vols, 1895-1897, Geddes and Colleagues, Edinburgh.

CHAPTER 8

Three Scottish Colourists, T.J. Honeyman. London, 1950

Three Scottish Colourists, Catalogue By T.J. Honeyman and William Hardie. Scottish Arts Council, 1970, contains a very full Bibliography by Ailsa Tanner

The Scottish Colourists, Roger Billcliffe. John Murray, London, 1989

F.C.B. Cadell 1883-1937. A Centenary Exhibition, Catalogue by Roger Billcliffe. Fine Art Society, London, 1983

F.C.B. Cadell; A Scottish Colourist, Tom Hewlett. Portland Gallery, London, 1988

Stanley Cursiter: Looking Back. A Book of Reminiscences. Privately printed, Edinburgh, 1974

Stanley Cursiter Centenary Exhibition, Catalogue by Erlend Brown, William Hardie *et al.* Pier Arts Centre and William Hardie Gallery, Stromness and Glasgow, 1986

J.D. Fergusson Memorial Exhibition, Catalogue by Andrew McLaren Young. Scottish Arts Council, Edinburgh, 1961

J.D. Fergusson Centenary Exhibition, Catalogue by Roger Billcliffe. Fine Art Society, London, 1974

The Art of J.D. Fergusson, Margaret Morris. Blackie, Glasgow, 1974

Colour, Rhythm and Dance. Paintings by Fergusson and his Circle in Paris, Catalogue by Elizabeth Cumming *et al.* Scottish Arts Council, Edinburgh, 1985

Fergusson's own writings include a short book *Modern Scottish Painting* (Glasgow, 1943); the article 'Art and Atavism: the Dryad' in *Scottish Art and Letters*, I, 1944; a Prologue (written in 1905) to an Arts Council exhibition of his work (Edinburgh 1954); and a 'Chapter from an Autobiography', *Saltire Review*, IV, 21.

Introducing Leslie Hunter, T.J. Honeyman. Glasgow, 1937

Peploe: an Intimate Memoir of an Artist and his Work, Stanley Cursiter, London, 1947

'Memoirs of Peploe', J.D. Fergusson. *Scottish Art Review*, new series, VIII, 3.

S.J. Peploe 1871-1935, Catalogue by Guy Peploe. Scottish National Gallery of Modern Art, Edinburgh, 1985

For *Rhythm* see also *Anne Estelle Rice*, Exhibition Catalogue by Malcolm Easton. Hull University, 1969.

E.A. Taylor's account of pre-1914 Paris (our source for the influence on Peploe and the others of the work of Auguste Chabaud) is the Honeyman papers (private collection).

The Cadell and Peploe ms material quoted is in the possession of the artists' families.

Stanley Cursiter's letters to William Hardie regarding the Futurist paintings of 1913, written in 1973, are in the National Library of Scotland Manuscripts Division)

CHAPTER 9

Edward Baird and William Lamb, Exhibition Catalogue by James Morrison. Scottish Arts Council, 1968

James Cowie, Memorial Exhibition Catalogue, Introduction by D.P. Bliss. Scottish Arts Council, 1957

James Cowie, Cordelia Oliver. Edinburgh University Press, Edinburgh, 1980

James Cowie, Richard Calvocoressi. National Galleries of Scotland, Edinburgh, 1979

Majel Davidson: an Artist's Life and Influences, Exhibition Catalogue by Frank Matthews. MacRobert Arts Centre Gallery, University of Stirling, 1984

Sir William Russell Flint, R. Lewis and K. Gardner. London, 1988

William Johnstone, Anton Ehrenzweig. Privately printed, London, 1959

William Johnstone, Retrospective Exhibition Catalogue by Douglas Hall. Scottish Arts Council, Edinburgh, 1970

William Johnstone, Douglas Hall. Edinburgh University Press, Edinburgh, 1980

Johnstone's own chief writings are: *Creative Art in England*, London, 1936, *Child Art to Man Art*, London, 1940, and *Points in Time, An Autobiography*, Barrie & Jenkins, London, 1980

James Kay, Exhibition Catalogue by Anne C. O'Neill. Perth Art Gallery, 1987

Henry Lintott RSA, Memorial Exhibition Catalogue by Cordelia Oliver. Scottish Arts Council, Edinburgh, 1967

William McCance, Exhibition Catalogue by William Hardie and Elizabeth Cumming. Dundee Art Gallery, 1975

The McCracken Collection, Illustrated Sale Catalogue. Webb's Auckland NZ, 1985

Mackintosh Textile Designs, Roger Billcliffe. Fine Art Society and John Murray, 1982

John Maclauchlan Milne RSA, 1885-1957. A Centenary Exhibition, Catalogue by Sinclair Gauldie. Dundee Art Gallery, 1985

Alastair Morton and Edinburgh Weavers: Abstract Art and Textile Design 1935-46, Catalogue by Richard Calvocoressi. Scottish National Gallery of Modern Art, Edinburgh, 1978

James McIntosh Patrick, Catalogue by Roger Billcliffe. Fine Art Society, 1987

Paintings by Four Generations of the McNairn Family, Catalogue by Geraldine Prince. Edinburgh College of Art, Edinburgh, 1987

D.M. Sutherland 1883-1973, Introduction by Adam Bruce Thomson. Aberdeen Art Gallery, Aberdeen, 1974

It's all writ out for you: The life and work of Scottie Wilson, George Melly. Thames and Hudson, London, 1986

Four Colourists of the 1930s I: (Drummond Bone, Francis McCracken, Graham Munro & Anne Redpath) and II: *(Majel Davidson, John McNairn, Graham Munro and Edward Overton-Jones)*, William Hardie. Edinburgh Festival, 1985 & 1989

CHAPTER 10

A Modern Scottish Painter: Donald Bain, W. Montgomerie. MacLellan, Glasgow, 1950

Donald Bain, Exhibition Catalogue by William Hardie and Elizabeth Cumming. Dundee Art Gallery, 1972

Donald Bain, Exhibition Catalogue by Callum McKenzie. Glasgow Print Studio, Glasgow, 1980

Robert Colquhoun, Memorial Exhibition Catalogue. Douglas and Foulis Gallery, Edinburgh, 1963

Robert Colquhoun, Exhibition Catalogue. Kilmarnock, 1972

Robert Colquhoun, Exhibition Catalogue by Andrew Brown. City of Edinburgh Art Centre, Edinburgh, 1981

Robert Colquhoun and Robert MacBryde, Catalogue by Richard Shone. Mayor Gallery, London, 1971

Douthwaite: Paintings and Drawings 1951-1988. Third Eye Centre, Glasgow, 1988

Joan Eardley, William Buchanan. Edinburgh University Press, Edinburgh, 1976

Joan Eardley RSA, Cordelia Oliver. Mainstream, Edinburgh, 1988

Alan Fletcher 1930-1958, Memorial Exhibition Catalogue with Foreword by Benno Schotz. Scottish Arts Council, Edinburgh, 1959

Carole Gibbons, Third Eye Centre Exhibition Catalogue. Glasgow, 1975

W.G. Gillies, Retrospective Exhibition Catalogue, Introduction by T. Elder Dickson. Scottish Arts Council, Edinburgh, 1970

W.G. Gillies, T. Elder Dickson. Edinburgh University Press, Edinburgh, 1974

Dorothy Johnstone ARSA, Exhibition Catalogue by Ian McKenzie Smith *et al.* Aberdeen Art Gallery in association with the Fine Art Society, 1984

Bet Low 1945-1985: Paintings and Drawings. Third Eye Centre, Glasgow, 1986

Robert MacBryde, Exhibition Catalogue. New 57 Gallery, Edinburgh, 1973

Tom Macdonald 1914-1985: Paintings, Drawings and Theatre Designs. Third Eye Centre, Glasgow, 1983

Sir William MacTaggart, Retrospective Exhibition Catalogue, Introduction by Douglas Hall. Scottish National Gallery of Modern Art and Scottish Arts Council, Edinburgh, 1968

Sir William MacTaggart, Harvey Wood. Edinburgh University Press, Edinburgh, 1974

Sir William MacTaggart, Studio Sale Catalogue. Christie's Glasgow, 1981

John Maxwell, David McClure. Edinburgh University Press, Edinburgh, 1976

Anne Redpath, George Bruce. Edinburgh University Press, Edinburgh, 1974

Anne Redpath, Patrick Bourne. Bourne Fine Art, Edinburgh, 1989

Eric Robertson, Exhibition Catalogue by John Kemplay. City of Edinburgh Art Centre, 1974

Benno Schotz: Bronze in my Blood – the Memoirs of Benno Schotz, Gordon Wright. Edinburgh, 1981

The New Scottish Group, Naomi Mitchison *et al.*, Foreword by J.D. Fergusson.

New Painting in Glasgow 1940-46, Exhibition Catalogue by Dennis Farr. Scottish Arts Council, Edinburgh, 1968

The Edinburgh Group. Exhibition Catalogue by John Kemplay. City of Edinburgh Art Centre, Edinburgh, 1983

Independent Painting in Glasgow 1943-56, Text by Louise Annand. William Hardie Gallery, Glasgow, 1990

CHAPTER 11

Craigie Aitchison: Paintings 1953-1981, Catalogue by Helen Lessore and John McEwen. Arts Council of Great Britain, London, 1982

John Bellany: paintings, drawings and watercolours 1964-1986, Text by Keith Hartley, Alexander Moffat and Alan Bold. Scottish National Gallery of Modern Art, Edinburgh, 1986

Elizabeth Blackadder, Judith Bumpus. Phaidon, London 1988

Beyond Image: Boyle Family, Lynne Green. Arts Council of Great Britain Exhibition, 1984

Watermarks: Robert Callender and Elizabeth Ogilvie, Text by Hugh Adams. Scottish Arts Council, Edinburgh, 1980

Alan Davie: Paintings and Drawings 1936-1958, Exhibition Catalogue, text by Bryan Robertson and Alan Davie. Whitechapel Art Gallery, London, 1958

David Donaldson. Painter and Limner to Her Majesty the Queen in Scotland, Catalogue by Anne Donald. Glasgow Art Gallery, Glasgow, 1984

The Edinburgh School 1946-1971, Introduction by William Kininmouth. Edinburgh College of Art, Edinburgh, 1971

Ian Hamilton Finlay, Stephen Bann. Ceolfrith Press and Wild Hawthorn Press, Edinburgh 1972

William Gear, Exhibition Catalogue. Gimpel Fils, London, 1961

William Gear. COBRAbstractions 1946-1949, Exhibition Catalogue. Galerie 1900-2000, Paris, 1988

Jack Knox: Paintings and Drawings 1960-1983, Exhibition Catalogue by Cordelia Oliver. Third Eye Centre, Glasgow, 1983

Rory McEwen. The Botanical Paintings, Exhibition Catalogue by Douglas Hall *et al.* Royal Botanic Garden, Edinburgh, 1988

Glen Onwin: i) Saltmarsh, Edinburgh, 1974; ii) *The Recovery of Dissolved Substances*, Bristol, 1978

Eduardo Paolozzi. Exhibition Catalogue by Frank Whitford and the artist. Tate Gallery, London, 1971

Robin Philipson, Maurice Lindsay. Edinburgh University Press, Edinburgh, 1976

James Morrison: The Glasgow Paintings, Text by James Morrison and David Walker. William Hardie Gallery, Glasgow, 1990

Sir Robin Philipson, Catalogue by Roger Billcliffe. Edinburgh Festival, 1989

Four Seasons: Paintings by Derek Roberts, Text by Peter Hill *et al.* Tyne & Wear Museums Service, Newcastle-upon-Tyne, 1988

William Turnbull, Exhibition Catalogue by Richard Morphet. Tate Gallery, London, 1973

Seven Painters in Dundee. Catalogue by William Hardie. Scottish Arts Council, Edinburgh, 1970

Scottish Realism, Catalogue by Alan Bold. Scottish Arts Council, Edinburgh, 1971

Richard Demarco Gallery 10th Anniversary Exhibition, Catalogue text by Richard Demarco *et al.* Edinburgh, 1976

CHAPTER 12

Steven Campbell: New Paintings, Exhibition Catalogue. Riverside Studios, London, 1984

Steven Campbell: Recent Paintings, 'Pre-Ramble' by the artist and text by Tony Godfrey. Marlborough Fine Art, London, 1987

Steven Campbell: Recent Work, 'Pre-Ramble' by the artist and text by Tony Godfrey. New York, 1988

Steven Campbell: On Form and Fiction, Exhibition Catalogue by Euan McCarthur. Third Eye Centre, Glasgow, 1990

Stephen Conroy: Living the Life, Exhibition Catalogue. Marlborough Fine Art, London, 1989

Ken Currie, Exhibition Catalogue by Julian Spalding. Third Eye Centre, Glasgow, and Raab Gallery, Berlin, 1988

Gwen Hardie, Paintings and Drawings, Catalogue by Marjorie Allthorp-Guyton, Fruitmarket, Edinburgh, 1987

Peter Howson: Text by Waldemar Januszczak. Angela Flowers, London, 1987

Peter Howson: The Inhuman Condition, Text by Donald Kuspit. Flowers East, London, 1989

Adrian Wiszniewski, Exhibition Catalogue. Walker Art Gallery, Liverpool, 1987

'Alan Bold: Glasgow's Great Hunger for Cultural Saviour', *Glasgow Herald*, 23 December, 1989

Andrew Brown and Others: Art in Scotland 1987. Published on the tenth anniversary of the 369 Gallery

Alexander Moffat: New Image Glasgow, Exhibition Catalogue. Third Eye Centre, Glasgow, 1985

The Vigorous Imagination. Exhibition Catalogue, text by Keith Hartley *et al.* Scottish National Gallery of Modern Art, Edinburgh, 1987

The Compass Contribution: 21 Years of Contemporary Art 1969-1990. Scottish Arts Council and Compass Gallery, Glasgow, 1990

INDEX

Abbreviations

BreaD HeAd

KITTIWAT UNARROM makes edible human heads and torsos out of dough! His workplace looks like a mortuary or a serial killer's dungeon, but it is in fact a bakery.

Visitors to Unarrom's workshop near Bangkok are alarmed to see the heads and torsos lined up on shelves, and rows of arms and hands hanging from meat hooks. The Thai art student, whose family runs a bakery, uses anatomy books and his memories of visiting a forensics museum to create the human body parts. In addition to heads crafted from bread, chocolate, raisins, and cashews, he makes human arms and feet, and chicken and pig parts, incorporating red food coloring for extra bloody effect. "When people see the bread, they don't want to eat it," he says. "But when they taste it, it's just normal bread. The lesson is, don't judge by appearances."

His macabre project started out as the centerpiece of his final dissertation for his Master of Arts degree, but as word spread about his novelty-shaped bread, regular orders began coming in from the curious or from pranksters who want to surprise their friends.

Basing the models on pictures from anatomy books, Thai art student Kittiwat Unarrom lovingly creates lifelike human heads from bread. Not surprisingly, most people think twice before eating the heads.

Some of Kittiwat's creations are really gruesome and would not look out of place in a chamber of horrors. And if they're not bloody enough, he adds red food coloring to increase the effect.

WEIRD

& WONDERFUL

ARTIST MARCO FIGGEN PAINTS in his studio in Pattaya City, Thailand, with his own beard. It measures 3 ft 7 in (1.1 m) long, and Figgen describes his unique paintbrush as an extension of his soul. He has been growing his beard for 13 years.

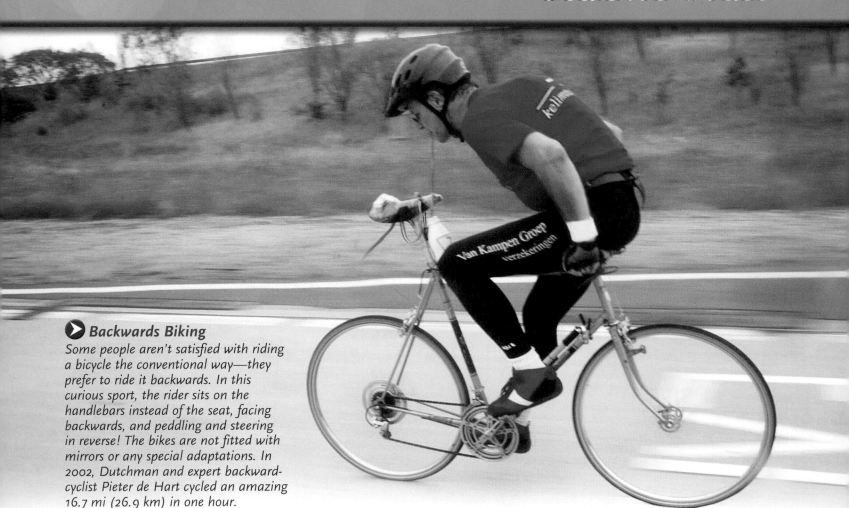

▶ Backwards Biking

Some people aren't satisfied with riding a bicycle the conventional way—they prefer to ride it backwards. In this curious sport, the rider sits on the handlebars instead of the seat, facing backwards, and peddling and steering in reverse! The bikes are not fitted with mirrors or any special adaptations. In 2002, Dutchman and expert backward-cyclist Pieter de Hart cycled an amazing 16.7 mi (26.9 km) in one hour.

Car Spike

The parking lot at the Cermak Plaza Shopping Centre, Berwyn, Illinois, looks like the scene of a horrific accident—shoppers turn a corner to discover eight cars impaled on a 40-ft (12-m) spike! Luckily, it is only a sculpture, named "The Spindle," created by Californian artist Dustin Shuler, from Los Angeles, in 1989.

Monkey Mayor

When the residents of Hartlepool, England, voted for a new mayor in 2002, they elected a man in a monkey costume! H'Angus the Monkey, mascot of the town's soccer team, campaigned successfully with the slogan "free bananas for schoolchildren."

Frog Race

Since 1946, Rayne, Louisiana, has hosted a Frog Derby. Girls from the town dress up frogs in jockey uniforms and encourage them to hop along a course.

Tree Tunnel

You can drive through trees at Leggett, California. The bases of giant redwoods have been tunneled out so that cars can pass through.

TWO HARBORS, Minnesota, must be the only place in the world that has a **museum** devoted solely to **sandpaper**. The collection is located in the house of **John Dwan**, one of the founders of the 3M Company. As a special treat, visitors are given *free* sandpaper samples.

Fireproof City

The Bolivian capital, La Paz, is very nearly fireproof. Located 12,000 ft (3,660 m) above sea level, there is barely enough oxygen in the air to support combustion.

Magnetic Hill

Bizarrely, cars seem to roll uphill at Magnetic Hill, near Moncton, New Brunswick. The phenomenon was first noticed in the 19th century when farmers observed their horses straining to pull wagons down the hill, but when going uphill the wagons would bunch up at the horses' feet. Today, tourists drive their cars to the foot of the hill, stop, put them into neutral and then coast backward, uphill.

The Goat King

For three days a year, Ireland is ruled by a goat! Before the Puck Fair, held in Killorglin, Kerry, every August, chief goat-catcher Frank Joy heads into the hills and captures a wild mountain goat. The goat is duly crowned King Puck and placed on an elevated platform in the center of the town square where, from a height of 50 ft (15 m), he looks down on his subjects for the three-day duration of the fair.

Fence Forte

Musician Simon Dagg from Kent, England, is so obsessed with his first love that he spent a whopping £60,000 ($105,000) fine-tuning the fence around his house so that it would play like a giant glockenspiel. He worked 12 hours a day for five years tuning the metal bars to play like the real thing.

Simon Dagg's musical garden fence measures 120 ft (36.5 m) long.

Tree Village

Believe it or not, the grounds of Alnwick Castle, England, are home to a remarkable tree house—or, rather, a 60-ft (18.3-m) high tree "village"—set among the branches of 16 lime trees. The brainchild of Jane, Duchess of Northumberland, it opened in January 2005, having cost over £3.3 million ($5.7 million). There are five rooms, which include a restaurant, and 6,000 sq ft (557 sq m) of suspended walkways.

Seasonal Snowman

A smiling snowman, 35 ft (10.6 m) tall, stands near Beardmore, Ontario. Made of wood over a steel frame, the snowman was built in 1960 to promote the community and the local ski hill. He even dresses for the time of year—in summer he has sunglasses and a fishing pole; in winter he wears a scarf and carries a curling broom.

On the Border

The Hotel Arbez at Les Rousses straddles the French–Swiss border and offers guests a choice of rooms in either France or Switzerland.

◄ Upside-down Bed

Fancy sleeping in an Upside Down Room, where all the furniture is suspended from the ceiling and you sleep and sit in boxes beneath the floorboards? Or how about the Symbol Room (above), made from 300 square, wooden plates decorated with black-and-white symbols? What about the Coffin Room or the Padded Cell Room? Propeller Island City Lodge Hotel in Berlin, Germany, has 30 rooms, each with a unique, wacky theme.

Movie Theater

The 2,908-ton Shubert Theater in Minneapolis, Minnesota, was moved in one piece to a new site three blocks away in 1999. The theater was transported on rubber wheels for a short journey that took 12 days.

Prophetic Name

When Nancy Araya opened a new restaurant in Santiago, Chile, in 2005, she decided to call it Car Crash because the area was an accident blackspot. But within a few weeks the restaurant had to close after a passing car crashed through the entrance of the building.

Lobster Derby

In a spoof of the Kentucky Derby, lobster racing takes place every May in Aiken, South Carolina, on a track called Lobster Downs. The track is a series of water-filled tanks where progress can be painfully slow. Indeed some lobsters have been known to die mid-race.

▲ Icy Weather

Gale-force north-easterly winds brought freezing temperatures and freakish weather to Lake Geneva, Switzerland, in January 2005. With 70 mph (120 km/h) winds and temperatures of 10°F (−12°C), waves swept over the lake's banks and droplets of water froze instantly on everything they touched.

Canadian Moulette

A popular pastime in rural areas of North America is cow patty bingo. To play, a field is divided into squares, which are wagered on by contestants. The prize goes to whoever has picked the square on which the cow deposits a pat. In 2003, a Canadian firm introduced a variation on this theme, moulette, using a 50-ft (15-m) long roulette board instead of a field. However, protestors said it was cruel to deprive a cow of dirt and grass on which to answer a call of nature.

Pub Grub

A restaurant in Germany enjoyed a rush of bookings in 2005 after adding maggots to the menu. The Espitas restaurant in Dresden served up such delicacies as maggot ice-cream, fried maggots with cactus and corn, maggot salads, and maggot cocktails. Owner Alexander Wolf said, "We were fully booked for weeks. Most people were disgusted but tried them out of curiosity or for a dare, and were amazed at how good the maggots tasted."

Deep Sleep

Near Västerås, Sweden, is a hotel where guests sleep in an underwater room. The brainchild of artist Mikael Genberg, the bedroom at the Utter Inn is situated 10 ft (3 m) below the surface of Lake Mälaren, with a window offering a panoramic view of passing marine life.

Fish Hotel

Chicago's newest downtown hotel caters solely for fish. This "fish hotel" is a series of small gardens densely planted with pondweed to satisfy the scaly inhabitants of the Chicago River. Some gardens are floating, others submerged, and all of the "rooms" are fitted with underwater cameras so that humans can catch a glimpse of the action.

In **Cleveland**, **Ohio**, stands a **gigantic** office **rubber stamp**. Made by artist **Claes Oldenburg** in 1985, the steel structure is **28 ft (8.5 m) tall** and **48 ft (14.6 m) long**.

Remote Island

The uninhabited Bouvet Island in the South Atlantic is probably the world's most remote island. The nearest land—Queen Maud Land in Antarctica— is 1,050 mi (1,690 km) away, and is also uninhabited.

Turtle Power

At Dunseith, North Dakota, a giant turtle has been welded together from over 2,000 steel wheel rims. The head alone weighs more than a ton.

◀ Big Smoke

This giant cigar, made in Miami, Florida, in 1994, is 6 ft (1.8 m) long, 11 in (28 cm) in diameter, and weighs 55 lb (25 kg)—holding enough tobacco to make 3,000 regular no.1-sized cigars! It took two men two weeks to hand roll.

Look Who's Talking

You never know who's talking to you at Vent Haven, as this museum at Fort Mitchell, Kentucky, is home to over 600 ventriloquists' dummies. It is the legacy of W.S. Berger, who collected ventriloquism memorabilia from the early 20th century up until his death in 1972.

Foam Home

At Centralia, Washington State, is a house covered in Styrofoam®™. The owner, former art teacher Richard Tracy, has been working on the house for more than 20 years.

Giant Chair

A steel chair, 33 ft (10 m) high, stands next to a furniture store in Anniston, Alabama. Built in 1981, the structure can withstand winds of up to 85 mph (137 km/h).

▶ Indoor Beach

With 3,350 sq yd (2,800 sq m) of white sand, the Ocean Dome beach, at Miyazaki, Japan, is one of the world's finest. But what makes it unusual is that it is indoors. The beach features plastic palm trees that sway in an artificial breeze, and 13,500 tons of salt-free "sea." A machine creates surf up to 11 ft (3.4 m) high, and even when the giant roof is open the temperature is a warm 86°F (30°C). There's no danger of sunburn or shark attacks and even the surrounding volcanoes are fake. But perhaps the oddest thing about the dome is that the real beach and sea are only 300 yd (275 m) away!

Wreck Replica
The world's most bizarre Stonehenge replica can be found near Alliance, Nebraska, made entirely from wrecked cars. Built by Jim Reinders in 1987, "Carhenge" has 38 cars, positioned in a circle 96 ft (29 m) in diameter, echoing its famous English counterpart.

Roadside Oddity

In 1930, to catch the eye of passing motorists, brothers Elmer and Henry Nickle built a roadside gas station at Powell, Tennessee—in the shape of an airplane. More recently the airplane building, complete with wings and a propeller, has been used as a car lot.

Junk House

When eccentric sculptor Art Beal bought a hillside plot at Cambria, California, in 1928 he set about building a junk house. He spent 50 years realizing his dream and, as the town's garbage collector in the 1940s and 1950s, he used the junk he collected in the construction. He called the result Nitt Witt Ridge, Beal's alias being Captain Nitt Witt.

Elephant Hotel

In 1881, James T. Lafferty built a hotel in the shape of an elephant. Nicknamed Lucy, this historical landmark is now located in Margate, New Jersey. Lucy is 65 ft (19.8 m) tall and weighs 90 tons. For $4 you can wander through its pink rooms and get an elephant's-eye view of the city.

Easier than ABC

Rotokas, a language of the South Pacific, has an alphabet with only 11 letters, comprising six consonants and five vowels.

Trans-Australian Swim

A group of 60 swimmers swam their way across Australia in a pool attached to the back of a truck traveling at 56 mph (90 km/h).

Petrified Dog

Loggers at Waycross, Georgia, looked inside a hollow tree—and found a mummified dog. It was thought the dog had died after getting stuck in the tree, probably 20 years earlier. The petrified dog is now a local tourist attraction and is displayed inside a cross-section of log.

When customers first saw Kittiwat's room of realistic-looking human body parts, they were shocked and thought he was crazy.

41

Let it Be

This toilet paper, auctioned at a starting price of £40,000 ($71,000), was removed from the toilets in the EMI studios at Abbey Road, London, England, when the Beatles refused to use it, objecting to its hardness and shininess. They were also said to have disliked the fact that EMI was stamped on every sheet.

The toilet paper, still on its original 1960s roll, was framed in a glass box.

Self-liposuction

Believe it or not, Yugoslav-born plastic surgeon Dimitrije Panfilov performed liposuction on himself to remove a double chin!

Tiny Letters

In 2004, physicists at Boston College, Massachussetts, managed to carve miniscule letters into a single strand of human hair. Using a laser, they created letters that were 15 micrometers tall. The technique can form items a thousand times smaller than the diameter of a human hair.

Miracle Birth

Nhlahla Cwayita was born healthy at Cape Town, South Africa, in 2003, despite developing in her mother's liver. She was only the fourth baby in the world to survive such a pregnancy.

▶ On a Shoestring

Big Bear City, California, is home to The Shoe Tree—no one quite knows how it started, but the tree continues to accumulate shoe upon shoe. Local police tried to prevent the tree being used in this way by removing all the shoes and fencing off the area, but by the next morning it was covered once again.

Circus Club

At one of the world's strangest nightclubs, the California Institute of Abnormalarts, you can dance the night away in the company of the remains of a dead clown, the stuffed carcass of a piglet-Chihuahua hybrid, a mummified arm, and such weird exhibits as Octopus Girl! The museum and nightclub is run by Carl Crew and Robert Ferguson, who collect circus memorabilia.

Bearded Lady

Vivian Wheeler has a weird claim to fame—she is the woman with the world's longest beard. Wheeler, who comes from Wood River, Illinois, was born with facial hair, having inherited a genetic hormonal disorder from her mother. Her father refused to accept her beard and forced her to shave it off from the age of seven, but she later traveled with sideshow acts under the stage name of Melinda Maxie, dying her natural red hair black for greater impact. Her full beard has now reached a length of 11 in (28 cm), although she usually wears it tied up.

Bead Art

Liza Lou of Topanga, California, used 40 million glass beads to create a kitchen and garden that was first displayed at the Kemper Museum of Contemporary Art in Kansas City in 1998. If the beads had been strung together, they would have stretched about 380 mi (610 km), the same distance as that between Los Angeles and San Francisco.

Two-faced Kitten

A kitten was born in Glide, Oregon, in June 2005, with two faces! Gemini astounded vets and owner Lee Bluetear with her two mouths, two tongues, two noses, and four eyes. Sadly, she died within a week.

Sentimental Value

Ezekiel Rubottom decided to keep his left foot after it was amputated in 2005! He stored it in the front porch of his Kansas home. After neigbors complained, he said "I'm not sick, I just wanted my foot."

Mark Hostetler, an ecologist at the UNIVERSITY OF FLORIDA, has written a book on how to identify **insect splats** left on your car. The book is titled *That Gunk On Your Car*.

Burning Passion

To demonstrate his love for his girlfriend, Todd Grannis set himself on fire before going down on one knee and asking her to marry him! Wearing a cape soaked in gasoline, Grannis, 38, climbed a 10-ft (3-m) scaffold at Grants Pass, Oregon, in July 2005. After being set on fire, he plunged into a swimming pool and told stunned sweetheart Malissa Kusiek: "Honey, you make me hot ... I'm on fire for you." After such a stunt, she had to say yes!

Bird Poop

Believe it or not, an American firm offers individually crafted models of birds made from genuine Californian horse dung!

Faking for Fun

Chaucey Shea of St. Catherine's, Ontario, has a potentially illegal hobby. He has mastered more than 2,000 forgeries of famous signatures, including English playwright William Shakespeare, and several presidents of the United States.

Seat of Learning

Bill Jarrett, a retired artist from Grand Rapids, Michigan, has been studying toilet paper for the past 30 years and now boasts a vast collection of tissue-related memorabilia.

Wacky Wedding

At a wedding in Calgary, Alberta, Canada, in 1998, the bride was a sword swallower, the groom tamed bees, and the maid of honor made a living eating live bugs and worms! Megan Evans married Jim Rogers (Calgary's "Bee Man") in front of 200 musicians and freak-show performers, including worm-loving bridesmaid Brenda Fox.

Half-size Jeanie

Born without any legs, Jeanie Tomaini achieved fame in U.S. sideshows as "The Half Girl." While on tour, Jeanie, who is 2 ft 6 in (0.76 m), married Al, who stood 8 ft 4 in (2.54 m) tall and wore size 22 shoes. They went on to form a successful act as "The World's Strangest Couple."

Ash Art
Bettye Jane Brokl incorporates the ashes of dead people into abstract paintings. The Biloxi, Mississippi, artist sprinkles the cremation ashes on the artwork to create a pictorial memorial for a loved one.

There's no *fast food* at **June**, a new restaurant in LAKEWOOD RANCH, FLORIDA. The **nine-course** meals take **four hours** to eat.

Gerbil Installation
An artist from Newcastle, England, made her pet gerbil the star of a 2005 exhibition. "The Gerbil's Guide to the Galaxy" showed Sally Madge's rodent chewing its way through a 1933 edition of the *New Illustrated Universal Reference Book*, "choosing" certain words to eat.

Fiberglass Shell
A mud turtle that had its shell broken into eight pieces by cars in Lutz, Florida, was given a new fiberglass one in 1982.

All Fingers and Thumbs
Filipinos Albert M. Perculeza and his son Karl Cedric each have 12 digits on their hands and 12 digits on their feet (see below). All 48 digits are fully functional.

Junk Exhibition
In 2005, an exhibition in London, England, by Japanese artist Tomoko Takahashi featured 7,600 pieces of junk. The exhibits included old washing machines, broken toys, a rusty muck-spreader, and three stuffed blackbirds.

Love Shack
In April 2005, a building was covered in 6,000 love letters, some penned by international celebrities, as part of the annual Auckland Festival in New Zealand.

Mind Reader
Matthew Nagle, of Weymouth, Massachusetts, has a brain chip that reads his mind. Severely paralyzed after being stabbed in the neck in 2001, he has a revolutionary implant that enables him to control everyday objects simply by thinking about them. After drilling a hole into his head, surgeons implanted the chip a millimeter deep into his brain. Wafer-thin electrodes attached to the chip detect the electrical signals generated by his thoughts and relay them through wires into a computer. The brain signals are analyzed by the computer and translated into cursor movements. As well as operating a computer, software linked to other items in the room allows him to think his TV on and off and change channels.

Soaring Success
For her 1999 work "100 Ideas in the Atmosphere," Canadian performance artist Marie-Suzanne Désilets launched 100 helium balloons from the rooftop of a Montreal shopping mall with self-addressed notecards and an invitation to reply.

Elastic Man

DUBBED "MR ELASTIC," Moses Lanham can turn his feet around 180 degrees, completely backwards, and then walk in the opposite direction!

Lanham puts his unique talent down to being born with extra ligaments and cartilage within the joints of his ankles, knees, and hips, which enable him to rotate his bones freely within the sockets of his joints.

Amazingly, he didn't realize he had this ability until he suffered a fall in gym class at the age of 14 and landed awkwardly. Jumping to his feet, he suddenly found that he could easily twist both of his feet around backward. Lanham, from Monroe, Michigan, has discovered that his son Trey also appears to have inherited the extra joint tissue. At 11, he can turn his feet backward just like his dad! "He can't walk backwards yet," says Moses, "but he is learning."

Moses Lanham's body contains extra joint tissue that enables him to turn his feet backwards. Moses can even walk backwards too!

Moses enjoys putting his best foot backwards, and often performs at local fund-raising events.

Wrist-breaker

That K.S. Raghavendra, from India, is capable of breaking 13 eggs in 30 seconds doesn't sound amazing in itself, except he doesn't break them by clenching his fist, but by bending his hand back over his wrist.

Hardy Eater

"Hungry" Charles Hardy, of Brooklyn, New York, describes himself as "the Michael Jordan of competitive eating." In 2001, he ate 23 hot dogs in 12 minutes, and also became Matzo Ball Eating world champion. But his talent has drawbacks. Hardy explains: "I found a place in Manhattan with all-you-can-eat sushi for $19.95. When the lady sees me coming, she hits the clock and gives me one and a half hours."

Button King

Dalton Stevens of Hartsville, South Carolina, has fixed an incredible 600,000 buttons to his Pontiac hearse. Another 60,000 buttons cover the coffin inside! Besides the hearse, he has shoes, musical instruments, and even a toilet covered with buttons.

Human Soap

A bar of soap that was said to have been made from body fat pumped from the Italian Prime Minister Silvio Berlusconi sold for almost $20,000 in 2005. Artist Gianni Motti said that he acquired the fat from a private Swiss clinic where Berlusconi reportedly underwent liposuction. Motti said the fat was "jelly-like and stunk horribly."

Heart Beat

Jeweler Didier Verhill, of Antwerp, Belgium, creates wedding rings engraved with the couple's heartbeat pattern taken from a cardiograph!

Ham Actors

Father and son, Olivier and Yohann Roussel, won one of Europe's most coveted prizes in 2005—the French Pig-squealing Championships. Dressed in pig outfits, the Roussels impressed the judges and spectators with squeals, grunts, and snuffles to represent the four key stages of a pig's life—birth, suckling, mating, and death under the knife.

Doctor, Doctor!

★ Dr. James T. Clack, of Wadley, Alabama, treated patients in the 1940s even though he was blind.

★ Allergist Dr. Edwin Dombrowski, of Stamford, Connecticut, had the automobile licence plate "AH-CHOO."

★ Dr. Anna Perkins, of Westerloo, New York, charged the same rates in 1993 that she had set in 1928: $4 for an office visit, $5 for a house call, and $25 to deliver a baby.

★ When Dr. William Price, of Llantrisant, south Wales, died in 1893, more than 6,000 tickets were sold for his public cremation, as specified in his will.

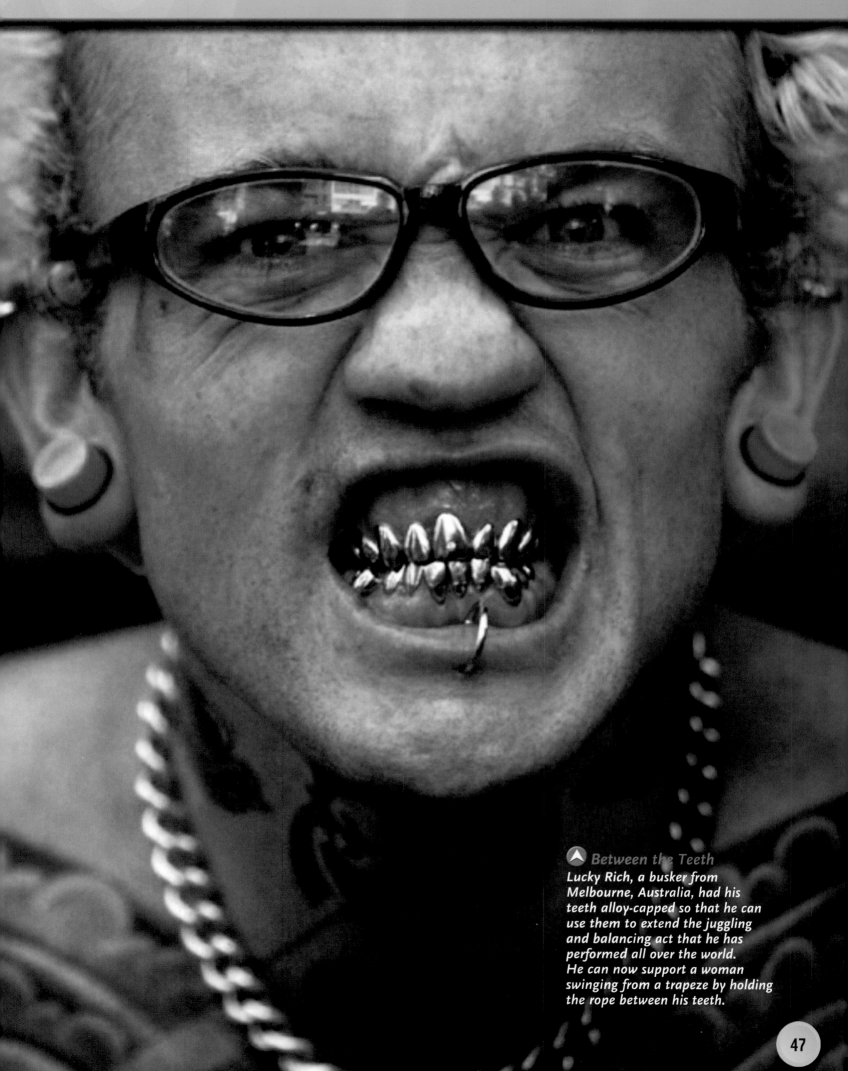

Between the Teeth
Lucky Rich, a busker from Melbourne, Australia, had his teeth alloy-capped so that he can use them to extend the juggling and balancing act that he has performed all over the world. He can now support a woman swinging from a trapeze by holding the rope between his teeth.

HAIRS AND GRACES
Jo Jo "the Dog-faced Boy" was a circus performer in the 1880s. He suffered from a rare condition called hypertrichosis, which meant hair grew all over his face.

GOGGLE-EYED
Avelino Perez Matos, of Baracoa, Cuba, had the ability to dislocate each of his eyes out of their sockets whenever he chose.

HALF AND HALF
John "half-and-half man" Pecinovsky, from Bonair, Iowa, dressed himself in a different color on each side of his body, as well as shaving and not shaving!

MINI MARRIAGE
In 1863, "General Tom Thumb," or Charles Stratton, married Lavinia Warren. Lavinia was heralded as a miniature of perfect proportions, and the marriage was a major event in New York society.

48

LITTLE AND LARGE
Welsh giant George Auger and midget Tom Sordie both performed with the Barnum and Bailey Circus. Auger stood at 8 ft 6 in (2.6 m), while Sordie was a diminutive 2 ft 5 in (0.74 m).

SKINNY
Miss Agnes Schmidt, of Cincinnati, Ohio, pictured here in 1934, had rubber skin owing to a rare disease called Elos Dandros Syndrome.

LOBSTER FEET
The fingers of this unidentified man from upstate western New York have mutated to look like lobster claws. This was the result of inbreeding.

INSEPARABLE TWINS
The "Tocci" twins were born with one body but two heads and four arms. The photo was taken in 1892 when they were 12 years old.

Looking Back

February 15th, 1890 **Frank Damek** stopped collecting stray cards from the street—he had at last made a full deck, after 20 years. September 9, 1930 **Thurber Brockband** took nine hours to find a needle in a haystack. May 2, 1802 **Timothy Dexter** published *A Pickle for the Knowing Ones*, a book that was full of intentionally misspelled words and without punctuation.

.

Species for Sale

A new species of rodent was discovered in 2005—for sale on a food stall in a market in Laos. The rock rat, or kha-nyou, was spotted by conservation biologist Robert Timmins who knew it was something he'd never seen before. The animal looks like a cross between a rat and a squirrel, but is not actually related to any other rodents.

◀ Ledger Balancing

Balancing ledgers while balancing on ledges or deep-sea diving with a tax return are just some ways to perform Extreme Accounting. First established by Arnold Chiswick, the extreme sport incorporates everything involved in an accounting desk job with the thrill of sporting action.

Snake Diet

Neeranjan Bhaskar claims to have eaten more than 4,000 snakes, including deadly cobras. Bhaskar, who is a vegetarian otherwise, hunts for snakes every morning on the banks of the Ghagra River near his home in India. He first ate a snake at the age of seven.

Skin Horror

After being prescribed a common antibiotic to treat a routine sinus infection in 2003, Sarah Yeargain from San Diego, California, looked on in horror as her skin began peeling away in sheets. With Sarah's condition—caused by a severe allergic reaction to the drug—getting worse, more of her skin came off in her mother's hands as she was carried into a hospital. She eventually lost the skin from her entire body—including her internal organs and the membranes covering her mouth, throat, and eyes. Doctors gave her no chance of survival, but they covered her body in an artificial skin replacement and within a few days her own skin returned.

Dog Diver

When Dwane Folsom went scuba diving, his dog went too! Folsom, from Boynton Beach, Florida, designed the first scuba-diving outfit for dogs, comprising a lead-weighted jacket, a helmet, and a tube that allowed the animal to draw air from the human diver's tank. Folsom and his dog, named Shadow, regularly dived to depths of 13 ft (4 m).

Thousands of worshipers flocked to a Chicago underpass in April 2005 and created a shrine of candles and flowers, after a watery mark on the concrete wall was interpreted as an image of the Virgin Mary. Visitors touched and kissed the mark, which was thought to have been caused by salt running down from the Kennedy Expressway overhead. However, the devout insisted it was a miracle that had appeared in order to mark the death of Pope John Paul II.

Live by the Sword

New Yorker Natasha Veruschka, 32, claims to be the world's only belly-dancing sword swallower, and defies a strict religious upbringing to risk her life for her passion.

When did you first become fascinated by swords?

"My British mother died when I was two. I don't remember my Siberian father—I was adopted into a strict Mennonite family in southern Ukraine. I wasn't allowed to hear music, or look in a mirror, or cut my hair. When I was four I saw a knife in a church—I was mesmerized. I remember putting the tip of it on my tongue to feel it."

How did your act begin?

"I grew up in countries including India, Egypt, and Iran, and later took belly dancing lessons in New York.

I learned sword balancing, but one night I ended a performance by kissing the sword—I realized then that I wanted to be a sword swallower. The first time I did it, nine years ago, it felt like home—it made me complete."

What kinds of swords do you swallow?

"The longest is 27½ inches—which is a lot because I am only 5 ft 4 in tall and weigh just over 100 lb. I have 25 different swords—including a Sai sword, which is an eight-sided Japanese war weapon. I can swallow up to 13 swords at once."

Which is the most dangerous?

"The neon sword, which is filled with poisonous gas and is so fragile that your stomach muscles can shatter it inside you. It is electric and heats up—one time, it started to burn and adhere to my insides. Since 1942, six people have died swallowing one."

Have you ever cut yourself on a sword?

"Once I nearly died—I lost 53 per cent of my blood. I had three swords inside me and a man pushed me. The blades scissored and cut my lower esophagus. After the show, I was vomiting blood everywhere and even had a near-death experience. They told me at the hospital that I would be in the morgue by the following morning. I was back swallowing swords within a month."

Where does the sword go?

"To the bottom of the stomach. I can swallow a chocolate cherry, put a sword down and bring it back up. You have to overcome much more than a gag reflex—the sword has to go past two muscle sphincters as well, on its way past the lungs and heart."

Do you have any special techniques?

"I say a prayer before every performance, and use yoga to go into 'a zone.' I use no lubricant, no special tubes. You need a lot of upper body strength—the swords weigh close to 12½ lb when I swallow them all at once—and a lot of lung capacity. It's not magic. I have been X-rayed and you can see the sword in me. The neon one glows through my body for all to see."

What drives you—and how long will you do this?

"My family have shunned me for what I do. To them, I am dead. I think this all stems from an 'I'll show you' attitude. As for how long, I won't be happy until I'm the oldest female belly-dancing sword swallower in the world!"

51

Free Pig

In an unusual bid to boost sales in 2005, an entrepreneurial British housing developer offered a free gift of a live pig to anyone who bought a property from him. Jeremy Paxton, who is based in Gloucestershire, England, promised that the rare breed Gloucester Old Spot pigs would be fully house-trained before delivery.

Giant Rodent

For a 2004 art festival, Dutchman Florentun Hofman built a sculpture of a beaver 100 ft (31 m) long and 25 ft (8 m) high, using just wood and reeds. The year before, he made a 37-ft (11-m) high rabbit.

▶ Pierced Glasses

An American artist has had permanent glasses pierced through the bridge of his nose. Twenty-three-year-old James Sooy, from Dallas, Texas, came up with the eye-catching invention to stop his spectacles from constantly slipping down his nose. The piercing features magnets, so that he can take the glasses off when he bathes and sleeps.

Nose Grown

Madina Yusuf had her face reconstructed by growing a new nose on her arm. The Nigerian woman was severely disfigured by a flesh-eating disease that left her without a nose and with very little mouth. But, in 2001, she flew to Aberdeen, Scotland, where Dr. Peter Ayliffe grafted her new nose from extra skin grown on her arm, plus bone and cartilage that had been taken from her right rib.

Balloon Sculpture

U.S. balloon sculptor Larry Moss used more than 40,000 balloons to construct a model of two football players at Mol, Belgium, in 2000. Each player was 40 ft (12 m) tall.

The Smell of Italy!

In 2003, Ducio Cresci, of Florence, Italy, created bathroom products—including soap, lotion, and bubble bath—that smelled just like pizza!

◀ Superhuman Suit

Japanese scientists have designed a robot suit that gives you superhuman strength. People wearing the HAL (Hybrid Assistive Limb) exoskeleton have been able to carry 88 lb (40 kg) more than they could normally. The equipment reads nerve signals sent from the brain to muscles in the wearer's arms or legs. Motors then start up to support the limbs as the wearer moves. It is hoped that the suit could help disabled people to walk.

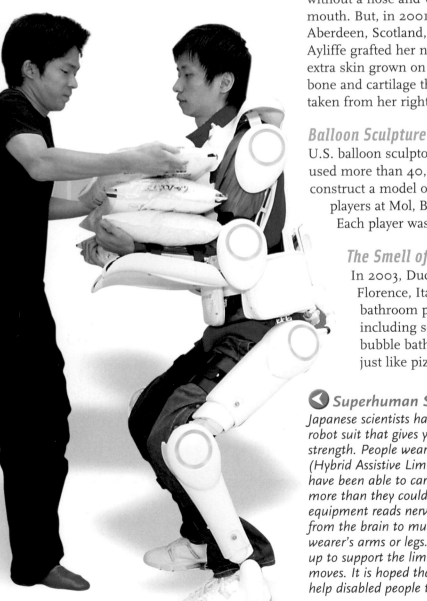

Tiny Tackler

The ace defence tackler on the football team at Flint Southwestern Academy High School, Michigan, was only 3 ft (0.9 m) tall, having been left with no legs after a 1994 railroad accident. Willie McQueen earned his place on the team by courage and tenacity. He didn't play in a wheelchair or wear prostheses, but scooted around to create havoc in the opposing backfield.

SWISS ENGINEERS have designed a car that **reacts to your mood**. The **Rinspeed Senso** can introduce **relaxing smells** and will even **shake** the seat to wake you up if it thinks you've dozed off at the wheel.

Garbage Tour

In Chicago in 2005, people were paying $7 to see some of the city's less desirable spots on a three-hour bus tour of garbage sites, landfills, and smelly sludge sewage fields. The excursion showed residents and visitors what happens to garbage once it leaves their trash cans.

Astral Grooming

Astronauts in space shave using razors equipped with tiny vacuum cleaners inside!

Mini Cows

In a bid to combat his country's serious milk shortage of 1987, Fidel Castro urged his scientists to create a breed of mini cows. Castro wanted the most productive cows cloned and shrunk to the size of dogs so that families could keep one inside their apartments. There, the cows would feed on grass grown under fluorescent lights.

Peculiar Pastimes

In Rieti, Italy, there is an annual washtub race in which contestants race wooden washtubs along a course 875 yd (800 m) long.

Extreme Carving

In Port Elgin, Ontario, Canada, there is an annual pumpkin festival that includes such events as underwater pumpkin carving.

▶ Wrappers Reborn

Finnish artist Virpi Vesanen-Laukkanen exhibited this dress, in St. Petersburg, Russia, made entirely of candy wrappers. The artist said that her creation reminded her of sweets eaten during long journeys.

◀ Huge Halloween

Belgian artist Michel Dircken sits in his carving, created during a competition for the fastest carving of a jack o'lantern in October 2005. The pumpkin weighed 637 lb (289 kg) and measured 131 in (333 cm) around.

Busse Load

When the Busse family marked the 150th anniversary of the arrival of their ancestors in the U.S.A. from Germany, it was no ordinary reunion: 2,369 family members turned up at Grayslake, Illinois, in 1998, some from as far away as Africa.

Space Oddity

Canadian performance artist Julie Andrée T. sought to redefine space by walking blindfold in a confined space for six hours, marking the walls and singing a children's song.

Competitive Kite-flying

Kite fighting is common at the spring Festival of Basant in Lahore, Pakistan. Skilled kite-flyers from all around the country use bladed and chemical-lined strings to bring down or capture their opponents' kites.

Birth Art

As part of an exhibition in a German art gallery, a woman gave birth in front of dozens of spectators. Ramune Gele had the baby girl, named Audra, in 2005, at the DNA gallery in Berlin. The father, Winfried Witt, called the experience "an existential work of art."

Two Noses

Bill Durks was born in 1913 with two noses, each with a single nostril. Between the bridges of his noses, he painted a third eye, over what may have been a vestigial eye socket, and became known in U.S. sideshows as "The Man with Three Eyes." He married Milly Durks, "The Alligator-skinned Woman From New Jersey."

FyRe EaTeR

EATING FIRE, swallowing swords, juggling machetes, hammering nails up his own nose—they're all in a day's work for the Amazing Blazing Tyler Fyre!

Fyre (real name Tyler Fleet), born in Georgia, was a one-off even as a kid, when he found that he could squirt milk, water, and even spaghetti and meatballs out of his nose. He learned trapeze, juggling, balancing, the high wire, and fire-eating, before progressing to a routine as a Human Blockhead. In ten years, Fyre, who also eats glass, razor blades, live crickets, and lit cigarettes, and has been known to pound a nail through a hole in his tongue, has done more than 7,500 live shows, sometimes performing 15 a day. He admits: "It's grueling on the body. At the Coney Island Circus Sideshow I was the Human Blockhead, the sword swallower, I ate fire, and I did the inverted escape act, cranked up by my ankles until my head was 6 ft (1.8 m) above the stage."

Tyler learned his fire-eating from a fellow student while training to be a circus performer. Of all his sideshow skills, it remains his first love.

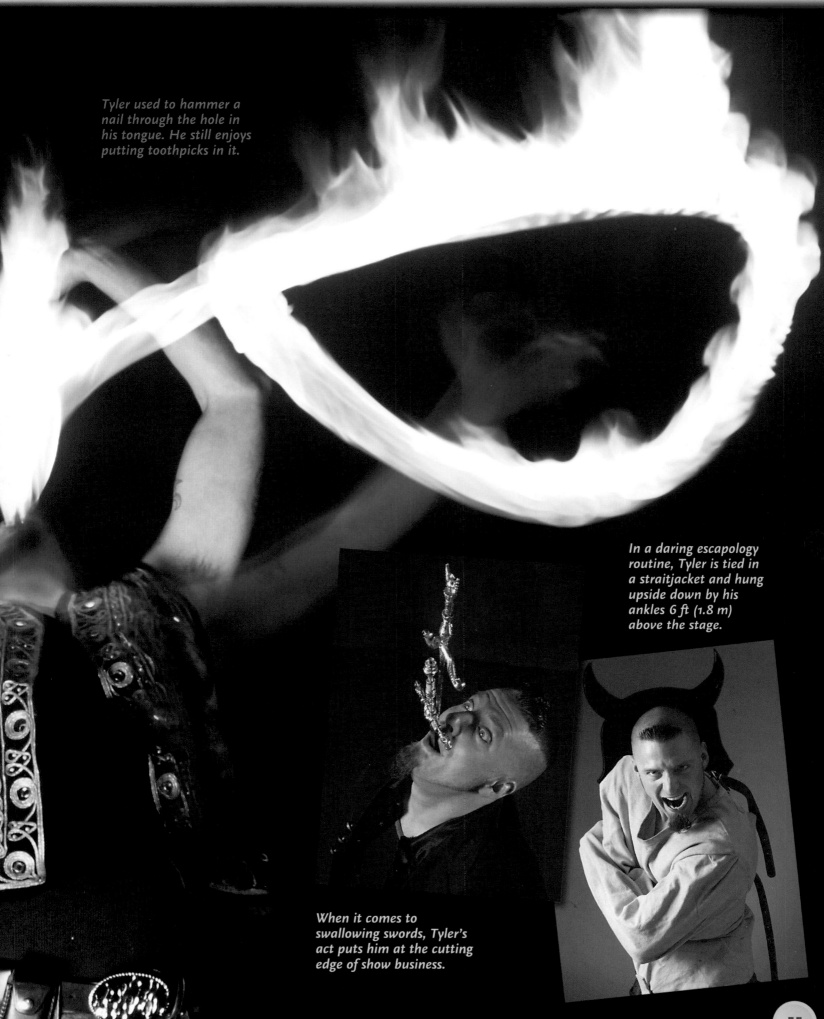

Tyler used to hammer a nail through the hole in his tongue. He still enjoys putting toothpicks in it.

In a daring escapology routine, Tyler is tied in a straitjacket and hung upside down by his ankles 6 ft (1.8 m) above the stage.

When it comes to swallowing swords, Tyler's act puts him at the cutting edge of show business.

Killer Tree

In 1860, nearly 200 years after his death, the Rhode Island Historical Society exhumed the body of Roger Williams—only to find that he had been eaten by an apple tree! The coffin was empty apart from the invading tree roots. A large root curved where his head should have been and entered the chest cavity before growing down the spine. It then branched at the two legs and upturned into feet.

Ice Sculptor

Richard Bubin, aged 44, from Wilkins, Pennsylvania, has been sculpting ice for over 20 years and once carved 61 blocks in under 4½ hours. For Pittsburgh's First Night celebration in January 2005, he turned ten giant blocks of ice into a sculpture of the Roberto Clemente Bridge.

Jumbo Junk

British artist Anthony Heywood made a full-size elephant sculpture in 2004 entirely from household junk, including TV sets, heaters, fans, radios, and a toilet.

Stair Ride

In the 2005 urban Down the Hill bike race, held in the town of Taxco, Mexico, competitors rode their mountain bikes through a house! They went in through a door, down a flight of stairs and exited through another door. They also sped through narrow alleys and jumped heights of 13 ft (4 m) on the 2-mi (3.2-km) course.

▲ Through the Nose

Jin Guolong, from China, can drink through his nose—he consumes both milk and alcohol using this method.

Legged It!

A man testing an artificial leg worth $17,000 ran off without paying the bill. The theft occurred after the man called in to collect a prosthetic from a specialist in Des Moines, Iowa, in 2005, and was allowed to take it away for a couple of hours to ensure that it fitted him properly.

Chicken Protest

Ottawa performance artist Rob Thompson caged a man and a woman in 1997 to protest about the conditions of commercially bred chickens. Eric Wolf and Pam Meldrum spent a week together in the small wooden cage to make the point. Their drinking water came from a dripping hose and they ate vegetarian mash.

Love Birds

During the Middle Ages, people in Europe are said to have believed that birds chose their mates every year on Valentine's Day!

X-ray Eyes

A teenage Russian girl appears to have X-ray vision, which enables her to see inside human bodies. Natalia Demkina has baffled scientists across the world by describing the insides of bodies in detail and using her talent to correctly diagnose the medical conditions of complete strangers. She says that she possesses dual vision when looking at others, but that she can't see inside her own body.

Natalia can switch from normal to X-ray vision by focusing on a person for two minutes.

Pet Pillows

In 2005, Nevada taxidermist Jeanette Hall offered to make fur pillows from dead pets. Each Pet Pillow was handmade for prices ranging from $65 for a cat to $150 for a horse. Hall described the idea as a "unique way of keeping your pets close to you even after they pass away."

Shopping Break

Tired shoppers in Minnesota's Mall of America can rest their weary legs for 70 cents a minute. In the Bloomington shopping center there is a store called MinneNAPolis aimed at bored spouses of shoppers and also at travelers, who need a nap after a lengthy flight, but aren't staying long enough to book a hotel.

Circus Sideshow

★ Prince Randian, known as "The Living Torso," had no arms or legs. However, he amazingly learned to roll, light, and smoke a cigarette by moving his mouth.

★ Myrtle Corbin, the four-legged woman from Texas, had a malformed Siamese twin, which resulted in Myrtle having two pairs of legs. She used to gallop across the stage like a horse.

★ Edward Mordrake was born a united twin, and had another face on the reverse of his—that of a beautiful girl whose eyes used to follow you around the room.

Pavement Picasso

Ben Wilson roams the streets of London, England, looking for used chewing gum, which he turns into works of art. He burns the gum with a blowtorch, adds a clear enamel as a base, then colors in acrylic enamels, and finishes with a coat of varnish. His gum gallery includes human portraits, animals, and buildings.

Cricket Lover

Danny Capps of Madison, Wisconsin, spits dead crickets from his mouth over distances of up to 30 ft (9 m). Capps, who has been fascinated by insects since he was a small boy, says that dead crickets have no flavor.

Winter Woollies

In 2001, a group of volunteers in Tasmania, Australia, knitted turtleneck sweaters for a colony of rare Australian penguins to protect the birds against oil spills!

Robot Riders

In 2005, Qatar, in the Middle East, staged a spectacular camel race using robot jockeys. Seven robots were placed on top of seven camels at Al Shahaniyya racecourse, near the country's capital Doha, after there had been widespread protests about the use of children as jockeys in the popular sport.

▲ Pretty as a Picture

A participant in the 13th International Tattoo Convention, held in Frankfurt, Germany, in 2005, sports a tattoo on the back of his head.

Sensitive Shirt

Italian designer Francesca Rosella has come up with the perfect gift for people involved in long-distance relationships—a hugging T-shirt. Fitted with sensors, the T-shirt simulates the missing partner's caress by recreating breath, touch, and heartbeat based on information transmitted via their cell phone.

Time Capsule

At the 1957 Tulsarama Festival in Tulsa, Oklahoma, a brand-new Chrysler car was buried in a time capsule, to be unearthed in 2007. People were asked to guess Tulsa's population in 2007. Whoever is closest wins the car; if that person is dead, the heirs get the car.

MUSEUMS
Mexico

CUTLERY ART
A figure made from ordinary knives, forks, and spoons.

ONCE THE WORLD'S BIGGEST, this museum in Mexico City can be found in an eye-catching replica medieval castle. Open since 1992, it features a full-size humpback whale skeleton and a giant solid jade Buddha with 1,000 hands.

TOAST ART
The *Mona Lisa* created in a toaster from 64 pieces of white bread.

THEATER MASK
A rare Indonesian Topeng mask of a bulging-eyed demon.

DON'T MISS!

- ▶ Painting on a rice grain
- ▶ Flag flown in space aboard *Apollo 7*
- ▶ Human faces painted on a human hair
- ▶ Spiked collar-torture device
- ▶ Leo Sewell junk art figures
- ▶ Collection of metal objects removed from a human stomach
- ▶ Egyptian mummified head
- ▶ Smallest working camera

CROCODILE NECKLACE
This necklace from New Guinea is made from crocodile teeth, and was worn for luck.

LINCOLN LOG CABIN
Made from 18,000 Lincoln pennies, this replica of Abraham Lincoln's place of birth weighs 200 lb (90 kg).

TONGUE DEXTERITY
Can you roll or fold your tongue? One in 1,000 can. Find out if you can with this interactive display inside the museum.

GATEKEEPER'S MASK
An Indian mask that is hung on gates and entrances to ward off evil spirits.

WHALE SKELETON
This humpback whale was the first ever to be put on public display in New York City in the 1840s.

ROOT CARVING
The material used to create this traditional Chinese carving is a tree root.

59

Pregnant Boy

When seven-year-old Alamjan Nematilaev's tummy began to bulge, his parents thought he had rickets, a common childhood disease in his native Kazakhstan. But, in 2003, a concerned schoolteacher took him to hospital, where doctors removed a 4-lb (1.8-kg) baby boy from Alamjan's stomach! Alamjan had been born with the fetus of his twin brother growing inside him. For seven years it had lived like a parasite, growing a head, a body, hair, and nails. Doctors were able to save Alamjan but not the 8-in (20-cm) fetus.

◢ Small Wonder

Ma Chaoqin from China is 22 years old, but still looks like a baby. She suffers from an incurable disease called Rachitic, or rickets, and as a result has failed to grow at a normal rate.

Medical Marvels

★ When teenager Doug Pritchard, of Lenoir, North Carolina, went to his doctor in 1978 with a sore foot, a tooth was found growing in the bottom of his instep!

★ Jens Jenson, of Denmark, fell into a pile of spiky barberries in 1990 and had to visit his doctor 248 times to have a total of 32,131 thorns removed from his punctured body.

★ After Peter Morris from Kingswinford, England, lost his thumb in a 1993 accident, doctors replaced it with his big toe.

★ Trampled by a bull in 1993, Jim McManus, of Calgary, Canada, had his left ear reattached by doctors—aided by 75 leeches to control the bleeding.

▶ In Fond Memory

Swedish artist and sculptor Lars Widenfalk has created a violin with a difference. He sculpted the working instrument from the tombstone of his late grandfather, Gustav. The violin's fingerboard, pegs, tailpiece, and chin rest are all made of ebony, and by lining the interior with real gold, it produces the finest possible tone. The instrument is considered to be worth in the region of $1.7 million.

Wall Eater

In 2005, Emily Katrencik ate through the wall of her Brooklyn gallery until she could put her head through it—all in the name of art. She said: "The wall has a mild flavor. The texture is more prominent than the taste—it's chalky with tiny sharp pieces in it." Visitors could eat bread made with minerals extracted from the wall.

Frog Birth

A woman from Iran was reported to have given birth to a gray frog-like creature in 2004. It apparently grew from a larva that had entered the woman as she swam in a dirty pool. A doctor described the creature as resembling a frog in appearance, particularly the shape of the fingers, and the size and shape of the tongue.

Talon Contest

Louise Hollis of Compton, California, has let her toenails grow to a staggering 6 in (15 cm) long. She has to wear open-toed shoes with at least 3-in (7.6-cm) soles to stop her nails dragging along the ground, and she needs 2½ bottles of nail polish to paint the nails on both her hands and feet.

Pan Christ

As Juan Pastrano, of Prairie Lea, Texas, was hanging up his frying pan after washing it in 2005, he spotted an uncanny image where the anti-stick coating on the pan had worn thin. There before him was the face of Jesus Christ in a crown of thorns. He promptly sealed the pan in a plastic bag to protect the image from curious visitors.

HEaRiNG CoLoRs

COLOR-BLIND art student Neil Harbisson wears a special device that enables him to "hear" colors.

Neil now points to vibrant colors.

Neil, from Spain, uses a device called the Eye-Borg, that was invented by Adam Montandon, a digital multimedia expert from Plymouth, England. It works by converting light waves into sounds, and consists of a digital camera and a backpack that contains the computer and headset for Neil to listen to the colors. A low-pitched sound indicates reds, a high-pitched sound indicates violet, while shades of blue and green fall somewhere in between.

Now Neil, who takes off the invention only when he sleeps, is able to buy clothes that he "likes the sound of." He can also order his favorite foods, whereas previously he struggled to differentiate between apple juice and orange juice.

When Neil first applied for a passport and sent a photo of himself wearing the camera, it was rejected. "So I sent a letter to the passport office explaining that I was a cyborg. They accepted me as a cyborg."

Snake Man

For more than 50 years, Bill Haast injected himself with deadly snake venom. He built up such powerful antibodies in his system that his blood was used as a snakebite antidote. Haast, who ran a Florida serpentarium, began in 1948 with tiny amounts of rattlesnake venom and built up the dosage until, by the time he was 90, he was injecting himself once a week with venom from 32 species. Although he was bitten more than 180 times by snakes from which a few drops of venom could kill any ordinary human, Haast managed to survive every single time.

Two Hearts

A boy in Tbilisi, Georgia, was born with two hearts. In 2004, doctors discovered that one-year-old Goga Diasamidze had been born with a second perfectly functioning heart near his stomach.

Steve Relles makes a living by scooping up **dog poop**! The *Delmar Dog Butler*, as he calls himself, has over **100 clients** in NEW YORK STATE who pay **$10**, each for a **weekly clean** of their yard.

Snail Trail

In Januray 2005, Chilean artist Paola Podesta promoted her new exhibition by gluing 2,000 plastic snails to a Santiago church. The snail trail led from the Church of Santo Expedito to the nearby Codar art gallery.

Omelette Surprise

When Ursula Beckley of Long Island, New York, was preparing an omelette in 1989, she cracked open an egg—only to see a 6-in (15-cm) black snake slither out. She sued her local supermarket for $3.6 million on the grounds that she was so traumatized by the incident that she could never look at an egg again.

⏏ Last Ride of your Life!

Gordon Fitch took his passion for motorcycles to a new level when he started his Blackhawk Hearse business. For a fitting and dignified last ride, bikers can have their coffins drawn by a Harley Davidson motorbike.

Head Reattached

Marcos Parra must be one of the luckiest guys alive. He survived a horrific car crash in 2002, in which his head was technically severed from the rest of his body. His skull was torn from his cervical spine, leaving his head detached from his neck. Only skin and his spinal cord kept the two body parts connected. Amazingly, however, surgeons in Phoenix, Arizona, managed to reattach his head. The bones were pulled into the right position by two screws placed at the back of his neck, enabling Parra to live.

Miracle Heart

Nikolai Mikhalnichuk leads a healthy life even though his heart stopped beating several years ago. He suffered a heart attack when his wife said she was leaving him, but doctors in Saratov, Russia, found that although his heart has stopped, its blood vessels are able to keep on pumping blood around his body.

Bushy Brows

In 2004, Frank Ames of Saranac, New York State, had his eyebrow hair measured at an incredible 3.1 in (7.8 cm). Ames said "I don't know why it grows like that. It just always has."

Hot Stuff

New Mexico State University has developed a special Halloween chili pepper, a miniature ornamental specimen that changes from black to orange. However, Paul Bosland, head of the university's chili-breeding program, warns that these hot peppers are actually too hot to eat.

Turtle Recall

In 2005, a Chinese man pretended to be a hunchback in order to smuggle his pet turtle onto a plane. The elderly man strapped the turtle, which was 8 in (20 cm) in diameter, to his back before boarding a flight to Chongqing, but after getting through security, he was stopped by a guard who thought his hump looked strange.

Snowball Flag

In 1998, Vasili Mochanou, of Ottawa, Ontario, created a replica of the Canadian Flag using 27,000 snowballs!

◀ Bizarre Menu

The Balaw Balaw restaurant in Angono, the Philippines, offers dishes that are more than simply unusual. The menu includes monitor lizard, cow testicles, giant eel, snake eggs, and giant python.

Fish Bones

Chinese artist Liu Huirong recreates famous works of art in fish bones! She took two years and used more than 100,000 fish bones to complete a copy of "Spring's Back," a 300-year-old painting by Yuan Jiang. She has been making fish-bone pictures for more than 20 years. Every day she collects fish bones from roadside garbage bins and degreases, marinates, and chemically treats them before sticking them on to canvas.

Branching Out

For more than 25 years, performance artist David "The Bushman" Johnson has been alarming people on Fisherman's Wharf, San Francisco, by jumping out from behind branches as they pass by. He has been arrested over 1,000 times as a result of people not getting the joke.

Bone Sculpture

In 2001, U.S. artist Sarah Perry created "Beast of Burden," a 9-ft (2.7-m) rocketship made from horse and cattle bones! She has created other sculptures from hundreds of tiny rodent bones, which she has painstakingly extracted from owl pellets. She also makes art using junk that has been discarded in the Nevada Desert and once made a 700-lb (318-kg) gorilla from old rubber truck-tires.

Speak with Forked Tongue

A multi-pierced and tattooed 25-year-old man, who wanted to be known only as "Ian," had his tongue split in May 2003 to resemble that of a snake. He also installed fang caps on his teeth.

Raw Talent

Gabriela Rivera horrified visitors to an art gallery in Santiago, Chile, in 2005, by showing a video of herself with her face covered in raw meat. She said it showed the relationship people have with themselves each day when they look in the mirror.

In 2001, an **insurance company** in Great Britain offered a "**Spooksafe**" policy for *death, injury, or damage* caused by a **ghost** or **poltergeist**.

Hair Force

Indian police have been trying to improve their public image by paying officers to grow mustaches. In 2004, chiefs in Madhya Pradesh announced a monthly mustache bonus of 30 rupees (about 50 cents) after research showed that officers with smart facial hair were taken more seriously. Mustaches are a sign of authority in India.

Over Your Head

Shanghai, in China, saw the premiere of what was billed as the first acrobatic ballet—a combination of Western dance and ancient Chinese acrobatics. In this scene from "Swan Lake the Acrobatic," a ballerina balanced on her toes on the head of a male dancer.

IN DEPTH
In a Twist

Los Angeles contortionist Daniel Browning Smith, 26, is otherwise known as The Rubberboy—he is so flexible he can cram his whole body into a box the size of a microwave oven.

When did you first discover your flexibility?

"I was four years old when I jumped off my bunk bed and landed in a perfect saddle split. I showed my father and he went to the library and brought me home pictures of contortionists—I tried to copy them, and I could. As a kid playing hide and seek I could hide in the sock drawer!"

How did you turn that into a career?

"When I was 18 the circus came through town where I grew up in Mississippi. I told my family I was joining it and would be back in three weeks—that was eight years ago."

What exactly can you do?

"I believe I am the most flexible person alive. Most contortionists can only bend one way—I can bend so far backwards the top of my head touches the seat of my pants, and so far forward I can kiss my own behind! I can also disconnect both arms, both legs, and turn my torso 180 degrees."

What is your favorite stunt?

"De-Escape—it is the complete opposite of Houdini's straitjacket routine. I have to dislocate my arms and squeeze into a locked straitjacket, then chain myself up with my mouth and flip myself into a box."

What else can you do?

"I can make my ribcage go up and my abdomen go down so you can see my heart beating through my skin! And I can get into a box about the size of a microwave. I get my shins in first, because I can't bend them, then my back, then my head and arms fill the holes. I have to slow down my breathing because my arms and legs put pressure on my lungs."

Does it hurt?

"I practice a stretch until just before it becomes painful, then hold it a bit until it feels normal, then stretch a bit further. The connective tissue between my bones is different genetically, inherited from both sides of my family. My father's father was in the military and it helped him to dislocate his hips when it was time to march. The stretches I do enhance that for me."

Have you ever got stuck?

"I can get through an unstrung tennis racquet or a toilet seat, but once a toilet seat got stuck around my torso with my thigh in the hole as well. I was home alone, and had to crawl into the kitchen and get a bottle of vegetable oil and pour it all over me. The seat finally came off—I just made a huge mess."

Are you working on future stunts?

"I'm trying to turn my head 180 degrees. I can get to about 175 degrees already. It's the only thing I've tried that's made me gasp—it's weird looking down and seeing your own butt!"

Rock Around the Clock

Thirty-six-year-old Suresh Joachim, from Mississauga, Ontario, spent 3 days 3 hours 3 minutes 3 seconds rocking in a rocking chair nonstop in August 2005. In the course of his challenge at the Hilton Garden Inn, Toronto, Ontario, he ate just one plain white bun, some noodle soup, three hard-boiled eggs, and one and a half potatoes. He also drank water and energy drinks, but not enough so that he would have to go to the toilet. His greatest fear was falling asleep because of the continuous rocking back and forth.

▼ Chomping Champ

Australian "Bushtucker Freddy" devours a locust during the 2005 Bug Eating Championships. He went on to win the competition that involved challengers from all over the world eating a variety of creepy crawlies, such as crickets, mealworms, hornets, and locusts.

Blood Stains

Mexican artist Teresa Margolles staged a 2005 exhibition in Metz, France, featuring clothing stained with human blood. She worked in a morgue for ten years and her display comprised clothes worn by corpses.

> Heads turn when **Paul Miller,** from **Alta Loma,** California, walks down the street. That's because his mustache is **10 ft (3 m)** long! It takes him *an hour* to groom it each day.

Hair Wear

Nina Sparre, of Vamhuf, Sweden, practices the art of Haarkulla, or "Hair Farming," creating art and clothing out of human hair!

Living Billboard

Forty models lived in a 3-D billboard on the side of a building for two days in July 2005, creating New York City's first-ever live billboard. They were advertising a new fragrance from Calvin Klein. The models were told to create an illusion of a big party, 24 hours a day.

Car Polish

You can't miss Yvonne Millner when she drives down the streets of Hopkins, South Carolina—hers is the car decorated in nail polish. She started by painting on a smiling face, but now she has designs and slogans all over her car, including a palm tree and the words "Hang Loose." She spends three to four hours a day on the creation and has used over 100 bottles of nail polish.

Hidden Monkeys

When Californian Robert Cusack was asked if he had anything to declare on arrival at Los Angeles Airport in 2002, customs officers could hardly have expected what they would find. They discovered a pair of pygmy monkeys in his pants and a bird of paradise in his suitcase. Cusack was subsequently sentenced to 57 days in jail for smuggling the monkeys, as well as four exotic birds, and 50 rare orchids into the U.S.A. from Thailand.

Fancy Dress

The first prize in the youth division of the July 4 Parade in Haines, Oregon, in 2005, went to three children dressed as dung beetles! Wearing tubes covered by garbage bags, they pushed huge rubber balls coated in sand, dirt, and dead grass.

Ambidextrous Bilinguist

In 2004, Amanullah, a 53-year-old man from India, learned to write different sentences simultaneously with both hands. Most amazing of all, he could write one sentence in English, and the other in Tamil.

▶ Pulling Power

The Great Nippulini can tow a car from the piercings attached to his nipples, as well as lift a phenomenal 55 lb (25 kg).

Holy Shower

In 2005, Jeffrey Rigo of Pittsburgh, Pennsylvania, sold a water stain on his bathroom wall for nearly $2,000 because he considered that it bore a resemblance to Jesus. Following the publicity for the "Shower Jesus," Rigo had requests from people who wanted to pray in his bathtub.

Emergency Repairs

Jonas Scott, from Salt Lake City, Utah, was left with no esophagus after industrial cleaning fluid at his workplace ate away his insides in 1988. With no stomach, he had to be fed intravenously. He went three years without eating solids until surgeons connected the remaining 7 ft (2.1 m) of his small intestine directly to the base of his throat so that he could eat almost normally again.

▼ Great Balls of Fire!

Stonehenge in Wiltshire, England, was the location for a massive synchronized fire-eating spectacular. Seventy fire-eaters came together to create a landscape of flames at the event in September 2004.

SIX BRITONS AND ONE AUSTRALIAN took dining to new heights when they prepared and ate a five-course meal 22,000 ft (6,705 m) up a mountain in Tibet. The diners dressed for the occasion with white ties and top hats and carried the tables, chairs, silver cutlery, floral centerpieces, candelabra, wine, and food all the way to the top.

BREAKING

Hurtling down a ramp at speeds of around 50 mph (80 km/h), a skateboarder leapt over the Great Wall of China
page 92

A rocketman took to the skies above England, reaching the height of a 12-storey building
page 96

A woman who wore a corset continually for over 20 years has reduced her waist to a tiny 15 in (38 cm)
page 97

BOUNDARIES

Building Ace

FOR THE PAST 14 years, Bryan Berg has been creating some of the world's most famous buildings from playing cards. At the 2005 Canada National Exhibition in Toronto, the celebrated cardstacker amazed audiences with his detailed replicas of the Taj Mahal, the Colosseum, and the Pyramids.

Berg bases his card towers on carefully constructed grids. He says that the combined weight of the cards actually adds to the stability of the structure.

Thirty-one-year-old Berg, who comes from Spirit Lake, Iowa, was introduced to cardstacking by his grandfather at the age of eight. By the time he was 17, Berg was building towers of cards over 14 ft (4.3 m) tall. In 1999, he built a 133-storey tower that was 25 ft (7.6 m) high from 2,000 packs of cards. He needed scaffolding so that he could reach the very top. In February 2005, as part of the Asian tsunami relief effort, Berg worked for 18 hours a day, ten days straight, to construct a skyline of New York City. He used 178,000 playing cards, each of which represented a victim of the disaster. The Empire State Building, the Chrysler Building, and Yankee Stadium were all there in breathtaking accuracy.

Berg puts the finishing touches to a Gothic cathedral.

The Taj Mahal stands in the foreground with Rome's Colosseum behind. Berg never uses adhesives. "There are no tricks," he adds. "It's all in the balancing."

Berg demonstrated a refreshing anarchy toward his art on the final night of his Canadian spectacle by enthusiastically destroying his patiently created work with a gas-powered leaf blower!

Air Guitar

At the 2005 Guilfest music festival in Guildford, England, 4,083 people gathered to play air guitars at the same time. With air-guitar "experts" on hand to dispense advice, the wannabee rockers mimed to "Sweet Child of Mine" by Guns 'n' Roses.

Eggs Galore

At the annual Easter egg hunt at Rockford, Illinois, on March 26, 2005, an incredible 292,686 eggs were hunted for and found by 1,500 children in just 15 minutes. The event involved 200 volunteers, 156 bales of straw, and 1,000 hours of stuffing plastic eggs.

▼ Eggstraordinary

Brian Spott from Colorado balanced 439 eggs on the floor at Melbourne's Australian Centre for Contemporary Art in 2005. He said the secret was to find the sweet spot on the base of an egg, adding: "You need a steady hand and a lot of patience."

Modern Houdini

Canadian escape artist Dean Gunnarson specializes in freeing himself from handcuffs and locked coffins. One of his most famous routines is the "Car Crusher," which he performed in Los Angeles, California, in 1990. First he was handcuffed and then chained into a 1970 Cadillac by the South Pasadena Chief of Police. Gunnarson's neck was chained to the steering wheel, his legs were bound to the brake pedal, and his arms fastened to the doors. The Cadillac was then lifted into a car crusher, which was set into motion, its steel jaws closing menacingly. A mere 2 minutes 7 seconds later, Gunnarson amazingly leapt to freedom from his automobile prison, just a few seconds before the vehicle was completely destroyed by the merciless crusher.

Plane Sailing

Canada's Ken Blackburn is no regular aviator—he deals strictly in paper airplanes. He has been making paper planes since the age of ten and broke his first record in 1983, when he managed to keep his creation airborne for 16.89 seconds. But he bettered that at the Georgia Dome, Atlanta, in 1998 with an unbeatable 27.6 seconds.

At Seattle's 2005 **Northwest Folklife Festival**, Andy Mackie led no fewer than **1,706 harmonica** players in a 13 min 22 sec rendition of "Twinkle, Twinkle Little Star."

Voice Broke

Terry Coleman of Denver, Colorado, sang continuously for 40 hours 17 minutes in July 2005. His target was 49 hours, but his voice gave out after 40. "The hardest thing was staying awake," he said afterward.

Wheelchair Star

In July 2005, neuroscientist William Tan from Singapore covered 151 mi (243 km) in a wheelchair in just 24 hours by completing a staggering 607 laps of an athletics track. Two months earlier, the redoubtable Tan had completed 6½ marathons on seven continents in the space of only 70 days.

▶ Lip Stick

Joseph Cervantez of Gurnee, Illinois, makes contact, puckering his lips up for an uninterrupted kiss lasting 7 hours 43 minutes on February 14, 2005. He beat rival Juan Hyde and won a new truck worth $32,235 for his achievement.

Unicycle Feats

Between 1976 and 1978, Wally Watts of Edmonton, Canada, rode a unicycle 12,000 mi (19,300 km) in various countries around the world. And through 1983 to 1984, Pierre Biondo of Montreal, Canada, rode a unicycle around the entire perimeter of North America, just over 12,000 mi (19,300 km).

Hula Heroine

Australian circus performer Kareena Oates created history in June 2005 by managing to spin 100 hula hoops around her waist for three full revolutions.

◀ Pulling Teeth

In June 1999, 36-year-old Krishna Gopal Shrivestava pulled a 270-ton boat a distance of 49 ft (15 m) in Calcutta harbor using only his teeth.

Birthday Bowl

Seventy-year-old Jean Beal bowled 70 games in one day (one game for each year of her life), on June 29, 2005, to celebrate her birthday. It took her nearly 14 hours. Jean, from Hickory, North Carolina, said of the challenge: "I was just doing it to see if I could."

The One that Got Away

In May 2005, Tim Pruitt of Alton, Illinois, caught a record 124-lb (56-kg) blue catfish in the Mississippi River. The monster-sized fish measured a staggering 58 in (147 cm) long and 44 in (112 cm) around. Alas, the fish, which was thought to be at least 30 years old, died the following week while being transported to a Kansas City aquarium where it was to go on public display.

Happy Birthday!
An incredible 27,413 birthday candles lit up New York City on August 27, 2005. Taking 1½ minutes, 50 people rapidly lit candles on top of a cake that measured 47 x 3 ft (14 x 0.9 m).

Backward Bowler
Jim Cripps isn't content with bowling scores of over 250—he does it backwards! It all started as a joke. Jim, from Nashville, Tennessee, was clowning around at the lanes one afternoon when he suddenly made a decision to bowl backwards. He turned his back on the pins, took a few steps, hurled the ball and got a strike! One of his friends bet him he couldn't bowl a 150 in reverse, but after six weeks of practice, Jim managed it. Bowling backwards, he rolled a 279 in a game that included 11 consecutive strikes.

Blind Date
In July 2005, Singapore's Nanyang Technological University staged a romantic event as part of its 50th anniversary celebrations, whereby 536 first-year undergraduates (268 couples) got together to stage a mass blind date.

Large Deposit
In June 2005, Edmond Knowles walked up to a Coinstar machine at a bank in Flomaton, Alabama, and cashed in 1,308,459 pennies, which amounted to $13,084.59. He had started saving pennies in 1967, keeping the coins in a 5-gal (19-l) can. But, by the time of his huge deposit, he had collected so many that they were being stored in four large 55-gal (208-l) drums and three 20-gal (76-l) drums.

Hockey Marathon
In June 2005, Canadian radio host Mike Nabuurs played air hockey for 48 hours straight, at a table in the lobby of McMaster University Medical Center, Hamilton, Ontario.

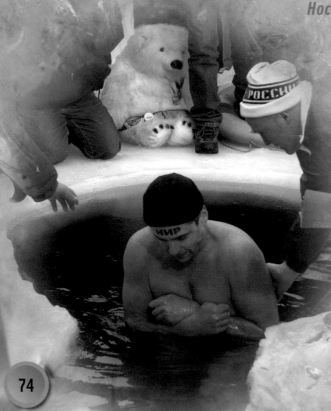

◀ Ice Statue
Russian Karim Diab stood motionless in the freezing Moscow River for one whole hour. He had prepared for two years to accustom his body to surviving in the icy water for an hour without moving. He recovered with a hot bath, but was still too cold to talk.

Fastest Fingers
Dean Gould of Felixstowe, England, can lay claim to being amazingly dexterous. Over the past 20 years the 42-year-old father-of-three has shown that he has the fastest fingers and the handiest hands by setting new standards in such reaction-testing skills as beer-mat flipping, winkle picking, pancake tossing, coin snatching, and needle threading.

Tongue-tied
Using only his tongue, Florida firefighter Al Gliniecki tied 39 cherry stems into knots in three minutes in 1999. On another occasion, he tied an incredible 833 stems in one hour. Yet Al nearly wasn't around to put his talented tongue to use. While working as a lifeguard at Pensacola in 1982, he was struck by a bolt of lightning that threw him 38 ft (12 m) and blew the fillings out of his teeth.

Ballpark Marathon
In 2005, Mike Wenz and Jake Lindhorst saw 30 baseball games in 29 days—each in a different major-league ballpark. The 22-year-old buddies from Chicago began their ballpark marathon in New York's Shea Stadium on June 12 and finished at Miami's Dolphin Stadium on July 10.

Wrap Artist

ON MARCH 11, 1965, a 14-year-old Canadian boy stuck a wad of Wrigley's gum in his mouth and carefully folded the wrappers into links. That night he scribbled an entry in his diary: "I started my gum-wrapper chain with 20 spearmint gum wrappers today."

Forty years later, Gary Duschl's gum-wrapper chain is made up of over one million wrappers and stretches for more than 47,000 ft (14,325 m)—9 mi (14.5 km)—at his home in Virginia Beach, Virginia. To travel the length of the chain would take 9 minutes in a car traveling at 60 mph (97 km/h)! What started out as a desire to have the longest chain in class, then in school, then in the area, has become a 630-lb (285-kg) monster. There is more than $50,000-worth of gum in Duschl's incredible chain.

Many of the wrappers are sent in by well-wishers. Duschl admits that even he couldn't have chewed that amount of gum during the past four decades!

Sky High

To celebrate her 99th birthday on February 17, 1996, Hildegarde Ferrera made a parachute jump over Hawaii. She came through the jump with nothing worse than a sore neck, but sadly died two weeks later from pneumonia.

Most people would use a **14-oz** (400-g) bottle of ketchup sparingly. Not **Dustin Phillips** from Los Angeles, California. In 1999, he drank **90 per cent** of a bottle through a straw in just **33 seconds** (and wasn't sick)!

Handstand Display

A total of 1,072 people turned up at Indianapolis in 2005 to perform an astonishing display of simultaneous handstands. Participants in the challenge came from as far afield as Kansas, Texas, and Oregon.

▶ Get the Picture

Australian artist Ando has created a huge painting of the outback, which measures an amazing 328 x 39 ft (100 x 12 m). Painted on a curved canvas, "The Big Picture" is complemented by more than 300 tons of red landscaped earth (see right), which adds to the image's 3-D effect. Only from certain angles are visitors able to see where 2-D meets 3-D.

▶ Short Story

Adeel Ahmed, a 24-year-old Pakistani seen here being interviewed, is only 37 in (94 cm) high. He was born a normal child, but by the age of five had stopped growing.

Giant Skis

In February 2005, in Jacques Cartier Park in Ottawa, Ontario, 100 skiers traveled 330 ft (100 m) on a gigantic pair of skis, 330 ft (100 m) long.

Check Mates

An incredible 12,388 players turned out to take part in simultaneous chess matches at a public park in Pachuca, near Mexico City, one day in June 2005. Around 80 per cent of the competitors were children.

Long Train

When Hege Lorence married Rolf Rotset in Norway in June 1996, her bridal train was 670 ft (204 m) long, and had to be carried by 186 bridesmaids and pageboys.

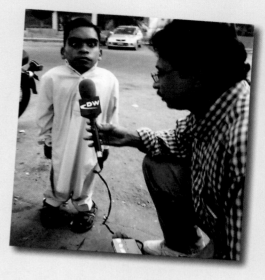

Delicious Worms

"Snake" Manohoran, a 23-year-old hotelier from Madras, India, ate 200 earthworms in 30 seconds in 2004. He said that he overcame any reservations about eating them by simply thinking of them as meat. He acquired the nickname from his trick of putting his pet snake up his nose and pulling it out through his mouth!

Icy Voyage

After chasing a coyote on the ice near Canada's Prince Edward Island in 2001, foxhound Scooter was carried out to sea in a blizzard. She was rescued five days later after traveling 43 mi (70 km) on an ice floe across the Northumberland Strait.

Whip-cracker

Illinois entertainer Chris Camp cracked a 6 ft (1.8 m) bullwhip 222 times in one minute on the Mike Wilson Show in April 2005!

Child Prodigy

Michael Kearney did not sleep as much as other babies. Instead, he just wanted to talk. By the age of just five months, he was using four-word sentences, and at six months he calmly told a pediatrician: "I have a left-ear infection." He enrolled at Santa Rosa Junior College when he was just six years old and graduated two years later with an Associate of Science in Geology. In 1994, aged ten, he received a bachelor's degree in Anthropology from the University of South Alabama. He achieved a master's degree in Chemistry at 14 and was teaching in college at the tender age of 17.

High Flyers

A team from Edmonds Community College, Washington State, flew a kite continuously for more than 180 hours (7½ days) at nearby Long Beach in August 1982.

▷ More than a Mouthful

This appetite-buster hamburger, made by Denny's Beer Barrel Pub in Clearfield, Pennsylvania, on June 1, 2004, weighed about 11 lb (4.9 kg).

Twisted Walk

Inspired by an item on the *Ripley's Believe It or Not!* TV show, an Indian teenager has perfected the art of walking with his heels twisted backward. Despite misgivings from his mother that he might injure his legs, Bitu Gandhi from Rajkot in the state of Gujarat practiced until he was able to walk 300 steps forward and 300 steps backward by twisting his ankles nearly 180 degrees.

TV Addicts

Believe it or not, Chris Dean, 16, and Mike Dudek, 17, from Grand Rapids, Michigan, watched television for 52 hours nonstop in August 2004!

TIGHTROPE WALKER
Clifford Calverley, of Toronto, Canada, crossed Niagara Falls on a steel cable in 1892, taking just 6 minutes 32 seconds.

STRONG CHEST
In 1938, Rasmus Nielsen, a tattooed weightlifter from California, lifted 115 lb (52 kg) with his nipple.

GIANT CHAIR
Built in 1934 by W.E. Houston of Orlando, Florida, this chair measured 26 ft (8 m) high by 12 ft (3.7 m) wide by 8 ft (2.5 m) deep, and weighed 1,400 lb (635 kg).

EYE-OPENER
Ever wanted a beer but couldn't find the opener? Bob Oldham of South Carolina was able to remove bottle tops with his eyes!

MISSISSIPPI MARATHON
Long-distance swimmer Fred Newton of Clinton, Oklahoma, swam an incredible 2,300 mi (3,700 km) down the Mississippi River in 1931.

ALL THUMBS
This 1920s photo shows Robert Jones of Pine Bluff, Arkansas, practicing "thumb-stands" on juggling pins!

HEAD TO TOE
Myra Jeanne of Buffalo, New York, specialized in tap dancing on her own head.

PRICKLY MATTRESS
This photograph of a young boy lying on a bed of nails was taken by missionary W.E. Morton in Benares, India, in 1926.

Looking Back

August 14, 1934 **Lee Chisman**, from Danville, Kentucky, was known as the "Big Bellow Man" because his voice could be heard from 8 mi (13 km) away. **October 11, 1942** **Warren Moore** from Jennings Lodge, Oregon, played 240 notes in one breath on the tuba. **May 20, 1952** **Myrtle Bliven**, aged 70, crocheted five tiny hats that could rest side by side on a single dime.

Sweet Treat

Jim Hager, a dental-plan manager from Oakland, California, ate 115 M&M's® with a pair of chopsticks in just 3 minutes in September 2003.

Endurance Test

Cathie Llewellyn of Wintersville, Ohio, won a new car in 2005 after living in the vehicle for 20 days. She triumphed when her last remaining opponent gave up because she needed to use the bathroom. All contestants had been allowed a five-minute break every six hours during the challenge, which took place in a Steubenville, Ohio, shopping mall.

Fast Fingers

Barbara Blackburn, of Salem, Oregon, can type 150 words per minute for 50 minutes (37,500 key strokes), and has a top speed of 212 words per minute and an error frequency of just 0.002 per 100 words. Her secret is a special keyboard, which has vowels on one side and consonants on the other.

⊽ Ear We Go

Lash Pataraya, 23, from Georgia, lifted 115 lb (52 kg) with his ears in Tbilisi in October 2003. He also used his ears to pull a minibus weighing 1½ tons a distance of 158 ft (48 m), by attaching it to his ears with string.

⚠ Using Your Loaf

In August 2005, in the small town of Mottola, Italy, a monster focaccia was baked. Measuring 78 x 41 ft (23.7 x 12.5 m), the traditional flat bread covered an area of 3,200 sq ft (297 sq m). It was baked in a special wood-and-coal burning oven 4,840 sq ft (450 sq m) wide. The cooked focaccia weighed an estimated 62,000 lb (28,000 kg) and was consumed by 40,000 spectators.

A Knife's Edge

The Great Throwdini is a world-champion knife-throwing minister from Freeport, New York, who takes the world of "impalement arts" to the extreme with his death-defying Maximum Risk act.

When and why did you become a knife thrower?

❝ My real name is the Rev. Dr. David Adamovich and for 18 years I was a professor of exercise physiology. When I was 50, I opened a pool hall and one of my customers brought in a small throwing knife. I threw it into a tree outside and struck it perfectly. Nine months later I came second in the world knife-throwing championship. ❞

What is Maximum Risk?

❝ I'm one of the world's best in competition throwing, and I've converted that skill into a stage act called Maximum Risk. The name is a line from the French movie 'Girl on the Bridge,' about a knife thrower who persuades suicidal girls to be his assistants. ❞

Do you just throw knives at your assistants?

❝ I throw knives, tomahawks, axes, and machetes—but I never throw 'at,' I throw 'around!' My assistant stands in front of a board, or is strapped on to the Wheel of Death while I throw two knives per revolution, one on each side of her. I also catch knives mid-air, and throw both right- and left-handed, blindfolded, and with my back to the board. I don't know why they call it 'impalement arts' because the last thing we want to do is impale our assistants. ❞

How fast can you throw?

❝ Throwing a single knife at a time, I can throw 75 in one minute. Throwing three knives at a time, my personal best is 144 knives around my partner in one minute. ❞

Do you have any special techniques?

❝ I video what I do and watch it back—I study my hands very carefully. When I throw blind, I use sound to judge where to throw. My assistant sets me up facing the board, and I know exactly where she's standing. ❞

Have you ever injured yourself or an assistant?

❝ I once had to stop because I stuck myself with the point of a knife and started bleeding from my fingers. Knives have bounced from the Wheel of Death and scraped the girl, but I've never impaled a girl. ❞

Is it difficult to find willing assistants?

❝ Very! I don't just want a girl to stand there as my target—it's about the way she flirts with me and the audience, while facing danger. ❞

Do you come from a performing family?

❝ Through my high school years I was a gymnast. I competed in the junior Olympics. One of my daughters is a surgeon who is very good with a knife in a different way! My wife Barbara was a knife thrower herself but retired—she has no wish to be my assistant. ❞

Mini Chain
These toothpicks have 28 chainlinks carved into each of them. They were made by Mallikarjun Reddy from Bangalore, India, in 2005.

ACTUAL SIZE!

Just for Laughs
In 1992, American comedian Mike Heeman set out to tell as many jokes as possible in 24 hours. By the end of his marathon gag-fest, he had cracked no fewer than 12,682 jokes.

Riding High
In June 2004, Terry Goertzen, a pastor from Winnipeg, Canada, completed a 328-yd (300-m) ride on a bicycle constructed like a ladder that stood 18 ft 2½ in (5.5 m) high and was powered by a chain measuring 35 ft 8 in (11 m) in length.

Mass Pillow Fight
No fewer than 766 people knocked the stuffing out of each other at Oregon State University in 2003 in a mammoth pillow fight. The event was organized by student Lige Armstrong as part of a class project.

Math Marvel
A 59-year-old man from Chiba, Japan, recited pi—or the ratio of the circumference of a circle to its diameter—to over 80,000 decimal places during a 12-hour challenge in 2005. Akira Haraguchi started the attempt shortly after noon on July 1 and stopped at 83,431 decimal places early the following day. In doing so, he comfortably beat his previous best of 54,000 decimal places.

Balloon Bonanza
In a bizarre challenge, students from Temasek Secondary School in Singapore set out to produce as many objects shaped from balloons as possible. In July 2005, a huge gathering of 1,471 students exercised their lungs to create 16,380 balloons in shapes that ranged from flowers to giraffes.

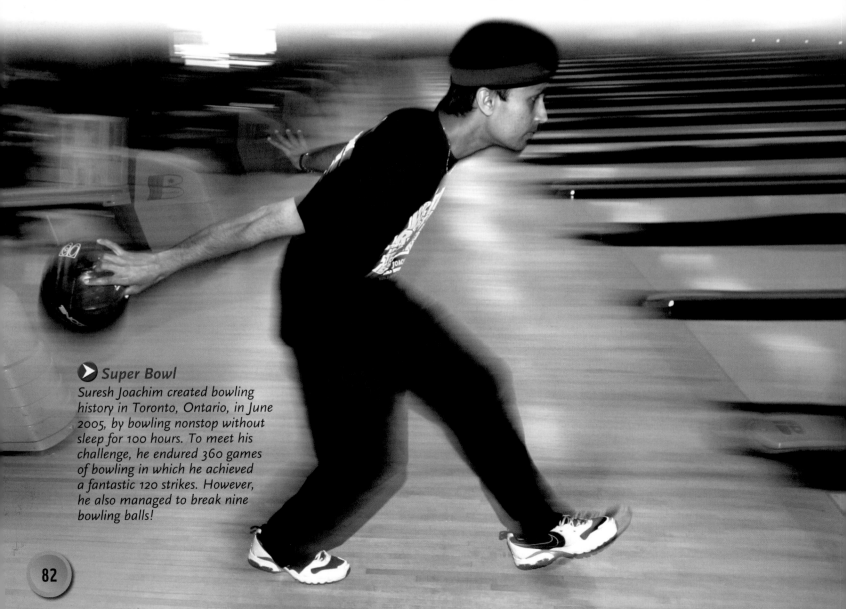

Super Bowl
Suresh Joachim created bowling history in Toronto, Ontario, in June 2005, by bowling nonstop without sleep for 100 hours. To meet his challenge, he endured 360 games of bowling in which he achieved a fantastic 120 strikes. However, he also managed to break nine bowling balls!

In Peak Condition

On May 21, 2004, Pemba Dorjie Sherpa, a 27-year-old Nepali, climbed the upper reaches of the world's highest mountain, Mount Everest, in just 8 hours 10 minutes. Everest is 29,039 ft (8,851 m) high and Pemba's climb—from base camp at 17,380 ft (5,297 m) to the summit—usually takes experienced mountaineers three to four days.

In September 1998, **1,000 students** from the University of Guelph in Ontario, Canada, formed an enormous human **conveyor belt**— passing a surfboard along the belt's entire length.

Wild Bill's Bike

When William "Wild Bill" Gelbke decided to build a giant motorcycle at a Chicago workshop, he had no plans or blueprints. It took him eight long years, but when the Roadog finally appeared in 1965, it created quite a stir. The mammoth bike measured 17 ft (5.2 m) in length, weighed 3,280 lb (1,488 kg), had a frame built from aircraft tubing, and had a cruising speed of a cool 90 mph (145 km/h).

Lawnmower Ride

As part of the Keep America Beautiful campaign, Brad Hauter, from Indiana, rode a lawnmower coast to coast across the U.S.A. He set off from San Francisco in April 2003 and arrived in New York 79 days later after a journey of more than 5,600 mi (9,012 km). The specially adapted mower had a top speed of 25 mph (40 km/h).

Full House

Believe it or not, 15,756 players took part in a single game of bingo at the Canadian National Exhibition in August 1983.

Human Ramp

Tim Cridland's feats are inspired by the mystics of the Far East. Through using "mind-over-matter" philosophy, he has taught his brain not to register the feeling of pain. He can swallow swords and dance on broken glass, but it is his car feat that he counts as his greatest achievement. While lying on a bed of nails with spikes 5 in (13 cm) long, he is able to endure the weight of a 1-ton car driving over him. His skin is not even punctured.

Basketball Marathon

At New England's Beatrice High School gym between July 28 and July 30, 2005, players staged a 52-hour marathon basketball game. "Everyone was exhausted by the end of the game," said organizer Jim Weeks. Some players struggled through the early hours of the mornings and were ready to give up when they reached 40 hours, but they bravely battled on. The final score was 7,935 points to 6,963.

Monster Board

In 1996, Todd Swank from San Diego, California, built a skateboard for himself and his friends that was 10 ft (3 m) long, 4 ft (1.2 m) wide, and 3 ft (1 m) high. It weighed 500 lb (227 kg) and used tires from a sports car. He said he wanted to create a skateboard that no one would ever forget.

Reading Aloud

In March 2005, 1,544 students from Pleasant Valley Middle School, Pocono, Pennsylvania, simultaneously read aloud *Oh the Places You'll Go* by Dr. Seuss.

Inflated Lizard

If attacked, the chuckwalla, one of the largest lizards in the U.S., will crawl into a space between two rocks and puff itself up with air so that it can't be pulled out. It can inflate its lungs to increase its body size by as much as 50 per cent.

49-DaY FasT

CHEN JIANMIN, a 50-year-old doctor of Traditional Chinese Medicine, went 49 days without food in 2004, drinking only water.

An exponent of the practice of fasting, Chen entered the sealed glass cabin, measuring 160 sq ft (15 sq m), on March 20, 2004. The box was fixed 30 ft (9 m) high above the ground on a mountainside near Ya'an City. More than 10,000 visitors who turned out to watch the fast could see into Mr. Chen's house, except for two areas where he showered and used the toilet. While doing so he had to keep his head above a curtain to prove that he wasn't eating. Chen entered the box weighing 123 lb (56 kg) and emerged from the box at least 33 lb (15 kg) lighter. He claimed to have once gone 81 days without food.

Chen takes a call. He claimed to have answered more than 8,000 telephone calls from all over China while in his box.

Suspended 30 ft (9 m) above the ground, Chen sits in his glass box watched over by his team below.

Chen pours himself a drink of water inside his box, which was equipped with items such as a fan, table, chairs, and electric power.

Clever Kids

★ Born in 1982, Anthony McQuone from Weybridge, England, could speak Latin and quote Shakespeare when he was just two years old.

★ David Farragut, who later served as a naval officer during the American Civil War, was given command of his first ship when just 12 years old.

★ American singer Tori Amos began to play the piano at 2½ years of age and wrote her first song when she was just five years old.

★ Romanian painter Alexandra Nechita had her first solo exhibition in 1993 at the age of eight at a library in Los Angeles, California.

Ding-Dong Merrily

Canadian choir leader Joe Defries had music ringing in his ears after playing the handbells for nearly 28 hours straight. Joe, from Abbotsford, British Columbia, has been playing the handbells for more than 25 years and drew up a list of 1,300 tunes for his marathon solo venture in July 2005. Although he had never previously gone beyond 8 hours of solo ringing, Joe rose to the challenge, even finding time to crack jokes in the 30-second breaks he took after each tune.

Horror Crawl

Colorado Springs students Leo Chau and Sean Duffy crawled on their hands and knees for an agonizing 32 mi (51.5 km) through hailstorms and lightning in June 2005 to raise money for charity. The tortuous 44-hour crawl took its toll. Duffy suffered hallucinations and motion sickness while Chau was struck by severe dehydration.

On a Roll

In May 2005, to raise money for the Asian tsunami relief fund, students at the Cornell School of Hotel Administration, New York State, created a huge spring roll 1,315 ft (400 m) long. The monster hors d'oeuvre contained 3,500 spring-roll wrappers, 400 lb (180 kg) of vermicelli noodles, 250 lb (113 kg) each of carrots and cucumbers, and 80 lb (36 kg) of lettuce.

Speed Juggling

Shawn McCue from Sedalia, Missouri, was surfing the Internet when he came across a site for speed juggling. In high school he had been able to bounce a soccer ball on his foot as many as 600 times in three minutes, so he resolved to recreate past glories. In July 2005, in Jefferson City, he performed 155 juggles in 30 seconds, maintaining perfect balance throughout, while the ball never once rose more than 1 in (2.5 cm) off his foot.

Super Boy
Eleven-year-old Bruce Khlebnikov tows an airplane with a rope attached to his hair on May 24, 2001, in Moscow, Russia. He has also pulled cars, lifted Russia's heaviest bodybuilder, torn thick books in half, and used his fists to break 15 ceramic plates that were attached together.

Waist Spinner

Ashrita Furman successfully hula hoops with a hoop that is 14 ft 7½ in (4.46 m) in diameter in New York's Flushing Meadow Park on July 15, 2005.

Elvis Lives!

They were all shook up in July 2005 in Cleveland, Ohio, when a total of 106 Elvis impersonators gathered on a high-school football field and performed a three-minute rendition of "Viva Las Vegas." Men, women, and children alike all donned gold shades and black plastic wigs for the occasion.

Bumper Bagel

For the 2004 New York State Fair, Bruegger's Bakeries created a bagel that weighed 868 lb (394 kg) and measured 6 ft (1.8 m) in diameter.

Whole Lotta Shakin'

While campaigning in Albuquerque for election as New Mexico's governor in September 2002, Bill Richardson, a former U.S. Ambassador to the United Nations, shook 13,392 hands in 8 hours, smashing President Theodore Roosevelt's previously esteemed total of 8,513. At the end of the gruelling session, Richardson immediately sunk his hand into ice.

High Tea

Dressed in formal evening wear, three explorers climbed into a hot-air balloon in June 2005 for an airborne dinner party. David Hempleman-Adams, Bear Grylls, and Alan Veal soared to a height of 24,262 ft (7,395 m) above Bath, England. Then, Grylls and Veal climbed 40 ft (12 m) down to a platform where, at a neatly laid dinner table, they ate asparagus spears followed by poached salmon and a terrine of summer fruits, all served in specially designed warm boxes to combat the freezing temperatures at altitude.

Jumping for Joy

Gary Stewart, of Ohio, made 177,737 consecutive jumps on a pogo stick in 20 hours in May 1990.

Chocolate Delight

Pastry cook Ugo Mignone is seen here working on a Christmas display made entirely of chocolate at a cake workshop in Naples, Italy, in November 2004. Twenty Neapolitan pastry chefs, using a huge 6,600 lb (3,000 kg) of chocolate, worked to create this tasty nativity scene.

The mouthwatering chocolate nativity receives its finishing touches.

MUSEUMS Gatlinburg

DANCE RATTLE
A Maori crocodile hand rattle from New Zealand.

OPENED IN 1970, the first Gatlinburg museum was destroyed by fire in 1992. Reopened the following year, the new museum was built as if crumbling during a severe earthquake. Gatlinburg has many exhibits, including a Mastodon skeleton, Yeti hair, and a giraffe made out of coat hangers.

BOTTLED ARROW
These wooden arrows were inserted through the bottle without any cutting or gluing!

FUTURISTIC ROBOT
Created by Simon Blades, this robot is made entirely from used automobile parts.

DON'T MISS!

- ▶ Extinct elephant bird egg
- ▶ World's largest gum wrapper chain
- ▶ Elephant jaw
- ▶ Fiji mermaid
- ▶ Berlin Wall
- ▶ Wood carved Vespa motorcycle
- ▶ Egyptian mummy
- ▶ Giant punt gun
- ▶ Car parts robot soldier

TALLEST MAN
When Robert Wadlow died in 1940, at the age of 22, he was 8 ft 11 in (2.7 m) tall, weighed 440 lb (200 kg), wore a size 37AA shoe, and had a 25 ring size.

MASTODON SKELETON
Robert Ripley watches over this mastodon, a prehistoric relative of the elephant discovered beneath a golf course in Ohio.

KUGEL BALL
Weighing 10,518 lb (4,770 kg), this ball can amazingly be moved by the touch of a finger.

SHRUNKEN HEAD
The Jivaro tribe of Ecuador claimed their enemies' heads as war trophies.

TWO-HEADED GOAT
Each head has a trachea and esophagus, but each leads to only one lung.

▼ Snow Boat

An amazing sculpture of an ancient warship was carved out of snow and ice in the city of Jilin, China, in January 2005. It was 82 ft (25 m) long, 20 ft (6 m) wide, and 30 ft (9.1 m) high.

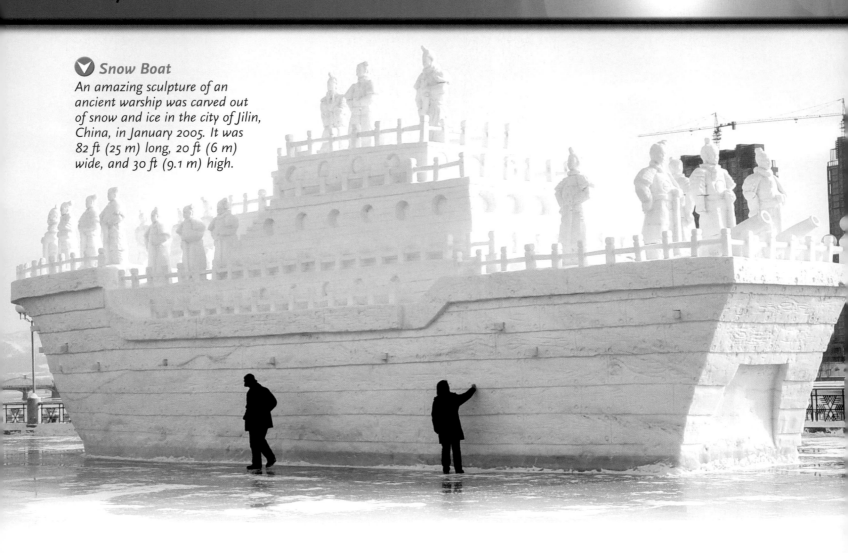

Night Skiing

Canadians Ralph Hildebrand and Dave Phillips water-skied for 56 hours 35 minutes around Rocky Point, British Columbia, in June 1994. They used spotlights and infrared binoculars during the night-time periods of the marathon.

Fish Swallower

In just one hour in July 2005, Indian yoga teacher G.P. Vijaya Kumar swallowed 509 small fish through his mouth and blew them out of his nose! Kumar was inspired by American Kevin Cole, who blows spaghetti strands out of a nostril in a single blow. After successfully ejecting peas and corn through his nose in earlier exhibitions, Kumar turned to live fish.

▼ Property Giant

The game of Monopoly was played on this huge board in Berlin in June 2005. To make a move, the pieces had to be lifted by two players!

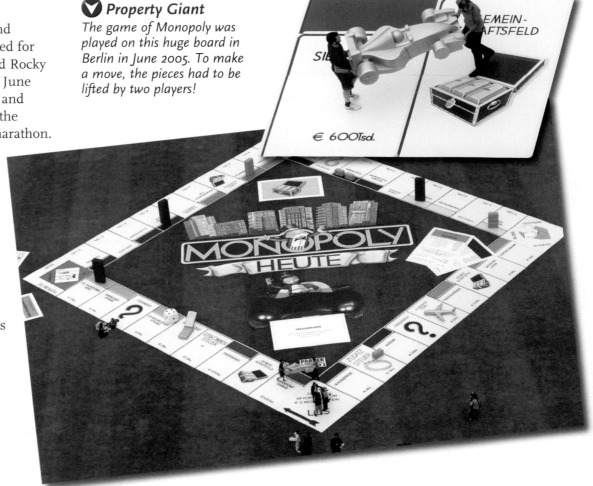

VicTory To ReLish

FOR THE FIFTH straight year, it was a moment for Takeru Kobayashi to relish when he consumed 49 hot dogs in just 12 minutes!

In 2005, the 27-year-old speed eater from Nagano, Japan, retained his crown at Nathan's Famous Fourth of July International Hot Dog Eating Contest at Coney Island, New York. Kobayashi, who stands 5 ft 7 in (1.7 m) tall and weighs just 144 lb (65 kg), beat runner-up Sonya Thomas of Alexandria, Virginia, by 12 hot dogs, enabling the coveted Mustard Yellow Belt to return to Japan for the ninth year out of the past ten. Kobayashi's personal best is a staggering $53\frac{1}{2}$ hot dogs in 12 minutes!

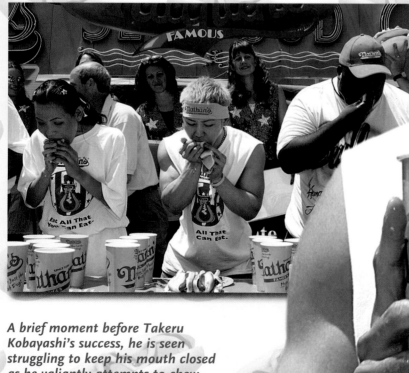

A brief moment before Takeru Kobayashi's success, he is seen struggling to keep his mouth closed as he valiantly attempts to chew and swallow his 49th hot dog.

Nailed Down

Lee Graber of Tallmadge, Ohio, was sandwiched between two beds of nails with a weight of 1,659 lb (752.5 kg) pressing on top of him for 10 seconds in June 2000. The weight was lowered into position by a crane.

Tree Planter

Ken Chaplin planted 15,170 trees in a single day near Prince Albert, Saskatchewan, on June 30, 2001.

Highly Strung

In June 2000, a team of 11 students from the Academy of Science and Technology at Woodlands, Texas, and their physics teacher, Scott Rippetoe, unveiled a fully playable Flying V guitar that measured 43 ft 7½ in (13.2 m) long and 16ft 5½ in (5 m) wide. It weighed 2,244 lb (1,018 kg) and used strings that were 8 in (20 cm) thick and 25 ft (7.6 m) in length.

▼ Danny's Way

Daredevil American skateboarder Danny Way created history in 2005 by clearing the Great Wall of China without motorized assistance. He hurtled down a 120-ft (36.5-m) specially constructed vertical ramp at a speed of approximately 50 mph (80 km/h) and leapt a 61-ft (19-m) gap to land safely on a ramp erected on the other side of the wall. The 31-year-old from Encinitas, California, spent eight months planning the two-second jump.

Mime Master

Bulgarian mime artist Alexander Iliev performed a 24-hour mime in July 2001 at the Golden Sands resort near Varna, Bulgaria, pausing for only a one-minute break every hour. His marathon effort featured more than 400 different pantomime pieces and saw him cover around 140 mi (225 km) on stage.

> **Jai Narain Bhati**, a barber from *Bhopal*, India, cut the hair of 1,451 people over a **108-hour** period in January 2002. His only breaks were for 10 minutes every hour.

Toga Parade

In August 2003, in the town of Cottage Grove, Oregon, 2,166 people dressed in togas paraded down Main Street re-enacting the parade scene from the movie *National Lampoon's Animal House*, which had been filmed in the town in 1977.

Maggot Bath

Christine Martin of Horsham, England, sat in a bathtub of maggots for 1 hour 30 minutes in 2002.

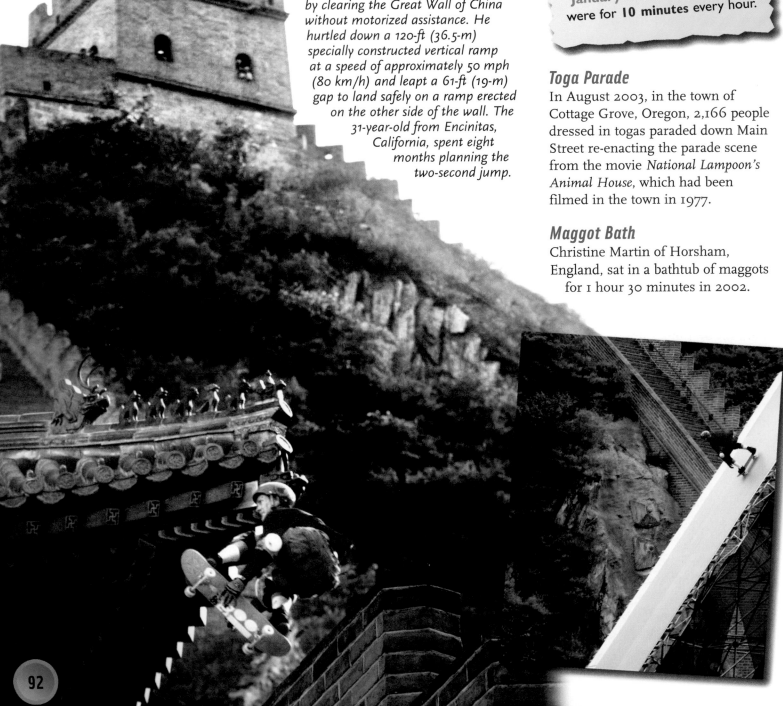

Brick It Up
Terry Cole balances 75 bricks weighing a staggering 328 lb (148.8 kg) on his head. Among other things, he has also carried a single brick held downward for 72 mi (116 km) and balanced 16 bricks on his chin!

Dog Tired
Andrew Larkey tried to walk 19 dogs simultaneously in Sydney, Australia, in May 2005. He began by being pulled in 19 directions before controlling 11 of the dogs single-handedly over the ⅔-mi (1-km) walk.

Coffin Ordeal
In May 2005 in Louisville, Kentucky, escapologist Aron Houdini (his legal name) spent an amazing 79 minutes inside a sealed coffin with no air. He was handcuffed, leg-cuffed, and chained inside the coffin. "I freaked out at first," admitted Houdini, who was able to communicate with his crew by way of a radio from inside the wooden box. "However, once I got my mind under control, I started what I had been practicing for almost a year. I slowed my metabolism down and then I concentrated on resting."

Stone Skipper
For years the leading exponent of the art of skipping a stone across the water was an American called Jerdone Coleman-McGhee. In 1994, he achieved 38 skips from a bridge on the Blanco River in Texas.

Wurst is Best
In June 2005, 80 cooks from Leipzig, Germany, created a sausage that was 108 ft (33 m) long and required 294 broilers (grills) to cook it. The attempt to broil the sausage had to be called off when gusts of wind scattered the burning charcoal.

Eye-watering
Brian Duffield from Newent, U.K., chewed and consumed a whole onion weighing 7.5 oz (212 g) in 1 minute 32 seconds. He said: "The hardest thing is actually swallowing it. You just have to get it down." A keen gardener, Brian grows his own onions and uses them for practice.

Group Hug
In April 2004, a staggering total of 5,117 students, staff, and friends from St. Matthew Catholic High School, Orleans, Ontario, joined forces—and arms!—to have an enormous group hug.

Tightrope Crossing

Age was no bar to American acrobat, balloonist, and tightrope-walker William Ivy Baldwin. During his lifetime, he made 87 tightrope crossings of the South Boulder Canyon, Colorado—the first when he was 14 and the last on July 31, 1948, his 82nd birthday! The wire was 320 ft (97.5 m) long and the drop was a terrifying 125 ft (38 m).

> Believe it or not, in **May 2004**, **927 students** and **staff** at Taylor University, Indiana, **leaped** over each other in a mammoth exhibition of **leapfrogging!**

Handcycle Tour

In 2005, paraplegic Andreas Dagelet set out from Coochiemudlo Island, Brisbane, to circumnavigate Australia on a handcycle—a sort of bicycle that is powered by arms and hands instead of legs and feet. The entire journey measured approximately 10,600 mi (17,000 km).

Self-taught Cowboy

There aren't too many cowboys in Maryland, but Andy Rotz is an exception. The self-taught cowboy from Hagerstown—who learned his art from watching John Wayne and Clint Eastwood movies—can do over 11,000 Texas skips, a maneuver that entails whipping a vertical loop of rope from side to side while jumping through the middle. He had to keep the rope spinning for 3 hours 10 minutes and perform a skip roughly every second.

Chorus Line

In 2005, 15,785 workers in Tangshan City, China, all sang "Workers are Strong" simultaneously.

Aerial Wedding

Nobody in the world has done more skydives than Don Kellner. Don from Hazleton, Pennsylvania, has over 36,000 skydives to his name and his wife Darlene is no slouch either, having made around 13,000. Naturally enough, their wedding in 1990 was conducted in mid-air, the ceremony being performed by fellow skydiver, the Rev. Dave Sangley.

Inside Job

In April 2005, a British couple drove the length of Europe without getting out of their car. Dr. James Shippen and Barbara May, from Bromsgrove, England, made the 2,000-mi (3,200-km) journey from John O'Groats, on the northern coast of Scotland, to the southern tip of Italy to demonstrate their invention, the Indipod, an in-car toilet.

▶ Baby Bike

Bobby Hunt (aka Circus Boy) reckons he has spent over $1,500 on building and fixing his bike—and it's only 3 in (7.6 cm) long, axel to axel, and 7³/₄ in (20 cm) tall. The bike's size might be a problem, but Bobby rides it with ease, and can even perform wheelies.

Open Wide

Jim Mouth, 51, is a comedy entertainer based in Las Vegas who has been performing incredible stunts for more than 20 years. These often involve putting absolutely *anything* in his mouth!

When did you get started—and why do you keep going?

❝My first stunt, when I was about 29, was playing drums for two weeks non stop. I had to drink lots of coffee to stay awake! I'm 51 now, and my comedy shows are more of a full-time thing, but my biggest drive is to use stunts to raise money for charity.❞

What is your most famous stunt?

❝I like doing the "most cigarettes in the mouth" stunt. I'm up to 159 cigarettes now. I've performed this on TV many times. I put all the cigarettes in apart from one which the host of the show puts in. Then they light them with two propane torches, I cough and wheeze for about three minutes, then spit them out. I'm dizzy for about half an hour afterwards. One time I coughed out about 100 cigarettes—the crazy thing is I'm actually a non-smoker. I've actually done this stunt on non-smoking days to support people giving up cigarettes.❞

Do you have a special technique?

❝Before a stunt I wedge corks into my mouth to stretch my lips, but my real secret is that I can dislocate my jaw. I didn't know I was doing it until they X-rayed me on a TV show last year. All I knew was that it was painful and made my eyes water!❞

What other stunts do you do?

❝Mouth stunts include smoking 41 cigars at once, and 41 pipes. We once had a whole band playing music under the water in a pool, and another time I sat on every seat in the University of Michigan football stadium, the biggest in the United States. There were 101,701 seats—it took me 96 hours and 12 minutes, and four pairs of pants!❞

How dangerous are your stunts?

❝Apparently when my jaw dislocates it rests on my larynx, which could suffocate me. No one will insure me!❞

Is there anything you would not do?

❝Because I play drums I really don't want to break a finger or an arm. But I will put up with anything in my mouth—I might try keeping a tarantula spider in my mouth for half an hour.❞

How long will you carry on?

❝My goal is to do one stunt every year for at least the next ten years. One I've got in the pipeline is "most hats on the head"—I'm aiming for a stack of 300, which will be about 8½ ft tall and weigh about 110 lb. I'll probably retire when I'm in my sixties—I'll do 170 cigarettes and then call it a day.❞

Climbing High

★ Czech climber Martin Tlusty survived a terrifying 1,000-ft (305-m) fall down the side of a mountain in Slovakia in 2005.

★ Swiss authorities wrap some mountain glaciers with aluminum foil in the summertime to stop them from melting.

★ Frenchman Christian Taillefer cycled down a glacier at 132 mph (212 km/h) in Vars, France, in 1998.

★ When Mount St. Helens in Washington State, the highest peak in the U.S.A., erupted spectacularly in 1980, the avalanche on the north slope reached incredible speeds of 250 mph (400 km/h).

Rocketman
Texan Eric Scott took to the skies in England in April 2004, rocketing upward to 152 ft (46 m)—the height of a 12-storey building. Eric remained airborne for 26 seconds. His "rocketbelt" was mounted on a fiberglass corset with two rocket nozzles and a belt that had basic controls for steering.

Biker Duo
American couple Chris and Erin Ratay covered 101,322 mi (163,058 km) on separate motorcycles during a journey that took them through 50 countries on six different continents. They set off from Morocco in May 1999 and arrived home in New York in August 2003.

Lengthy Lecture
Errol Muzawazi, a 20-year-old lecturer from Zimbabwe, delivered a lecture lasting for 88 hours in 2005, talking nonstop for more than three days. His audience at Jagellonian University in Krakow, Poland, fell asleep!

Internet Marathon
In November 1997, Canada's Daniel Messier spent 103 hours nonstop surfing the internet—that's more than four days!

Giant Noodle
Believe it or not, participants at Canada's Corso Italia Toronto Fiesta in 2003 created a spaghetti noodle that was an amazing 525 ft (160 m) long.

Sore Hands
Peter Schoenfeld of Ontario, Canada, chopped 209 wooden blocks by hand in just two minutes in October 2001.

Making Whoopee
In July 2005, following a baseball game in Bowie, Maryland, an incredible 4,439 Bowie Baysox fans sat on whoopee cushions simultaneously to create a gargantuan flatulence sound!

Quick Solution

If you need help with math, ask Gert Mittring. The 38-year-old needed just 11.8 seconds to calculate the 13th root of a 100-digit number in his head during a special challenge near Frankfurt, Germany, in 2004. He even solved the problem faster than onlookers with electric calculators.

In Flight

Australian professional golfer Stuart Appleby drives off on one of the runways at Sydney Airport, Australia, on November 22, 2004. Appleby was competing against fellow golfers in a golf driving distance contest, which he won with a massive shot that reached an incredible distance of 2,069 ft 3 in (630.58 m)— over one-third of a mile.

On a Sydney Airport runway, Appleby makes his golf ball fly.

Sundae Best

On July 24, 1988, a giant ice-cream sundae was made by Palm Dairies of Alberta, Canada. It featured an amazing 44,689 lb (20,270 kg) of ice cream, 9,688 lb 2 oz (4,394 kg) of syrup, and 537 lb 3 oz (244 kg) of toppings!

Balancing Act

At the age of 12, Tim Johnston, of Piedmont, California, balanced 15 spoons on his face for 30 seconds in May 2004.

Corset Cathie

Cathie Jung, now aged 68, has been wearing a corset, even when asleep, for over 20 years. At 5 ft 6 in (1.68 m) tall and weighing 135 lb (61 kg), her waist measures a tiny 15 in (38 cm). The only time Cathie removes the corset is when she showers. Cathie's corset training started with a 26-in (66-cm) corset in 1983 when she had a 28-in (71-cm) waist. She gradually reduced the size of the corsets as they became comfortable.

Freestyle Rap

Toronto rapper D.O. performed a freestyle rap that went on for 8 hours 45 minutes in July 2003.

In what was an enormous gathering of Christmas carolers, **519** hardy souls braved the **New York** cold for a mass sing-along on the steps of **Manhattan's General Post Office** in December 2003.

Having a Ball

David Ogron has a ball every day of his life. In fact, in an average year he has 400,000 balls. The Californian hit on his unusual career some years ago when he was practicing with friends on the golf range. "We were seeing who could hit the ball the fastest. That's when I realized I had a talent." With the help of ball-setter Scott "Speedy" McKinney, who puts each ball on the tee, Ogron hit 1,388 balls in 30 minutes in May 2005 at Louisville, Kentucky. And in July 2005, he hit 82 in one minute in Miami. On another occasion, he hit 10,392 balls in 24 hours.

BLIZZARD IS AN EXTREMELY rare 8-ft (2.4-m) adult albino alligator. Although a vicious predator, he's also very vulnerable. His white skin, the result of a total lack of pigment in his body, leaves him very susceptible to sunburn. Because of this he was kept under cover in a specially designed tent while at the Maritime Aquarium in South Norwalk, Connecticut.

AMAZING

A herd of miniature
pigs compete in the
Pig Olympics
page 121

Miniature horses, 24 in
(61 cm) tall, wearing sneakers
and warm blankets were spotted
in a busy shopping mall
page 123

Bruce, an Oranda goldfish,
measures a staggering 17.129 in
(43.507 cm) from snout to tail fin
page 124

ANIMALS

WEB OF INTRIGUE

INSTEAD OF USING traditional canvases, Enrique Ramos of Mexico City, known as "The Fly Guy," creates tiny portraits of famous people on flies, feathers, beans, animal bones, and even bats!

Without the help of any kind of magnification, Ramos has handpainted Da Vinci's "Mona Lisa" on a bird feather, a bean, and a stuffed bat. Often his pictures take under two minutes. He has even painted seven faces on a single human hair!

Sometimes Ramos uses no paint at all. He made a portrait of The Beatles from more than 60 dung beetles and hundreds of butterfly wings, and a bust of Abraham Lincoln from the hair of his son and daughter.

Ramos likes to paint subjects on real cobwebs too. He is unable to correct mistakes and also considers himself lucky if one-third of the gathered webs survive to form one of his cobweb paintings.

George Washington, Marlon Brando, "The Lighthouse Man," and Alfred Hitchcock painted on quails' eggs, measuring only 1 in (2.5 cm) high.

ACTUAL SIZE!

This bat was created to celebrate Halloween and the Mexican Day of the Dead festival and depicts Bela Lugosi as Dracula, and Lon Chaney as the Wolfman.

These butterflies are part of a 35-piece Mexican history series. The first shows the Spanish conquistador, Hernando Cortez, and the second depicts the tragic Aztec-Mayan love story of Popoca and Miztla.

To gather enough spiderweb for his re-creation of "The Last Supper," Ramos spent two weeks scouring the most remote areas of Mexico with the help of his family. In an old abandoned village he came across thousands of spiderwebs, and managed to gather the 22 lb (10 kg) needed for his picture. After carefully removing all living creatures from a web, Ramos placed it in a bucket of soapy water to clean it, before flattening it by placing it on a plastic canvas on the ground and wringing out the water with his hands and feet. As the web dried, it began to take shape with Ramos gently massaging it to stretch it as thinly as possible. Within a day the web had dried completely and was ready for use.

A depiction of Spiderman—one of Ramos's most recent works—is made from nearly 20 lb (9 kg) of large wolf spiderwebs, and stands over 2 ft (60 cm) in height.

This miniature painting of Moses kneeling before the burning bush, painted on spiderweb, measures 2 x 1 in (5 x 2.5 cm) and was done without the use of magnification.

Nation in Mourning
China went into mourning for Mei Mei, the world's oldest captive giant panda, raised at Guilin Zoo. She died in July 2005 at the age of 36. An elaborate funeral was held during which visitors filed past, paying their respects to the much-loved animal.

Golf-ball Guzzler
Doctors in England removed 28 golf balls from the stomach of a German shepherd who frequently takes walks along a golf course with his owner.

Vanishing Act
Seven years after mysteriously disappearing, Ewok, a nine-year-old Shih Tzu, suddenly returned to Crofton, British Columbia, home of Jim and Barbara Reed in 2001.

Barking Math
Alissa Nelson of Urbandale, Iowa, has a mongrel named Oscar who can do math addition problems. He answers a variety of mathematical sums by barking. For example, when asked the sum of two and two, he responds with four barks.

The Yap of Luxury
Dudley's bakery is a dog's dream come true. Created by Vickie Emmanuele, the bakery offers specially made fancy gourmet treats and dog cakes.

Duck Dialects
It sounds quackers, but an English scientist has discovered that ducks have regional accents. Ducks in London are noisier than those in rural Cornwall as they have to raise their voices to compete with traffic.

Canine Candidate

In a bid to add color to the 2002 French presidential campaign, and to warn politicians against complacency, Serge Scotto tried to enter the name of his dog Saucisse as a rival candidate. But despite picking up over four per cent of the vote in municipal elections in Marseille, Saucisse failed to obtain the necessary backing to oppose Jacques Chirac in the final stages of the presidential election.

Expert Witness

A police dog took the stand in a Pittsburgh, Pennsylvania, courtroom in 1994. The defense attorney tried to prove that the dog, not his client, was the aggressor in a fight.

Punch-drunk

A black bear in Baker Lake, Washington, was found passed out on a resort lawn. He got that way after stealing and drinking 36 cans of campers' beer!

Gone in a Flash

A single lightning strike on a farm in northern Israel killed an incredible 10,000 chickens.

High Marking

Giant pandas mark their territory by performing a handstand and urinating as high as possible up the side of a tree!

◀ Frog Festival

A live frog is dressed in lavish finery as a "King" for a competition during the frog festival in the city of San Fernando in the Philippines.

Lost and Found

A dog that had been reported missing from his home in Columbus, Ohio, in 2002 turned up inside a 10-ft (3-m) long python that was found lurking under a neighbor's house. The neighbor called the police when she spotted the large snake with an ominous bulge in its middle.

Holy Cat

Mike McGregor, from Edinburgh, Scotland, had never spotted anything unusual about the markings of his pet cat Brandy, until he saw Christ's face, just as it appears on the Turin Shroud, staring out at him. He said: "It's not every day that you see the face of Jesus in your cat's fur."

Cow Hide

It takes an incredible 3,000 cows to supply the National Football League with enough leather for just one season's worth of footballs!

Inheritance Kitty

In the 1960s, San Diego doctor William Grier left his entire fortune of $415,000 to his two 15-year-old cats, Brownie and Hellcat.

Survived Fall

Andy, a cat owned by Florida senator Ken Myer, fell 16 floors (200 ft/61 m) from a building in the 1970s—and survived!

First-class Hamster

Emptying a mail box in Cambridge, England, one day, mailman Robert Maher was stunned to see a hamster peeping out from an envelope marked "Do Not Bend." He took it to veterinary surgeon Patrick von Heimendahl, who said that the animal—nicknamed First Class—was lucky to be alive. The hamster, thought to be about a year old, had miraculously survived a journey through the postal system.

First Class emerges from his envelope unscathed.

Unusual Passenger

When a man rides a bike, it's nothing special, but when a dog rides a man who rides a bike, that is special! The dog is Spike, a Jack Russell terrier, who can be seen perched on the shoulders of his owner, Denton Walthall, as the latter cycles around the streets of Henrico, Virginia. Mr. Walthall explained how the unusual pose started: "One day I was calling him and he came running at a fast pace. I was squatting down to catch him but he flew up, landed on my leg and then scrambled up on my shoulder. And he was at home. Sometimes I try to get him down, but he simply positions himself further on my back so that he can stay there."

Central Heating

This amazing X ray of a snake clearly shows the electric heating pad that the snake has swallowed!

Human Zoo

In August 2005, visitors to England's London Zoo were in for a big surprise at the bear enclosure. Instead of black bears, prowling around on the rocky landscape were eight human beings wearing little more than fig leaves. The volunteers spent three days on Bear Mountain, entertaining themselves with games and music. The zoo explained that the exhibition was designed to show the basic nature of humans.

Cattle Wedding

In July 2005, a pair of dwarf Brahman cattle were married in a lavish Thai wedding ceremony. Krachang Kanokprasert, the owner of the bull, originally wanted to buy the bride, but when her owner refused to sell, the two farmers agreed to join the miniature breeding stock in matrimony.

Mighty Plunge

Sam, a German shepherd with California's Lodi Police Department, jumped 50 ft (15 m) into a river from a bridge while pursuing a suspect in 2001. Once in the water, Sam swam after the suspect and proceeded to herd him to his human colleagues on the bank.

An **ant colony** built beneath **Melbourne**, Australia, in 2004 measured a **staggering 60 mi** (97 km) wide. The **ARGENTINE** ants formed a giant **supercolony** as a result of co-operative behavior.

Great Escape

Who let the dogs out? That's exactly what staff at Battersea Dogs' Home in London, England, wanted to know.

In 2004, several mornings in a row, staff arrived at Battersea Dogs' Home to find that as many as nine dogs had escaped from their compounds and were causing chaos in the kitchen. In a bid to solve the mystery of how the dogs managed to get free, the dogs' home installed video surveillance cameras. These revealed that a three-year-old Lurcher called Red had learned how not only to unbolt his own kennel door using his nose and teeth, but also how to to free his fellow hounds to join in the adventure, helping themselves to food in the kitchen.

Having studied how staff moved the bolt to unlock the kennel door, Red the Lurcher used his teeth to do the same.

Red (right) and his friends make good their escape, heading toward the kitchen to forage for food.

Scary Creepy Crawly
This enormous cockroach is an amazing 3 in (80 mm) long and weighs 1¼ oz (35 g). Found in Brisbane, Australia, in 1997, it now holds permanent residence at the Queensland Museum.

ACTUAL SIZE!

Green Bears
In 2004, the usually white coats of Sheba and her son Inuka, Singapore Zoo's two polar bears, turned green! The color change was caused by harmless algae growing in the bears' hollow hair shafts, and was the result of Singapore's tropical climate. Both bears were successfully bleached with hydrogen peroxide.

Large Litter
Tia, a Neopolitan blue mastiff from the village of Manea in the U.K., gave birth to an amazing 24 puppies in January 2005. Four puppies died shortly after birth, but the remaining 20 were more than a handful—the puppies had to be bottle-fed every four hours! Fully grown the dogs will stand 2 ft (0.6 m) high.

Walking Octopus
Scientists in California have discovered an octopus that appears to walk on two legs! A species of the tiny tropical octopus has developed a technique whereby it wraps itself up into a ball and then releases just two of its eight tentacles so that it can "walk" backward along the ocean floor.

Crazy Gator
An albino alligator at Blank Park Zoo in Des Moines, Iowa, turned pink when it became excited!

Rooster Booster
Melvin the giant rooster just can't stop growing. At 18 months old, he stood 2 ft (60 cm) tall and weighed more than 15 lb (6.8 kg), twice as much as other Buff Orpingtons. His owner, Jeremy Goldsmith of Stansted, U.K., said: "We're staggered. No one's heard of a cockerel this big."

Toad Marriage
A female toad is painted with vermilion during a traditional Hindu wedding ceremony between two giant toads at Khochakandar, India. The ceremony was held by villagers in the hope that the raingods would end a dry spell.

Mixed Parentage
Nikita the foal earned her stripes soon after her birth in Morgenzon, South Africa, in 2004. Her mother, Linda, was a Shetland pony and her father, Jonny, was a zebra!

Animal Crackers

★ A giraffe has the same number of bones in its neck as a human.

★ When feeding, an anteater sticks its tongue in and out up to 160 times a minute and can eat 30,000 ants a day.

★ The mouth of a hyena is so tough that it can chew a glass bottle without cutting itself.

Happy Shopper
We've all heard of dogs that fetch newspapers or slippers. Well, J.C., a golden retriever from Penn Hills, Pennsylvania, goes a step further. He regularly fetches prescriptions for his owners, Chuck and Betty Pusateri, from a nearby drugstore.

Well-groomed
A Denton, Texas, firm called Groom Doggy offers tuxedos, bow ties, and wedding dresses for our canine friends. In fact the company has everything a dog could ever want to fulfill its formal-wear needs.

▶ My Little Pony
Even miniature horses expect to reach a height of 3 ft (1 m) or more, but Peanut, the miniature dwarf stallion, stands just 20 in (50 cm) tall. He owes his diminutive stature to his mother, who was only 26 in (66 cm) tall.

Flying Dog
Star of the 2002 Great American Mutt Show, held in Central Park, New York, was Rhoadi, a small brown dog who flew through the air on a bungee cord, reaching heights of over 6 ft (2 m). Another contest at the show, which was open to only mongrels and strays, was for the dog that was the best kisser!

Sniffer Rat
Gambian giant pouch rats are used to sniff out deadly landmines in Mozambique. The rats are trained to associate the smell of explosives with a food reward and indicate the potential danger to their handlers by frantically scratching the earth.

Muddy Swim
For his act "Becoming Earthworm," performance artist Paul Hurley of the U.K. spent nine days in the mud and rain wearing only swimming trunks and goggles.

Big Mouth
The North American opossum can open its mouth wider than 90 degrees when trying to scare away an attacker.

Flying Snake
Believe it or not, there is a snake that flies! The little-known U.S. Navajo flying snake has lateral wing-like membranes running down its body, enabling it to glide through the air.

Two-nosed Dog
There is a rare breed of dog in the Amazon basin that has two noses. The double-nosed Andean tiger hound was first described a century ago but, in 2005, an expedition led by British adventurer John Blashford-Snell came nose to noses with a specimen. Not surprisingly, the dogs are valued for their excellent sense of smell, which they use to hunt jaguars that prey on villagers' cattle.

back to the archives

MATHEMATICAL GENIUS!
Clever Hans, a horse, lived during the early 1900s. His owner, a math professor named Wilhelm von Osten, taught him how to solve math problems by stomping his feet to count out numbers.

WOOLLY COAT
In 1932, an Angora goat, 30 in (76 cm) tall, owned by Lester Pierce of Eureka, California, had hair 5 ft (1.5 m) long!

TREE-CLIMBER
Ted, a four-year-old terrier, could climb 10 ft (3 m) up a tree and retrieve his ball. He was owned by Bill Vandever from Tulsa, Oklahoma.

STRETCHY
This dog, owned by Pat Murphy, had skin that stretched at least 18 in (46 cm) in any direction.

FROG-LIFTER
Bill Steed, professor of Frog Psychology at Croaker College, Emeryville, California, trained frogs to lift barbells.

INDIAN MARKING
This horse, owned by J.F. Daniel and R.L. Anderson of Craigsville, Virginia, had a marking on its neck in the shape of an American Indian head.

HAIRY HORSE
An extraordinary horse from California had a 14-ft (4.3-m) mane and 13-ft (4-m) tail.

BEE BEARD
When Fred Wilcutt of Falkville, Alabama, captured a queen bee and placed it under his chin, the colony of bees arranged itself around his neck like a beard.

Looking Back

October 2, 1930 Buddy, a cat from Roxbury, Massachusetts, ate corn and carrots, and drank tea and coffee. **October 24, 1935** Little **Margaret Rigon** of Corozal, Panama, aged 2½, chewed the head off a deadly coral snake but was unharmed. **March 20, 1946 A milkmaid** discovered that a cow had swallowed a watch when she heard the watch ticking.

Winged Wizards

★ A North American osprey once built a nest that consisted of three shirts, a bath towel, an arrow, and a garden rake.

★ The wandering albatross can glide for six days without beating its wings and can even sleep in mid-air.

★ An African gray parrot named Prudie had a vocabulary of almost 800 words.

★ When awake, hummingbirds have to eat almost constantly to prevent themselves from starving to death.

Regular Customer

One of the best customers at The Chocolate Moose restaurant in Farmland, Indiana, is Missy Jo, a 60-lb (27-kg) bulldog. Even though she never actually sets foot inside the place, Missy Jo sits outside on the patio with owner Tony Mills for a daily treat of plain cheeseburgers and vanilla milkshakes!

▶ Bamboo Cast

Malai, a 98-year-old female elephant in Thailand, broke her leg in June 2005. Her trainers put a bamboo splint on her front leg in the hope that she would fully recover.

Diving Pig

Meet Miss Piggy, the amazing diving pig! Miss Piggy jumped into the record books in July 2005 when she dived 11 ft (3.3 m) into a pool from a platform 16 ft (5 m) high at Australia's Royal Darwin Show. Owner Tom Vandeleur, who had been training Miss Piggy for a month leading up to the show, said: "She does everything herself. She goes up the 16-ft (5-m) ramp herself, she dives herself."

Marcy Poplett of **PEORIA**, **Illinois**, was injured and knocked off a personal watercraft on the **Illinois River** after a **silver carp** leaped out of the water and smacked her in the face!

Legal Rooster

Charged with raising poultry without a permit, David Ashley appeared in court in Seneca Falls, New York, carrying a rooster. When the judge ordered the bird to be removed, Ashley replied that it was his attorney!

◀ Ugliest Dog

In June 2005, a 14-year-old Chinese crested pedigree dog named Sam, won the title that no dog wants—World's Ugliest Dog. And this was the third year running that Sam had won the title. Until his death in November 2005, Sam was famous for his ugliness. He was pale-eyed, wrinkled, had a withered neck, and appeared to have almost no hair.

Dual-sex Crab

In May 2005, a fisherman caught a blue crab in Chesapeake Bay, Virginia, that was female on one side and male on the other. Females have red-tipped claws, while males have blue—but this crab had one of each. Experts at the Virginia Institute of Marine Science said the crab was an extremely rare creature called a bilateral gynandromorph, meaning it is split between two genders. They said that the crab's condition probably resulted from a chromosomal mishap shortly after its conception.

Snapped Back

Cooper, a five-year-old golden retriever, managed to fight off a 14 ft (4.3 m), 700 lb (318 kg) alligator in a canal near Lake Moultrie, South Carolina, in June 2005. The dog was swimming across the canal when the reptile—three times Cooper's size—pounced. Cooper lost a few teeth and some skin, but the alligator retreated after being bitten repeatedly on the snout. Cooper's owner, Tom Kierspe, said afterward: "We've changed the dog's name to Lucky."

IN DEPTH
Still Life

Californian taxidermist Tia Resleure, 47, stuffs animals to create fairytale worlds where pigeons wear ball gowns, chickens tell fortunes—and even kittens are framed!

How did you get the idea to create art from dead animals?

❝As a child I felt closer to our pets and farm animals than to my own family. I read 'Alice in Wonderland' and wanted to morph into an animal. I inherited my grandfather's collection of taxidermy from Australia, where he grew up, and my father was always picking up bones—he once made a headdress out of a zebra head.❞

How did you learn how to create the animal art?

❝I started using animal remains in my sculptures in the early eighties, but in 1998 I went on a two-week taxidermy course just to see if I had the nerve to work with fresh specimens.❞

What was the first piece you ever did, and do you have a favorite now?

❝On that course, I did the Mallard on a Circus Ball and the Fortune Telling Chicken. The director of the school mocked me and said it was unnatural. I didn't think there was anything natural about a conventional duck flying against a piece of driftwood! My favorite piece is 'Little Shrill Voices,' which uses fetal kittens from a cat that had to undergo an emergency pregnancy spay.❞

What inspires your work?

❝Old European curiosity cabinets, and French, German, and Russian fairy tales. When I'm working on my pieces, I imagine little stories for them.❞

Where do you get the animals you use?

❝Because of my work in the animal welfare community, I have a lot of contacts with hobby and livestock breeders. Nothing is killed for my work—I just recycle animals that have already died.❞

Have you ever taxidermied your own pets?

❝Yes. Part of the process of dealing with the loss of my pets is doing something with their remains. The first one I did was my first Italian greyhound, Aissi. I had to keep her in the freezer for about three years before I could start. The first time I pulled her out of the bag to let her thaw, my heart just clenched up. But then it all just went away and became very peaceful.❞

Do you have a future project you'd love to do?

❝I have a huge old doll's house that I want to fill with animals. I want to fill the lowest level with moles, then ground-level animals on the next floor up, and little birds in the attic.❞

Fishy Kiss

In 1998, Dan Heath of Medford, Oregon, could barely believe his eyes when he saw Chino, his golden retriever, standing over a fishpond, nose to nose with Falstaff, an orange-and-black carp. Each day, Chino sprints out to the backyard, peers into the water and waits. Within seconds, Falstaff pops up and the two gently touch noses. Heath doesn't know how or why Chino and Falstaff became friends, but it's obvious to everyone that their friendship is watertight.

Resourceful Hamster

Two house moves and some years after thinking they had lost their pet hamster, the Cummins family, from Edmonton, Alberta, were amazed when it reappeared. It turned out that the hamster had never actually left home but had burrowed into the sofa, using it as a nest. The animal had survived by sneaking out at night and taking food and water from the bowls of the family's other pets.

▽ Swimming for Deer Life!

At a wildlife refuge in Georgia, Rangers saw a 13-ft (4-m) alligator that had attacked an adult deer and carried it off, swimming with the animal in its mouth!

Cat on a Hot Tin Roof

Torri Hutchinson was driving along the highway near Inkom, Idaho, in 2005 when a fellow motorist alerted her to the fact that her cat was on the car roof. Hutchinson, Torri's orange tabby, had been clinging to the roof for 10 mi (16 km). Torri hadn't even noticed the cat when she stopped for gas!

Jumbo Artist

The biggest draw at Taman Safari Park in Bogor, Indonesia, is Windi the artistic elephant. By holding on to the brush with her trunk, she dabs the paint on the canvas to form her own forest of colors. In her first six months at the park, the 18-year-old female created 50 paintings, many of which sold at over 20,000 Indonesian rupiahs ($2) each. Others were exhibited outside the park's restaurant.

Bear's Breath

In May 2005, vets at Seneca Park Zoo, Rochester, New York, used a hammer and chisel to remove an infected tooth from the mouth of an 805-lb (350-kg) polar bear named Yukon. The tooth had been giving the bear bad breath.

Invisible Bears

Polar bears are so well insulated they are almost invisible to infrared cameras.

Five-legged Dog

Believe it or not, a five-legged dog was found near a state park near Raleigh, North Carolina, in November 2003. Although it was previously unheard of for such an animal to live much past birth, this dog—a Maltese–terrier mix named Popcorn—was at least nine months old. A vet removed the extra leg because it was hampering the dog's movement, as well as another rear leg that rotated at a 90-degree angle, making it useless. The dog with five legs became a dog with only three.

A talented *tabby cat* named **Bud D. Holly**, who lived with **SHARON FLOOD** at her art gallery in Mendocino, California, had a **number of his paintings exhibited** in 1992. **Twenty** of the works, created with **paws** and watercolors, were sold, some fetching over **$100**.

Kiss of Life

When one of Eugene Safken's young chickens appeared to have drowned in a tub in 2005, the Colorado farmer saved the bird by giving it mouth-to-beak resuscitation! After swinging the chicken by the feet in an attempt to revive it, he blew into its beak until the bird began to chirp. The farmer said: "I started yelling, 'You're too young to die!' And every time I'd yell, he'd chirp."

Déjà Vu

A Canadian sailor and his dog were rescued from the same island twice in a week in May 2002. Melvin Cote was hoping to spend the summer in the Queen Charlotte Islands, British Columbia, but severe weather capsized his boat. After the rescue, Cote and his dog sailed back to the shipwreck to salvage their things, but sank again in the same spot!

 More than a Mouthful
Auggie was a dog who liked to do tricks with tennis balls. His owner Lauren Miller demonstrated his trick of picking up five tennis balls in his mouth at the same time!

Buried Alive

Thoughtful elephants in Kenya frequently bury sleeping hunters under leaves and piles of branches, thinking that the humans are dead.

Deadly Struggle

A 73-year-old Kenyan grandfather reached into the mouth of an attacking leopard and tore out its tongue to kill it. Farmer Daniel M'Mburugu was tending to his crops near Mount Kenya in June 2005 when the leopard leaped on him from long grass. As the leopard mauled him, M'Mburugu thrust his fist down the animal's throat and gradually managed to pull out its tongue, leaving the beast in its death throes. Hearing the screams, a neighbor soon arrived to finish the leopard off.

Cat Call

After receiving an emergency call, police smashed down the door of a house in Auckland, New Zealand, in 2005—only to find that the call had been made by the homeowner's cat! The cat, named Tabby, had managed to contact the police while walking across the phone.

Opportunity Knocks

A bear in Croatia has learned how to trick householders into letting him into their homes by knocking at the door. Experts think that the 490-lb (222-kg) brown bear learned the ruse while nudging at a door in an attempt to get it open.

Young and Old

A baby hippo, weighing about 660 lb (300 kg), was orphaned when the Asian tsunami in December 2004 washed away his mother. Named Owen, he has been adopted by a 120-year-old tortoise, Mzee. Owen was spotted on the coast and taken to the Haller Park in Mombasa, Kenya. There are other hippos at the Park, but on his arrival he made straight for the ancient tortoise and the pair are now inseparable! Owen often lays his head on Mzee's shell to rest when he's tired.

The young hippo affectionately nuzzles Mzee's outstretched neck.

Un-BEE-LieVaBLe

MARIN TELLEZ created a buzz around the Colombian city of Bucaramanga in September 2005 when he covered his entire body in 500,000 bees!

Wearing just a cap and shorts, and no protective chemicals, the 35-year-old beekeeper allowed the aggressive Africanized bees to swarm all over him for two whole hours.

Once the queen bee had landed on Tellez, the rest of the colony followed on behind her, guided by her scent.

Spectators were kept 30 ft (9 m) from the platform to avoid being stung, while other beekeepers stood by wearing protective suits and carrying smoke canisters in case of emergency.

Tellez explained: "I have been working with beehives for 23 years and I know how bees behave. I have to be very calm to transmit that serenity to them and to prevent them from hurting me."

He claims to have been stung so many times that his body has built up some resistance to the potentially lethal formic acid. His worst experience was being attacked by more than 150 bees when he was just 17 years old. On that occasion he saved himself by jumping into a water tank.

Once the queen bee had landed on Tellez, the other 499,999 followed, coating the beekeeper's entire body with their swarm.

Tellez claims that the key to his success was, perhaps unsurprisingly, staying very calm! The bees, he says, picked up on this, and just went about their ordinary business.

Mini Marvel

Each fall, despite weighing just 0.2 oz (6 g), the ruby-throated hummingbird propels its tiny body, only 3½ in (9 cm) long, on a nonstop 500-mi (800-km) flight from North America across the Gulf of Mexico to South America.

Lap of Luxury

Under the terms of their owner's will, Chihuahua Frankie and cats Ani and Pepe Le Pew live in a $20 million San Diego mansion while their care-giver lives in a small apartment.

▼ Birdie Two

In 2005, a pair of storks made a nest on a German golf green and filled it with stolen golf balls. The birds gathered so many balls that they built a second nest on the course, too. Amazingly, storks rarely build nests on the ground.

▶ Chickenwalk

Twenty chickens strutted their stuff on a Japanese catwalk in the latest styles for the fashion-conscious hen. A range of clothing, by Austrian designer Edgar Honetschlaeger, caters for sizes small, medium, large, extra large, and turkey.

Flight of Fancy

Pigeon-lover John Elsworth of Houston, Texas, decided to propose to his girlfriend via a message delivered by homing pigeon. But the bird got lost and took the note instead to the home of Rita Williams. Rita invited John over and they fell in love and got married.

A Lot of Lobster

At the Weathervane Restaurant lobster-eating competition in 2004, Barry Giddings of Chester, Vermont, devoured 19 lobsters in 35 minutes!

Monkey Business

U.S. showbiz chimp Mr. Jiggs (who was actually female) was not everybody's favorite ape. On her way to entertain at a Scout jamboree, and accompanied by her trainer Ronald Winters, Mr. Jiggs walked into a bar at Freehold, New Jersey, wearing full Boy Scout's uniform. The shock caused customer Joan Hemmer to drop her drink, fall against a wall, and injure her shoulder. She sued Winters, but lost.

Remarkable Reptiles

★ North American garter snakes can give birth to as many as 100 young at a time.

★ When two-headed snakes are born, the two heads often fight each other for food.

★ To prevent indigestion. crocodiles invariably carry about 5 lb (2 kg) of pebbles in their stomach.

Frisbee Champion

Dog Ashley Whippet was such an accomplished Frisbee catcher that he was invited to appear at the 1974 World Frisbee Championships, which had previously been for humans only. Captivated by his display, the WFC devised a Catch and Fetch competition for dogs, of which Ashley became the first world champion. He performed at the Super Bowl and at the White House, and upon his death in 1985 he received a tribute in *Sports Illustrated*.

Dog Giovanni

Australian opera singer Judith Dodsworth is never short of an accompaniment—even if it is provided by her pet greyhound, Pikelet. Ms. Dodsworth says the canine virtuoso began copying her during rehearsals and hasn't stopped singing since. "As soon as I opened my mouth, he started singing. He's not bad but he's pretty loud and pretty high." And Pikelet's favorite composer? Pooch-ini, of course!

Kangaroo Bar

Boomer, an 18-month-old orphaned kangaroo, is fed peanuts by Kathy Noble, owner of the Comet Inn in Hartley Vale, Australia. In 2005, the baby kangaroo was found inside the pouch of his dead mother on the side of the road. After rearing, Boomer decided he liked the bar so much that he is now a regular visitor.

Cat Flap

When Tabitha the tabby cat escaped from her cage during a flight to California in 1994, it was the start of an unscheduled 13-day, 30,000-mi (48,300-km) trip that took in Los Angeles, Miami, Puerto Rico, and New York. Eventually, passengers reported hearing a faint mewing sound, prompting the missing pet's owner, Carol Ann Timmel, to obtain a court injunction to ground the plane at JFK Airport in New York so that officials could carry out a search. Sure enough, they found Tabitha in a ceiling panel behind the passenger compartment. Undaunted by her ordeal, the cat went on to become a national celebrity and the subject of a bestselling book.

Chasing a seagull near **Beachy Head**, **England**, in 2001 a retriever named HENRY fell over the edge of the cliff and **plunged 140 ft (43 m)** into the sea below. Owner **Louise Chavannes** thought he must be dead but was amazed to see him swimming back to shore with **merely** a broken leg. He had smashed his leg on a rock, but the water had broken his fall.

Strange Bedfellows

Rattlesnakes hibernate through winter in groups of up to 1,000. Amazingly, they often share a site with prairie dogs—their favorite prey when not in hibernation.

OPENED IN 1991, this U.K. museum forms part of Blackpool's famous Pleasure Beach Amusement Park, and features several oriental artifacts from Ripley's two New York homes. It replaced an earlier Ripley's museum in the city, which was Ripley's first overseas venture.

WEST AFRICAN
FEMALE TRIBAL COFFIN

AFRICAN FERTILITY FIGURE
Figures such as this one made in Nigeria were carved and placed in the home of hopeful parents, often under the woman's bed.

INDONESIAN DANCE MASK
Ripley traveled the Far East in the 1930s collecting many beautiful and elaborate masks.

MOCHE SKULL
A Moche Indian who lived in Peru c. 700. Victims were sacrificed to their fierce god.

DON'T MISS!

▶ Full size six-legged cow

▶ Chinese camel bone carvings

▶ Albino beaver

▶ Rice writing

▶ Two-headed deer

▶ Yap stone money (the biggest and most unusual currency in the world)

▶ Shaman's outfit decorated with toucan bird beaks

▶ Car parts robot soldier

BONE CARVING
Made from camel bone, this carving took 18 craftsmen over three months to complete.

STRAW GUITAR
A fully-working acoustic guitar made in the Caribbean.

WALTER HUDSON
Weighing 1,400 lb (635 kg) in 1987, Walter became famous for spending 27 years inside his bedroom.

STRING BALL
Taking nine years to make, this ball is 4 ft (1.2 m) in diameter and weighs over 600 lb (272 kg).

CROCODILE PUK PUK
The crocodile is feared by the New Guinea natives, but also revered as the father of all mankind.

119

◀ Litter-Kwitter
No more unpleasant messy litter trays with the Litter-Kwitter, the ingenious invention that trains household cats to use the same toilet as their owners. Three disks slide into a seat-like device that can be positioned on the toilet bowl. The red, amber, and green disks have progressively larger bowls with smaller amounts of cat litter in them to help the cats adjust to using their owner's toilet.

Milli-magic
Capuchin monkeys use an unusual natural mosquito repellent—they rub themselves with millipedes.

Friends Reunited
Seven years after going missing from her Florida home, Cheyenne the cat was reunited with owner Pamela Edwards in 2004—after being found 2,800 mi (4,500 km) away in San Francisco.

Freak Fetus
A two-headed moose fetus, which measured about 1 ft (30 cm) long, was discovered in Alaska in 2002 after the animal's mother had been shot by a hunter.

Great Survivor
Talbot, a six-month-old stray cat, wandered into a car plant at Ryton, England, in 1999, and went to sleep in the body shell of a Peugeot 206 on the assembly line. With the cat still asleep inside, the shell then went into the paint-baking oven at a temperature of 145°F (63°C)! Amazingly, he survived, although his paw pads were completely burned off and his fur was singed.

▶ Skateboarding Dog
Few sporting pets are more accomplished than Tyson the skateboarding bulldog. Tyson, from Huntington Beach, California, skates every day and is able to get on the board unaided. He runs with three paws on the tarmac and the fourth steering his skateboard. Then, as soon as he reaches a decent speed, he jumps aboard properly and skates for his life.

PiG OLymPics!

Two piglets compete in the swimming race.

IN APRIL 2005, thousands of Shanghai residents trotted out to a city park to watch a herd of miniature pigs compete in what organizers called the "Pig Olympics."

Piglets race down a track, jostling and jumping for key positions in the hurdle race.

The pigs, a midget species from Thailand, begin training soon after birth and can start performing when they are a year old. They learn to run over hurdles, jump through hoops, dive into water, and swim—in fact, these amazing sporting pigs can do almost anything... except fly.

Five-legged Frog

In August 2004, nine-year-old Cori Praska found a five-legged frog with 23 toes near Stewartville, Minnesota. Three of the frog's legs appeared normal, but the fourth had another leg as an offshoot, with its own three feet attached to it.

Healing Paws

In the 1980s, Jane Bailey of Lyme Regis, England, owned a cat named Rogan that was said to have healing powers. By "laying paws" on his patients' bodies, the cat was apparently able to cure sufferers of arthritis and back injuries. He became so famous that up to 90 people a week sought his help. His fur, which was combed daily, also possessed special properties and Jane would send parcels of it to those in need.

Long Trek

In 1923, Bobbie the collie became separated from his family on a visit to Indiana. Lost and alone, he returned to the family home in Silverton, Oregon, six months later, having walked 2,800 mi (4,500 km) across seven states!

In **Phoenix**, Arizona, the SWAT team announced plans in 2005 to train a **small monkey** as a spy. The CAPUCHIN monkey will wear a **bullet-proof vest**, video camera, and two-way radio, and, intelligence experts hope, be able to access areas that no officer or robot could go.

Back to Work

At the start of the 20th century, when sheep still grazed in New York's Central Park, a collie named Shep had the job of controlling the flock. When Shep was retired he was sent to a farm 40 mi (64 km) away in upstate New York. However, the determined dog quickly escaped and, even though he had never previously been beyond Manhattan, managed to find his way back to the Big Apple by first stowing away on a ferry that would take him to Manhattan Island, and then sniffing his way back from 42nd Street to Central Park!

Gorilla Talk

Born in 1971, Koko the gorilla has appeared in *The New York Times* and on the cover of several prestigious magazines. Three books have been written about her, and scientists hang on her every word. She has even had her life story told on TV. For Koko, who lives at the Gorilla Foundation in Woodside, California, can communicate with humans. The 35-year-old primate has been taught sign language since she was an infant by Dr. Francine (Penny) Patterson and has now mastered more than 1,000 words. In addition, she understands around 2,000 words of spoken English and has a tested IQ of between 70 and 90 on a human scale where 100 is considered normal. Koko has also learned to use a camera and loves the telephone.

Parrot Banned

In November 1994, a defense lawyer in San Francisco, California, wanted to call a parrot to the witness stand in the hope that the bird would speak the name of the man who killed its owner. However, the judge refused to allow it.

Pets' Send-off

In 1997, Patrick Pendville started the first Belgian pets funeral service. Animatrans, as it is known, offers transport, burial, individual or collective certified cremation, collection of ashes, taxidermy, facial masks, and urns. About 1,200 animals pass through the doors every year. His customers bring not only cats and dogs, but other animals such as birds, goats, horses, and sheep—and even exotic breeds, such as crocodiles, tigers, snakes, and monkeys.

Patrick Pendville holds a beloved pet in his taxidermy workshop.

Helping Hooves

Shoppers in Raleigh, North Carolina, have been witnessing some unusual sights around town—namely miniature horses, 24 in (61 cm) tall, wearing sneakers and warm blankets. These horses are the equine version of guide dogs and are being put through their paces in busy shopping malls. Janet and Don Burleson began training mini horses to help blind and visually impaired people in 1999.

Great Trek

In 1953, Sugar, a Persian cat, trekked 1,500 mi (2,414 km) from Anderson, California, to Gage, Oklahoma, after her owners had moved there. The family had left the cat with a friend because of her bad hip, but despite the injury Sugar made a 14-month journey to be reunited with them.

Trumpet Tunes

Thailand's elephant orchestra has 12 jumbo elephants playing oversized instruments! Their last CD sold 7,000 copies in the U.S.A. alone.

Computer Blip

In 1988, Mastercard sent a letter to Fustuce Ringgenburg of Hemet, California, with the offer of a $5,000 credit limit, unaware that Fustuce was in fact the family cat.

Mini Cat

A blue point Himalayan cat from the U.S.A. called Tinker Toy was just 2¾ in (7 cm) tall at the shoulder and 7½ in (19 cm) long—about the size of a check book.

Baby-dry Diaper

Dr. Kobi Assaf, of Jerusalem's Hadassah Hospital, once treated a 12-month-old baby boy who survived a venomous snake bite because the boy's diaper absorbed the venom.

Kennel of Love

The doggy love motel, complete with a heart-shaped mirror on the ceiling and a headboard resembling a dog bone, opened in August 2005 for loving doggy couples. Billy and Jully, two Yorkshire terriers, stayed at the pet motel in Sao Paulo, Brazil. The air-conditioned room has a paw-print decorative motif, special control panels to dim the lights, romantic music, and films that can be screened. The rooms cost 100 reais ($54) for two hours.

Language Problem
A customer at a pet shop in Napierville, Quebec, threatened to report the shop to the Canadian government's French-language monitoring office in 1996 after being shown a parrot that spoke only English.

Shark Escape
Dolphins rescued four swimmers off the New Zealand coast by encircling them for 40 minutes while a great white shark swam nearby!

Believe it or not, a **sunglasses**-wearing Dalmatian rides a **motorbike with sidecar** in the Chinese city of **NANJING!** Its owner says the dog can drive for about **656 ft (200 m)** at speeds of up to 5 mph (8 km/h).

Equine Allergy
Teddy the horse has to sleep on shredded newspaper, because he has an allergy to, of all things, hay! If exposed to hay or straw, he immediately starts coughing and sneezing in an equine version of hay fever. His owner, Samantha Ashby from Coventry, England, also has to damp down his feed to remove any dust spores.

Trendy Terrier
New York boutique-owner Heather Nicosia ensures that her Yorkshire terrier Woody is one of the most fashionable dogs in town. She makes him his own line of WoodyWear clothes and dresses him in a range of trendy outfits ranging from pajamas to Batman and Spiderman costumes.

Fantastic Fish
Bruce, an Oranda goldfish, measures a staggering 17.129 in (43.507 cm) from snout to tail fin! Named after the late kung fu star Bruce Lee, Bruce swims with normal-sized goldfish at Shanghai Ocean Aquarium.

ACTUAL SIZE!

Doggy Beach

Bau Beach, north of the Italian capital, Rome, is a beach with a difference. Opened in 2000, it has been designed specially for dogs. Most Italian beaches ban dogs, but here for 5 euros ($6) they are given an umbrella, a towel, and a dog bowl, and their owners are handed a shovel to clean up any mess. After frolicking happily in the waves, the dogs can also take a shower under a high-pressured hose.

Bull Chase

Despite six instances of human pile-ups, often injuring over a hundred people, during the annual Running of the Bulls in Pamplona, Spain, since 1900, only 15 people have lost their lives.

125

Mothers' Milk
A dog feeds two tiger cubs at a zoo in Hefei, China, in May 2005. The tigers' mother did not have enough milk to feed the cubs, so the zookeepers found a dog to act as wet nurse.

Eager Beavers
Police searching for stolen money in Greensburg, Los Angeles, discovered beavers had found the money in their creek and woven thousands of dollars into their dam!

Bark Park!
Dog Bark Park is home to Toby and Sweet Willy. Toby is a 12-ft (3.7-m) statue and Sweet Willy, officially known as Dog Bark Park Inn, is a bed-and-breakfast establishment where guests can enter the body of the beagle to sleep. Alternatively, they can enjoy curling up in the cosy reading place in the dog's muzzle.

Ferret Lover
C.J. Jones is mad about ferrets. After falling in love with an injured ferret that was brought to the animal hospital where she worked, C.J. opened her home to the furry little creatures, and in 1997 founded the "24 Carat Ferret Rescue and Shelter" in Las Vegas, Nevada. She looks after a maximun of 90 ferrets at a time and has rescued more than 1,500 so far in total.

Mayor Hee-Haw
The small town of Florissant, Colombia, elected Paco Bell as its mayor. Believe it or not, he is a donkey!

Jumping Jack
Jack, a six-year-old terrier, gained notoriety when he was banned from darts tournaments in a Welsh pub in 2001, because after each round he kept jumping up to the board, snatching the darts, and then running off with them. In his youth Jack could reach the height of the bull's eye (5 ft 8 in/1.73 m) with ease and would even snatch darts that had landed at the very top of the board.

Speaking Cat
Pala, a black-and-white tomcat that lived in the Turkish town of Konya in the 1960s, had a vocabulary equivalent to that of a one-year-old baby. His owner, Eyup Mutluturk, explained that the cat began talking after becoming jealous of the attention lavished upon the family's grandchildren and was able to speak freely in Turkish.

Henry Lizardlover, 47, shares his Hollywood home with 35 lizards and takes amazing pictures of them in human poses. He loves them so much he even changed his name for them!

How long have you shared your house with lizards?

66 *Since 1981. I have a large house with separate rooms for the lizards—they don't live in cages so they get used to people. That's my secret.* 99

Why the change of name?

66 *I changed my surname from Schiff to Lizardlover in the early eighties. I wanted to show my love and dedication to the lizards. I resented the stereotype that they are creepy-crawly and evil, and felt that by taking that name I was making myself a part of the lizard family.* 99

How do you get the lizards to pose for pictures?

66 *If a lizard is calm and trusts you, it will demonstrate remarkably intelligent behavior, and will be happy to maintain these posed positions for up to an hour on furniture that is comfortable for him or her.* 99

Do you have to train them?

66 *Not at all. I give them a comfortable room to hang out in, they see me come and go every day in a graceful and non-threatening way. They recognize that I am a friendly creature.* 99

What are your favorite lizard pictures?

66 *A favorite is of Hasbro, an iguana I used to have, holding a guitar and singing into a microphone. There's also one of a big iguana cradling another in his arms—to portray that they can be loving to each other. My top models for postcards and calendars include iguanas Lovable and Prince Charming, and Chinese Water Dragons Larry Love, Laura Love, and Lana Love.* 99

They pose like humans—do they behave that way too?

66 *I used to take some out to a parking lot to sunbathe—after 20 minutes they would walk back to my truck and get back in on their own. Hasbro used to scratch at night on my bedroom door, get into my bed and go to sleep. In the morning this lizard, weighing 20 lb, and measuring 6 ft in length, would lie*

on my chest or, if it was chilly, poke his nose underneath the blanket. 99

Does everyone love what you do?

66 *Some people can't believe the lizards are real, or they say I drug them, hypnotize them, put them in the refrigerator first, or paralyze them. They say they can't breathe when they're posing—it's all untrue. They're calm and relaxed—scared lizards run around and bounce off the walls.* 99

Could anyone do what you do with lizards?

66 *Not all act the way mine do. Male adult iguanas can be dangerous if they are in breeding season moods, they can confuse humans for other male iguanas and become violent. They can attack, rip flesh, bite off a section of nose. You have to read their body language.* 99

NISSAN TAMIR FROM OMER, Israel, has been growing organic vegetables for years. In 2006 he was amazed to discover two radishes that have been growing non-stop—each one weighed a staggering 22 lb (10 kg).

LARGER

A Brazilian family created a car that transforms into a robot
page 147

An enormous mushroom weighing 56 lb (25 kg) was unearthed in Montana
page 150

For preserved and personalized cockroaches, visit the Cockroach Hall of Fame
page 151

THAN LIFE

CAR-nivoRous

Robosaurus, a mechanical dinosaur 40 ft (12 m) tall and weighing 30 tons, is a mean machine. Dwarfing its famous predecessor T-Rex, this awesome beast can lift, crush, burn, bite, and ultimately destroy cars—and even airplanes!

Robosaurus lifts 40,000-lb (18,145-kg) cars higher than a five-storey building. It crushes cars, splitting them in two, and incinerating paint and plastic. It bites and rips out roofs and doors with its fearsome stainless-steel teeth.

Whereas T-Rex had a jaw-crushing force of 3,000 lb (1,360 kg), Robosaurus—with teeth some 12 in (30 cm) long—is seven times stronger, and can also shoot 20-ft (6-m) flames from its giant nostrils. And while T-Rex's front claws were of little use, Robosaurus's are so strong that they can crush vehicles and 50-gal (190-l) metal drums at will.

Created by American inventor Doug Malewicki in 1988 at a cost of $2.2 million, Robosaurus is controlled by a human pilot strapped inside the monster's head. The pilot initiates the robot's movements by making similar movements himself and uses foot pedals to drive Robosaurus around.

Robosaurus has appeared in movies and on TV, and has amazed spectators at live events across the U.S.A., Canada, and Australia.

Robosaurus is a giant electro-hydromechanical machine. Seen here towering over a fighter jet, the giant robot seizes a Vandenberg missile, raises its mammoth head, and breathes flames through its nostrils.

Standing upright, Robosaurus is as high as a five-storey building, dwarfing the cars parked alongside its huge frame.

Battle of the Giants

	Height	Weight	Length of teeth	Jaw-crushing force
Robosaurus	40 ft (12 m)	58,000 lb (26,300 kg)	12 in (30 cm)	20,000 lb (9,070 kg)
T-Rex	16 ft (5 m)	14,000 lb (6,350 kg)	8 in (20 cm)	3,000 lb (1,360 kg)

Young Elvis

Sal Accaputo from Toronto, Ontario, became an Elvis impersonator at the tender age of eight. Better known as "Selvis," he has been paying tribute to the King for more than 27 years.

Baby Driver

When his three-year-old cousin was hurt in a fall in 2005, Tanishk Boyas drove him straight to hospital. Nothing unusual in that—except that Tanishk was only five at the time! The youngster had been learning to drive for three months at his home in India, but when he climbed into the family van it was the first time he had driven it without adult supervision. His father said, "He used to watch me drive and grasped the basics."

Plaid Car

Car artist Tim McNally of Upper Montclair, New Jersey, has covered his 1985 Buick Skyhawk in plaid. He hand-painted the plaid squares on the vehicle, which also boasts beads, rhinestones, tiles, marbles, and gargoyles.

Ice Cap

In February 2004, 69-year-old Josef Strobl finished another of his annual ice sculptures in Italy. Strobl has been building the sculptures every year for 42 years, with some of them soaring to more than 66 ft (20 m). Each sculpture takes 300 hours of work, and is made of around 265,000 gal (one million liters) of water!

Bunny Heaven

You know how rabbits multiply, but at a house in Pasadena, California, they've gone to ridiculous lengths! In 1992, there was just one rabbit; now there are over 12,000. The house is the Bunny Museum, home to Steve Lubanski and his wife Candace Frazee, and is the result of 14 years of dedicated collecting. Toy bunnies are everywhere and all the furniture, books, light fittings, kitchenware, toiletries, and games are bunny-themed. And among the collectibles there are five real rabbits making themselves at home.

Completely Bananas?

Becky Martz of Houston, Texas, has a collection of more than 5,000 banana labels! She began her collection in 1991 and has even traveled to Europe to meet fellow banana-label enthusiasts. But Becky doesn't only collect bananas, she has also collected 157 asparagus bands and 93 broccoli bands.

▼ Bunny Pots

Ebony Andrews, a 22-year-old British student of Fine Art, displays her dead-animal works of art, which include not only rabbit plant pots, but a pen pot made from a decapitated owl.

ACTUAL SIZE!

Hermits of Harlem

Brothers Homer and Langley Collyer were popularly known as the Hermits of Harlem. They lived alone in a three-storey mansion at 2078 Fifth Avenue, New York City, along with 136 tons of junk. Homer was blind, paralyzed, and dependent on his brother who, in order to deter burglars, set a series of booby traps that would bring tons of garbage crashing down on any intruder. Langley had carved tunnels through the junk so that he could crawl to the spot where his brother sat day after day. In March 1947, Homer was found dead, but there was no sign of Langley. Three weeks later, Langley's body was found amid the garbage. He had, in fact, died first, having accidentally sprung one of his own traps and suffocated beneath the debris. With nobody to feed him, Homer had then starved to death.

◀ Lightweight Literature

This book measures a tiny ½ x ¼ in (13 x 6 mm) and contains an amazing 208 pages. Entitled Letter from Galileo to Madame Cristina di Lorena, *it is kept with 50,000 other priceless books at the Cappuccini Library in Palermo, Italy.*

Santa's Helper

Every day is Christmas for Jean-Guy Laquerre of Boucherville, Quebec, Canada. He has more than 13,000 items of Santa Claus memorabilia—including yo-yos, pens, candle holders, and music boxes—that he has collected since 1988. His festive hobby began when an aunt left him a papier-mâché Santa in her will.

Hopping Mad

★ The ears of a rabbit called Nipper's Geronimo, from Bakersfield, California, were measured at more than 31 in (79 cm) in 2003.

★ A French scientist created a glowing rabbit in 2000 by splicing the green fluorescent protein of a jellyfish into the genes of an albino rabbit.

★ In 2004, a Dutch rabbit named Roberto measured nearly 4 ft (1.2 m) long and weighed 47 lb (21 kg). He had to sleep on a dog's bed because he wouldn't fit in a hutch!

★ A rabbit owned by J. Filek of Cape Breton, Nova Scotia, Canada, gave birth to a litter of 24 bunnies in 1978.

Buttmobile

The Stink Bug is an unusual car with a serious message. Conceived and created by Carolyn Stapleton of Orlando, Florida, to highlight the dangers of smoking, the Volkswagen Beetle is covered in cigarette butts. The words "Kick Butt" appear above the windshield and there is a skull and crossbones on the hood.

Corny Appeal

When lovelorn farmer and divorcee Pieter DeHond decided to place a personal ad, he didn't put it in a paper or magazine, but in a field. His love message came in the form of 50-ft (15-m) letters made from corn stalks on his farm at Canandaigua, New York, in 2005. Beneath the message, which took him an hour to create, an arrow 1,000 ft (305 m) long pointed females toward his house. Although the plea, measuring 900 x 600 ft (274 x 183 m), was visible only from the air, the publicity it attracted led to 700 phone calls and e-mails.

Sports Fan

John Carpenter, of Firebrick, Kentucky, owns over 4,000 pieces of sports memorabilia, including autographed baseballs, basketballs, jerseys, plates, helmets, and letters. Best of all is the ball that Babe Ruth hit for his 552nd career home-run.

⊙ Serious Surfing!

Forty-seven surfers spent 4 minutes surfing their way along the Gold Coast in Australia on March 5, 2005, on a massive surfboard 40 ft (12 m) long and 10 ft (3 m) wide—possibly the largest board ever built!

Hoover Lovers

Founded in 1982, The Vacuum Cleaner Collectors' Club boasts around 40 American members with a passion for suction. They include Stan Kann of St. Louis, Missouri, who has a suit made of vintage vacuum-cleaner bags. He has more than 125 cleaners in his collection and can distinguish individual models by their whine and by the smell of their bags.

Stardate 6.21.97: **Star Trek fans** Jo Ann Curl and Vince Stone had a **Klingon wedding** at Evansville, Indiana, in front of some 300 costumed guests. The bride wore a dark wig, a **furrowed** latex brow, and spoke the vows in **Klingon**!

Plastic Wrap Ball

Andy Martell of Toronto, Ontario, Canada, created a ball of plastic wrap that in 2003 measured 54 in (137 cm) in circumference and weighed 45 lb (20.4 kg). He made it at the Scratch Daniels restaurant, where he worked as a day cook.

Duck Girl

Whenever Ruth Grace Moulon wandered through New Orleans' French Quarter, she would nearly always be followed by up to a dozen ducks. She trained the ducks to follow her everywhere and achieved local fame from the late 1950s as "The Duck Girl," charging tourists to take her photo. She called all her ducks variations on the name of Jimmy Cronin, her policeman friend.

Munster Mansion

Something spooky has sprung up on the outskirts of Waxahachie, Texas. Charles and Sandra McKee have spent $250,000 creating a replica of the house from *The Munsters* TV show. Designed from set photos and TV clips, the two-storey, 5,825 sq ft (540 sq m) house contains secret passages, Grandpa's dungeon, and a trap door leading to the quarters of Spot—the McKees' German shepherd dog, who was named after the fire-breathing dragon that the Munsters kept as a pet.

Citizen Cane

Robert McKay, of Manitoba, Canada, has a collection of more than 600 wooden walking canes, each one handmade.

Playing with Fire

In 2004, Steve performed over 50 full body burns—more than most stunt people do in an entire career.

Believe it or not, Steve Truglia encourages people to set him on fire! Britain's top fire stuntman has appeared in many films and TV shows burning from head to toe at temperatures of around 800°F (425°C).

Steve often performs these stunts without oxygen and can hold his breath for more than two minutes while on fire. "Breathing is not an option," he explains, adding that one gasp of air would almost certainly be his last. Steve is also planning to break his present record for the longest time spent totally on fire. His current best is 2 minutes, 5 seconds.

As a professional stuntman, he has been blown up, crushed, thrown down flights of steps, and "killed" more times than he can remember. To improve road safety, he also drives specially crash-test dummies. He has driving cars into aluminum highway signs at speeds of more than 60 mph (100 km/h)— and walking away unharmed.

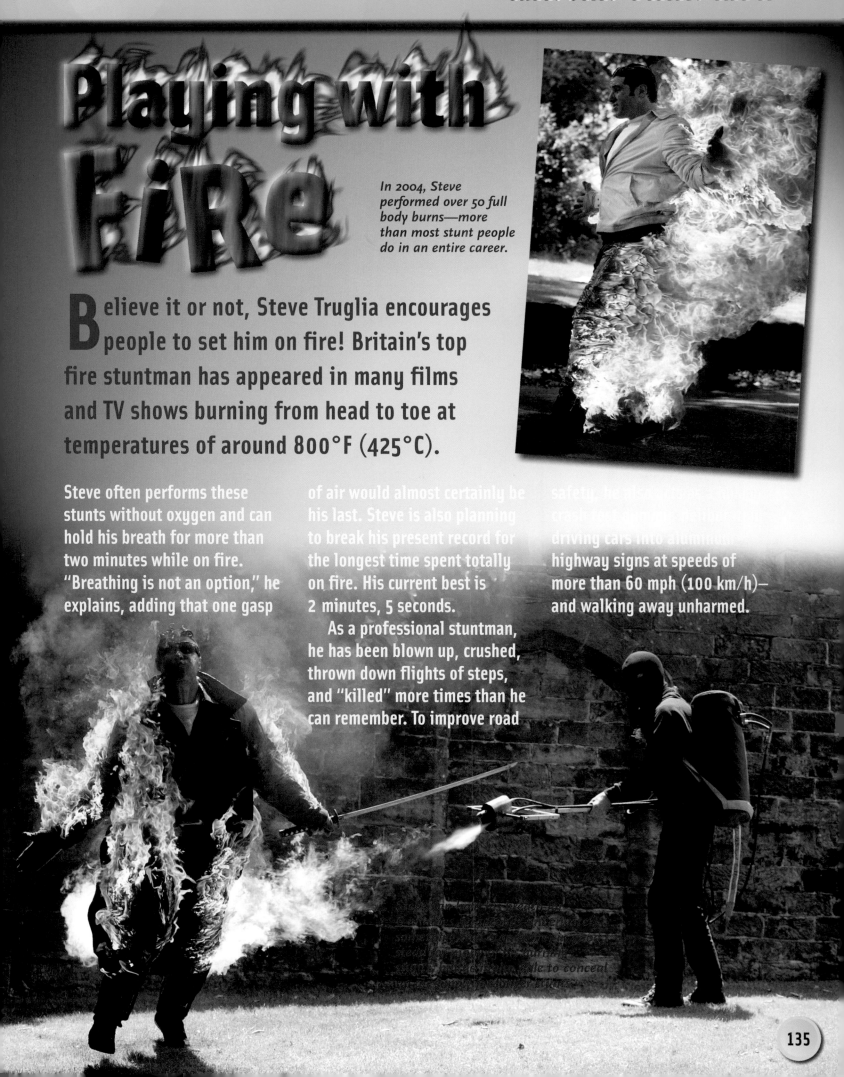

135

▶ Tall Tipple

This giant bottle of wine, auctioned at Sotheby's, holds the equivalent of 173 regular bottles, 1,200 glasses of wine, or 34 gal (130 l) of Beringer Cabernet Sauvignon Private Reserve 2001, and is protected by its own hard case.

Labor of Love

French postman Ferdinand Cheval spent 33 years building his Palais Idéal, or ideal castle. He began building it in 1879, collecting stones on his daily mail route, carrying them in his pockets, then in a basket, and eventually in a wheelbarrow. He often worked on the construction at night to the bemusement of his neighbors. When the authorities refused to allow him to be buried in his castle, he spent the following eight years building himself a mausoleum in the cemetery of Hautes-rives, southwest France. He finished it just in time: little over a year later, in August 1924, he died.

Chicken Robber

A man from Hillard, Ohio, robbed a grocery store while wearing a giant chicken costume!

Lucky's Yo-yos

John Meisenheimer is an avid yo-yo collector. Nicknamed "Lucky," Meisenheimer began doing yo-yo tricks while on his rounds at medical school in Kentucky. His collection now stands at more than 4,250.

Menu Master

New Yorker Harley Spiller has his own "celebration of Chinese takeout food in America." His collection features 10,000 Chinese takeout menus, from every state in the U.S.A. and more than 80 countries. The oldest menu dates back to 1879. He also has an assortment of restaurant shopping bags and even a life-size, delivery-man doll. "It's one of the nicest things you can ask a friend to do," he says, "to bring you a menu from their trip: it's lightweight and it's free."

◀ Alien Landing!

A shocked homeowner in County Durham, England, sparked a major police alert with the discovery of a slimy egg-shaped container with an alien-like fetus inside it. Detectives, forensic specialists, and a police surgeon were called before the egg-like object was identified as a child's toy.

Ups and Downs

★ The town of Luck, Wisconsin, was the yo-yo capital of the world during the 1940s, producing an incredible 3,600 yo-yos an hour.

★ In 1962, the Duncan Company alone sold 45 million yo-yos in the U.S.A., which is a country with only 40 million children!

★ In 1990, the woodwork class of Shakamak High School, Jasonville, Indiana, constructed a yo-yo that was 6 ft (1.8 m) in diameter and weighed 820 lb (372 kg). The giant yo-yo was launched from a 160-ft (49-m) crane and managed to yo-yo 12 times.

★ American Hans Van Dan Helzen completed 51 different yo-yo tricks in just one minute in 2004.

Flying Granny

In September 2002, 84-year-old grandmother Mary Murphy made the 62-mi (100-km) trip from Long Beach, California, to Catalina Island by the extreme sport of hydrofoil water-skiing. She said she wanted to make the four-hour journey while she was still young enough.

Gum Blondes

It takes approximately 40 hours and 500 sticks of pre-chewed gum to complete one of Jason Kronenwald's Gum Blonde portraits. Kronenwald dislikes chewing gum himself, so has enlisted a team of chewers who chew a variety of flavors and colors for him—he uses no paint or dye. The portraits are made on plywood, and measure 24 x 32 in (60 x 80 cm). Kronenwald, from Toronto, Ontario, Canada, started his Gum Blonde series in 1996 and has made sticky portraits of such celebrities as Britney Spears, Paris Hilton, and Brigitte Bardot.

WALKING TALL
In 1958, Angelo Corsaro from Catania, Italy, walked 558 mi (898 km) to the Vatican City on wooden stilts.

WORKING DOG
William Beck managed to train his Labrador Retriever as a golf caddy. The dog offered the added advantage of being especially good at retrieving lost balls.

FANTASTIC FIDDLE
Mr A.K. Ferris from Ironia, New Jersey, is pictured here playing a giant bass violin in 1934. The huge fiddle measured 14 ft (4.3 m) in height.

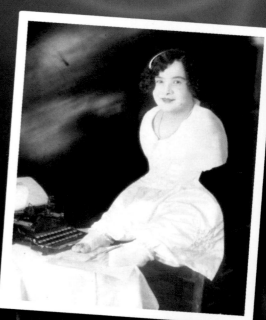

MARVELOUS MARTHA
Martha Morris was born without arms, but was still able to write, sew, knit, and type by using her feet instead of her hands.

TITANIC TRUMPET
This trumpet was so big that it required six boys to lift it! Only the mouthpiece and the valves were of normal size, so that the instrument could be played.

GREAT BALL OF TWINE
Started in the late 1950s by Francis Johnson of Darwin, Minnesota, this massive ball of string was 12 ft (3.7 m) in diameter and weighed 17,400 lb (7,892 kg) when Johnson died in 1989.

FLEA CIRCUS
These fleas, displayed inside a walnut shell, were dressed by Katherine Nugent of Los Angeles, who also made the tiny clothes.

TURNED TO STONE
George Kern of Columbus City, Iowa, is pictured with a giant ham on his knee: the amazing thing is that the ham has become petrified!

Looking Back

December 17, 1931 In Washington **a huge omelette** made of 7,200 eggs was fried in a pan 8 ft (2.4 m) across and weighed half a ton. **August 7, 1930** A massive **apple pie** was baked at the **Orleans County Fair** in New York—it contained 125 bushels of apples, 600 lb (270 kg) of flour, and 500 lb (230 kg) of sugar, and measured 12 ft (3.7 m) across.

Rhino Party

For 30 years, the Canadian political scene was enlivened by a party that claimed to be the spiritual descendants of a Brazilian rhinoceros! The Rhinoceros Party was founded in 1963 by writer Jacques Ferron and contested seven federal elections without ever winning a seat. In 1980, the party declared war on Belgium after the character Tintin blew up a female rhino in a cartoon adventure!

Scale Model

Models scaled the sides of the world's tallest building—the 1,667-ft (508-m) high Taipei 101 in Taiwan—for a fashion show that featured a vertical catwalk.

▼ Body Toast

British artist Antony Gormley traced the shape of his own body within 8,000 slices of white bread. He ate the missing slices—the equivalent of his own body's volume.

Pet Project

In 1999, in a bizarre sponsorship deal, Australian Rules footballer Gary Hocking changed his name to a pet-food brand to help his cash-strapped club. Gary became "Whiskas" in return for a donation to the club.

Living Library

In 2005, instead of lending books, a library in Malmo, Sweden, lent out humans. In an attempt to overcome common prejudices, borrowers were able to take the human items, including a homosexual, a journalist, and a blind person, for a 45-minute chat in the library's outdoor café.

Branching Out

American tree surgeon Peter Jenkins has pioneered an exhilarating new sport—extreme tree climbing. Along with other devotees, Jenkins climbs trees and performs acrobatic stunts, including balancing on the branches and running across the canopy. "We also do tree surfing, where we go high into the canopy on a windy day and ride the branches. You can see the wind coming toward you in waves over the other trees."

A team of European researchers has put together a CREEPY-CRAWLY ROBOT called **InsBot** that *behaves and smells* like a **cockroach** and is accepted by the insects as **one of their own**.

Look Who's Tolkien

Believe it or not, American *Lord of the Rings* fan Melissa Duncan is so obsessed with the films that she takes cardboard cutouts of the characters out to dinner!

Bishop of Broadway

American playwright and producer David Belasco was known as the Bishop of Broadway, because he often roamed the streets of New York dressed up as a priest.

Love on a Roller Coaster

Angie Matthews and Steve Krist, from Puyallup, Washington, were married while riding a roller coaster!

Speedy Toilet

Paul Stender's jet-powered, portable toilet on wheels can reach speeds of 40 mph (64 km/h). He races it against his friend's jet-powered bar stool!



Pedal Power

Vancouver unicyclist Kris Holm, 32, takes off-road riding to the extreme, tackling volcano craters, molten lava, and cliff tops all on one wheel.

How did you discover the unicycle?

❝I saw a street performer when I was a child. He performed while playing the violin, and I had a violin too. I asked for a unicycle for my 12th birthday. I grew up doing adventure sports and rock climbing, so it was a natural progression to combine the two.❞

Where are the most unusual places you have ridden?

❝I rode an ancient trade route in the Himalayan kingdom of Bhutan, an area very few westerners have visited. I also rode the Great Wall of China—the security guards didn't know what to make of me. They were so surprised, they just left me alone.❞

Are the rides dangerous?

❝I have ridden on the rail of a 200-ft-high bridge, and on the edge of an 800-m-high cliff. I have also ridden on a lava flow in the Volcanoes National Park in Hawaii—the lava had crossed a road and solidified. It was too hot to touch but could hold my weight—I was riding within 10 m of actively flowing, red and bubbling lava.❞

What kind of unicycle do you use?

❝A 'muni'—a mountain unicycle—is stronger than a normal unicycle, with a fatter tire. I have developed my own range—they are sold all over the world. I realized I wasn't the only one doing it when I checked the internet by chance in the late nineties. Now there are tens of thousands of unicyclists—from Pro Skiers to Hollywood stars.❞

What are the hardest skills to master?

❝Riding on a narrow surface, and hopping over obstacles. I can hop up to 95 cm vertically. It's also hard on the legs because you have to pedal all the time, even downhill—you can't freewheel. You can learn to take your feet off the pedals, but it's a skill, not a chance to relax. And the endurance aspect is hard—riding along the edge of a volcano crater is not technically difficult, but it is at 18,500 ft and in below-zero temperatures.❞

How do you practice?

❝I try to ride every day. I take a unicycle to work and ride at lunchtime. My climbing background and my day job as a geomorphologist assessing landslide risks mean I'm good at judging where a fall could kill me. You learn to ride something narrow as a coin just a metre off the ground, so when you have to ride something a foot wide but several hundred metres off the ground it feels as easy as crossing the street.❞

What is "competitive trials unicycling?"

❝I organized the first formal trials competition for unicycles in the late nineties, and out of that grew the competitive trials. I have been a winner of the European, North American, and World trials.❞

Do you sustain bad injuries?

❝Just lots and lots of bruises, and stitches in my chin and elbow. You don't typically fall badly—with a bicycle you fall over the handlebars head-first, whereas with a unicycle you can usually get your feet beneath you.❞

Where else would you like to ride?

❝There's a couple of volcanoes in Bolivia I've got my eye on!❞

Bear Necessities

A German travel agent announced in 2005 that he was offering holidays for teddy bears! Christopher Böhm said the vacations are "a great opportunity for the real man's best friend to see something different for a change." The teddies stayed in a luxury Munich apartment and spent the week sightseeing, playing games, and visiting a teddy bears' picnic and a beer house. And each bear received souvenir pictures to take home.

Two lucky teddies spend some time fishing and relaxing on a riverbank.

Newspaper Collector
Miao Shiming is never short of reading material at his home in China's Shanxi Province. He has collected more than 368,000 issues of over 30,000 different newspaper titles, 55,000 issues of 10,200 magazines, and 3,200 books.

⊙ Big Read
This massive tome, Bhutan, A Visual Odyssey Across the Kingdom, shown in Japan in December 2003, is 5 ft (1.5 m) high and 7 ft (2.1 m) wide. Only 500 copies were published.

Solar Jacket
U.S. inventor Scott Jordan has developed a jacket that has integrated solar panels to recharge electronic gadgets in its pockets.

Play Mate
In 2002, computer-game fan Dan Holmes officially changed his name to PlayStation2. Holmes, from Banbury, England, played for four hours a day and had previously asked a few vicars to marry him to his console. "But none were keen," he said. "So I took its name instead."

Santa Plea
For the past four years Alan Mills, from Milford, Ohio, has been trying to change his name legally to Santa Claus—with little success. All judges have refused, just in case he uses the name for profit.

Everyman
In 2004, Andrew Wilson from Branson, Missouri, legally changed his name to "They." He says he made this unusual choice to address the common reference to "they." "They do this" or "They're to blame for that," he explained. "Who is this 'they' everyone talks about? 'They' accomplishes such great things. Somebody had to take responsibility."

Elvis Roots

Singer Elvis Presley's genealogical roots have been traced back to Lonmay, Scotland, where a new tartan was created in his honor.

Oldest Schoolboy

Kimani Maruge stands out from his classmates at Kapkenduiywa primary school in Kenya, for he is twice the height and 17 times the age of most of his fellow pupils. The 85-year-old student sits with his long legs folded under the tiny desk during classes. He is also the only pupil at the school to wear a hearing aid and carry a walking stick.

Sleepy Traveler

Tom Wilson of Los Angeles, California, is the first person to "sleep across America." He toured the country in a chauffered Winnebago that traveled only while he was fast asleep.

Young Doctor

In 1995, Balamurali Ambati graduated from the Mount Sinai School of Medicine, New York City, aged just 17. The average age for graduates from medical school is 26 or 27. Despite his young age, his first patients didn't realize they were being treated by a teenager—at 6 ft (1.8 m) tall, they thought he was much older.

Bumper Horse

This sculpture of a mustang horse was made by Sean Guerrero of Colorado from stainless-steel car bumpers. It stands nearly 14 ft (4.3 m) high and weighs several thousand pounds.

Premium Bond

Matt Sherman thinks he's a real-life James Bond. He spends his spare time practicing survival techniques near his home in Gainesville, Florida, and turns routine shopping trips into pretend MI6 missions in which his two young children are given assignments to fetch certain groceries within a specified time. A collector of 007 memorabilia for more than 20 years, he has turned his den into a shrine to James Bond, complete with books, jewelry, and even cologne relating to his hero. He has also spent more than $10,000 on spy equipment that he uses for monitoring purposes.

Green-eyed

Ever since he was a child, Bob Green has been obsessed with the color from which his last name is derived. He lives on West Green Street, Greencastle, Indiana, invariably wears green clothes, drives a green car, and even named his three children after various shades of green—Forest, Olive, and Kelly.

Roller-coaster Ride

During the 2005 summer vacation, a 14-year-old boy from Offenburg, Germany, built a roller coaster in his backyard that was 300 ft (91 m) long. He even designed his own carriage, which was able to reach speeds of up to 30 mph (48 km/h) on the 16-ft (4.9-m) high wooden construction.

Blowing BuBBLes

Fan Yang can do just about anything with bubbles. He has created bubbles within bubbles, smoking bubbles, and spinning, bouncing, floating bubbles of every imaginable size, shape, and color.

In Seattle, Washington, in 1997, the Canadian bubble enthusiast created an amazing bubble wall that measured 156 ft (48 m) long and 13 ft (4 m) high—the equivalent of walking onto a football field and forming a giant bubble from the end zone to the 50-yard line. Three years later, he built a bubble so sturdy that his daughter was able to slide into a bubble hemisphere without bursting the film.

In 2001, Yang managed to arrange 12 bubbles inside each other; and in the same year, in Stockholm, Sweden, he interlinked nine bubbles to make one long chain that floated in mid-air.

In 2004, Fan Yang managed to fit 15 people in a bubble at the Santa Ana Discovery Science Center, California.

Fan Yang has dedicated the past 20 years to developing the art of bubbles. His skill has been recognized by science centers all over the world, and was born out of a childhood fascination with bubbles.

Cereal Devotion

Roger Barr of Richmond, Virginia, has been dedicating his life to saving Boo Berry cereal from extinction. He is so devoted to the product that he has set up an Internet fan site and even hides rival brands on supermarket shelves in the hope of slowing their sales. And he's not alone. One woman once drove a staggering 26,000 mi (41,850 km) to get her hands on a packet of Boo Berry.

Walking Tall

Jeff Jay has taken the art of stilt walking to extremes—he is able to walk on stilts that are 60 ft (18 m) tall. They were specially designed and created by him, and require a crane in order to get on to them!

Last Request

Before his suicide in February 2005, popular American writer Hunter S. Thompson asked to be cremated and to have his ashes fired from a cannon. Accordingly, his remains shot into the sky six months later from a 153-ft (47-m) tower behind his home in Woody Creek, Colorado.

Crackpot King

In 2003, plain Nick Copeman changed his name officially to H.M. King Nicholas I. Calling himself "Britain's other monarch," he rode on horseback in full uniform through his home town of Sheringham, Norfolk, sold nobility titles over the Internet, and started the Copeman Empire from his royal palace, which was, in fact, a two-berth caravan.

Off His Trolley

An inventive designer has been turning Britain's unwanted supermarket carts into furniture. About 100,000 old carts are destroyed in Britain every year, but Colin Lovekin, from Exeter, Devon, has come up with a new use for them. He has been turning them into chairs and sofas, complete with cushioned seating, wheeled legs, and even a basket at the back.

Monster Ball

While working in the post room of a law firm near his home in Wilmington, Delaware, John Bain had to collect mail from the post office every day. At the post office he would routinely grab a handful of free rubber bands, which he then made into a ball. Five years and two months later, the monster ball, made up of 850,000 rubber bands, weighed 3,120 lb (1,415 kg), stood 5 ft (1.5 m) high, and had a circumference of 15 ft (4.6 m). Bain estimated that it would have cost him $25,000 to make.

Slingshot Lobes

Nicknamed "Slingshot Ears," Monte Pierce uses his amazingly long earlobes to launch coins distances of up to 10 ft (3 m)! Pierce, from Bowling Green, Kentucky, began tugging on his earlobes when he was young, not only increasing their length but also their ability to snap back. His lobes permanently hang down an inch (2.5 cm), but for his launches he can stretch them to 5 in (13 cm). He can also pull them up over his eyes and can even roll them up and stuff them into his ears.

▲ Transformer!

Brazilian Olésio da Silva and his two sons Marcus Vinicius and Marco Aurelio have teamed up to create a life-size robocar. They transformed their Kia Besta van into a 12-ft (3.7-m) robot that plays loud music as it transforms. It cost them $122,000 and takes six minutes to transform.

Tattoo Tribute

Dan Summers, from Thompsonville, Illinois, is a living tribute to The Three Stooges. He has tattoos of Larry, Moe, and Curly covering his entire body, including his face.

> Believe it or not, *animal behaviorist* **Jill Deringer,** from **LANTANA**, Florida, can mimic the distinctive barks of **261** different **breeds of dog!**

Crazy Craft

How about sailing down the river in an electric wheelchair or in a two-seater pedal-powered floating tricycle? Well, wacky inventor Lyndon Yorke, of Buckinghamshire, England, can make your dreams come true. Among his ingenious seaworthy designs are the tricycle (the PP Tritanic) and the Tritania, a 1920s wheelchair complete with wind-up gramophone, champagne cooler, and picnic basket.

American Patriot

Ski Demski was the ultimate patriot. He owned a Stars and Stripes flag that measured 505 x 225 ft (154 x 68.6 m), weighed 3,000 lb (1,360 kg), and took 600 people to unfurl. Each star was 17 ft (5 m) high. He also had a tattoo of Old Glory on his chest. Before his death in 2002, Demski ran unsuccessfully for mayor of Long Beach, California, whenever there was an election.

Kissing Cobras

Gordon Cates of Alachua, Florida, kisses cobras for fun. The owner of more than 200 reptiles, he says that he can anticipate the snakes' actions by reading their body language.

▶ Heavyweight

Hercules is a three-year-old liger. An "accident," his father is a lion and his mother is a tiger. Standing 10 ft (3 m) tall on his back legs, he already weighs more than 900 lb (408 kg) and is still growing. Hercules consumes 20 lb (9 kg) of meat a day, usually chicken and beef, but can manage to eat 100 lb (45 kg) in one meal. This amazing animal is as strong as a lion and as fast as a tiger, reaching speeds of 50 mph (80 km/h)!

147

MUSEUMS Niagara Falls

RIPLEY'S SECOND OLDEST MUSEUM and the first outside the U.S., Niagara Falls, Ontario, was opened in 1963. Extensively renovated in 2003–2004, it features an exhibition on Niagara Fall's daredevilry, and portraits painted on the body of a housefly.

MAGPIE BIRD
Found in the 1990s in England, this bird has two heads and three legs.

STEGOSAURUS
This stegosaurus skeleton, found in China, is over 145 million years old.

SHARK JAWS
A megalodon shark's jaw containing teeth 6 in (15 cm) long. The jaws were large enough to bite a small car.

HORSESHOE CRAB
More closely related to scorpians than crabs, these creatures have existed for over 200 million years.

JUNK ART
These figures are made from kitchen utensils, plumbing supplies, auto parts, toys and rubbish.

SHRUNKEN HEAD
Fist-sized, this head is decorated with an ocelot fur headband and parrot feathers

UNICORN
A lamb was born in England with a single horn, 4 in (10 cm) long, growing out of its head.

DON'T MISS!

▶ Tibetan shaman's robe

▶ Matchstick model of the Statue of Liberty

▶ Two-headed turtle

▶ Ripley's personal giant beer stein

▶ Mustache collection

▶ Prehistoric giant beaver skull

▶ Large lint art mural

▶ Peerskill meteorite, a tiny meteorite famous for having hit a car

EIGHT-LEGGED BISON
Discovered in a wild herd in South Dakota, this bison has eight legs.

Mega Mushroom

Ty Whitmore, of Kansas City, Montana, discovered this 56-lb (25-kg) mushroom while cutting firewood. Desperate to get the fungus verified, he waded across creeks, protecting it from brushwood, until he reached a grocery store, where staff kindly obliged with their scales.

Ty proudly shows off his giant mushroom, measuring 30 in (76 cm) across.

Crawl to Work

A lifeguard from Essex, England, has hit upon the perfect way to avoid rush-hour traffic—by swimming to work. Each morning, 45-year-old Martin Spink walks down to the beach near his home, checks the tides, strips down to his shorts and flippers, and swims across Brightlingsea Creek. Ten minutes later, he emerges on the other side, pulls a clothes bag from his back, and dresses for work. He does it to save a 20-mi (32-km) round trip by road from home to his workplace.

On Top of the World

In May 2005, a Nepalese couple became the first to be wed on top of the world's highest mountain, Mount Everest. Moments after reaching the summit, Mona Mulepati and Pem Dorje Sherpa briefly took off their oxygen masks, donned plastic garlands, and exchanged marriage vows. The only witness was the third member of the party, Kami Sherpa.

Pac Mania

Tim Crist of Syracuse, New York, has a shrine to Pac Man in his home and calls himself Reverend of the First Church of Pac Man.

Waste Energy

The methane in cow dung collected at the Blue Spruce Farm in Bridport, Vermont, produces enough electricity to power 330 homes!

Super Saver

Roy Haynes from Huntington, Vermont, prides himself on being the cheapest man in the world. He splits his two-ply toilet paper into two rolls of one-ply, and dries out and reuses paper towels over and over again. He also saves money by taking ketchup packets from restaurants and squeezing them into his own ketchup bottle at home.

Surfing Mice

Australian surfing enthusiast Shane Willmott has been training three mice to surf small waves on tiny mouse-sized surfboards at beaches on the Gold Coast. The mice—Harry, Chopsticks, and Bunsen—live in miniature custom-made villas and own specially made jet skis. They train in a bathtub and then have their fur dyed when it's time to hit the beach. Willmott explains: "Because they're white, when they get in the whitewash of big waves, it's hard to find them."

Stair Climb

In September 2002, Canadian Paralympian Jeff Adams became the first person to climb the 1,776 stairs of Toronto's CN Tower in a wheelchair. It took him seven hours, moving backwards up the steps.

▶ Wicked Whiskers

There were some hair-raising creations at the 2005 World Beard and Moustache Championships in Berlin, Germany. Elmer Weisser (above, center) won the Full Beard Freestyle category with his Brandenburg Gate beard and moustache.

CockRoAch CElebriTies

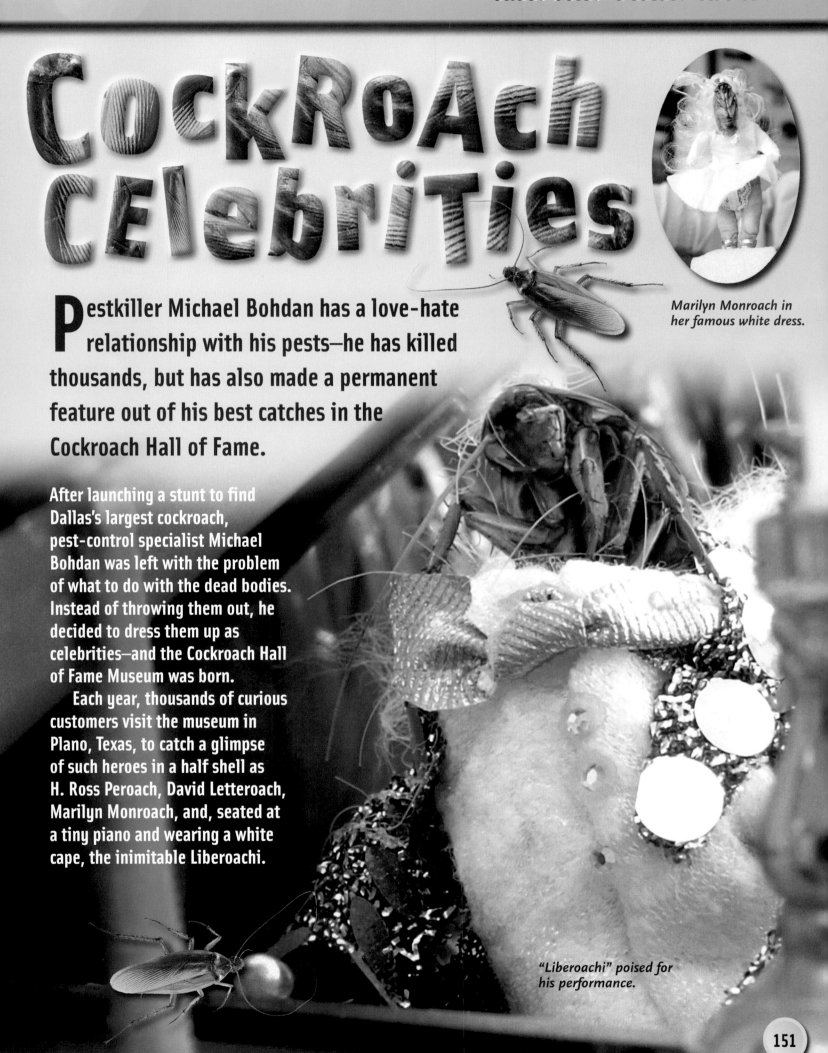

Marilyn Monroach in her famous white dress.

Pestkiller Michael Bohdan has a love-hate relationship with his pests—he has killed thousands, but has also made a permanent feature out of his best catches in the Cockroach Hall of Fame.

After launching a stunt to find Dallas's largest cockroach, pest-control specialist Michael Bohdan was left with the problem of what to do with the dead bodies. Instead of throwing them out, he decided to dress them up as celebrities—and the Cockroach Hall of Fame Museum was born.

Each year, thousands of curious customers visit the museum in Plano, Texas, to catch a glimpse of such heroes in a half shell as H. Ross Peroach, David Letteroach, Marilyn Monroach, and, seated at a tiny piano and wearing a white cape, the inimitable Liberoachi.

"Liberoachi" poised for his performance.

Apple of Your Eye
Emma Karp and her father Helge Lundstrom have been making giant apple mosaics since 1988 for the Kivik Apple Market in Sweden. Some of their creations include as many as 75,000 apples in 15 different varieties—that's 8,820 lb (4,000 kg) in weight!

Old Player
At 96, Henry Paynter was still a regular player at Kelowna Badminton Club, British Columbia, traveling to games across the region. He died in April 2005, aged 98.

State Names
The former editor of *The Wall Street Journal* was named Vermont Connecticut Royster. Indeed, his great-grandfather called his sons Iowa Michigan, Arkansas Delaware, Wisconsin Illinois, and Oregon Minnesota; while the girls were Louisiana Maryland, Virginia Carolina, and Georgia Indiana!

Secret Throne
Following the death of janitor James Hampton in 1964, it emerged that for the previous 14 years he had been building a secret throne from scavenged materials in a rented garage in Washington, D.C. The glittering throne was made from silver and gold foil, old furniture, pieces of cardboard, old light bulbs, shards of mirror, and old desk blotters. He had pinned the magnificent chair together with tacks, glue, pins, and tape. The throne, with its biblical messages, was later donated to the National Museum of American Art.

Giant Stocking
In 2004, J. Terry Osborne and friends, from King William County, Virginia, created a Christmas stocking over 35 ft (10.7 m) high and 16½ ft (5 m) wide. It was filled with presents for children in need.

Baseball Boy
Zach Spedden called an entire nine-inning baseball game on radio station WHAG 1410 AM, in Hagerstown, Maryland, in 2002, when he was ten years old. He also presented the pre-game show and the post-game analysis. It had been his ambition since the age of five.

▶ And They're Off!

The first Office Chair World Championships took place in Olten, Switzerland, on June 11, 2005. The race, which was 200 m (650 ft) long, saw 64 competitors from Germany, France, and Switzerland take part.

Hemingway Days

The highlight of the annual Hemingway Days' festival in Key West, Florida, is the Ernest Hemingway look-alike contest. The event attracts national and international entrants, who dress themselves up in fishermen's wool turtlenecks and other sporting attire, and make their way to Sloppy Joe's Bar—Hemingway's favorite watering hole when he lived in Key West in the 1930s. Beating off 146 white-bearded, ruddy-faced rivals to snatch the coveted title in 2005 was 61-year-old Bob Doughty, a letter-carrier from Deerfield Beach, Florida.

High Church

In August 2003, ten couples took their wedding vows in mid-air aboard an airplane flying from Orlando, Florida, to Las Vegas, Nevada. Fittingly for such a bizarre occasion, the in-flight ceremony was conducted by a minister dressed as Elvis Presley.

▼ Big Easter Buns

Baker Brian Collins proudly shows off his giant hot cross bun at Pegrum's Bakery in Rustington, England. His bun measured more than 48 in (122 cm) in diameter.

Ginger Ninja

From his nickname, you could guess that "Orange" Mike Lowrey of Milwaukee, Wisconsin, wears nothing but orange. He is usually seen out and about in an orange hat, orange shirt, orange belt, orange pants, orange sneakers, and orange wristwatch band. "It's no big deal," he insists. "I just like the color orange."

Underwater Wedding

Chandan Thakur and Dipti Pradhan's wedding took place underwater in June 2003 at the Vashi Marine Centre on Thailand's Kradan Island. First, diving instructor Ravi Kulkami conducted the engagement as the couple exchanged rings while suspended by ropes 50 ft (15 m) above the Vashi pool. Then, 11 days later, Kulkami, the bride and groom, and seven relatives dived under the water for the 30-minute ceremony. The couple had metal strips sewn into the hems of their wedding outfits so that they kept their shape in the water.

▲ Big Foot
Matthew McGrory of Los Angeles had size 29½ feet, measuring an amazing 15⅝ in (39.7 cm), and had to pay as much as $22,745 for a pair of shoes. Matthew had always been large—at birth he measured 24 in (60 cm) in length, and he stood 5 ft (1.5 m) tall when he graduated from kindergarten!

Lucky Numbers
Kevin Cook, from Colorado Springs, has been collecting playing dice since 1977. His collection currently totals more than 15,500.

Bungee Bride
A pair of adrenaline junkies got married while on a bungee jump in 2005. Huang Guanghui and his bride Zhang Ruqiong had applied for a special licence to get married on the amusement park ride in the city of Wenzhou in Zhejiang province, China. After a short marriage ceremony at the top of the ride, the pair, already prepared in their safety harnesses, jumped from the platform. Huang hopes the excitement of their unusual wedding will maintain the bond between them for the rest of their lives.

Rocket Mail
In the 1930s, German inventor Gerhard Zucker devised a plan to deliver mail and medical supplies from the Scottish island of Scarp to the nearby island of Harris by rocket! However, Zucker's test rocket scattered the mail all over the place, so the idea was scrapped.

Rob Poulos, of Kansas City, Missouri, and several others around the world, helped author **Shelley Jackson** write a short story by each having their bodies *tattooed* with a **single** word.

Rotating Home
Every room is a room with a view at Al Johnstone's unusual mountaintop residence in La Mesa, California. This is because Al lives in a rotating house, which completes a full circle every 30 minutes.

Boxing Dog
A former world champion kickboxer has trained his dog in the martial arts! Russ Williams, who runs a kickboxing school in North Wales, has trained Ringo, a Russian terrier, to jump up on command and kick with his two front legs. Williams said: "He can deliver a knock-out punch with his paws."

Flying Car
Imagine a vehicle that you can drive to the shops or fly in the sky. Molt Taylor did. In 1949, the inventor from Portland, Oregon, came up with the Aerocar, a four-wheeled car with a tail and wings, which was powered by an airplane engine: it was part car and part airplane. To demonstrate its dual purpose, Taylor would remove the wings and tail section and drive it into town—much to the amazement of his fellow motorists.

All Taped Up

Wisconsin brothers-in-law Tim Nyberg and Jim Berg, are the Duct Tape Guys—they have collected well over 5,000 uses for the product and say there's virtually nothing it can't fix.

Tim, when did you first develop your passion for duct tape?

❝We were at Jim's sister's home for Christmas in 1993 and a storm caused a power outage. Jim said, 'If I knew where that power outage originated, I could probably fix it with duct tape.' His wife agreed, 'Jim fixes everything with duct tape!' They rattled off a few of his recent fixes, and I thought, 'There's a book here!' So we all sat around in the candlelight brainstorming uses for duct tape. By the end of the day, we had 365 uses listed.❞

How did you become the Duct Tape Guys?

❝Back home, I illustrated and designed a book and sent it off to a few publishers. One acquisitions editor who happened to be familiar with duct tape humor from his college years pulled it out of the reject pile and convinced his editor by duct taping him into his chair until he agreed to publish it. That was seven books and close to three million copies ago. I have a background in stand-up comedy, and Jim is naturally funny, so we created the Duct Tape Guys to provide interviewable characters to accompany our books.❞

What are some of the strangest uses for duct tape?

❝A dermatologist wrote us about nine years ago saying he successfully treated warts by simply adhering a strip of duct tape over the wart until it died. No chemicals needed. Five or six years later, there was a medical white paper written about the same treatment. Now people send us their wart testimonials. Jim's personal favorite use is duct taping his television remote control to his arm so he doesn't lose it (and doesn't have to relinquish remote use to his wife and kids).❞

Why is it so well-loved?

❝It's a quick fix. It needs no directions, so there is no limit to one's creativity. It's extremely versatile. By folding it over onto intself two or three times it's strong enough to pull a car out of a ditch, yet you can rip it with your bare hands. Enough duct tape is sold each year to stretch to the moon 1.2 times. We've even heard of funerals where families have honored grandpa's fondness of duct tape by giving each family member a little strip of tape to seal the coffin.❞

Does anything else come close?

❝We have two tools in our tool box. A roll of duct tape and a can of WD-40®. There are two rules that get you through life: If it's not stuck and it's supposed to be, duct tape it. If it's stuck and it's not supposed to be, WD-40 it.❞

Is there anything you can't do with duct tape?

❝That's the leading question in our seventh book, 'Stump the Duct Tape Guys.' The question that finally stumped us was, 'How do you stop somebody who loves duct tape from using only duct tape?' We have no idea. Give someone more duct tape and they love it all the more, finding more and more uses for the stuff. Take it away and the heart only grows fonder.❞

Party Animal

American financier George A. Kessler loved parties. In 1905, he threw a birthday party at London's Savoy Hotel with a Venetian theme. He had the hotel courtyard flooded with blue-dyed water to simulate a canal and, against a painted backdrop, his two dozen guests sat inside a vast silk-lined gondola, served by waiters dressed as gondoliers and serenaded by opera singer Enrico Caruso. Kessler's birthday cake was 5 ft (1.5 m) high and arrived strapped to the back of a baby elephant, which was led across a gangplank to the gondola.

Joel Freeborn, from **Wauwatosa,** Wisconsin, is a *human bottle opener.* He can open **bottles of beer** with his **belly button**!

Four-year Fast

In May 2005, German scientist Dr. Michael Werner announced that he had eaten nothing for the previous four years. He said he drank only water mixed with a little fruit juice and claimed to get all his energy from sunlight.

Scorcher

Dr. Bunhead, aka Tom Pringle, is a teacher with a difference. He tries to bring science alive to both old and young by making it exciting—mainly with big bangs. His feats include firing eight potatoes from a potato launcher in three minutes and setting light to his head.

Quirky Castle

While both his parents were out at work one day, 17-year-old Howard Solomon ripped the back wall off their new suburban home and started adding on a porch. Now his parents live in a back room of their son's home—a castle in a central Florida swamp. That early brush with homebuilding inspired Solomon's love for grand creations. He began his castle at Ona in 1972 and it now covers 12,000 sq ft (1,115 sq m) and stands three storeys high. The exterior is covered in shiny aluminum printing plates, discarded by the local weekly newspaper, and the interior is home to his quirky sculptures, including a gun that shoots toilet plungers.

Inflatable Alarm

Chilean inventors Miguel Angel Peres and Pedro Galvez created the "Good Awakening Pillow," a device originally intended as an alarm clock for the deaf. The pillow very gently shakes the owner's head by slowly inflating and deflating.

Elvis Impersonator

New Yorker Mike Memphis will go to any lengths to look like his hero Elvis Presley. An Elvis impersonator since the age of 16, Mike underwent several facial procedures on Elvis's birthday in 1994 so that he could look more like the King. The multiple operations comprised liposuction of the face, cheek implants, a lower-lip implant, a chin implant, liposuction of the neck and chin, and implants on both sides of his jaw.

Klingon Pizza

American Star Trek fan Shane Dison is obsessed with being a Klingon! He makes sure that his daily diet includes Mexican-style pizzas, because they're the closest things to Klingon food on Earth.

Game's Up

Devoted baseball fan Joe Vitelli, of Westborough, Massachusetts, was so desperate to watch game seven of the New York Yankees–Boston Red Sox American League Championship series in 2003 that he faked a broken leg in order to get out of attending his girlfriend's sorority formal on the same day. He even wore a fake cast for six weeks, used a wheelchair, and "attended" various bogus doctor's appointments before he was spotted walking—and the game was up!

Howzat!

A cricket ball, made in Sri Lanka, boasts 2,704 diamonds, and is claimed to be the first life-size diamond-and-gold cricket ball.

ACTUAL SIZE!

Brooklyn Miser

Henrietta Howland Green was one of the world's richest women. She had more than $31 million in one bank account alone, yet she lived a frugal life in a seedy Brooklyn apartment where the heating remained firmly switched off—even in the depths of winter. Her lunch was a tin of dry oatmeal, which she heated on the radiator at her bank. She never bothered to wash and usually wore the same frayed old black dress. Tied around her waist with string was a battered handbag containing cheap broken biscuits. When she died in 1916, she left an estate worth $100 million.

Mug Maestro

Since 1972, mug collector Harold Swauger from New Philadelphia, Ohio, has collected more than 4,500 examples from all over the world.

Riding High

New Jersey mountain biker, Jeff Lenosky can ride down stairs, over cars, and even along the top of a rail 2⅓ in (6 cm) wide. He also made a vertical leap of 45½ in (116 cm).

Chimp Marriage

After flirting through the bars of their respective enclosures for four months, two chimpanzees were married at a Brazilian zoo in 2003 in an attempt to encourage them to breed. The "couple" at Rio de Janeiro Zoo wore wedding gowns for the ceremony and had their own wedding cake.

T Set

Greg Rivera and Mike Essl are the A-Team of collectors. They are crazy about Mr. T and have more than 5,000 Mr. T items. The items include 600 Mr. T dolls, as well as lunch boxes, ceramic piggy banks, pencil sharpeners, toothbrushes, drinking glasses, and four boxes of Mr. T cereal.

Presidential Campaign

Ron Regen's goal in life was to meet his namesake, former President Ronald Reagan. "I was named after him by my parents. My mother liked him, and they thought it was kind of funny." Regen began writing to Reagan when the latter was Governor of California and he subsequently sent telegrams to every member of Congress (twice), joined various political groups, and paid to attend expensive dinners at the White House. His mammoth quest cost him more than $20,000, but the closest he ever came to meeting his hero was kissing Reagan's dog on a tour of the White House.

▼ Face-off

Sculptor Ron Mueck exhibited his work—a lifelike sleeping face—in the Museum of Contemporary Art in Sydney, Australia, in 2002. A self-portrait, it is made from a fiberglass resin and is part of a collection of "hyper-real" figures made by the artist.

PETE CABRINHA OF HAWAII surfed a 70 ft (21.3 m) wave at the break known as Jaws on the North Shore of Maui, Hawaii, on January 10, 2004. It was the largest wave ever ridden at the Global Big Wave Awards. Cabrinha set off to practice on a brand-new board to warm up before the event, but when the jet ski was removed he surfed in on this staggering wave.

IMPOSSIBLE

A regurgitator swallows light bulbs, coins, live goldfish, and glass eyes before bringing them back up again
page 181

"Super Bill" performed 109 backhanded push-ups in 60 seconds
page 182

An American performer had concrete blocks broken on his face with a sledgehammer and escaped from a quarter of a mile of plastic food wrap, while holding his breath
page 184

FEATS

Ice BreAKeR

Lewis Pugh combines extreme swimming with polar adventure. Besides being the first person to complete a long-distance swim in all five oceans of the world, British swimmer Pugh has also completed the most southern swim ever undertaken, earning him the name "The Ice Bear."

Wearing only swimming shorts, goggles, and a cap, Pugh plunged into the freezing sea off the Antarctic Peninsula in December 2005 to swim 0.6 mi (1 km) in a water temperature of only 32°F (0°C). To reach the spot just below the 65th parallel off Petermann Island, an ice-breaker ship had to cut through 25 mi (40 km) of thick pack-ice. Although it was dusk and snowing heavily, Pugh decided to undertake the swim on the night of December 14

Before Pugh entered the water, he was able to raise his core body temperature to 101.1°F (38.4°C) without doing anything other than looking at the icy water.

Pugh attributes much of his success to the rigorous mental training he undergoes, with the help of his coach, before each polar swim.

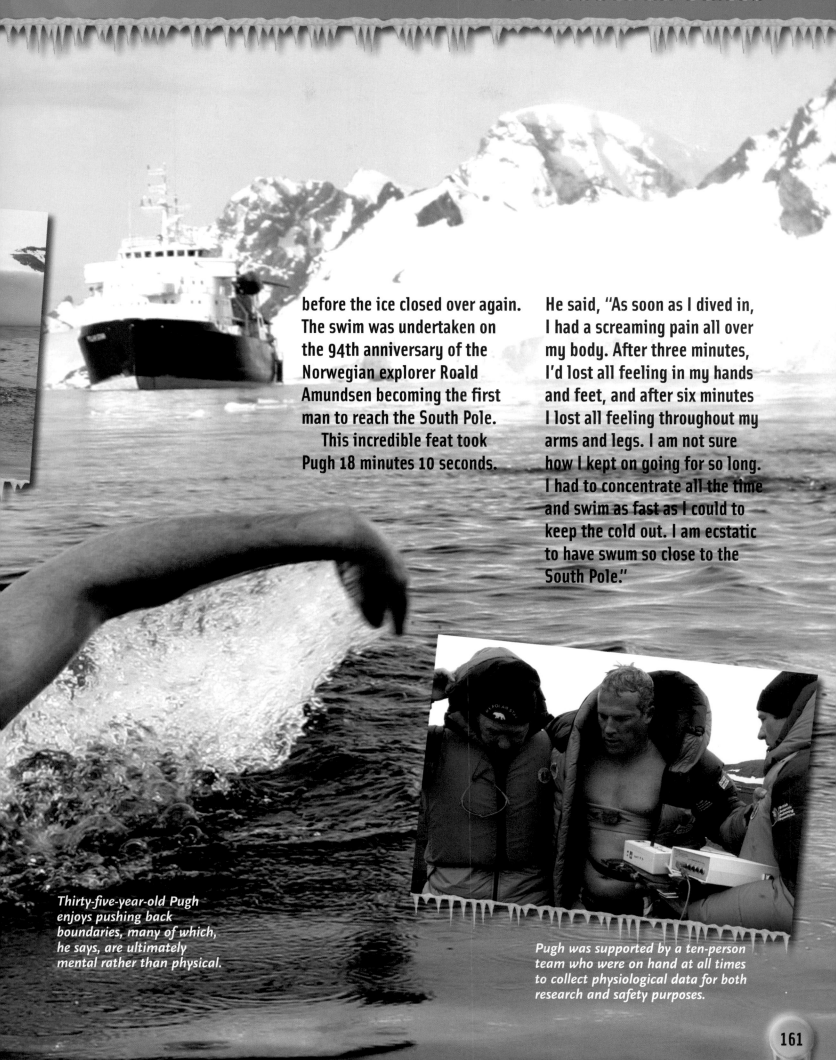

before the ice closed over again. The swim was undertaken on the 94th anniversary of the Norwegian explorer Roald Amundsen becoming the first man to reach the South Pole.

This incredible feat took Pugh 18 minutes 10 seconds.

He said, "As soon as I dived in, I had a screaming pain all over my body. After three minutes, I'd lost all feeling in my hands and feet, and after six minutes I lost all feeling throughout my arms and legs. I am not sure how I kept on going for so long. I had to concentrate all the time and swim as fast as I could to keep the cold out. I am ecstatic to have swum so close to the South Pole."

Thirty-five-year-old Pugh enjoys pushing back boundaries, many of which, he says, are ultimately mental rather than physical.

Pugh was supported by a ten-person team who were on hand at all times to collect physiological data for both research and safety purposes.

Joe's Jaunts

Aged 62, Joe Bowen made his third trip across the U.S.A. He became famous in 1967 when he cycled 14,000 mi (22,530 km) on a winding route from California to his home in eastern Kentucky. Then, in 1980, he walked on stilts from Los Angeles, California, to Powell County, Kentucky, on a more direct route. It took him six months to plod more than 3,000 mi (4,828 km) through driving rain and desert heat. And, in 2005, he retraced his original cycle route, this time with 58 lb (26.3 kg) of equipment strapped to his bike.

Shark Rider

Fearless Manny Puig isn't content with getting right up close to sharks—he rides them, too! He follows hammerhead sharks in a boat off Florida Keys, then leaps on them and hangs on while they thrash about in the water. He even tackles more dangerous bull sharks, grabbing them by two holes near the gills before climbing on. Manny also dives into swamps in the Everglades and rides alligators with his bare hands. He says: "I rely on proper technique and the grace of God."

Stunt Kid

When he was just 2½ years old and still wearing diapers, Evan Wasser was an American skateboarding ace! Riding a skateboard that was almost as tall as he was, he could perform amazing jump stunts.

Mighty Molars

A 71-year-old Chinese woman pulled a car a distance of 65 ft (19 m) in 2005—with her teeth. Wang Xiaobei attached one end of a heavy rope to the car and wrapped a handkerchief around the other end before biting on the rope. Among other items she can carry in her mouth are a 55-lb (25-kg) bucket of water and a bicycle.

Courageous Swim

In September 2001, Ashley Cowan, aged 15, from Toronto, Ontario, became the youngest person and first disabled athlete to swim across Lake Erie. She managed to complete the 12-mi (19-km) swim in 14 hours, despite having had all four limbs amputated below the joints when she had meningitis as an infant.

Fish School

Dean and Kyle Pomerleau teach fish to perform tricks. Sir Isaac Newton, the Betta Fish pictured here, learnt to go through a hoop after a week of training.

Quick on the Draw

German artist Gero Hilliger can produce portraits faster than a Polaroid camera. He is able to complete a portrait in just over six seconds and once rattled out 384 in 90 minutes. He can also do portraits blindfolded—purely by touch.

On Yer Bike!

★ In 2004, a German inventor came up with the Dolmette, a huge superbike powered by 24 chainsaws.

★ Argentina's Emilio Scotto rode 457,000 mi (735,500 km) on a motorcycle between 1985 and 1995. He went round the world twice and visited more than 200 countries.

★ In 2003, Swede Tom Wiberg constructed a mini motorcycle that was just 2½ in (6.4 cm) high and 4½ in (11.4 cm) long. It had a top speed of 1.2 mph (1.9 km/h), thanks to a miniscule, ethanol-powered combustion engine.

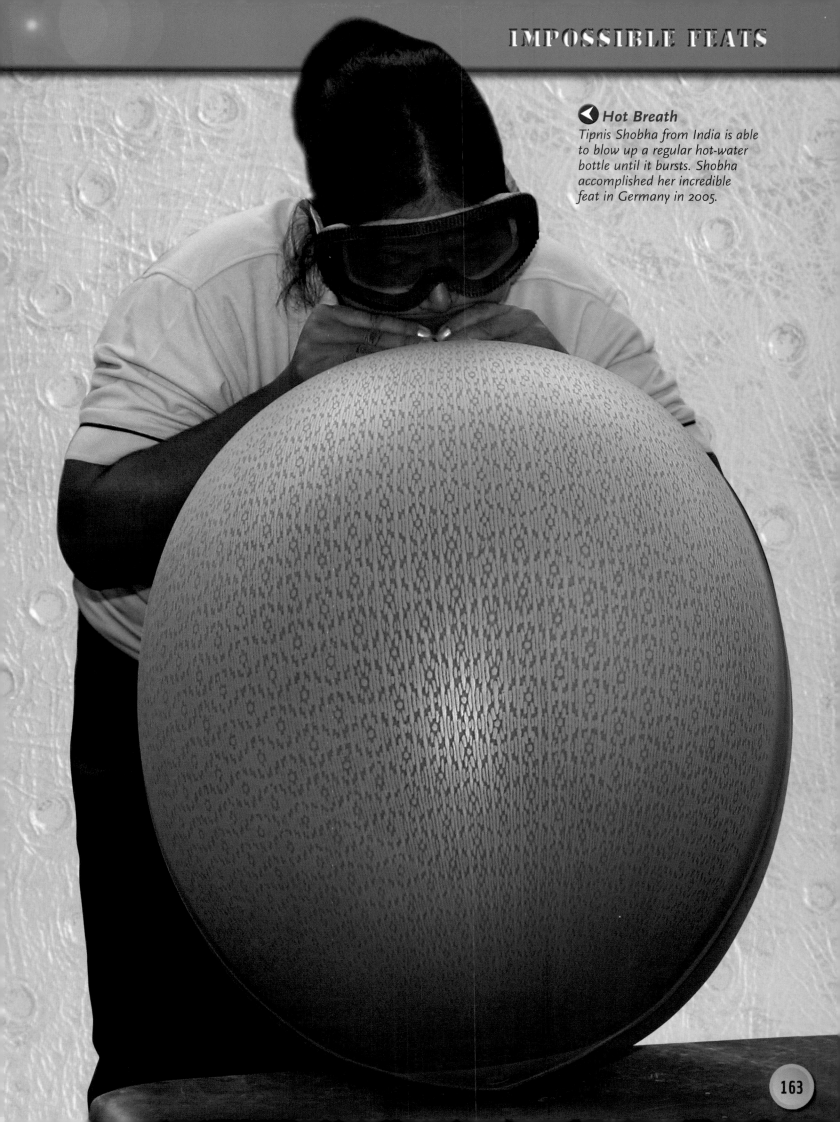

Hot Breath
Tipnis Shobha from India is able to blow up a regular hot-water bottle until it bursts. Shobha accomplished her incredible feat in Germany in 2005.

On Target

Darts player Perry Prine, from Mentor, Ohio, threw 1,432 bull's-eyes in 10 hours in March 1998. In that time, he threw a total of 6,681 darts—that is 11 darts a minute, of which on average 2.39 were bull's-eyes. He calculated that in the 10 hours, he walked more than 3 mi (5 km) to and from the dart board.

A 34-year-old Indian *policeman*, R. Velmurugan, **jumped** from a height of **34 ft** (10 m) into a **tub** containing just **7 in** (18 cm) of **water** in 2005.

Indian Trail

A Hungarian immigrant now based in Edgewater, Florida, 58-year-old Peter Wolf Toth traveled the U.S.A. from 1971 to 1988, carving faces into logs in each state. Sculptor Toth enjoys carving images of American Indians—so much so that his 67 towering statues (some as tall as 40 ft/12 m high) can be found in every U.S. state, as well as in Canada. This "Trail of Whispering Giants" stretches from Desert Hot Springs in California, to Springfield, Massachusetts.

Long Throw

Believe it or not, the magician and card-trick specialist Rick Smith Jr., of Cleveland, Ohio, can throw a playing card a distance of 216 ft (66 m)!

▶ Brick Lift

Eighty-seven-year-old Xie Tianzhuang from China lifted 14 bricks, weighing a total of 77 lb (35 kg), with his teeth, in Hefei in October 2005. He managed to hold the bricks suspended for 15 seconds.

Instant Art

Using only a palette knife and wads of toilet tissue, "Instant Artist" Morris Katz has created and sold over 225,000 original oil paintings in a 50-year career. In July 1987, he painted for 12 consecutive hours at a hotel in his native New York City, during which time he finished 103 paintings and sold 55 on the spot. He once painted a 12 x 16 in (30 x 40 cm) canvas of a child in the snow in just 30 seconds.

Super Size

Isaac "Dr. Size" Nesser of Greensburg, Pennsylvania, started lifting weights at the tender age of eight. As a result, it's perhaps of little surprise that he ended up boasting a 74-in (188-cm) chest, 29-in (74-cm) biceps, and the ability to bench press a massive 825 lb (374 kg). And if you ever need someone to carry 100-gal (380-l) drums filled with gas, Dr. Size is definitely the man for the job.

Slice of Luck

When veterinarian Jon-Paul Carew looked at this X ray he could hardly believe his eyes–a puppy aged six months had somehow swallowed a 13-in (33-cm) serrated knife!

Jane Scarola had been using a knife to carve a turkey at her home in Plantation, Florida, in September 2005. She put the blade on the counter away from the edge, but thinks that one of her six other dogs must have snatched it. From there it came into the possession of Elsie, her inquisitive St. Bernard puppy, who swallowed it! Elsie probably had the blade between her esophagus and stomach for four days before Dr. Carew removed it in an operation lasting two hours.

Dr. Carew admitted: "I was just amazed that a dog this small could take down a knife that big and not do any serious damage, and be as bright, alert, and happy as she was."

Jon-Paul Carew with Elsie after her operation to remove the knife.

X ray of the knife lying between Elsie's esophagus and stomach.

The offending knife on the operating table, after removal.

Spinning Around

Suspended 525 ft (160 m) above the Rhine River, Germany, two German tightrope artists made a spectacular motorcycle river crossing in 2003. The bike was connected to a trapeze dangling beneath the high wire. Johann Traber sat on the trapeze, while his son, 19-year-old Johann, rode the motorcycle. They spun around the wire 14 times during the 1,900-ft (579-m) crossing, using shifts in their weight to keep revolving.

Marathon Mission

Margaret Hagerty has run a marathon on each of the Earth's seven continents—quite an achievement for a woman of 81. The elderly athlete, from Concord, North Carolina, completed her mission by taking part in Australia's Gold Coast Marathon in 2004, having previously run in locations including Greece, Brazil, and the South Pole. Asked how long she will keep going, she said: "Some days I think I am going to pick a date, run, and quit. But then I think, 'Well, they can just pick me up off the street one day.'"

Action Man

Although born without arms, Jim Goldman, from St. Louis, Missouri, can play baseball by placing the bat between his neck and shoulder. Using this method, he can hit a 60-mph (97-km/h) fastball thrown by a semi-pro ball player.

Quest

For more than eight years, Rafael Antonio Lozano has been making his way across North America—as part of his mission to visit every Starbucks coffee shop on the planet. By September 2005, the 33-year-old coffee lover from Houston, Texas (who uses the name Winter), had visited an incredible 4,886 Starbucks shops in North America and 213 in other countries including Spain, England, France, and Japan. His record for a single day was visiting 29 shops in southern California.

Bar-tailed Godwit

The bar-tailed godwit is a migratory bird that would be hard to beat in an endurance flying contest—it migrates 7,456 mi (12,000 km) from Alaska to New Zealand in six days and six nights at speeds of up to 56 mph (90 km/h) without stopping to feed.

In **July 1998, Super Joe Reed** made a **65-ft** (20-m) leap on a **250cc dirtbike** from the **roof** of one building to another in **Los Angeles, California.** The **roofs** were **140 ft** (43 m) above street level.

Hungry Eyes

This pine snake, found in Gainesville, Florida, was discovered in a chicken coop after having eaten two lightbulbs he mistook for eggs. The bulbs were three times the size of the snake's head and would have been fatal, but for a successful operation to have them removed.

The High Life

Walking a tightrope 300 ft (91 m) above ground would be scary enough for most people, but Jay Cochrane has done it blindfold! In 1998, Cochrane, from Toronto, Ontario, walked 600 ft (184 m) between the towers of the Flamingo Hilton, Las Vegas. Known as the "Prince of the Air," Cochrane once spent 21 days on a high wire in Puerto Rico. In 1995, he walked a tightrope 2,098 ft (639 m) above the Yangtze River in China, and in 2001 he walked 2,190 ft (667 m) between two 40-storey buildings on opposite sides of the Love River in the city of Kaohsiung in Taiwan.

In Father's Footsteps

U.S. motorcycle stuntman Robbie Knievel (son of the famous daredevil Evel Knievel) made a spectacular 180-ft (55-m) jump over two helicopters and five airplanes parked on the deck of the Intrepid Museum, Manhattan, New York, in 2004. He had to construct a ski ramp 30 ft (9 m) high to help the motorbike build up enough speed to clear the aircraft-carrier-turned-museum.

Lug Tug

A Chinese man can pull a train with his ear! Thirty-nine-year-old Zhang Xinquan pulled a 24-ton train 130 ft (40 m) along a track in June 2005 by means of a chain attached to his right ear. After years of practice, he admits that his right ear is now bigger than his left. The previous month he had pulled a car 65 ft (20 m) with both ears while walking on eggs, without breaking them. The father of 15 children can also stand on eggs and pick up a 55-lb (25-kg) bicycle with his mouth.

▶ Cable Car Survival

On March 16, 2004, in Singapore, 36 teams of two took up the challenge of surviving seven days inside a cable car. They were allowed only one ten-minute toilet break each day. Nineteen of the couples survived the challenge, emerging on April 23 after experiencing 168 hours of stifling humidity, motion sickness, and claustrophobic conditions.

Blind Corners

Blindfolded and with a hood over his head, 19-year-old Samartha Shenoy, from India, rode a motor scooter for 15 mi (24 km) through the streets of Mangalore in 2004.

Flying Visit

In May 2004, Geoff Marshall traveled to all 275 stations on the London Underground system in just 18 hours 35 minutes 43 seconds.

Moonwalk Relay

In October 2002, a relay team comprising Adam Hall, Ramsey Brookhart, and Joshua Dodd moonwalked 30 mi (48 km) from Boulder, Colorado, to Denver.

Juggling Heavyweight

Believe it or not, Bob Whitcomb, from Ohio, juggles bowling balls. He can catch three 16-lb (7.3-kg) balls 62 consecutive times.

EYE-BLOWING FEAT
By forcing air out of the tear ducts in his eyes, Alfred Langevin of Detroit was able to blow up balloons, smoke, and even blow out candles.

BACK-WALKING
Yvonne Burkett was so flexible that she could walk on her own back. This photograph shows her performing this feat in 1934.

STRONG TEETH
Sam Marlow of Chelsea, Massachusetts could lift a barrel of beer weighing 260 lb (118 kg) with his teeth whilst doing a handstand.

TOP-HEAVY
Johnny Eck was born in Baltimore without the lower portion of his body. He got around by walking on his hands, as seen in this photo, taken in 1937.

HAIR-RAISING
Joseph Green, from
Brooklyn, New York, was
known as "the man with
iron hair." His hair was
so strong that he could
use it to bend an iron bar.

CRAZY DRIVER
"Texas Zeke" Shumway of Dallas,
Texas, drove more than 50,000 mi
(80,500 km), both in cars and on
motorcyles, within an almost vertical
drome only 46 ft (14 m) wide.

MONSTER FISH
Herman Newber of New York
caught this ocean sunfish in
1932 when it got stranded in
shallow water. It weighed
more than 700 lb (318 kg).

Looking Back

September 1, 1925 Charles Coghlan returned home when a flood in Galveston, Texas,
washed him from his grave, took him around Florida, and up the coast to Prince Edward Island—
some 2,000 mi (3,220 km) away—where he used to live. **April 27, 1939 Mrs Earl Palmer**
miraculously survived when her jugular vein was slit and she didn't get treatment for 17 hours.

The Ice Man Swimmeth

Dutchman Wim Hof says that, like fish, his body contains a form of antifreeze. In 2000, he swam 187 ft (57 m) under ice in a lake near Kolari, Finland, wearing only trunks and goggles. Then, in 2004, he spent 1 hour 8 minutes in direct, full-body contact with ice.

Instant Beauty

"One-minute beautician" Uma Jayakumar can create a hairstyle using a hairpin in seven seconds. In July 2005, the Indian hairdresser created 66 hairstyles in a minute, using a chopstick.

Boat Pull

At the age of 65, Maurice Catarcio, from Middle Township, New Jersey, swam the backstroke while tugging an 80-ft (24-m) sightseeing boat across a lake. And at 72, the former wrestler dragged a 27,000-lb (12,247-kg) bus down a New York City street.

Look, No Hands!

At the 2002 X-games, Mat Hoffman, a 30-year-old BMX bike rider from Oklahoma City, performed the first no-handed 900, where the bike goes through 2½ spins.

Cold Comfort

Gilberto Cruz remained buried in ice for 1 hour 6 minutes 24 seconds at a Brazilian shopping center in 2005. The 42-year-old performed the stunt in a transparent box in the mall at Ribeirao Preto with only his head sticking out of the ice.

Religious Vision

Indian sculptor Rama Satish Shah makes intricate models of religious figures, while blindfold. Over the past five years, she has created 36,000 figures from plaster of Paris, ranging in height from ⅕ in (½ cm) to 9 in (23 cm). Each one takes her about three minutes to make.

All At Sea

★ When a Russian yacht lost its rudder in the Southern Ocean in 2005, the resourceful crew used a cabin door as a replacement.

★ In 1992, Kenichi Horie of Japan managed to steer a pedal boat 4,660 mi (7,500 km) from Hawaii to Japan. His pedal-powered voyage took him 3½ months.

★ A boat moored at Newport Beach, California, was sunk in 2005 when 40 invading sea lions piled on to it!

◀ Walking on Water

When Rémy Bricka first crossed the Atlantic in 1972, it was on board a luxury liner. For his second Atlantic crossing—16 years later—he decided to walk! The Frenchman set off from the Canary Islands on April 2, 1988, with his feet lashed to 14-ft (4.3-m) fiberglass pontoons. Behind him he towed a raft that contained a coffin-sized sleeping compartment, a compass, and water desalinators. He took no food, eating only plankton and the occasional flying fish that landed on his raft. Walking 50 mi (80 km) a day, he reached Trinidad on May 31, highly emaciated, and hallucinating, at the end of his 3,502-mi (5,636-km) hike across the ocean.

Tooth and Nail

Georges Christen, 43, is one of the world's strongest men. He can stop a plane from taking off with his teeth, pull trains, bend nails, and power a Ferris wheel—but insists he is a gentle giant.

What inspired you to become one of the world's strongest men?

"As a child in Luxembourg, I was fascinated by circus strongmen. Aged 16, I started lifting weights, and then I saw a French guy on television bending 50 iron carpenter's nails. I broke his record by bending 250 with my teeth when I was 19.**"**

What are your most famous stunts?

"I prevented three 110-horsepower Cessna Sport airplanes from taking off at full power—one with my teeth and two with my arms. I have also pulled trucks, buses, railway carriages, and a 95,000-kg ship— all with my teeth. At Luxembourg's Schobermesse fair, I made a 45-m, 60,000-kg Ferris wheel turn by pulling it with a rope by my teeth. And I like tearing telephone books—I can rip 1,344-page books into several pieces.**"**

Are your stunts dangerous?

"A favorite is blowing up a hot-water bottle until it bursts—the pressure could blow back into my lungs and kill me. But I train and calculate the risks.**"**

So how do you train—and how do you protect your teeth?

"I train every day—a mixture of physical strength and mental concentration to liberate all the force you need at one special moment. My teeth aren't perfect—when I was about 20, my dentist told me not to use my teeth in this way, but I did anyway and now he often comes to my shows because I'm good publicity for him! I used to work for an insurance company, but they won't insure me because they have no way of knowing how dangerous it is to prevent a plane taking off.**"**

What is the most difficult stunt to do?

"I can now bend 368 nails in one hour. And, although it's not as spectacular, the hardest one is tearing a deck of 120 playing cards, because they are small and hard to grip, and also because they are plastic-coated.**"**

How do you think of new stunts?

"I have a collection of books and posters of old-time strongmen, and I try to adapt their stunts for modern times. If they were holding back horses, I make it airplanes. I might lift a table with my teeth—and have a woman sitting on top.**"**

Has your strength ever got you into trouble?

"I try not to be a strongman in my private life—if people want to pick a fight, I tell them it's just my job. I once accidentally pulled the bumper off a car at a car show. And I also once unintentionally broke a 'test your strength' machine at a fairground.**"**

How long will you carry on testing your strength?

"I taught the telephone-book stunt to my office worker father, and he was still doing it when he was 94! I have bought an old blacksmith's forge and I'm turning it into a small museum full of things strongmen used to use and wear. People can come and train the way they did. My main vision now is to entertain.**"**

Beer on the Brain
A Wushu (martial arts) enthusiast performs a headstand on a beer bottle in Nanjing City, China, on May 3, 2005.

Climbing Granny
When 78-year-old grandmother Nie Sanmei accidentally locked herself out of her fifth-floor apartment in Changsha, China, in 2005, she started scaling the outside of the building! Using window grills as handholds and footholds, she reached the fourth floor before her concerned daughter-in-law arrived with the key.

Bird Man of Devon
When Jonathan Marshall goes hang gliding near his home, in Devon, England, he not only flies like a bird: he flies with birds. He has trained wild birds to join him in flight. Marshall became obsessed with the idea of flying with birds when he was eight years old and has spent the past decade training a few falcons to fly with him. "Flying with birds puts you right into their world," he says. "Up there, flying at 1,000 ft (305 m), I see everything from their point of view. How many people have that experience?"

Grape Catch
In 1991, in the town of East Boston, Massachusetts, Paul J. Tavilla, who is known as "The Grape Catcher," incredibly caught a grape in his mouth after it had been thrown by James Dealy from a distance of 327 ft 6 in (99.8 m).

Marathon Push
Rob Kmet and A.J. Zeglen, from Winnipeg, Manitoba, pushed a 2,600-lb (1,180-kg) sports car 43 mi (70 km) around Winnipeg's Gimli racetrack in 2005. At the end of the 24-hour push, the two men were hardly able to walk.

Car Jump
Believe it or not, Andy Macdonald once jumped over four cars on a skateboard! He made the jump of 52 ft 10 in (16.1 m) at East Lansing, Michigan, in 1999.

Blind Racer
Blind motorcyclist Mike Newman from Manchester, England, raced a powerful 1,000cc motorbike at speeds of up to 89 mph (143 km/h), guided only by radio instructions!

Mouth Control

Despite having no movement in her arms and legs, a British woman, Hilary Lister, was able to sail solo across the English Channel in August 2005 by steering her boat, *Malin*, with her mouth. Aged 33, Hilary controlled the boat by sucking and blowing on two plastic tubes connected to pressure switches that operated the tiller and sails. She navigated the 21-mi (34-km) voyage from Dover, England, to Calais, France, in a specially modified keelboat in 6 hours 13 minutes.

Hilary used a "sip and puff" technique to steer her boat.

Doug's Delight
In 2005, at the end of a 25-year marathon, Doug Slaughter, from Greentown, Indiana, finally achieved his goal of cycling 25,000 non-road mi (40,230 km). Doug had always wanted to bike the distance of the world's circumference, but because he was born with a mild handicap, he has never cycled on a road. Instead, he rode on driveways, parking lots, and forest trails, using an odometer to track his progress. He also used a stationary bike to cover some of the distance. Having achieved that target, Doug has no intention of stopping there: he's now aiming for 50,000 mi (80,465 km).

Juggling Jogger
Believe it or not, 33-year-old Michal Kapral, from Toronto, Ontario, ran a marathon in 3 hours 7 minutes in September 2005 while juggling three balls at the same time!

Driving **monster truck** **Bigfoot 14**, Dan Runte, from St. Louis, Missouri, jumped **202 ft** (62 m) over a **Boeing 727** airplane at Smyrna Airport, Tennessee, in 1999.

In the Dark
Teenage bowling champion Amy Baker, from Houston, Texas, has an unusual recipe for success—she practices blindfold. As soon as she started bowling wearing a dark eyemask—at the suggestion of her coach Jim Sands—her scores improved dramatically, enabling her to become a national champion.

Backwards Bob
Known to his friends as "Backwards Bob," Canada's Bob Gray can write backward and upside down with both hands simultaneously. He can also spell backward phonetically.

Ms. Dynamite
Protected by only a helmet and a flimsy costume, American entertainer Allison Bly has blown herself up more than 1,500 times with explosives equivalent to the force of two sticks of dynamite. "The Dynamite Lady" performs the stunt inside a box she calls the "Coffin of Death," but has so far suffered nothing worse than broken bones, concussion, and powder burns.

Young Soldier
Calvin Graham, the youngest U.S. serviceman in World War II, was wounded in combat, then later discharged for lying about his age—he was only 12 years old.

Fantastic Feet
Claudia Gomez of Baton Rouge, Louisiana, can use her feet to shoot a bull's-eye with a bow and arrow while doing a handstand!

Sporting Double
In October 2003, just 22 hours after making a hole-in-one at Pleasant View Golf Course, Paul Hughes, 74, of Waunakee, Wisconsin, bowled a 300 game at Middleton, Wisconsin.

Ear Power
A Chinese man is able to blow up balloons and blow out candles with his ears. Wei Mingtang, from Guilin City, discovered more than 30 years ago that his ears leaked, after which he came up with the idea of using them to inflate balloons with the aid of a pipe. And he once blew out 20 candles in a line in just 20 seconds using a hose attached to his ears.

Speedy Seventy
Ed Whitlock, aged 72, of Toronto, Ontario, Canada, became the first person over the age of 70 to run a marathon in under three hours.

Walking on Air
An Uygur tightrope walker spent a long 37 days and nights living on a 100-ft (30-m) high wire stretched across a dam in Nanjing, China, in May 2005. Thirty-two-year-old Aisikaier comes from a family of high-wire walkers, and had spent 26 days on a wire in 2004, but this time he managed to stay up longer. He spent his nights in a makeshift shelter attached to the thick wire. To kill time and alleviate the boredom during the day, he performed daring hula-hoop, unicycle, and balancing tricks. The only contact he had with the world below was via his cell phone, which he used so that he could answer questions about his feat, or talk to fans.

Sharp PRacTice

The daredevil ethnic games that took place in Guiyang, southwest China, in May 2005, were certainly at the cutting edge of sport.

The Miao people, whose favorite pastime is buffalo fighting, used the games to demonstrate their expertise at such feats as swallowing a red-hot sword and walking barefoot on the razor-sharp blade of a giant knife. Children got in on the act too, with a 10-year-old girl balancing delicately on the tips of knives. The opening ceremony was also a festival from the Dijon Arts, a group of Miao kung-fu artists performing a series of amazing stunts.

Standing on broken glass and walking on a series of knife points are two of the amazing feats in these unusual games.

Instead of using his hands, this man is swinging bricks around using his chest. They are tied to a needle that pierces his body.

174

This performer can be seen swallowing a red-hot sword as spectators look on.

As this Miao man inches along the edge of a giant knife, he stretches out his arms to balance.

◄ Marital Bliss

Zhang Jiuyu and Guo Changlan celebrate their marriage of 80 years 15 days in Shijiazhuang, China, on October 23, 2005. The 96-year-old couple have one child, three grandchildren, and three great-grandchildren.

Egg Catcher

Brad Freeman didn't end up with egg on his face in 2005. For the 25-year-old from Calgary, Alberta, caught a boiled egg in his mouth thrown from an amazing distance of 275 ft (84 m).

Karaoke King

Barry Yip, a D.J. from Hong Kong, spent 81 hours 23 seconds singing 1,000 karaoke songs.

Mule Train

Desperate to attend a 2005 Mule Days festival in Ralston, Wyoming, Pam Fedirchuck and Tara Lewis reckoned the only way to get there from their home in Rocky Mountain House, Alberta, was by mule. Riding two mules and leading a third that carried supplies, they made the 857-mi (1,380-km) trip in 52 days.

Oldest Ace

Aged 101, Harold Stilson became the oldest golfer to make a hole-in-one when he landed an ace at the 16th hole at Deerfield Country Club, Florida, in May 2001. A 27-handicap golfer, he started playing at the age of 20, but did not make the first of his six holes-in-one until he was 71.

Iron Bear

Harold "Chief Iron Bear" Collins, from Shannon, North Carolina, pulled a 22.87-ton truck 100 ft (30 m) in under 40 seconds in New York City in 1999. A full-blooded Lumbee Native American, Collins is certainly built for the part: he has a 63-in (160-cm) chest.

Viking Voyage

Robert McDonald aims to cross the Atlantic in a replica Viking ship made from 15 million ice-cream sticks held together by 2 tons of glue. The former Hollywood stuntman, from Florida, spent two years gluing together the sticks that make up the *Mjollnir* (*Hammer of Thor*), which is 50 ft (15 m) long. McDonald plans to sail the ship from Holland to Key West, Florida, via Denmark, Scotland, Iceland, Greenland, and Canada—the route the Vikings are believed to have taken to America 1,000 years ago.

The 15-ton ship will be powered by oars and a sail from a 30-ft (9-m) high mast.

Sweet Catch

One of the weirdest acts on the U.S. entertainment circuit features Scott Jeckel blowing marshmallows from his nose into the mouth of Ray Perisin, who then swallows them. The Illinois pair started performing their act with popcorn, but switched to marshmallows, as they were more aerodynamic.

Stair Crazy

Most people would take the elevator up an apartment block, but not Bernadette Hallfeld Duychak. She's crazy about climbing stairs! In August 2005, she climbed Harbor Point—her 54-storey condominium in downtown Chicago, Illinois—more than 55 times in 24 hours, making a total of around 40,000 stairs. "When I started, I could barely climb 20 floors. Now I climb at least 2,000 floors a week!"

◀ Incredible Hunk

Although he weighed only 88 lb (40 kg) at the age of 16, Dennis Rogers, from Houston, Texas, could lift twice his body weight over his head! Once the smallest boy in his class, Rogers, who weighs in at 160 lb (72.5 kg), is pound-for-pound the strongest man in the world. He can tear thick books vertically using only two fingers and can bend a solid steel bar around his neck into a U-shape. In 1995, he successfully prevented four Harley Davidson Sportster motorcycles, powered at full throttle, from moving for 12 seconds.

MUSEUMS
Surfer's Paradise

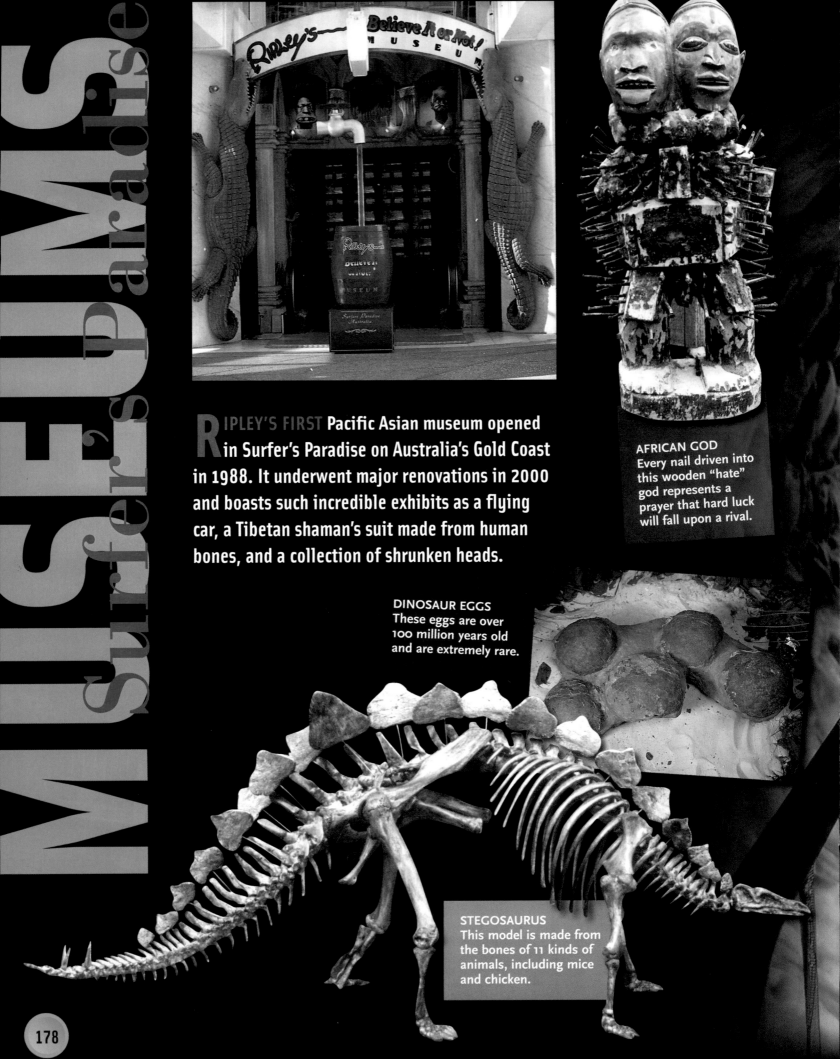

RIPLEY'S FIRST Pacific Asian museum opened in Surfer's Paradise on Australia's Gold Coast in 1988. It underwent major renovations in 2000 and boasts such incredible exhibits as a flying car, a Tibetan shaman's suit made from human bones, and a collection of shrunken heads.

AFRICAN GOD
Every nail driven into this wooden "hate" god represents a prayer that hard luck will fall upon a rival.

DINOSAUR EGGS
These eggs are over 100 million years old and are extremely rare.

STEGOSAURUS
This model is made from the bones of 11 kinds of animals, including mice and chicken.

GERMAN WOLPERTINGER
This mythological creature is part bird and part mammal. Its saliva is considered to be a powerful aphrodisiac.

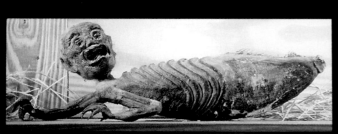

MERMAID
In 1842, when this fusion of a monkey and a fish was first exhibited to the public, many thought it was a real mermaid.

ROTATING TUNNEL
The rotating walls of this tunnel make those walking through feel like the floor is moving, even though it is still.

JUNK ART DUCK
Created by American artist Leo Sewell, this duck is made from a variety of pieces of junk.

DON'T MISS!

▶ Triceratops dinosaur skull

▶ A large turtle that was clamped on to a sea plane and taken for an aerial ride

▶ Narwhal tusk

▶ Robert E. Lee paddlewheeler made from matchsticks

▶ Human dentures made from dolphin and crocodile teeth

▶ A flying car

▶ Portrait painted on a housefly

ASARO NATIVE DANCE MASK
Worn in New Guinea, "Mud Men" masks are believed to transform the wearer into an invincible spirit.

179

Handicap Golfer

A Florida golfer achieved three holes-in-one over a six-month period—all while swinging one-handed! Sixty-eight-year-old Bill Hilsheimer, from Nokomis, lost most of his right hand in a childhood accident, and uses only his left arm when he swings. But after waiting 50 years for his first ace, he racked up three between September 2003 and March 2004. The odds of an amateur golfer hitting a hole-in-one are 12,600 to 1. The odds of Bill's feat would be impossible to calculate.

Jill Drake of KENT, England, won a contest for the loudest screamer, with a scream of 129 decibels— that's as loud as a pneumatic drill.

Human Cartoon

New Yorker Rob Lok is known as "The Human Cartoon" because he is able to smash a watermelon with his head!

Biker Marathon

In May 2002, British couple Simon and Monika Newbound set off from Dublin, Ireland, on a monumental motorcycle journey that would take them more than three years. By May 2005, the pair had clocked up visits to 54 countries and had ridden an amazing 105,000 mi (169,000 km). As well as circumnavigating the world, they rode north of the Arctic Circle three times on three different continents, crossed the U.S.A. from coast to coast five times, and visited every U.S. state and Canadian province. They rode 1,600 mi (2,600 km) off-road in Mongolia, had an audience with the Pope in Rome, and camped on the Great Wall of China.

▲ Ear-lifting

Zafar Gill, from Pakistan, lifted an ear-bending 121 lb (55 kg) and held them for 12.22 seconds suspended from one of his ears! He successfully completed this amazing feat in Germany, in November 2005.

Egg-head

New Yorker Barnaby Ruhe can throw a boomerang on a 100-ft (30-m) elliptical path so that it returns to hit an egg that he has carefully placed on top of his own head! Ruhe has made more than 100 successful hits and has been whacked only a few times. He says of his eggsploits: "What you throw out is what you get back."

Globe Trotter

In three years of travel between 2000 and 2003, Charles Veley visited a staggering 350 countries, enclaves, islands, federations, and territories, spending over $1 million on journeying almost a million miles. His most difficult destination was Clipperton Island, a remote French territory 700 mi (1,126 km) off the coast of Mexico in the Pacific Ocean. Owing to a treacherous reef, his boat was unable to land, forcing him to swim to shore. "There was nothing else I could do," he smiles. "By then I was obsessed with completing my goal."

S Hard to Swallow

Stevie Starr, a 34-year-old Scotsman, is a professional regurgitator. He swallows such objects as light bulbs, coins, live goldfish, and glass eyes before bringing them back up again.

Having swallowed the goldfish with plenty of water, Stevie safely retrieves them.

Stevie also swallows butane and soap, and then blows out a gas-filled bubble. He swallows a ring and locked padlock—when the articles are returned, the ring is locked inside the padlock! When Stevie swallows numbered coins, he can retrieve them at will, and in whichever order the audience requests.

He learned his talent while living in a children's home in Glasgow, Scotland. "I used to swallow pennies to hide them from the other kids... I didn't realize that someday I'd be doing it for a living."

Stevie regurgitates dry sugar after having previously swallowed a bowlful with a glass of water.

181

Super-fit
In June 2005, at Hartford, Connecticut, Bill Kathan Jr., from Vermont, became the first person in the world to do more than 100 backhanded push-ups in one minute. "Wild Bill," as he is known, proved he was super-fit by performing 109 backhanded push-ups in the 60-second limit.

Blinding Speed
In September 2005, Hein Wagner, 33, of Cape Town, South Africa, drove a car at a speed of 168 mph (270 km)—even though he has been blind since birth.

Pacific Crossing
Steve Fisher from Toledo, Ohio, crossed the Pacific Ocean from California to Hawaii in 1997 on a 17-ft (5.2-m) windsurfer. The 2,612-mi (4,200-km) journey on *Da Slippa II* took him 47 days.

Escape Artist
Queensland-based escape artist Ben Bradshaw freed himself from a straitjacket while fully submerged in a tank of water in just 38.59 seconds in Sydney, Australia, in April 2005.

Gran Tour
A Californian grandmother completed a journey down the west coast of North America in 2002, riding solo on an 11-ft (3.4-m) watercraft. Jane Usatin, 56, from Carlsbad, set off from Blaine, Washington, and reached Mexico 28 travel-days later at the end of a 1,828-mi (2,941-km) trip.

Ball Tower
In November 1998, David Kremer, of Waukesha, Wisconsin, stacked ten bowling balls vertically without using any adhesive.

Mexican Wave
An amazing 42 Brazilian surfers rode a wave together on Macumba Beach in Rio de Janeiro on November 18, 2005.

American Odyssey
In June 2005, Jason Hill climbed on his bike in Deadhorse, Alaska, and began pedaling. By January 2006, he had reached Missoula, Montana, but his ultimate destination is Tierra del Fuego in Argentina. He reckons the 19,000-mi (30,600-km) journey, from the Arctic Circle to the very bottom of South America, will take him more than two years.

Saddle Weary

In April 2005, Randy Davisson, from Decatur, Alabama, succeeded in his mission to ride the same horse in every state in the U.S. and in each Canadian province and territory. The quest, on his faithful appaloosa Eli Whitney, took Randy nearly five years to complete and finished when he climbed into the saddle on the island of Oahu in Hawaii.

Randy and Eli stopped for pictures outside post offices along the way.

Up and Down
Robert Magniccari of Rockaway, New Jersey, made 190 take-offs and landings in 24 hours at two airports in New Jersey.

Tour of America
Don Boehly, of Grayson, Kentucky, set off in September 2004 aiming to cycle through the 50 U.S. states. He expects to complete the 25,000-mi (40,000-km) trip in 2007.

Wheelbarrow Push
In 1975, Rev. Geoffrey Howard, a priest from Manchester, England, took 93 days to push a Chinese sailing wheelbarrow 2,000 mi (3,218 km) across the Sahara Desert.

Generous Donor
Frank Loose of Germany donates blood every week and has given more than 800 times.

Sharp Practice
Red Stuart from Philadelphia, Pennsylvania, swallowed 25 swords at once in September 2005! The result of years of training, his intake consisted of a 32-in (80-cm) long broadsword plus 24 smaller swords 18 in (46 cm) in length.

Chin Up
In December 2003, David Downes, of Felixstowe, England, balanced an open ironing-board on his chin for 3 minutes 32 seconds.

Crazy Golf
When Dave Graybill said he was off for a round of golf in 2003, he wasn't planning on playing any ordinary course. The Glendale, Arizona, firefighter had designed a golf course 4,080 mi (6,566 km) long that would take him right across the U.S.A. The first tee was on Santa Monica Pier, California, and the 18th hole was in Central Park, New York. The round took seven months, through 16 states, and incorporated some of the best-known U.S. landmarks. He hit balls through deserts, across rivers, down streets, even out of an airplane!

House Hole

A family in Waihi, New Zealand, escaped without injury after their house fell into a hole 50 ft (15 m) wide in the middle of the night!

Lucky Numbers

Kris Wilson spends two hours a day writing numbers on notepads as part of his ultimate goal to become the first person in the world to write by hand every number from one to a million. Wilson, from Provo, Utah, began his challenge in February 2004. Eighteen months later he had reached nearly 600,000. His numbers are for sale—people buy anniversary and birthday numbers, and get a certificate signed by "Mr. Million" himself.

❂ Nail Suspension

Harley Newman can suspend himself on just four nails—a variation on the normal bed of nails. Nothing seems to faze him. The U.S. performer can pick combination locks with his teeth by feeling the numbers with his tongue, and has had concrete blocks broken on his face with a sledgehammer. He has also supported a 1,700-lb (771-kg) human pyramid while lying on a bed of nails, and can even escape from a quarter of a mile of plastic food wrap, while holding his breath.

Baby Walker

Believe it or not, a four-year-old Chinese girl can walk 300 ft (91 m) along a tightrope, suspended 100 ft (30 m) above ground level! Yin Feiyan, from Anhui province, has been tightrope walking since she was two.

Australia's **R.J. Brunow** performed **64 consecutive 360-degree spins** (donuts) in a **Holden Gemini** car at **Queensland Raceway** in May 2005. He **destroyed** a brand new **set of tires** in the process.

Dancing Feet

U.S. entertainer David Meenan managed to tap dance 32 mi (52 km) in 7½ hours at Red Bank, New Jersey, in October 2001.

Ancient Wheel

Archeologists in Slovenia have discovered a wheel that is between 5,100 and 5,350 years old—it is believed to be the oldest ever found.

Back Flip

Josh Tenge from Incline Village, Nevada, performed a back flip measuring 44 ft 10 in (13.7 m) in length on a sandboard in 2000.

Jumping Granny

Thelma Tillery believes in keeping her word. She promised her grandson that she would make a parachute jump when she turned 85, so she did just that. In September 2005, the skydiving grandmother landed safely at Kearney, Nebraska.

Fjord Rescue

Inge Kavli, age 73, dove into a fjord in Norway and swam out 66 ft (20 m) to rescue a baby boy after his mother accidentally crashed her car into the water.

My Left Foot

When Tad Lietz, from Appleton, Wisconsin, plays the cello, it is a considerable achievement—not only because he's an accomplished cellist, but also because he is missing his left arm and bows with his left foot.

Wheelie Fast

In March 2005, Australia's Matt Mingay reached a speed of 140 mph (225 km/h) doing a motorbike wheelie over a distance of 0.6 mi (1 km) at Temora Aerodrome, New South Wales.

IN DEPTH

Paintball Wizard

Australian martial-arts expert Anthony Kelly, 41, has such quick reactions that he can catch flying arrows and punch faster than Muhammad Ali in his prime—as well as catch speeding paintballs blindfold.

How did you first develop your quick reactions?

❝I grew up watching martial-arts star Bruce Lee and boxer Muhammad Ali and was fascinated by how fast people could move. I have trained all over the world and have black belts in seven martial arts. I developed the world's first electronic device for testing reaction speeds, based on a traditional Chinese wooden dummy. My reaction time was under three hundredths of a second. **❞**

When did you start to catch things?

❝In 1999, I saw an old kung-fu movie where the hero had to catch an arrow. I learned how to do this within a week. I can now catch 38 arrows from three archers in two minutes at a distance of eight meters. **❞**

How did you get the idea to catch paintballs?

❝A student at my martial-arts center in Armidale, New South Wales, owned a paintball field. He said 'Okay, you can do arrows, how about paintballs?' My record now stands at 28 caught unbroken at 20 meters in two minutes, and 11 caught blindfold in the same conditions. **❞**

How dangerous is it?

❝They shoot the paintballs through a paintball gun at a minimum speed of 240 feet per second—around 70 balls in two minutes. They're really painful, like a cricket ball coming at you at speed, and when I go for a record I'm black and blue. Once an arrow nearly went through my head—it took everything I had to block it. It's stupid to do it, I guess. **❞**

Do you have a special technique?

❝I'm very in tune with sound. I can get a stopwatch and tell you if it is two or three hundredths of a second between the beeps. So when I catch paintballs blindfold, I can tune into the noise and then bring the ball towards me, slowing its velocity down in milliseconds. **❞**

How fast can you punch?

❝I hold the record for most punches in one minute, which is 347, and the most in one hour, which is 11,856. I punch on average ten punches per second—Bruce Lee could supposedly do eight, Muhammad Ali six or seven. **❞**

How do you train?

❝Every day I do crazy things, like trying to slide into a shop door as it's closing. My diet is quite strange in that I only eat meat and potatoes and have never eaten fruit or vegetables—I don't know if that makes a difference! **❞**

Do you use your skills in other areas?

❝I travel the world doing T.V. appearances of my skills, and am the world's leading reaction training coach. I am also a full-time martial arts instructor. **❞**

Do you have any future projects?

❝I'm working on how fast the body can go. I have taken the old martial-arts stunt of breaking a board one step further—I suspend three boards together, and can break the middle board while the outside boards stay intact. Experts can't work out how! The old masters believed noise could implode human organs, but that's a difficult one to test—so far I'm sticking to breaking balloons! **❞**

Backwards Biker
Roger Riddell, from Charlotte, North Carolina, jumped over six cars while sitting backwards on his Harley Davidson motorcycle, in the town of Yakima, Washington State, in 2003.

In Reverse
American Steve Gordon unicycled backwards for an amazing 68 mi (109 km) in Springfield, Missouri, in June 1999.

Sew Clever!
Despite being unable to use her arms and legs, American Sapna Goel still manages to paint and sew unassisted. Sapna, who contracted polio when young, has developed the amazing ability to thread a sewing needle with her tongue.

High Jump
New Zealander A.J. Hackett jumped 764 ft (233 m) from the Macau Tower on August 17, 2005. He is estimated to have hit speeds of more than 95 mph (150 km/h) during the 20-second descent. Hackett was tied on to a special cable that dramatically slowed his rate of descent once he was just 33 ft (10 m) above the ground, to allow for a safe landing.

Living Underwater

Two Italian divers spent ten days living underwater in September 2005. Stefano Barbaresi and Stefania Mensa endured cold, fatigue, and, ironically, dehydration to live at a depth of 26 ft (8 m) on the seabed off the island of Ponza, Italy. They slept beneath bedframes, which were turned upside down to stop the sleeper floating upward, and spent most of their time in their underwater "house," that contained two sofas, an exercise bike, books, and a waterproofed television.

Cast Adrift

Fishermen Lafaili Tofi and Telea Pa'a from Western Samoa, survived for six months after drifting 2,480 mi (3,990 km) in the Pacific Ocean in a small metal boat.

Scientists in AUSTRALIA used a **laser** to **sculpt** a replica of the **Sydney Opera House** that was so **small** that it appears as a **speck of dust** to the naked eye.

Camel Vaulting

At the 2004 Yemeni Traditional Sports Festival, Ahmed Abdullah al-Abrash was crowned world camel-jumping champion after using a trampoline to vault over a line of camels 10 ft (3 m) long.

World Trek

On June 20, 1970, brothers David and John Kunst set off from their hometown of Waseca, Minnesota, aiming to become the first people to walk around the world. Four years, 3 months, and 21 pairs of shoes later, David completed the 14,450-mi (23,255-km) trek (he flew across the oceans), arriving back in Waseca with mixed emotions. Sadly, his brother had been killed by bandits in Afghanistan only halfway through the expedition.

All of a Quiver

Terry Bryan from Colorado Springs, caught an arrow traveling 135-mph (217-km/h) with his bare hands on an edition of the *Ripley's Believe It or Not!* TV show. Not only did he successfully complete the challenge, he went on to do it again—blindfold!

Bit by Bat

Jeanna Giese of Wisconsin became the first documented person to survive rabies without being given a vaccination! A bat bit the 15-year-old girl in September 2004.

Chopper Bike

Believe it or not, Las Vegas stunt rider Johnny Airtime once jumped his motorcycle over the spinning blades of four helicopters!

Speed Jumping

Forty-seven-year-old Jay Stokes from Arizona made no fewer than 534 successful parachute jumps in 24 hours at Lake Elsinore, California, in November 2003. With the help of three pilots working in two planes in rotating two- to three-hour shifts, he was able to average just under 2 minutes 45 seconds per run.

BOONTHAWEE SEANGWONG and Kanjana Kaetkeow tied the knot on Valentine's Day on February 14, 2006 at Pattaya beach resort in Thailand. The highlight of the Thai wedding, complete with chanting monks, centipedes, and scorpions, was that the "wedding room" took the shape of a coffin. The bride's 32 days spent in a plastic cage with 3,400 scorpions in 2002 can only be matched by the groom's 28 days in a cage with 1,000 centipedes in 2003.

SIMPLY

UNBELIEVABLE

SouNds CRazy

IF KEN BUTLER'S COLLECTION of musical instruments doesn't strike a chord with some listeners, it's hardly surprising. Ken dismisses conventional instruments in favor of the toothbrush violin, the golf-club sitar, or the hockey-stick cello.

New Yorker Ken created his first hybrid instrument in 1978 by adding a fingerboard, tailpiece, tuning pegs, and a bridge to a small hatchet, which he then played as a violin. The success of his ax violin led him to create more than 200 additional wacky instruments from such diverse objects as bicycle wheels, umbrellas, shotguns, and snow shovels. He usually chooses objects that are of roughly similar shape or proportion to the instrument that they then become.

The American musician and visual artist, who studied the viola as a child, has seen his creations displayed in museums and galleries in Peru, Europe, and Tokyo, as well as in several Ripley's museums. In 1997, he released an album—*Voices of Anxious Objects*—and he has performed with ensembles playing 15 of his instruments.

Ken can conjure up a tune out of just about anything. Here he demonstrates his prowess playing the bicycle wheel.

Musician Ken Butler, surrounded by some of his wacky instruments, including a hockey-stick cello in the top row.

To decide what would make a good instrument, Ken Butler seeks out objects that are relatively strong, but also relatively lightweight, and that allow for the placement of tuning pegs and strings.

Lightning Conductor

With Carl Mize, lightning doesn't just strike twice—it's struck four times already! In 2005, Mize was hit for the fourth time, while working on the University of Oklahoma campus. Mize was hospitalized for four days before being discharged.

Bulletproof Case

British manufacturers have devised a special bulletproof briefcase. If the user is fired at, the brown leather case can be flipped open and used as a shield able to withstand handguns up to a .44 Magnum.

Pumpkin Paddlers

Howard Dill grows pumpkins partly for their seeds and partly for carving out for racing. He cultivates an oversized variety of pumpkin called Atlantic Giant, and after selling the seeds he donates the hollowed-out fruit for use in the famous annual pumpkin paddling regatta at Windsor, Nova Scotia, Canada. In the 2005 event, 40 competitors paddled their way across Lake Pesaquid while sitting in pumpkins that weighed more than 600 lb (272 kg). The winner usually manages to get round the course in about 10 minutes.

Mitch Maddox, of **DALLAS, Texas**, legally changed his name to "**DotComGuy**" and lived for an *entire year* by buying *everything* he needed off the Internet!

Lifted Car

Despite fracturing her spine and damaging two vertebrae in a car crash near Washington, England, Kyla Smith managed to lift the one-ton car—about 20 times her own weight—6 in (15 cm) off the ground in the attempt to free her trapped friend.

Uninvited Guest

When Beverly Mitchell returned to her home in Douglasville, Georgia, after two weeks' holiday, she discovered that the lights were on and a strange car was parked in her driveway. Another woman, a stranger, had moved in, redecorated the rooms, and was even wearing Mitchell's own clothes.

Flying Nun

Madonna Buder has definitely got the triathlon habit. As well as being a Canadian record-holder and Ironman legend, she leads a quieter life as a Roman Catholic nun. Now in her seventies, Sister Madonna, from Spokane, Washington, has completed well over 300 triathlons. She took up running in 1978. Before entering her first Boston marathon, she sought permission from the local Bishop to take part.

🔵 Mind-bender

Magician Paul Carpenter, from Houston, Texas, performs the art of psycho-kinetics, or metal bending, wowing audiences across the United States.

Long-life Bread
Vivien Anderson from Cambridgeshire, England, holds a bread roll that dates from World War I! It was given to her grandfather in a ration pack while he was serving in the conflict. Handed down through the family, the roll is estimated to be about 90 years old.

Ice Fall
Although it was a warm summer's day, a cricket match near Faversham, England, was interrupted in 2005 when a huge chunk of ice fell from the sky and exploded onto the field. At the time, the sky was cloud-free and there were no aircraft in sight.

Perfect Present
Helen Swisshelm received the best Christmas present in 2001—a class ring that she had lost 53 years earlier! She last saw the gold-and-onyx ring in 1948 while swimming with friends in the Hudson River near her home in Cohoes, New York. She gave up hope of ever seeing it again until, over half a century later, she received a call at her home in Lutz, Florida, from a nun at the Catholic school she had attended in Albany. A man with a metal detector scouring the Hudson had found a 1948 class ring bearing the school's shield and, via initials on the ring, the nuns matched the year and letters to Mrs. Swisshelm.

High and Dry
A seal was left high and dry when he found himself stranded on top of a post off the coast of Scotland. He had to wait nine hours before the tide came back in sufficiently for him to roll back into the water.

Bullet Surprise
After waking up with a headache, swollen lips, and powder burns in June 2005, Wendell Coleman, 47, of Jacksonville, Florida, went to hospital, where doctors found a bullet embedded in his tongue. Coleman didn't even know he'd been shot.

House Spared
A houseowner in California must be the luckiest in the world. When the fires that devastated 663,000 acres (268,300 ha) of southern California in 2003 reached the wealthy suburb of Scripps Ranch, 16 mi (26 km) from San Diego, flames destroyed every house in the street except one.

Smoking Nest
Fire chief Donald Konkle, of Harrisburg, Pennsylvania, decided that a house fire had been started when a bird picked up a smoldering cigarette while building its nest!

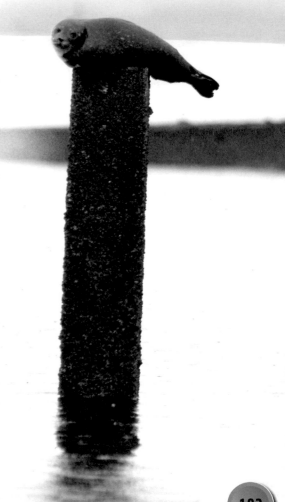

Strong Boy
When Rique Schill, from Jamestown, North Dakota, was pinned under the family Ford in 1984, his nine-year-old son Jeremy lifted the 4,000-lb (1,814-kg) car despite weighing only 65 lb (30 kg) himself.

Caught on Camera
Michael Adams, from Manchester, England, chose an unwise target to rob—a shop specializing in security cameras. His raid was caught on eight different CCTV cameras!

Car Plunge
In 2004, a car containing four teenage girls plunged over a 108-ft (33-m) cliff in Britain and flipped over three times before landing upright on rocks just a few feet from the swell of a raging sea. Incredibly, the girls' worst injury was a broken ankle.

Static Spark
In 2002, Bob Clewis, 52, of San Antonio, Texas, survived a gas station explosion after a simple spark of static electricity from his jacket ignited and engulfed him in flames.

Two Lauras

In June 2001, when Laura Buxton, from Staffordshire, England, released a balloon at her tenth birthday party, it traveled 140 mi (225 km) before being found in Wiltshire, England, by another ten-year-old girl, Laura Buxton! Not only did the girls share the same name and age, but they discovered they also had the same hair color and owned the same kinds of pet—a dog, a guinea pig, and a rabbit.

When **Harry Dillon**, aged 71, sent out a letter addressed with **nothing** but a former comrade's **name** and a **guessed city**, the British ex-soldiers were **reunited** after **50 years**!

Missing Pen

In 1953, Boone Aiken lost his engraved fountain pen in Florence, South Carolina. Three years later, while in New York City, Mrs. Aiken spotted a pen on the street next to their hotel. It was the lost one.

Wallet Recovered

When James Lubeck's wallet slipped from his pocket into Marblehead Harbor, Massachusetts, in 1966, he never expected to see it again. But in August 2005, he heard from Antonio Randazzo, who had hauled in the wallet's collection of credit cards in a netful of cod, flounder, and haddock 25 mi (40 km) away from where Lubeck had lost it.

Same Birthday

Four generations of one family from Brisbane, Australia, share the same birthday—August 1. Norma Steindl was born on August 1, 1915; her son Leigh on August 1, 1945; Leigh's daughter Suzanna on, August 1, 1973; and Suzanna's son Emmanuel on August 1, 2003.

Holding On

Skydiver and sky-surfer, Greg Gasson regularly performs amazing stunts in the air. Here he hangs precariously over Eloy, Arizona, holding on by only one strap of his parachute, thousands of feet above the ground.

Christmas Cheer

When Matilda Close was born on Christmas Day 2003, in Victoria, Australia, believe it or not, she was the third generation of her family to be born on December 25! Her mother Angela and her grandmother, Jean Carr, were both born on Christmas Day.

Heart-stopper

While remodeling his bathroom in 2005, Nigel Kirk, from Burton-on-Trent, England, came within 0.04 in (1 mm) of dying after accidentally shooting himself in the heart with a nail gun. As he worked, 53-year-old Nigel slipped and managed to fire a 2-in (5-cm) steel tack straight into his heart. Luckily, the tack hit hard scar-tissue that had built up from an illness he had suffered from 30 years earlier and just missed his vital heart vessels.

Chewing Chalk

Rena Bronson, of Macon, Georgia, has a weird food craving—she eats chalk every day! She has been devouring chunks of the white clay called kaolin since 1992. Although it has made her constipated, she says that she likes the creamy consistency in her mouth.

Desert Ordeal

Max, a one-year-old golden retriever, survived after spending 3 weeks and 3 days stranded in the Arizona desert in 2005. Max ran off after his owner Mike Battles's truck was involved in a road accident. The dog was eventually found lying under a bush.

Double Birth

Twins Mary Maurer and Melanie Glavich gave birth to sons 35 minutes apart in 2005. They had the same due date, May 27, but both sisters went into labor early. They delivered in adjoining rooms at the same hospital in Middleburg Heights, Ohio.

HeaDLeSs FoWL

ON SEPTEMBER 10, 1945, farmer Lloyd Olsen chopped off 5½-month-old Mike's head with an ax in readiness for the cooking pot, but the headless rooster continued pecking for food around the farm at Fruita, Colorado!

Olsen visited Los Angeles, San Diego, Atlantic City, and New York working the sideshows with his "Wonder Chicken" Mike.

Olsen decided to spare Mike and began feeding him grain and water with an eyedropper. Although most of Mike's head was in a jar, part of his brain stem and one ear remained on his body. Since the majority of a chicken's reflex actions are controlled by the brain stem, Mike was able to function relatively normally.

Over the next 18 months, the chicken's weight increased from 2½ lb (1.1 kg) to 8 lb (3.6 kg) and, insured for $10,000, Mike toured the U.S.A. as the "Wonder Chicken," with Lloyd charging 25 cents for a peek. Finally, he choked on his way back from an appearance in Arizona. Olsen was unable to find the eyedropper used to clear Mike's open esophagus and Mike died.

Mike the Headless Chicken would "peck" for food and "preen" his feathers, just like the other chickens on the farm.

Surprise Mail

Former Polish soldier Karol Brozda, 79, now living in the Czech Republic, holds up a letter he sent to his parents from a U.S. prison camp in France in February 1945, assuring them that he was alive. His parents received the letter in March 2005!

Brozda's letter took a staggering 60 years to arrive.

Insect Invasion

In November 2004, tourists holidaying in the Canary Islands, which lie off the northwest coast of Africa, received a shock when they were joined on the beach by a swarm of approximately 100 million pink locusts. Many of the migrating insects didn't live long enough to enjoy the scenery, however, having suffered broken legs and battered wings while crossing the sea in high winds and heavy rain.

Unwanted Gifts

Horst Lukas, of Iserlohn, Germany, was sent 12 bicycles, four boats, a mobile home, and dozens of tickets for rock concerts after a hacker spent $500,000 on eBay using his name.

Fruit Fight

Every year, villagers at Ivrea in northern Italy re-enact a medieval battle by dressing up as soldiers and pelting each other with oranges!

Croc Attack

Shelly Hazlett has had 29 operations since being savaged by a huge crocodile during a show at her uncle's croc park in Australia. When Shelly slipped in mud, the reptile clamped its jaws on her lower torso and let go only when her father gouged out its eyes.

Magnetic Power

Erika zur Stimberg is irresistible—to forks, spoons, and frying pans, which for the past 12 years have been flying toward her and sticking to her body. Doctors, in Brakel, Germany, are at a loss to explain her magnetism.

♥ Bendy Bodies

Contortionists with the State Circus of Mongolia perform extraordinary feats by bending their bodies into seemingly excrutiating shapes. Their limbs and joints are so flexible that they are able to bend into extreme positions.

Favorite Drink

A family in Cheshire, England, are so addicted to the fruit-cordial drink Vimto that they have a subterranean tank of the stuff in the garden. Pipes carry the liquid from the tank to the kitchen, where it is available on tap.

Experiencing blurry vision, **Patrick Lawler,** of DENVER, Colorado, went to a dentist in January 2005, only to learn that he had shot a **4-in (10-cm) nail** through his mouth into his skull with a **nail gun!**

Shrimp Shower

It rained shrimp on Mount Soledad, California, in April 2005. Hundreds of the tiny crustaceans fell from the sky during a storm. Experts said that juvenile shrimp frequently gather together in large numbers in shallow water during rough weather out at sea and that they had probably been carried inland by a sea spout.

Angel Camera

Laurie Robinson is no ordinary photographer. She likes to take pictures of tombstones in cemeteries in Los Angeles, California. And when she has her prints developed, ghosts and angels mysteriously appear in the photographs. She believes that the spirits show up in her pictures because of the positive energy she sends out.

Crushing Blow

Two men escaped from a Kentucky jail in 2005 and hid in a garbage truck—only for their bodies to be discovered in a nearby landfill the following day. The jailbirds hadn't realized that, to prevent exactly this kind of escape, the prison requires that all garbage be compacted twice before it leaves the grounds.

Lion Guard

Believe it or not, a 12-year-old Ethiopian girl owes her safety to a pack of lions. The girl was abducted in June 2005 by seven men who wanted to force her into marriage, but the kidnappers were chased away by three lions that amazingly then stood guard over the girl for at least half a day. A police sergeant said: "They stood guard until we found her and then they just left her like a gift and went back into the forest. Everyone thinks this is some kind of miracle." A wildlife expert suggested that the girl's crying might have been mistaken for the mewing sound of a cub, which would explain why the lions didn't eat her.

▶ Not Strictly Ballroom

MS DanceR is a robotic dance partner that has been manufactured in Japan. The robot's memory holds the waltz pattern, predicting the next step of the dance and following a human lead, but it can also sense pressure in its arms and back in order to stay in sync with its human partner.

Shocking Experience

A man built up at least 30,000 volts of static electricity in his jacket simply by walking around the Australian city of Warrnambool, Victoria, in September 2005. Frank Clewer left a trail of scorch marks, carpet burns, and molten plastic behind him.

GALLERY
back to the archives

MUSICAL MAESTRO
Mort Mortensen of New York could perform two different piano pieces on two pianos, at the same time. At his peak, he could do this trick blindfold with a cloth over each keyboard and wearing gloves.

ARMLESS HUNTER
Despite being born without either of his arms, J. Oscar Humphrey became the best bird-hunter in the state of Arkansas.

ALL BUTTONED UP
Professor Leo Kongee could sew buttons to any part of his body, including his tongue, as seen here, as well as put skewers through his chest, cheeks, and ears. This photograph was taken in 1932.

BACKWARD HOOLA
At the age of just ten, Joyce Hart, of New Jersey, could do a backward somersault through two hoops.

198

TRUNK ROAD
In 1934, a fallen redwood tree, which was about 2,000 years old, was converted into an auto highway in the Giant Forest, California.

CORN LADY
In 1938, Virginia Winn, of Texas, stitched 60,000 grains of corn onto an evening dress, one by one. The gown weighed 40 lb (18 kg).

TIGHTROPE FLYER
Aviator Gus Manhart got himself stuck on some high-tension wires shortly after take-off, but, luckily, he was able to climb out unharmed.

WATER-LOGGED
A tree spouting water was found in Fort Defiance, Virginia. This photograph was taken in 1932.

Looking Back

January 26, 1917 Matilde Kovacs burned her 500 million kronen legacy the day before she died just to spite her heirs. **October 20, 1927** Susan D. Marcich, of Chicago, lost all her hair in one night—she had gone to sleep with a full head of hair, but when she awoke there was no trace of it. **May 14, 1849** Black rain fell over an area of 400 sq mi (1,036 sq km) in Ireland.

◄ **Ghost Radar**
This pocket-sized gadget aims to help people avoid "other-world" spirits. Shown here being used in a Tokyo cemetery, it claims to detect "unknown energies, ghosts, and spirits," by sensing tiny variations in magnetic turbulence, light, and temperature, and then giving position and movement. Instructions contain details on eight types of specter that range from harmless lost souls stuck in this world to evil spirits.

Dozed Off
A cargo plane circled for more than half an hour in March 2005 because an air-traffic controller at Nice Airport, France, had fallen asleep.

Old Neighbor
Gilbert Fogg of Nettleham, England, discovered that his neighbor Tom Parker was actually a long-lost comrade from World War II, whom he thought had died in battle!

Bail Blunder
After being arrested for possession of counterfeit money in 2005, fraudster Darrell Jenkins from Springfield, Massachusetts, tried to pay his $500 bail using fake notes!

Dog's Dinner
A man from Schaarbeek, Belgium, set his apartment on fire in April 2005 after trying to cremate his pet dog on a barbecue and using too much gasoline!

Tea Thief
A man who stole a tractor-trailer truck in Washington State in 2005 had to call 911 for medical help after drinking from a cup he found in the cab. What he thought was a refreshing drink was in fact the truck driver's tobacco spit!

Happy Accident
Eddie May Jr., of Georgia, choked on a piece of food while driving, blacked out, then hit a passing car. The impact knocked the food from his throat and he awoke uninjured!

Pot Shot
While sitting on the toilet in April 2005, an off-duty Texan police officer accidentally shot a man. Officer Craig Clancy was answering a call of nature in San Antonio when his gun fell from its holster as he pulled down his pants. In trying to catch the gun, he grabbed the trigger and fired two bullets, one of which went through the cubicle wall and grazed the leg of a man who was washing his hands at the time.

▶ **King of Cubes**
Believe it or not, 14-year-old Shotaro Makisumi, of Japan, can solve a "3 x 3 x 3" Rubik's cube puzzle in a mere 13.72 seconds.

Incriminating Evidence
After ordering a pizza and asking for a job application form, a man suddenly produced a gun and robbed a Las Vegas pizza parlor of $200 in June 2005. But police didn't have to do much detective work to catch him. He left behind the partially completed form, which included his name and address.

IN DEPTH
The Great Escape

The Dark Master of Escape, Canadian Steve Santini, 42, also known as "The World's Most Extreme Escape Artist," puts the fear back into escapology with his blend of heavy metal and medieval torture.

How did you become interested in escapology?

❝I did a book report for school on Houdini, and then started to experiment on my own. There were no instruction books—my parents kept getting calls: 'Your kid's jumping into our pool wrapped in bike chains.'❞

How did it develop?

❝I broke out of my first jail cell at a police station when I was 14 (I was put in there voluntarily!). I used to buy up old cuffs and locks, rip them apart, and see how they worked. I didn't know trick locks existed—I just learned how to defeat normal mechanisms.❞

Have you ever feared for your life during a stunt?

❝On New Year's Eve 2005, when I performed the Cremation Chamber. It was watched by an audience of 35,000 people and 15 million live on television—the most ever to witness a single escape. I was in a vault with walls just one-eighth of an inch thick, and I was handcuffed and padlocked to a chain welded inside the door. On three sides of the vault were propane flame throwers—I was supposed to be out within one minute, when the temperature hit 400°F and the air became unbreathable. But one of the cuffs jammed, and I had to hold my breath until I could break free.❞

What other escapes have you performed?

❝Lots—my favorites include escaping from a nailed and padlocked coffin submerged under 30 ft of water, and breaking out of a maximum security cell on Canada's Death Row, which had held the last man to be publicly hanged in that country.❞

What makes your shows different?

❝I got tired of the image of escapologists in the glitzy suit in Vegas. I wanted to remove the magic from it—by doing all escapes in full view of the audience. What really grabs people has to involve pain and danger. I use sinister heavy-metal music to play that up.❞

Why "Dark Master"?

❝I came up with that not because I'm Satanic or because I'm portraying an evil person, but because I'm facing devices from people's nightmares, from the darkest periods of human history. I combine modern technology—like being pulled towards a chain saw—with ancient devices, like thumb screws and iron maidens.❞

Do you use hypnotism or contortionist techniques?

❝I'm not a contortionist—I'm not a svelte guy! I use hypnotism techniques to focus. But it basically comes down to extreme stubbornness and an incredibly high pain tolerance.❞

Do you get nervous beforehand?

❝Terribly. Every time I do these things, there's genuinely the chance that something will go horribly wrong. Once you're in, you can't panic though—if you do, you're done.❞

Are you working on any future projects?

❝I want to be stretched on a medieval rack and have that lowered under water. No-one's ever got off a rack, let alone a submerged one. No, I'm not a masochist—I just know what will make people go 'whoa!'.❞

Black Spot

In 1966, Christina Cort narrowly escaped death when a truck smashed into her home in Salvador, Brazil. She was still in the same house 23 years later when another truck crashed through the wall—driven by the same man.

Train Spotting

★ Russian Vladimir Rasimov drank so much vodka that he fell asleep between train tracks and didn't wake up even when a 140-ton cargo train passed over him.

★ A Jack Russell terrier named Sam survived after being hit by a train in Cheshire, England.

★ In 2002, a train driver delayed hundreds of passengers for over an hour near Birmingham, England, after admitting he didn't know the route.

Potato Ring

Forty years after losing her wedding ring in a potato field, a German farmer's wife found it again while eating—it was inside a potato!

Screen Damage

When four horses broke out of their field in Hausen, Germany, in April 2003, only three survived. One horse was killed instantly when he raced across the road and was hit by a car, crashing through the windscreen. Miraculously, the 26-year-old driver was unhurt.

In the Stars

Born in 1835, the year of Halley's comet, U.S. writer Mark Twain said that as he had come into the world with the comet, so he would pass with it. The comet returned in 1910 and Twain died that April, aged 74.

Perilous Putt

Harold Parris, who has been playing golf regularly for 55 years, made the mistake of teeing off without his glasses in April 2005. Parris managed to land the ball on the back of an alligator while playing a round at the Robber's Row golf course, South Carolina!

Clip Chain
Eisenhower Junior High School in Taylorsville, Utah, is a school with a difference. The pupils have a habit of setting themselves amazing challenges. On March 26–27, 2004, the students created a "Mega Chain" that measured 22.17 mi (35.68 km) long and used 1,560,377 paper clips. They took 24 hours and divided the team into different roles to achieve this incredible feat.

Dog Train Ride
When Archie the black Labrador became separated from his owner at a Scottish railway station in 2005, he decided to take the train, not only choosing the right one, but also getting off at the correct station! When the Aberdeen to Inverness train pulled in to the station, Archie, having lost sight of his owner and perhaps fearing a long walk home, trotted aboard. The clever dog got off 12 minutes later at the next stop, Insch, his local station.

Delayed Revenge
In 1893, Texan Henry Ziegland jilted his girlfriend, as a result of which she killed herself. Bent on revenge, her brother shot Ziegland in the face, but the bullet only grazed him before lodging in a nearby tree. A full 20 years later, Ziegland was using dynamite to uproot that same tree when the explosion blasted the bullet from the trunk. The bullet struck Ziegland in the head, killing him.

Bermuda Triangle
While riding a moped in Bermuda in 1975, a man was killed by a taxi. A year later, his brother was killed riding the same moped after being hit by the same taxi, driven by the same driver. The taxi was even carrying the same passenger.

A **baby** hurled from a car during a **MASSACHUSETTS** road accident in 2004 went *flying through the air*, landed on the **pavement**, and was nearly struck by another car, but **miraculously survived** with just a few bruises.

Elvis Relics
Among the many Elvis Presley relics that have sold on eBay are a branch from a tree ($900) and a hanging plastic fern ($750), both from his Graceland home, and a ball from his pool table ($1,800). However, a tooth said to be from Elvis's mouth failed to sell when no one bid the asking price of $100,000.

Wave Rider
Brazilian surfer Serginho Laus achieved a lifetime's ambition in June 2005 when he rode one continuous wave for 33 minutes, and a distance of 6.3 mi (10.1 km). He was able to ride the wave up the mouth of the Araguari River in northeast Brazil thanks to a "bore" created by a change in the tides.

Underwater Mail
The island nation of Vanuatu in the Pacific Ocean has opened the world's first underwater post office, which is manned by postal workers in diving gear!

Super Seller
Bargain hunter Suzie Eads, of Rantoul, Kansas, has sold so many items on eBay that she has been able to build a house for her family with the proceeds. She has auctioned more than 17,000 items altogether, including a discarded beer can for $380. She even drives with the licence plate EBAY QUN.

ShiNiNG ExAmpLe

THE AVERAGE LIGHTBULB lasts no longer than 1,000 hours. But a carbon filament bulb has been burning in the fire department at Livermore, California, for more than 100 years!

Since being installed in 1901, the four-watt bulb has burned through the birth of powered human flight, women being granted the vote, two world wars, space exploration, 19 U.S. presidents, and 25 Olympic Games. Visitors come from as far away as South Africa and Sweden to check out the famous bulb. Engineers attribute its longevity to a combination of low wattage and filament thickness.

What makes its survival all-the-more remarkable is that before a local reporter uncovered its history in 1972, Livermore firefighters often batted it for good luck as they clung to the side of the departing fire truck. It has also experienced countless near misses from footballs and Frisbees. Now it is treated like a precious stone. As Tim Simpkins, Inspector with the Livermore-Pleasanton Fire Department, says: "I don't want to be on duty when and if it ever goes out."

Appropriately, the town slogan—adopted in the 1920s because of the area's clean air—is "Live Longer in Livermore."

Such is the worldwide interest in the LIvermore lightbulb that it has its own official website, complete with a live webcam that allows browsers to see that it is still burning.

Wright Brothers Flight 1903
Ford Makes Model-T 1908
Television Invented 1927
Nuclear Age Begins 1945
Pres. Kennedy Assassinated 1963
Pres. Nixon Resigns 1974
PC's Sold By IBM 1981
Internet Growth 1993

Flagpole Raised 1906
WW I 1914
Women Get The Vote 1920
WW II 1941
Disneyland Opens 1955
Man Lands On The Moon 1969
Titanic Found 1985
Berlin Wall Falls 1989

Light Bulb Installed 1901
Livermore 1st Rodeo 1918
Stock Market Crashes 1929
Lawrence Livermore Lab 1952
Woodstock & Altamont 1969
Lightbulb Moved 1976
LPFD Formed 1996
Lightbulb Century 2001

1901 — 1920 — 1940 — 1960 — 1980 — 2001

As the world's oldest-known working lightbulb, when the Livermore fire department bulb was moved to its new home in 1976, it was handled with the greatest care. The bulb was granted Code 3 status and transported with truck lights flashing and sirens wailing.

Animal Artist

Koopa the turtle, owned by U.S. artist Kira Varszegi, has sold more than 100 pieces of his own artwork. He creates the paintings by covering his underbelly in paint and sliding around on a canvas. The works usually sell for around $135 a piece.

Shot by Dog

Bulgarian hunter Vasil Plovdiv was shot by his own dog in 2005 when he tried to knock a bird out of its mouth with the butt of his rifle. The German pointer refused to drop the quail and instead leaped at Plovdiv, knocking the trigger and peppering his chest with shot.

Poetic Justice

After two U.S. thieves stole a checkbook from the home of Mr. and Mrs. David Conner, they went to a bank with a $200 check made out to themselves. The female teller asked them to wait a minute, then called security. The teller was Mrs. David Conner.

Heavy Breathing

Three police cars raced to answer an emergency at a house in Lake Parsippany, New Jersey, one night in August 2005, only to be told by the owner that she had been teaching her German shepherd dog to make 911 calls. The 911 operator heard only "heavy breathing."

Tight Squeeze

Contortionist Hugo Zamoratte—"The Bottle Man"—can dislocate nearly every bone in his body and squeeze into a bottle!

Smith Party

In Vermont, all 57 of the David Smiths listed in the state's phone books got together for a "David Smith Night!"

Bright Spark

After locking himself out of his still-running car in Glen Burnie, Maryland, in 2005, an 82-year-old man had the idea of stopping the engine by removing all the gasoline. Unfortunately, he used an electric vacuum cleaner to siphon the fuel and when a spark ignited the vapors he was taken to hospital with burns.

Church Afloat

In 2003, the 2,000-sq-ft (185-sq-m) Malagawatch United Church was moved by water and road 20 mi (32 km) to its new home in Highland Village, Iona, Nova Scotia.

Hidden Bullet

For 25 years, Adrian Milton of New York had a bullet in his skull but didn't know it. He remembered an incident back in 1976 when blood had suddenly spurted from his head, but he always assumed that he'd been hit by debris from a building site. In fact he'd been shot in the head. His secret emerged in 2001 during a routine visit to the doctor.

Cash Flow

Two motorcyclists lost $20,000 in cash in 2005 when their backpack burst open on a highway near Winchester, England. Although drivers stopped to help, strong winds blew the notes across the road and only a small portion of the money was recovered.

Physicists from **MANCHESTER, England**, and **CHERNOGOLOVKA, Russia**, have created a **flat fabric** called "*Graphene*," which is only **a single atom thick**!

What's in a Name?

Even by the standards of Martha Stewart's colorful career, the U.S. kitchen goddess came up with a moment to remember in September 2005. On her TV show, she gathered no fewer than 164 Martha Stewart namesakes. They included Martha Stewarts who were married to men with equally famous names—a Jimmy and a Rod—and even a bulldog named Martha Stewart.

Head Space

Karolyne Smith, of Salt Lake City, Utah, offered her forehead for sale on eBay as the site for a permanent, tattooed advertisement. The winning bid of $10,000 was made by the Golden Palace online casino.

Body Talk

Believe it or not, an Indian man lived with his mother's corpse for 21 years. Syed Abdul Ghafoor kept the embalmed body of his mother in a glass casket at his home in Siddavata and even consulted the corpse before making important decisions.

Future Vision

One of the most popular crazes in Las Vegas is the "morph booth," where as many as 300 couples a day line up to see what their virtual reality child would look like. The fotomorphosis machine merges you and your partner's images to produce a supposedly accurate simulation of any future offspring. Some couples are reportedly using the machine before deciding whether or not to get married!

Toad Toxin

Dogs in Australia's Northern Territory are getting high by licking toxins from the backs of cane toads. Local veterinarian Megan Pickering said that some dogs were becoming addicted to the hallucinogens and she had treated more than 30 that had overdosed on bufo toxin.

Drawbridge Drama

A 79-year-old grandmother had an incredible escape in 2005 after she was left dangling 100 ft (30 m) in the air from a drawbridge. Retired teacher Helen Koton was crossing a canal in Hallandale Beach, Florida, when the drawbridge began to rise. She clung on to the railing as the bridge rose to its full height, leaving her hanging in the air, her handbag swinging from her ankle. Drivers alerted the bridge operator, who lowered Helen back to the ground.

Two-headed peacock
This two-headed peacock was raised on a farm in Texas, and lived to be almost two years old. It was taxidermied by Tim Dobbs of Midland, Texas, in 2003. Ripley has yet to perform DNA testing to determine if the two heads do indeed belong to the same bird.

TOBACCO LEAF
An image is etched onto the skeleton of this tobacco leaf.

HAVING SURVIVED the terrors of Hurricane Katrina relatively unscathed, this museum located in New Orleans' historic French Quarter is now open. It features a display on JFK's killer, Lee Harvey Oswald, that includes a lock of his hair and his mortuary toe tag.

LION COFFIN
The man for whom this coffin was created in Ghana was especially proud of his hunting prowess.

SKULL BOWL
Made from the skull of a Tibetan monk, this bowl was used by monks to drink from.

LOUIS ARMSTRONG
This portrait of the jazz artist is made up of 21,000 individually cut crystals.

DON'T MISS!

- Scrimshaw human skeleton
- Mortician's toe tag with hair lock from the body of Lee Harvey Oswald
- Camel bone carving
- Matchstick London Tower Bridge
- Mummified head of American cannibal Alferd Packard
- Giant tire
- Car parts robot soldier

O-KEE-PA TORTURE RITE
The Mandan held a festival each summer to placate the spirits by practicing self-mutilation.

CHINESE SLIPPERS
These 19th-century "Golden Lily" slippers were made for women with bound feet.

OWNER KILLS OSWALD

ASSASSINATION CAR
Lee Harvey Oswald was a passenger in this car on the day of President Kennedy's assassination. On the back seat, wrapped in papers, lay the $12 rifle that he used to shoot Kennedy.

VAMPIRE KILLING KIT
A 14-piece traveling vampire killing kit used in Europe in the 19th century.

ROTATING TUNNEL
In this interactive room, the eye deceives the brain into thinking the floor is moving.

209

🔺 Deep Blue Sea

The Poseidon Undersea Resort is a new hotel in the Bahamas where you can spend $1,500 a night on a room that is situated 65 ft (20 m) below the sea. Alternatively, you can rent Poseidon's Lair—a two-room private bungalow "hung" over the edge of the aquatic shelf and accessible only by submarine. The $20,000 room rate includes a private submarine captain and a butler.

Weighty Problem

Steven Newell, of London, Ontario, Canada, was hospitalized in 2005 after putting his wading pool, which was 8 ft (2.4 m) in diameter, on the balcony of his house and filling it with 640 gal (2,423 l) of water. The balcony collapsed under the 2½-ton weight.

Explosive Laundry

Daphne Jones, of Great Yarmouth, England, went to work leaving her washing machine on. The vibrations from the spin cycle knocked over a can of spray paint, followed by a pair of scissors, which punctured the can. The can was then ignited by the furnace, causing an explosion that tore the roof off the house.

Woolly Wonder

A sheep was found alive after being buried in a snowdrift for 50 days in the Scottish highlands in 1978.

Feet First

A 26-year-old Croatian woman fell 40 ft (12 m) from her apartment window in Zadar in 2005, but survived after landing on her feet.

Cypriot **Kively Papajohn**, 76, was **trapped** in an *elevator* from **December 28, 1987**, to **January 2, 1988**. She survived by *eating the food* in her **shopping bag**.

What a Sucker!

Fleeing with a case of brandy from a liquor store in Buffalo, New York, in 2005, Thomas L. Hunter dropped the case, shattering the bottles on the sidewalk. He was arrested when he returned to the scene of the spillage and began sucking up the brandy with a straw!

Mountain Fall

Martin Tlusty from Prague, Slovakia, was climbing with friends in 2005 when he lost his footing, slipped, and fell 1,000 ft (305 m) down the side of a mountain. He escaped with just cuts and bruises.

Rope Jumper

James Thompson from Willow Glen, California, can jump rope while bearing the weight of four adults on his back! He can also jump rope both in a squat position with a 170-lb (77-kg) person on his back, and in a standing position with a 250-lb (113-kg) person on his shoulders.

Frazzled Cat

When a cat climbed a 40-ft (12-m) power pole to reach a bird's nest in 2005, it got a nasty electric shock. Yet despite plunging from the 25,000-volt pole in Gardnerville, Nevada, and sparking a fire that left its fur singed from head to toe, the frazzled cat survived.

Brace Yourself

An English teenager discovered in 2004 that he had been living with a broken neck for at least ten years. Liam Careless was told by doctors in Manchester that just one push in that time could have killed him.

First Word

After a 1984 Arkansas car crash left him paralyzed and in a coma, Terry Wallis lay silent for 19 years. Then, in June 2003, aged 39, he came out of the coma and spoke his first word since the accident—"Mom."

Deadly Dream

While away for the weekend in April 2005, Chicago schoolteacher Charisse Hartzol had a dream that foretold her death. Worried, she packed her bags and headed for home. Halfway there, her car was involved in an accident and she died.

PickLed DraGoN

The dragon was actually built by BBC model makers and turned out to be part of an elaborate publishing hoax.

SCIENTISTS AT BRITAIN'S Natural History Museum could hardly believe their eyes in 2003 when confronted with a pale baby dragon, preserved in a jar of formaldehyde.

The dragon had apparently been discovered by David Hart, the grandson of a former museum porter, during a garage clear-out in Oxfordshire.

Accompanying the find were documents suggesting that the dragon had originally been offered to the Natural History Museum in the late 19th century by German scientists, but that the museum had rejected it as a hoax.

While modern scientists began to re-examine the tale, it emerged that the 19th-century museum curators were right—the dragon was a hoax. But, the current story was also a hoax! Hart had invented it in order to promote a novel written by Allistair Mitchell. The dragon had been made for a BBC TV series *Walking With Dinosaurs*.

Hoaxers claimed that the dragon was more than 100 years old, and was preserved in a jar of formaldehyde.

Dancer the Dog

The latest craze for America's dog owners is "doggie dancing." Although essentially a fun event, competitors take it very seriously, with judges rating the couples on technical merit and artistic impression. "You need to go from move to move with flow and transition," says Patie Ventre, seen here with Dancer.

The dogs are allowed to wear a decorative collar during their dance routines.

Long Overdue

A book was returned to a Californian library in 2005—78 years late! Jim Pavon said he discovered the copy of Rudyard Kipling's *Kim* in a box belonging to his late aunt, who had borrowed it from a library in Oakland in 1927. The library waived the fine of around $600, which had accrued on the overdue book.

False (Teeth) Alarm

Three years after losing his dentures in a fall, a Taiwanese man discovered in 2005 that they had been stuck in one of his bronchial tubes all the time. The 45-year-old complained to a doctor of breathing difficulties, leading to the discovery of the missing dentures.

▶ Knitted Art

The Canadian artist Janet Morton's Domestic Interior, *a piece that includes this knitted telephone and table, is just one of her hand-knitted wool creations. In another work, entitled* Cozy, *she covered a cottage situated on Toronto Island in more than 800 recycled sweaters!*

Nice Surprise

When a landslide destroyed Albert Trevino's home in Bluebird Canyon, California, in 2005, all he had time to salvage was his passport, a few important papers, and his wife's favorite painting, which she had bought for under $100 in a garage sale back in the 1980s. However, the 74-year-old later learned that the rescued painting was in fact a $500,000 masterpiece by U.S modern artist Joseph Kleitsch!

Sting for your Supper

A Chinese man not only catches wasps, he also eats them! Zhong Zhisheng, from Shaoguan City, does not charge people for removing wasps nests from their homes, on condition that he is allowed to take the insects home and fry them.

Corn Zeppelin

In August 2005, a church in British Columbia, constructed an airship made entirely of popcorn! Members of Prince George's First Baptist Church used 2,865 lb (1,300 kg) of popcorn kernels (and a similar amount of syrup to hold them together) to create an airship 20 ft (6 m) high. The pre-made moulds for the body, nose, 10-ft (3-m) long wings, and 3½-ft (1-m) barrel-shaped engines needed two forklifts and a tower of scaffolding to move them.

Grab a Grape

Whenever Steve Spalding opens his mouth, there's a fair chance a grape will drop into it. "The Grape Guy" from Carrollton, Texas, specializes in catching as many as 60 grapes a minute in his mouth, usually thrown by his brother Scott. Steve is deadly serious about his art. When he first met his wife Denise, he got her to drop grapes into his mouth from the 22nd floor of the Sahara Hotel in Las Vegas, Nevada. His ambition is to catch a grape dropped from the top of Las Vegas's towering Stratosphere Hotel—a distance of around 900 ft (274 m).

Extra Fingers

Devender Harne, an 11-year-old boy from Nagpur, India, has a total of 25 fingers and toes. The five extra digits are functional and normal in size and do not prevent Devender playing his favorite sport of cricket.

Twin Tragedies

In March 2002, Finnish twin brothers, aged 71, were killed in identical bicycle accidents along the same road, two hours apart. Both men were hit by trucks, the second twin's fatality occurring half a mile from the first's.

When stranded in the **Andes**, **Leonard Diaz** from Colombia was **rescued** after a phone company employee called him on his **expired cell phone** to ask if he wanted to **buy more time**!

Yak-skiing

Yak-skiing is the new extreme sport that is catching on in Manali, India. A person on skis stands at the foot of a hill holding a bucket of nuts while attached by a long rope fed around a pulley to a yak at the top of the hill. When the bucket is rattled loudly, the yak charges down the hill, yanking the skier up the slope.

Desperately Seeking ...

The Lutheran Church of Landeryd, Sweden, put a "wanted" ad in a local newspaper asking for churchgoers.

Ironic Theft

Among items stolen from All Souls Church in Peterborough, England, in July 2005, was a 2-ft (0.6-m) high statue of St. Anthony of Padua, who is the patron saint of lost and stolen items.

Name Check

On business in Louisville, Kentucky, in the late 1950s, George D. Bryson registered at room 307 at the Brown Hotel. When he jokingly asked if there was any mail for him, the clerk gave him a letter addressed to the previous occupant of the room, another George D. Bryson!

Totally Barking

Mark Plumb, aged 20, of Houma, Louisiana, was arrested in August 2005 after he allegedly ran barking from a house and bit the local mailman on the shoulder.

▶ Playing with Food

The Vienna Vegetable Orchestra is seen here performing in London, England, at a concert that included only vegetables! Formed in 1998, the orchestra consists of musicians playing instruments made almost exclusively of vegetables.

Sniff and Tell

A German telecommunications company is presently developing the world's first cellular phone that will alert users when their breath is bad!

Timely Delivery

After accidentally locking herself out of her home in Berkeley, California, in 1974, Mrs. Willard Lovell tried several ways to get back in. Just when she was about to give up, the mailman arrived with a letter from her brother who had stayed with her a few weeks earlier. In the letter was a spare key that he had forgotten to return before he left.

Pig Saviour

Joanne Altsman owes her life to Lulu, her Vietnamese pot-bellied pig. When Joanne suffered a heart attack while on a trailer home holiday on Presque Isle, Pennsylvania, in 1998, Lulu squeezed out of the trailer's dog flap, pushed open the gate and waddled out into the middle of the road where she lay on her back with all four trotters in the air to stop the first passing car. Sure enough, a driver stopped, followed Lulu back into the trailer and found Mrs. Altsman semi-conscious. Doctors later said Joanne would have died within 15 minutes but for the pig's actions. Lulu received a bravery award and a big jam doughnut.

Lick Art

Fifty-year-old Wang Yide from Jianyang, China, uses his tongue and fingers to make paintings. He is one of the few artists still making traditional Chinese paintings using this method.

Hidden Mineshaft

When Pete Taviner offered to repair an uneven kitchen floor at a media training center in Bristol, England, in 2001 he discovered an old 40-ft (12-m) deep mineshaft under the linoleum. The floor had rotted away and the only thing covering the hole was the linoleum.

Registered Hair-do

The "comb-over," in which a partially bald person grows hair long on one side and then combs it over the bald spot, is a U.S. patented invention!

Shock Factor

The Great Voltini, Welsh electrocution artiste Sebastian Vittorini, 39, loves nothing more than sending half a million volts of electricity through his body until lightning shoots from his fingers.

How did you become interested in electricity?

❝I saw a cabaret act with an electric chair and I was fascinated to know how it worked, so I started building one myself. It went from there!❞

What is your most famous act?

❝The 'Lightning Man' act. I stand or sit on top of a huge Tesla coil—a 14ft-high column of wire named after its inventor Nikola Tesla and made by manufacturer HVFX. It transforms electricity into about half a million high-frequency volts—my body basically becomes a human conductor, and sparks and lightning strands shoot out through my fingertips.❞

Does it hurt?

❝Actually, when you do it right, it's a pleasant kind of tingly feeling. It's only when you do it wrong that it hurts.❞

What are the dangers involved?

❝When you get it wrong, your muscles contract involuntarily, which is very unpleasant—it's the same effect as when a person who has got an electric shock is thrown across the room. It can also cause cardiac arrest—people have died doing this kind of act. Long-term, it can cause partial paralysis owing to long-term nerve damage.❞

Why do you take the risk?

❝So far, I've been shocked only a few times and had minor burns from the sparks. The most frightening thing is that when I'm on the machine, I can't control it myself—so my safety is in someone else's hands. But when I'm doing it, it's amazing. The lightning strands are constantly waving about in front of me. It's the most beautiful thing I've ever seen—I absolutely love it.❞

Why doesn't the shock kill you instantly?

❝It is believed that the frequency is so high—300 kHz as opposed to the 50 Hz of regular household electricity—that the nerves can't sense it, like you can't hear a dog whistle. It would kill me if I was in a complete circuit—if a bolt of lightning connected with something grounded, like a curtain rail, I would die instantly.❞

Do you do other work with electricity?

❝My show features lots of electricity and static stunts—I spend quite a lot of time electrocuting my beautiful assistant Nurse Electra, who is also my girlfriend! I can light a gasoline-soaked torch with the sparks from my hands—I've done that one on national television.❞

Has it ever got you into trouble?

❝In the early days I practiced on machines in my kitchen. When I was building my first coil, I got a knock on my door from my next door neighbor—it had destroyed his computer.❞

What will you do next?

❝I'm working on a character called Sir Voltalot for a show loosely based on the Arthurian legends. He will use a huge Tesla coil and electricity to rescue damsels in distress and find the Holy Grail.❞

▶ Amazing Meditation

In December 2005, Ram Bahadur Bomjon, aged 15, from southern Nepal, claimed to have mastered the art of meditation to such an extent that he had gone without food and water for more than seven months. He plans to meditate for six years to achieve enlightenment.

Unlucky Clover

Despite spending more than half his life in U.S. jails, George Kaminski has collected nearly 73,000 four-leaf clovers. He found all of them in the grounds of various Pennsylvania prisons, but when he was moved to a minimum-security facility in 2005, he was horrified to find that there were no clovers to be found anywhere in the grounds. Kaminski feared that his great rival, Edward Martin Sr., a retiree of Soldotna, Alaska, would seize the opportunity to expand his own collection of 76,000 four-leaf clovers.

Night Stalkers

★ Ian Armstrong from Cheshire, England, got up to mow the lawn in the middle of the night while sleepwalking.

★ Stephen Hearn crashed his car at 70 mph (113 km/h) while sleepwalking near Birmingham, England. When he was found, he was in his pajamas and still snoring.

★ Sleepwalker Thomas Manninger climbed out of the first-floor window of his house in Eltville, Germany, shimmied up a drainpipe, and walked across the roof. Upon waking up, he lost his balance and fell 20 ft (6 m) to the ground.

Slice of Fortune

A slice of singer Justin Timberlake's half-eaten French toast (complete with fork and syrup) sold on eBay for a staggering $4,000.

Mad Leap

A man was injured in 2005 when he jumped from a car traveling at 60 mph (96 km/h) in an effort to retrieve a cigarette that had blown out of the passenger-side window. Jeff Foran suffered trauma to his eyes, nose, and chin.

Bank Folly

Thomas E. Mason was charged with robbing a Winona, Minnesota, bank in June 2005, having been arrested nearby and identified by bank staff. The main evidence against him was his hold-up note, which began: "Hi, I'm Thomas Mason."

Park Patrol

In an incredible feat of endurance, Christopher Calfee, a 38-year-old schoolteacher from Richmond, Virginia, ran around a park for nearly 92 hours in September 2005 without stopping for sleep. For four days and four nights he lapped Chesterfield's Pocahontas State Park. Apart from a three-hour halt to recover from the effects of dehydration, Calfee's only other breaks were for food at the end of each 25-mi (40-km) stint. But he never slept during the 316-mi (508-km) run. The pain was so intense that he had to protect his blistered toes with duct tape.

Packed Church

Canadian bride Christa Rasanayagam didn't exactly want her wedding in Ontario in 2004 to be a quiet affair. She was accompanied up the aisle by no fewer than 79 bridesmaids, aged from one to 79, who jostled for room with the groom's 47 best men.

Bumpy Landing

A German driver who was using an airport runway to practice high-speed driving had a lucky escape in 2005 when a plane landed on his roof! The 55-year-old Porsche driver was traveling at more than 100 mph (160 km/h) near Bitburg when the bizarre collision occurred.

In 2005, Sasha Gardner advertised a **bucket of seawater** from BOURNEMOUTH, England, *for sale* on eBay at **$100**. A London man **snapped it up** within a week.

Short Term

Believe it or not, there was a man who was president of the U.S. for just one day! When James K. Polk's term ended at noon on Sunday, March 4, 1849, and his successor, Zachary Taylor, refused to be sworn in until the following day, David Rice Atchison, the president pro tem of the Senate, technically ruled the country in the intervening period. Asked what he did on that historic day, Rice admitted that he mostly slept after a succession of late nights.

▶ Human Dart Board

Evgeny Kuznetsov, from Dzerzhinsk, Russia, set himself up as a human dartboard in Moscow in January 2006. Darts were hurled at his back—amazingly, without drawing a drop of blood.

Young at Heart

Although she is an impressive 96 years old, Peggy Barrett regularly takes to the skies in a glider. She and other 90-and-over pensioners from Gloucester, England, have formed the Gliding Nonagenarians.

Peggy in her glider at the Cotswold Gliding Club, England.

Niagara Plunge

In October 2003, Kirk Jones, of Canton, Michigan, went over Niagara Falls without safety equipment and lived. Tourists saw Jones float by on his back in the swift Niagara River, plunge over the 180-ft (55-m) Horseshoe Falls on the Canadian side, then drag himself out of the water onto the rocks below.

Parachute Ahead

Parachutist Maria Ganelli, aged 40, had a fortunate escape in August 2005 when she landed in the middle of Italy's busy Adriatica Highway. She had planned to come down in a nearby field, but gusting winds pushed her off her chosen course and stunned drivers were forced to swerve to avoid hitting her.

THE ANNUAL LEMON FESTIVAL in Menton, France, is a world-famous carnival with a difference. All the decorations and carnival floats are constructed out of lemon and orange sculptures. An incredible 500,000 elastic bands and 130 tons of citrus fruits are used each year with more than 300 people spending 20,000 man hours to get the festival ready for its opening day.

THE FINAL

RECKONING

Full of ENteRprise

TONY ALLEYNE has boldly gone where no interior designer has gone before by converting his apartment into a replica of the starship *Enterprise*.

Star Trek fan Tony, from Hinckley, England, watched hours of *Star Trek* videos to help him recreate the transporter console from the *Enterprise*. When he was unable to find a home for it, he redesigned his apartment to accommodate it.

Between 1999 and 2004 he worked to give the small apartment a futuristic feel, complete with voice-activated lighting, realistic console panels, and an infinity mirror above the toilet. Where most people have a bedroom, Tony has a replica of the transporter unit that beams crew members to far-flung locations. Speakers in the rooms replay sound effects from *Star Trek*, and there is a cardboard cut-out of Patrick Stewart as Capt. Jean-Luc Picard, the commander from *Star Trek: The Next Generation*. "If you're going to do something, you have to go all the way," says Tony.

Tony and the cardboard cut-out of Capt. Jean-Luc Picard in his main living room space, which also houses his transporter console.

Every detail, from this screen, which faces into the kitchen, to the windows of the apartment, follows the Star Trek theme.

Tony in his converted kitchen, complete with futuristic white units and specialist lighting underneath the cupboards.

These panels show Alleyne's amazing craftsmanship, as well as his fidelity to the Star Trek original.

UNITED FEDERATION OF PLANETS STARFLEET HEADQUARTERS

TACTICAL/SECURITY

🔵 *Pencil Passion*

Emanuel Petran, aged 62, from the Czech Republic, has collected an amazing 3,333 pencils over almost 30 years. He plans to combine his collection with another to form a museum dedicated to the graphite wooden pencil.

Sketch Wizard

George Vlosich III, of Lakewood, Ohio, produces detailed portraits of famous people—from The Beatles to baseball star Mickey Mantle—all on an Etch-a-Sketch®. He spends up to 100 hours on each picture and sells the best as unique works of art. He has even had an Etch-a-Sketch® signed by President Clinton.

Human Robot

A Japanese company has enabled human movement to be operated by remote control. A headset sends a low-voltage current through the wearer's head, affecting the nerves that help maintain balance.

Full Facial

Three teams of scientists, from the U.S.A., France, and Egypt, have created incredibly detailed facial reconstructions of the ancient Egyptian king, Tutankhamun. The teams each built a model of the young Pharaoh's face based on approximately 1,700 high-resolution images taken from CT scans of his mummy. They reveal what King Tut looked like on the day he died nearly 3,300 years ago. The scans, which are the first ever of an Egyptian mummy, suggest that he was a healthy, yet slightly built 19-year-old, standing 5 ft 6 in (1.67 m) tall.

Horn Haul

A Chinese pensioner can lift up to 14 bricks with a "horn" that has grown on his forehead. When doctors told him that they couldn't operate on the tumor—which is 2 in (5 cm) long—because of its location, 74-year-old Wang Ying decided to incorporate it into the strong-man act he had been performing since the age of eight. He lifts the bricks by means of a length of rope looped around the protruding facial growth.

Escape Relay

In October 2005, more than 50 escapologists in different venues from Australia to California took part in the Worldwide Escape Artist Relay—the largest ever coordinated performance by escape artists. One of the most daring feats was that of Paul Sautzer (a.k.a. Dr. Wilson) who, in Mount Desert Island, Maine, escaped from a combination of padlocks, manacles, and chains, and an iron collar called the Chrysalis.

Boy Racer

While his father was in a shop buying a chocolate bar, three-year-old Oliver Willment-Coster, of Bournemouth, England, managed to release the handbrake of the family car, take the car out of neutral gear, and steer it one-handed down the street, until he smashed into a parked police van.

Oliver had been strapped into the passenger seat of his father's car when he managed to drive off.

Field Trials

Nova Scotia farmer Andrew Rand proposed to his girlfriend by hopping onto a tractor and using a harrow to carve the words "LISE MARRY ME" in huge letters in a rye field. His efforts probably inspired Chris Mueller from North Dakota to use a plough to pop the question to Katie Goltz in a soybean field. He had almost finished his message when he realized there wasn't enough room for all the letters. Fortunately, "Katie will you M-A-R-Y me?" still won her heart when she viewed it from the air.

Married 162 Times

Believe it or not, a 75-year-old Bosnian man claims to have married 162 times—and counting! Nedeljko Ilincic says he first got married when he was 15 and since then it has been "just one wife after another."

▲ Lawful Wedded Dolphin

In 2005, Sharon Tendler married Cindy the dolphin at a special ceremony in Eilat, Israel. She got down on one knee and gave Cindy a kiss and a piece of herring. Sharon met Cindy 15 years ago and has since visited the dolphin two or three times a year.

Hanging Around

Scottish artist David Mach has definitely got the hang of sculpture—he makes lifelike models out of wire coat hangers! First he makes a plastic mold of the model shape, around which he shapes the coat hangers. Each coat hanger is individually formed and bent, then welded several times to its neighbor. He leaves the hooks protruding out to create a ghostly fuzz around the object, which he says gives the final sculpture a kind of aura and makes it more enticing to look at.

Depressing Date

Psychological researchers in the U.K. claim that January 24 is the most depressing day of the year.

A **TOKYO** department store has a pair of slippers inspired by the **Wizard of Oz**. They glisten with **690 rubies** and are worth **$2 million!**

Odd Love

When political activist Regina Kaiser was arrested at her Berlin apartment in 1981 and taken to the Communist Stasi security police headquarters for questioning, she feared the worst. However, to her surprise, she fell in love with her interrogator, Uwe Karlstedt, and the couple are still together 25 years later.

223

▶ A Lot of Hot Air

Hot-air balloons prepare to take off (left) at an air base in Chambley, northern France, on July 23, 2005. The 261 balloons lined both sides of the road as they aimed to float into the air at the same time—and in a line.

Tenpin Pong

For the bowler who can sniff victory, Storm Products, based in Brigham City, Utah, manufactures a range of scented bowling balls, including cinnamon, orange, amaretto, and cherry. They cost between $150 and $250.

Ice-cream salesman **Derek Greenwood**, of **ROCHDALE, ENGLAND**, had a **funeral cortege** that consisted of **12 ice-cream vans** all playing jingles on their way to the cemetery!

Surprised Patriarch

Mick Henry of Yorkshire, England, discovered at the age of 59 that he is a tribal chief of the Ojibway Tribe of Manitoba, Canada.

Big Order

After Gita, a 47-year-old Asian elephant, resident at Los Angeles Zoo, California, had infected portions of a toe removed from her left front foot in September 2005, orthopedic shoemaker Cesar Lua was asked to create a boot to keep the wound clean while it healed. Working from photographs and measurements supplied by the zoo, Lua took a full 12 hours to craft the $450 circular shoe. Made mostly of brown leather, ½ in (1 cm) thick, the finished shoe measured 53 in (135 cm) in circumference and 19 in (48 cm) in diameter. It was held to the elephant's ankle by means of a strap.

Alcatraz Swim

A nine-year-old boy succeeded in 2005 where many before had failed—by escaping from Alcatraz. Johnny Wilson, from Hillsborough, California, swam 1.4 mi (2.2 km) from the island to San Francisco in less than two hours in October 2005 to raise money for the victims of Hurricane Katrina.

Hippo Sweat

In 2005, Professor Christopher Viney, of the University of California, collected and studied hippopotamus sweat, hoping that the ingredients would help develop new human sunscreens!

WOLF BOYS

THERE IS NO MISTAKING Jesus Aceves in a crowd. By a 50-billion-to-one chance, the gene that controls his hair-growth failed to "turn off" the hair that grows on his face.

The condition, known as hypertrichosis (meaning "extra hair"), has left his face covered in dark hair and has earned him the nickname "The Wolf Boy." The condition is hereditary—24 members of his family have had it, including his sister, and his great-uncle, Manuel the Wolf Man. Although unable to get a regular job in his native Mexico, Jesus has traveled the world with circuses and sideshows. He considers his hirsute appearance to be a gift from God and mostly enjoys the attention he receives for it. "I like it when children look at me in wonderment," he says. "It makes me feel like a star."

A rare genetic condition means that Jesus Aceves has his face covered in dark hair, earning him the nickname "The Wolf Boy."

Ear Hole
Venezuelan tattoo-artist Constantino has stretched his earlobe so much that he can place a shot glass in it.

Screw Loose
When Etienne Verhees, from Antwerp, Belgium, started coughing in October 2005, he coughed up a metal screw! It was one of four screws that had been used to hold a metal plate in place in his neck after he had broken two vertebrae falling from a ladder in 2001. Doctors said that the screw must have moved following an infection.

Linda Dagless and Brad Wheeler, of NORWICH, ENGLAND, named their baby daughter "Ikea" after the Swedish furniture company!

Potter Potty
Fifteen-year-old Harry Potter fan Sandra Luchian, from Moldova, spent over a month of her 2005 summer vacation writing out the latest book, because she couldn't afford to buy it. She borrowed a copy of *Harry Potter and the Half-Blood Prince* from a friend and wrote down the 607-page story word for word in five notebooks.

Giant Bunny
Visitors to a northern Italian mountain could be forgiven for thinking they were seeing things. In 2005, a huge pink rabbit was erected on the side of the 5,000-ft (1,524-m) high Colletto Fava mountain. The soft toy, which is 200 ft (61 m) long, is expected to stay in place until 2025, and was designed by Austrian artists.

Dead Chrysler
Angry because his car wouldn't start, a Florida man pulled out a gun and shot it! John McGivney, 64, fired five rounds into the hood of his Chrysler outside his home in Fort Lauderdale. When startled neighbors asked him what he was doing, he calmly replied: "I'm putting my car out of its misery."

Touch Test
A blind German woman can distinguish between colors simply by touch. Gabriele Simon, from Wallenhorst, uses her fingertips to recognize the different colors of various items of clothing. She says it has taken her 20 years to master the skill, which gives her greater independence, as she no longer has to ask her mother what to wear.

Free-falling
"Jump for the Cause," a nonprofit organization that specializes in skydiving fund-raisers, succeeded in performing an amazing 151-person formation skydive. The skydivers were made up of women from 24 different U.S. states, 15 different countries, and varied occupations.

Greedy Thief
A 308-lb (140-kg) thief, who ransacked a pie store near Fagaras, Romania, was caught after getting stuck on his way out. When the owner arrived to open the store the following morning, he found a pair of legs hanging out of the window!

Fake Cow Stolen

Believe it or not, a full-size, fiberglass cow was stolen from a roadside billboard in eastern Virginia, in October 2005. One of a pair valued at $3,200, the 500-lb (227-kg) black-and-white cow was removed from the billboard along Interstate 464 in Chesapeake.

Love Letters

Every year, in the build-up to February 14, the tiny post office in the small Texas town of Valentine becomes one of the busiest in the world. Postmaster Maria Elena Carrasco and her lone part-time assistant suddenly have to deal with a flood of mail as more than 7,000 romantics, from all corners of the globe, dispatch cards to be stamped with the postmark of Valentine.

Queasy Rider

Millard Dwyer from Pulaski County, Kentucky, was fined $225 in 2005 for "driving" a horse under the influence of alcohol. Dwyer, who was stopped by police as he tried to steer his horse Prince around a street corner, was three times over the legal limit after downing a 12-pack of beer. Kentucky state law classes a horse as a vehicle.

Foxy Thief

After frolicking in the waves in the summer of 2005, beachgoers on Prince Edward Island, Canada, returned to the shore only to find that their sandals had been stolen— by a marauding family of foxes.

Unplanned Landing

On a forced landing, Mark and Mercedes Davies landed their single-engine plane atop a moving semi-truck before crashing onto the highway. Incredibly, both of them emerged unharmed!

Roses are Red

★ For Valentine's Day 2005, Brazilian teenager Frederico Skwara bought girlfriend Juliana Magalhaes a pregnant sheep called Waffle.

★ Special "flirt" carriages were created on the subway in Vienna, Austria, for Valentine's Day 2003 to encourage all single passengers to find love.

★ The most popular Valentine's gifts in China are not chocolates or flowers, but tropical fish!

Testing Times

Seo Sang-moon finally passed the academic part of his driver's licence examination in South Korea in 2005—on the 272nd attempt.

Walking Underwater

Lloyd Scott, from Rainham, England, completed a marathon underwater (26.2 mi/42.2 km) starting in Lochend, Scotland, in October 2003, while wearing a lead-booted early diving suit weighing 120 lb (54 kg). It took him 12 days to finish the walk emerging at Loch Ness.

▲ Served-up Heads!
Villagers dressed as heads on plates during the New Year's Carnival in the village of Vevcani, Macedonia, in 2006. The 1,300-year-old carnival features the villagers performing in a variety of events.

Whopper Chopper
Mark Henry is altogether a little young to be long in the tooth. But the nine-year-old Canadian stunned dentists with a top right front tooth that measured nearly 1 in (2.5 cm) long. Dr. Gabriela Gandila of Owen Sound, Ontario, who had to pull out the tooth, said it was like a horse's.

The Quicker Flicker
In August 2005, Sheeshpal Agarwal was officially declared the fastest dentures remover in India. The 51-year-old can remove and reinsert his teeth with a single flick of his tongue 176 times in 5 minutes.

Wide Awake
Silvio Jarquin Rostran and Janeth Margarita Cerrato from Nicaragua won a no-sleep marathon in 2005 by staying awake for 51 hours.

Believe it or not, a **100-year-old** Belgian motorist, **Cyriel Delacauw**, was given an insurance discount in 2005 because he **hadn't** had an **accident** in more than **80 years** of driving!

Lying Low
A 6-ft (1.8-m) tall man on the run from police was found four months later in a bizarre hideout—curled up inside a TV set in a mobile home near Bainbridge, Georgia. The fugitive had escaped from Florida police in September 2004.

Cheerers' Chant
A man who left the scene of a road accident in Ann Arbor, Michigan, in August 2005, was tracked down, not by police but by local cheerleaders. Members of the Lincoln High School varsity cheerleading squad witnessed the crash, and turned the man's licence plate number into a cheer so that they would be able to remember it.

Car Possessed
We've all heard of cars being repossessed, but Christine Djordjevic is convinced that her car is possessed. In March 2005, the driverless vehicle started itself and reversed into a neighbor's home, at South Haven, Indiana, causing damage worth several thousand dollars. Police officers were sceptical of the story until they saw the 1995 Mercury Tracer Trio start itself again and head down the road. They stopped it before it hit anything.

GLOWING PiGS

WHAT'S GREEN, grunts and glows in the dark? A Taiwanese pig, of course!

Scientists in Taiwan have bred three fluorescent green pigs by adding genetic material from jellyfish into normal pig embryos. Although other countries have created partially fluorescent pigs, these are the first to be green from the inside out. Even each pig's heart and internal organs are green.

DNA from jellyfish was added to around 265 pig embryos, which were implanted in eight different sows. Four of the female pigs became pregnant and gave birth to three green male piglets in 2005.

Two years earlier, Taiwanese scientists had created the world's first glowing green fish. Now researchers hope that the pigs will be able to help in the study of stem cell research to combat human diseases.

In daylight, the pigs' eyes, teeth, and trotters look green, and their skin has a greenish tinge. But in the dark, if a blue light is shone on them, they glow as bright as a torch!

▶ Making a Splash
Underwater hockey was invented in 1954 by field hockey players looking for a way to keep fit during winter. Here, a team from Roger Bacon High School in Cincinnati, Ohio, take on Michigan State University in a nationals match.

Isak and the Beanstalk
When nine-year-old Isak Spanjol planted a squash seed in the family yard in Brooklyn, New York, in 2004, he had no idea that it would grow into a monster plant. The rare species of gourd coiled around cable lines and stretched over fences into neighboring yards. Some of the vegetables hanging from it were 6½ ft (2 m) long, nearly 2 ft (0.6 m) bigger than the botanist himself!

Driving Green
Mali Blotta and David Modersbach drove 11,000 mi (17,700 km) from California to Argentina in 2004, in a station wagon that ran on recycled vegetable oil instead of gas!

Prize Pumpkin
When Ron and Sue Boor paraded their prize pumpkin at the 2005 West Virginia Pumpkin Festival, it took five men and a forklift to get it onto the scales! The Boors, who have been raising large pumpkins since 1990, had produced a 1,082-lb (492-kg) monster. At its peak, the pumpkin grew 35 lb (16 kg) a night and "drank" 198 gal (750 l) of water a day.

Self-healing
Pedro Lopez, a 39-year-old Mexican, amazed physicians by successfully performing complex surgery on himself. By inserting a needle through his navel, he drained fluid from his lungs that was hampering his breathing. Specialists described it as a miracle. "We do this kind of surgery draining liquid in small quantities," said one, "but this man drained three liters of liquid—and without anesthesia!"

Young Juror
Nathaniel Skiles, of Kirkland, Washington, has been summoned for jury duty three times in two years—and he's only six years old! The blunder occurred after his birthdate was listed incorrectly on a state identification card.

◀ Jumbo Treadmill
Finding that Maggie, an African elephant, was 1,000 lb (454 kg) overweight, officials at Alaska Zoo introduced a specially made treadmill to help her exercise off the excess pounds. The treadmill is 20 ft (6 m) long, 8 ft (2.4 m) wide, and weighs 15,972 lb (7,244 kg). It is believed to be the first treadmill in the world built specifically for an elephant.

Late Mail
Evelyn Greenawald, of Anamosa, Iowa, received a postcard from her daughter Sheri in Germany in October 2005—27 years after it had been mailed. At the time of writing the postcard, Sheri was beginning her opera career in Europe. She now lives in San Francisco, California.

Cookie Lady
Merry Debbrecht, of Rose Hill, Kansas, has been baking up to 480 cookies a day and sending them to U.S. soldiers who are stationed in Iraq. By the summer of 2005, she had sent more than 30,000 cookies and said that she wouldn't stop until the war was over.

Seal of Disapproval
A man from Colorado was arrested in 2004 when he tried to board a plane at Logan Airport, Boston, Massachusetts, carrying the severed head of a seal. Security staff discovered the head in a small canvas cooler.

Bike Tree
Most people keep their Harley motorcycle on the driveway or in the garage. But Richard Woodworth keeps his in a tree outside his home in Raleigh, North Carolina. He insists that hanging the bike from the branches is art.

After a **television** belonging to **Chris van Rossman**, of **CORVALLIS, Oregon**, began emitting an international satellite **distress signal**, police and military **rescue units** showed up to save it!

Name Game
A man called Pete set up a website in 2005 with the aim of getting another 1,999 Petes to attend a gathering in London, England! Pete Trainor started his quest as a bet.

Ghost Guard
Dave Davison has one of America's most unusual jobs—he guards a bonafide ghost town. Built during the late-19th century by prospectors looking for silver and gold, Silver City, Idaho, is a ghost town in the winter. Its 40 homes (which are owned by summer vacationers) become deserted and the town is usually cut off by road from the outside world because of snow. As watchman, Davison thwarts thieves on snowmobiles to ensure that Silver City doesn't disappear from the map altogether.

Pretty in Pink
When 700 prisoners had to walk 2 mi (3.2 km) to be transferred from their old overcrowded jail to a brand new, bigger facility in Phoenix, Arizona, in 2005, Sheriff Joe Arpaio came up with a surefire way to prevent the convicts from escaping—he dressed them in fluffy pink underwear and flip-flops! He reckoned that the hardened criminals would simply be too embarrassed to run.

Flip-flop Sculpture
Australian John Dahlsen puts the finishing touch to his sculpture made from hundreds of flip-flops on Sydney's Bondi Beach in 2004 as part of the "Sculptures by the Sea" exhibition. Dahlsen scours Australian beaches for plastic objects washed up by the ocean to make into artworks.

WRITTEN IN SKIN
Rosa Barthelme of Kansas picked up the name "The Human Slate" because messages written lightly on her skin stood out and remained for about 30 minutes.

WHAT A HANDFUL!
Julius B. Shuster, of Pennsylvania, perfected the art of holding 20 baseballs in one hand!

OPEN PRISON
People of the city of Anna Maria, Florida, were so proud of their lack of crime that they bragged their jail had no bars, roof, doors, or windows.

LARGE LUMP
This 6,725-lb (3,050-kg) piece of solid coal from Dawson, New Mexico, was paraded proudly at a Cowboys Reunion on July 4, 1930.

CROSS-LOG SKIING
The log-packed Androscoggin River was crossed in 1955 by Kenneth Lambert on a pair of snow skis.

FAMILY TRANSPORT
In 1938, the Harriman family rode from Portland, Oregon, to Toledo, Ohio, on a motorcycle. The total weight of the four people and their dog was 590 lb (268 kg).

WELL RISEN
In Ravenna, Kentucky, a well that had previously been sunk into the ground gradually rose out of it. In 1932, it had risen 8 ft (2.4 m) above the earth.

OFFICE PET
Mrs. Brodie's boss, although a car dealer by day, was also a game hunter. Mrs. Brodie is pictured here in 1941 with a tame lion that her boss captured as a cub, and whom she raised in her office.

Looking Back

April 29, 1927 Bobby Leach, who survived going over Niagara Falls in a barrel in 1911, died from injuries received when he slipped on a banana skin while walking along the street.

December 2, 1927 Little **Marie Finster** jumped from the roof of a building and was saved miraculously by falling into her mother's arms, who happened to be passing at that very minute.

Toilet Snake

Going to the bathroom will never be the same for Alicia Bailey of Jacksonville, Florida—not since she was bitten by a venomous snake hiding in her toilet bowl. As she lifted the toilet lid, a water moccasin bit her on the leg. She survived the ordeal, but admitted that she had become "toilet shy."

Hopelessly Lost

In 2005, three elderly U.S. ladies took 24 hours to get home after becoming lost on their 20-mi (32-km) journey home from church. What should have been a short drive to Upson County, Florida, turned into an A.P.B. from worried relatives, as 72-year-old Alice Atwater took Florence King and Ruthelle Outler on an unintentional detour through Birmingham, Alabama, and the Georgia cities of Atlanta and Macon.

Mature Mother

Adriana Iliescu, aged 67, claims to be the oldest recorded woman to give birth. A university professor and children's author, she is from Bucharest, Romania. Adriana gave birth to a daughter after doctors reversed the effects of the menopause and then used in-vitro fertilization and the sperm and eggs from younger people to impregnate her.

Adriana Iliescu with her one-year-old daughter Eliza Maria, on January 16, 2006.

Stop Thief!

Having cut through a security fence at a shop in Durham, North Carolina, in 2005, a thief stole 50 red, octagonal stop signs valued at $1,250. He was arrested after being spotted pushing a shopping cart filled with signs and trying to sell 16 of them for $28.

Blooming Great!

In Vienna, West Virginia, Brenda Wilson lovingly tends a rosebush that just won't stop growing. The bush was planted in 1966 and stands more than 16 ft (4.9 m) tall—over four times the usual height for a rose bush.

◀ Extra Tongue

Delores Whittington's cat is truly unique in the feline world. Not only was she born with five toes on each paw (hence her name Five Toes), but the black Burmese mix also has two tongues! Delores, from Dobson, North Carolina, noticed the twin tongues for the first time back in December 2004.

Hiss-terical

A woman was attacked by a 4-ft (1.2-m) long python while watching a movie at a cinema in the United Arab Emirates, in June 2005. A friend uncoiled the snake from the hysterical woman's leg and removed the serpent from the cinema. Both women continued watching the film.

Believe it or not, Stormy, a *groundhog* at CHICAGO'S BROOKFIELD ZOO, had braces fitted to his **lower teeth** in 2005 to enable them to **grow straight** and help him eat!

Odd One Out

Debby Cantlon, from Seattle, Washington, couldn't help noticing that there was something unusual about one of the pups being fed by Mademoiselle Giselle, her Papillon dog. The strange "pup" was actually an orphaned newborn squirrel, who was happily being allowed to feed from the dog right alongside its canine "brothers and sisters."

Big Knit

By the spring of 2007, Darlene Rouse hopes to have knitted a scarf that is a mile long! With help from a close-knit group of friends and family in Opelika, Alabama, she has been working on the inspirational Hope Scarf, a garment that will carry each knitter's name, along with a short, life-affirming message.

Mother Love

Reggie the hamadryas baboon was the star attraction at England's Paignton Zoo in 2005—but for all the wrong reasons. After being born with a normal covering of hair on his head, Reggie had it all licked off by his overly attentive mother, leaving one bald baby baboon!

Smoking Chimp

A chimpanzee at a zoo in China has finally managed to quit smoking—after 16 years of nicotine addiction. Ai Ai, a 27-year-old chimp at Qinling Safari Park, started smoking cigarettes given to her by visitors after her mate died in 1989. When a second mate died and her daughter was moved to another zoo, in 1997 the lonely Ai Ai began chain-smoking. Worried about her deteriorating health, keepers tried to get her to kick the habit by giving her earphones and allowing her to listen to music on a Sony Walkman. At first Ai Ai still squealed for cigarettes but, ultimately captivated by her new interest, she soon forgot about her smoking habit altogether.

▶ A Bit Cheesy!

Room 114 at the Washington Jefferson Hotel in New York City was redecorated by the artist Cosimo Cavallaro, in May 1999, using 1,000 lb (454 kg) of melted cheese! Cavallaro explained that he did it to show his joy for life. The installation of "cheese art" remained on display for a month.

Rock Champions

One of Canada's more unusual sporting events is the Rock Paper Scissors World Championships, held in Toronto. Although originally a children's game, there are now more than 2,200 members of the World Rock Paper Scissors Society, and players travel to Toronto from Oslo, Prague, Sydney, London, and all over the U.S.A. The victor collects $7,000 in prize money.

Hamster Power

A 16-year-old boy from Somerset, England, has invented a hamster-powered cellular phone! Peter Ash attached a generator to the exercise wheel of Elvis the hamster and connected it to his phone charger. He said: "Every two minutes Elvis spends on his wheel gives me around 30 minutes of talk time on my phone."

Lucky Jim

Jim McClatchey died 100 times on November 20, 2004, but still came back to life! Doctors at the Piedmont Hospital, Atlanta, Georgia, were stunned as McClatchey suffered repeated cardiac arrests needing immediate shock treatment. In the first hour alone, his heart stopped 50 times. He had to be shocked so frequently that he sustained second-degree burns to his chest.

Hard Cheese

A year after intentionally sinking 1,760 lb (800 kg) of cheese into the water off the Saguenay fjord, north of Quebec City, Canada, a cheese company finally gave up hope of its recovery when divers and high-tech tracking equipment failed to locate it to bring it back to the surface. Leaving the $50,000 cheese in 160 ft (50 m) of water for months was supposed to produce a unique flavor.

Jackpot!

Once jailed for lottery fraud, when freed, Romanian Stancu Ogica won $33,000 playing the lottery!

Christmas Bonus

In December 2004, Richard and Donna Hamann paid that month's electric bill for all of Anthon, Iowa!

Heart Beats

★ A human heart beats 100,000 times a day and during an average lifetime it will beat more than 2.5 billion times.

★ Blood pumped out from your heart travels 60,000 mi (96,560 km) around your body each day—that's 20 times the distance across the U.S.A. from coast to coast.

★ The human heart pumps about one million barrels of blood during an average lifetime—enough to fill more than three super-tankers.

▼ Metal Skyline

Chinese artist Zhan Wang chose kitchen utensils as his medium to recreate London's urban landscape. He even included a dry ice machine to give the work an atmospheric London fog.

Junior Filmmaker

Nine-year-old Kishen from Bangalore, India, made history in 2005 by directing a full-length feature film. The movie is called *Care of Footpath* and is about slum children. Kishen has been acting since the age of four and has appeared in 24 movies and more than 1,000 TV shows.

Chat Tomb

Driven by a desire to speak to his late mother, Juergen Broether from Germany has devised a $1,940 mobile phone and loudspeaker device that can be buried next to a coffin. The device enables people to talk to the dead for up to a year.

Home Is Where Your Car Is

After being evicted from her London, England, home, Ann Naysmith lived in her car for 26 years. When health inspectors confiscated her old Ford, community members bought her a Mercedes!

Cannon Fodder

Missouri daredevil David "The Bullet" Smith, 28, calls himself a "human cannonball" and is blasted from his cannon 500 times a year worldwide.

How did you become a human cannonball?

"My parents were circus performers and my father David Smith Sr. became a human cannonball himself more than 30 years ago. All of my nine siblings have done it, and when I was 17 my father said I was ready. A year or so later he hurt his back and asked me to stand in for him, and that was that."

What happens when you are "fired?"

"I can't tell you how the cannon is ignited—it's a family secret. But there is a tremendous force on my body—10 Gs, which is ten times my bodyweight. I start off at the bottom of the 34-ft-long barrel—before I get to the end I've already traveled 30 ft. I then go from 0 to 50 mph in a fifth of a second. The whole flight of about 150 ft takes under 4 seconds."

How do you land?

"I fly about 80 ft up in the air, somersault, and land on my back in a net which is usually about 20 x 50 ft big."

What do you feel when you are in the air?

"I'm very aware—it's like slow motion. I think about what direction the wind is hitting me from, where my netting is, whether I need to correct my flight path, if I have clearance of obstacles above, and below me. I even occasionally wonder what we're having for dinner! It all happens so fast, my mind's just along for the ride."

What unusual places have you been fired over?

"I was shot over part of the Grand Canyon. I also shoot over Ferris wheels, and was once shot into slime for a world record. I stood in for Ewan McGregor in Tim Burton's movie Big Fish."

Who makes your cannons?

"My father has built seven cannons himself. I'm just putting the wheels on my first. We've got cannons ranging from 18 ft long to 36 ft."

Does your father still perform?

"Yes, he's 63. He was recently shot from Tijuana, Mexico, into the U.S.A.—the first person to be shot over an international border. He held his passport in his hands as he went. We also once performed in cannons side by side—I broke my father's previous distance record as I came out, and he landed one second later and broke mine. He holds the current record of 201 ft 4 in."

Does it hurt—and have you had any injuries?

"It hurts your whole body. I've never missed the net—I wouldn't expect to live through that. I did blast a hole in the net once—I woke up eight minutes later surrounded by paramedics, but miraculously I wasn't badly injured."

Will your own young daughters follow you into the act?

"My six-year-old isn't interested, but my youngest is nearly two and is a daredevil, so she might. Her mother would shoot me—but then she shoots me anyway: she pulls the trigger on the cannon!"

www.humancannonball.us

237

ONE OF RIPLEY'S latest museums, Key West opened in 2003. Among its varied unbelievable exhibits are a Jivaro Indian shrunken torso, once owned by Ernest Hemingway, and a portrait of Vincent van Gogh made from butterfly wings.

PHURBU DAGGER
Tibetan monks use these daggers to exorcise evil spirits.

DON'T MISS!

▶ Collection of multi-leaf clovers

▶ Giant tree climbing coconut crab

▶ Spiked torture chair

▶ Human bone rosary

▶ Toast art: "Adam" (from Michelangelo's Creation)

▶ Woman's bolero cape made from human hair

▶ A pair of gold lamé panties autographed by Madonna

▶ Three-legged chicken

RAMA STATUE
This Thai statue of Rama, a Hindu god, was set in rice fields to assure a good harvest.

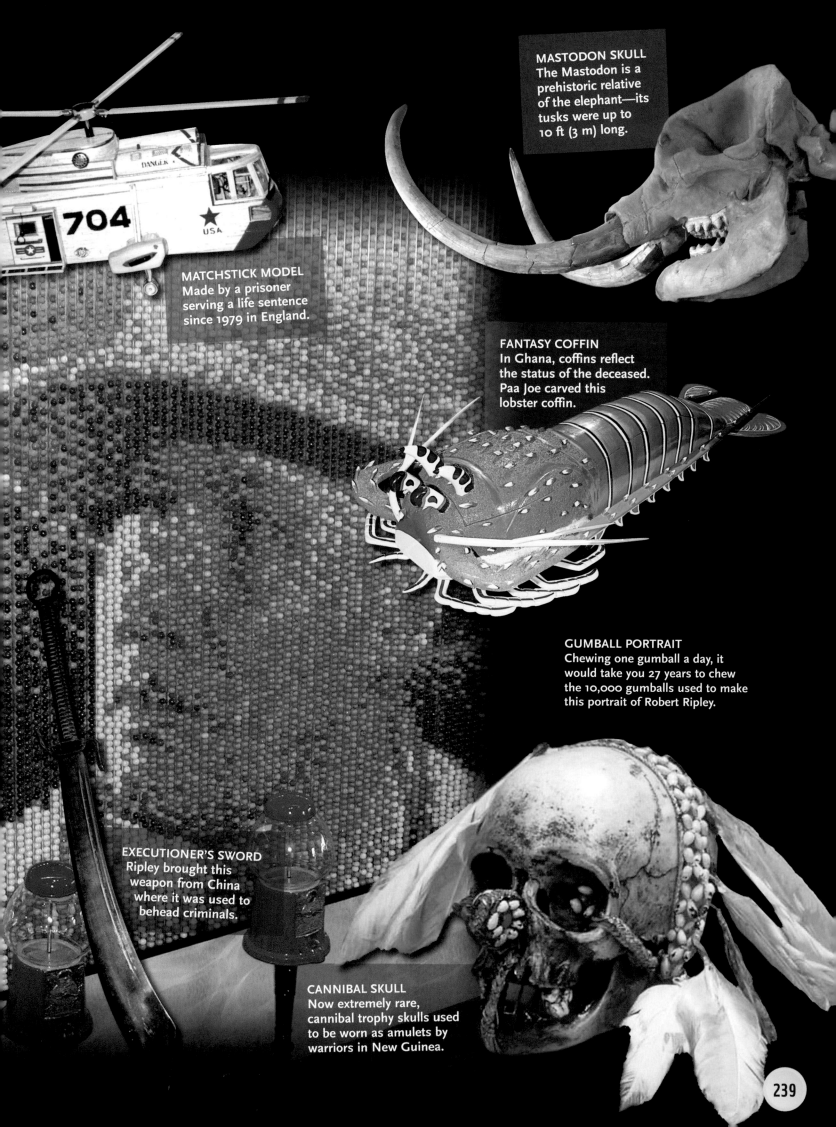

MASTODON SKULL
The Mastodon is a prehistoric relative of the elephant—its tusks were up to 10 ft (3 m) long.

MATCHSTICK MODEL
Made by a prisoner serving a life sentence since 1979 in England.

FANTASY COFFIN
In Ghana, coffins reflect the status of the deceased. Paa Joe carved this lobster coffin.

GUMBALL PORTRAIT
Chewing one gumball a day, it would take you 27 years to chew the 10,000 gumballs used to make this portrait of Robert Ripley.

EXECUTIONER'S SWORD
Ripley brought this weapon from China where it was used to behead criminals.

CANNIBAL SKULL
Now extremely rare, cannibal trophy skulls used to be worn as amulets by warriors in New Guinea.

239

Wood You Believe It!

THE RESIDENTS OF VENICE are used to watching gondolas navigating the city's famous network of canals, but to see a Ferrari floating along the waterways is a different matter altogether.

This soft, leather flying jacket may look authentic, but it's actually made from the same material as the hanger—wood.

But, this is no ordinary car—it is made entirely from wood, right down to the steering wheel, upholstery, and mirrors. The Ferrari F50 is one of several full-size wooden cars created by Italian artist Livio De Marchi, a man who combines skill, wit, and panache to design lifelike sculptures from wood.

In De Marchi's bathroom is a wooden dress that has been "washed and hung up to dry."

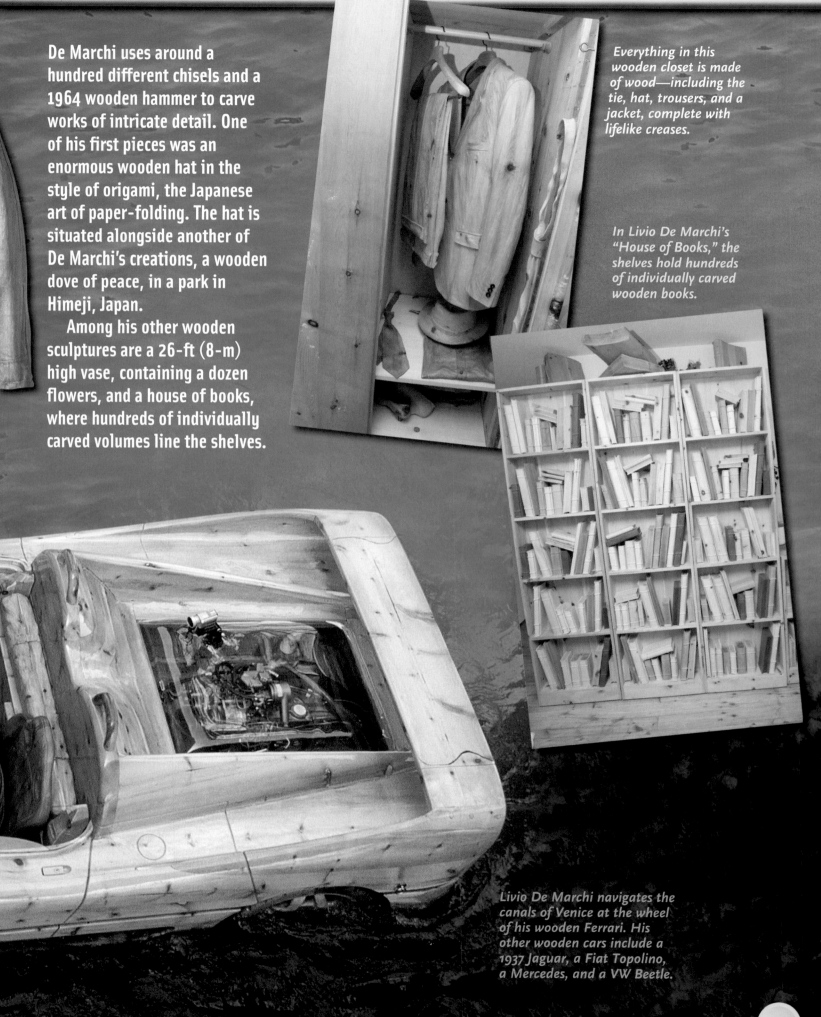

De Marchi uses around a hundred different chisels and a 1964 wooden hammer to carve works of intricate detail. One of his first pieces was an enormous wooden hat in the style of origami, the Japanese art of paper-folding. The hat is situated alongside another of De Marchi's creations, a wooden dove of peace, in a park in Himeji, Japan.

Among his other wooden sculptures are a 26-ft (8-m) high vase, containing a dozen flowers, and a house of books, where hundreds of individually carved volumes line the shelves.

Everything in this wooden closet is made of wood—including the tie, hat, trousers, and a jacket, complete with lifelike creases.

In Livio De Marchi's "House of Books," the shelves hold hundreds of individually carved wooden books.

Livio De Marchi navigates the canals of Venice at the wheel of his wooden Ferrari. His other wooden cars include a 1937 Jaguar, a Fiat Topolino, a Mercedes, and a VW Beetle.

241

Lion on a Leash
Whenever Jaroslav Kana ventures out from his home in the Czech Republic, he takes a walk on the wild side. Accompanying him is his pet, Leon, who is a two-year-old lion! Jaroslav obtained the lion from a private breeder two years ago and has trained him so that he will perform in advertisements and TV shows.

Rotating Car
A new Japanese electric car could make parking problems a thing of the past. The Nissan Pivo, with its 180-degree rotating cabin, always faces forward—so there's no need to reverse!

Divorce Cake
Baker Georgius Vasseliou from Berlin, Germany, has introduced a new line at his cafe—personalized divorce cakes. To celebrate a split, he has devised cakes with a large smiley face or a torn up photo of the "ex" iced on the top. And with over 10,000 divorces a year in the city, he thinks he's on to a winner.

Eyes Tight Shut
Trying to moisten her eyes in January 2005, 78-year-old Australian Terry Horder accidentally grabbed a wrong container and glued her eyes shut. Doctors were able to get them open and her eyes were unharmed.

Roller Ride
Richard Dickson, a 37-year-old father-of-five, won a new car in May 2005 by riding the "Twister Two" roller coaster at Denver, Colorado, for nearly 53 hours, in the process covering a total of 757 mi (1,218 km).

It's **not** only your car that goes in for a wash at a **Madrid, Spain**, gas station. A coin-operated **pet-washing** machine enables animals to get a *soapy wash and dry* for approximately **$5**.

Cat Theater
Yuri Kuklachev is founder of the Moscow Cats Theater, which boasts around 30 trained housecats in its company. The cats' tricks include front-paw stands, "tightrope" walking on a pole, and traversing the pole from underneath by grasping it with four paws.

Artistic Ape
Tama Zoo Park, in Tokyo, Japan, has discovered a new talent among its residents. Gypsy, a 50-year-old orangutan, is just one of three orangutans who have taken to drawing with crayons. Her favorite colors are yellow and blue.

Jumping for Joy

Austrian B.A.S.E. jumper Felix Baumgartner, 37, has thrown himself off some of the world's most challenging structures—and has even mastered the art of flying.

What does B.A.S.E. mean?

"It stands for Building, Antenna, Span (or bridge), and Earth (or cliffs). You have to jump off all four, with a parachute, to register as a B.A.S.E. jumper."

How did you start?

"As a kid, I used to hang out at the airport watching the guys jumping out of airplanes, and as soon as I was 16, and could get my parachute license, I started skydiving. Ten years later, I made my first B.A.S.E. jump from a bridge in West Virginia, and a year after that I had become the first European to win the international championships."

What is the highest jump you have made?

"The Petronas Towers in Kuala Lumpur in 1999. At the time they were the highest buildings in the world, and hard to get into—my preparations took two months. I put my parachute and a hand-held camera in a little suitcase and sneaked to the 88th floor disguised as a businessman. I climbed onto a window-cleaning platform and jumped from 451 m—eight seconds in freefall at 170 km/h before the parachute opened."

What is the lowest jump you have ever made?

"The Christ the Redeemer statue in Rio de Janeiro. I saw it on a documentary and thought the right arm was far out over the mountain and that it would be a high jump—in fact I had just 29 m, which gave me only 1½ seconds to open the parachute. I didn't want to sneak up the inside stairs, so I used a crossbow to shoot an arrow over the right arm with a steel cable attached and pulled myself up. I stepped off the 25-cm wide hand and pictures of it went across the world."

When and where did you learn to "fly"?

"In 2003, I was the first person to "fly" across the English Channel unaided. I have always dreamed of flying—we spent years preparing, with a team of 40 people working on different types of wings. Eventually, we found the perfect wing—a 6-ft carbon-fiber fin—and I jumped out of a plane over Dover at 30,000 ft and "flew" 22 mi at speeds of up to 225 mph until I reached the other side."

Did you fear you might not make it?

"There was a big chance of losing my life if something went wrong with the oxygen tank I was wearing. At that altitude you need every breath, and if there's no oxygen you die in less than a minute. But I was well-prepared—I trained in a wind tunnel, and was even strapped onto the roof of a Porsche car speeding down an airport runway to see how it feels at that speed."

Was it the scariest thing you've done?

"No. That was jumping into the Mamet cave in Croatia's Velebit National Park. Usually I can see when I jump, but that was totally dark and I had to use an MP3 player to give a countdown of when I'd get to the bottom, 190 m down at 170 km/h."

What makes you jump—and how long will you carry on?

"I like to be in the air—it's like my second home. I have made more than 2,600 parachute jumps and 130 B.A.S.E. jumps, and I think I'll be doing it for a long while yet."

No Ordinary Chimp
Charlie the chimpanzee is a black belt at karate! The 17-year-old chimp, who weighs 200 lb (90 kg) and stands 4½ ft (1.4 m) tall, is seen here practicing with his owner Carmen Presti of Niagara Falls, New York.

Time Warp

A gas-station manager, in Lincoln, Nebraska, accidentally turned back the clock 50 years in October 2005 by selling premium gasoline for 32 cents a gallon instead of the usual $3.20. Drivers could hardly believe their luck as they pulled into Kabredlo's Convenience Store. The mistake with the decimal point was corrected after 45 minutes.

Satanic Turtle

For Bryan and Marsha Dora, Lucky the turtle is the devil in a half-shell. The only survivor of a fierce fire that killed 150 other animals at their pet shop in Frankfort, Indiana, in 2005, the red-eared slider turtle emerged from the inferno with the face of the devil on his shell. The heat gave the shell a new pattern, with Satanic eyes, lips, goatee, and devil's horns.

Baby Driver

A four-year-old boy drove his mother's car on a late-night trip to a video store. Although he was too small to reach the accelerator, the boy put the car into gear and the idling engine took him to the shop 400 yd (370 m) away in Sand Lake, Michigan. Unfortunately, the video store was shut and on his return journey the youngster hit two parked cars, and then reversed into a police car. His mother said that he had learned how to drive the car while sitting on her lap.

▶ Flushed Fish

Some of the oldest public lavatories in Paris, France, have been transformed into havens of wacky chic by introducing live goldfish into the fake plumbing!

Lofty View

Katya Davidson has a different view of the world than most people—the 15-year-old walks about her house on 32-in (80-cm) stilts, jumps rope on a bouncy ball 3 ft (1 m) high, and unicycles down to her local grocery store in Roseville, California. Her love of circus apparatus began when she was aged nine, and she got her first unicycle for Christmas.

Street Skiing

Olympic ski champion Jonny Moseley helped transform one of San Francisco's streets into the venue for a king-of-the-hill contest in September 2005. Trucked-in snow was dumped on two blocks of Fillmore Street, a section so steep that the sidewalks have staircases. The skiers raced down the run, which measured 400 ft (120 m).

On **November 25, 2004,** a robber took **$14,500** from a bank in FUKUOKA, JAPAN, but was so **overcome with guilt** that he *mailed the money back* with an *apology note* a week later!

Pension Imposter

After a Turkish mother died in 2003, her 47-year-old son, Serafettin Gencel, buried her in his basement and disguised himself as her for the following two years so that he could collect her retirement pension. He regularly visited the bank dressed in a woman's overcoat, headscarf, and stockings until employees became suspicious of his voice.

Serafettin Gencel, dressed as his dead mother, sitting in the bank where he drew her pension.

Pug Dressers

At Naples, Florida, there is an annual beauty contest, although it is not for people, but for pug dogs. The Pug o'ween event was started in 1998 by pug-owner Karen Coplin for those who like to dress up their pugs in fancy costumes.

Still Alive

Dona Ramona, from Sampues, Colombia, was still very much alive in October 2005, despite being wrongly declared dead on four separate occasions. Doctors defended their prognoses, saying that they were fooled because the 97-year-old kept slipping into a diabetic coma.

▶ Cyclops

A kitten named Cy, short for Cyclops, was born on December 28, 2005, in Redmond, Oregon, with only one eye and no nose. A ragdoll breed, sadly it survived for only a few hours.

Kicking Out

Twelve-year-old Michael Hoffman, a taekwondo black belt from Ann Arbor, Michigan, managed to kick a cushioned pad 2,377 times in a single hour in October 2005. He alternated between using his right and left leg every minute.

Key to Success

After a joke backfired and Arthur Richardson, of North Platte, Nebraska, ended up swallowing the key to his friend's truck, a doctor X-rayed Richardson's stomach and said that the key posed no danger to his health. But his friend still needed to use the truck. So they took the X rays to locksmith John Somers, who used the pictures to fashion a new key. Amazingly it worked in the truck!

Sand Painting

In October 2005, 70 schoolchildren created a sand portrait, measuring 85 x 59 ft (26 x 18 m), of Lord Nelson and the HMS *Victory* on the beach at Scarborough, England, to celebrate the 200th anniversary of the Battle of Trafalgar. They used half a ton of pigment, a quarter of a ton of sand, and over a mile of string to create the sand painting in ten different colors. Painting began at 9.30 a.m. and had to be completed before high tide at 7 p.m.

Slow Way

Paul Kramer took the slow way to his niece's wedding. He hopped onto his bicycle at his home in southern California on April 12, 2005, and pulled into his brother's driveway at North Olmsted, Ohio, 71 days and 4,250 mi (6,840 km) later.

Honey Trap

An estimated one million bees were living inside the walls of St. Mark United Church of Christ in Knox, Pennsylvania, in 2005. The problem became so serious that honey was oozing through the walls!

The entire town of **KIRUNA, SWEDEN**, is being **relocated** at a cost of more than **$2.5 billion** to save it *sliding* into the **abandoned iron mines** below.

Hypnotic Robber

A crook in Moldova found a new way of robbing banks in 2005—he put cashiers into a trance before making them hand over the money. With the hypnotist still at large, the country's bank clerks were warned not to make eye contact with customers.

Pigeon Fancier

In 2005, a Los Angeles, California, man was found to be sharing his house with 300 birds—dead and alive—including 120 dead pigeons. The man was reportedly often seen walking with his favorite pigeon.

◀ Inverted Feet

Wang Fang, from Chongqing, China, has inverted feet. She can still walk and run and successfully manages her own restaurant business.

Underwater Juggling
American performer Ashrita Furman juggles in an aquatheater in Kuala Lumpur among nurse sharks and 3,000 other marine animals. His personal best is juggling continuously for 37 minutes and 45 seconds at a depth of more than 13 ft (4 m).

INDEX

INDEX

ACKNOWLEDGMENTS

FRONT COVER AND TITLE PAGE Kevin Kolczynski/Universal Orlando/Reuters; 8–9 John Gress/Reuters; 10–11 (dp) DPA/Empics; 10 (b/l) & 11 (t/r, t/l, c, b/r & b/l) Crazy Horse memorial photos by Robb DeWall; 12 Hrywniak Bogdan/Empics; 13 (c) Paul Pikel; 14 (t, c/l & b) Masatochi Okauchi/Rex Features, (c/r) www.fuerrot.at/Rex Features; 15 David Lin/Reuters; 16 Norm Betts/Rex Features; 17 (t) Norm Betts/Rex Features, (b/l) Australian Customs Service/Reuters, (b/r) Rex Features; 20 Gavin Hansford/Image courtesy of Charles Robb and the Dianne Tanzer Gallery, Melbourne; 21 Fredrik Schenholm/Ultimate Freedom Photography; 22 George Whiteside; 23 (t) Yuriko Nakao/Reuters, (b) Phil Noble/Empics; 24–25 David Giles/Camera Press; 26 Randy Finch/Derek Maxfield/iceguru.com; 27 (t) Luray Caverns, (b) John Paul Brooke/Rex Features; 30 Solent News/Rex Features; 31 Skip Snow, The United States National Parks Service; 32 Dani Cardona/Reuters; 33 (t) Scott Wishart/Rex Features, (b) Camera Press; 34 (t) Paul Pikel, (b) Pacific Press Service/Rex Features; 35 Action Press/Rex Features; 36 (t) Simon Jones/Rex Features, (b/l & b/r) Lars Stroschen/Rex Features; 37 Sean Dempsey/Empics; 38–39 Sukree Sukplang/Reuters; 40 (c/l) Chaiwat Subprasom/Reuters, (r) Leon Schadeberg/Rex Features; 41 (l) Leon Schadeberg/Rex Features, (r) Chaiwat Subprasom/Reuters; 42 (t) Ben Phillips/Barcroft Media, (b) Craig Barritt/Barcroft Media; 43 (t) Malissa Kusiek/Empics, (b) Mark Mirko/Rex Features; 45 Moses Lanham; 46 (t) Indranil Mukherjee/AFP/Getty Images; 47 Will Burgess/Reuters; 50 (t) Barcroft Media, (b) John Gress/Reuters; 51 Natasha Veruschka; 52 (t) Camera Press, (b) Kimimasa Mayama/Reuters; 53 (t) Francois Lenoir, (b) Alexander Demianchuk/Reuters; 54–55 (dp) Jim McNitt; 54 (b/l) Jim McNitt; 55 (b/c) Jim McNitt, (b/r) CLY Creation; 56 (t) Ma Qibing/Camera Press, (b) Stuart Clarke/Rex Features; 57 Kai Pfaffenbach/Reuters; 60 (t) Chinafotopress/Camera Press, (b) Gary Roberts/Rex Features; 61 Simon Burt/Rex Features; 62 Incredible Features/Barcroft Media; 63 Doug Hall/Rex Features; 64 (t) Chip East/Reuters, (b) Claro Cortes IV/Reuters; 65 JulianCash.com; 66 Ben Phillips/Barcroft Media; 67 (t/l & t/r) Heather Insogna, (b) Toby Melville/Reuters; 68–69 Camera Press; 70–71 Norm Betts/Rex Features; 72 James Bodington/Reuters; 73 (t & c/r) John Gress/Reuters, (b/l) Arko Datta/Getty Images; 74 (t) Reuters, (b) Konstantin Postnikov/Camera Press; 75 Deborah Ann Duschl; 76–77 (dp) Ando Art; 76 (t/r) Aamir Qureshi/AFP/Getty Images, (c) Ando Art; 77 (t/r) Rex Features, (c/r) Ando Art; 78 (t) Historical Photo Archive Collection/Niagara Falls Public Library; 80 (c/l & b/l) Caricato/Rex Features, (r) Vano Shlamov/Getty Images; 81 (t/r) Laure A. Leber, (b/l) Dale Rio; 82 (t) Dibyangshu Sarkar/AFP/Getty Images, (b) J.P. Moczulski /Reuters; 84 (b/l & r) China Photos/Reuters; 85 Sipa Press/Rex Features; 86 East News/Getty Images; 87 (t & c) Shannon Stapleton/Reuters, (b) Alessia Pierdomenico/Reuters; 90 (t) China Newsphoto/Reuters, (c/r & b) Tobias Schwarz/Reuters; 91 Seth Wenig/Reuters; 92 China Newsphoto/Reuters; 93 (t) Michael Fresco/Rex Features, (b) Anthony Devlin/Rex Features; 94 Bobby Hunt; 95 Jim Mouth; 96 Rex Features; 97 (b/l) Emily Baron/Barcroft Media, (t/r) Tim Winborne/Reuters; 98–99 Mary Schwalm/Empics; 100–101 Paul Pikel; 102 (t) China Newsphoto/Reuters, (b) Anna Kelly; 103 (t) Romeo Ranoco/Reuters, (b) Rex Features; 104 (b) Stephen Hird/Reuters; 105 Rex Features; 106–107 (dp) M. Usher/Rex Features; 106 (t/l) Reuters, (t/r) Stringer/Reuters; 107 (t) Sam Barcroft/Barcroft Media; 110 (t) Sukree Sukplang/Reuters, (b) Incredible Features/Barcroft Media; 111 aCaseofCuriosities.com; 112 The United States National Parks Service; 113 (b) Gary Roberts/Rex Features; 114–115 Eliana Aponte/Reuters; 116 (t) Masatoshi Okauchi/Rex Features, (b) Christian Charisius/Reuters; 117 David Gray/Reuters; 120 (t) Rex Features, (b) Stewart Cook/Rex Features; 121 Claro Cortes IV/Reuters; 122 Thierry Roge/Reuters; 123 (t) Erik S. Lesser, (b) Fernando Cavalcanti/Reuters; 124–125 Claro Cortes IV/Reuters; 126 (t) China Newsphoto/Reuters, (b) Camera Press; 127 Henry Lizardlover; 128–129 Azulai/Rex Features; 130–131 www.robosaurus.com; 132 Joe Klamar/AFP/Getty Images; 133 (t) Iberpress/Barcroft Media, (b) Owen Humphreys/Empics; 134 Steve Holland/Empics; 135 Sam Barcroft/Barcroft Media; 136 (t) Mike Segar/Reuters, (b) Owen Humphreys/Empics; 137 Jason Kronenwald; 140 Toby Melville/Reuters; 141 seanwhite.net; 142 (t) Sam Barcroft/Barcroft Media, (b) Toru Yamanaka/Getty Images; 144–145 Nino Fernando Campagna; 146 Paul Ortiz; 147 (t) Barcroft Media, (b) Sam Barcroft/Barcroft Media; 149 (c/l) Paul Pikel; 150 (t) Bill Graham/Empics, (b) Fabrizio Bensch/Reuters; 151 Matt Slocum/Empics; 152 Thorsten Persson/Barcroft Media; 153 (t) Sebastian Derungs/Reuters, (b) Chris Ison/Empics; 155 Octane Creative; 156 (t) Tom Pringle/Cardiff SF, (b) Sena Vidanagama/AFP/Getty Images; 157 David Gray/Reuters; 158–159 Erik Aeder/Empics; 160–161 Terje Eggum/Camera Press; 162 (t) Joe Bowen, (b) Camera Press; 163 Michaela Rehle/Reuters; 164 China Newsphoto/Reuters; 166–167 (dp/t) Deutsche Press-Agentur/Empics; 167 (b) Camera Press; 170 Vince Bucci/AFP/Getty Images; 171 (t) Georges Christen, (b) Mirgain & Huberty and Georges Christen; 172 (t) Cheng Jiang/Camera Press, (b) Chris Ison/Empics; 173 China Newsphoto/Reuters; 174–175 China Newsphoto/Reuters; 176 (t) China Newsphoto/Reuters; 177 Dennis Rogers; 180 Michaela Rehle/Reuters; 181 Stevie Starr/Mike Malley; 182 (t) Bob Child/Empics, (b & dp) Sergio Moraes/Reuters; 183 (t/l & t/r) Randy and Mary Ellen Davisson; 184 James Keivom/Getty Images; 185 (t) Christine Shing-Kelly, (b) Tim Barnsley/Armidale Express; 187 Emiliano D'Andrea/Empics; 188–189 Sukree Sukplang/Reuters; 190 (l) Jerilyn Tabor, (r) Alison Slon; 191 Doug Levere; 192 Paul Carpenter; 193 (t/l) Chris Radburn/Empics, (b/r) Dougie Hendry/Rex Features; 194 Joe Jennings/Barcroft Media; 195 Troy Waters; 196 (t) Drahoslav Ramik/Camera Press, (b) China Newsphoto/Reuters; 197 Chie Morifuji/Reuters; 200 (t) Sutton-Hibbert/Rex Features, (b) Noah Berger/Empics; 201 (t) Scott Stewart, (b) Ken "Spear" Flick and Steve Santini; 202 (t) Deutsche Press-Agentur/Empics, (b) Andy Reed/Barcroft Media; 203 R. Clayton Brough and Eisenhower JHS; 204 Steve Bunn; 205 Dick Jones; 206 (t) Camera Press; (b) Canadian Press/Empics; 210 Poseidon Resort/Rex Features; 211 Allistair Mitchell/Reuters; 212 (t) Courtesy Patie Ventre/WCFO, Inc., (b) Ben Phillips/Barcroft Media; 213 David Bebber/Reuters; 214 Feature China/Barcroft Media; 215 www.voltini.com; 216 Gopal Chitrakar/Reuters; 217 (t) Barry Batchelor/Empics; (b) Thomas Peter/Reuters; 218–219 Eric Gaillard/Reuters; 220 www.24thcid.com; 221 (t/l), (t/r) & (b/r) www.24thcid.com, (b/l) Camera Press; 222 (t) Czech News Agency/Empics, (b) Richard Crease/Rex Features; 223 Israel Sun/Rex Features; 224 Jean-Christophe Verhaegen/Reuters; 225 (t) Rex Features, (b) Tao-Chuan Yeh/AFP/Getty Images; 226 (l) Jorge Silva/Reuters, (r) Norman Kent/Jump for the Cause/Reuters; 227 Jeff J Mitchell/Reuters; 228 Ognen Teofilovski/Reuters; 229 (t) Jay Cheng/Reuters, (b) National Taiwan University/Reuters; 230 (t) Marsha Ruff, (b/l) & (b/r) John Gomes/The Alaska Zoo; 231 David Gray/Reuters; 234 (t) Bogdan Cristel/Reuters; 235 Mark Lennihan/Reuters; 236 Alastair Grant/Empics; 237 www.humancannonball.us; 240 (t) & (dp) Livio De Marchi, (b/l) Barcroft Media; 241 (t/r) & (c/r) Barcroft Media; 242 (t) Czech News Agency/Empics; (b) Noboru Hashimoto/Reuters; 243 Reuters; 244 (t/l & t/r) Christie Presti/The Karate Chimps (sm); 245 (t/l) & (t/r) Xavier Lhospice/Reuters, (b) IHLAS News Agency/Reuters; 246 (t) Traci Allen/Empics; (b) Chinafotopress/Camera Press; 247 Vincent Thian/Empics.

Key: b = bottom, c = center, dp = double page, l = left, r = right, t = top

All other photos are from MKP Archives, PhotoDisc, and Ripley's Entertainment Inc.
Every attempt has been made to acknowledge correctly and contact copyright holders and we apologize in advance for any unintentional errors or omissions which will be corrected in future editions.

The front cover shows Ryan Oman taking part in a preview of the "Fear Factor Live," which is based on the hit NBC TV show "Fear Factor," at Universal Studios theme park in Florida.